A MODERN MOSAIC

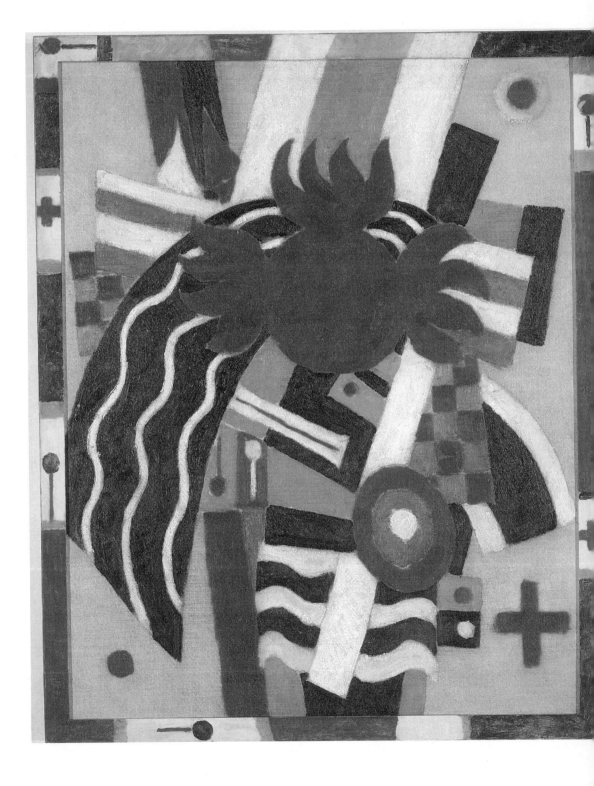

A MODERN MOSAIC

Art and Modernism in the United States

EDITED BY TOWNSEND LUDINGTON

Assistant Editors: Thomas Fahy & Sarah P. Reuning

THE UNIVERSITY OF NORTH CAROLINA PRESS Chapel Hill & London

© 2000 The University of North Carolina Press

All rights reserved

Set in Monotype Garamond by Keystone Typesetting, Inc.

Manufactured in the United States of America

The paper in this book meets the guidelines for permanence
and durability of the Committee on Production Guidelines
for Book Longevity of the Council on Library Resources.

Maren Stange's essay, "Illusion Complete within Itself:
Roy DeCarava's Photography," has appeared in slightly
different form in the Yale Journal of Criticism 9, no. 1
(Spring 1996): 63–92.

Library of Congress Cataloging-in-Publication Data

A modern mosaic: art and modernism in the United States /
edited by Townsend Ludington; assistant editors, Thomas
Fahy & Sarah P. Reuning.

p. cm.

Includes bibliographical references and index.

ISBN 0-8078-2578-6 (alk. paper)—

ISBN 0-8078-4891-3 (pbk.: alk. paper)

1. Modernism (Art)—United States. 2. Arts, Modern—
20th century—United States. 3. Popular culture—
United States—History—20th century. I. Ludington,
Townsend, 1936–

NX504.M584 2000

709'.73'09041—dc21 00-064843

04 03 02 01 00 5 4 3 2 1

CONTENTS

A section of color plates follows page 216.

ACKNOWLEDGMENTS

Creating a book such as *A Modern Mosaic* requires the cooperation of many people. In particular, I would like to acknowledge the patience and goodwill of the fourteen contributors to the volume. The intelligent work of Thomas Fahy and Sarah P. Reuning, assistant editors, was essential to complete the project, as was that of David Perry, Pamela Upton, and Mark Simpson-Vos, our editors at the University of North Carolina Press. Stevie Champion brought order to our manuscript. Richard Hendel did a superb job of designing the book. I thank them all.

Thanks also to the numerous people who helped us obtain the many illustrations, which I trust make the volume an American Studies venture because of what it shows as well as because of what it tells.

Townsend Ludington
Chapel Hill, North Carolina
March 2000

TOWNSEND LUDINGTON

..

Introduction

Taken together the essays in this volume offer an interdisciplinary study of the modernist movement as found in American literature, painting, sculpture, music, architecture, dance, photography, and film during the period from the late nineteenth century to the present. *A Modern Mosaic* is a study, but not an assertion, of the exact nature of modernism, the definition of which has become an industry during the past several decades. What can be agreed on is that the ideas of modernism and the modern things that surround us such as automobiles, electronic devices, and a good deal of art and architecture are very much with us. Modernism, in fact, has dominated the last one hundred years as has no other movement. Some might argue that it is too amorphous to be called a movement, but the artists, sculptors, writers, photographers, filmmakers, dancers, and architects who have practiced their trades since the early twentieth century would protest adamantly, and that includes even the substantial numbers opposed to something they believed was decadent, immoral, and certainly negative.

"On or about December 1910, human character changed," Virginia Woolf famously asserted about the advent of modernism.[1] No one believes that all of humanity changed in one fell swoop, but what did occur was that artists, sculptors, and so forth became aware of a movement afoot; for many of them, "the New" that it represented expressed what they felt as they strove to break from Victorianism in its many forms. Old truths came to seem hollow in the face of modern technology and industry, urban squalor had long since become a reminder that laissez-faire capitalism was not an unmitigated good, and the various conflicts of imperialist nations had already made people aware of the horrors of modern warfare before the guns of August 1914 began to bring home the fact that killing on a massive scale was going to be a part of the modern era.

"Make it new," blared Ezra Pound, and a generation of Americans took heed,

but they would have even if he had not worked assiduously for modernism.[2] Americans had many European examples: Paul Cézanne, Pablo Picasso, and Georges Braque, for instance, were but three of the artists who had a profound influence. Max Weber, Marsden Hartley, John Marin, Georgia O'Keeffe, and other painters saw the Europeans' works, understood them, more or less, and wove into their own efforts the elementalism of Cézanne and the simultaneity and three-dimensionality of Picasso and Braque (Plates 1 and 2). Modernists in one field influenced the new generation in other mediums. Cézanne, for example, not only affected visual artists; he affected Gertrude Stein, for one (Plate 3), who early on bought his paintings, explained them later to others such as Ernest Hemingway, and drew from them in her own avant-garde writing. Writer John Dos Passos, whose best works of the 1920s and 1930s—*Manhattan Transfer* (1925) and the trilogy *USA* (1930–36)—were as modernist as any by an American, wrote an introduction in 1930 to his translation of a long poem by French poet Blaise Cendrars. Cendrars's work, Dos Passos asserted,

> was part of the creative tidal wave that spread over the world from the Paris of before the last European war. Under various tags: futurism, cubism, vorticism, modernism, most of the best work in the arts in our time has been the direct product of this explosion, that had an influence in its sphere comparable with that of the October revolution in social organization and politics and the Einstein formula in physics. Cendrars and Apollinaire, poets, were on the first cubist barricades with the group that included Picasso, Modigliani, Marinetti, Chagall; that profoundly influenced Maiakovsky, Meyerhold, Eisenstein; whose ideas carom through Joyce, Gertrude Stein, T. S. Eliot (first published in Wyndon Lewis's "Blast"). The music of Stravinski and Prokofieff and Diageleff's [*sic*] Ballet hail from this same Paris already in the disintegration of victory, as do the windows of Saks Fifth Avenue, skyscraper furniture, the Lenin Memorial in Moscow, the paintings of Diego Rivera in Mexico City and the newritz styles of advertising in American magazines.[3]

We probably would place futurism, cubism, and vorticism under the more general rubric of modernism; nevertheless, Dos Passos's point was well taken: the modernist movement was all-pervasive and affected almost every aspect of twentieth-century culture, which, of course, *A Modern Mosaic* makes apparent.

Although this volume is not a history, it has a rough chronology about it. Thus, Robert Cantwell's "White City Elegy" takes us back to the late nineteenth century as it examines the Chicago Exposition of 1893, an event that its organizers intended to be a celebration of the past in the belief that the civilization of the United States marked the apex of all that had come before. "Greece lives, but Greece no

more!" the thoroughly traditional poet Richard Watson Gilder wrote to celebrate the "White City." For him the exposition marked a new blooming of "the undying seed" that had been blown westward to America, "a veiled and virgin shore!" "Ah! happy West," he exalted, "Greece flowers anew, and all her temples soar!"[4] They soared briefly in Chicago, but as Cantwell points out, the buildings were sheathed in staff, a fiber and plaster material that literally began to melt away on being applied to the frames of the pseudo-Greek edifices. "The White City was only a mock-up," he notes, "perplexingly suspended between reality and representation. . . . in many respects a simulacrum formally indistinguishable from its postmodern counterparts in theme parks, shopping malls, and redeveloped urban centers." Still a distance from such "postmodern counterparts," Carl Sandburg's 1914 poem "Chicago" suggests how far toward modernity that city had come some two decades after the White City. Not steeped in the issues that would affect his more intellectually sophisticated contemporaries such as T. S. Eliot, Ezra Pound, Wallace Stevens—the list goes on and on—Sandburg nevertheless giddily exalted the new city he saw before him, admiring it—with good American optimism, one might observe—as "Hog Butcher for the World, / Tool Maker, Stacker of Wheat, / Player with railroads and the Nation's Freight Handler; / Stormy, husky, brawling / City of the Big Shoulders."[5] Like artists of the Ashcan School who were painting American cities at about the same time, Sandburg knew what was the landscape of the emerging modern nation; but they had an inherent optimism that differentiated them from Eliot, for instance—one has only to think of the London of his early poetry—or artist Max Weber, whose 1915 cubist work *Rush Hour* (Plate 4) is much more ambivalent about the urban scene than are most of the works of the Ashcan artists.

Dealing with an event chronologically prior to what is generally considered the era of high modernism in the United States—the 1910s to the 1960s and beyond—Cantwell perceives the threads of modernism and even postmodernism woven into one late nineteenth-century episode. The other essays work similarly: each fits into the continuum of the twentieth century while always touching thematically on the issue of modernism in practice. Jon Michael Spencer's essay about "Modernism and the Negro Renaissance" engages the debate about how successful the renaissance was as a modernist movement, and he concludes that it was more successful than not. The work of writers, artists, composers, critics, and performers such as Countee Cullen, Langston Hughes, Arna Bontemps, Zora Neale Hurston, Aaron Douglas, William Grant Still, W. E. B. Du Bois, Alain Locke, Paul Robeson, and Marian Anderson made Americans aware of the vibrant eclecticism in African American culture. No longer did the African American artist have to engage in what critic Houston Baker termed the "mastery of form," that is, "manipulating the stereotypes whites had of blacks." As a result of the renaissance

years artists could engage in the " 'deformation of mastery'—the straightforward debunking of white people's racist radicalism,"[6] something seen in William H. Johnson's *Street Life, Harlem* (Plate 5).

Spencer agrees with commentator Edwin Embree that "the triumph of the first half of the century involved the transformation of the minds of whites to the point where no intelligent white person could believe any longer that blacks were their biological inferiors," a matter Thomas Fahy considers in his examination, "Exotic Fantasies, Shameful Realities," of the freak show in the late-nineteenth- and early-twentieth-century United States. Although white people still resented growing racial and ethnic minorities as the twentieth century progressed, they could no longer assuage their feelings with crude—and cruel—representations of these minorities. "In part," notes Fahy, "the Harlem Renaissance had helped facilitate a greater recognition of oppression, for its artistic accomplishments challenged the devaluing of black individuals and culture." By the 1940s and after, the freak show was attacked in literature "for perpetuating abusive treatments of nonwhites." Modernist literature, that is, was a significant force in causing social change. No longer could a P. T. Barnum degrade an African American by exhibiting him as "Congo, the Ape Man" or "The Wild Dancing South African Bushman." Rather, a writer such as Ralph Ellison could engage in the "deformation of mastery" and satirize white stereotyping, and photographer Roy DeCarava could undertake a project about the people of Harlem that was " 'serious,' 'artistic,' and universally 'human,' " Maren Stange notes in her essay about DeCarava's photography. That the "formal autonomy" he and other modernists dreamed of has not been achieved is no surprise; it remains "a distant ideal."

The last two essays, those about film by Lucy Fischer and Ray Carney, demonstrate how that medium draws on themes at the core of modernist thought at midcentury and after. Industrialization, urbanization, immigration, changes in ideas about religion and natural law, and the growth of science as a dominant influence in our lives have had a profound effect on our culture, moving it away from the sureties of Victorianism to the doubts of the modern age. Fischer, in "The Savage Eye: Edward Hopper and the Cinema," quotes from *All That Is Solid Melts into Air: The Experience of Modernity* by Marshall Berman. Although he was defining the late-nineteenth-century cultural landscape of Europe, she observes that Berman might well have been speaking about "the world contained in the canvasses of Edward Hopper," one of the most recognized—and recognizable—modernist painters in the United States. Berman saw "the highly developed, differentiated and dynamic new landscape" as one of

> steam engines, automatic factories, railroads, vast new industrial zones; of teeming cities that have grown overnight, often with dreadful human consequences; of daily newspapers, telegraphs, telephones and other mass media, commu-

nicating on an ever wider scale; of increasingly strong national states and multi-national aggregations of capital; of mass social movements fighting these modernizations from above with their own modernizations from below; of an ever expanding world market embracing all, capable of the most spectacular growth, capable of appalling waste and devastation, capable of everything except solidity and stability.[7]

Ray Carney writes about "Two Forms of Cinematic Modernism," idealist and pragmatic. Whereas idealist, visionary film holds to "quick, summary, shorthand truth," pragmatic works provide "lumpy, rough, dirty knowledge"—"hazy expressions" is how Carney defines their truths, and he notes that "the pragmatic narrative imagines a somewhat loose universe, with room for inconsistent, unique, and mutable expressions." "Life is lived minute by minute in the present, not from the perspective of eternity,'" Carney asserts, in effect describing the existentialism at the center of modernism. Lest we think he is actually describing postmodernism, he adds toward the end of his essay,

> It is equally important to emphasize the chasm separating the pragmatic position from the skepticism and suspension of value judgments implicit in postmodern understandings. In the open-endedness and sprawl of their narratives, in their rejection of monotonic paths through experience and their relish of different angles of vision, pragmatic artists are not arguing (in the postmodernist vein) that there are no truths, but that there are many. The pragmatist replaces truth with truths—plural truth replacing unitary truth, present truth leaving past truth behind, your truth compared with my truth.

What is important to understand is that there *are* truths, and Carney's pragmatist filmmakers, like his idealists, are modernist in that they construct their works of art as assertions about what is knowable, hence true, no matter how partially or fleetingly. "The Modernist world-view," wrote Daniel Joseph Singal, "begins with the premise of an unpredictable universe where nothing is ever stable, and where accordingly human beings must be satisfied with knowledge that is partial and transient at best." It "eschews innocence and demands instead to know 'reality' in all its depth and complexity, no matter how incomplete and paradoxical that knowledge might be, and no matter how painful."[8]

And painful it often is: God is frequently not in His heaven, nor are things right with the world. Although he was discussing literature, Irving Howe in an introduction to a volume of essays entitled *Literary Modernism* described characteristics of the movement that apply to modernism generally.[9] Among them is that "The Problem of Belief Becomes Exacerbated, Sometimes to the Point of Dismissal." As in the films Ray Carney examines, Howe saw existentialism in modern literature; also as in the films, Howe noted that "A Central Direction in Modernist

Literature is Toward the Self-Sufficiency of the Work." When life is a matter of shifts and partial truths, the work of art, the architecturally striking building, or many another cultural artifact becomes the creator's assertion of self. "We are freeing ourselves of the impediments of memory, association, nostalgia, legend, myth, or what have you, that have been the devices of Western European painting," declared, in 1948, abstract expressionist painter and critic Barnett Newman, whose mature work gives little hint of any such devices (Plate 6). His group of artists, which includes most famously Jackson Pollock, chose not to make "*cathedrals* out of Christ, man, or 'life,' [and] are making it out of ourselves, out of our own feelings. The image we produce is the self-evident one of revelation, real and concrete, that can be understood by anyone who will look at it without the nostalgic glasses of history."[10]

Not that most modernists did away with history, as Newman might have been suggesting. Rather, they perceived it in new ways, as in the case of the writers Lucinda MacKethan considers in "Barren Ground, Mother Earth: Female Embodiments of Southern Modernism." These writers present their southern women characters not as "fruitful," maternal figures but as threatening, "women whose potential for both fecundity and barrenness represents a confusing, threatening challenge to male identity, power, and creativity." MacKethan writes about the high culture represented in works by T. S. Eliot, Eudora Welty, William Faulkner, and James Agee. But the modernist themes she finds there are in popular culture as well, which she demonstrates in discussing Margaret Mitchell's *Gone with the Wind*.

Her inclusion of the film version of Mitchell's remarkably successful novel leads us to an interesting point: modernism is not just a high culture matter; the modern and modernism pervade popular culture, which, after all, is hardly surprising when we recognize that all of our cultural expressions, high and low, emanate from the relationship between the creator and his or her community. The artist may tend toward what Marshall Berman would call "the modernism of withdrawal," that espoused by Barnett Newman, for example, or by "serious" writers such as Eliot, Saul Bellow, Ralph Ellison, or any number of other literary giants. "When one cannot choose but be ascetic, when the self can only be celebrated as it is excluded from society, or as it is exercised and admired in a fantastic one, we then, I think, do not have much reason to be cheery," declared Philip Roth in an essay entitled "Writing American Fiction" (1961). Roth was stupified, sickened, and infuriated by the reality of American culture. "The actuality," he asserted, "is continually outdoing our talents, and the culture tosses up figures almost daily that are the envy of any novelist."[11] Well, perhaps, we might respond, but such a vision, or one akin to it that sees modernism "as an unending permanent revolution against the totality of modern existence," to quote Berman again, is not the only modernism. He recognized that there is also an "affirmative vision of modernism" that developed in the 1960s and became the stance of pop art.[12]

Certainly pop art emerged in the 1960s as one significant strain of artistic expression, and its playfulness made it a part of postmodernism, but affirmation was hardly that new. Joan Shelley Rubin points out in her essay, "Modernism in Practice"—about the use of the "new poetry" in popular readings, that it was turned into something positive, even though, as in the case of Edwin Arlington Robinson, he "was self-consciously in revolt against the unnatural syntax and safe sentiments of late Victorian idealists. His dark vision of the human condition and his sense of the emptiness of old rules and pieties marked him as an early modernist." But the Literary Guild, a thoroughly bourgeois, money-oriented operation, drew freely from his work; so, too, did Methodist minister William L. Stidger from the poetry of another modernist, Edna St. Vincent Millay. Neither the guild nor Stidger was interested in conveying any dark vision of the human condition. Each used the new poetry in an attempt to uplift the middle classes and, in the case of the guild at least, to make a profit.

Modernism is such an all-encompassing thing that it contains the positive as well as the negative. Hence a number of the essays in *A Modern Mosaic* describe the exuberance that was part of modernism even in the 1930s, the era of the Great Depression. Writing about the "Dances of the Machine," John F. Kasson shows how "machine production drummed irresistible new beats and demanded new patterns of highly coordinated human movement that affected the entire society and became one of the defining elements of modernity." Kasson believes that "mechanical production in the early twentieth century stimulated not only profound changes in the workplace but also what may be regarded as varieties of modernism in the popular arts." Henry Ford's assembly line, Charlie Chaplin's film *Modern Times*, Fred Astaire's dancing, and Busby Berkeley's film spectacles all reflect the imposition of "the values of speed, standardization, interchangeability, uniformity, division of labor, and specialization of task."

The machine movement was one of the major outcroppings of modernism, Kasson demonstrates. Another example of this is the work of George Antheil, whose *Ballet Mécanique* might be considered one of the most extreme expressions of modernist enthusiasm to be created by an American. A native of Trenton, New Jersey, he became an expatriate "dramatically affected by international impulses— especially those of the machine movement," notes Carol Oja. First performed in 1927 in New York City, the ballet reflected "the new" that is fundamental to modernism. Antheil was much affected by Dada, the post–World War I avant-garde movement that sprang out of Europe and whose leaders such as Francis Picabia and Marcel Duchamp presented artistic experiments "amidst the chaotic swirl of ideologies and 'isms' that fed into Dada, ranging from futurism to the cubism of artists as different as Pablo Picasso and Max Weber." Antheil's *Ballet*, judged a failure at the time of its first performance, nevertheless has had a long

shelf life and is one of the most remembered of the various Dada experiments, a composition that celebrates the Machine Age and with its chaotic, sometimes absurdist style is a precursor to the postmodernism that came later, fueled by a hatred of what the Machine Age had wrought: wars, degradation, urban miseries, and conformity that 'belittled individuals.

As Kasson and Oja make clear, American modernism often displayed an exuberance that we tend to overlook. Nowhere is that more apparent than in the New Deal art projects of the 1930s, a decade, William Leuchtenburg points out in "Art in the Great Depression," that is frequently "deplored as 'the dreary aesthetic stepchild of American art.'" Such is hardly the case; government-sponsored programs generated a remarkable amount of art in many forms: paintings, sculpture, and so forth. A New Deal muralist declared that the programs "kept the arts alive, . . . [and] turned what could have been a dead period into something very vital, vibrant." Established painters could continue their work and develop; new artists did not have to drop their work. All in all, modernism in the visual arts flowered when artists gave expression to such movements as surrealism, magic realism, and precisionist abstraction, and soon-to-be major figures such as Jackson Pollock had the freedom to develop, in his case into the leading artist in the post–World War II movement of abstract expressionism. Had the government programs not existed, the movements and their ideas would surely not have emerged so quickly, if at all; American art would have had less opportunity to develop its distinctive qualities; and the nation would never have benefited from the vast amount of public work that came to grace public buildings throughout the nation.

Every bit as important for the arts and as a way of coming to understand American culture better was the Farm Security Administration (FSA) program for photographers. Miles Orvell, discussing the work of John Vachon in "Portrait of the Photographer as a Young Man," observes that "The FSA project was a crucial part of the pivotal turn of American twentieth-century culture—toward a central government's vision of reshaping habits of individualism through agricultural engineering and technocratic control, through social intervention and the rational employment of philanthropic surveillance." Vachon's work is less well known than that of photographers such as Walker Evans, Dorothy Lange, and Arnold Rothstein, but in fact he was every bit their equal in capturing "the honest presentation and preservation of the American scene," to quote him. Rather like the other great photographers of the FSA era, Vachon in his photographs and his writings conveys "the sense that his own existence is wrapped in the totality of modern civilization, its rhythms, its pleasures, its sights and sounds, its comforts. Yet deep within, not easily erased by the emoluments of the big money, there is an abiding sense of detachment and alienation."

The New Deal made public art a part of our national culture. Not everyone

believed that this was an unmitigated benefit, of course. Such is the point of Casey Nelson Blake's essay, "Between Civics and Politics: The Modernist Moment in Federal Public Art," which examines the tensions during the last several decades between those who advocated government-funded public art and those who did not. In the spirit of the New Deal and in a generally liberal moment in the life of America, works by modernists such as sculptor Alexander Calder were funded by local and federal programs for the arts. The city of Grand Rapids, Michigan, proudly accepted a Calder piece in 1969. Five years later amid great hoopla Chicago dedicated another Calder work, this one bigger than the Grand Rapids piece. The ceremony had all the excitement and American boosterism of the imaginary celebration in the musical *The Music Man*. Seventy-six trombones did not lead the parade, but "thirteen circus wagons, eight clowns, ten unicyclists, bands, elephants, and countless other marchers, including Ronald McDonald and a man in a gorilla suit, made their way down State Street to the sculpture," according to Blake. Calder was part of the spectacle; he rode in "an enormous Schlitz beer wagon pulled by forty horses" as Chicago made the most of its "Whatchama-Calder."

Times change, however, and in 1989 the General Services Administration (GSA), having installed in lower Manhattan a minimalist steel sculpture entitled *Tilted Arc* by Richard Serra, ordered it removed, marking, in effect, the end of the "modernist moment in federally funded public art." What a shame, one might respond, for such extravaganzas as the Chicago celebration brought art to everyone and removed its elitist stamp. But "the very presence of modernist public arts works politicized the aesthetics of public spaces. . . . The result was a political crisis of the liberal-modernist project in public art that has still not been resolved." By 1993 the situation was such that the GSA turned down the proposal for an abstract sculpture by Nizette Brennan for a federal building in Knoxville, Tennessee. Brennan responded with " 'Knoxville Flag,' a limestone Stars and Stripes" that, Blake observes, "signals the replacement of modernism as an official style by a new patriotic realism, dressed up in the rhetoric of conservative identity-politics." Times will change again, no doubt, but whether the mind of the American public can accept avant-garde art such as the best modern work is certainly unclear.

The issue of what is American in modernism is a constant in these essays. Not all of them dwell on it, but an at least unspoken theme that runs through the essays is that American modernism draws on a culture seen increasingly to be distinct from Europe's. Thus Antheil, while embracing Europe, wrote a ballet that emphasized American technology; the Literary Guild's and Reverend William Stidger's appropriations of modernist poetry are manifestations of American middle-class morality, and so forth. So, too, is modern dance distinctly American, as Randy Martin demonstrates in "Modern Dance and the American Century." This dance "brings into focus the means, the very techniques, through which the modern self

is made," and its "coming into being is . . . a story of the century in which the United States itself comes into world prominence."

A Modern Mosaic is about how the modern self is made and how it exists in the twentieth century. The volume makes no attempt to discuss every aspect of modern American culture; an encyclopedia of modernism would be thousands of pages long. What this volume does is remind us that modernism has been and remains at the center of our collective being. To quote Marshall Berman one more time:

> The culture of modernism will go on developing new visions and expressions of life: for the same economic and social drives that endlessly transform the world around us, both for good and for evil, also transform the inner lives of the men and women who fill this world and make it go. The process of modernization, even as it exploits and torments us, brings our energies and imaginations to life, drives us to grasp and confront the world that modernization makes, and to strive to make it our own.[13]

Often seen as a lonely and alienating thing, modernism is also enlivening, and if it causes conformity in ways these essays demonstrate, it has broken people free from the bonds of earlier conformities. And so we go forward, not "borne back ceaselessly into the past" as Scott Fitzgerald saw it, but experimenting with new forms, coping with change, and more than occasionally discovering "the pleasures of merely circulating," as the great modernist poet Wallace Stevens would have it.[14]

NOTES

1. Woolf, "Mr. Bennett and Mrs. Brown," 320.
2. Pound, "Make It New."
3. Dos Passos, Translator's Foreword, in Cendrars, *Panama*, vii–viii.
4. Gilder, *Poems*, 201–2.
5. Sandburg, *Harvest Poems*, 35.
6. See Jon Michael Spencer's essay, n. 11 (Baker), in this book.
7. Berman, *All That Is Solid*, 18–19.
8. Singal, "Towards a Definition," 15–16.
9. Howe, "Idea of the Modern."
10. Newman, *Readings in American Art*, 135.
11. Roth, "Writing American Fiction," 224.
12. Berman, *All That Is Solid*, 30–31.
13. Ibid., 348.
14. Fitzgerald, *The Great Gatsby*, 182; Stevens, "The Pleasures of Merely Circulating," *Poems*, 54.

BIBLIOGRAPHY

Baker, Houston A., Jr. *Modernism and the Harlem Renaissance*. Chicago: University of Chicago Press, 1987.
Berman, Marshall. *All That Is Solid Melts into Air: The Experience of Modernity*. New York: Penguin, 1988.

Dos Passos, John. Translator's Foreword. In Blaise Cendrars, *Panama, or the Adventures of My Seven Uncles*. New York: Harper, 1931.

Fitgerald, F. Scott. *The Great Gatsby*. New York: Scribner's, 1953.

Gilder, Richard Watson. *The Poems of Richard Watson Gilder*. Boston: Houghton Mifflin, 1908.

Howe, Irving. "The Idea of the Modern." In Howe, comp., *Literary Modernism*, 11–40. New York: Fawcett, 1967.

Newman, Barnett. "From *Tiger's Eye*, No. 6 (December, 1948)." In Barbara Rose, ed., *Readings in American Art, 1900–1975*, 134–35. New York: Praeger, 1975.

Pound, Ezra. *Make It New*. New Haven: Yale University Press, 1935.

Roth, Philip. "Writing American Fiction." *Commentary* 31 (March 1961): 223–33.

Sandburg, Carl. "Chicago." *Harvest Poems*. New York: Harcourt, Brace and World, 1960.

Singal, Daniel Joseph. "Towards a Definition of American Modernism." *American Quarterly* 39 (Spring 1987): 7–26.

Stevens, Wallace. *Poems*. New York: Vintage, 1959.

Woolf, Virginia. "Mr. Bennett and Mrs. Brown." *Collected Essays*. Vol. 1. New York: Harcout, Brace and World, 1967.

ROBERT CANTWELL

. .

White City Elegy

Modern and Postmodern at the World's Fair

Look on my works, ye mighty, and despair.
—Percy Bysshe Shelley, "Ozymandias"

Theree was much engineering but little "architecture," at the White City of 1893—not, at least, unless structures made to dissolve, to be dismantled, sold, and carried away in pieces can be counted as architecture. "Buildings in their proper sense they do not pretend to be," wrote the official historian of the World's Columbian Exposition, Hubert Howe Bancroft. Instead, "we have what may be termed so many architectural screens."[1]

Any architect must make concession to and reconcile the transitory nature of earthly materials, but few frankly capitulate to it for the sake of greater imaginative license. It was such a capitulation that erected and defined the White City of 1893. What British traveler James Fullarton Muirhead called its "pathetic transitoriness" still sighs elegaically in the deteriorating surfaces of our own civic infrastructure, especially where, as in the few traces of Daniel Burnham's City Beautiful that survive on Chicago's lakefront, the grandiose imperiality of the fin-de-siècle commercial city succumbs to the prolonged melancholy expiration of the millennial dreams that gave rise to it.[2]

That melancholic strain French journalist Paul Bourget marked on his own departure from the White City. "All white they had been that morning, the morning of my farewell," he wrote of the buildings, "white as a marble town outlines against a sky untarnished as themselves." He continued:

> How they stood out, still white, in the dense enshrouding fog; but it was the whiteness of a phantom village, whose contours were merged in mist, whose domes, colonnades and towers lost all solidarity—a dreaming vision of architecture, vague scenery about a phantom crowd. . . . In the last glance I gave that fading, shifting panorama, it seemed to me . . . I had experienced in a few short hours the extremes of that city's fascination: first, its dazzling brilliancy, then its

fading gloom. . . . I had realized the melancholy touch with which every human masterpiece requires to make it truly beautiful—effacement in the past.[3]

The meaning of the White City is bound up with this odd contradictory fusion of monumentality and ephemerality, of grandiosity and sham, that the design and execution of the exposition buildings conscientiously revealed in scales apparently enlarged beyond the limits of physical possibility, in styles capriciously detached from place and time, and, primarily for this discussion, in a fiber and plaster sheathing material called "staff."

"Great is 'staff!'" exclaimed architectural critic Clarence Clough Bird. "Without staff this free-hand sketch of what the world might have as solid architecture, if it were rich enough, would not have been possible. . . . A workman may walk to his job with a square yard of the side of a marble palace under each arm and a Corinthian capital in each hand. While it is a little green it may be easily sawed and chiseled, and nails are used as in pine. . . . Great is staff!"[4]

Staff introduced into White City architecture a dramatically accelerated transitory element apart from which no other aspect of the buildings could really be understood or experienced. The coordinated spatial inflation, stylistic riot, and temporal acceleration of the White City confounded customary spatial-temporal assumptions; disordered the relation of the visitor's body to the built environment; eroded the distinction between exterior and interior, public and private, civic and commercial space; and offered to reverse the flow of historical time.

Architect Daniel Burnham, the exposition's chief of works, conceived of the White City buildings as "great architectural sketches, carried out with sufficient elaboration and finish to give an effect of solidity and magnificence." The key word here is "effect." Architectural critic of the period Montgomery Schuyler captured the moral basis of this emphasis; he attributed the success of what he called "cloud-capped towers and the gorgeous palaces" to "unity, magnitude, and illusion." Classical forms, having "lost touch with their origins, become simply forms . . . used without a suggestion of any real structure or any particular material." Their essence, he noted, was insubstantiality; "inordinate dimensions" distracted from the empty gesture. The buildings "have realized in plaster," he said, "the illusion of monumental masonry, a painter's dream of Roman architecture."[5]

The White City raises a number of issues that bear on the complex interrelations among modernity and postmodernity, modernism and postmodernism. Apart from the design contributions of any individual architect to it, and apart from the considerable feats of ironwork, steel manufacturing, engineering, and bureaucracy required to carry it out, the White City was only a mock-up, perplexingly suspended between reality and representation. It summoned to perception a scene that, though constituted in its particular elements by what had been seen before in the world, could never have existed nor could exist in it, in many respects a sim-

ulacrum formally indistinguishable from its postmodern counterparts in theme parks, shopping malls, and redeveloped urban centers.

Bancroft saw in the White City "the forums, basilicas, and baths of the Roman empire, the villas and gardens of the princes of the Italian renaissance, the royal court-yards of the palaces of France and Spain"; art historian W. Lewis Fraser, "a union of Rome, Palmyra, Athens, Venice, Constantinople," but what in reality was "only a collection . . . of plaster shells." Here was material sufficient, added painter Hopkinton Smith, "for all the painters of the earth, with almost every variety of subject." James Whistler "could float in Venetian gondolas along the edges of white palaces that are as real in color, form, and water reflections, as their beloved Bride of the Adriatic. Tadema could find porticos, loggias, and courts—backgrounds for his figures—infinitely more perfect and useful in his studio than could be discovered in a year's travel along the Mediterranean."[6]

This confusion of representation and referent, signifier and signified, throws the White City squarely into the problematics of periodization associated with the idea of the postmodern. Insofar as it conjoined "transient, fleeting and contingent" materials with architectural ideas supposed to be "eternal and immutable,"[7] the White City belongs, as art, to modernism, at least as Charles Baudelaire thus formulated it; insofar as it called on advanced techniques of steel frame engineering, quasi-military management, and top-down corporate administration to do so, it was outspokenly modern; insofar as it presented a systematic heterogeneity of stylistic allusion, quotation, and metaphor, much of it imitative and all of it simulated, it was curiously postmodernist. With a convergence of races, tribes, states, and nations, moreover, the exposition looked forward to the social condition of postmodernity, with its general collapse of boundaries and its pervasively touristic social surface (Fig. 1).

Monumentality and ephemerality both have their meaning, not only as possible ways of manipulating space or matter, but also as temporal projections embodied in those manipulations. Monumentality, of course, implies permanence, invested in structures and materials; but ephemerality in architecture belongs mainly to modeling, sketching, or representing, as we find it in the grottoes, ruins, cottages, and temples of a landscape garden or on the stage. Were such representation simply a matter of appearances, however, as in art formally so marked, its nature would be comparatively unproblematic; but at the White City, as in the landscape garden, perception and apprehension are squarely at odds, for we have in effect stepped into the frame and become art ourselves. "The aesthetic sense," wrote Muirhead, is "as fully and unreservedly satisfied as in looking at a masterpiece of painting or sculpture, and at the same time soothed and elevated by a sense of amplitude and grandeur such as no single work of art could produce."[8] What appears to be for all time or utterly out of time is demonstrably of the moment, as

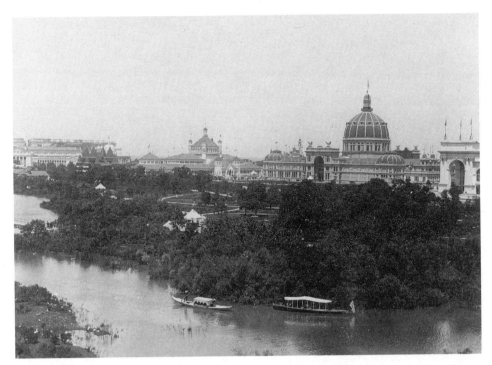

Figure 1. Administration Building from across the Wooded Island. Liberal Arts Building is on the right and Fisheries Building on the left. (Chicago Historial Society)

transient as sugar candy; what is manifestly artificial is nevertheless obdurately real; out of a cosmetic expedient arises a transcendent beauty.

"There was an air of unreality about this congregation of edifices," Bancroft averred, "so strange in dimensions and design."[9] H. C. Bunner echoed his sentiment:

> Perhaps the first thing that would strike a stranger entering the World's Fair grounds in the summer of 1892 would be the silence of the place, the next the almost theatrical unreality of the impression by the sight of an assemblage of buildings so startlingly out of the common in size and form. . . . It is not only the grouping of the huge white and pale-yellow buildings that gives this impression, although it is hard enough to believe in that at first sight: for it cannot but suggest the extravagant fancy that a dozen or so palaces from distinct lands— some unmistakably out of the Arabian Nights—have taken a sudden fancy to herd together. . . . You watch two or three workmen moving apparently aimlessly upon the face of what seems a stupendous wall of marble. Suddenly a pillar as tall as a house rises in the air, dangling at the end of a thin rope of wire. The three little figures seize this monstrous showy shaft and set it in place as though it were a fence-post. Then a man with a hand-saw saws a yard or two off it, and you see that it is only a thin shell of stucco.[10]

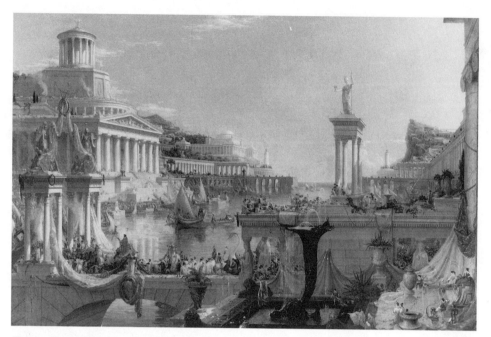

Figure 2. Thomas Cole, The Course of Empire: Consummation, *oil on canvas, ca. 1836. (Collection of The New-York Historical Society)*

The substantiality of the scene had already been compromised by the imaginary historical narrative implicit in it. Within mid-to-late-nineteenth-century outlooks normally thought of as romantic, and reflecting the impact of the social changes broadly associated with industrialism on the sense of historical time, monumentality, particularly that of the classical world, was already conceived in terms of decline, decay, disappearance. Throughout the century Thomas Cole's *Course of Empire* of 1843 was one of the most popular and widely reproduced visual statements of the theme. Cole's painting *The Consummation* (Fig. 2), third in the series after *The Pastoral State*, might have inspired the White City itself, miraculously raised in a year in the Jackson Park swamps:

> . . . the rude village has become a magnificent city. . . . From the water on each hand piles of architecture ascend—temples colonnades, and domes. . . . The harbor is alive with numerous vessels—war galleys and barks with silver sails. . . . The statue of Minerva with a Victory in her hand, stands above the building of the Caryatids on a columned pedestal, near which is a band with trumpets, cymbals, etc.

> In this scene is depicted the summit of human glory. The architecture, the ornamental embellishments, &c, show that wealth, power, knowledge and taste have worked together, and accomplished the highest meed of human achievement and empire . . . man has conquered man,—nations have been subjugated.[11]

*Figure 3. Staff deterioration of the facade of the Transportation Building.
(Photograph by Laban Dierdorff; Chicago Historical Society)*

Yet neither Cole's narrative nor the White City ends here. "Luxury," Cole observes of the next painting in the cycle, *Destruction*, "has weakened and debased. A savage enemy has entered the city. . . . Description of this picture is perhaps needless—carnage and destruction are its elements." At last, in *Desolation* (Plate 7), "Daylight fades away, and the shades of evening steal over the shattered and ivy-grown ruins of that once proud city . . . the empire is extinct."[12]

The cyclic theme and the elegaic tone reconcile monumentality and ephemerality, turning them to an allegory of the futility of human efforts against time and mutability figured as social breakdown. Thus, within its founding paradigm the White City is already implicitly marked for decay, deterioration, and, ultimately, ruin—a process vividly dramatized in the use of staff, which, however practical for its purpose, began to decompose almost as soon as it was applied, its projected life of six years quickly compromised by Chicago's extremes of climate, and showed increasing signs of erosion throughout the summer of 1893 (Fig. 3). Moreover, the collective "story" of the fair, as realized in journalistic and fictional narratives about it, almost invariably incorporates, with significant parallels to the Great Fire of 1871, the two fires, in November 1893 and July 1894, that brought thousands of spectators to the site and carried the great edifices away, leaving a vast plain of

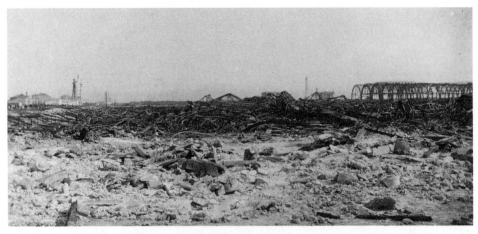

Figure 4. The ruin of the World's Columbian Exposition, Summer 1894, looking south over the rubble of the Manufactures and Liberal Arts Building. (Chicago Historical Society)

twisted rubble (Fig. 4)—almost compulsively linking its destruction to a new "savage enemy," the legions of tramps encamped in the abandoned buildings.

That the White City was many things to many people goes without saying. But its grades of temporality, shaped by inference and interpretation of its various aspects—design, exterior covering, interior and exterior scale, interior structure, the contents of the exhibits themselves—point revealingly both to its role in the development of a popular urban culture and to the subtle social stratifications comprehended by its enormous public space. The by now facile symmetry, in the historical account, of a popular Midway and an elite White City, a symbol of moral, racial, and sexual purity and respectable middle-class standing, with the increasingly bipolar industrial caste system, though broadly applicable, obscures the sense in which the White City was a site at which many sensibilities, of many origins and purviews, converged in the process of sense-making.

Such apparently different perspectives as the effete detachment of the well-traveled and self-involved flaneur, or the more naive delights of the amateur landscape painter or photographer, for example, each work to mitigate the fleeting grandeur of the buildings, with more permanent visual images of them achieved psychologically, artistically, or technologically. A high-cultural elegaic vision of empire such as Cole's lingers to inform local contemporary narratives in which the fair was embedded and that it actually played out. The assimilation of a popular, and provincial, Protestant eschatology with a popularized Spencerian notion of social and technical progress proved propitious for the eventual absorption of the century's strong millennial thrust into the commercial spectacle. These several viewpoints, taken together, seem to radiate, in spite of their apparently divergent end points, from a common source: the general effort to reconcile the double consciousness of the White City's image and imagery with its acknowledged and

visible impermanence and imitation, on the one hand, and with its message of progress and power, on the other.

Hence the two prevailing views of the fair, what broadly may be called the elite and the vernacular, can be contrasted in terms of the temporal position to which each has assigned the White City. For the provincial visitor, the fair was a vision of an essentially utopian future, steeped in Protestant eschatology at once subverted by and displaced upon the wonders of technology and commerce. The elite response, however, that of the flaneur or grand traveler, belongs to a decadent romantic sensibility—a mere "passage," as Walter Pater expressed it, "of impressions, images, sensations . . . the strange perpetual weaving and unweaving of ourselves"—luxuriously feeding on its own decay.[13] For the flaneur the White City, while palpably and materially present, was nevertheless dreamlike, elusive, shimmering in a border realm between object and subject, a contemplated perception almost purely subjective, a sensory text more durational than spatial—not a monument, but the ghost of one, to and of the past.

The World's Columbian Exhibition, like its earlier counterparts in London, Paris, and New York (and in several other American cities around the turn of the century), generally promoted economic development and mass consumption. It also displayed economic and industrial strength in ideologically coherent spaces in which, from the perspective of the Anglo-American ruling elite which represented the principal investors, differences of race, class, and nationality were enlisted as elements in a grand narrative of social and industrial progress. Carrying the logic of its predecessor exhibitions to its ultimate paradoxical conclusion, the White City at Chicago at once epitomized and sabotaged the idea of progress by enfolding an emergent idea of time in a residual one, or, to put this another way, by enclosing the embryonic body of the real future in the crumbling shell of an imaginary one. The past was subsumed by means of icons and relics already enshrined in the national mythology, such as the sword belonging to Judge John Hathorne of the Salem witch trials, a lock of Thomas Jefferson's red hair, or Miles Standish's pipe. Even the iconic Liberty Bell, guarded by police and decorated with flowers, rode on a truck spangled with soap ads.[14] Palpable artifacts of an ascendant species of power, on the other hand, many of them utterly unprecedented, shockingly novel, outsized, or magical—the first electric chair used at Sing Sing, the century's most extensive electrical network, towers of electric light, prodigious abundance of industrial or agricultural bounty, the forbidding Krupp cannon—opened to ordinary view backstage production and technical processes and massive wholesale accumulations from within what was both an engineering marvel and a simulacrum of old Europe.

In this respect the White City anticipated postmodern theme parks such as

Disneyland, concentrating its touristic discourse of second-order signs in a dense environment of simulation, a kind of tour of the touristic, rallying its meanings on its own behalf. In *Scribner's, Century Magazine*, and other highbrow periodicals that spread news of the exhibition, including many of the pieces that form the research base of this essay, reports and pictures appeared directly alongside strictly touristic accounts of European journeys, lithographs of the White City placed on a continuum with images of Venice and Rome. Figured and represented in this fashion, the White City appeared to magazine readers as an imploded domestic Grand Tour, with all of the social affiliations and cultural opportunities implied, animated by the activity of memory upon it.

Tourism, argues Dean MacCannell, is allied to postmodernity as "a kind of collective striving for a transcendence of the modern totality, a way of overcoming the discontinuity of modernity, of incorporating its fragments into unified experience."[15] It is, again, a Barthian "second order" semiotic system, in which signs made meaningful in various social, historical, and cultural contexts, the tourist "sight" or site such as the Eiffel Tower or Ellis Island, are appropriated as signifiers in the special discourse of tourism, which is constituted by the totality of its literature, its art and photography, its commercial packages, and so on. The tourist seeks the sensation of recognition that arises when these displaced signs-as-signifiers find their referents in the tourist discourse—a moment sometimes reiterated to the point of transcendence when the actual sight/site, when we encounter it, at once summons its own representation and invalidates it, producing what Fredric Jameson calls a hallucinatory "breakdown in the signifying chain."[16] Still further this moment of recognition, breaking through the tourist discourse itself, dips psychodynamically into the tourist's own reservoir of memory, imparting to the site, often in imperfect or ambiguous ways, its deepest significance, in which lies the quality of authenticity itself.[17]

These formulations would seem to describe both a range of responses to the White City as well as to its own idea of itself. Most telling, of course, is the fact that the production and circulation of images of the White City were strictly controlled, since it was the image of the site, quite literally the "sight," that was ultimately for sale. "Millions could not attend the Fair during the short season of its duration," reported Horace Herbert Markley, "yet it will be an insignificant minority in all countries who will not, at one time or another, have seen it photographically."[18]

The process was not left to chance. The exhibition had contracted its own official photographers, such as C. D. Arnold and Laban Deardorff, whose work has provided us with most of our images of the fair, and two large commercial firms rented cameras at the gate. Personal cameras, without payment of a fee, were confiscated. Surveillance was not limited to cameras. Easel painter F. Hopkinton Smith describes being stopped at the gate for attempting to carry in his artist's kit.

The guard's "orders were to seize everything that . . . might possibly reproduce any of the beauty and the glory of the white city within." Once having gained entry, moreover, Smith was detained by an official who told him that he could not paint without a permit.[19]

The authoritarian and inquisitorial character of the control exercised over images was remarked by Teresa Dean, who saw it of a piece with a series of locked gates, barred doors, and "No Admittance" signs, but even more pertinently with the all-season passes issued to the approximately 60,000 people officially photographed for identification: "to be known," she wrote, "to the numerous Lord High Chancellors—collectively high, and individually very much higher—of the World's Fair, by number."[20]

In this officially managed production and reproduction of images we observe a tourist discourse, alongside a covalent system of surveillance, in the process of its formation, as well as the ultimate inadequacy of the image, once recognition of the site has been achieved semiotically, to represent the sight/site in the irreproducible intensity of its own being. "There's the unexpectedness of it!" exclaimed Walter Besant. "Never was anyplace so unexpected. The special correspondents and the illustrated papers have done their best to bring the place home to us: but, you see, description never describes . . . oh! you may point at once, on arrival, to the Woman's Building, or to the Manufactures Building; you recognize them because you saw the pictures in the Illustrated London News. Quite faithful pictures they were, yet—yet—did you expect, at all, what you see before you?"[21]

For many visitors, then, particularly for travel and nature writers, the site of the exposition emerged as a storied, picturesque, or exotic region from which the writer might report, even if it would ultimately be visited by almost thirty million people. Cosmopolitan travel writers found no difficulty in treating the White City as an inventory of memories of European monuments, the psychological counterparts of the amateur photographer's collection of souvenir images. "Venice, Naples, Rome, Florence, Edinburgh, Athens, Constantinople," wrote Muirhead, "each in its way is lovely indeed; but in each view of each of these there is some jarring feature, something that we have to ignore in order to thoroughly lose ourselves in the beauty of the scene. The Court of Honor was practically blameless."[22]

"There are certain mastering impressions in one's life," recalled Will Low, searching for an analogy to the White City, "certain scenes which stamp the memory, like the priceless kakemono which the reverent Japanese withdraws from hiding when in the mood to enjoy it, rise obedient to one's thought in aftertime. Such a memory is that of a first sunny morning in Paris: a ride from the Madeline across the Place de la Concorde, along the Tuileries Gardens and the Louvre, across the Seine with the island and Notre Dame in the distance, and through older Paris to the gardens of the Luxembourg. Or, again, a certain moonlit evening in Florence, with the Duomo looming at the end of the street."[23]

This withdrawal into the stubborn, even petulant subjectivity of the elite decadent or exquisite traveler, heir of Charles Baudelaire, Joris-Karl Huysmans, and Oscar Wilde, rejects on aesthetic grounds the vulgarity of commercial appeals, the unseemly boast of industrial display, happily embracing, according to a doctrine that makes of all perception a kind of hallucination, artifice as such. "But your true flaneur," insists M. G. Van Rensselaer, "feels a genuine interest in one thing—his own capacity for the reception of such new ideas and emotions as may be received without exertion of any kind. He does not care for facts or objects as such, or for what they teach, but he does care for their momentary effect upon his eyes and nerves. He does not crave knowledge, but he delights in thought of Chicago, because it suggests hard work at sight-seeing, and his idea is the easy work of holding himself passive yet perceptive."[24]

If you go "in perfect freedom," he wrote, "you will find such an idler's paradise as was never dreamed of in America before, and is not equaled anywhere in Europe today":

If, as I say, you go wholly consciousless,—not like a painstaking draftsman, but like a human kodak, caring only for as many pleasing impressions as possible, not for the analyzing of their worth,—you will be delighted in the first place by the sight of such crowds of busy human bees, and the comfortable thought that, thank heaven! you are not as they. And what a setting for these crowds! What a panorama of beauty to drink in and dream over, and to carry home, in general views, and bits of detail, for the perceptive adornment of your mental picture-gallery!

Or as Besant put it, pointing superciliously to the bourgeois status of the entire enterprise, with its lurid paean to Progress, its naked hucksterism, and its cheap deceptions, "What I have desired all my life is an Exhibition without exhibits. . . . For the uncommercial drummer, the bagman without his bags, for one who is not in the least interested in machinery, processes, and the way in which things are made, there need be no exhibits at all and one can meditate undisturbed by the intrusion of exhibits, as long as he pleases, about and around and among the buildings, and the waters and the walks of the Fairy palaces beside the lake."[25]

Nevertheless, the comparatively accessible White City represented, especially for its rural and small-town midwestern visitors, a radical democratization of the system of tourism, opening in simulated form opportunities for experiences—but experiences reduced, it must be added, to the purely visual—traditionally reserved for the privileged classes. "Oh, this dear old Fair!" cries a woman in Teresa Dean's report, tears streaming down her cheeks. "What will I do without it?"

Only five days have I missed since the opening. They have been the happiest months of my life . . . we have taken chairs and have been rolled almost

everywhere, it did not make much difference where, and have taken the electric launches, and the gondolas, and drifted up and down and around the lagoon. We have watched the sun set over the white domes and have waited for the illuminations to take away the gray, weird mist of night. We have listened to the music, and to the trickling of the water from the fountains. . . .

. . . It has been the romance of our lives—journeying around the world. It was too grand to last. I came to-day for one more glimpse. The good-by is as sad as any I have known in all the years that I have lived.[26]

Naturally the opening of cultural privilege, as everywhere in tourism, implies the claim of social prestige. In Mary Crowley's didactic juvenile novel *The City of Wonders* (1894), apparently constructed largely out of the fair's official documentation, a middle-class family visits, among other locations, the Italian exhibit in the Manufactures and Liberal Arts Building, a collection of mosaic-framed mirrors, crystal vases, Venetian glass, marble statuary, bronzes, laces, and the like. "My dears," tutors Uncle Jack, "such are the beautiful objects you would see in almost every shop window of St. Mark's Square in Venice, or through the streets of Florence. . . .":

"How foreign everything seems!" commented Ellen.
"Now we come to the English pavillion," said Uncle Jack. "The front is a reproduction of Hatfield House. . . ."
"How delightful!" cried Ellen. "Can you not fancy, Nora, that we are traveling with the Colvilles?" . . .
"Yes, we shall be able to talk quite as if we had been abroad," declared Nora.[27]

At a deeper level, however, the White City initiated a psychological process where the various discourses of tourism intersected with the cultural systems in which their signs originally acquired meaning, stirring the compelling but often unconsummated process of recognition that lent to the White City its true mystery and grandeur, satisfying what John Ingalls called the "unspoken aspirations of the soul for unattainable beauty."[28] "Most of us, when we were young," wrote one visitor, "dreamed dreams and had glorious visions which in soberer years we dismissed as foolish and incapable of realization. It is only in this way I can account for the fact that the Fair impressed me with a strange familiarity. I felt sure I had seen it before, though I could not tell when or where. That splendid Court of Honor . . . all bore to me some incomprehensible affinity to something I had seen or read or dreamed in the present or a previous existence."[29]

This psychological neuralgia, defeating barriers to the willing suspension of disbelief that might have been erected against the exhibition's explicit commercialism or the cheapness and ephemerality of its construction, paved the way for the transcendent experience most reported, not by international tourists, but by more

naive midwestern visitors unprepared by tourist discourses for the encounter, and hence most vulnerable to it—"plain and unassuming people," as Dean wrote, whose "hearts were always alive to the sentiment. Theirs were not the coldly critical eyes that saw 'staff' and effect. They lived contentedly in the magnificence while, perhaps, like everyone else, they could not always understand."[30]

"The class most largely represented in proportion to its numbers," wrote Robert Grant, "was the rank and file of the American people."[31] Walter Besant observed that "the great mass of people are Americans, and as might be expected, people of what in Europe they call the lower class . . . in a word, the Average People. It is for them that this Fair has been designed":

> Let us remember that many of these people belong to that vast country west and south and northwest of Chicago which is newly settled, newly populated, and without noble or venerable buildings . . . here they see, for the first time, such buildings as they have never before imagined. These lines of columns; these many statues standing against the deep, blue sky; these domes; these carvings and towers are marvels reflected in the waters of the Lagoon . . . can they . . . ever forget the scene? Never. It will remain in their minds as the Vision of St. John— an actual sight of the New Jerusalem. . . . A new sense has been awakened in them."[32]

The White City evoked such quasi-religious or religious responses from sophisticated and unsophisticated visitors alike. Owen Wister was "dazzled to a standstill"; William James, in a letter to his brother Henry, noted with bidirectional irony that in the White City people seemed to "cast away all sin and baseness, burst into tears and grow religious under its influence."[33] Hamlin Garland, whose parents were pioneers in Iowa and South Dakota, described his mother's reaction to the White City: "Stunned by the majesty of the vision, my mother sat in her chair, visioning it all yet comprehending little of its meaning. Her life had been spent among homely small things, and these gorgeous scenes dazzled her, overwhelmed her, letting in upon her in one mighty flood a thousand stupifying suggestions of the art and history and poetry of the world. . . . At last utterly overcome she leaned her head against my arm, closed her eyes and said, 'Take me home, I can't stand any more of it.' "[34]

Clara Louise Burnham's Jack Van Tassel, mourning the death of his father while wandering amid the White City palaces, catches a mysterious intimation. "Since such a miracle of beauty as now lay about him was possible in this lower world, might it not be indeed true?" Gazing about him "with reverence and a species of awe," he finds that "The Court of Honor had given him his first approach to a realization of the possibilities of the Celestial City."[35]

Even as sophisticated an observer as Hubert Bancroft could, with a stuffy

circumlocution, make the religious inference: "As seen from the waters of the lake and especially at eventide, when their long array of columns and porticos, their lofty towers and stately domes, mirrored in the waters, stand forth against a glowing sky, they are in truth a revelation surpassed only by the inspired vision of him by whom was beheld the city not made with hands."[36]

That the World's Columbian Exposition was widely associated at the vernacular level with the sacred or secular end of history is suggested as well by some of the various proposals received by the directors in the planning process. A self-styled seer claimed that the fair had been foreordained from the beginning of time, and a self-appointed messiah offered to exhibit himself there. An inventor would bring the long-sought perpetual motion machine; a mathematician would square the circle; a cosmetician would transform a "wrinkled hag" into a beautiful young woman. At this level millennial interpretations sink to the level of humbug—a fact to which L. Frank Baum, as a pioneer department store window dresser and publisher of a popular magazine on the subject, might have been particularly sensitive. His City of Oz was an obvious allusion to the White City, which in the *Wizard of Oz* (1900) turns out to be only a mechanical fantasy, the cultural equivalent of the old traveling medicine show with its mendacious and pompous "doctor" and his ineffectual nostrums and elixirs—perhaps connected in the same way to the wholesale distributor with his phalanx of commercial travelers. There is, of course, "no place like home" on the Kansas farm, as the exposition's most popular painting, Thomas Hovenden's *Breaking Home Ties* might suggest—but in Baum's many sequels Dorothy returns irresistibly to the glamorous Oz, for, humbug or not, no return to the old preindustrial way of life is possible, either for Dorothy or for Theodore Dreiser's Carrie.[37]

A condescending irony informs the work of two contemporary novelists who expose the provincialism of the business sensibility that erected the exposition and that figures necessarily in the rhetoric surrounding it. "This is the American businessman's fair! The businessman—he did this!" boasts Will Payne's Mr. Arlington, a bank clerk who has risen to the eminent height of an officer in a coal company, making an "oratorical gesture" with his "short, fat arm" and adding, vaguely, "It shows what the Chicago businessman can do when he gives his attention to things of this kind—art, architecture, and so on!" Just what the White City may be to him, however, is unclear: "All bore the air of something ancient, august, haunting the mind with an idea of power."[38]

Robert Herrick, in a conversation between his ex-governor Walton and industrialist Colonel Stively in the novel *Waste*, who are recalling to one another the days when Chicago was only a frontier town set up on stilts in a swamp, outlines, with a kind of sad disparagement, the myth of cultural flowering out of capital growth, a book-club history of civilization that had justified the White City to its investors:

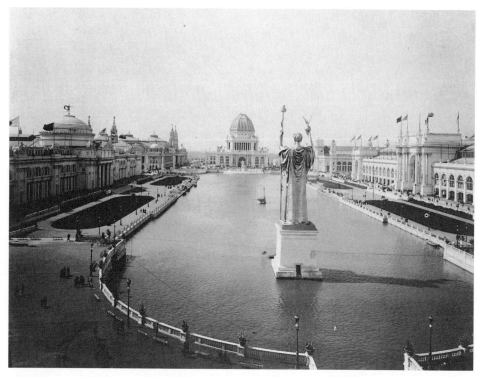

Figure 5. The Court of Honor. (Chicago Historical Society)

"There was much talk about the significance of this great effort in Chicago, of the 'educational' and 'cultural' influence it must have on the nation; of the international aspect of these conglomerate gatherings of exhibits and peoples. . . . Growth, bigness, multiplicity, these they had witnessed, been a part of, struggled to achieve, and now came this soaring prodigal city of plaster, which to them seemed the acme of fine art, of beauty—the one accomplishment that hitherto had been lacking in their country."[39]

But even Herrick cannot entirely banish a certain ambivalence concerning the White City. He can chasten the elder generation (*Waste* appeared in 1924) only through two members of the younger, whose developing romance hinges on the innocent receptivity of the one as against the gritty (and au courant) realism of the other. "Oh Auntie—it's such a glo'rious day!" exclaims Walton's daughter Cynthia, leaning out of her hotel window on the morning after her arrival in the city. "I can see the Lake, miles and miles of it, all bluey gray and shiny. . . . And over there in the Park is a big white building. Immense'—some'thing like a Greek temple. . . . Oh, it's won'derful."

Young Jarvis Thornton, an architect, is skeptical. "You like this?" he asks her scornfully as they explore the Court of Honor, where the "the somewhat grandiose scene of white buildings, gilded statues, dashing water, and human throngs

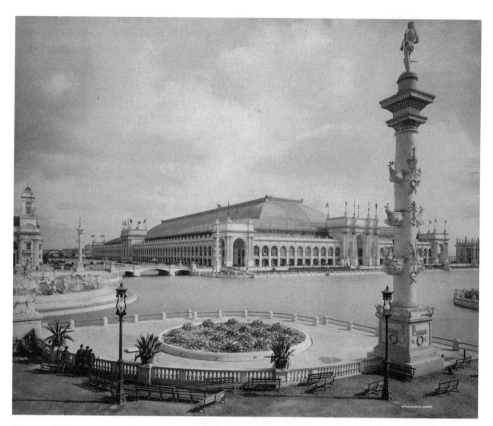

Figure 6. The Manufactures and Liberal Arts Building. (Chicago Historical Society)

thrilled her" (Fig. 5). The real Chicago, Thornton insists, "is back yards and tumbled down grimy houses and dingy brick blocks and dirty streets"; he offers to show her the Midway, which, he says, is "alot more like Chicago than all this white plaster stuff!" Yet when Cynthia opines that there must be more to Chicago than dirt and grime, Thornton concedes, revealing his own dedication to Burnham's vision, "Yes, there are the Parks—and the Future. In Chicago one lives mostly on the Future."[40]

"Vastness of all kinds oppresses the soul with sadness," Besant reflected.[41] What was dreamlike and transcendent or, depending on one's reading of its exterior materials, meretricious and false, could not but stagger the imagination nevertheless in the "stupendous" scale of the White City. Consider, for instance, the enormous Manufactures and Liberal Arts Building (Fig. 6). As early visitor Clarence Bird testifies, it was "the unparalleled leviathan of the structural world"—the largest structure in history to that point.[42] To lay the floor required three million board feet of lumber and five carloads of nails; the hinged iron trusses of the central hall, the largest in the world, weighed twelve million pounds. The central hall could seat 300,000, and the entire Russian army mobilized on its floor—that is,

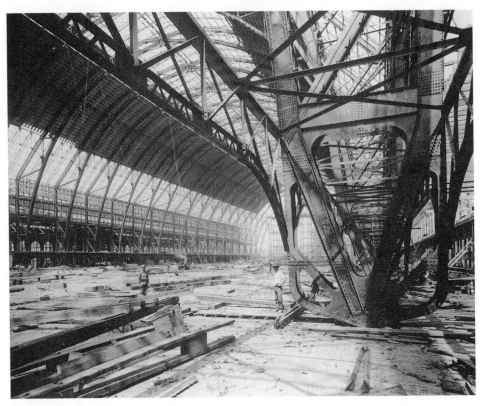

Figure 7. The Manufactures and Liberal Arts Building under construction. (Chicago Historical Society)

half a million soldiers.[43] The roof of the building was what Bird called "a noble nave" a third of a mile long, capable of "swallowing three colosseums," and comprehended a floor space of over forty-four acres.

The Manufactures and Liberal Arts Building challenged its documenters to record its magnitude in a variety of quantitative measures and scalar metaphors that called the nature of the building almost metaphysically into question and, more than any of the other buildings on the Court of Honor, dislodged the appreciation of it from conventional markers of design and decoration toward a kind of modernist formalism whose root was the heroic engineering feat itself (Fig. 7). Bird takes us to the giant footings on which the building, like its lofty counterparts downtown, rested:

> Each rounded base is hinged by a massive eyelet and a great tie-pin to the foundation-plate. Thus each truss arch (consisting of two parts like the span formed by the arms of a man raised over his head, with fingers touching), is pivoted at the bases; and when the halves meet in the peak they are again linked with a pin, the upper ends of the semi-arches, as well as the bases, being so rounded that with the changes in temperature their great masses may bridge or

recede without cross-strain. The weight of each truss is 300,000 pounds; they were brought from afar, in pieces, and put together without an error in boring or bolt.[44]

Although nearly every commentator takes note of the eclecticism of the building's ornamental exterior, for most its genuine beauty, as Bird's cathedral metaphor suggests, lies in its dramatic reconciliation of form to function. As F. D. Millet testifies, "The ugly forms of ordinary bridge builders' construction, which have hitherto been endured as necessary for rigidity and strength, have been largely eliminated, and graceful curves, well-balanced proportions, and harmonious lines unite to make the iron-work beautiful in itself"—promulgating the "great truth" that "the useful may be beautiful even in engineering."[45]

We can perhaps more immediately grasp the nature of these many and varied responses by comparing the White City to its contemporary counterparts. We have already invoked, as theme park, Disneyland; let us briefly consider it, then, in both material and scalar terms, with reference to the midwestern "Main Street" just inside the entrance gate. From Anaheim—a vast, diffuse, dim, and featureless postmetropolitan automotive waste, we arrive by car at the postmodern equivalent of Jackson Park's featureless plain, the frontier of the even more arid and diffuse asphalt tundra of the Disneyland parking lot, whose margins dissolve and disappear into the smog that effaces the horizon on all sides. A shuttlebus, like a pilotboat through a fogbound harbor, ferries us to the gate; at this point we are almost literally nowhere.

But once we are through the gate, we are instantly commuted, as if supernaturally, onto a small-town midwestern Main Street of the 1880s or 1890s, realized in virtually indestructible polymer building materials, as spiffy as a brand-new tract house development, free of the merest trace of disrepair, decay, or dereliction, and thus frozen in time, continually policed of all refuse and reduced, imperceptibly for most visitors, to ⅝ths scale: a technique originally designed by Hollywood studios for the movie camera.

The sensation is one of physical seizure, as if by ten thousand invisible hands, and an accompanying sense of almost beatific relief, as if some constant physical pain or discomfort, so accustomed as to be almost forgotten, were to be suddenly removed, and a resulting exhilaration that touches the scene with a kind of hallucinatory shimmer. From within the vast, dull, nameless oppression that is the postmodern urban landscape we have been released into a familiar world of which we are the undisputed masters; we seem to grow and expand physically; from a condition of temporal and spatial disorientation we are suddenly geographically, historically, and culturally, decisively situated, endowed with a sense of personal power, social inclusion, and freedom from anxiety.

It is all, of course, an illusion. The visitor to the Columbian Exposition, whether farmer or flaneur, her sense of life perceptibly more confused and her social world at once contracting and expanding with increasing industrialization, metropolitanization, with the extension of railroad transport and telegraphic communications, her sense of personal significance concomitantly diminished historically and practically, moved typically on a train through increasingly complex, strange, forbidding, and unfamiliar rings of urban and industrial development. At the southern rim of the city at Jackson Park, however, on the lakefront, the accustomed scales, textures, functions, and forms of provincial existence would have been suddenly and violently eradicated and, as if by a kind of explosion, replaced by a visionary city of dreamlike proportions: in visible, tangible, and familiar forms already imaginatively linked, either to upper-class European travel, or, through the imagery and iconography of evangelical Protestantism, to the consummation of history in the Celestial City.

If entrance to Disney's Main Street is a kind of rebirth, the moment of entry to the White City, then, was a kind of symbolic and virtual death: the sudden reduction of the visitor's body to a mere social particle in the face of an overwhelming creative power; its violent transport from congenial home circumstances to an exotic "Europe" more densely and essentially European than any actual capital could be; the absolute abolition of the sense of personal mastery, and, in its place, a sensation of ecstatic subjugation, as to a religious vision; a radical isolation, sense of powerlessness, and insignificance, perhaps a kind of delirious happiness associated with what Jacques Lacan calls "the signifier in isolation."[46] If on Disney's Main Street we are seized, situated, and enlarged, in the White City we would have been uprooted, dislocated, reduced, and dissolved.

In Disney's Main Street and the White City, then, a socially promulgated but interior vision has been in the manner of postmodern spectacle exteriorized and dramatized in ways—the reduction of scale on the one hand, the expansion of it on the other—that at once preserve the visionary quality and drive home its radically subjective character. If Main Street in modernist fashion encloses and concentrates subjectivity, the White City in postmodernist fashion must be said to have dispelled it.

If Main Street and the White City each in their different way invoke, arrest, accelerate, and project historical time, the interior spaces and the massive human and material aggregation they support concomitantly redistribute subjective experience into the sphere of public or official "history" and the rituals whose regular reiterations reinforce and sustain it. Only consider the situation of the White City visitor on Opening Day (Fig. 8), overwhelmed by the vision of a Celestial City bafflingly realized in structures palpably unreal, who then passes into the Manufac-

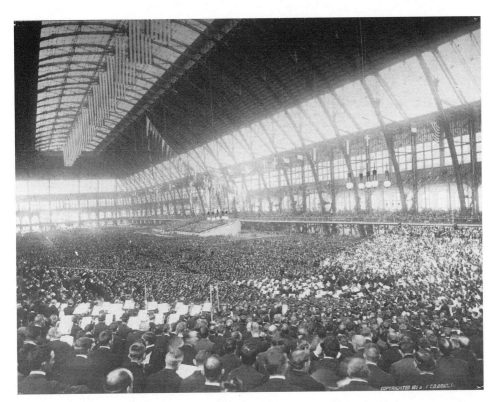

Figure 8. Opening Day. (Chicago Historical Society)

tures and Liberal Arts Building carrying the message of cosmic finality elaborated outside into the strangely familiar interior, part bridgework, part railroad terminal, part urban streetscape, where tens of thousands of souls have massed together in song, "a vast, whispering, rustling audience which could not hear."[47] Within the huge assembly hall, Daniel Gilman reported,

> perhaps one hundred thousand people—some say one hundred and fifty thousand—were gathered. . . . The military bands played while the cannon roared. An orchestra and chorus, said to number five thousand musicians, performed a new composition; but the notes of it were only faintly heard on the speakers' stand half-way across the building. A Methodist bishop and a Catholic cardinal, not unused to vast assemblies, offered up prayers, which we may hope were heard in heaven, but were not heard by most of the audience. The penetrating voice of a lady accustomed to public reading carried a musical note to a distance, but it was only a note and not a word. The Vice-President of the United States read an address, but his hearers might have been deaf for all the pleasure they received. Two orators of distinction spoke in succession,—men who are wont to appear upon the hustings,—but in the gallery directly opposite the platform their eloquence was that of the dumb appealing by gesture and attitude.[48]

Despite the remark of Louis Henri Sullivan that it had "set architecture back fifty years," the White City in fact structurally reduplicates the architecture of the Chicago school. It drew on the basic innovation of the downtown skyscraper, the steel truss frame, sheathed in staff as opposed to terra cotta, and projected it horizontally in proportions that could never have been realized in stone. And, like the downtown skyscrapers, the buildings were for the most part literally floating on "spread" foundations, rather than set on pilings sunk to bedrock; the exceptions were the southern half of the Manufactures and Liberal Arts Building and the northeastern portion of Agriculture, which rested in a "crescent-shaped swale of muck."[49]

The Beaux Arts style of Second Empire Paris that influenced the design has been misleadingly called "neoclassical," with emphasis laid on the late-nineteenth-century revival of classical forms. But its models are, again, less Greek and Roman originals, or those of Italian Renaissance city-states, but, as Schuyler's painterly metaphor suggests and steel frame construction enables, merely their visual forms deployed in romantic dream visions of ancient cities: massed piles of imperial power on a vast superhuman scale set against the background of a pastoral arcadia. Thomas Cole's work again supplies a clue to this aesthetic. Cole's *The Architect's Dream*, painted in Spring 1840 for New Haven architect Ithiel Town, presents an allegorical tableau of the history of the architecture of Mediterranean civilizations. It was, however, strongly influenced technically by scene and panorama painting, especially backlighting for theatrical effect, and by Louis Jacque Mande Daguerre's diorama theaters in London and Paris, which used three-dimensional papier-mâché columns, pilasters, and other structures outside the proscenium to create a sense of "spatial progression."[50]

This Claudist integration of the idea of classical antiquity with its idealized pastoral landscape, with its increased emphasis on Roman models, the vast increase in scale, luminosity, mass, and antiquity, in a sense "romanticized" and ultimately transfigured the neoclassical vision. Neoclassicism is a civic ideal, the architectural expression of the idea of polity; but the architecture of the Second Empire as its name implies was an emblem of imperial power, distant, impersonal majesty, and sublime grandeur. Projected imaginatively into a pastoral landscape, it drifts out of time in a limitless intellectual and finally subjective space, a dehistoricizing and depoliticizing form perfectly suited to emergent consumer capitalism with its faceless, ubiquitous, remote, and unaccountable authority on the one hand, and the passive, solitary observer, the consumer, on the other. *The Architect's Dream* places in the foreground, almost sitting on the frame, a solitary figure seen from behind, overawed by the architectural dreamworld rising before him.

The White City, then, as architecture, was made more of mental than of material stuff. And what of the exhibits within? The Manufactures and Liberal Arts Building, with its hardwood display cases, plate glass, velvet curtains, decorative kiosks

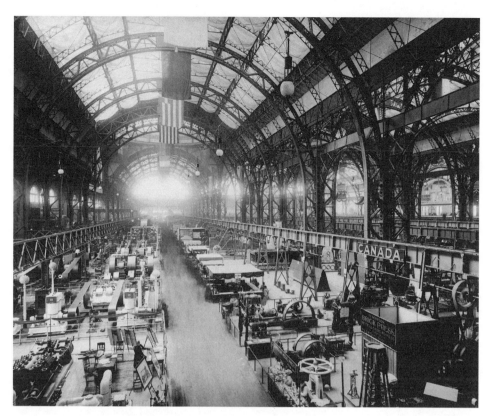

Figure 9. The interior of Machinery Hall. (Chicago Historical Society)

in the forms (to scale) of European churches, temples, guild halls, and so on, might have been a cathedral of international trade; the Transportation Building, with its locomotives and ship models, might have been a technological museum; Machinery Hall, with its power-driven lathes, woodcutting machines, power generators, engines, looms, presses, typesetters, canning machines, and so on, might have resembled a gigantic factory (Fig. 9). In the "noise and confusion of Machinery Hall," writes Mary Crowley, following her characters on a kind of factory tour, "It was interesting here to watch the processes of the arts of peace,—the manufacture of carpets, the looms with their mysterious patterns; and the weaving of ribbon, in which little boat-shaped shuttles, like toy skiffs, rode with a curtseying motion to and fro upon the waves of a many-tinted silken sea."[51]

The interiors of White City were assimilated to factories, shops, stores, and even streets at the same time as they were transformed, by virtue of scale, into public, that is, into a kind of virtual "outdoor" space. In this respect they were exteriorized, not unlike the "retail drama" of our own shopping malls—becoming in effect public thoroughfares, capable of housing entire structures such as tombs, churches, halls, and other architectural relics and the civic space of European culture, now consumed and supplanted by commercial space.

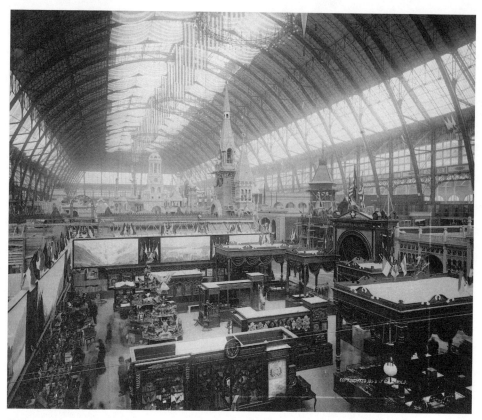

Figure 10. The interior of the Manufactures and Liberal Arts Building. (Chicago Historical Society)

When the visitor entered the Manufactures and Liberal Arts Building, wrote Ben Truman, "his impression will be that he is . . . visiting a city of palaces, temples, castles, arches, monuments, and hanging gardens. But his eye will necessarily be drawn toward a beautiful structure in the center of the building. The great central landmark, looking like a spire of a cathedral in alabaster, is the clock tower, 135 feet high." Its ringing chimes "sound like the music of heaven reverberating through the immense spaces of the building" (Fig. 10).[52]

As Bancroft notes, the interior aisles of Liberal Arts were named like city streets and lined with pavilions in which one might visit "the new German Reichstag, on the corners of which are towers surmounted by a dome, its apex in the form of an imperial crown, finished in burnished copper and overlaid with gold," or "the Bavarian pavilion, fronting on Columbia Avenue, and forming an integral portion of the German display. It is a temple-like structure, with arches, central portico, and roof, cornice, and frieze richly adorned with statuary and bas-relief." The Russian pavilion, following the thematic pattern, was built in "the ecclestiastic style of Russian seventeenth century architecture, with the principal entrance at the corner, in the form of a lofty arch surmounted by a tower."[53]

Not surprisingly, this roofed city demanded reckoning with reference to the unroofed world. Of Liberal Arts, Bancroft wrote that "no better idea can be taken than to state that on its site could be erected about 500 residences, each with a lot of 25 by 100 feet, capable of accommodating in all at least 5,000 persons, and that with far less crowding than is felt in the more crowded portions of Chicago"— in effect, transforming the floor of the building into an imaginary real estate development.[54]

Mary Crowley's characters recur to the same measures. When young Ellen observes that Liberal Arts is "a city in itself," Uncle Jack replies fancifully that if it were possible to put the Rookery, one of the largest of Sullivan's great buildings, on a mammoth wheelbarrow and wheel it through the arch, it would not touch the sides or the top by several feet. "One thousand cottages" he adds, "could find room within these walls." Craning her neck to see the vast glass roof, Nora completes the idea by saying, "It is as if the building had a sky of its own."[55]

At the White City, then, inside was outside and outside was inside; private was public and public, private; commercial was civic and civic, commercial. It was the ultimate festive inversion, turning the whole of industrial civilization into the content of a shallow and ephemeral cultural spectacle aligned to the purposes of commerce. Its second nature physically assimilated to first nature, capitalism had created its own firmament, and, in the darkened corridors of the Fisheries Building, its own inner sanctum, an exotic and mysterious Nature at the very heart of the industrial artifice:

> They advanced to a great curved corridor, behind whose crystal walls was a sea of green water, in which many kinds of fish were swimming about. In the middle of the Rotunda was an immense pool, from which rose a mass of rocks covered with mosses and lichens; and from between the crevices of the stones gushed forth bright streams, that fell sparkling amid the tangle of reeds and river plants below. . . .

> . . . and arrived, finally, in the mysterious and exotic Egyptian building, at the "anemone grotto," where it was as if "they had been transported to an ocean cave."[56]

Kevin Lynch's *The Image of the City* (1960), according to Fredric Jameson, argues "that the alienated city is above all a space in which people are unable to map (in their minds) . . . their own positions in the urban totality in which they find themselves": "grids such as those of Jersey City, in which none of the traditional markers (monuments, nodes, natural boundaries, built perspectives) obtain. . . . Disalienation in the traditional city, then, involves the practical reconquest of a sense of place, and the construction or reconstruction of an articulated ensemble which can be retained in memory and which the individual subject can map and remap."[57]

From this perspective, Disney's Main Street is a kind of hypospace in which we remap our position, accommodating to its reduced scale, by moving nostalgically in history. In effect, we have returned to the days of our collective but personalized childhood, finding that everything "seems smaller." John Portman's Bonaventura Hotel, as Jameson has explained, by contrast "aspires to being a total space, a complete world, a kind of miniature city" that corresponds to a "new collective practice, a new mode in which individuals move and congregate." Portman's buildings, argues Jameson, transcend "the capacities of the individual human body to locate itself," a symbol and an analogue of "the great global multinational and decentered communicational network in which we find ourselves caught."[58]

Yet the White City, too, would seem to have aspired to become such a total space, a city unto itself, one that "reconquers" the surrounding urban grid with a utopian projection of it. If Disneyland shrinks the movie studio Main Street for cinematic representation, the White City shrank its visitors, drawing them into a gigantic outdoor pageant set that palpably and compellingly, but temporarily, even fleetingly, for the merest moment, realized in steel and iron cloaked in staff the visionary seaport capitals of landscape painters such as Claude Lorraine and Cole, ancient imaginary empires that were but compensatory historical fantasies designed to accommodate psychologically already achieved social transformation. Inside, however, a concomitant reduction in scale would have restored a sense of mastery over the historical legacy of Europe-as-tourist oyster, colonized in effect by the colonized.

The cognitive disorientation, moreover, that Jameson associates with the postmodern hyperstructure seems to have been equally characteristic for visitors to the White City. "In estimating the scope of the design," wrote Bancroft of Liberal Arts, "an observer would find himself at a loss for standards of measurement, for here the scale was so vast that there was nothing upon which to base a comparison. . . . To compare it with other buildings, either in Europe or America was impossible, for there were none in existence; and to compare it with those on the grounds would be equally impossible, for adjacent structures, covering several acres of floor space, were dwarfed and dominated by this mammoth edifice."[59]

Teresa Dean relates the stories of many people exhausted and lost, especially elderly people, including that of a woman who thinks she has lost her children because she cannot distinguish one corner of the Liberal Arts Building from another. The wonders of technology in Dean's account touch most movingly on older sensibilities anchored in the very structures those technologies would ultimately erode. She tells of a "gray-haired" old man who, on hearing the strains of "Annie Laurie" but unable to locate the source of them, approaches one of the Columbian guards: "Them words sound sweet to me. It is a long time since I heard that'ere song. Ken you tell me who it is? I would like—I would like—of course I

don't 'spose I could—but I would like ter thank some one for singing it. It goes right hum. You see, my darter—."[60]

When the sympathetic guard attempts to instruct him on the wonders of the telephone, which can transmit a voice from New York, the old man first thinks that it is a joke. "When I passed on," Dean writes, "he was still asking questions. I heard him ask if he could hear his son talk in New York if he should come up to the telephone. The guard said 'yes.' His face lighted up, and I knew he had not heard the son's voice in a good many years."

Michel Foucault offers us some insight into the historical role of such an imperial spectacle as the White City. In his account of the Napoleonic moment in European history, he writes:

The importance, in historical mythology, of the Napoleonic character probably derives from the fact that it is at the point of conjunction of the monarchial, ritual exercise of sovereignty and the hierarchical, permanent exercise of indefinite discipline. He [the monarch] is the individual who looms over everything with a single gaze which no detail, however minute, can escape. . . . At the moment of its full blossoming, the disciplinary society still assumes with the Emperor the old aspect of the power of spectacle. As the monarch who is one and the same time a usurper of the ancient throne and the organizer of the new state, he combined into a single symbolic, ultimate figure the whole of the long process by which the pomp of sovereignty, the necessarily spectacular manifestations of power, were extinguished one by one in the daily exercise of surveillance, in a panopticon in which the vigilance of intersecting gazes was soon to render useless both the eagle and the sun.[61]

It does not require too much interpolation to understand the pertinence of this formulation to the situation at the end of the nineteenth century in America, where the residual but pervasive presence of the imagery of the Protestant imagination, as well as more fully secular and class-inflected cultural ideas represented by old Europe and the Grand Tour, could be deployed by corporate and governmental power, "at the moment of its full blossoming," to posit a quasi-religious totalitarian vision, its surveillance and reproduction fully administered and controlled, of the end of history in a capitalist utopia.

This cultural statement—corporate capitalism as imperial power as consummation of history—through the sad relics of the City Beautiful movement, is still evident on Chicago's public face. The city's lakefront facade of boulevards, parks, and monumental buildings such as the Shedd Aquarium, Soldiers' Field, the Field Museum, and of course the Museum of Science and Industry (the exposition's Palace of Fine Arts), its public works, which continue the Beaux Arts theme and even project onto the skyscrapers of the 1920s such as the Wrigley Building and

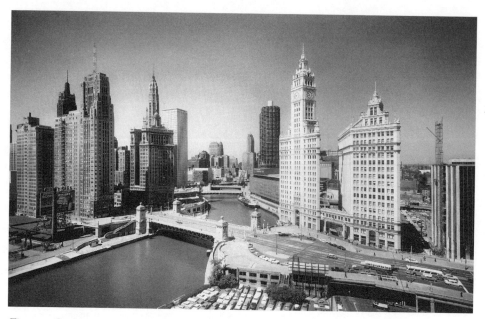

Figure 11. Contemporary downtown Chicago. (Photograph by Walter Krutz; Chicago Historical Society)

Tribune Tower, are the cultural insignia of the city's corporate and technological might articulated as a Mediterranean imperial civilization mediated as a dream vision (Fig. 11). It is at once nostalgic and futuristic, an effort to reconcile the disorienting and inexorable thrust of technological and industrial development with a psychological attachment to the only imaginative resources available, before the decisive emergence of modernism in art, to realize such change as cultural.

The White City was not unprecedented; its original might have been found in the tropical capitals (Chicago's summer climate was regarded as such by Europeans) of France and Spain—architectural spectacles addressed to subject populations—in which staff had served the imperial design: Burnham himself would later have a hand in the design of the capitol at Manila. "Staff is an expedient borrowed from the Latin countries, and is much cultivated in South America," Bird instructed his readers. Chicago was itself a kind of internal colony, its patterns of settlement and finance emanating from New York, New England, and London, driving its postfire growth and shaping the attitudes of the men and women who planned the exhibition.[62] In this sense the White City, especially given the central role of photography in promulgating, controlling, and distributing its image, may be regarded as a vast advertisement, enlisting cultural nostalgia, class aspiration, religious piety, and even haute bourgeois ennui on behalf of expanded markets, increased commerce, improved industry, and, ultimately, the greater concentration of money and power fostered by industrial capitalism.

And yet, as I have argued, this realized image of the consummation of history

was not only manifestly ephemeral, but also bound up with an elegaic narrative in which its own eventual ruin was already guaranteed. Like the landscape garden, a realized picture, the White City translated the formally insulated imaginative participation of art into a practical encounter secured by fictionality: which is to say, the visitor knows, and must know, that the buildings are not real—for if they were, they would become a display of technical, social, and political power nightmarish and horrifying in extent. In this respect the form, as against the function, of staff becomes more evident: the buildings must be seen, instantly and on the visible surface, to be temporary and, in a word, fake.

Like Cole's *The Course of Empire* or *The Architect's Dream*, the White City was by implication an allegory; but it was also a sort of cathexsis, like Portman's hotel, of what was to become the "cognitive orientation" to the colossal crypto-natural economic/political/technological environment of corporate capitalism. Unlike Cole's paintings, however, it did not enjoy the formal condition of fictionality. Thus at the same moment that the White City announced the new capitalist hegemony, it pronounced it humbug and predicted its ultimate demise.

To summarize, the White City projected a vernacular Protestant dream vision that it at once exploited for eschatological meaning and exposed as fantasy; it inverted private and public spaces, reducing the old European *civis* to the content of a commercial spectacle understood and intended to be hallucinatory. Like much of the high art of the late nineteenth century, it called on the available resources of the cultural imagination, in the moment just preceding the advent of modernism, to figure Western society's most violent discontinuity as the telos of a received historical narrative that begins in Greece and ends, like the railroad, at Chicago.

What distinguished the White City was that it betrayed the futility of that effort, the inadequacy of the received account to incorporate the historical rupture; the White City in effect bade farewell to the vision that summoned it, looked forward to its own ruin, and prepared the level plain of the Jackson Park muck on which to erect a new but unknown world—a ghastly revelation of the expiration of what the cultural imagination had required ten centuries to create.

But it also promised metamorphosis. The meaning of the White City lies in the imaginary and actual epiphany that its whole existence implied, which was the moment when its plaster skin would ultimately slough off to reveal a new world, the modern, and modernist, world of naked steel girders making bizarre designs against a furnace-reddened industrial sky. In this respect its architectural message, like that of the skyscrapers to the north, was also an ecological one. Certain architectural themes such as the Roman arch or classical column remained consistent as building fronts changed from stone or brick—which signify monumentality, stability, and power—to iron; but the conspicuous use of iron and steel in achieving these forms announced the ascendancy of the new sources of that

power in mining, energy, heat, combustion, and fossil fuels—a fundamental shift in the material basis of society. If Henry Hobson Richardson's Romanesque banks, houses, and stores were redolent of fortresses erected against immigrants and restive workers, and of traditional craft masonry, the iron fronts of the steel frame skyscrapers belonged to a new industrial world of foundries, boilers, coal-burning furnaces, machine fabrication, mass production, and alienated labor.

If, however, as Guy Debord argues, the image is the "final form of commodity production," then the "staff" of the White City facades is on a continuum with commercial advertising, with housing and clothing and life "styles," and, finally, with the near-total videoization of contemporary social and political life. As Edward Bellamy observed, "the underlying motive of the whole exhibition, under a sheer pretense of patriotism," was "business, advertising with a view to individual money-making." The exposition inaugurated on an unprecedented scale the effort of a business elite to enforce what Henry Adams called the "capitalistic, centralizing, mechanical" forces abroad in society. But it went a step further. If the White City was designed to end in a photograph, the civilization it inaugurated has literally ended in an image, a society that consumes its own institutions on television and computer screens. In a sense, then, the White City already prophesied, at the apex of its aesthetic effect, the city of Chicago a century later, where in Grant Park a homeless man lies clutching himself on the seat of an elegant Beaux Arts bench where wafer-thin plates of disintegrating concrete expose the rusted iron skeleton beneath, as if to suggest that the whole city, and capitalism itself, were sheathed, ideologically speaking, in "staff."[63]

Traces of the hegemonic spirit of the exposition were with us at least until the 1950s, the constituent elements of a national hagiography and iconography of social and technological progress, patriotism, and technological and commercial supremacy. By the time of America's defeat in Vietnam and the Arab oil embargo, when, in David Harvey's analysis, Fordist production gave way to a new capitalist regime of "flexible accumulation," this spirit had run its course, only to be revived on the political right in the form of a business agenda that, like the White City itself, is advanced under cover of religious and political shibboleths.[64]

"And the buildings themselves have gone into mourning," wrote Teresa Dean near the end of Summer 1893, "for 'the days that have been, and shall be no more.' They are grey and grimy. . . . Perhaps the leafless trees and the absence of contrasting colors have something to do with the apparent accumulation of Chicago coal dust, which seems to have appropriated what a little while ago was so brilliant and pure; but surely, now, the White City needs a bath of soap and water."[65]

But the White City's apocalypse was to come by fire, not water. On October 28, 1893, the next-to-last day of the exposition, Mayor Carter Harrison was shot dead by a lonely, crazed civil servant, almost a modernist figure in himself—later to be

defended by Clarence Darrow on the then-novel claim of insanity—who imagined that the mayor had passed him over for a city appointment. On the last day of the fair, on the Midway, one writer recalls, "brawling and lewd crowds, waving whiskey bottles and signs, rioted until the small hours," while at City Hall "weeping processions . . . viewed the Mayor's bier . . . he was buried, and at the same time the dream-city on the lake's edge ceased to be."[66]

The sad unraveling of the World's Columbian Exposition, far more than the event itself, exposed some of the understructure of life in Chicago as it was actually being lived. With the closing of the fair and the descent of a particularly cold winter (as, to Carrie Meeber's distress, only in Chicago can winters be), the streets were clogged with the unemployed and homeless—beggars, peddlers, and tramps, many of whom took shelter in White City buildings that the city could not afford to maintain. "The most spectacular proof," wrote Hull House culture worker Julia Lathrop, "of the poverty entailed upon Chicago by the general business depression of 1893, and locally by the human debris left by the World's Fair, could be daily seen during all the severer months of the winter of 1893 and 1894. It was a solid, pressing crowd of hundreds of shabby men and shawled or hooded women, coming from all parts of a great city . . . standing hour after hour with market baskets high above their heads, held in check by policemen, polyglot, but having the common language of their persistency, their weariness, their chill and hunger."[67]

Nothing, perhaps, more starkly exposes the grip of Cole's elegiac narrative on the imagination of the urban elite than its tendency to associate and even conflate impending social and economic apocalypse with the literal fires that destroyed the White City. "About dusk on the night of January 8th," Bancroft writes, "a fire broke out in the casino and thence swept across the peristyle to the music hall . . . by a sudden shifting of the wind the flames were carried towards the Manufactures Building, and through its glass roof and the clear-story beneath, a shower of firebrands fell among cases packed with exhibits. . . ."

> . . . On the evening of the 5th of July some lads at play near the terminal station observed a gleam of fire within; and entering the depot tried for several minutes to stamp it out; but these few minutes were fatal. . . . It was a hot summer day; the buildings were dry as tinder; water was scarce; the fire engines far away, and a fierce gale was blowing from the southwest. . . . By the time the engines were fairly at work the terminal station was one flaming mass, and leaping across the plaza the fire had seized on the Administration Building, the dome of which fell with an appalling crash, covering with burning cinders and brands the Mining and Electricity buildings, both of which were quickly ablaze. To these were added, a few minutes later, the halls of Manufactures and Transportation. . . . Meanwhile from the railroad terminus the conflagration had spread to the

Machinery and Agricultural buildings, the one being utterly destroyed and the other damaged almost beyond recognition.[68]

It was in the loss of the Manufactures and Liberal Arts Building, however, that Bancroft found both his "historical mythology" and its political theme:

Almost as soon as the fire laid hold of it the vast semi-circular roof fell in. . . . Then it was seen that the whole interior was aflame, while from hundreds of windows tongues and jets of flame cast far on the dim waters of lake and lagoon their red and fearsome glare. Presently the frame began to totter; one after another the huge facades fell inward with a deafening roar, and of this mammoth temple of the Exposition there was nothing left, save for the lurid skeleton of a wall. It was now the time of the railroad strike, and as the conflagration reflected in the sky was seen by neighboring cities inland and on the shores of Michigan, messages of inquiry came pouring in by the hundreds. Fresh in the minds of many was the great fire of 1871, and with anarchy and lawlessness still unchained, it was feared that the rabble was inflicting on Chicago a repetition of that dread disaster. As to the origin of the conflagration nothing definite was ascertained, though both were believed to be the work of incendiaries, probably of the vagrant horde which infested the streets by day and slept at night wherever darkness overtook them.

It was "a fit apotheosis," wrote Robert Herrick, the "dream of beauty made of plaster" reduced "to ashes and twisted steel. . . . Those spectres of threatening disaster, unemployment and panic, that had haunted the imagination of its leaders during the summer of 1893 had arrived to take possession. Thousands of idle, starving people prowled the ice-cold streets and slept in the filthy alleys. Violence broke forth. Once more Chicago became the frontier village, unkempt and unsafe."[69]

Reflecting once more on the White City, the Beaux Arts tradition generally, and especially on its broader impact on the City Beautiful movement and even, in decorative form, on the steel frame building, I am struck by the fact that the assertion of imperiality that all of these forms make, with its inevitable historical gesture toward an idealized but fallen Rome, Venice, or Constantinople, is the very thing that lends to the Chicago cityscape, then and until recently, the strange and in many ways sublime forlornness that is the real subject of this essay and, I believe, the essential aspect of the elegaic White City.

Its hollow sylistic gesture, unrooted in the practical challenges of architectural science, while attempting to annex a history, both exposes its own want of history and saturates the field of temporality, in effect arresting or killing it. At the same moment that it animates a narrative whose implicit end is its own ruin, it forecloses

the possibility of all successive narratives, which can only be "inscribed" on the surface of an appearance.

That is what is so profoundly melancholy about the city that Burnham proposed, one that only went out of existence, culturally speaking, within our own lifetimes. The urban landscape has since mostly succumbed to redevelopment catastrophes. The new, emergent city, with its corporate trophy buildings and commuter archipelagoes, is like the rest of urban America one of the outposts—and there are now *only* "outposts"—of global finance capitalism, pitched amid the ruins, human and otherwise, of America's gloriously failed urban empire.

NOTES

1. Bancroft, *Book of the Fair*, 136.
2. Muirhead, *Land of Contrasts*, 205.
3. Bourget, "Farewell to the White City," 133.
4. Burg, *Chicago's White City*, 99.
5. Trachtenberg, *Incorporation of America*, 229–30.
6. Bancroft, *Book of the Fair*, 131; Fraser, "At the Fair," 15; Smith, "White Umbrella," 154.
7. Baudelaire, "The Painter of Modern Life," quoted in Berman, *All That Is Solid*, 133.
8. Muirhead, *Land of Contrasts*, 206.
9. Bancroft, *Book of the Fair*, 49.
10. Bunner, "Making of the White City," 406–8.
11. Cole, "The Course of Empire," *American Monthly Magazine*, 159, 168, and *The Knickerbocker*, 180.
12. Ibid.
13. Pater, *The Renaissance*, 551.
14. Dean, *White City Chips*, 41. It "is so sacred to the American public," Dean wrote, "that it is guarded in this journey by sheriffs, police, and soldiers of two cities; that it was escorted today by the mayors of both—the crowd saw the bell come down the avenue decorated with flowers drawn by some magnificent black horses and resting on a white truck that told you in gilt letters all around its sides what kind of soap to use. . . . Alack and alas that liberty should come to this."
15. MacCannell, *The Tourist*, 13.
16. Jameson, *Postmodernism*, 27.
17. See Cantwell, *Ethnomimesis*, 276–88.
18. Markley, "Amateur Photography," 170.
19. Smith, "White Umbrella," 150–56.
20. Dean, *White City Chips*, 30.
21. Besant, "First Impression," 532.
22. Muirhead, *Land of Contrasts*, 205.
23. Low, "Art of the White City," 504.
24. Van Rensselaer, "At the Fair," 11.
25. Besant, "First Impression," 534.
26. Dean, *White City Chips*, 417–18.
27. Crowley, *City of Wonders*, 55–58.
28. Ingalls, "Lessons of the Fair," 144.
29. Boyesen, "New World Fable," 178.
30. Dean, *White City Chips*, iv.
31. Grant, "People Who Did Not Go," 163.
32. Besant, "First Impression," 536.

33. Trachtenberg, *Incorporation of America*, 220.

34. Garland, in *A Son of the Middle Border* (1928), quoted in Levine, *Highbrow/Lowbrow*, 213.

35. Burnham, *Sweet Clover*, 180–81.

36. Bancroft, *Book of the Fair*, 136.

37. Gilbert, *Perfect Cities*, 224.

38. Payne, *Mr. Salt*, 55–57.

39. Herrick, *Waste*, 112.

40. Ibid., 107–8.

41. Besant, "First Impression," 531.

42. Bird, "Preliminary Glimpses," 617.

43. Burg, *Chicago's White City*, 106.

44. Bird, "Preliminary Glimpses," 617.

45. Millet, "Decoration of the Exhibition," 606.

46. Lacan, quoted in Jameson, *Postmodernism*, 27.

47. Quoted in Burg, *Chicago's White City*, 107.

48. Gilman, "The Eye and the Ear," 477.

49. Sullivan, *Autobiography of an Idea* (1924), quoted in Trachtenberg, *Incorporation of America*, 225. See Shankland, "Construction of Buildings, Bridges," 8–9.

50. Truettner and Wallach, *Thomas Cole*, 219.

51. Crowley, *City of Wonders*, 100.

52. Truman, *History of the World's Fair*, 451.

53. Bancroft, *Book of the Fair*, 197–98.

54. Ibid., 137.

55. Crowley, *City of Wonders*, 102.

56. Ibid., 102, 109.

57. Jameson, *Postmodernism*, 51.

58. Ibid., 44, 40.

59. Bancroft, *Book of the Fair*, 960.

60. Dean, *White City Chips*, 82–83.

61. Foucault, *Discipline and Punish*, 217.

62. Bird, "Preliminary Glimpses," 617. See Cronon, *Nature's Metropolis*, 263–78, and Gilbert, *Perfect Cities*, 23–44.

63. Jameson, *Postmodernism*, 18 (Debord, *The Society of the Spectacle*, 1967); Trachtenberg, *Incorporation of America*, 215 (Bellamy), 226 (Adams).

64. Harvey, *Condition of Postmodernity*, 147–97 and passim.

65. Dean, *White City Chips*, 424.

66. Badger, *Great American Fair*, 130.

67. Ibid., 130.

68. Bancroft, *Book of the Fair*, 960–61.

69. Herrick, *Waste*, 117.

BIBLIOGRAPHY

Badger, Reid. *The Great American Fair: The World's Columbian Exposition and American Culture*. Chicago: N. Hill, 1979.

Bancroft, Hubert Howe. *The Book of the Fair: An Historical and Descriptive Presentation of the World's Science, Art, and Industry, as Viewed through the Columbian Exposition at Chicago in 1893*. 5 vols. Chicago: Bancroft Co., 1893.

Besant, Walter. "A First Impression." *Scribner's Magazine* 14, no. 4 (October 1893): 528–39.

Bird, Clarence Clough. "Preliminary Glimpses of the Fair." *Century Magazine* 45, no. 4 (February 1893): 615–25.

Bourget, Paul. "A Farewell to the White City." Translated by Walter Learned. *The Cosmopolitan* 16, no. 2 (1893?): 133–40.

Boyesen, Hjalimar Hjorth. "A New World Fable." *The Cosmopolitan* 16, no. 2 (1893?): 173–86.

Bunner, H. C. "The Making of the White City." *Scribner's Magazine* 12, no. 4 (October 1892): 399–418.

Burg, Daniel F. *Chicago's White City of 1893*. Lexington: University of Kentucky Press, 1976.

Burnham, Clara Louise. *Sweet Clover: A Romance of the White City*. Boston: Houghton Mifflin, 1894.

Cantwell, Robert. *Ethnomimesis: Folklife and the Representation of Culture*. Chapel Hill: University of North Carolina Press, 1993.

Cole, Thomas. "The Course of Empire." *American Monthly Magazine*, n.s. 2 (November 1836): 513, and *The Knickerbocker* 8 (November 1836): 629.

Cronon, William. *Nature's Metropolis: Chicago and the Great West*. New York: Norton, 1991.

Crowley, Mary Catharine. *The City of Wonders: A Souvenir of the World's Fair*. Detroit: William Graham Co., 1894.

Dean, Teresa. *White City Chips*. Chicago: Warren Publishing Co., 1895. Originally published serially in the *Chicago Daily Inter-Ocean*, Spring–Fall 1893.

Foucault, Michel. *Discipline and Punish: The Birth of the Prison*. Translated by Alan Sheridan. New York: Random House, 1979.

Fraser, W. Lewis. "At the Fair: Decorative Painting at the World's Fair." *Century Magazine* 46, no. 1 (May 1893): 14–21.

Fuller, Henry B. *Under the Skylights*. New York: Appleton, 1901.

Gilbert, James. *Perfect Cities: Chicago's Utopias of 1893*. Chicago: University of Chicago Press, 1991.

Gilman, Daniel C. "The Eye and the Ear at Chicago." *Century Magazine* 45, no. 3 (January 1893): 447–78.

Grant, Robert. "People Who Did Not Go to the Fair." *The Cosmopolitan* 16, no. 2 (1893?): 158–64.

Harvey, David. *The Condition of Postmodernity*. Cambridge: Blackwell Publisher, 1990.

Herrick, Robert. *Waste*. New York: Harcourt, Brace, 1924.

Howells, William Dean. *Letters of an Altrurian Traveller* (1893–94). Introduction by Clara M. Kirk and Rudolf Kirk. Gainesville, Fla.: Scholars Facsimiles and Reprints, 1961.

Ingalls, John J. "Lessons of the Fair." *The Cosmopolitan* 16, no. 2 (1893?): 141–49.

James, Henry. "The Grand Canal." *Scribner's Magazine* 12, no. 5 (November 1892): 531–50.

Jameson, Fredric. *Postmodernism: Or, the Cultural Logic of Late Capitalism*. Durham, N.C.: Duke University Press, 1991.

Levine, Lawrence. *Highbrow/Lowbrow: The Emergence of Cultural Hierarchy in America*. Cambridge: Harvard University Press, 1988.

Low, Will H. "The Art of the White City." *Scribner's Magazine* 14, no. 4 (October 1893): 504–12.

MacCannell, Dean. *The Tourist: A New Theory of the Leisure Class*. New York: Schocken Books, 1976.

Markley, Horace Herbert. "Amateur Photography at the World's Fair." *The Cosmopolitan* 16, no. 2 (1893?): 165–72.

Millet, F. D. "The Decoration of the Exhibition." *Scribner's Magazine* 12, no. 6 (December 1892): 692–709.

Muirhead, James Fullarton. *The Land of Contrasts: A Briton's View of His American Kin*. Boston: Lamson, Wolffe and Co., 1898.

Pater, Walter. "From *The Renaissance*, Conclusion." In *Prose of the Victorian Period*, ed. William E. Buckler. New York: Houghton Mifflin (Riverside Editions), 1958.

Payne, Will. *Mr. Salt*. Boston: Houghton Mifflin, 1904.

Read, Opie. *The Colossus: A Novel*. Chicago: Laird and Lee, 1893.

Shankland, E. C. "The Construction of Buildings, Bridges, etc. at the World's Columbian Exposition." In *Inland Architect and News Record*, no. 22, August 1893, 8–9. Chicago: Inland Publishing Co., 1887–1908.

Skiff, F. J. V. "Mines and Metallurgy." *The Cosmopolitan* 15, no. 5 (September 1893): 592–99.

Smith, F. Hopkinton. "A White Unbrella at the Fair." *The Cosmopolitan* 16, no. 2 (1893?): 150–56.

Trachtenberg, Alan. *The Incorporation of America: Culture and Society in the Gilded Age*. New York: Hill and Wang, 1982.

Truettner, William, and J. Alan Wallach, eds. *Thomas Cole: Landscape into History*. New Haven: Yale University Press, 1994.

Truman, Ben C. *History of the World's Fair*. Philadelphia: H. W. Kelley, 1893.

Van Rensselaer, M. G. "At the Fair." *Century Magazine* 46, no. 1 (May 1893): 3–13.

Walker, John Brisben. "The World's College of Democracy" (A World's Fair Introductory). *The Cosmopolitan* 15, no. 5 (September 1893): 517–27.

JON MICHAEL SPENCER

...

Modernism and the Negro Renaissance

One of the most important interpreters of the Harlem or Negro Renaissance is African American literary critic Houston Baker. In his book *Modernism and the Harlem Renaissance* (1987), Baker contests the several scholars who argue that the Renaissance failed, particularly Nathan Huggins (and, I would add, David Levering Lewis). Baker's criticism of Huggins is that to begin an account of the Renaissance with the question of why it failed is naturally going to result in a negative account: "To ask *why* the renaissance failed is to agree, at the very outset, that the twenties did not have profoundly beneficial effects for areas of Afro-American discourse that we have only recently begun to explore in depth." Huggins concludes that the Renaissance failed as a modernist movement because of its inability to produce an art that was not "provincial," a word understood by Baker to mean "old-fashioned" or "moribund."[1] Huggins asserts that by the 1930s the Renaissance had ended. No "New Negro" had emerged.[2] He means that there was failure not only in Harlem but also in such places as Philadelphia, Washington, Atlanta, Chicago, and Nashville—cities that Renaissance intellectual Alain Locke said in 1929, the year of the stock market crash, had joined the cultural awakening of the Renaissance.[3] According to Huggins, the Great Depression abruptly caused people to concentrate on the essentials of living rather than on the aesthetics of black culture, which resulted in the end of the "promoted culture" of the Renaissance.[4]

David Levering Lewis dates the Renaissance from around 1919 to 1932, having drawn the same conclusion as Huggins regarding the devastating effects of the country's economic crisis. In the final chapter of his book, *When Harlem Was in Vogue*, Lewis says that the depression accelerated the inevitable failure of the Renaissance as a positive social force.[5] His choice of a chapter title, "It's Dead Now," recalls an article of 1942 in *Opportunity*, in which Trinidad-born novelist and essayist Frank Hercules wrote, "the Negro Renaissance, already growing old, died a violent death at the hands of the World Market in 1929."[6]

W. E. B. Du Bois

Alain Locke

Figure 1. A collage of some leaders in the Harlem Renaissance. (Photographs by Carl Van Vechten; Yale Collection of American Literature, Beinecke Rare Book and Manuscript Library, Yale University)

Scholars who have focused on the music of the Renaissance rather than its economic and political aspects have also concluded that the Renaissance failed. They seem to have accepted Huggins's and Lewis's conclusions, even though both historians marginalize music in their discussions of the movement. For instance, Martin Blum comes to the same conclusion as Huggins in his 1974 article "Black Music: Pathmaker of the Harlem Renaissance." After arguing briefly but insightfully that black music enjoyed a prophetic and practical role in the Renaissance as catalyst, contributor, and beneficiary, Blum concludes that the Renaissance ended with the coming of the depression, a mere decade after, he says, the movement began.[7] Samuel Floyd, in the introduction to *Black Music in the Harlem Renaissance*, agrees with Huggins and Lewis that the Great Depression brought an end to the Renaissance and thus concludes: "It also happened that the Renaissance ended before composers could fully develop their skills."[8]

In contrast to these views of the Renaissance as a failure and the view of Renaissance literature as moribund rather than modern, Houston Baker identifies two modernist "discursive strategies" that Renaissance artists and intellectuals used to reproach the racism of whites. The first, the "mastery of form," comprised

James Weldon Johnson

Paul Robeson

Marion Anderson

Countee Cullen

Zora Neale Hurston

Arna Bontemps

Langston Hughes

Aaron Douglas

William Grant Still

the ability to sound stereotypically "colored" when what the artist or intellectual was doing was manipulating whites' stereotypes of blacks, including the nonsensical stereotypes of minstrelsy, for the purpose of liberating blacks. Baker cites as the prototypal example Booker T. Washington's Atlanta Exposition address of 1895, explaining that Washington went so far as to take up forms and sounds of minstrelsy to earn a national reputation and the resultant benefits for the black masses. He concludes that Washington "demonstrates in his manipulations of form that there *are* rhetorical possibilities for crafting a voice out of tight places."[9]

A musical equivalent of this modernist "mastery" in Washington's address is R. Nathaniel Dett's "Mammy," one of the four pieces in the black composer's piano suite of 1912, *Magnolia*. On the one hand, the image of the mammy fits comfortably into the stereotypical views that whites, southern whites in particular, held of blacks, which is why music scholar George Pullen Jackson, a typical white southerner of Dett's day, seemed enamored by Dett's "Mammy." After hearing the piece performed by Dett at a recital at Fisk University in 1923, Jackson waxed emotional in a newspaper review: "the determined applause that compelled Mr. Dett to halt the trend of his *Magnolia Suite* to repeat that unspeakably soulful poem-without-words, 'Mammy,' was proof conclusion that his hearers had had an experi-

ence of rare beauty." The racial stereotype surrounding the mammy and the lush sounds that evoked nostalgic images of the Old South and the Old Negro enamored Jackson, but Dett was also re-imaging the mammy in sophisticated art (via his "mastery of form") which had as one of its goals what Alain Locke called the "vindication of the Negro." Dett demonstrated in this composition that in an age of Jim Crow there were modern rhetorical possibilities for forging out a voice in tight places.[10]

Dett's "Mammy" represents the antithesis of the second discursive strategy of modernism, which Baker terms the "deformation of mastery"—the straightforward debunking of white people's racist racialism. Baker argues that the spirituals, as repositories for an African cultural spirit untainted by European forms and folly, are examples of this "creative deformation." A musical instance of this modernist "deformation" was Paul Robeson's concert debut at the Greenwich Village Theatre in New York in 1925, on which program Robeson sang only spirituals—the first concert of its kind (which Robeson repeated the following year in the city's Town Hall). This deformative act was in a sense akin to Antonio Salemme sculpting in bronze a full-size nude Robeson, which he titled *The Spiritual* (1926). The sculpture was so deforming, in fact, that the art alliance of Philadelphia refused to allow it to be exhibited in the city. The problem was not the nudity per se, figured Howard University professor Kelly Miller, but specifically black nudity—in other words, Miller explained, not prudery but race prejudice.[11] The disposition of this "creative deformation," as Baker also calls it, was further expressed in Duke Ellington's comment in 1944 that "Jazz, swing, jive, and every other musical phenomenon of American musical life are as much an art medium as are the most profound works of the famous composers. . . . [To] attempt to elevate the status of the jazz musician by forcing the level of his best work into comparisons with classical music is to deny him his rightful share of originality."[12]

By identifying these two discursive strategies used by black artists and intellectuals, Baker enables us to view the Renaissance as a broader, ongoing, and successful movement that commenced around the turn of the century, burgeoned in the 1920s, and, he contends, has continued to the present day. He terms this broader period of modernism "renaissancism."[13] Locke said this very thing in a 1938 essay appearing in *The Crisis*: that a new movement of self-conscious racialism commenced in 1895 and laid the groundwork for the burgeoning of the Negro Renaissance in the 1920s. Not only did Locke mention the key figures and works on which Baker relies for his claim of renaissancism—Washington's Atlanta Exposition speech (mastery of form) and W. E. B. Du Bois's *The Souls of Black Folk* (deformation of mastery)—but he also described the musical contribution to this burgeoning epoch.

James Weldon Johnson's *Autobiography of an Ex-Colored Man* (1912) also belongs

prominently to this "new era." In 1899 Johnson began thinking about the idea that would lay the groundwork for the cultural racialism of the burgeoned Renaissance of the 1920s. Of that year Johnson wrote, "I now began to grope toward a realization of the importance of the American Negro's cultural background and his creative folk-art, and to speculate on the superstructure of conscious art that might be reared upon them." Within the next three to six years the *Autobiography* began to take shape. Thus, the book belonged prominently in the new era that pushed toward the modernism of the 1920s, even though Johnson did not seem to realize this prior to its republication in 1927. It was prophetic of the Negro Renaissance that would come to be recognized in the mid-1920s: All the major motifs important to an understanding of the Renaissance were present in this work of so-called fiction. Regarding this aspect of Johnson's novel, Carl Van Vechten wrote: "I was particularly interested to discover that you were apparently the first to sense the musical possibilities of ragtime and to predict for it a future as an art-form." Aaron Douglas, the Renaissance artist who designed the cover for the 1927 reprint of the book, said even more about the work's importance to the Renaissance:

> I have just finished reading the book and I am carried away with amazement and admiration. Your depth of thought, breadth of vision, and subtlety and beauty of expression awakens in me the greatest admiration. I am amazed at the gigantic effort which must have been necessary for the writing and publishing of the book at such an early date. The post-war Negro, blinded by the glare and almost sudden bursting of a new day, finds much difficulty in realizing the immense power and effort, which the pre-war Negro has made to prepare the country for what we now feel to be the "Awakening."

The work was therefore only "published out of time" to the degree that it was prophetic, for its prophecy was part of what Locke called a racialism comprised of a "new dynamic of self-help and self-assertion."[14]

Locating Booker T. Washington at the beginning of this period of modern renaissancism that burgeoned in the 1920s, a placement permitted by our comprehension of the two discursive strategies that Baker says Renaissance African Americans utilized, is also suggested by the title of the edited book to which Washington contributed (and which prominently displays his name as though he were the author), *A New Negro for a New Century* (1900). This broader perspective on and time frame of the Renaissance as a much more protracted modern movement is further suggested in William Pickens's book, *The New Negro* (1916), in the opening essay titled "The Renaissance of the New Negro." Pickens wrote: "The history of the race has been distorted or buried in contempt. But along with the great advance which the Negro can be expected to make in the United States in the next fifty years, every few years should see a book up to date on the general subject of

'The Renaissance of the Negro Race' or 'The New Negro.'"[15] Locke's *The New Negro* (1925) and *The Negro and His Music* (1936) also fit into this lineage of books that update the Renaissance of African Americans, as does James Weldon Johnson's *Autobiography of an Ex-Colored Man*, which was greatly influenced by Du Bois's *Souls of Black Folk* (1903).[16] The books *A New Negro for a New Century* (1900), *The Souls of Black Folk* (1903), *The Autobiography of an Ex-Colored Man* (1912), and *The New Negro* (1916) thus were not foretelling a Renaissance to come; rather, they were part of the spirit of nationalistic engagement expressed by Baker's two discursive strategies, which commenced with artists and intellectuals around 1895 and burgeoned with extensive expression and broad recognition during the 1920s.

In 1936 Locke's *The Negro and His Music* appeared and gave the impression that the Renaissance was still in motion. A few years earlier, in 1933, black composer Shirley Graham had written an article on African American music for *The Crisis*, in which she also spoke as though the Renaissance was still under way: "The Fisk Jubilee Singers blazed a path; they marched around the walls of Jericho and 'da walls came a-tumblin' down'.... Now the challenge comes to us, the New Negro." One year later, in 1934, the *Negro Folk Symphony*, by African American composer William Dawson, was premiered on November 14, 15, and 17 by the Philadelphia Orchestra under Leopold Stokowski at the Philadelphia Academy of Music and on November 20 at Carnegie Hall; it was a great success and a modernist landmark in black cultural progress. Without considering the world of literature, then, the Negro Renaissance was evidently still in progress. According to Locke, the literary world of the Renaissance was not halted by the depression. "Things seem to be at an awful ebb," he wrote in late 1932 to Charlotte Mason, a white patron of the Renaissance, "but of course we drained our own pond long before the great ebb came. In fact it is rather a pity we have the general depression as an alibi. I am challenged with that whenever I criticize the young Negroes who certainly had their chance."[17]

It is with regard to Locke's mastery of form (his mask of accommodation) in dealing with Mason that we are to understand not only the latter remark but also Locke's comment to Mason a month later—"I'll someday have to write out for my own satisfaction, and absolution, the inside story of 'the Negro renaissance' and how it was scuttled from within"—which David Levering Lewis erroneously cites as evidence that Locke viewed the Renaissance as a failure.[18] Lewis's thorough historical research should have revealed to him that Locke never did write that "inside story"; and that if he had written it, it would have been so inside as to have been for Mason's satisfaction only—as appeasement to her for the fact that the Renaissance artists had neglected to adopt her antimodernist philosophy of artistic primitivism. Whatever the inside story between Locke and Mason, the outside

story that Locke wrote in 1933 was that that year of economic depression had not adversely affected African American literature, except for the fact that many manuscripts probably had gone unpublished.[19] Years later, Locke was still appeasing Mason by saying that the Renaissance had failed, but he had not and would not commit the notion to writing. *Her* Renaissance had failed, he seemed to be thinking, but *the* Renaissance had not.

At the beginning of 1935, for instance, Locke informed Mason that in a lecture on "The Negro Contribution to American Culture" at Bennett College, a black women's institution in Greensboro, North Carolina, he had hinted that the Renaissance had failed. "The talk was sound, I think," he wrote Mason, "especially since it admitted what we haven't done—and that statement seems to have [pre]pared the way for me to speak out in an article on 'Why the Negro Renaissance Failed.'" Locke went on to tell Mason that the failure of several of the artists who had betrayed her, including Langston Hughes, could make up the text of the article and that he was wondering if she would care to see such an article published. But having worn this mask of accommodation ever so adroitly, Locke withdrew the idea as quickly and shrewdly as he posited it. "However, it does not seem the right moment for this, even if there were the right medium," his letter continued. "However, it is impossible to keep completely silent, having been so intimately involved."[20] In fact, nothing in his notes for the Bennett College lecture suggests that the Renaissance failed.[21] To the contrary, the notes indicate that the Renaissance was a success and the New Negro was still making an important contribution to American culture. Furthermore, if the Bennett lecture at all resembled Locke's article titled "The Negro's Cultural Contribution to American Culture," published four years later, then we can reasonably surmise that Locke was telling Mason that the Renaissance was failing while saying quite the opposite in his articles and lectures. In this article of 1939 Locke spoke positively not only of the Negro Renaissance but also of those who had allegedly betrayed Mason, indeed those whom he and Mason had belittled in their private conversations.[22] Similarly, James Weldon Johnson, as early as 1926 and until his accidental death in 1938, lectured at universities, churches, and other institutions, white and black, on "The Negro's Cultural Contribution to American Civilization" or "The Negro's Contribution to American Culture."

Locke thus was not about to concede the end of the Negro Renaissance, no matter what he said privately to appease Mason and continue receiving her patronage. Instead, in 1934 he was busy lauding Sterling Brown as the New Negro who superseded even Hughes in an intimate knowledge of folklife, which he skillfully encased in classic poetic form.[23] It was just good fortune that Brown was someone Mason approved of, so Locke would not have to maneuver around her views as he did when discussing Paul Robeson, Roland Hayes, and Langston

Hughes. "It was joyous news that you liked Sterling Brown's book," he wrote to Mason with a portion of relief and a plethora of appeasement. "I was hoping you would—but scarcely dared hope—for there have been so many disappointments—and so much has turned out to be tinsel under your revealing light."[24] If Locke felt that anything about the Renaissance had been "scuttled from within," he saw it to be that facet of the movement promoted by the white Negrophiles who were its benefactors (including Mason herself).

As early as 1928 Locke had foretold the passing of the "vogue" of the Negro and the emergence of a more mature phase of the Renaissance, of which he evidently viewed Sterling Brown as exemplary. Writing at the end of 1928, the year he called "the floodtide of the present Negrophile movement," Locke said:

> In this, as with many another boom, the water will need to be squeezed out of much inflated stock and many bubbles must burst. However, those who are interested in the real Negro movement which can be discerned behind the fad, will be glad to see the fad subside. Only then will the truest critical appraisal be possible, as the opportunity comes to discriminate between shoddy and wool, fair-weather friends and true supporters, the stock-brokers and the real productive talents. The real significance and potential power of the Negro renaissance may not reveal itself until after this reaction, and the entire top-soil of contemporary Negro expression may need to be plowed completely under for a second hardier and richer crop.
>
> To my mind the movement for the vital expression of Negro life can only truly begin as the fad breaks off. There is inevitable distortion under the hectic interest and forcing of the present vogue for Negro idioms. An introspective calm, a spiritually poised approach, a deeply matured understanding are finally necessary.[25]

This idea that the real significance and potential power of the Renaissance was yet to reveal itself following the floodtide of the Negrophile fad was no mere passing thought, for two years later, in early 1931, Locke repeated the point in no uncertain terms:

> The much exploited Negro renaissance was after all a product of the expansive period we are now willing to call the period of inflation and overproduction; perhaps there was much in it that was unsound, and perhaps our aesthetic gods are turning their backs only a little more gracefully than the gods of the marketplace. Are we then, in a period of cultural depression. . . ? By some signs and symptoms. Yes. But to anticipate my conclusion,—"Let us rejoice and be exceedingly glad." The second and truly sound phase of the cultural development of the Negro in American literature and art cannot begin without a collapse of the boom, a change to more responsible and devoted leadership, a revision of

basic values, and along with a penitential purgation of spirit, a wholesale expulsion of the money-changers from the temple of art.[26]

At the beginning of 1934, in his retrospective review of black literature for 1933, Locke reemphasized his belief that a second and truly sound phase of black cultural development in the arts and letters was taking root: "As year by year the literature by and about the Negro not only maintains its volume, but deepens and clarifies in quality, there can be no doubt that the Negro theme has become a prominent and permanent strain in contemporary American literature. No mere fad or fashion could have sustained itself for ten or more years with increasing momentum and undiminished appeal and effect. In fact, as the fad subsides, a sounder, more artistic expression of Negro life and character takes its place."[27]

Carl Van Vechten may have read this assessment, which appeared in the January 1934 issue of *Opportunity*, for a month later he made a similar comment to James Weldon Johnson. Considering such works as Johnson's *Along This Way*, Hughes's *The Ways of White Folks*, and Zora Neale Hurston's *Jonah's Gourd Vine*, Van Vechten observed, there was much more solid evidence of a Negro Renaissance then, in 1934, than around 1926 and 1927. Johnson himself viewed such works as fulfilling the mandate of the Renaissance to challenge white stereotypes of blacks by capturing the life, ambitions, struggles, and passions of the Negro race within the "higher" classical forms. "Some" of this work had already been done, he wrote in 1934 in *Negro Americans, What Now?* To this he added, "but the greater portion remains to be done—and by Negro writers and artists."[28] Three years later Johnson had not changed his opinion about this, and Van Vechten had not changed his mind about the Renaissance being stronger than in the mid-1920s. With regard to the new edition of *The Autobiography of an Ex-Colored Man* due out, he told Johnson: "I would suggest . . . that you yourself add a further Introduction (or appendix) to this new edition, a chapter in which you can relate how much further the Negro has progressed, how his presence at the opera, concert, and art gallery is now very generally expected."[29]

About seven months later, in his retrospective review of African American literature for 1937, Locke identified the years 1917 to 1934 as comprising the first generation of Renaissance artists. As though he were anticipating the criticism of someone like Harold Cruse, author of *The Crisis of the Negro Intellectual*, he argued that the first generation was "choked in shallow cultural soil by the cheap weeds of group flattery, vainglory and escapist emotionalism," tainting the movement with exhibitionism and demagoguery. But the demise of this phase was but the beginning of a "second generation" of writers and artists, which included Langston Hughes, Zora Neale Hurston, Arna Bontemps, and Sterling Brown. Of these artists Locke wrote, "Their more penetrating, evenhanded and less-illusioned portrayal of Negro life is realizing more deeply the original aims of what was too

poetically and glibly styled 'The Negro Renaissance.' "[30] From Locke's perspective, then, what "failed" was but the early phase of the Negro Renaissance, an early phase of modernism that gave way to "a sounder, more artistic expression of Negro life and character." Understanding this gives further meaning not only to Locke's comment to Mason that the Renaissance was "scuttled from within," but also to Claude McKay's observation that the Renaissance seemed like a "hopeless mess" and to Langston's Hughes's pronouncement that the Renaissance was but short-lived fun.[31]

In his retrospective review of black literature for 1938, Locke explained the "hopeless mess" of the Negro Renaissance. Addressing the question of whether the present artistic movement was a matured phase of the Renaissance or a countermovement (as some black artists of the younger generation were arguing), Locke contended that the former was true and that the Renaissance was just coming into its own after a "frothy adolescence," just as he had predicted. Almost two years later, in 1940, Locke was still excited about the burgeoning of the Renaissance—a Renaissance where sobriety, poise, and dignity dominated the approach to black subject matter. In addition to his enthusiasm for a few visual artists, he was exuberant about William Grant Still's completion of his oratorio *And They Lynched Him on a Tree*, about Dorothy Maynor's concert career, and about Ulysses Kay (one of Still's protégés whom Locke called "another straightforward, sincere genius"). He assertively related this to Charlotte Mason, of all people, but not (as we would suspect) without the requisite appeasement. "You know real Negro genius has been spurting up lately like an oil-well freshly drilled," he proclaimed. "And just at this moment of the almost complete downfall of white civilization. It has great significance to those who understand—or rather I should say—to those whose eyes have been opened by you." Even Hughes, who had characterized the Renaissance as a fad that was fun while it lasted, came around to the point where Locke had been all along. While visiting Los Angeles in 1946, Hughes publicized his opinion that there had been a reawakening of interest in blacks, particularly with regard to the arts. "We are going through a second Negro renaissance in the arts," declared Hughes.[32]

Even when at the end of 1949 the National Urban League suspended publication of *Opportunity*, a magazine that had been an important source of artistic and intellectual expression for the Renaissance Negro, Locke still considered the movement to be progressing. The 1950 fortieth anniversary of the *Pittsburgh Courier* must have confirmed this for him and many others with the review by foremost African American writers of black progress along every important front.[33] A total of twenty-one articles (rather than the planned twenty-six), published approximately every other week for the entire year, celebrated the advancement of the

New Negro (the Renaissance or modernist black man and woman) in literature, music, theater, art, religion, civil and human rights, public and higher education, journalism, the professions, human welfare, and so on.

The first article in the *Courier*'s series, appearing during the second week in January, was a general overview of race progress by W. E. B. Du Bois. In this article, illustrated by photographs of such black artists as James Weldon Johnson and Harry T. Burleigh, Du Bois asked: "What have we gained and accomplished?" He acknowledged: "The advance has not been equal on all fronts, nor complete on any. . . . But we have advanced. Of that there can be no atom of doubt." Did he agree with Locke that advances had been made in literature? Like Locke, Du Bois criticized African American literature that was not authentically about black people but about those things that whites liked to hear about blacks; but he also concluded that there was an increasing number of excellent black writers. With regard to the other arts, Du Bois noted: "We have done something in sculpture and painting, but in drama and music we have markedly advanced. All the world listens to our singers, sings our music and dances to our rhythms."[34]

"Fifty Years of Progress in Literature" was written by James W. Ivy, who had taught black literature for five years on the faculty at Hampton Institute before becoming the acting editor of *The Crisis*. In this article, containing photographs of writers like Johnson, Hughes, Countee Cullen, Jessie Fauset, Sterling Brown, Locke, and Du Bois, Ivy observed that the common task of African American writers during the first quarter of the century was to rid their art of the plantation perspective on black life represented by Paul Laurence Dunbar's dialect verse. On the other hand, wrote Ivy in agreement with Locke, Charles Chesnutt foreshadowed the spirit of the rebellious 1920s. "What then has been the Negro's contribution to the last fifty years of American literature," Ivy asked? "We have brought a new sensitivity and a new point of view into American letters," he answered. "We have contributed a creditable body of work in every literary form and we have produced writers of real achievement who are appraised as American and not just 'Negro' writers. And we have all but abandoned the old crippling concern with the gap between the Negro and the white audience." Ivy concluded with words that coincided with Locke's views: "We can look forward to every new generation of Negro writers adding a new chapter and a new verse to the book of American literary achievement."[35]

Alongside the development of modernist black literature was that of black art, as James A. Porter reported in an article titled "Progress of the Negro in Art during the Past Fifty Years." Porter, a professor of art at Howard University, credited the Renaissance for the advances made in his field. He maintained that artists such as Aaron Douglass, Richmond Barthe, Sargent Johnson, Jacob Lawrence, Augusta Savage, and Selma Burke were to be credited for doing the actual creative work,

whereas writers such as Alain Locke and Benjamin Brawley were to be credited for broadening the perspective of blacks on the history of African American art.[36] He was evidently referring to Locke's *Negro Art: Past and Present* (1936) and Brawley's *The Negro Genius* (1937).

In "Fifty Years of Progress in the Professions," Ira Reid, a black professor of sociology at Haverford College, formerly at Atlanta University, covered such areas as teaching, medicine, dentistry, law, technology, religion, and the "cultural professions." With regard to the cultural professions he said that black musicians—singers, arrangers, composers, and conductors—had made great strides. The black singer, for instance, was not only a respected interpreter of African American spirituals, but also a foremost interpreter of Bach.[37]

William Grant Still elaborated on this point in his essay for the series, "Fifty Years of Progress in Music." Supported by photographs of Burleigh, Hayes, Dett, and Clarence Cameron White, Still listed all the evidence of black progress in the choral and instrumental areas (i.e, the historic "firsts" and subsequent achievements). He concluded: "we can indeed look back over the last half century with pride and forward to the next with keen anticipation. We can be proud, yes—but not complacent. The time for fighting has just begun!"[38] This certainly did not represent a pessimistic view of the Renaissance, but rather an optimistic presumption that African American culture revealed steady progress into modernism.

This progress was evident not only in the "cultural professions" in general and music in particular, but also in the black church, as documented in "Fifty Years of Progress in the Negro Church" by Morehouse College president Benjamin Mays. As we would anticipate in the modernist age of the New Negro, Mays wrote on the black social gospel. He cites evidence of progress in those churches that supplemented their spiritual ministry with a social ministry that was concerned with such aspects of secular life as education, recreation, business, and politics.[39] This was the kind of modernist expression of Christianity that Locke and Johnson approved of.

The New Negro's advances in the arts, letters, professions, and religion during the Negro Renaissance were accompanied by advances in those areas that were perhaps most important to the masses of blacks—their acquisition of civil and human rights. Walter White, secretary for the NAACP, wrote in "Civil Rights: Fifty Years of Fighting" that the civil rights organizations founded early in the century joined forces with black newspapers in calling for the civil rights of African Americans. According to White, "the first half of the Twentieth Century has been devoted to a struggle to move the ball from the shadow of one's own goal posts up to the center of the field. The advocates of civil rights have certainly moved the ball at least to the fifty-yard line." He concluded: "I might be even more optimistic and say that it has been rushed even further into the enemy's territory. The fight during the second half of the century will be that of carrying further down the field and

across the goal line of the enemy."[40] Following these words is a list of twenty-four cases that the NAACP had won before the U.S. Supreme Court.

Finally, in the piece titled "Fifty Years of Progress in Human Relations," all areas of black progress were tied together by Edwin R. Embree, who with Walter White was the moving force behind the founding of the American Council of Race Relations. Above photographs of such diverse scholars, leaders, and artists as W. E. B. DuBois, Duke Ellington, Marian Anderson, and Ralph Bunche, Embree discussed the contribution of the Negro Renaissance alongside economic advances. He viewed all of this as distinct progress over the previous fifty years when the social and economic position of blacks permitted whites to go unchallenged in their belief in white supremacy. He wrote, "There was nothing like the present Harlem or South Chicago or the dozen other flourishing centers where Negroes today form their own societies, publish their own newspapers, develop their own businesses, and foster their own arts." In terms of my argument that the Renaissance was a modernist movement that helped blacks transgress America's racist color line, Embree noted that in 1900 white supremacy was accepted throughout America and the world as the law of nature but that in 1950 white supremacy was finished, even if vestigial traces remained. He wrote: "While glaring discriminations persist, they, too, are but remnants of an outgrown order. No intelligent man today claims the biological superiority of one race over another. . . . The triumph of the first half of the Twentieth Century is not yet seen in democratic practices, but it is a triumph nonetheless, a transformation in the minds of men."[41] What sweet vindication, Locke must have been thinking.

Returning to the notion that the Renaissance failed, we must recognize first of all that the artistic productivity of the Renaissance continued beyond the onset of the depression and the uncertainty of its initial artistry. The "hopeless mess" that Claude McKay said characterized the Renaissance in 1930 was but the passing of a faddish phase that made way for "a sounder, more artistic expression of Negro life"; and the decreasing quantity of published output caused by the depression was compensated for by a rise in the quality of the art. Second, the modernist strategy that undergirded the Renaissance increasingly became a very good answer to the old problem of racism; for as Edwin Embree commented in "Fifty Years of Progress in Human Relations," the triumph of the first half of the century involved the transformation of the minds of whites to the point where no intelligent white person could believe any longer that blacks were their biological inferiors. Locke concluded that this re-imaging of the African American, the prerequisite to "culture-citizenship," resulted in the freeing of all black artists:

> Not that all contemporary Negro artists are conscious racialists—far from it. But they all benefit, whether they choose to be racially expressive or not, from

the new freedom and dignity that Negro life and materials have attained in the world of contemporary art. And, as might be expected, with the removal of the cultural stigma and burdensome artistic onus of the past, Negro artists are showing an increasing tendency toward their own racial milieu as a special province and in their general work are reflecting more racially distinctive notes and overtones.[42]

Indeed, not all contemporary artists were conscious racialists—far from it, as Jean Toomer proved. But all artists, whether they chose to be racially expressive or not, benefited from the new freedom and dignity that modernist Renaissance art had attained. This was a concept that Toomer failed to grasp. He acknowledged that the Renaissance movement had "some valuable results," but only for those who had and would benefit by it, which did not include him, he said.[43]

Thus, when Nathan Huggins measures the Negro Renaissance artists against artists of the late 1960s and early 1970s and asserts that the later writers exploded into the American mind in a way that the Renaissance literati would not have dared to do,[44] he is disregarding the sacrifice of their predecessors who removed "the cultural stigma and burdensome artistic onus of the past." He is disregarding those whose modernist strategy of mastery of form enabled the next generation of black artists to show "an increasing tendency toward their own racial milieu." The accomplishments resulting from the "mastery of form" by the Renaissance blacks opened the door for the "deformation of mastery" to become the dominant modernist strategy, as well as a luxury, beginning in the early 1960s. However, the radical black youths of the late 1960s and the 1970s failed to understand their indebtedness. For instance, they attacked William Grant Still, as they had the literati of the 1920s. Still recalled that while he was teaching a college music class as a visiting lecturer, two militant black students rudely challenged him. "Basically, they told me my music was not Negro music which, in their opinion, was the jungle-type sounds heard over a particular radio station in that city. All else was what they termed 'Eur'-American music, rather than Afro-American. . . . One of them prattled about the bourgeois and White man's music, while the other made it a point to let me know that he did not 'identify' with my music, no doubt expecting me to be crushed by this verdict."[45]

The militants who confronted Still were of a new generation that did not acknowledge benefiting from the modernist strategy of the mastery of form, which had opened the doors for that generation to be able to appreciate the spirituals and blues without needing to fear the image of inferiority once associated with these forms of folk music. Renaissance blacks ushered in an atmosphere of artistic freedom by removing the cultural stigma and the burdensome artistic onus of the past. Still maintained that there were as many different kinds of African American music as there were different types of blacks. If the film industry would

depart from its stereotypes of blacks long enough to show the public a "finer type of Negro and more sophisticated Negro music," then even African Americans themselves could enjoy the "cruder aspects of Negro life" because they would know that the public, at home and abroad, no longer held a one-sided view of their race.[46]

The point of the militants' challenge to Still is that history has repeatedly borne out the fact that it is from within the interstices of a mastered "form" that blacks have gleaned the ability to debunk the form most effectively. In other words, people brought up in an age of Jim Crow could and did move most capably and confidently from mastering form to stripping themselves of these formulaic limitations in order to forge out a voice in tight places. Mastery of form has long functioned strategically in the black community as a means of holding the oppressor at bay long enough to permit the fashioning of "deformative creativity" as a strategy. This is exactly what occurred after the 1920s. The "deformation of mastery," which was a subdued or masked characteristic in the "mastery of form" during the 1920s and early 1930s, began to "strip" and run parallel to its incubator around 1934 and during the 1940s and 1950s when the maturer phase of the Renaissance evolved. The transition that caused "creative deformation" to be at the center of the discourse of self-conscious racialism had begun around 1934 and was well in place by the late 1940s, if we accept Locke's view of the Negro Renaissance. In his retrospective review of black literature for 1947, Locke said: "There can be little doubt that we have entered an era of crisis literature and crisis art, when even our fiction reflects, like a sorcerer's mirror, instead of the face of society, the crucial inner conflict and anxiety of society itself. Our artists increasingly become social critics and reformers as our novelists are fast becoming strident sociologists and castigating prophets."[47] Among the crisis literature was not only the fiction of Richard Wright, Chester B. Himes, Ralph Ellison, and James Baldwin, but also the nonfiction of James Weldon Johnson—namely, his powerful little book, *Negro Americans, What Now?* (1934). Among the crisis art was William Grant Still's oratorio *And They Lynched Him on a Tree* (1940).

The Negro Renaissance and a concurrent modernism had their roots in the end of the nineteenth century and began to grow in 1917, burgeoning in the mid-1920s and then receding during a six-year anticlimax that the Great Depression helped bring on in 1929—thus Locke's designation of the years 1917 to 1934 as comprising the first generation of the Negro Renaissance. In 1934 the second generation of the Renaissance and the emergence of protest literature also commenced. It was a transitional period, lasting about three decades, during which "creative deformation" began to run parallel with and eventually surpassed "creative mastery." By 1964 the Negro Renaissance was something else, not because it "died" but because it was irrevocably modified: The modernist strategy of creative mastery became

tradition, and the tradition of creative deformation became the second-generation modernist strategy.

NOTES

1. Baker, *Modernism and the Harlem Renaissance*, 12, xiii–xiv; Huggins, *Harlem Renaissance*.

2. Huggins, *Harlem Renaissance*, 303.

3. Locke, *Critical Temper*, 29.

4. Huggins, *Harlem Renaissance*, 190.

5. Lewis, *When Harlem Was in Vogue*, 305.

6. Hercules, "An Aspect of the Negro Renaissance," 306.

7. Blum, "Black Music," 74, 76.

8. Floyd, "Music in the Harlem Renaissance," 23–24.

9. Baker, *Modernism and the Harlem Renaissance*, 17, 24, 27, 30, 33.

10. Jackson, "Nathaniel Dett's Real Artist," 101.

11. Baker, *Modernism and the Harlem Renaissance*, 56, 60; Miller, "Negro Nudity in Art," 24.

12. Tucker, "Renaissance Education of Duke Ellington," 122.

13. Baker, *Modernism and the Harlem Renaissance*, 91–92.

14. Johnson, *Along This Way*, 152, 193; Carl Van Vechten to Johnson, March 23, 1925, Aaron Douglas to Johnson, June 6, 1927, and Johnson to Heywood Broun, May 2, 1924 ("published out of time"), Johnson Collection.

15. Pickens, *New Negro*, 15.

16. Johnson, *Along This Way*, 203.

17. Graham, "Black Man's Music," 179; Locke to Mason, November 10, 1932, Locke Papers.

18. Locke to Mason, December 1932, ibid.

19. Locke, *Critical Temper*, 225.

20. Locke to Mason, January 13, 1935, Locke Papers.

21. Locke, "The Negro's Cultural Contribution to America," MS of Bennett College Lecture, January 12, 1935, ibid.

22. Locke, "The Negro's Cultural Contribution," 521–29.

23. Locke, *Critical Temper*, 53.

24. Locke to Mason, September 9, 1932, Locke Papers.

25. Locke, *Critical Temper*, 201.

26. Ibid., 205–6.

27. Ibid., 221.

28. Van Vechten to Johnson, February 25, 1934, Johnson Collection; Johnson, *Negro Americans, What Now?*, 92–93.

29. Van Vechten to Johnson, June 26, 1937, Johnson Collection.

30. Locke, *Critical Temper*, 259.

31. Claude McKay to Charlotte Mason, February 13, 1930, Locke Papers; Hughes, *The Big Sea*, 228.

32. Locke, *Critical Temper*, 271–72; Locke to Mason, April 6, 1940, Locke Papers; Hughes, " 'Second Negro Renaissance in Arts.' "

33. "The Courier's 40th Anniversary in '50."

34. Du Bois, "20th Century," 6–7.

35. Ivy, "Fifty Years of Progress in Literature," 6–7.

36. Porter, "Progress of the Negro in Art," 6–7.

37. Reid, "Fifty Years of Progress in the Professions," 7.

38. Still, "Fifty Years of Progress in Music," 15.

39. Mays, "Fifty Years of Progress in the Negro Church," 6–7.

40. White, "Civil Rights," 6–7.

41. Embree, "Fifty Years of Progress in Human Relations," 6–7.

42. Locke, *Critical Temper*, 174.

43. Jean Toomer to James Weldon Johnson, July 11, 1930, Johnson Collection.

44. Baker, *Modernism and the Harlem Renaissance*, 91–92.

45. Locke, "The American Negro as Artist," *Critical Temper*, 174; Still, *Essays on American Music*, 228.

46. Ibid., 108.

47. Locke, *Critical Temper*, 329.

BIBLIOGRAPHY

Archival Sources

Johnson, James Weldon. Johnson Collection, Beinecke Rare Book and Manuscript Library, Yale University, New Haven, Conn.

Locke, Alain L. Locke Papers, Manuscripts Division, Moorland-Spingarn Research Center, Howard University, Washington, D.C.

Books and Articles

Baker, Houston A., Jr. *Modernism and the Harlem Renaissance*. Chicago: University of Chicago Press, 1987.

Blum, Martin. "Black Music: Pathmaker of the Harlem Renaissance." *Missouri Journal of Research in Music Education* 3, no. 3 (1974): 72–79.

"The Courier's 40th Anniversary in '50." *Pittsburgh Courier*, January 7, 1950, sec. 2.

Du Bois, W. E. B. "20th Century: The Century of the Color Line." *Pittsburgh Courier*, January 7, 1950, 6.

Embree, Edwin R. "Fifty Years of Progress in Human Relations." *Pittsburgh Courier*, March 11, 1950, 6.

Floyd, Samuel A., Jr. "Music in the Harlem Renaissance: An Overview." In Floyd, ed., *Black Music in the Harlem Renaissance: A Collection of Essays*, 1–27. Knoxville: University of Tennessee Press, 1993,

Graham, Shirley. "Black Man's Music." *The Crisis* 40, no. 8 (August 1939): 178–79.

Hercules, Frank. "An Aspect of the Negro Renaissance." *Opportunity* 20, no. 10 (October 1942): 305–6, 317–19.

Huggins, Nathan Irvin. *Harlem Renaissance*. New York: Oxford University Press, 1971.

Hughes, Langston. " 'Second Negro Renaissance in Arts'—Langston Hughes." *Now*, Second-Half January 1946.

———. *The Big Sea: An Autobiography*. New York: Hill and Wang, 1963.

Ivy, James W. "Fifty Years of Progress in Literature." *Pittsburgh Courier*, February 11, 1950, 6.

Jackson, George Pullen. "Nathaniel Dett's Real Artist." *Nashville Banner*, February 27, 1923. Cited in Anne Key Simpson, *Follow Me: The Life and Music of R. Nathaniel Dett*. Metuchen, N.J.: Scarecrow Press, 1993.

Johnson, James Weldon. *The Autobiography of an Ex-Colored Man*. Boston: Sherman, French and Co., 1912.

———. *Along This Way: The Autobiography of James Weldon Johnson*. New York: Viking, 1933.

———. *Negro Americans, What Now?* New York: Viking, 1934.

Lewis, David Levering. *When Harlem Was in Vogue*. New York: Knopf, 1981, 1984.

Locke, Alain L. "The Negro's Cultural Contribution to American Culture." *Journal of Negro Education* (July 1939): 521–29.

———. *The Critical Temper of Alain Locke: A Selection of His Essays on Art and Culture*. Edited by Jeffrey C. Stewart. New York: Garland, 1983.

Mays, Benjamin E. "Fifty Years of Progress in the Negro Church." *Pittsburgh Courier*, April 8, 1950, 6–7.

Miller, Kelly. "Negro Nudity in Art." *New York Amsterdam News*, June 11, 1930, 24.

Pickens, William. *The New Negro: His Political, Civil, and Mental Status and Related Essays*. New York: Neale Publishing Co., 1916.

Porter, James A. "Progress of the Negro in Art during the Past Fifty Years." *Pittsburgh Courier*, July 29, 1950, 6–7.

Reid, Ira De A. "Fifty Years of Progress in the Professions." *Pittsburgh Courier*, July 1, 1950, 7.

Still, William Grant. "Fifty Years of Progress in Music." *Pittsburgh Courier*, November 11, 1950, 15.

———. *The William Grant Still Reader: Essays on American Music*. Edited by Jon Michael Spencer. A special issue of *Black Sacred Music: A Journal of Theomusicology* 6, no. 2 (Fall 1992).

Tucker, Mark. "The Renaissance Education of Duke Ellington." In Samuel A. Floyd Jr., ed., *Black Music in the Harlem Renaissance*, 111–27.

White, Walter. "Civil Rights: Fifty Years of Fighting." *Pittsburgh Courier*, January 28, 1950, 6.

THOMAS FAHY

..

Exotic Fantasies, Shameful Realities

Race in the Modern American Freak Show

By the early twentieth century, many middle-class white Americans felt threatened by the growing presence of racial and ethnic difference in urban areas. Between 1880 and 1914 over 23 million immigrants came to the United States, and by 1920 half of all Americans lived in cities.[1] This diversity—especially its inescapable visibility—fostered anger, fear, resentment, and shame in many whites and motivated a great deal of abuse directed at minorities. In many cases, the middle class limited social opportunities for blacks to maintain existing racial hierarchies. Public entertainment offered one forum for this. It provided a space where whites could contain and label blackness as inferior, primitive, and at times monstrous. The freak show in particular fashioned many exhibits that mitigated racial divisiveness by transforming human curiosities who were racially threatening (Asians, blacks, members of non-Christian tribes from Africa, and other immigrants) into representatives of remote, exotic fantasies. These exhibits were often presented as scientific studies in primitivism; by tapping into categories of inclusion and exclusion (self/other, civilized/savage, normal/freak), they reinforced white, middle-class superiority on both social and racial levels.[2] Equally important, they offered ways of looking at difference without engaging in the politically and culturally charged problems of race in America.[3] By making the racial body grotesque or anomalous, freak shows privileged whiteness as normal, placing their (white) audiences in a position of control. The freak show therefore became a space where anxieties about racial and physical binaries could be more safely managed and observed.

The exoticizing of racial minorities in nineteenth-century freak shows left a powerful literary and cultural legacy for modernist America. In black and white fiction of the 1920s, 1930s, and 1940s, freak shows and the enfreakment of racial difference became metaphors and strategies for reconsidering representations of

African Americans.[4] For black authors, tacit acceptance of white images for blackness, the desire for white approval, and assimilation into the dominant culture engendered a self-loathing centered on the black body. Disfigured bodies in this literature, therefore, were used to explore the feelings of shame and resentment African Americans felt as a result of their (un)conscious acceptance of white images for themselves. By invoking freak shows and the freakish, writers such as Charles Chesnutt, Jean Toomer, Nella Larsen, Richard Wright, and Ralph Ellison also tried to expose and work against representations of blackness as something grotesque—something to be put on display. Even though some white authors (Willa Cather, F. Scott Fitzgerald) reinforced stereotypes by enfreaking black characters, others (Mark Twain, Eudora Welty) used freak shows to attack racism and express guilt for the widespread acceptance of these negative images. By the 1940s, literary depictions of freak shows suggest an increasing recognition of the disparity between exotic representations of ethnic difference and the intellectual and artistic achievements of the African American community.

Ultimately, rethinking literature by and about African Americans from the perspective of freak shows and freakish bodies offers insight into the complex impulses shaping attitudes about racial difference in America. As a literary trope, the freak show and its depictions of blackness as freakish call attention to pervasive racial stigmas outside the confines of these exhibits. This essay specifically appraises the black body as spectacle in literature by African American and white authors in the early twentieth century. Many of these writers invoke freak shows literally and metaphorically to express social anxieties about racial relationships that foster feelings of isolation and rage. The first section of this essay examines the literary impact of ethnically diverse audiences on freak shows. To accommodate this diversity, showmen modified certain ethnic exhibits, but they still considered the exoticization of blackness essential to their success. Not surprisingly, dark skin was still equated with inferiority and primitivism, and contemporary literature explores some of the effects these inherently racist constructions had on both black and white viewers. Second, I consider boxing (a staged event often used in freak shows) as a metaphor for the ways white middle-class men enfreaked the black body as a means of containing it. In these boxing matches, which often pitted black men against each other, fighting literally marks the black body, damaging it and reinforcing its role as spectacle. Finally, this essay discusses passing as a form of enfreaking the self and the other. On the surface, it seems a viable solution to social prejudices based on racial difference. Yet the act of passing is not satisfying. When race is no longer visibly distinguishable, passing not only undermines tenuous racial hierarchies, but it also threatens to deform or destroy those who suppress their cultural identity. Overall, a trajectory of black containment emerges—from the exotic displays of blackness behind freak show cages to social enfreakment through

boxing. These attempts at control, however, are undermined by the loss of external markers. Passing forces white middle-class society to reevaluate the use of race to define identity. It exposes their ultimate failure to contain blackness by showing "race" to be an artificial construction that masks shameful hatreds and fears.

THE COLOR OF MONEY

Displaying racial difference in nineteenth-century freak shows involved a complex awareness and negotiation of white fears and anxieties. Managers such as P. T. Barnum continually had to accommodate the changing interests and expectations of audiences. His notorious *What Is It?* (Henry Johnson), an exhibit featuring a mentally retarded African American with microcephaly, reinforced popular white beliefs about the connection between blacks and animals.[5] At the same time, he recognized the importance of mitigating the threat of potential black violence by carefully advertising this "man-monkey" as docile and harmless: "PLAYFUL AS A KITTEN" (Fig. 1). Johnson's passivity, which is captured in both the sketch and the photograph (Fig. 2), reinforced whites' feelings of physical and intellectual dominance. His calm face, dull staff (like the harmless twig in the drawing), stationary pose, and averted head invite the audience's gaze, giving it control. The exotic presentation—primitive backdrop, monkey suit, and shaved head—also appealed to their desire for novelty. As Robert Bogdan explains, "white Americans had no interest in seeing the run-of-the-mill negro, but they did want to see the warriors, the bestial Africans, and the pygmies. Showmen thus had a mandate to mold the presentations of the Africans they exhibited to justify slavery and colonialism— that is, to confirm Africans' inferiority and primitiveness."[6] Ethnic exhibits continued using exotic modes of representation into the twentieth century to attract audiences. At the 1904 World's Fair in St. Louis, for example, Philippine tribes were displayed as primitive, barbaric, and un-Christian in an attempt to help justify American imperial expansion after acquiring the Philippines.[7] After the fair, one of these tribes was then leased and displayed as part of a traveling sideshow for several years.

This emphasis on the exotic not only constructed non-Anglos as inferior, but it also helped mitigate many middle-class anxieties about racism. Even though growing immigrant populations in urban areas meant more diversified audiences and created a heightened sensitivity to the display of ethnicity in public amusements,[8] freak shows still appealed primarily to whites. To make blackness a viable exhibit, however, such shows needed to disassociate the black body from some of the political and social problems surrounding African Americans in the United States. As a result, shows often cast blacks as fantastic others whose origins and existence called out for scientific verification. Neil Harris's *Humbug: The Art of P. T. Barnum,*

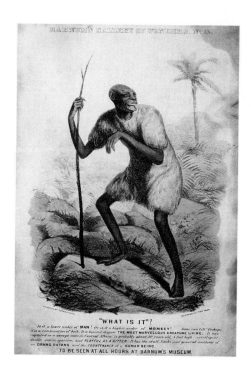

Figure 1. What Is It? *Number 12 in the series Barnum's Gallery of Wonders, published by Currier & Ives. (Shelburne Museum, Shelburne, Vermont)*

for example, explains that Barnum removed the moral anxieties surrounding racial and ethnic exhibits by playing to his audience's desire to discover a freak's authenticity. Scientific and rational skepticism were part of America's national identity, and "Barnum's audience found the encounter with potential frauds exciting. It was a form of intellectual exercise, stimulating even when literal truth could not be determined."[9] Exhibits featuring African American performers, therefore, incorporated strange lands and fabricated customs that were foreign to most audience members, so an American of almost any ethnic background might pay a dime to see *Congo, the Ape Man* or *The Wild Dancing South African Bushman*. Clearly freak shows were not willing to charge for black audiences, however, consistently relying on negative representations of African Americans to draw crowds. Whether those on display were from South Africa or the Congo, they were commonly presented as culturally inferior and socially barbaric. For whites, blackness under the guise of the exotic was something that could be contained; it was safe because freak shows did not challenge the status quo concerning middle-class racial hierarchies. Such shows never asked their audiences to see those onstage as part of American society or, in many cases, as human beings.[10]

As an example, Mark Twain, an acquaintance of Barnum, enfreaks Jim in *The Adventures of Huckleberry Finn* (1884) to criticize the type of double standard associated with race in and outside of freak shows. The Duke's scheme to advertise Jim as a "SICK ARAB—BUT HARMLESS WHEN NOT OUT OF HIS HEAD" (p. 152) solves his and Huck's temporary concerns about the Fugitive Slave Law by substituting one

Figure 2. Henry Johnson, Barnum's What Is It? *(Photograph by Mathew Brady, ca. 1872; Meserve Collection, National Portrait Gallery, Smithsonian Institution, Washington, D.C.)*

set of prejudices for another. In the style of a freak show exhibit, the Duke paints Jim's body a solid blue "like a man that's been drownded nine days" and coaches the act in a Barnumesque fashion: "if anybody ever come meddling around, he must hop out of the wigwam, and carry on a little, and fetch a howl or two like a wild beast" (p. 152). For the time being, Jim's construction as an exotic wild man displaces his identity as a slave, removing his threat as a fugitive. Twain thus highlights the capricious racial constructions (that is, labels such as "slave" or "sick Arab") that white America uses to maintain control over black identity and culture. The enfreaked other does not threaten power, but Jim as a successful runaway slave does.

In another imaginative—though anachronistic—example, Toni Morrison's *Beloved* illustrates the increasingly complicated role of audience for freak shows before the modern period. When Paul D, Sethe, and Denver arrive at the carnival, they notice that

> [t]he barker called them and their children names ("Pickaninnies free!"). . . . Two pennies and an insult were well spent if it meant seeing the spectacle of whitefolks making a spectacle of themselves. So, although the carnival was a lot less than mediocre (which is why it agreed to a Colored Thursday), it gave the four hundred black people in its audience thrill upon thrill upon thrill.
>
> One-Ton Lady spit at them, but her bulk shortened her aim and they got a big kick out of the helpless meanness in her eyes. (p. 48)

In some ways, "Colored Thursday" functions like "Colored People's Day" at the White City of the 1893 Columbian Exposition with one difference—in Morrison's novel the black audience is empowered through interpretation. This freak show, an entertainment usually catering to white expectations and prejudices, inadvertently fashions whiteness and the derision that white performers express toward blacks (a "helpless meanness") as a spectacle. For its audience, the helplessness of whites is an entertainingly freakish display; for the performers, black freedom, as embodied in their status as paying customers, is a repulsive, freakish spectacle: the One-Ton Lady spits and the barker shouts epithets—behavior more typical of a white audience's reaction to freaks. Audience, in other words, is responsible for the interpretation of freakishness. When Paul D recognizes the Wild Savage, he undermines the "authenticity" that such an exhibit would claim: "When Wild African Savage shook his bars and said wa wa, Paul D told everybody he knew him back in Roanoke" (pp. 48–49). Recognizing the identity of this man makes the exhibit laughable; it also transforms it into a display about white fears of blackness and black power.[11] As with the example from *Huckleberry Finn*, the construction of "wild savage" places blackness in a nonthreatening context, the ethnological exhibit. As Morrison demonstrates, the freak show's success depended on white audiences and suggested underlying fears about the social and economic position of African Americans.

By the 1940s this racism was being interpreted differently by white audiences that felt increasingly complicit in the abuse of those on display. In part, the Harlem Renaissance had helped facilitate a greater recognition of oppression, for its artistic accomplishments challenged the devaluing of black individuals and culture. The exploitation of nonwhites within the freak show was specifically coming under attack in literature during this period. By 1940, after a decade of financial disaster and continued racial upheaval, this form of entertainment had lost a significant amount of its appeal. Bogdan explains that

> the years 1840 to 1940 witnessed the rise and fall of the freak show in the United States. By 1840 "human curiosities," who up to then traveled and were exhibited independently, were joining burgeoning amusement organizations. . . . By 1940, economic hard times, technological and geographic changes, competition from other forms of entertainment, the medicalization of human differences, and changed public taste resulted in a serious decline in the number and popularity of freak shows, although they continued through the 1950s and 1960s, and vestiges exist even today.[12]

In the short story "Keela, the Outcast Indian Maiden" (1941), late modernist author Eudora Welty captured some of the unmitigated racial guilt that made the rejection of freak shows inevitable by the late modern period. Steve, a former

carnival barker and the narrator, seeks out a clubfooted black man (Little Lee Roy) who years earlier was coerced into performing geek acts while dressed as a savage Native American woman.[13] Burdened by years of guilt after discovering that Keela was actually a disabled black man, Steve journeys to find him as an act of atonement. To mitigate his role in Keela's construction as a freak, Steve claims to have been duped by the carnival, but when his temporary travel partner questions his inability (years earlier) to recognize Keela's gender and race, Steve reacts violently: " 'Bet I could tell a man from a woman and an Indian from a nigger though,' said Max. . . . [H]e reached out and without any warning hit Max in the jaw with his fist" (p. 66). Steve strikes him because his version of events erased his own culpability for the racist brutality inflicted on Keela; for years he has convinced himself that he did not know the truth—a common standpoint for freak show audiences to assume. Throughout the late nineteenth century Barnum used the idea of not knowing to promote his exhibits—publicizing scientific debates over the legitimacy of the *Fejee Mermaid* and *What Is It?* and even advertising some of his own exhibits as humbugs (such as *Joice Heth*).[14] The question of authenticity in freak exhibits was a significant part of their allure because ambiguity challenged nineteenth- and early-twentieth-century audiences to decide the truth for themselves. By 1941, the time Welty's story was written, Steve, who had moved from itinerant showman to perpetual hitchhiker, represented a period that could no longer hide behind questions of humbug.[15] After the discovery of Keela's identity—as well as humanity—the carnival owners are sent to jail, and Steve attempts to come to terms with his complicity in Keela's exhibition.

On a performative level, Steve's language shapes the audiences' understanding of Keela ("Ladies and gents! Do not try to touch Keela, the Outcast Indian Maiden—she will only beat your brains out with her iron rod, and eat them alive!" [p. 62]), but the effectiveness and power of his language is contingent on both Keela's silence and his scripted behavior. Even though Steve sees his participation as a type of helpless meanness resulting from the carnival owner's deception, he acknowledges that he "was the one was the cause for it goin' on an' on an' not bein' found out—such an awful thing. It was me, *what I said* out front through the megaphone" (p. 61; my emphasis). Welty, in other words, sees linguistic enfreakment—the way a barker and freak advertisements constructed difference and presented it to others—as equally responsible as coercion for the abuses in freak shows. Even though "Keela, the Outcast Indian Maiden" is exposed as a fraud by a Texan who opens his palms to Keela in a gesture of acceptance, his humanity remains in question until he speaks. "They made it stay in jail to see if it could talk or not, and the first night it wouldn't say nothing. Some time it cried. . . . And it could talk—as good as me or you" (p. 64). From the bars of the exhibit to a jail cell, Keela is detained in both "cultures" (sideshow and legal) because of his race,

which suggests the persistent racial biases of modernist culture; outside of the freak show, Keela's status as savage is still suspect. Ultimately, it is language that frees him from his identity as Keela. His ability to speak removes Steve's and the carnival's former linguistic control and enables him to become (once again) Little Lee Roy—someone who can voice his own history.

Welty's story also captures modern America's gradual rejection of freak exhibits by enacting a defreaking show in which we "watch" Keela's move from freak to human being:

> And they undressed it an' found out it wasn't no outcast Indian woman a-tall. It was a little clubfooted nigger man. . . . Washed its face, and it was paint all over it made it look red. It all come off. And it could talk—as good as me or you. But they told it not to, so it never did. They'd tole it if anybody was to come near it they was comin' to get it—and for it to hit 'em quick with that iron bar an' growl. . . . I was yellin' outside, tellin' 'em to keep away, keep away. You could see where they'd whup it. They had to whup it some to make it eat all the chickens. (pp. 64–65)

Welty invokes so many freak conventions in the character of Keela (savage, exotic other, disabled, geek, hermaphrodite) that he embodies and symbolizes the freak show; as a result the stripping action in jail exposes not only the artifices of freakishness, but also its inherently brutal prejudices. Despite the revelation of Keela's humanity, Steve still refers to him as "it"—unable to let go of his objectification and enfreakment. His desire to look also intensifies at this moment, suggesting that his quest is motivated, in part, by a desire to look at the real Keela. Before the exhibit closed, he watched Keela "a thousand times" (p. 60), being both fascinated and repulsed by his savage exoticism and geek act. But his present desire to look is a self-indulgent form of pity ("I was goin' to give him some money or somethin', I guess, if I ever found him, only now I ain't got any" [p. 67]). The narrative makes clear that Steve does not want to speak to Lee Roy, only to stare one more time. When Max gives Lee Roy money, sending him inside, he literally enacts modern America's reaction to a shameful history of racial prejudice—offering money or charity in an attempt to atone for white sins. Lee Roy, in effect, is still a freak, but his act has changed. This new audience pays for his image to go away as well. Although the freak show as a form of entertainment had declined, the problems of accepting racial difference and disability still had a long way to go in modern America.

Modern vestiges of the freak show, such as *The Guinness Book of World Records*, *Jerry Springer*, and any number of shows on the Fox network, suggest that we are still intrigued by and ashamed of our desire to look at freaks. So we close the blinds and watch in private, afraid of what this interest says about us. This anxiety is also

evident in "Keela, the Outcast Indian Maiden," which concludes with two acts of silence. First, Max silences Steve when they leave Lee Roy: " 'I didn't go ask you a question. . . . You eat, and I'll listen to the juke box' " (p. 68). Then the story offers a second ending in which Lee Roy speaks articulately for the first time:

> "Today while all you all was gone, and not a soul in de house," said Little Lee Roy at the supper table that night, "two white mens come heah to de house. Wouldn't come in. But talkes to me about de ole times when I use to be wid de circus—"
>
> "Hush up, Pappy," said the children. (p. 68)

Lee Roy's humanity (the family meal) is juxtaposed with Steve's and Max's perception of his behavior (his inexplicable guffawing) throughout the story. His family's need to silence any connection with the freak show is also a way of preserving his dignity and humanity. Not to speak of this history is to reject it, and silence affirms the identity of the present as distinct from the past.

RINGSIDE SEATS

Persistent prejudice and claims of black inferiority in the early part of the twentieth century ran counter to the artistic achievements of the Harlem Renaissance. The popularity of blues singers (Ma Rainey, Bessie Smith), musicians (Louis Armstrong, Fats Waller), performers (John Bubbles, Josephine Baker), and writers (Langston Hughes, Jean Toomer, Nella Larsen) with both black and white audiences made African American arts and intellectualism a powerful dimension of American culture. In the 1920s Renaissance writers had established a vibrant intellectual and artistic community that was attempting to forge ties between black and white Americans. Instead of accepting them, most white, middle-class Americans were still forcing blacks to accept roles as social and intellectual inferiors. They rejected Renaissance hopes for multiracial and multiethnic community by responding with hatred and fear—as illustrated by texts such as Madison Grant's *The Passing of the Great Race* (1916), the goals of the Creel Committee (1916), the resurgence of the Ku Klux Klan, and the National Origins Acts (1924). African American literature during this period and into the midcentury often responded to the hypocrisy of white double standards (economic support of black art and social marginalization of the black community) with dual feelings of resentment and shame. Boxing specifically appeared as a metaphor for the enfreakment of black bodies, and its brutality became an image for white attempts to contain blackness physically (by manipulating the events inside the ring) and socially (through token gestures of equality).

George Bellows's painting *Both Members of This Club, 1909* (Plate 8) captures the

Figure 3. Battle of the Giants. *Illustration from Barnum's* Struggles and Triumphs, *1872.*

contrived, performative role ascribed to blacks in fighting salons and, arguably, society as a whole. The title attempts to show an "equality" of sorts, but within a specific and temporary context. Black boxers were allowed to become members only to keep fights between blacks and whites legal; under no other circumstance could they have entered such a place. In the painting, the ring is surrounded by twisted faces and wicked smiles much like those watching the battle royal in Ellison's *Invisible Man* (1952). Inside, a white bloodied body with a distorted face turns upward from the impact of a blow; a strong black body aggressively charges forward, seemingly on the verge of pushing the other boxer backward. Although both figures are generalized in appearance, the dark one is almost completely unidentifiable—suggesting both white America's tendency to see all blacks as the same abstract threat. The person, in other words, becomes a nameless force (blackness/racial otherness) that needs to be stopped before it topples white America.

Harlem Renaissance writers also addressed this type of social and racial marginalization by drawing the tradition of boxing (and staged fights) used in freak show performances (Figs. 3 and 4). Even though this first image from Barnum's autobiography foregorunds the extraordinary height of these performers through the label "Battle of the Giants," the text also makes ethnic and racial difference central to their appeal: "One day they quarreled, and a lively interchange of compliments ensued, the Arabian calling the Frenchman a 'Shanghai,'" and receiving in return the epithet of "Nigger'" (p. 162). Barnum clearly does not mind their anger; he simply

Figure 4. Henry Johnson (What Is It?) and Benjamin Ash (the "Spotted Boy") in a staged boxing match. (Photograph by Swords Brothers, ca. 1887; Becker Collection, Syracuse University)

wants enough time to stage a profitable fight. Both pictures display acts of violence (safely controlled within the rules of the sport) that reinforced white attitudes about the animalistic brutality of the other, particularly blacks. Alluding to this aspect of freak shows, Renaissance literature often used boxing as a type of freakish performance in which the artifice of the exotic was dropped and the black body was transformed into something grotesque. Jean Toomer, Richard Wright, and Ralph Ellison specifically depict men disfigured by boxing as a metaphor for the social enfreakment of blacks in America. By literally marking and damaging black bodies, these boxing matches expose the white coercion of African Americans.

In Jean Toomer's *Cane* (1923), a collection of short fiction, vignettes, poems, and drama, "Box Seat" specifically does this by linking the multiple oppressions facing African Americans with the degradation of freaks. Dan Moore has followed Muriel to a comic show that features a boxing match between dwarfs. For the narrator, the event is a grotesque spectacle: "[the dwarfs] kick and spit and bite. They pound each other furiously. . . . Cut lips. Bloody noses. . . . The house roars. The dwarfs bow, are made to bow. The house wants more" (p. 65). The real violence of the match is defused for the audience by the subsequent act the dwarfs must perform. After being made to bow, the victor, Mr. Barry, returns to the stage and sings love songs to different women in the audience. His performance, however, inverts the gaze directed at his body, for he uses a mirror to reflect each face he sings to—essentially asking audience members to view themselves in the act of looking. He eventually turns to Muriel, who is trying to assimilate into white,

middle-class Chicago society, only to find her repulsed: "Mr. Barry bows. He offers Muriel the stain upon its petals. Blood of his battered lips is a vivid stain upon its petals. Mr. Barry offers Muriel the rose. The house applauds. Muriel flinches back. The dwarf steps forward, diffident; threatening. Hate pops from his eyes and crackles like a brittle heat about the box. The thick hide of his face is drawn in tortured wrinkles" (p. 66).

On one level, the narrator captures a characteristic response to freak shows (part repulsion, part derision; "the house roars") by perceiving the dwarf as monstrous. This transformation clearly mirrors the white gaze in regard to enfreaked black bodies. On another level, this threatening enfreakment mirrors Dan's humiliation and anger as a black man who has migrated to the North. Ridiculed by Muriel and disconnected from both white middle-class society and his southern African American roots, Dan himself has become a freak. He empathizes with Mr. Barry and is able to read the "words from in the eyes of the dwarf" as saying "Do not shrink. Do not be afraid of me. See how my eyes look at you. I too was made in His image. I give you the rose" (p. 66).[16] Like the dwarf, Dan seeks a recognition and acceptance that transcends race, class, and physical deformity.

In the memoir *Black Boy* (1945), Wright juxtaposes a freak figure, Mr. Shorty, with his own performance as a boxer to examine his shameful complicity in white middle-class attempts to degrade and debilitate black men. Wright initially constructs Shorty as a type of freak, describing him as "the round, yellow, fat elevator operator . . . [with] beady eyes, . . . the complexion of a Chinese, a short forehead, and three chins; Psychologically he was the most amazing specimen of the southern Negro I had ever met" (pp. 259–60). As with any ethnological exhibit, his color is exoticized, his physical abnormalities emphasized and exaggerated through both narrative descriptions and his name. Despite Shorty's intelligence and passion for reading, the narrator explains that "in the presence of whites he would play the role of a clown of the most debased and degraded type" (p. 260). Day after day he demands a quarter to operate the elevator, humiliating himself through dancing, humming, moaning, making faces, drooling, and then allowing white men to kick him:

"But this black sonofabitch sure needs a quarter," Shorty sang, grimacing, clowning, ignoring the white man's threat.

"Come on, you black bastard, I got to work," the white man said, intrigued by the element of sadism involved, enjoying it. . . . "What would you do for a quarter?" the white man asked, still gazing off. . . .

"You can kick me for a quarter," he sang, looking impishly at the white man out of the corners of his eyes.

The white man laughed softly, jingled some coins in his pocket, took out one and thumped it to the floor. Shorty stooped to pick it up and the white man

bared his teeth and swung his foot into Shorty's rump with all the strength of his body. (p. 261)

Shorty's performance, which he justifies by claiming he has a "tough ass," elicits money from white men who enjoy seeing this self-degradation. Like a carnival barker, Shorty sells his own attraction—talking, prodding, coaxing them into a kick "for just a quarter, just two bits!"

Despite the white man's frustration with Shorty, he approves of the performance because it gives him an excuse to act out his aggressions against African Americans; it also enacts black behavior as freakish and animalistic:

> "Yeeeess, siiiiir," Shorty sang; but first he picked up the quarter and put it into his mouth. "This monkey's got the peanuts," he chortled. . . .
>
> "You're all right, Shorty, you sonofabitch," [the white man] said.
>
> "I know it!" Shorty screamed, then let his voice trail off in a gale of wild laughter. (p. 261)

Acting wildly and referring to himself as a monkey gets him the quarter; his social acceptance, in other words, is predicated on his behavior as a stereotypical black—in this case, a freakish spectacle. But the narrator recognizes that this is not "all right." His description of Shorty's self-enfreakment reflects the "disgust and loathing" he feels while watching this ritual (p. 261); he resents blacks who disfigure themselves by accepting stereotypical modes of behavior. This elevator freak show therefore reflects a complex and disturbing tension facing blacks in white culture—expressing revulsion for the white other by being complicit in demeaning the black self.

Subsequently, Wright behaves no differently than Shorty when he acquiesces to a boxing match for his white bosses and coworkers. The juxtaposition of Shorty's performance and the narrator's fight presents boxing as another white vehicle for brutalizing and humiliating black men. Boxing in this context turns blacks against each other, making the black body an outlet for the violence and anger felt for whites. Even though the narrator and Harrison sidestep the foreman's attempts to trick them into a knife fight, they eventually agree to a boxing match for money. "The fight was on, was on against our will. I felt trapped and ashamed. . . . We fought four hard rounds, stabbing, slugging, grunting, spitting, cursing, crying, bleeding. The shame and anger we felt for having allowed ourselves to be duped crept into our blows and blood ran into our eyes, half blinding us. The hate we felt for the men whom we had tried to cheat went into the blows we threw at each other" (p. 276). Each fighter projects his own loathing, hatred, and shame onto the other. The danger for Wright is that African Americans have grown accustomed to oppression and abusive treatment. They have come to accept it and, as a result, engage in self-destructive, enfreaking behavior.[17]

Ralph Ellison's *Invisible Man* (1952) also uses distorted and freakish black bodies as visible signs for the self-destructive behaviors that alienate black men from each other, their southern African American roots, and middle-class white America. The novel begins with a type of boxing match—the battle royal—that makes spectacles out of the participants. Before the match begins, a naked blond woman stands in the center of the ring surrounded by ten boxers: "The hair was yellow like that of a circus kewpie doll, the face heavily powdered and rouged, as though to form an abstract mask, the eyes hollow and smeared a cool blue, the color of a baboon's butt. . . . Her breasts were firm and round as the domes of East Indian temples" (p. 19). Her doll-like hair, grotesque makeup (baboon-blue), and exoticized description transform her into a freak exhibit that the black men can look at but not touch.

The narrator cannot see the connections between himself and the objectification of the white woman. Her presentation and performance (a sensual dance in the ring) disfigure her face (she looks out with "terror and disgust") as she is tossed about the room. Ironically, he responds in a way typical of freak show audiences— with a mixture of revulsion and attraction: "I wanted at one and the same time to run from the room, to sink through the floor, or go to her and cover her from my eyes and the eyes of others with my body; to feel the soft thighs, to caress and destroy her" (p. 19). Yet this response to her act mirrors the duality that whites feel about his performances as boxer and speaker. On one level, the humiliation of the battle royal can be measured through the narrator's physical injuries: his "right eye [was] popping like a jack-in-the-box," his nose and mouth bled like the dwarf's in "Box Seat," and his hands and back were scorched by the electrified rug. Here whites' revulsion for the freak is manifested in the brutality they inflict on him (as well as the brutality they force African Americans to inflict on each other). Although the narrator still gives his rehearsed speech, believing "that only these men could judge truly my ability" (p. 25), he functions as a novelty act for them; his injuries are a type of vulgar makeup. Ultimately, the opportunity to go to a black state college is a meaningless gesture because it does not disturb existing intellectual hierarchies.

At the end of the novel, images of a distorted doll also capture the narrator's and black men's isolation and marginalization in white America. Disillusioned and on his own, Clifton leaves the Brotherhood, the Communist Party in Harlem, and tries to make money, in part, by performing exaggerated and demeaning dances with Sambo dolls that play to white stereotypes about African American bodies:

A grinning doll of orange-and-black tissue paper with thin flat cardboard disks forming its head and feet and which some mysterious mechanism was causing to move up and down in a loose-jointed, shoulder-shaking, infuriatingly sensuous motion, a dance that was completely detached from the black, mask-like

face. It's no jumping-jack, but *what*, I thought, seeing the doll throwing itself about with the fierce defiance of someone performing a degrading act in public, dancing as though it received a perverse pleasure from its motions. (p. 431)

Because of this performance with the Sambo doll, Clifton recognizes that invoking self-degrading images of African Americans is profitable; like Shorty from *Black Boy*, he embraces this self-effacement with "fierce defiance." It serves as a means to an end and as an act of resistance. He can capitalize on white interest in seeing blacks demean themselves without accepting these images. As the one operating the doll, he controls the act while distancing himself from the stereotypes embodied by the doll. Even though the narrator despises this contribution to racial stigmas about blacks on ideological and social levels, Clifton's fall from the Brotherhood—his realization that this organization ultimately wanted to pit blacks against each other—captures the resentment and degradation experienced by most black Americans who cannot escape white perceptions of them as ignorant and animalistic.

The narrator's blindness to Clifton's plight exposes his role as a freakish puppet for white men and the Brotherhood. As the narrator tries to confront him about the dolls, Clifton must run from the police; in his hurried escape "the doll [goes] over backwards, wilting into a dipping rag of frilled tissue, the hateful head upturned on its outstretched neck still grinning toward the sky. The crowd turned on me indignantly. The whistle came again. I saw a short pot-bellied man look down, then up at me with amazement and explode with laughter, pointed from me to the doll, rocking" (p. 433). For the audience, the narrator is indistinguishable from the freakish doll; he too is an object of derision, a spectacle like the naked woman in the ring. His association with the Sambo doll also recalls the battle royal when someone called out to him, " 'That's right, Sambo,' a blond man said, winking at me confidentially" (p. 26). This moment of enfreakment, followed by the boxing match, parallels Clifton's use of the Sambo doll and his subsequent fight with a police officer: he "spun on his toes like a dancer and swung his right arm over and around in a short, jolting arc, his torso carrying forward and to the left in a motion that sent the box strap free as his right foot traveled forward and his left arm followed through in a floating uppercut" (p. 436). Clifton is a performer in this impromptu street fight that seems almost choreographed, suggesting that the outcome is part of a large dance in which he must die for this transgression. Unlike the Bellows painting *Both Members of This Club, 1909*, no illusion of equality exists here. The streets of New York offer an unfair and destructive arena for black men without the pretense of "sport" or "membership." The confines of the boxing ring in this novel and in the painting (the black fighter is surrounded by whites as well as ropes) represent white control of blacks in society more broadly. And the stakes for the black man are death (Wright's and Ellison's narrators fear dying in arranged

fights, for example). Ultimately, these grotesque bodies act as a framing device in *Invisible Man*, suggesting that African Americans are forced to respond with violence to their enfreakment.

WHO'S PASSING FOR WHO?

One night in a smoke-filled, New York bar, three white schoolteachers from Iowa were introduced to Langston Hughes and a friend. Excited about meeting Negro artists, they bought round after round of drinks, talked of novels and paintings, and listened eagerly to stories about avant-garde life in Harlem. Suddenly at an adjacent table, a black man rose angrily and struck a blond woman. Within seconds, one of the Iowa men jumped up in her defense and hit him: "Keep your hands off that white woman," he demanded. At this point, a waiter quickly explained that the blond was actually "colored," and the white man sheepishly dropped his chivalric stance—lowering his fists and mumbling an apology.

A few moments later, the friends of this failed Lancelot told Hughes that, as a matter of fact, they too had been passing—masquerading as white for over ten years. "Then everybody laughed. . . . All at once we dropped our professionally self-conscious 'Negro' manners, became natural, ate fish, and talked and kidded freely like colored folks do when there are no white folks around." The next morning, after partying all night, one of the schoolteachers shocked Hughes by telling him "[w]e're white. We just thought we'd kid you by passing for colored a little while—just as you said Negroes sometimes pass for white." Unsure of the truth, Hughes felt betrayed: "Whatever race they were, they had had too much fun at our expense—even if they did pay for the drinks."

His essay "Who's Passing for Who?" (1952) addresses both black and white anxieties about passing. It also suggests that a politics of visibility continued to create a fundamental barrier between these groups well into the twentieth century. Just as the Iowa man retracts his defense of the black woman, Hughes communicates meaningfully with the couple only when he believes them to be black. In other words, he prevents expressing his own sense of self in the presence of racial difference, but at what cost he does not say. This section examines the enfreakment of passing bodies in modernist African American and white literature. The terms "passing" and "miscegenation," used interchangeably, serve as an umbrella concept for the breakdown of racial hierarchies based on visible difference. Passing, which is often perceived as something freakish, also becomes a metaphor for the loss of cultural identity within both African American and white communities. One form in which this freakishness appears is in the image of the minstrel. For African American authors, minstrel imagery can be used to reject the degradation of black men and women based on a history of prejudice by looking directly at this

tradition without shame. It draws attention to the inequalities of the present in the hopes of finding ways to build new roads for acceptance between races. As Brother Tarp's chain link teaches the narrator in *Invisible Man*, African Americans need to embrace the uniqueness of their history or risk losing connections with their cultural identity.

Ellison's essay "Change the Joke and Slip the Yoke" argues that the primary anxiety underlying white men's use of blackface was a fear of becoming the other: "he is not simply miming a personification of his disorder and chaos but that he will become in fact that which he intends only to symbolize" (p. 53). At the same time, we could infer that minstrelsy raised questions about the other becoming white. If one could "act white," in other words, one could *be* white. Modernist literature and contemporary anthropological-sociological studies specifically confronted this anxiety as many whites began to feel threatened by interracial marriages. As Eric Lott explained in *Love and Theft: Blackface Minstrelsy and the American Working Class*, the act of blackface, a "combined fear of and fascination with the black male, cast a strange dread of miscegenation over the minstrel show" (p. 25). Even though the minstrel figure traditionally enacted a "safe" version of racial passing, the possibility of black passing for white undermined the politics of visibility that governed the treatment of racial others. Thus the grotesque minstrel in white literature reinforced racial difference; it fashioned blackness as a spectacle in an attempt to salvage deteriorating social hierarchies based on visible difference.

Not surprisingly, P. T. Barnum, who was always putting himself on display for the public, performed in blackface:

> I blacked myself and sung the advertised songs, 'Zip Coon,' etc., and to my surprise was much applauded. . . . One evening after singing my songs I heard a disturbance outside the tent and going to the spot found a person disputing with my men. I took part on the side of the men, when the person who was quarrelling with them drew a pistol and exclaiming, 'you black scoundrel! how dare you use such language to a white man'. . . . Quick as thought I rolled my sleeve up, showed my skin, and said, 'I am as white as you are, sir.' He dropped his pistol in positive fright and begged my pardon.[18]

Although Barnum uses this anecdote to illustrate his quick wit and ingenuity, it highlights the "positive fright" whites felt about passing and the fluidity of racial boundaries. If whites could pass as black, which they did in minstrel shows, then blacks could pass for white. In the early twentieth century, some of the white fiction that uses minstrel and mulatto figures often punishes them for the transgression of miscegenation by either making the black body grotesque or destroying it. This enfreakment suggests that anxieties about passing only intensified in the modern era. Through the disfigured minstrel body, for instance, Willa Cather's

My Ántonia (1918) and F. Scott Fitzgerald's *Tender Is the Night* (1934) offer powerful examples of white anxieties about miscegenation that were common in early modern America.[19] Conversely, the mulatto figure suffers a dual enfreakment in African American literature; she or he poses a threat to blacks and whites and therefore is outcast from both communities. By associating passing with the enfreakment of black bodies, Charles Chesnutt and Nella Larsen use it as a metaphor both for the loss of self and for feelings of shame that result from buying into white stereotypes.

Before the deformed, mulatto pianist Blind d'Arnault appears, Cather presents minstrelsy as an active part of the traveling entertainment that passed through the sleepy town of Black Hawk. In the Harling house, for example, "[Sally] sat down in her hat and coat and drummed the plantation melodies that Negro minstrel troupes brought to town" (p. 119). Blind d'Arnault, however, does not embody the positive connotations of this earlier scene; instead, his physical deformities ("ugliness" and blindness) intensify the freakish spectacle of his performance: "He was a heavy, bulky mulatto, on short legs, and he came tapping the floor in front of him with his gold-headed cane. His yellow face was lifted in the light, with a show of white teeth, all grinning, and his shrunken, papery eyelids lay motionless over his blind eyes" (p. 139). The narrative conflates the minstrel tradition with freak shows through his exaggerated smiles, musical act, and grotesque descriptions of his body and blindness. The narrator, Jim Burden, goes on to describe him as having "almost no head at all; nothing behind the ears but folds of neck under close-clipped wool. He would have been repulsive if his face had not been so kindly and happy" (p. 139). The repeated emphasis on his "conical little skull" (p. 142) casts him as a type of freak show "pinhead"—an exhibit featuring someone with microcephaly (Fig. 5). Pinheads were often displayed as missing links and animals, and, in line with this trope, d'Arnault's head and body resemble an animal's. The link between his "repulsive" physical characteristics, his racial identification as a mulatto (yellow skin), and his disability (blindness) enhances his abnormality and freakishness. Although Cather is mostly critical of prejudices based on ethnic difference throughout the novel, *My Ántonia* keeps blackness in a separate category; it remains an exotic spectacle that suggests a fear of interracial relationships.

In his correspondence and writings, Fitzgerald also expresses an acute racial paranoia about the threat of miscegenation. Tom Buchanan in *The Great Gatsby* (1925) laments that "[i]t's up to us, who are the dominant race, to watch out or these other races will have control of things" (p. 13); later he makes his concerns more explicit: "Nowadays people begin by sneering at family life and family institutions, and next they'll throw everything overboard and have intermarriage between black and white" (p. 130). Fitzgerald himself discussed the impact of miscegenation on both race and art in a November 1921 letter to Edmund Wilson: "God damn the continent of Europe. . . . The negroid streak creeps northward to defile

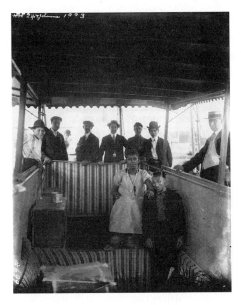

Figure 5. Frederick Whitman Glasier, Side Show Pit with Zip. *(The John and Mabel Ringling Museum of Art, State Art Museum of Florida, Sarasota)*

the Nordic race. . . . Already the Italians have the souls of blackamoors. Raise the bars of immigration and permit only Scandinavians, Teutons, Anglo-Saxons and Celts to enter. . . . My reactions were all philistine, anti-socialistic, provincial and racially snobbish. I believe at last in the white man's burden. We are as far above the modern French man as he is above the Negro. Even in art!"[20] The social and cultural mixing of races, particularly the relationship between white and black ("[t]he negroid streak"), frightened Fitzgerald because it threatened white power and damaged art. "Purity" of art, for him, demanded "purity" of ethnic background.

Tender Is the Night is preoccupied with these dangers, linking Dick Diver's fall to the construction of ethnic and racial difference as freakish.

Early in the novel, a decimated minstrel/freak figure appears to highlight Dick's racist attempts at removing racial difference from his world. Jules Peterson, an African American who helps one of the Divers' friends, is murdered, and Rosemary discovers his body on her bed: "the face, harassed and indirect in life, was gross and bitter in death; the box of materials was held under one arm but the shoe that dangled over the bedside was bare of polish and its sole was worn through" (p. 110). First, the images of his body "stretched upon her bed" (p. 109) and the blood-stained sheets suggest the sexual threat black men supposedly presented to white women.[21] Second, Peterson's association with the shoe repair business and the polish by his body allude directly to the minstrel tradition of blackface. Clearly Fitzgerald fashions this image for both its demeaning racial connotations and its sexual overtones.

In addition to viewing Peterson's body, specifically his face, as gross and bitter, Dick also exoticizes Peterson in a typical freak show manner by associating him

with stereotypical images of violent Native Americans (for instance, as hunters and murders). From Barnum's museum through the early twentieth century, freak shows often featured "savage Indians"; as Barnum explains in an 1843 letter to Moses Kimball: "I have them stretched out in the workshop all day, some of them occasionally strolling about the Museum. D—n Indians *anyhow*. They are a lazy, shiftless set of brutes—though they will *draw*" (p. 22). Dick expresses a similar attitude toward the blacks in France; after the murder he concludes "that Abe's first hostile Indian had tracked the friendly Indian and discovered him in the corridor . . . had hunted him down and slain him" (p. 110). Both of these images for Native Americans obviously rely on stereotypes, but the surprising description of Peterson as a Native American suggests that Dick conflates racial and ethnic difference by considering African Americans and Native Americans as equally violent and savage threats to whiteness. Like a freak show manager, Dick imposes one set of racial stereotypes onto another in his presentation of Peterson, reducing the murder to a violent racial tendency that Native Americans and African Americans apparently share.

This incident with Peterson also foreshadows Tommy Barban's sexual and racial threat to Dick's marriage. Barban is an exotic, cultural hybrid, being half American, half French, educated in England, and having "worn the uniforms of eight countries" (p. 29), and Nicole is sexually attracted to his racial otherness: "His handsome face was so dark as to have lost the pleasantness of deep tan, without attaining the blue beauty of negroes—it was just worn leather. The foreignness of his depigmentation by unknown suns, his nourishment by strange soils, his tongue awkward with the curl of many dialects . . . these things fascinated and rested [*sic*] Nicole" (p. 266). Her attraction to Tommy's foreignness points to the narrator's (and Fitzgerald's) underlying concerns about racial and ethnic differences. When Tommy confronts Dick about his affair with Nicole, the narrator explains that "Tommy was moved by an irresistible *racial* tendency to chisel for an advantage" (p. 308; my emphasis). These descriptions suggest that Dick's downfall culminates with both Nicole's desire for a divorce and her impending marriage to a non-Anglo. Whenever Tommy appears in the novel, his ethnicity, either through physical descriptions or the fact that he often chooses to speak French, is always foregrounded; the only issue that rattles Dick's composure in the final showdown with Barban involves ethnic difference. "Tommy returned to Dick. 'Elle doit avoir plus avec moi qu'avec vous?' 'Speak English! What do you mean 'doit avoir'?'" (p. 307). Faced with Nicole's love for Tommy, Dick finds that his personal empire has been destroyed by this interracial relationship. Arguably, his demise, losing his wife to a racial other, reflects Fitzgerald's and much of white America's fears about the dissolution of Anglo-Saxon purity and culture through exotic appeal or racial hybridity.

In modernist African American fiction, enfreaking the black or mulatto body suggests a type of self-destruction. Specifically, the body that passes or is visibly mixed represents the dilution of African American culture, for those who pass have often lost contact with their racial heritage. Recognizing oneself as black, therefore, can be a startling moment in which one's own body has become freakish. This literature explores the costs of enfreaking blackness for whites. In *The House behind the Cedars* (1900), for example, Charles Chesnutt presents both white and black perceptions of blackness as freakish. On one level, these images reflect white anxieties about the destabilizing of racial and class barriers based on visible difference. When Tryon (white) discovers that his fiancée Rena is a mulatto, he dreams that "[i]n all her fair young beauty she stood before him, and then by some hellish magic she was slowly transformed into a hideous black hag. With agonized eyes he watched her beautiful tresses become mere wisps of course wool, wrapped round with dingy cotton strings; he saw her clear eyes grow bloodshot, her ivory teeth turn to unwholesome fangs. With a shudder he awoke, to find the cold gray dawn of a rainy day stealing through the window" (pp. 146–47). This dream fuses images of freak, vampire, and slave. Her transformation into a fanged animal marks her for the violation of passing. A vampire, like a mulatto, takes someone else's blood, and Rena metaphorically becomes a vampire of white blood. Her ability to pass so completely within the white upper class is monstrous and dangerous. This mutation is also based on Tryon's assumptions about African Americans as rural, cotton-picking, unkempt slaves. He suppresses her individuality and love for him underneath these prejudices, which ultimately destroy their relationship. Through these biases, he realizes that he has hurt himself as well as her, but this revelation happens too late to restore their love.

Even though Rena's brother John Walden considered himself white because of his light skin color, whites force him to accept his status as black by marking his body or, more specifically, beating his race into him. "He was informed one day that he was black. He denied the proposition and thrashed the child who made it. The scene was repeated the next day, with a variation,—he was himself thrashed by a larger boy. When he had been beaten five or six times, he ceased to argue the point, though to himself he never admitted the charge. His playmates might call him black; the mirror proved that God, the Father of all, had made him white" (pp. 160–61). By implication, these beatings bruise his body. He has been isolated and targeted for his difference, and through these fights he symbolically becomes colored (black and blue). These incidents do not lead him to embrace his African American culture and roots like the characters in Wright's and Ellison's novels. Instead, he hides these scars and colors to maintain the opportunities and successes that passing offers him. Accepting the social disparities between black and white, he passes without shame or regret.

Almost thirty years later, however, Nella Larsen's *Passing* (1929) uses the language of enfreakment to explore black anxieties about passing as a loss of self.[22] Unlike John Walden, her characters struggle with feelings of shame and remorse for hiding their color. Both the narrator, Irene, and Clare pass, but Clare depends on passing to maintain a particular, white middle-class lifestyle. Eventually, after years of rejecting her African American roots and culture, guilt drives her to reestablish ties with her former friend Irene who lives as a black woman. For women like Clare, blackness is dangerous and freakish because it can reveal the truth. When she talks about the possible dangers of having a dark child, for example, she explains that "[i]t's only deserters like me who have to be afraid of *freaks of nature*" (p. 169; my emphasis). The term "freaks" labels blackness as something abnormal and repulsive; as Gertrude, another black woman who passes, explains: "But, of course, nobody wants a dark child."[23]

Later in the novel, at the Negro Welfare League dance, Irene also uses similar labels to protect Clare, but in doing so she reveals her own detachment from her African American identity. While Clare dances with various black men, Hugh Wentworth comments that " 'all the ladies of my superior race . . . are always raving about the good looks of some Negro, preferably an unusually dark one. . . . Do you think he's—er—ravishingly beautiful?' " (p. 205). Wentworth's question speaks to his own fears about the lure of blackness for white women (even though Clare is mulatto). Irene assuages this concern by immediately dismissing this notion and explaining that white women are only excited by novelty and the strangeness of difference: " 'the sort of thing you feel in the presence of something strange, and even, perhaps, a bit repugnant to you; something so different that it's really at the opposite end of the pole from all your accustomed notions of beauty' " (p. 205). Irene constructs blackness as exotic with the same type of justification used in freak show exhibits. She also sees it as harmless by presenting African American culture as something that does not threaten existing racial hierarchies. Dark skin is therefore "repugnant"; its only appeal comes from its strangeness. At the same time, this rejection and enfreakment of blackness is a rejection of self. Irene has set herself above Clare in moral terms because she does not pass as a way of life. Yet by viewing blackness as grotesque, she has aligned herself completely with white notions of beauty and superiority and, like Clare, has lost contact with her racial heritage through passing.

This essay began by discussing the ways freak show managers mitigated white middle-class anxieties about blackness through exotic constructions of African Americans. Labels, such as "barbaric" and "savage," were a way of containing black bodies and reinforcing commonly held beliefs about the social and cultural inferiority of non-Anglos. This form of entertainment lasted well into the twen-

tieth century, and many authors (black and white) invoked freak shows literally and metaphorically to criticize racial prejudice and to examine the shame surrounding it. In addition to carnival images, authors used boxing (a common performance in freak shows) as a symbol for some of the ways white society still marked and disfigured black bodies well into the modern era. Making the black body a visible spectacle offered one way to mitigate white anxieties about immigration and miscegenation. The act of passing, however, undermined white reliance on a politics of visibility for judging and treating others. When visible signs of racial identity were not apparent, social expectations about behavior had to be based on actions, not race.

As all of these examples illustrate, racial tensions in early modernist America created both helplessness and meanness in both blacks and whites. Sometimes these tensions led to feelings of shame and resentment; sometimes they led to blows. In any case, modernist literature in the first half of the twentieth century often expressed and tried to come to terms with racial anxieties by enfreaking blackness. Some African American and white writers transformed the black body into a spectacle to resist existing prejudices; others used literal and metaphoric enfreakment to reinforce racism. Ultimately, the coercion of the black body through freak exhibits and boxing and the loss of the black self through passing suggest that African Americans bore the brunt of racial anxieties in the early modernist era. Miscegenation/passing posed a serious threat to both white hegemony and black cultural identity in America because, as many of these authors show, it only exposes the superficiality of racial distinctions. By employing freaks/freak shows literally and metaphorically, these authors captured the feelings of hatred, fear, and shame motivating many of the relationships between blacks and whites—feelings that remain a cruel legacy from the first half of the twentieth century.

NOTES

1. See Sollors, "Immigrants and Other Americans," 569–70.

2. See Rydell, *All the World's a Fair*, 40.

3. In antebellum America, Barnum felt it was important not to represent Joice Heth as a slave in the North. To offer another example, Adam's *E Pluribus Barnum* discusses the ways Barnum juxtaposed his racial freak exhibits with some of the more controversial dramas appearing in his Lecture Room. The display of *What Is It?* between acts of Dion Boucicault's *The Octoroon* essentially made this play "safe for even the most anti-abolitionist of patrons" (p. 163).

4. I am borrowing the term "enfreakment" from Hevey's *The Creatures Time Forgot*, 53.

5. Bogdan (*Freak Show*) defines microcephaly as "a condition associated with mental retardation and characterized by a very small, pointed head and small overall stature" (pp. 111–12). African Americans with this condition were often "cast as 'missing links' or as atavistic specimens of an extinct race" (p. 112).

6. Ibid., 187.

7. See Vaughan, "Ogling Igorots." See also Rydell, *All the World's a Fair*, chaps. 6–7.

8. In *Going Out: The Rise and Fall of Public Amusements*, Nasaw explains that "amusement entre-

preneurs . . . had to provide commercial amusements and amusement sites that were public in the sense that they belonged to no particular social groups, exciting enough to appeal to the millions, and respectable enough to offend no one" (p. 5).

9. Harris, *Humbug*, 75.

10. Darwin's *Origin of the Species* (1859) defined "evolution" in both progressive and retrogressive terms, which helped make racial and physical improvements (or ideals) social goals. And scientists used Darwin, in part, to justify Anglo-Saxon superiority. As Davis argues in "Constructing Normalcy," Darwin, statistics, and eugenics, which established "the idea of a perfectible body undergoing progressive improvement" (p. 14), also contributed to the marginalization of disabled people: "Darwin's ideas serve to place disabled people along the wayside as evolutionary defectives to be surpassed by natural selection" (p. 15).

11. When Barnum first tried the *What Is It?* exhibit in England (1846), he hired an actor, Harvey Leech, who was known as the "Gnome-Fly." Bogdan, *Freak Show*, 135. Leech was recognized on the first day and the exhibit failed. Saxon, *Letters of P. T. Barnum*, n. 36.

12. Bogdan, "The Social Construction of Freaks," 23.

13. "In present teenage vernacular, 'geek' means a strange person, a person who does not have the proper social graces. In the amusement world, a 'gloaming geek' was a wild man who, as part of his presentation, would bite the heads off of rats, chickens, and snakes." Bogdan, *Freak Show*, 262.

14. *Joice Heth* was Barnum's first exhibit as a showman. Her previous owner claimed that she was 161 years old and had been George Washington's nurse. Barnum purchased the rights to display her in 1835.

15. Donaldson's "Making a Spectacle" argues that Welty's *A Curtain of Green* invites the reader into a voyeuristic role. As a result, she or he is responsible in part for making a spectacle of women's bodies: "But we are also urged to consider those who do the scrutinizing and the act of scrutiny itself. As a result, reading [this collection] is roughly akin to looking at an exhibit and being vaguely uneasy about the possibility of being an exhibit oneself" (p. 574). Although Donaldson applies this only to grotesque women's bodies, suggesting that they are a site of resistance (blurring boundaries between viewer and subject), she does not examine disabled bodies and the enfreakment of figures such as Keela.

16. In claiming "JESUS WAS ONCE A LEPER," Dan also transforms Jesus into a freak—a moment that reflects his own sense of having become a spectacle and an outcast.

17. In other aspects of *Black Boy*, Wright also describes the disenfranchisement of African Americans by white society in terms of disability. For example, his next-door neighbor, who had become an insurance agent, is "handicapped by illiteracy" (p. 159).

18. Barnum, *Struggles and Triumphs*, 90.

19. Fitzgerald began writing *Tender Is the Night* in 1925.

20. Turnbull, *Letters of F. Scott Fitzgerald*, 326.

21. Smith discusses the sexual connotation of this scene as well in "Figure on the Bed." See also Washington's (*Politics of Exile*) discussion of African Americans in Fitzgerald.

22. McDowell ("The Changing Scene") also reads "passing" as functioning on the level of sexuality. See also Judith Butler's chapter on Larsen in *Bodies That Matter*.

23. Gertrude Stein uses the language of enfreakment similarly in "The Good Anna" to undermine heterosexist norms. See Fahy, "Iteration as a Form of Narrative Control."

BIBLIOGRAPHY

Adams, Bluford. *E Pluribus Barnum: The Great Showman and the Making of U.S. Popular Culture.* Minneapolis: University of Minnesota Press, 1997.
Allen, Robert C. *Horrible Prettiness: Burlesque and American Culture.* Chapel Hill: University of North Carolina Press, 1991.

Bakhtin, Mikhail. *Rabelais and His World*. Translated by Hélène Iswolsky. Bloomington: Indiana University Press, 1984.

Barnum, P. T. *Struggles and Triumphs; or, Forty Years' Recollections of P. T. Barnum, Written by Himself*. Buffalo, N.Y.: Warren, Johnson, and Co., 1872.

Bogdan, Robert. *Freak Show: Presenting Human Oddities for Amusement and Profit*. Chicago: University of Chicago Press, 1988.

——. "The Social Construction of Freaks." In Rosemarie Garland Thomson, ed., *Freakery: Cultural Spectacles of the Extraordinary Body*, 23–37. New York: New York University Press, 1996.

Butler, Judith P. *Bodies That Matter: On the Discursive Limits of "Sex."* New York: Routledge, 1993.

Cather, Willa. *My Ántonia*. 1918. Reprint, New York: Vintage Classics, 1994.

Chesnutt, Charles Waddell. *The House behind the Cedars*. 1900. Reprint, Athens: University of Georgia Press, 1988.

Davis, Lennard J. "Constructing Normalcy: The Bell Curve, the Novel, and the Invention of the Disabled Body in the Nineteenth Century." In Lennard J. Davis, ed., *The Disability Studies Reader*, 9–28. New York: Routledge, 1997.

Donaldson, Susan V. "Making a Spectacle: Welty, Faulkner, and Southern Gothic." *Mississippi Quarterly* 50, no. 4 (Fall 1997): 567–83.

Ellison, Ralph. *Invisible Man*. 1952. Reprint, New York: Vintage International, 1995.

Fahy, Thomas. "Iteration as a Form of Narrative Control in Gertrude Stein's 'The Good Anna.'" *Style* 32, no. 5 (Spring 2000).

Fitzgerald, F. Scott. *The Great Gatsby*. New York: Scribner's, 1925.

——. *Tender Is the Night*. New York: Scribner's, 1933.

——. *Six Tales of the Jazz Age and Other Stories*. New York: Scribner's, 1960.

Harris, Neil. *Humbug: The Art of P. T. Barnum*. Boston: Little, Brown, 1973.

Hevey, David. *The Creatures Time Forgot: Photography and Disability Imagery*. New York: Routledge, 1992.

Hutchinson, George. *The Harlem Renaissance in Black and White*. Cambridge: Belknap Press of Harvard University Press, 1995.

Larsen, Nella. *Passing*. 1929. Reprint, New Brunswick, N.J.: Rutgers University Press, 1986.

Lott, Eric. *Love and Theft: Blackface Minstrelsy and the American Working Class*. New York: Oxford University Press, 1993.

McDowell, Deborah E. *"The Changing Same": Black Women's Literature, Criticism, and Theory*. Bloomington: Indiana University Press, 1995.

Morrison, Toni. *Beloved*. New York: Plume Contemporary Fiction, 1988.

Nasaw, David. *Going Out: The Rise and Fall of Public Amusements*. New York: Basic Books, 1993.

Orvell, Miles. *The Real Thing: Imitation and Authenticity in American Culture, 1880–1940*. Chapel Hill: University of North Carolina Press, 1989.

Orwell, George. *Inside the Whale and Other Essays by George Orwell*. London: Victor Gollancz Ltd., 1940.

Ostman, Ronald E. "Photography and Persuasion: Farm Security Administration Photographs of Circus and Carnival Sideshows, 1935–1942." In Rosemarie Garland Thomson, ed., *Freakery: Cultural Spectacles of the Extraordinary Body*, 121–36. New York: New York University Press, 1996.

Rydell, Robert W. *All the World's a Fair: Visions of Empire at American International Expositions, 1876–1916*. Chicago: University of Chicago Press, 1984.

Saxon, A. H. *P. T. Barnum: The Legend and the Man*. New York: Columbia University Press, 1989.

——, ed. *Selected Letters of P. T. Barnum*. New York: Columbia University Press, 1983.

Smith, Felipe. "Figure on the Bed: Difference and American Destiny in *Tender Is the Night*." In J. Gerald Kennedy and Jackson R. Bryer, eds., *French Connections: Hemingway and Fitzgerald Abroad*, 187–213. New York: St. Martin's Press, 1998.

Sollors, Werner. *Beyond Ethnicity: Consent and Descent in American Culture*. New York: Oxford University Press, 1986.

——. "Immigrants and Other Americans." In Emory Elliott, ed., *Columbia Literary History of the United States*, 568–88. New York: Columbia University Press, 1988.

Thomson, Rosemarie Garland. "Introduction: From Wonder to Error—A Genealogy of Freak Discourse in Modernity." In Thomson, ed., *Freakery: Cultural Spectacles of the Extraordinary Body*, 1–19. New York: New York University Press, 1996.

——. *Extraordinary Bodies: Figuring Physical Disability in American Culture and Literature*. New York: Columbia University Press, 1997.

Toomer, Jean. *Cane*. 1923. Reprint, edited by Darwin T. Turner, New York: Liveright, 1975.

Trachtenberg, Alan. *The Incorporation of America: Culture and Society in the Gilded Age*. New York: Hill and Wang, 1982.

Turnbull, Andrew, ed. *The Letters of F. Scott Fitzgerald*. New York: Scribner's, 1963.

Twain, Mark. *The Adventures of Huckleberry Finn*. 1884. Reprint, New York: Bantam Books, 1981.

Vaughan, Christopher. "Ogling Igorots: The Politics and Commerce of Exhibiting Cultural Otherness, 1898–1913." In Rosemarie Garland Thomson, ed., *Freakery: Cultural Spectacles of the Extraordinary Body*, 219–33. New York: New York University Press, 1996.

Washington, Byran R. *The Politics of Exile: Ideology in Henry James, F. Scott Fitzgerald, and James Baldwin*. Boston: Northeastern University Press, 1995.

Weiss, M. Lynn. *Gertrude Stein and Richard Wright: The Poetics and Politics of Modernism*. Mississippi: University Press of Mississippi, 1998.

Welty, Eudora. *A Curtain of Green and Other Stories*. 1941. Reprint, New York: Harcourt Brace Jovanovich, 1991.

Wright, Richard. *Black Boy: A Record of Childhood and Youth by Richard Wright*. New York: Harper, 1945.

LUCINDA H. MACKETHAN

Barren Ground, Mother Earth

Female Embodiments of Southern Modernism

The South of the Great Depression was, as Franklin Roosevelt proclaimed in 1938, "the Nation's Number One economic problem." A half century later, however, we also point to the South of the 1930s as America's richest literary territory. One year, 1936, marked the publication of William Faulkner's masterwork, *Absalom, Absalom!*, and three other significantly southern events in the nation's literary history as well. June brought the long awaited debut of Margaret Mitchell's *Gone with the Wind* (*GWTW*). In the same month an editor at *Fortune* magazine sent writer James Agee and photographer Walker Evans to investigate the living conditions of sharecroppers in Alabama, an assignment that resulted eventually in *Let Us Now Praise Famous Men* (1941). Last, but not least, Eudora Welty published "Death of a Traveling Salesman" in the small literary magazine, *Manuscript*. This story, her first to be published, quietly contributed, as did Faulkner's, Mitchell's, and Evans's and Agee's books, to making the thirties what Louis Rubin has called "the high point, the culmination, of the South's literary history."[1]

Absalom, Absalom!, *Gone with the Wind*, *Let Us Now Praise Famous Men*, and "Death of a Traveling Salesman" share prominent positions in the roll call of works that make up the phenomenon we now call the Southern Renascence. Rubin, who has done more than any other scholar to shape critical perceptions of this literary flowering, observes that the best southern writing of the period "was concerned with human change, with the urgency of facing up to the impact of new ways and new demands upon an historical community."[2] To extend this view, we can argue that Faulkner, Welty, Agee, and Mitchell belonged not only to a southern movement but also to the American development of modernism, a cultural designation signaling just that attention to radical change that Rubin describes for the South. A central component of the southern renascence writers' vision, and one that illustrates their participation in the broader stream of American modernism, is their

visual representations of maternally defined women. The following review of several key texts of the southern literary renascence demonstrates how pervasively the bodies of women, visually embedded in rural landscapes emphasizing cyclic patterns of barrenness and fecundity, dominate the versions of modernity that southern writers crafted during the 1920s and 1930s.

"Death of a Traveling Salesman" typifies the southern modernist vision of the female body in ways that make it a useful starting point for our discussion. Welty's first published story, it shows her attraction to the thematic imperatives of trusted literary advisers such as Robert Penn Warren but also reflects her experiences in traveling down Mississippi backroads as a photographer for the Works Projects Administration. The result is a deft recasting, in rural Mississippi, of the thematics and imagery of *The Waste Land*. T. S. Eliot's 1922 poem, perhaps more than any other single work, ushered in the period of "high modernism" among American writers, including Warren and other Nashville Fugitive poets. *The Waste Land* abounds in, indeed defines, the modernist anxiety over the maternal. Through a series of vignettes featuring women as both speakers and subjects, *The Waste Land* presents the possibilities of birth or rebirth shrouded in fear of the feminine as a destructive force.[3] "Death of a Traveling Salesman," recounting the last afternoon of a shoe salesman named Bowman, invokes Eliot's wasted land and its inhabitants. Bowman is a lost modern Percival whom we meet on his lonely journey down a deeply rutted Mississippi back road. Although it is winter, the weather is uncomfortably hot; people out working in their fields resemble *Waste Land* inhabitants, "leaning sticks or weeds," as Bowman drives by, maneuvering his car "through a heap of dead oak leaves."[4] When the car runs off the road into a ditch, Bowman, still recovering from a debilitating bout of influenza, seeks assistance at the primitive cabin of a tenant farmer named Sonny. The disturbingly maternal woman who allows Bowman to enter emerges as the story's visual center.

Bowman in his Ford represents modern disembodiment and impotence. He exists without love, disconnected from the land and from human engagement, a fitting representative of his lost generation. Nothing shows his wasted condition better than the way in which he assumes that Sonny's pregnant wife is instead "Sonny's" mother, an "old" woman of about fifty "with a weather-beaten but unwrinkled face" (p. 121). When Bowman finally realizes that the woman is Sonny's wife, actually a young woman who soon will bear a child, he responds in "unbelieving protest," terribly shocked "with knowing what was really in this house. A marriage, a fruitful marriage. That simple thing" (pp. 128–29).

As Eliot in *The Waste Land* and Welty in "Death of a Traveling Salesman" show, a "fruitful" relation between man and woman was not, for moderns, "simple" at all. In the disconnected, mechanistic modernist landscape, simple interaction between the sexes has become unfathomable. In both Eliot's and Welty's settings, a dry and

depleted land constitutes the outward sign of inward human debility. Disassociation from the earth's fecundity is accompanied by confusion and fear concerning the sexuality, the potential fertility, of woman. Welty's Bowman cannot "see" a young, fertile, child-carrying woman for what she is, and so in her shapeless, heavy body she becomes the projection of his own impotence. By making her old and weak, Bowman seeks to keep Sonny's wife within boundaries that his diseased heart can control. Finally, aware that the young pregnant woman contains a maternal power beyond his own capacities, Bowman can only wish "that the child were his" (p. 129).

The quiet saga of Welty's traveling salesman presents what other southern texts of the 1920s and 1930s also display: fear of life, fear of physical connection, a dual repulsion/attraction to sexual experience. Masculine desire is channeled in these texts toward women whose potential for both fecundity and barrenness represents a confusing, threatening challenge to male identity, power, and creativity. Modernist southern texts present women's sexuality and maternity as deeply menacing and disruptive. The South's endorsement of white male dynastic control meant that both race and gender differences must be seen as destabilizing forces. Women's physical bodies, either within themselves or displaced onto the southern landscape, are presented visually in ways that demonstrate the southern cultural uneasiness over what the feminine could or should contain. A prelude to the full flowering of this concern in southern literature occurs in the poetry of John Crowe Ransom and Jean Toomer. Although they wrote within traditions as different as the Fugitives' Vanderbilt and Black Harlem, Ransom's and Toomer's poems of the early 1920s demonstrate the influence of Eliot most noticeably in their ambivalence toward women, who are bodily identified with the land.

Following Toomer and Ransom's lead, from the late 1920s to 1940 the modernist ambivalence toward the sexual and the maternal, wrought in doubled, opposed images of barrenness and the fertility, dominated the visual dynamics of much southern writing. Ellen Glasgow, William Faulkner, Margaret Mitchell, and James Agee—in works representing techniques and traditions as different as those of Ransom and Toomer, constructed feminine mythologies of the land that both promoted and undermined the South's tradition of patriarchal dominance. To trace the presentation of women's physical bodies in their writing provides a way to see the literature of the Renascence South, in all its variety, as more firmly reflective of modernist modes and messages than many critics have been willing to address.

For the South in the modern period, the symbolic visual eliding of woman, land, fecundity, and barrenness has been inevitably charged with specific regional ideology. The figure of the white woman-as-lady was *the* icon of the Old South's lost glory and the New South's attempt to recover that glory in and as myth. Whereas

women of other regions moved fairly naturally, throughout the late nineteenth century, into new economic and social roles, this transition was stalled for women of the post–Civil War South. The lag was tied to the continued idealization of the white woman of the South in terms of what she needed to symbolize for male power keepers who had traditionally made resistance to change the center of their ideology. As John Ruoff writes, between 1865 and 1920 the dominant themes were "stability and order rather than change for southern [white] women of the upper and middle classes. The rapid changes which the South was undergoing in these years in urbanization, industrialization, and racial relations put added emphasis on the need for some institution which was stable and which confirmed social order. The family was that institution, and the maintenance, more or less unchanged, of traditional female roles confirmed the family's stability."[5] Moreover, when associated metaphorically with land, women were confirmed as property, their submission a necessity, like the land's fertility, to the prosperity of family, community, and region.

The frontispiece (Plate 9) to Ellen Glasgow's 1913 novel, *Virginia*, provides a revelation of how the white southern woman on the eve of World War I was viewed, and how the phenomenon Ruoff describes was played out in a southern iconography of denial. Enclosed in her garden, Virginia carries a smothering bouquet of flowers. She herself is sexually desirable, alluring, yet also pristine and inviolable. Glasgow's novel begins Virginia's history in the year 1884. Virginia's name makes her the female embodiment of the land, the "state," she belongs to, but also declares her virginity, not as a biological condition but as a permanent feature of her identity. In the garden scene that the frontispiece portrays, Virginia is about to meet the man she will fall in love with and marry. Her biological and cultural destiny is to become the mother of the Old South myth, but Glasgow's agenda (one that the frontispiece does not reflect) is to assess the cost of the myth. Thus Virginia's story ends some twenty years later with images of her blighted middle age and the dissolution of her marriage. Virginia loses her thoroughly modernized playwright husband to a woman of whom Glasgow says, "She stood not only for the elemental forces, but for the free woman; and her freedom, like that of man, had been built upon the strewn bodies of the weaker. The law of sacrifice, which is the basic law of life, ruled here as it ruled in mother-love and in the industrial warfare of men."[6] *Virginia*'s frontispiece, then, gives us the lovely young woman in her bower, like the "lady in beauty waiting" in one of John Crowe Ransom's famous poems ("Piazza Piece"), holding forth flowers to adorn her own entombment.

Annette Kolodny in *The Lay of the Land* writes of the imaging of "Land-as-Woman" and of how Americans have been bound since the beginning of national consciousness "by the vocabulary of a feminine landscape and the psychological

patterns of regression and violation that it implies."[7] In the South, the associations of woman with land also serve the patriarchal structuring of southern society. Such a power structure secures white masculinity by equating women with the passive, tamed, and well-ordered earth. As Diane Roberts writes, "To construct women in such a way was to attempt to control them, investing them with the enduring strength of the land itself, insisting that their fortunes followed its fortunes: property mirroring the material, if never the moral, decline of the Old South."[8]

Roberts and other feminist scholars have pointed out the foundations that governed the construction of the chaste white southern lady as icon of an idealized agrarian society. The icon's potency depended in large part on the simultaneous promotion of its opposite, the image of the compliant black slave woman and, later, the sexually promiscuous black and white lower-class women of the soil. Race, gender, and ultimately class are thus all essential considerations for any study of how southern modernist writers represented threatened values through women's bodies.[9] What this essay will emphasize is a unifying element of works by writers who represent distinct race, class, and gender differences; their different identities and traditions notwithstanding, they constitute, specifically through their creative manipulations of women's mothering bodies, a narrative mirror of the changing and divided modern South.

The modernist conjunction of women's sexuality/maternity and the threat of spiritual and artistic barrenness made perhaps its most auspicious visual entrance into the South in 1923. In this year a young Vanderbilt University student nick-named "Red" Warren, caught up in undergraduate enthusiasm for *The Waste Land*, painted murals illustrating the poem on the walls of his dormitory room. His room-mate, Allen Tate, "remembered years afterward, the rats creeping softly through the vegetation, and the typist putting a record on the Gramophone" that adorned the walls.[10] It seems hardly coincidental now that Eliot's publication of *The Waste Land*, the great poem of his early period, occurred in 1922, the year that Tate had joined with Robert Penn Warren and other Nashville poets to found the poetry journal *The Fugitive*. Although some in this group, particularly Tate's professor John Crowe Ransom, would challenge Tate and Warren's championing of Eliot, *The Waste Land* can now be seen as the work of "high modernism" that best defined the Fugitives' poetic agenda, however much they might quarrel with certain specifics of Eliot's vision.[11] Even Ransom would write in 1966 that *The Waste Land* gave young poets of his generation "a feeling of having been starved of something or other in the poverty of their intellectual interests, and now of knowing that what they had missed was the religious sense in which they had been reared."[12] Eliot, with this poem, created a whole, teeming symbolic world for habitation by the Fugitive-Agrarian poet-critics whose themes have long dominated critical assessments of southern literature of the period 1920 to 1945.

The Waste Land, early in the third section, projects the image of a rat creeping "through the vegetation / Dragging its slimy belly on the bank."[13] The focus on the rat precedes a vignette in which a typist "home at teatime" engages in an unsatisfying, even boring, session of sex with an equally bored "carbuncular" clerk from her office (p. 38). Eliot provides a kind of tragic voice-over to this meaningless tryst by assigning its narration to Tiresias, the blind seer of Greek drama. Eliot's "old man with wrinkled breasts" is identified as "the most important personage" in *The Waste Land* as a whole (pp. 38, 50). In an authorial note to this section, Eliot speaks of how the male characters of the poem as a whole "melt" into one another, and how "all the women are one woman, and the two sexes meet in Tiresias" (p. 50). Thus for Eliot the old seer is the unifying agent of *The Waste Land*, the human corollary to the poem's visual elements. These present alternating images of lush, rotting vegetation and barren waste as the backdrop to narratives of women's sexual experiences, either forced or unsatisfying, either empty of passion or too violently passionate. *The Waste Land*, so often interpreted as a poem about modern western civilization in desperate need of regeneration, names women's sexuality as the ground on which the mind is capable of understanding its need for personal as well as cultural regeneration. Eliot's Tiresias, who has bodily learned women's erotic experience, becomes the poetic means by which the modern sense of disembodiment, the modern dis-ease with fertility, the terror of losing creativity, are confronted.

Ironically, John Crowe Ransom, who fought his students' attraction to Eliot, most resembles Eliot in rendering a modernist worldview through the regulation of female bodies in his poetry. Most of Ransom's poems, as Louise Cowan has noted, "center on women and sexuality."[14] "Antique Harvesters," Ransom's 1926 poem, is no exception and has special significance for the Fugitive movement; it signaled the philosophical turn to Agrarianism that the group took in the last years of the decade. As Louis Rubin sees it, "In 'Antique Harvesters' we have the prescription for *I'll Take My Stand*."[15] Paced with Ransom's characteristic dry, ironic tone, "Antique Harvesters" begins by evoking the wasteland: "What shall this land produce? / A meager hill of kernels, a runnel of juice; / Declension looks from our land, it is old." In the midst of barrenness, the old men who speak in the poem rebuke the "young men" who "would be joying in the song / Of passionate birds."[16] Passion should yield to the "echoes" that "are the old man's arts," the endurance of memory, reverence for tradition and ritual. In agrarian terms, the barrenness that is associated with the South as antique land, land of valued heritage, is its virtue. By the same token, the "Proud Lady" evoked as muse/mistress of this autumnal world is aged and yet "she hath not stooped." Ransom's courtly and antiquated language holds at bay the implications of his own beginning, with its threat of infertility, meager harvest, "declension."

In "Antique Harvesters" we see Ransom employing a favored technique for answering the threat of modern chaos. The formal, civilizing influence of tradition promotes a religious sense to preserve what is sacred, conceived of as feminine beauty and grace, desexualized mainly through poetic language. What Cowan calls "the cultivated asceticism of the gentleman" becomes Ransom's answer to the wasteland, yet, as Cowan also notes, there is "a disturbing and frightening strangeness" about his "revolt against modernity."[17] In "Antique Harvesters," as the poet-speaker resorts to an increasingly antiquated language ("Angry as wasp music," "see, if you peep shrewdly," "Why, the ribs of earth subsist frail as a breath"), he detaches himself from the threat he has named ("if one talk of death"). He is left as a champion only of his own sterility before the untouchable vitality of the Proud Lady.

Many Ransom poems offer dramatic juxtapositions of the violence and brutality that threaten beautiful women against courtly, formal, reverential language; the special importance of the disjunction in "Antique Harvesters" lies in its ideological positioning. As poetic harbinger of an agrarian manifesto, it relates the land to woman, idealized yet devoid of sexuality. The unspoken tension between physical passion and formal reverence distorts both the courtly medium and the ideological message. While the old men's faith is offered as a cure for chaos, barrenness remains ascendant. Ransom's position relates him to another southern writer of the 1920s who, in his own poem of harvesting, replicates Ransom's evocation of barrenness within the unknowability of the maternal feminine. Jean Toomer's *Cane*, in fact, abounds with ironic Madonna figures who suggest fertility and redemption while they remain untouchable.

The poem "Harvest Song," the centerpiece of Toomer's collection of stories and poems in *Cane*, presents a harvester mourning that "my eyes are caked with dust . . . I am a blind man who stares across the hills." He is "too fatigued" to bind his oats, and he is hungry but "fear[s] knowledge of [his] hunger."[18] He sings to his "brother" harvesters as does Eliot's fisher-king or the old men in Ransom's poem, all of these male voices identifying the poet's role as that of harvester. This identification also names the speakers' problem, however; the harvest is associated with dried and depleted land, and the modern male poet as harvester, facing his own creative limits, is afraid to explore the full implications of his own poetic material.

Like *The Waste Land*, *Cane* is narrated through a brooding male voice, while the most vivid characters are women and the majority of narratives present women's sexual experience. "Harvest Song," which Toomer called his book's "spiritual" end piece, is placed in the book's center. Preceding the poem are stories of young black women placed in rural southern settings. Following it are stories of black women transplanted to the arid urban centers of the North. The women of part one are overtly sexual, their physical bodies the focus of action and vision. They are also

obsessively the objects of male gaze: Karintha—"Men had always wanted her"; Carma—"Maybe she feels my gaze"; Fern—"Men were everlastingly bringing her their bodies" (pp. 1, 10, 14). The sexuality these women exude is haunting, tormenting, tempting, but unavailable or destructive. Karintha murders her child; Carma's infidelities send her husband to prison; Fern has eyes that "desired nothing that you could give her" (p. 14).

In part two the women's sexuality itself is stunted. In "Calling Jesus," a woman's soul is described as "a little thrust-tailed dog that follows her, whimpering." "Box Seat" tells of Dan Moore's lust for Muriel, who hides herself from her passion to be respectable and lives in a "bolted" house. With the change of geography from rural South to urban North comes a shift not so much in the sense of what women's bodies are, their alluring physicality, but in how those bodies are contained in time and space. Repressed women are linked, in part two, to the split between body and mind in the modern consciousness, the modern loss of integration of identity that was throughout his text Toomer's essential concern.

Finally "Kabnis," the long story that closes *Cane*, presents the Madonna figure of Carrie K., symbolically the one who carries the possibility of the redemption of the culture in her body. Carrie appears before Kabnis in a dark cellar, where he has gone for a night of debauchery. In the womblike cellar he has found a disturbing relic from his own slave heritage, the old man Father John, whom Carrie nurses. Kabnis is infuriated by the old slave's enigmatic chanting, yet briefly soothed as Carrie appears, "lovely in her fresh energy of the morning, in the calm untested confidence and nascent maternity which rise from the purpose of her present mission" (p. 114). She has come to help Kabnis rise from the cellar, symbolic both of the womb of his African American southern past and his own combined dread of and immersion in his maternal origins. As Carrie tries to help Kabnis, telling him that "I'm not a child, . . . as I'll show you now," Kabnis puts her off, remarking, "twont do t lift me bodily. You don't understand. But its the soul of me that needs the risin" (p. 114). Carrie's reply is to talk of going to church, and her own "nascent maternity" seems threatened by the constraining respectability of the rigid middle-class black religious community she honors. Indeed, as Madonna she suggests the physical fecundity of motherhood but also a removal from the physical—the same split that Kabnis feels in himself between body and soul. Carrie remains in the basement to minister to the inarticulate remnant of the past, Father John, while Kabnis trudges off to his work, ambiguously carrying a "bucket of dead coals" (p. 116). All of the birth and sexual imagery of this section rests in the unresolved, ambiguously presented body of Carrie (Carry), framed within mixed references to "sin," to church, to bodily rising, and to mothering.

Toomer defined his first and only book as a "swan song," designed to record the

ironic birth and then inevitable passing of his own sources of artistic inspiration in the South. A related concern for Toomer, as for many artists of the Harlem Renaissance, is the middle-class African American's participation in the dominant culture's paralysis. Upwardly mobile blacks, in particular, embraced strict, repressive religious creeds, reflecting white America's Puritan sensibility that associated sex with sin and linked fertility to promiscuity. In this respect, *Cane* prefigures the artistic crisis defined by Alain Locke's influential collection of black writing, *The New Negro*. This 1925 anthology, which included two pieces from *Cane*, proclaimed, and in many ways itself constituted, the birth of modern African American culture. This culture, announced Locke, was embodied in an explosion of black creativity, rooted in ancestral Africa but also participating fully in the national, modernist movements of the 1920s. *The New Negro*, like *Cane*, visualized women's bodies in a manner that reflected an unresolved tension concerning that creativity. The arbiters of New Negro culture wanted the black female body to represent two warring elements of creative process—desire and control. The only essay included by Locke to define the social situation of the New Negro woman demonstrates the problem. Elise McDougald, in "The Task of Negro Womanhood," intones, "Within her soul, she [the modern Negro woman] knows little of peace and happiness. But through it all, she is courageously standing erect, developing within herself the moral strength to rise above and conquer false attitudes. She is maintaining her natural beauty and charm and improving her mind and opportunity."[19] The black woman is basically disembodied here, placed on an ironic reproduction of the white woman's pedestal. It is instructive to put McDougald's sociological account in the context of two contrasting illustrations of black women that appear in *The New Negro*. The frontispiece to the anthology is a genre study by Winold Reiss. Entitled "The Brown Madonna" (Plate 10), it presents a serious, pure-looking, straight-haired young mother holding her resting infant on her lap. Like Toomer's Carrie, this young mother is obviously proper, restrained, purified of the sexuality that produced her passive infant. For African Americans of the 1920s, images of the black woman as Madonna and Race Mother, embodying moral strength and "rising above," could compensate for a racial past whose shame was epitomized in the sexual degradation inflicted on slave women by white men.

Reiss's study, placed at the beginning of Locke's groundbreaking anthology, signals a preference for treatments of black women's bodies that holds them up as purifiers of the past. Yet within the collection an interesting visual contrast to the frontispiece is presented in a drawing by Miguel Covarrubias (Fig. 1). The sketch accompanies a poem by Langston Hughes, "Nude Young Dancer." Hughes's poem, which asks, "What jungle tree have you slept under, / Dark brown girl of the swaying hips?," could easily be a reference to Josephine Baker, whose exotic nude dancing at Paris jazz clubs was the rage throughout the 1920s.[20] Entitled "Blues

Figure 1. "Blues Singer" from The New Negro. *(New York: Albert and Charles Boni, 1925)*

Singer," Covarrubias's sketch hardly replicates Baker's open display of sexual freedom, but, for the overall tone of *The New Negro*, it makes a frank statement of the female sexuality that was so carefully hidden in the prim "Brown Madonna's" recasting of black woman as sacred mother. In *Cane*, Toomer replicates the modern, newly empowered African American's ambivalence about black women's sexuality in his portraits of women subjected to a male gaze combining longing, desire, horror, and frustration. His poems and prose sketches confuse the sexuality, vulnerability, and inviolability of the black woman. Moving female bodies from the smoky canefields of the South to the stifling enclosures of northern cities, Toomer defined his own and his culture's fears of dissolution. *The New Negro*, with contradicting presentations of the black female body clearly connected to the ideal of male artistic control, bears witness to the same fears.

The function and fertility of the mother's body are simultaneously invoked and denied in the work of black writers of the Harlem Renaissance. Female sexuality/ maternity was understandably a theme with particularly painful associations for black writers.[21] Yet white southern writers, both male and female, also pursued (or were pursued by) the same kinds of inscriptions of motherhood and sexuality. Gender difference, like race difference, threatens hierarchies, and the southern woman, especially one whose maternal power is openly—bodily—displayed, represents the most dangerous challenge to male order. The "out of bounds" white woman who endangers white cultural order provides a strong link between *Barren Ground* (1925) and *Light in August* (1932). Faulkner and Glasgow are not often paired, yet the never-married Glasgow, who chafed against her role as pillar of conservative Richmond society, and Oxford's "bad boy" Faulkner, who self-consciously posed as a country gentleman, are both obsessively interested in the disturbing effects of maternal power. *Barren Ground* and *Light in August* place at their narratives' center the figures of women who project both the ideal and the threat of fertility in bodies openly cast as physical embodiments of earth.

Figure 2. Book jacket, Barren Ground.
*(New York: Doubleday, 1925; Alderman Library,
University of Virginia)*

The bodies of Dorinda in *Barren Ground* and Lena Grove in *Light in August* are immediately identified as sexual, fertile, physically bound to and carrying the rhythms of ripe earth. However, the dust jackets of both books show only a house set in a field—the house primitive and decrepit, the field scrubby and unplanted (Figs. 2 and 3). The book jackets erase the bodies of the women whose sexually defined journeys dominate the texts and replace them, visually, with images of houses on barren land. Inside the book covers, both Dorinda and Lena are in a sense buried by words that constantly associate them with earth. Lena Grove is forever fixed in the description of her—and her type—that Gail Hightower conceives as he looks down on her after she has given birth: "the good stock peopling in tranquil obedience to it the good earth."[22] In *Barren Ground*, Dorinda finds the overriding theme of her life in the prescription given to her by an old farmer: "Put yo' heart in the land."[23] Both female characters, then, in spite of or perhaps because of their nascent maternity, are neutralized, grounded, as it were, within the passive earth. The book jackets can be seen as reflecting their cultural as well as physical sublimation.

On the first page of *Barren Ground*, Dorinda, wearing a brilliant colored orange shawl, is described as standing in an attitude "of arrested flight, as if she were running toward life," yet the next sentence reads, "Bare, starved, desolate, the country closed in about her." Lena, in the opening of *Light in August*, as she walks through the thick red dust of a Mississippi road, is described as "swollen, deliber-

Figure 3. Book jacket, Light in August. *(New York: Vintage, 1932; Alderman Library, University of Virginia)*

ate, unhurried and tireless as augmenting afternoon itself." The first words spoken about Lena by one of the men who watch her in this scene are, "I wonder where she got that belly." Thus Lena is immediately marked as maternal, as well as taking her embodiment from the hot, swelling land that she walks on.

Dorinda, though not pregnant in the opening scene of *Barren Ground*, soon will be, as all her bodily signs, in contrast to those of the land, suggest. Her head is "like some exotic flower"; her "inner life" feels to her like "a hidden field in the landscape, neglected, monotonous, abandoned to solitude, and yet with a smothered fire, like the wild grass, running through it" (pp. 10, 12). Dorinda is a standard romantic heroine at this point, looking for her completion in a man. Ironically her meeting with her imagined "prince charming" comes to her as she is "driving on one of the muddy roads through the broomsedge" (p. 12). The road that introduces her to Jason Greylock is a twisted, rutted one, and the man she preconceives as her lover will leave her betrayed, pregnant, and abandoned.

In some ways *Barren Ground* and *Light in August* seem to take completely different paths in treating the sexual within the maternal. Glasgow conveys Dorinda's pregnancy with great reticence; as Julius Raper notes, references to her pregnancy "are subtle, . . . and subject to misinterpretation because we see them through Dorinda's consciousness, and given her repressive body, she does not yet recognize what is happening to her body."[24] Faulkner, on the other hand, opens the novel with the story of Lena's promiscuity and its (for her) inevitable result. Whenever she appears thereafter, her pregnancy becomes the immediate and exclusive sub-

ject of conversation. Two similarities within these very different representations of Glasgow and Faulkner can be noted, however; both Dorinda and Lena feel their first stirrings of restlessness in the company of women for whom childbirth has been a yearly experience, women worn out with childbearing. Lena lives with her brother and his "labor—and childridden wife. For almost half of every year the sister-in-law was either lying in or recovering" (p. 13). Dorinda works in Nathan Pedlar's store, where daily she watches her friend, his dying wife, the mother of four small children, as she knits "babies' sacques which she sold in the city" (p. 20). Rose Emily Pedlar and Lena's sister-in-law are defined by maternity as a debilitating destiny detached from, indeed destroying, physical health and mobility. On the other hand, Lena and Dorinda are both presented as women of great energy, always associated with their sexuality. The many other mothers whom we meet in both novels have lost all access to sexuality and fertility. They are confined by socially determined roles and represented for the most part as silent, often abused and bitter wives bound to routines of functionally maternal duties—feeding and cleaning—and to their husbands' economic fates. It is Dorinda who cynically thinks, "Mother love was a wonderful thing, . . . a wonderful and ruinous thing" (p. 315). Both Glasgow and Faulkner are interested in showing, within southern contexts, the way that motherhood socially and personally silences and disempowers women. However, in their characterizations of Dorinda and Lena, Glasgow and Faulkner leave unresolved the issues of fertility and sexuality that mothers' bodies also represent.

In *Barren Ground*, as Raper notes, Glasgow displays Dorinda's maternal body only through Dorinda's own dim and eventually resistant knowledge of it. Faulkner, on the other hand, treats Lena's body exclusively through the gaze of the southern community, which is obsessed with containing her moral transgression within a physical definition of her identity. Dorinda might be said to lose all associations with bodily maternity when she miscarries after a fall in a street in New York City, where she has fled in shame after finally coming to a knowledge of her pregnancy. After this point, Dorinda rejects any sexual stirrings or needs of her body; she cannot bear to be touched, and she consents to marriage with the widowed Nathan Pedlar only with his consent that there will be no sexual consummation. In direct contrast, Lena goes from being the embodiment of pregnancy, of physical ripeness, to becoming the embodiment of fulfilled motherhood when she delivers her child. At that point she is viewed as Madonna by Hightower: "He comes to the cot and looks down at her, at the tiny, weazened, terracotta face of the child which seems to hang suspended without body and still asleep from the breast" (p. 385). Hereafter Lena is never shown without the baby at her breast, whereas before, she was always envisioned in terms of her belly.

Dorinda might be said to epitomize barrenness, while Lena epitomizes fecun-

dity, yet both states are dangerously unstable. We can see how both barrenness and fecundity resist the boundaries of women's bodies through the fact that Dorinda, while physically barren, fulfills herself through her success in forcing physical abundance out of the land. Still very feminine in spite of the overalls she wears, she becomes a dairy farmer instead of a planter. This change from plowing to milking reinforces her identification with the female and with motherhood. She becomes the stepmother to Nathan's handicapped son and even a mother figure to her former lover, Jason, as she nurses and provides for him in his last illness. Moving in the opposite direction, Lena, while nothing if not fecund, repels sexual references in all of her conversations, repels finally even Byron's awkward sexual advances because they are not proper, she insists, without marriage. She rejects these advances with a stolid innocence that, if it does not make her asexual, certainly removes her, even in her maternity, from any suggestion of sexual activity.

Dorinda's and Lena's mothering bodies ultimately are housed, as the two novels' book jackets suggest, in the land. In one of the novel's most symbolically rendered scenes, Dorinda dreams a clearly Freudian dream in which she is plowing "abandoned fields" with her horses; the fields, though, are not cleared but full of "purple thistles," each of which bears within it the face of Jason, who had impregnated and betrayed her. As she attempts to plough these under, they spring back and multiply, "millions of purple flaunting heads," and Dorinda thinks, "I am going to plough them under if it kills me" (pp. 239–40). Although most critics' interpretations of this dream associate it, as Raper does, with "a deep misanthropic streak," with a "male-destroying impulse," the dream functions for Glasgow as a visual statement of how Dorinda associates her psyche and her sexuality with the soil. In the dream she appropriates both masculine and feminine, as the purple thistle is in shape and color something of both. She identifies with both the "dun-colored earth" and the one who ploughs that earth, with both the furrows and the plow. Perhaps most important, at least for Glasgow's purpose, is the plot function that this dream has: Dorinda turns almost immediately on waking from it toward the farming vocation that will become her life, in the physical and emotional as well as economic sense. Finally, Glasgow does not so much deny Dorinda's sexuality as she redirects the energy it supplies. When associated with her romantic attachment to a clearly weak and unworthy man, Dorinda's sexuality is a trap, which combines with culturally promoted illusions and sanctions to lead her to Jason, and thus to her own victimization. Dorinda's fullest eroticism comes alive in her relation to the land itself, because here her passion is free and self-directed. At the end she is a physically vigorous woman who feels as she walks her land a "quickening" that is "deeper than all other emotions . . . the living communion with the earth under her feet" (p. 509).

Faulkner, in *Light in August*, consistently links Lena with the "teeming" and

"spawning" earth. By associating Lena with "the good earth," Faulkner safely embeds the sexual in the maternal so that its energies are channeled into the nurture and renewal that the male modernist writers so often longed to recover. Lena is the maternal container of life, passively agreeing (and in another sense, through her journeying, actively demanding) to be contained herself within a system of male domination. In her pregnant body she appeals to the modern need for reassurance that against all the combined array of technological and societal changes, the family is secured through and by women's acquiescence to her biological/cultural destiny.

Faulkner plays to a maternally organized myth of the family, so strongly promoted in the South, yet he also darkens it through his pairing of Lena with Joanna Burden. If Lena is the ripe embodiment of the maternal feminine, Joanna is the dry and barren embodiment of the androgynous. A spinster entering the state of menopause, she enacts in the various stages of her passionate trysting with Joe Christmas both male and female sexual roles. Yet she has no place in the South until the community, after her murder, labels her white-woman-raped-by-nigger; in that role she confirms her society's fears and engenders its revenge for both her own and Joe's transgressions. As Judith Wittenberg has pointed out, the women of *Light in August* "simultaneously fascinate and terrify the men with whom they come in contact."[25] Joanna and Lena are alike in this aspect, and Joanna pays with her life the price for breaking gender boundaries within her own menopausal body.

Certainly the safest place to leave Lena would be in Gail Hightower's fixing gaze, as one of the "good stock" who will "in tranquil obedience" follow the dictates of the "good earth," her fertility defined as the earth's produce. Yet Faulkner does not quite leave her there, for at the end he shows how she used her own swelling body as a way to take one first and last, long, adventurous trip before settling down to a motherhood that includes mothering not only the infant at her breast but also the obedient and childlike Byron Bunch. As earth goddess, she is only tenuously contained herself.

Neither Lena Grove nor Dorinda Oakley is representative of the South's most alluring class of womanhood, the belle. Both Faulkner and Glasgow created such figures only to quickly transform them. Glasgow's Virginia and Eva Birdsong of *The Sheltered Life* quickly fade from beautiful belles to betrayed dowagers; Faulkner's Judith Sutpen (*Absalom, Absalom!*) and Drusilla Hawk (*The Unvanquished*) despise the role of dutiful, marriageable daughter. Yet the public enchantment with the southern belle was more than gratified in 1936 with the arrival of Margaret Mitchell's Scarlett O'Hara. Beyond her promotion in the role of the belle, however, Scarlett also became the South's most potent and most contradictory version of modern earth goddess. From the time *Gone with the Wind* made its way into readers'

hands, the issue of Scarlett's embodiment became a cultural question of startling magnitude. The question of which film actress would literally embody Mitchell's creation in a screen version was as engrossing as the novel itself. The character and actress were so combined in the public mind that the *New York Times* review pronounced, "Miss Leigh's Scarlett is the pivot of the picture."[26] The novel's appearance in 1936, at the moment that Hollywood cinema was beginning to dominate American popular culture, made it impossible that the book could ever be clearly separated from the film. That the casting and costuming of the film character Scarlett monopolized public interest is an indication of how important visual representations of women had become for this period.

David Selznick's film Scarlett, rightly embodied, posed, dressed, and handled, could contain and be contained in all kinds of establishment messages for the 1930s. To southerners, for instance, she was both the indomitable New South rising out of the ashes of the old, and she was the desecrator of cherished traditional ideals being returned, in the end, to the "roots" of her identity. When the president of the United Daughters of the Confederacy publicly approved of the Vivian Leigh Scarlett, it became clear what stakes her visualization represented. Yet beyond the South, for the mass popular culture of the thirties that Hollywood films both created and fed, *Gone with the Wind* could articulate many of the entangled associations of women's sexuality and maternity that T. S. Eliot's poem evoked for highbrow literary culture in the twenties.

Margaret Mitchell's novel, while looking back at a civilization "gone with the wind," utilized Scarlett as the feminine embodiment of what remained of that civilization as well as what replaced it. The sprawling novel surrounds Scarlett with women-dominated families—the list of mothers includes Ellen O'Hara, Ellen's own mother, the strong mothers of plantations bordering Tara like Grandmother Fontaine and Beatrice Tarleton. And of course, there is Melanie, Scarlett's foil and double, the pure southern Madonna who struggles to give birth while the genteel South she epitomizes burns down around her. Melanie later dies in childbirth. Scarlett, who has an easy time bearing her own three children (two of whom were not included in the film version), suffers in her fourth pregnancy a miscarriage that blights her chances of restoring her relationship with Rhett. Yet like Dorinda's, Scarlett's sexual energy, dangerous and out of bounds when associated with her own body, is a positive force when channeled into the needs of the land.[27] The words that Dorinda recalls so often in *Barren Ground*, "Put yo' heart in the land. The land is the only thing that will stay by you," are a significantly close echo of those that become Scarlett's motivation in *Gone with the Wind*, where her father preaches to her that "Land is the only thing in the world that amounts to anything . . . for 'tis the only thing in the world that lasts. . . . 'Tis the only thing worth fighting for—worth dying for."[28] In both Glasgow's and Mitchell's novel, father

Figure 4. Scarlett and Tara.
(Courtesy of Turner Entertainment and Film Stills Archive, The Museum of Modern Art, New York)

figures pass on to much stronger daughter figures the gospel of womanly identification with the earth.

David Selznick, in making the movie version of the novel, strengthened both the associations of Scarlett with the land and the authority of men in directing those associations. Selznick felt, he said, that "the one thing that was really open to us was to stress the Tara thought more than Miss Mitchell did."[29] Hence Selznick inserted many lingering shots of Scarlett's girlhood home, in varying conditions, often framed by sunrise or sunset and whenever possible visually related to the body of the heroine herself. The film opens with Scarlett running down the drive in an all-white dress (a change from an earlier print costume) in front of the mansion's white-columned facade to greet her father (Fig. 4); later the plantation in its disrepair is also reflected through Scarlett's costuming. From the time of her arrival at Tara during the war, when she finds her mother dead and the land in ruins, Selznick's Scarlett wears a plain calico dress (Fig. 5); for the filming, twenty-seven copies of this dress were made "in gradual stages of disintegration that seemed to mirror the collapse of the South."[30]

The costuming of Scarlett for the film *Gone with the Wind* is significant as a method of containment in many other respects as well. In addition to the white

Figure 5. Scarlett in calico dress. (Courtesy of Turner Entertainment and Film Stills Archive, The Museum of Modern Art, New York)

dress of the opening and the calico dress that takes Scarlett back into the land, she is robed in the famous red dresses that, like her name, express but also control her sexuality: the seductive red dress that in the film Rhett forces Scarlett to wear to Ashley's party (Mitchell sent her to the party in a green dress), as Helen Taylor notes, "is continued into the dark red dressing-gown Scarlett dons before descending the crimson carpeted staircase to get a drink" (Fig. 6).[31] In the following scene, she encounters the drunken Rhett, who then carries her, in the flowing red gown, up the staircase to ravish her. As Taylor observes, these "scarlet woman" taints of red are related to "the red earth of Georgia—intended unequivocally in both book and film to suggest the womblike security of hearth and home, the loss and restoration of Tara itself which are at the heart of *GWTW*" (p. 80). In this way the heroine's sexuality is redefined in terms of the safety of place. We can note as well that on "the morning after," as the scene after the night of ravishment was suggestively labeled for the movie's production (Fig. 7), Scarlett is allowed her first and only look of sexual fulfillment as she lies in bed, but she is wearing for the occasion a chaste-looking, girlish white nightgown laced at neck and cuff.

Staircases, like the costuming of Scarlett, hold her visually in place when she might otherwise seem to be breaking away from various confinements. In an early scene, Scarlett sneaks downstairs, while all the proper belles are taking a nap, to find Ashley. From this point on, staircases frame Scarlett like vertical fencing in almost every scene related to her sexuality; in addition to the "ravishment" scene with Rhett, the scene in which Scarlett at Tara kills the sexually threatening Yankee deserter takes place on the staircase (Fig. 8), and Scarlett's fall down the Atlanta

Figure 6. Scarlett in dressing gown. (Courtesy of Turner Entertainment and Film Stills Archive, The Museum of Modern Art, New York)

mansion staircase completes the cycle begun with Rhett carrying her up those stairs—in this fall she miscarries, losing the life conceived during the ambiguously framed night of sexual activity with Rhett (Fig. 9). Whirling to the bottom of the long flight of stairs, Scarlett loses her role as mother and as sexual female; after this, Rhett will reject her. As Edward Campbell notes, Scarlett will come down the staircase for one last time in the final scene on her way "back to Tara, where she belongs."[32]

For the film's ending, Selznick emphasizes Tara and Scarlett in tandem, but with a further innovation: the voices that Selznick chose to fill Scarlett's head as she contemplates her return to Tara are all the voices of men—images of Gerald, Ashley, even Rhett, are recalled, as their voices express what the land must mean to her. Selznick felt that his ending gave the picture "a tremendous lift,"[33] but the ideological effect of this ending is clear. In Selznick's rewriting Scarlett follows the dictates of the men of her life in deciding to return to the place "from which you get your strength—the red earth of Tara." More so than Mitchell herself, Selznick played to a cultural bias that looked nostalgically for a time when women knew their place and were set securely "in place." As Helen Taylor has concluded, "Scarlett has no alternative but to go home. . . . Back at home, where everything has symbolically gone full circle and been restored to the status quo, she can regain a childlike status free of the complications of adult female sexuality."[34]

In the novel, Mitchell shows Scarlett, at the very end, thinking, not so much of the land and certainly not through the dictation of any men, but thinking of, longing for, Mammy: "And Mammy would be there. Suddenly she wanted Mammy

Figure 7. Scarlett in "morning after" scene.
(Courtesy of Turner Entertainment and Film Stills Archive, The Museum of Modern Art, New York)

desperately, as she had wanted her when she was a little girl, wanted the broad bosom on which to lay her head, the gnarled black hand on her hair" (p. 689). Mammy here replaces the white southern lady bodily, as she has already become, for the narrative, the voice of white patriarchal values. Indeed, Mammy has presided over Scarlett's body in many ways, as in the early corseting scene and the later one (Fig. 10), in which she points out to Scarlett, with her measuring tape, how childbearing has forever altered her figure. Yet her final metamorphosis into Black Madonna is perhaps ideologically her most significant role in the novel. Early in the story, the narrator tells us: "When Scarlett was a child, she had confused her mother with the Virgin Mary. . . . To her, Ellen represented the utter security that only Heaven or a mother can give" (p. 40). Mitchell's ending recasts Mammy in that role. Ellen had died, in a manner appropriately symbolic, when Tara was ransacked—the white southern lady as icon was destroyed in body with the plantation system she came on her pedestal to stand for. Yet the black Mammy as surrogate Madonna, her "broad bosom" a resting place for the "scarlet" woman returned to childlike innocence, could offer Mitchell and her modern readers, and particularly her southern ones, many kinds of comfort, not the least of which was the soothing of racial tensions. Anne Jones has summarized the effect that Mitchell sought: her

"real concern in *GWTW* is to see whether the traditional South can absorb new modes of behavior, especially but not only new gender roles. That it, ultimately, cannot is clear in the conclusion."[35] Mammy replacing Ellen as Madonna is yet another recasting of woman's body in the mothering, nurturing role. Selznick with Tara, and Mitchell with Mammy, reclaim Scarlett's body for cultural sanctification and restoration.

The distance from Mitchell's Tara to the George Gudger home of James Agee and Walker Evans's *Let Us Now Praise Famous Men* might seem hardly measurable in terms of time or space. The Evans photograph in which Anna Gudger (in real life Allie Mae Burroughs) walks with her toddler, carrying the pail of milk back to her shack, places us in more familiar territory than we might at first recognize (Fig. 11).[36] Here, in a work begun in the same month and year in which *Gone with the Wind* was published, we witness the same fascination with the mothering woman's body, again ambiguously representing sexuality, maternity, and barrenness. The assignment to write the text for a photographic essay on Alabama sharecroppers might seem to have been one way for Agee to take on all the ideological misconceptions about the South that Mitchell's novel and Selznick's film conveyed. The "nominal subject" of his work, at least, was "North American cotton tenantry as examined in the daily living of three representative white tenant families."[37] The word "family" provides a link between the women of *Gone with the Wind* and those of the book ironically titled to "praise famous men." The women of Agee and Evans's text dominate the visual and written narrative as Scarlett and the mother-

Figure 9. Scarlett's fall on staircase.
(Courtesy of Turner Entertainment and Film Stills Archive, The Museum of Modern Art, New York)

ing women surrounding her dominate Mitchell's—and all present women's bodies posed to define them within socially maternal roles that contain their sexuality and physicality within the earth itself. The intertwined contexts of mother and earth allow exploration of the dangerous blurring of boundaries between fecundity and barrenness that modern maternity represents.

In their treatment of women figures, Agee and Evans drew self-consciously on Eliot's *The Waste Land*. The poem's influence is especially noticeable in a long early scene that provides the clearest written introduction to the sharecropping families. As Agee lies awake listening to the Gudger family, all preparing for sleep in the bedroom next to the one they have given him, he notes the Gudger family's ritual saying of "Good night" to one another. As the bedroom scene ends, the oldest daughter begins the litany: "and Louise says, Good night Immer, and Emma says, Good night Louise; and Louise says, Good night mamma; and Annie Mae says, Good night Louise ; and Louise says, Good night daddy . . . night; good night; good night" (p. 73). In the second part of *The Waste Land*, Eliot records the conversation of wartime Londoners who have been sitting in a pub, talking in particular about a woman named Lil, who has had an abortion. Finally the group

Figure 10. Scarlett and Mammy.
(Courtesy of Turner Entertainment and Film Stills Archive, The Museum of Modern Art, New York)

receives the bartender's closing imperative, "HURRY UP PLEASE ITS TIME," and as they leave, they tell each other "Goonight": "Goonight Bill. Goonight Lou. Goonight May. Goonight" (p. 35). Eliot ends the section with an allusion to Ophelia's lines in Shakespeare's *Hamlet*: "Good night, ladies, good night, sweet ladies, good night, good night." With his own "Goodnights," and the names "Louise" and "George" that he chooses for the Gudger daughter and father, Agee calls up *The Waste Land*'s associations of women's threats to and of fertility.

Like Eliot, Agee in his opening scene raises questions about the value of maternity itself (the woman in *The Waste Land*'s pub, telling Lil's story, reports her advice to Lil: "Well, if Albert won't leave you alone, there it is, I said, / What you get married for if you don't want children?" (p. 35). Annie Mae and the other share-cropping mothers of *Let Us Now Praise Famous Men*, their bodies worn out with poverty and childbearing, resemble Eliot's Lil, who has had "five already and nearly died of young George." Eliot's "Goodnights" set a tawdry story of meaning-less sex and abortion in modern working-class women's lives against Shakespeare's tragedy of Ophelia's hopeless love and madness. Agee, whose brooding tone, heavy with allusions, often echoes Eliot's, brings Eliot's tragic ambivalence toward maternal women to bear on his Alabama characters.

Figure 11. Mrs. Gudger and child, tenant houses. (Library of Congress)

Agee's most compelling character, and Evans's most compelling photographic subject, is the sharecropping mother, Annie Mae Gudger. Agee provides this prose sketch of her asleep on the other side of the wall in the house where he is both spy and guest: her body is "slender, and sharpened through with bone, that ten years past must have had such beauty, and now is veined at the breast, and the skin of the breast translucent, delicately shriveled, and blue" (p. 57). The body of Annie Mae Gudger provides Agee's sprawling narration with its visual center. Linda Wagner-Martin notes how in the opening, Agee "assembles a montage of female parts, ranging from mature to childlike," and how throughout the long text, Annie Mae becomes a kind of reference point for "the womanliness of whatever human interaction he chooses to show."[38]

In Annie Mae the figures of child and Madonna merge to evoke the sacredness of the human. Agee is sexually aroused by his sense of Annie Mae's body, but very much like Toomer with the fertile women of the first part of *Cane*, Agee makes Annie Mae inviolable. In Evans's photograph (Fig. 12), Annie Mae is both starkly present, intensely connected to the camera through her straight gaze, yet also somehow through both starkness and intensity unreachable, removed. In his prose, Agee matches Evans's presentation of this dualism. He tells of using Annie's actual bodily absence from her home to rifle and expose her belongings, and through them indeed both her bodily and her inner life. He is clearly aware that his probing is a kind of rape: at the moment that he is left alone at the Gudgers', Agee recalls how "in hot early puberty," he would explore his grandfather's house. Then he compares that past moment to this one, in which the Gudger house becomes the surrogate for Annie Mae's absent body: "It is not entirely otherwise now, in this inhuman solitude, the nakedness of this body [the house] which sleeps here before

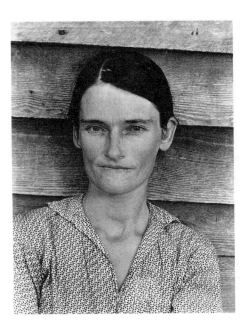

Figure 12. Annie Mae Gudger. (Library of Congress)

me, this tabernacle upon whose desecration I so reverentially proceed" (p. 137). The reverential language in which he describes what he clearly sees as a ravishment confuses all the senses in which his description is operating.

Agee displaces Annie Mae's body in several ways. The house becomes her surrogate, available for his gaze. When he finds her wedding hat, "ruined and saved" in a table drawer, he uses it to create a vision of Annie Mae's body when she was a bride of sixteen: "her skin would have been white, and clear of wrinkles, her body and its postures and her eyes even more pure than they are today." He reinforced our sense of her as mother-saint when he concludes, "she was such a poem as no human being shall touch" (p. 286). In his long survey of all of the sharecroppers' houses, Agee gives a direct quotation only to Annie Mae. The words that he ascribes to her offer the text's most searing exposure yet also again, a kind of romantic removal: "The only direct opinion I got on the houses as such was from Mrs. Gudger, and it was, with the tears coming to her eyes, 'Oh, I do *hate* this house *so bad*! Seems like they ain't nothing in the whole world I can do to make it pretty" (p. 210).

Two other female characters are, through both Agee's prose and Evans's photographs, sexual surrogates for Annie Mae—her daughter Louise, who is immediately sexually attractive to Agee (Fig. 13), and her young stepmother Ivy Woods (Fig. 14). The daughter is a figure not unlike Toomer's Carrie or even Faulkner's prepregnant Lena, full of a "nascent maternity," on the verge of full sexuality, and drawing the male gaze toward her. Addressing Louise as she had appeared for her picture taking, Agee remarks, "very quietly I realize that I am probably going to be in love with you . . . it is this sobriety, and stolidity and resolute dutifulness in the

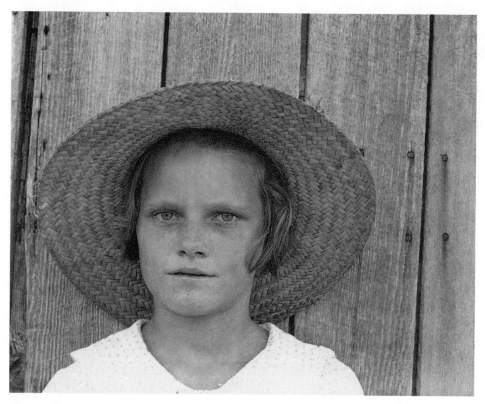

Figure 13. Louise Gudger. (Library of Congress)

sunshine, and the way your mouth and throat worked, which has done the job on me" (pp. 369–70). Evans's picture of Louise picking cotton (Fig. 15) is also revelatory; here she is identified with the land, her body bent and turned away from the camera, head obscured, surrounded by plants in dry soil. Agee tells us that "Louise is an extraordinarily steady and quick worker for her age" (p. 343), but in the photograph she seems rooted, still, patterned into the land.

Louise's sexuality is part of her health, cleanliness, and innocence. She evokes her own mother as child bride, preserving both in a kind of holy aura of protection against the twin ravages, copulation and time. Ivy Woods, whom Annie Mae's father had married after the death of her mother, receives no such protection, and so through her Agee exposes the rank sexuality that he cannot bear to associate with the holy mother he has made of Annie Mae. Though twice Annie Mae is described nursing her baby in the narrative text, interestingly it is Ivy who is pictured nursing her child by Woods, while an older child stands nearby. We are told, as well, that there is a "great, somber, blooddroned, beansprout helmed fetus unfurling within Woods' wife" (p. 324). Thus Ivy's fertility is rampant and unchecked—she is Whore. Agee reports the town talk—"Why, Ivy Pritchert was one of the worst whores in this whole part of the country" and adds his own observa-

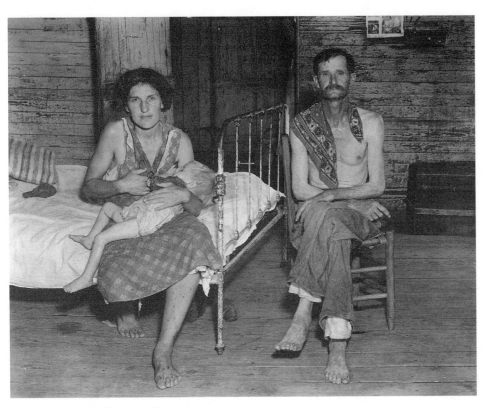

Figure 14. Ivy Woods. (Library of Congress)

tion: "we all know . . . that she is also a serenely hot and simple nymph, whose eyes go to bed with every man she sees" (pp. 79, 372). Evans's photograph (Fig. 16) shows her indeed *on* a bed, her hot eyes looking out while her youngest sleeps beneath her breast, and her husband, mother, and two other children, one a boy with no clothing hiding his penis, look out noncommittally as well.

The third sharecropper mother of *Let Us Now Praise Famous Men* is a foil for Annie not in her sexuality but in her ruined body. Sadie Ricketts appears in one Evans photograph full-length (Fig. 17), and Agee describes her at the moment of the picture taking in this way: "to you it was as if you and your children and your husband and these others were stood there naked in front of the cold absorption of the camera in all your shame and pitiableness to be pried into and laughed at; and your eyes were wild with fury and shame and fear, . . . and one hand continually twitched and tore in the rotted folds of your skirt" (p. 364). In Agee's account of the picture-taking scene, Mrs. Ricketts realizes that Annie Mae has dressed up her children for the occasion, whereas she herself has not been able to; against Annie Mae's pride and cleanliness is Sadie Ricketts fully exposed in the dirt, squalor, and humiliation that strip away her womanliness. Early in the text Agee had created a disembodied woman's voice that says, "O, we become old . . . not thunder nor the

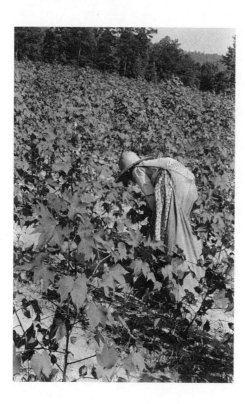

Figure 15. Louise Gudger picking cotton. (Library of Congress)

rustling worms nor scalding kettle nor weeping child shall rouse us where we rest" (p. 78). This condition describes Annie Mae, but even more so, Sadie. For Sadie, as well, Agee conjures the likelihood of the tragedy of having a child die. In a late section that accompanies an Evans photograph of a child's grave (Fig. 18), Agee connects the photographed grave to four-year-old Clair Bell Ricketts: "for it will only be by a fortune which cannot be even hoped that she will live much longer" (p. 438). It is doubtful, he adds, that her parents will be able to decorate her grave with even such little mementos as Evans's photograph shows ringing the earth that marks the child's grave.

Let Us Now Praise Famous Men ends with several prose vignettes; the description of the children's graves is one of these and is also the one that most directly pulls Agee's text back to the photographs that begin the text. This section places all the children portrayed in several of Evans's photographs into the frame of death depicted in the one of the child's grave. One of two prose images that Agee chose for a conclusion, labeling them "last words," portrays in frankly erotic language a picture of Annie Mae nursing her young child: "his hands are blundering at her breast blindly, as if themselves each were a newborn creature, or as if they were sobbing, ecstatic with love" (p. 442). The erotics here makes the nursing child into a lover and thus identifies him with Agee himself, voyeur author who in writing Annie Mae's body inevitably becomes sexually involved with her. For southern

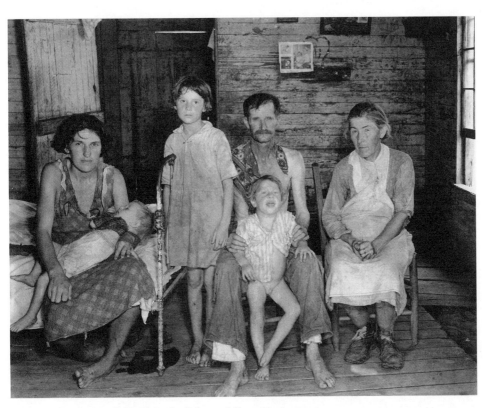

Figure 16. Ivy Woods on bed, with family. (Library of Congress)

literature of the modernist era, Annie Mae Gudger's body is one last ambiguously framed Madonna, as she nurtures, stimulates, arouses, and feeds her male child.

Throughout the twenties and thirties, southern writers, forced into acute sensitivity to the dramatic social, economic, and physical changes in their region, wrote the narrative of their entrance into modernity through their characterizations of maternal female bodies that posit both fertility and barrenness. Through this visual ordering of a modernist thematics, southerners produced a formidable literature that binds together imagery of waste and fecundity to embody the risks of new life and rebirth in connection with the realities of loss and death. Southern visualizations of women's ambiguously fertile or barren bodies become the cultural sign of what Marianne DeKoven has called "the undecidable modernist simultaneity of destruction and renewal."[39] Beautiful women are sterilized by the formality of the distanced poet's gaze, as in Ransom's poetry. Young, fertile women sometimes kill their newborns, as Karintha does in *Cane*; or, like Dorinda in *Barren Ground* and Scarlett in *Gone with the Wind*, they suffer miscarriages and lose both sexual and maternal functions but are revitalized by identification with the land. Women become the image bearers of both sexual promise and sexual threat and

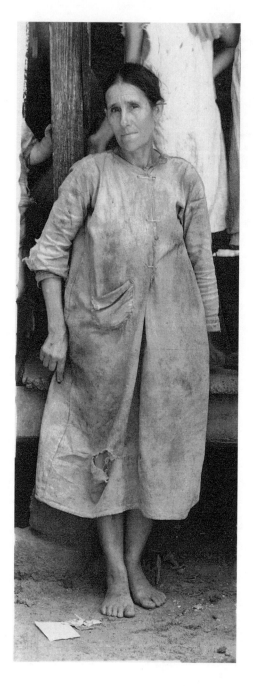

Figure 17. Sadie Rickets. (Library of Congress)

are associated with both the fruitfulness and the rape of the land, as in Faulkner's *Light in August*. In all of these renderings, the relation of mothers to children and childbearing is both redolent of possibility and fraught with terror. *Let Us Now Praise Famous Men*, begun during the Great Depression, was published only a few months before Pearl Harbor was bombed. In one final irony, Agee reserved the book's last page (except for notes and appendices) for the biblical verses that gave

Figure 18. Child's grave. (Library of Congress)

the book its title; there we find recorded the words, "Let us now praise famous men," and the prophecy, "Their seed shall remain for ever, and their glory shall not be blotted out." Women, seed carriers and child bearers, are not mentioned in this final epigram.

By 1941 Agee's book and the new decade both were cast into the darkness of world war. Some of the best words to describe the new round of radical change facing the modern world come from the meditation that Agee presents, early in his text, in the voice of an unidentified woman: "How, how did all this sink so swift away, like that grand august cloud who gathers . . . and scarcely steams the land? How are these things?" (p. 78). The clouds of world war, holocaust, and atomic bomb were on the horizon. After the war, the representations of women's bodies would reflect different dimensions of horror and displacement, as southern writers in particular, represented by Carson McCullers and Flannery O'Connor, began to endow their female characters with openly grotesque proportions. By century's end, the modernist crisis over artistic authority, displayed so often through images of barrenness and fertility in southern women's bodies, would again be redefined by postmodern questions concerning the very nature of art and author. Left behind, for southern literature, would be a body of work in which the threat of the wasteland was a challenge and a renascence was the result.

1. Rubin, "Trouble on the Land," 96.

2. Ibid., 112.

3. Several recent studies have debated Eliot's use of women in *The Waste Land*. See Brooker and Bentley, *Reading* The Waste Land; Clark, *Sordid Images*; Gilbert and Gubar, *No Man's Land*; and Menand, *Discovering Modernism*.

4. Welty, "Death of a Traveling Salesman," *Collected Stories*. All quotations refer to this edition.

5. Ruoff, "Southern Womanhood," 188.

6. Glasgow, *Virginia*, 486.

7. Kolodny, *The Lay of the Land*, 146.

8. Roberts, *Faulkner and Southern Womanhood*, 10.

9. A number of revisionist studies of modernism look at ways in which African American literature relates to the traditionally white, male-dominated canon. See Baker, *Modernism*; Doyle, *Bordering on the Body*; Nielsen, *Writing between the Lines*; and North, *Dialect of Modernism*.

10. Rubin, *Wary Fugitives*, 82.

11. Eliot's relationship to southern writers, particularly figures belonging to the Fugitive-Agrarian group, has been highlighted by Brooks, "T. S. Eliot."

12. Ransom, "Gerontion," 389.

13. Eliot, *The Waste Land*, 36. All quotations refer to this edition.

14. Cowan, "Innocent Doves," 198.

15. Rubin, *Wary Fugitives*, 42.

16. Ransom, "Antique Harvesters." All quotations refer to this edition.

17. Cowan, "Innocent Doves," 192–93, 197.

18. Toomer, *Cane*, 69. All quotations refer to this edition.

19. McDougald, "Task of Negro Womanhood," 382.

20. Hughes, "Nude Young Dancer," 227.

21. Two African American women writers of the Harlem Renaissance, Nella Larsen in *Quicksand* and Zora Neale Hurston in *Their Eyes Were Watching God*, explore women's bodies in relation to southern space associated ambiguously with fertility. See, in this connection, Kaiser, "The Black Madonna."

22. Faulkner, *Light in August*, 356. All quotations refer to this edition.

23. Glasgow, *Barren Ground*, 323. All quotations refer to this edition.

24. Raper, "Barren Ground," 154.

25. Wittenberg, "Women of *Light in August*," 104.

26. Quoted in Harwell, *Gone with the Wind*, 224.

27. See Bauer, "Intertextual Reading," in which she analyzes the possible influences of Glasgow and *Barren Ground* on Mitchell's creation of Scarlett and Tara.

28. Mitchell, *Gone with the Wind*, 23. All quotations refer to this edition.

29. Harwell, *Gone with the Wind*, 225.

30. Flamini, *Cast of Thousands*, 260.

31. Taylor, *Scarlett's Women*, 80.

32. Campbell, "The Old South as National Epic," 180.

33. Flamini, *Cast of Thousands*, 296.

34. Taylor, *Scarlett's Women*, 153.

35. Jones, "Bad Little Girl," 115.

36. Agee changed the names of the families. They are identified in titles to the *Let Us Now Praise Famous Men* photographs housed in the Farm Security Administration Collection in the Library of Congress. The prints I refer to here were obtained from this collection.

37. Agee and Evans, *Let Us Now Praise Famous Men*. All quotations refer to this edition.

38. Wagner-Martin, "Agee's Absorption," 49.

39. DeKoven, *Rich and Strange*, 192.

BIBLIOGRAPHY

Agee, James, and Walker Evans. *Let Us Now Praise Famous Men*. Boston: Houghton Mifflin, 1988.

Badger, Tony. "The Modernization of the South: The Lament for Rural Worlds Lost." In Lothar Honnighausen and Valeria Gennaro Lerda, eds., *Rewriting the South: History and Fiction*, 272–85. Tübingen: Francke, 1993.

Baker, Houston A., Jr. *Modernism and the Harlem Renaissance*. Chicago: University of Chicago Press, 1987.

Bauer, Margaret D. " 'Put Your Heart in the Land': An Intertextual Reading of *Barren Ground* and *Gone with the Wind*." In Dorothy Scura, ed., *Ellen Glasgow: New Perspectives*, 162–81. Knoxville: University of Tennessee Press, 1995.

Brooker, Jewel Spears, and Joseph Bentley. *Reading* The Waste Land: *Modernism and the Limits of Interpretation*. Amherst: University of Massachusetts Press, 1990.

Brooks, Cleanth. "T. S. Eliot and the American South." In Lewis P. Simpson, James Olney, and Jo Gulledge, eds., *The* Southern Review *and Modern Literature 1935–1985*, 197–206. Baton Rouge: Louisiana State University Press, 1988.

Campbell, Edward D. C., Jr. "*Gone with the Wind*: The Old South as National Epic." In Richard Harwell, ed., *Gone with the Wind as Book and Film*, 175–86. Columbia: University of South Carolina Press, 1992.

Clark, S. H. *Sordid Images: The Poetry of Masculine Desire*. New York: Routledge, 1994.

Cowan, Louise. "Innocent Doves: Ransom's Feminine Myth of the South." In J. Gerald Kennedy and Daniel Mark Fogel, eds., *American Letters and the Historical Consciousness*, 191–216. Baton Rouge: Louisiana State University Press, 1987.

DeKoven, Marianne. *Rich and Strange: Gender, History, Modernism*. Princeton: Princeton University Press, 1991.

Doyle, Laura. *Bordering on the Body: The Racial Matrix of Modern Fiction and Culture*. New York: Oxford University Press, 1994.

Eliot, T. S. *The Waste Land and Other Poems*. New York: Harcourt, Brace, 1958.

Faulkner, William. *Light in August*. New York: Vintage, 1932.

Flamini, Roland. *Scarlett, Rhett, and a Cast of Thousands*. New York: Macmillan, 1975.

Gilbert, Sandra M., and Susan Gubar. *No Man's Land: The Place of the Woman Writer in the Twentieth Century*. Vol. 1. New Haven: Yale University Press, 1987.

Glasgow, Ellen. *Virginia*. New York: Doubleday, 1913.

——. *Barren Ground*. New York: Doubleday, 1925.

Haney, Thomas L. "Literary Modernism: The South Goes Modern and Keeps on Going." In Philip Castille and William Osborne, eds., *Southern Literature in Transition: Heritage and Promise*, 43–54. Memphis: Memphis State University Press, 1983.

Harwell, Richard, ed. *Gone with the Wind as Book and Film*. Columbia: University of South Carolina Press, 1992.

Hughes, Langston. "Nude Young Dancer." In Alain Locke, ed., *The New Negro*, 227. New York: Albert and Charles Boni, 1925.

Jones, Anne. "The Bad Little Girl of the Good Old Days: Sex Gender, and the Southern Social Order." In Darden Asbury Pyron, ed., *Recasting:* Gone with the Wind *in American Culture*, 106–16. Miami: University Presses of Florida, 1983.

Kaiser, Laurie. "The Black Madonna: Notions of True Womanhood from Jacobs to Hurston." *South Atlantic Review* 60 (January 1995): 97–110.

Kaplan, E. Ann. *Motherhood and Representation: The Mother in Popular Culture and Melodrama*. New York: Routledge, 1992.

Kolodny, Annette. *The Lay of the Land: Metaphor as Experience and History in American Life and Letters.* Chapel Hill: University of North Carolina Press, 1975.

Locke, Alain, ed. *The New Negro.* New York: Albert and Charles Boni, 1925.

McDougald, Elise. "The Task of Negro Womanhood." In Alain Locke, ed., *The New Negro*, 369–82. New York: Albert and Charles Boni, 1925.

Menand, Louis. *Discovering Modernism: T. S. Eliot and His Context.* New York: Oxford University Press, 1987.

Mitchell, Margaret. *Gone with the Wind.* New York: Macmillan, 1936.

Nielsen, Aldon L. *Writing between the Lines: Race and Intertextuality.* Athens: University of Georgia Press, 1994.

North, Michael. *The Dialect of Modernism: Race, Language, and Twentieth-Century Literature.* New York: Oxford University Press, 1994.

Ransom, John Crowe. "Antique Harvesters." In *John Crowe Ransom: Poems and Essays*, 53–54. New York: Vintage, 1955.

——. "Gerontion." *Sewanee Review* 74 (Spring 1966): 389–90.

Raper, Julius Rowan. "*Barren Ground* and the Transition to Southern Modernism." In Dorothy M. Scura, ed., *Ellen Glasgow: New Perspectives*, 146–61. Knoxville: University of Tennessee Press, 1995.

Roberts, Diane. *Faulkner and Southern Womanhood.* Athens: University of Georgia Press, 1994.

Rubin, Louis. *The Wary Fugitives: Four Poets and the South.* Baton Rouge: Louisiana State University Press, 1978.

——. "Trouble on the Land: Southern Literature and the Great Depression." In Ralph P. Bogardus and Fred Hobson, eds., *Literature at the Barricades: The American Writer in the 1930s*, 96–113. University, Ala.: University of Alabama Press, 1982.

Ruoff, John C. "Southern Womanhood, 186–1920: An Intellectual and Cultural Study." Ph.D. diss., University of Illinois at Champaign-Urbana, 1976.

Taylor, Helen. *Scarlett's Women:* Gone with the Wind *and Its Female Fans.* New Brunswick, N.J.: Rutgers University Press, 1989.

Toomer, Jean. *Cane.* 1923. Reprint, edited by Darwin T. Turner, New York: Liveright, 1975.

Van Buren, Jane Silverman. *The Modernist Madonna: Semiotics of the Maternal Metaphor.* Bloomington: Indiana University Press, 1989.

Wagner-Martin, Linda. "*Let Us Now Praise Famous Men*—and Women: Agee's Absorption in the Sexual." In Michael A. Lofaro, ed., *James Agee: Reconsiderations*, 45–58. Knoxville: University of Tennessee Press, 1993.

Welty, Eudora. *The Collected Stories of Eudora Welty.* New York: Harcourt, Brace, 1980.

Wittenberg, Judith Bryant. "The Women of *Light in August*." In Michael Millgate, ed., *New Essays on "Light in August,"* 103–22. Cambridge: Cambridge University Press, 1987.

JOAN SHELLEY RUBIN

··

Modernism in Practice

Public Readings of the New Poetry

O
n a Sunday evening in May 1927, an overflow crowd filled Manhattan's Little Theater for a highly publicized performance and reception. The occasion was not the opening of a play but rather a presentation less commonly associated with spectacle: the reading of a poem. Yet the event—a preview of Edwin Arlington Robinson's *Tristram*, which Macmillan was about to publish—drew the same stylish audience that patronized the Broadway stage. Mrs. August Belmont, a society matron and actress known professionally as Eleanor Robson, served as both reader and one of three dozen well-placed sponsors. Seventeen more supporters formed the "reception committee." One or the other group included Mrs. E. H. Harriman, Mr. and Mrs. Kermit Roosevelt, and the Thomas Lamonts, figures of wealth and social power. Lending literary reputation and glitz to the affair were Edna St. Vincent Millay, Hamlin Garland, Edwin Markham, and novelists Hervey Allen and Fanny Hurst. Designers (Norman Bel Geddes, Robert Edmond Jones), journalists (Franklin P. Adams, James Rorty, Bruce Bliven), a composer (Daniel Gregory Mason), and critics (John Erskine, Louis Untermeyer, and William Lyon Phelps) added their endorsement as well. The only dignitary notably absent for most of the night was the reclusive poet himself, who nevertheless made an appearance toward the end. The next morning, papers throughout the country treated the gathering as a news story, stressing the brilliance and discrimination of the "invited guests" who had honored Robinson.

In fact, the *Tristram* evening, although it capitalized on sincere desires to pay homage to the poet, was essentially a marketing ploy for the Literary Guild, founded the previous year. Carl Van Doren, the guild's chief judge, had decided that it needed to offer subscribers a book that would turn a profit, but that it could not afford the appearance of pandering to mass taste. Invitations printed like wedding announcements and specifying that Mrs. Belmont would read Robinson's

poem "in advance of publication" created the requisite aura of exclusivity. After the event, the Literary Guild selected *Tristram* for its members, incorporating a description of the Little Theater tribute and list of sponsors into its newsletter. In order to charge more than its discounting policy allowed for *Tristram* alone, the guild packaged the poem with a book on Robinson that Carl Van Doren's brother Mark produced in three weeks. These strategies worked: although by 1924 Scribner's had printed fewer than a thousand copies of its 1921 edition of Robinson's collected works, readers bought more than 75,000 copies of *Tristram* in the two years following its publication.[1]

Surely Van Doren's promotion of Robinson reflects the politics of culture; it is a reminder that an author's reputation is a social construct, not an inevitable consequence of intrinsic quality. Such orchestrations were hardly unusual: publishers in the 1920s (not only upstart, aggressive marketers like Simon and Schuster but even staid, older firms like Macmillan) crammed the book world's social calendar full of "literary teas" and similar efforts to advertise new titles. If the *Tristram* evening corroborates that well-known phase of the development of the book trade, however, it is equally instructive concerning a more complex, less familiar process: the shifting history of American modernism.

Beginning with the privately published verse that became the core of *The Children of the Night*, Robinson's work prefigured and eventually intersected with the movement known as the "new poetry." Although older and more solitary than the artistic rebels who flocked to Chicago and Greenwich Village in the 1910s, Robinson was self-consciously in revolt against the unnatural syntax and safe sentiments of late Victorian idealists. His dark vision of the human condition and his sense of the emptiness of old rules and pieties marked him as an early modernist; his experimentation with the language of ordinary speech, even though it occupied conventional poetic form, did the same. Given the fact that Robinson found a champion in Theodore Roosevelt, it may go without saying that his alienation was not nearly as sharply defined as that of T. S. Eliot or other "high modernists" of the 1920s. The same applies to Amy Lowell, Robert Frost, Edna St. Vincent Millay, Vachel Lindsay, Edgar Lee Masters, and the other figures with whom he became allied. Noting the preponderance of lyricism within the movement, literary scholar Bernard Duffey declared that the "new poetry's" proponents did not constitute an avant-garde.[2] Yet, as Henry May depicted them in *The End of American Innocence*, these writers were nevertheless part of a wider assault against the optimism and faith in progress that permeated turn-of-the-century American culture. To various degrees, and in tension with their desire to build an audience, they shared the conviction, as William Carlos Williams phrased it to Harriet Monroe, that poetry required a "tincture of disestablishment." The initial difficulty that many "new poets" had in reaching a wide readership—Scribner's apparently rejected Robinson

as too innovative, Millay first appeared in Mitchell Kennerley's tiny deluxe editions, Frost had to resort to publication in England, Monroe's magazine *Poetry* never had more than three thousand subscribers—underscores the group's oppositional stance.[3]

In the aftermath of the *Tristram* episode, however, Robinson (despite his aloof temperament and disdain for commercialism) was no longer positioned as disaffected outsider but, instead, as the possession of the cultural mainstream. The nature of the guest list, which conferred artistic taste on figures endowed with social prestige, and vice versa, suggests how far toward the center Robinson's cultural status had migrated. It would be simplistic, of course, to ascribe that shift solely to the Van Doren's promotional activities. Robinson's poetry was not static: *Tristram*, Emery Neff noted, "offered no character enigmas and emotional complexities"; it was more linear, less ambiguous in tone, and thus more accessible than his previous work.[4] Moreover, the appeal of the poem derived from the needs of a reading public that had evolved over the preceding decade. Nevertheless, the Little Theater event highlights the extent to which individuals and institutions mediated texts in light of those needs. More broadly, it signifies that the attack on bastions of tradition (to retain May's warfare metaphor at least provisionally) was only the beginning of the tale; that, subsequently, a process of dissemination entailing some accommodation to established values rather than wholesale assault on them widened the audience for modernist literature beyond the cosmopolitan coterie.

Historians have, by and large, overlooked that process, tending instead to see modernism as entirely distinct from the outlook it challenged and to locate it solely within high culture.[5] Furthermore, the practice of writing literary history only as a succession of attempts to "make it new" has obscured the ways in which innovation, instead of completely displacing older forms, coexisted alongside them. It is time to consider what might be called the sequel to May's story—what happened *after* "the end of American innocence"—in terms of both the popularization of the new and its entanglement with the old. Implicit in such an investigation is the question of whether "modernist" was as significant a term in the lexicon of the popularizers as it has been in the vocabulary of subsequent chroniclers.

Similarly, those scholars who have moved beyond the text in an effort to chart the process of canon formation have underestimated the range of social settings in which readers encountered verse. The compilations and writings of anthologists and critics (the Van Dorens among them) on which literary historians have profitably focused were crucial avenues of dissemination. The role of publishers, also the subject of some attention, was central as well. Yet poetry, in particular, reaches audiences at multiple sites; paradoxically, given its connection with intimacy (lovers reciting sonnets to one another), its connections to performance make it an especially public genre. In the early twentieth century, the "new poetry" made its

way into American culture not only in private, silent sessions with books but also in classroom recitations, speaking-choir concerts, Girl Scout campfire gatherings, religious services, poetry society meetings, radio broadcasts, and—as the *Tristram* episode demonstrates—celebrity readings. Given that multiplicity, one cannot presume, as Craig Abbott does in an otherwise valuable essay on early modernism in the school curriculum, a top-down process of diffusion in which a single canon emerged as it passed from anthologists to teachers to students. Too many venues shaped readers' experiences of literary culture to warrant a unitary, hierarchical model. By the same token, the "central assumption" literary scholars have imputed to anthologists and critics after 1900—that, in Alan Golding's words, "the best American poets react against rather than support the poetic and cultural values of their times"—did not necessarily govern other textual transmissions.[6]

The *Tristram* episode thus indirectly sets an agenda both for extending the story of the 1912 rebellion through the interwar period and for recovering the precise bases on which the popularization of the "new poetry" occurred. Among the items on that agenda are a number of questions: What understandings permitted the assimilation of new to older works? To what extent did the process of dissemination sustain or subvert the early modernists' self-conscious (if partial) break with the past? On what terms did "new poets" enter a given canon, and from what cultural sources did those terms spring? What functions did early modernist poetry serve as the object of various reading practices? This essay begins the inquiry by venturing into three of the aforementioned sites for poetry reading: the classroom, the choral speech movement, and the church service.

The most salient feature of poetry instruction in the American school between 1917 and 1945 was the persistence of the nineteenth-century curriculum. Despite the familiar scenario of moribund gentility succumbing to the incursions of imagism, sexual explicitness, and free verse, in a sample of thirty state and local high school courses of study, Robert Frost's *Birches* was the only specimen of the "new poetry" assigned as often as Henry Wadsworth Longfellow's *Evangeline* and Samuel Taylor Coleridge's *The Rime of the Ancient Mariner*.[7] The longevity of particular titles typically coincided with continuities in instructional philosophy and technique: memorization exercises to fill the mind with moral, religious, and patriotic "gems" held sway. Poetry also promised the pleasure that accompanied aesthetic sensitivity; a lesson plan for Longfellow's "Excelsior," for instance, reminded teachers to convey both "enjoyment" and "appreciation of a certain moral idea."[8] Those gratifications derived, however, from practices associated with self-denial: repetition, patience in deciphering unfamiliar words, structured extraction of meaning (Fig. 1). That mode of reading had a purpose beyond the printed page. Given the growth of socioeconomically diverse high schools, as well as the threat of new

Figure 1. Schoolchildren in the mid-1930s. The original caption proclaimed "Reading Maketh a Full Man." (New York City Board of Education Archives, Milbank Memorial Library, Teachers College, Columbia University)

media, an insistence on "effort, steadiness of purpose, sometimes even pain" could counteract the uncomfortable reality that many students came from homes without "somebody reading beside the lamp."[9] That is, the majority of teachers perpetuated approaches to poetic texts that could stabilize the authority of high culture by promoting discipline and deference.

Nevertheless, by the mid-1920s the same discomfitting social trends that entrenched older methods of reading also licensed the introduction of recent works, on the theory that pupils "of coarse fibre" would find them more appealing.[10] Where institutional constraints were limited and teacher interest was high, early modernist verse gained ground within the curriculum. The spread of honors tracks and elective courses created enclaves for instruction in contemporary verse: the 1933 "enriched" course of study for Chicago high school sophomores, for example, included four poems by Ezra Pound, three by T. S. Eliot, and numerous examples from Carl Sandburg, Robert Frost, Edwin Arlington Robinson, and Edna St. Vincent Millay. Many educators revamped pedagogy as well. Revisions in both content and approach largely reflected a single paramount development: the rise of progressive education.

Although historians have debated the extent of the influence that pedagogical reformers exerted on public schools, progressive educators had an undeniable impact on the private, experimental classrooms of the 1920s.[11] The uses of poetry are especially visible in one account of such a school, Hughes Mearns's *Creative Youth*. Mearns, a writer himself, taught English at the Lincoln School, the laboratory school affiliated with Teachers College, Columbia University. Blessed with many gifted Columbia faculty brats among their students, Mearns and his colleagues nevertheless saw themselves as liberators of the "creative spirit" that all young people possessed as a "primal" instinct. "The large liberty permitted us in our school" in terms of curriculum and method, Mearns explained, was supposed "to set more free that sure, right, beautiful, and wise self" within each individual. Like other progressives, Mearns replaced an emphasis on preparation for later responsibilities with the vocabulary of self-expression and immediate "experience." The point of literary study, in his view, was "never, What have you learned? but What has it done to you?," a process that "at its best, is an exquisite release."[12]

For Mearns, poetry—especially contemporary verse—was the richest source of experience and release. To maximize exposure to stimulating texts, he abandoned a fixed syllabus and, with it, most nineteenth-century staples. Here anthologies did play a major role: Mearns's pupils made their own course of study by paging through collections largely devoted to contemporary or recent poetry, among them Harriet Monroe and Alice Henderson's *The New Poetry*, Marguerite Wilkinson's *New Voices*, and Louis Untermeyer's *American Poetry since 1900*. (Another classroom resource, Burton Stevenson's *The Home Book of Verse*, provided the opportunity to delve into older works.) Divided into committees, students then chose "the best poems of an author" to share aloud in daily "programs." Despite publishers' insistence, in the same period, that single volumes of poetry would not sell, the results of their deliberations document both the relative status of individual "new poets" and the nature, in part, of the audience they had achieved by the mid-1920s: bright, sophisticated, urban boys and girls and the well-educated, self-consciously open-minded adults who taught them.[13]

In the eleventh grade's program of thirty-two "favorites-so-far," Millay appeared most frequently, with ten selections. Next in popularity were Frost and Adelaide Crapsey, each with four selections, and British poet Ralph Hodgson, with three. The rest of the "favorites" consisted of figures from both England and the United States, each represented by one or two works. These included Vachel Lindsay ("The Congo" and "General William Booth Enters into Heaven"), Amy Lowell, William Rose Benet, James Oppenheim, John Masefield, Walter de la Mare, Alfred Noyes, and Dudley Poore.[14] The same pupils singled out Carl Sandburg, Arthur Guiterman, Sidney Lanier, and Orrick Johns for intensive study. Four boys presented a program of works by a group they named "*Dial* poets," Alfred

Figure 2. Group study, P.S. 98, Bronx, 1935. (New York City Board of Education Archives, Milbank Memorial Library, Teachers College, Columbia University)

Kreymborg and the early T. S. Eliot among them, although they confessed that they did not find Eliot "interesting."[15]

The dominance of "new poetry" among the class's choices was largely a product of Mearns's encouragement. Yet he also welcomed "side excursions" into such writers as Shakespeare and William Wordsworth. One group of students named Matthew Arnold's "The Forsaken Mermaid" a favorite while apologetically recognizing that Arnold was not "exactly a modern poet."[16] Rudyard Kipling and Walt Whitman both appealed to the juniors. Among the more recent favorites, some, such as Alfred Noyes, wrote in a predominantly conventional vein. This moderate eclecticism (the chronological, national, and stylistic mix) even at the Lincoln School is a reminder of the diversity and range that an individual's reading experience can encompass at a given time. It is also the case that some teachers retained aspects of older methods while simultaneously adopting elements of newer instructional approaches (Fig. 2). Mearns, however, prescribed and practiced a "purist" progressive pedagogy that blurred differences of tone and style even within the "new poetry" itself.

One characteristic of that pedagogy was "the demolition of teacher supremacy." Reflecting his confidence in youthful intuition and his desire to enhance experi-

ence, Mearns structured his eleventh-grade English course not as a traditional class but as "a literary society, the Robert Frost Club," in which the instructor functioned only as a "fellow member" (except for supplying the fudge at reading parties). That posture went hand in hand with an emphasis on the "inner reality of thought and feeling" as opposed to the "formal side of literature." In place of inculcating moral lessons, classifying imagery, or even ascertaining meaning—activities ostensibly at odds with creativity—progressive teachers strove to make literary study "spontaneous and natural."[17] It followed that instead of decoding the language of a poem, readers were to "revel" in its "music," "idea," or "artistry," submitting to the text rather than gaining control over it.[18] As educator John Hooper later lamented in *Poetry in the New Curriculum*, teachers who erroneously "emphasize the element of comprehension, and fail to recognize the existence of apprehension . . . preclude any possibility of encouraging feeling without knowledge"—a possibility he decidedly welcomed. Hence one boy earned praise when, after reading a classmate's poem, he assented to Mearns's comment that the author had "stopped to think": "Exactly! And Bea has no right to think. She's too fine for thinking; she is great when she's herself." Similarly, a young woman reflected the atmosphere Mearns approved by beginning her book report on Millay's *The Harp-Weaver and Other Poems*: " 'It is cruel to review it. It is too lovely. Nothing can be said better than, "Read it!" ' "[19] Capitulation to emotion, the progressives paradoxically implied, fostered the self-integration that education was supposed to accomplish.

That essentially romantic way of reading reinforced the conclusion that even recent verse was accessible, or, as one pedagogue averred, that there was "nothing inherently hard" about it. Such language, which also informed certain of the anthologies that Mearns employed, suggests a neglected context for the "new criticism" by bringing immediately to mind Eliot's contrary insistence that poetry "must be difficult." Yet merely to note the message of simplicity, as if its appeal were self-evident, is to forget that an animus against difficulty is itself a cultural construct. As Randall Jarrell (thinking of the Dylan Thomas craze of the 1950s) queried, "*Is* Clarity the handmaiden of Popularity, as everybody automatically assumes?" In this case, the emphasis on readily apprehensible experience did not make reading verse a passive activity, as literary critics have claimed; rather, it enlisted the reader in a number of tacit cultural projects.[20]

First, the progressive vocabulary reinforced and diffused the spirit as well as the letter of much of the "new poetry." For example, it was entirely consistent with the atmosphere of Millay's public performances, one of which the entire Lincoln senior class attended. A figure who combined innocence and sexuality, Millay swept onto the stage in flowing scarves she described as more like a negligee than a dress, and then read in a "little girl voice" (Fig. 3). The same consonance of spirit and approach is evident in Mearns's description of a student reciting Sarah Teas-

Figure 3. Edna St. Vincent Millay.
(Library of Congress)

dale's "The Crystal Gazer": "her first line was given in the most perfect of all silences, that silence within a silence, when not only is every bodily movement of the audience stilled but their minds seem to stop all conflicting vibrations and willingly surrender to attention." In other words, both these vignettes of reading aloud capture what Duffey has ascribed to early modernist lyric poets generally: the transmission of "intimate feeling," held in check by a measure of decorum.[21]

Yet the sameness of tone pervading *Creative Youth*—its celebration of feeling regardless of the range in the tenor and message of the works that students encountered—promoted some dissonance as well. Mearns's stance, however suitable for Millay or Teasdale, wrenched the verse of Frost and Robinson (which Duffey has called a poetry of "arrested will") from its antiromantic moorings. By appropriating their taut, dark meditations on the limits of human action to an effusive ideology of self-realization, Mearns and his colleagues undermined Frost and Robinson's challenge to nineteenth-century expressions of optimism and certainty. Furthermore, for all their language about personal liberation, progressive educators imbued their approach to poetry reading with their own moral agenda and their own expectations of conformity. Mearns, citing John Dewey, declared the study of literature to be "the hope of civilization" because it would direct youthful energies toward the "betterment" of society; he commended his colleagues who were "doing their share in the forward movement toward a new spiritualization of public education." This rhetoric was consistent, perhaps, with Lindsay's mystical democratic project, but it bore little resemblance to Amy Lowell's preoccupation with the image for its own sake. Furthermore, the emphasis on "apprehension" and ease had as much potential to revivify the authority of high

culture as the more traditional stress on discipline. No longer intimidated by poetry, students, as Mearns envisioned them, would discover the works "known generally by the world of cultivated persons"; they would mount a "stairway of literary taste leading upward to finer air and more beautiful vistas." Adopting a different metaphor, he conceived as well of reading "standard authors" and "writers of consequence" as a "passport to the regions of our equals and our betters." For all of Mearns's Deweyite language about a "new future," that position entailed not a "tincture of disestablishment" but a healthy dose of conformity to the status quo. Finally, Mearns's use of *Creative Youth* as his title freighted his book with an additional moral purpose specific to the mid-1920s. Although that phrase alluded to Edward Yeomans's *Shackled Youth*, an attack on conventional pedagogy, it also implicitly refuted the picture of wanton indulgence in another work of the period, *Flaming Youth*. Arguably even the doctrine of submission to the text idealized and contained students' sexual impulses.[22]

Although mid-twentieth-century critics of "masscult and midcult" (e.g., Macdonald, 1960) might have viewed such transmutations in the early modernist project solely in terms of the distortion and betrayal of high culture, the lesson for historians in the progressive educators' mode of reading lies rather in underscoring the importance of recognizing the multiple appropriations that the process of popularization permitted. That is, to think of literary history as a series of reorientations in sensibility, or even in the conditions of authorship, does not account for the susceptibility of texts to a range of cultural preoccupations—in this case, experience, self-realization, and social and moral authority—that might lead readers to sustain, challenge, or respond ambivalently to those reorientations.

Another enterprise, the creation of verse-speaking choirs, further illustrates the diverse meanings and purposes that texts could support as a consequence of their use at a particular kind of public site. Speaking choirs, which many progressive teachers embraced, initially became popular in Great Britain shortly after World War I as a result of several related efforts. First, playwrights Gordon Bottomley and John Drinkwater, mindful of Greek choruses, began experimenting with unison voices in stage productions. In addition, a British speech teacher, Mona Swann, embraced the tenets of French music instructor Jacques Dalcroze, who insisted on regarding artistic performance as a personal experience instead of a "task"; the result was Swann's propagation of a poetry-reading technique she called "language eurhythmics." Most important, however, was a development that incorporated civic as well as aesthetic ideals: the inclusion, after 1919, of solo verse recitations at national music festivals. Those presentations, by students of a speech instructor named Marjorie Gullan, prompted poet John Masefield also to envision a revival of the Greek chorus and to put choral selections from *The Trojan Women* on the

Figure 4. A choral speaking group in an elementary school, ca. 1945. (New York City Board of Education Archives, Milbank Memorial Library, Teachers College, Columbia University)

program of the 1922 Glasgow Festival. Gullan took up the challenge, forming the Glasgow Verse-Speaking Choir and, three years later, a similar group in London. Many participants were teachers, who saw choric speech as a way of revitalizing poetry lessons in school. In the same period Masefield founded the Oxford Recitations, a verse-speaking contest for adults, to enhance appreciation for the "British poetic inheritance."[23] By the early 1930s the vogue of the speaking choir had spread to other locales, including Germany, France, Canada, Russia—and the United States.

The American movement flourished in settings ranging from elementary schools (Fig. 4) to state universities; it thrived particularly on the campuses of private eastern women's colleges. In addition, churches, men's and women's clubs, scouting organizations, summer camps, and settlement houses added speaking choirs to their roster of programs. Two types of popular drama—the pageant and the Little Theater production—overlapped with and gave impetus to the phenomenon. As verse choirs spread across the country, their proponents invested group poetry reading with diverse hopes and purposes, which they disseminated in numerous writings intended to clarify the "art" of choral speaking and to make available texts that were suitable for "concerts." Many such works were published

by a Boston firm called Expression Company (its motto was "Expression is but Revelation"), the existence of which testifies to the perception—or perhaps the wish—that the movement had created a substantial American market for expertise on the subject.[24]

Indeed, one unstated goal animating choric speech manuals and anthologies was the choir director's desire to consolidate the professionalization of speech as an academic discipline. Commenting that she frequently received inquiries from English teachers and from "people with no training," Cecile de Banke, a British-educated member of the Wellesley College speech faculty, insisted on "the seriousness and difficulty of the proposed undertaking."[25] In this connection, several speaking-choir enthusiasts ambivalently acknowleged the example of Vachel Lindsay, who, at readings where he intoned his own rhythmic verse, organized audiences to chant in unison the refrains to "The Congo." Although Lindsay properly recognized the potential of the form as "communal art," his "leadership," one writer complained, was "always temporary"; furthermore, "it may have tempted less gifted group leaders to mistake their forms of noise for tone, and their outlets of brute force for strength."[26] The professional choir conductor, by contrast, "experimented" with technique to produce a controlled sound that conformed to preexisting standards of appropriate diction.

These standards, certified by professionals, served a second aim of the movement: to assist the disadvantaged in overcoming the perceived liabilities of their backgrounds. In that respect, the verse choir phenomenon (like pageantry) was a species of progressive reform. Specifically, choir leaders strove to help people to lose their foreign, lower-class, or pronounced local accents. As scientists of speech, they prescribed instead the speaking style "common to the best-educated people in the region of the speakers."[27] "Many little children," California teacher Elizabeth E. Keppie observed, "come from homes where baby talk or foreign speech has been encouraged"; the choir could reverse that influence. In particular, advocates of choric speech in the United States condemned nasality, which de Banke pronounced an "almost nation-wide handicap." As she explained, "Nasality . . . is a mark of boorishness, lack of culture, carelessness, or ignorance, or a combination of any number of these. It is offensive and inelegant in the extreme. No pains should be spared to eradicate it." To the extent that choirs followed that directive, they employed poetry in the service of a version of Americanization where "American" meant middle or upper class; more to the point, they indiscriminately yoked all of the poetry they read (whether or not part of a protest against idealism) to a genteel definition of culture as refinement.[28]

Improving pronunciation, however, was only one of the contributions speaking-choir advocates thought the activity could make to individual advancement. Drawing on the burgeoning field of psychology, which they invoked as an allied science,

they inflected group poetry reading with a third, more sweeping purpose: the achievement of "personality adjustment."[29] Part of that process entailed channeling aggression; for that reason the technique found favor in school. Yet older individuals could also benefit. Although "various fears and complexes and lack of self confidence have paralyzed their efforts," Keppie remarked of shy adults, the "association and support afforded by the choir has given them courage. . . . Thus a new self has been discovered and revealed through the means of choral interpretation." "Release," the same term that Mearns employed, was central to this therapeutic vision. As Keppie phrased it, "The inhibitions, the diffidence, and the self-consciousness which have bound" the maladjusted person "will fall away when he experiences the joy of speaking poetry in this cooperative way. By the abandon which must come to one thus released of his self-consciousness, there comes an ease and relaxation which leads him on to braver and bolder undertakings. Something which he thought lost in his childhood has come back into his life."[30] That language, connected in a general way to various forms of mind cure, reflected in particular the spread (and the misinterpretation) of the Freudian concept of repression.

In 1931 two influential popularizers of psychology—the husband-and-wife team of Harry and Bonaro Overstreet—added their imprimatur to the concept of poetry reading as a catalyst for adjustment. Writing under her maiden name, Bonaro Wilkinson that year issued one of the more intriguing artifacts of the dissemination of modernism, *The Poetic Way of Release*. Wilkinson argued that verse originated in intensified emotion "which finds no ready release in activity"; this pent-up feeling "quicken[ed] one's sense of rhythm and tend[ed] to express itself in a manner of speech adequate both to the thought and to the pulsing motion of that thought." By appreciating and reliving that transfer of "release" to poetic expression, readers gained heightened "power" that allowed them to substitute "unity" for frustration, routine, and "the boredom that comes from emotional poverty." In making those claims, Wilkinson quoted examples from Shakespeare to Pound, but featured late Victorians and American "new poets." Not a fan of "modernistic" writers (e.g., Wallace Stevens), whose work she found pretentious, manipulative, and insincere, she nevertheless embraced those contemporary authors whose experiments resulted in greater accuracy of mood and image.[31] Although connections to the choric speech movement here remained implied, H. A. Overstreet contributed an introduction to the book, explaining that its purpose was to show the promise of poetry for grown readers in the way that Mearns had for children.

Finally, in addition to professionalization, "Americanization," and personality adjustment, speaking-choir advocates endowed the practice with the potential to promote social as well as psychic harmony. In *A Guide to Civilized Leisure*, H. A. Overstreet declared that "to join with others in the rendering of a great poetic

Figure 5. Teenagers ostensibly acquiring wholesomeness and refinement in a speaking choir of the mid-1930s. (New York City Board of Education Archives, Milbank Memorial Library, Teachers College, Columbia University)

experience" as a choir member was "to feel oneself swept into a oneness of life that is well worth the having." As in the case of folk dance, which he also recommended, for Overstreet the "sociability" inherent in "communal" reading represented an alternative to the "frenetic demands" of "our economic civilization."[32] Verse choir leaders, who gratefully cited Overstreet's endorsement, described the social value of their enterprise in similar terms. As the affiliation of anthropologist Gilbert Murray with the British speaking-choir movement suggests, some proponents conflated primitive ritual and recitation with a salutary folk culture, which they saw themselves as perpetuating. From that perspective, the practice of oral group reading appeared to be a wholesome alternative to gangster movies and jazz, lending it a conservative moral purpose and making it a form of opposition to mass culture (Fig. 5).

At the same time, however, a belief in the potential of choric speech to enhance community yoked it, from Gullan on, to the democratic political agenda that, during the Great Depression, an interest in the art of the "people" often served. As de Banke explained, "Certain prevailing tendencies in modern men and women are found to be anti-social; they are for the most part introspective preoccupation, and exclusiveness resulting from diffidence or from a sense of class distinction. There has been a general move to combat these unhappy tendencies by gathering people

together for the object of group enjoyment and experience in such forms of expression as community singing and country dancing, and to these we now add verse speaking in choirs."[33] One Vassar faculty member both classified choric speech as "oral arts and crafts" and identified it as instrumental in national recovery: "The unemployed may well profit from the experience and the employed will find themselves stimulated by this cooperative work. Such a united choir or group may live equally well within a fashionable club or in a settlement house, in urban or rural districts. . . . The fireside may once more become a center for small groups whereas the settlement, mission, parish house, or village hall may become the working center for the larger and more ambitious groups."[34] That vision not only reflected the writer's desire to secure federal aid for such activities but also addressed the need for a sense of belonging that animated many Americans in the aftermath of economic collapse. Group reading even promised global unity. In 1937 de Banke pointed to a performance at the foot of the Acropolis, ironically by the speaking choir of the University of Berlin, as evidence that the "welding influence of mass artistic achievement" could create international understanding.[35]

All of the perceived individual and social benefits of choric speech derived from overarching assumptions about the relationship between reading and "life." Devotees of poetry as a genre (including Mearns) often maintained that it captured the essence of existence, or even that it *was* life. Yet speaking-choir advocates, concerned about a shrinking audience for silent verse, stressed that speech uniquely bridged the gap between cold type and human emotion. Endowing the practice with the power to create an additional form of unity, they argued repeatedly that reciting poetry aloud (provided speakers steered clear of the mechanical techniques of elocution) invigorated otherwise "dead language on paper."[36] "It is amazing to see a poem grow into life," one observer exulted, "when the whole choir recreates it."[37] Choir leaders thus perpetuated the romantic approach to reading that the progressives also shared—one that recognized no separation between heart and intellect, books and experience.

Even so, they sharply delimited the aspects of life that speakers customarily expressed by declaring certain types of poems inappropriate for performance. Sound and structure influenced judgments of suitability. Speech teachers favored selections that incorporated different parts for high- and low-pitched, or what they termed "light" and "dark," voices; they also preferred repeated lines or passages permitting antiphonal reading and solos. Works too long for easy memorizing fell outside the repertoire unless they could be cut. Younger students, Keppie noted, required verse with "a robust and definite" beat. Poetry "inspired by" the "Negro rhythm and Negro dialect" seemed to work especially well, as did those built on the tempo of the Machine Age. Yet in de Banke's view, free verse had its place as long as speakers became attuned to its "circular movement" and "authentic" beat.[38]

Gender stereotypes inflected the criteria applied to selections for men's choirs: poems with a "virile, hearty appeal" promised better results than those replete with "rheumy-eyed intellectualism."[39] The most significant distinction governing the choice of pieces, however, was between "objective" and "subjective" verse. The goal of psychological growth notwithstanding, choric speech advocates assumed that introspective, "purely personal" poetry ought to give place to works that "contained a feeling of universality of experience."[40] Thus their compilations and lists tended to exclude records of a "mood," however full of "life," in favor of narratives or lyrics with vivid, contrasting images.[41]

These stipulations fostered the dissemination of much "new poetry" beyond the obvious "boomlay, BOOM" refrain of Lindsay. Sandburg's "Jazz Fantasia," "Grass," and "Four Preludes on Playthings of the Wind" became standard offerings; as Gullan noted, Sandburg's "very impersonality" made his poems especially suitable for the chorus, "perhaps more so than that of any other American writer."[42] In *The Speech Choir*, a collection of mainly American verse she compiled after spending a term on the faculty of Teachers College, Gullan also highlighted Robinson's "The House on the Hill" and Harriet Monroe's "Supernal Dialogue" as examples of two-part texts; Sara Teasdale's "There Will Come Soft Rains" for "sequence work"; selections from William Carlos Williams, Louis Untermeyer, and Leonie Adams for unison performance; and excerpts from Pound, Frost, and Millay to encourage individual training. Another choral-reading teacher of the late 1930s singled out Millay's "God's World" as an example of the rare "objective" sonnet.[43] Amy Lowell's "Patterns" frequently appeared on lists of recital possibilities. Even later and less accessible modernists, although more controversial, reached a wider public by means of the speaking choir. Although one director advised, "I should avoid at all times the intricately geometrical and fanciful outbursts of some of our modern self-expressionists" because no one "knows what they mean," others championed Eliot's *Collected Poems, 1909–1935* with equal fervor, recommending choruses from "The Rock," "Sweeney Agonistes," and "The Hollow Men" as well as "Triumphal March" (which fairly demanded a choral rendition).[44]

Here again one may note the double implications of a reading practice with respect to the fate of the impulses that engendered the "new poetry." If oral group techniques affirmed and disseminated the spirit as well as the words of "God's World" or Lindsay's incantations, in other instances—"The Hollow Men," or Sandburg's grim meditations on industrialization, or Robinson's bleak observation of "ruin and decay"—the message of the text, however "objective," belied the assumptions about individual and social progress brought to bear on its performance.

The history of speaking choirs is instructive in two further respects. First, in the absence of Mearns's bias toward early modernism, eclecticism had free reign. Especially suited to school programs, Walt Whitman (e.g., "I Hear America Sing-

ing," "O Captain! My Captain," "Pioneers! O Pioneers") appeared even more frequently than Sandburg in Gullan's anthology, together with selections from Shakespeare, Longfellow, Tennyson, and English ballads. De Banke's suggestions mixed Eliot, Conrad Aiken, Edgar Lee Masters, and Amy Lowell with William Blake, Ben Jonson, John Keats, and John Dryden. "Masculine" poems, one teacher counseled, included Lord Byron's "Ocean," Kipling's "Boots," and three works by Lindsay. As Gullan reported, some choirs may at one time "present a program of old and modern ballads and, at another, seventeenth-century verse or modern and modernist poetry, or nonsense verse, or all combined."[45] This eclecticism spanned poetic structure as well as chronology, while amalgamating the high and the popular. In short, although, as Gullan illustrates, choir directors retained "modernism" in their critical vocabulary, it was less useful as a category than psychological potential, "sound values," virility, and objectivity.[46] To comprehend the terms in which the movement disseminated verse is thus to see early-twentieth-century American literary history from another angle of vision—one at variance with and independent of the usual idealist/modernist or traditional/modernist dichotomies that have dominated the scholarly record.

Second, the development of the choir repertoire along lines of "objectivity" reflected and reinforced two premises about public art. The first, the idea that it ought to be readily understandable, echoed attitudes in the classroom. The emergence of verse drama and other poetry on the radio, however, literally broadcast that assumption. As Milton Allen Kaplan put it, the "heterogeneity of the audience" required that the language of radio be "lucid to the point of transparency." The second premise radio encouraged was that brooding reflection or subtle emotion ought to be consigned to private sites for reading. The medium disseminated diverse poetic texts, from Arnold's "Sohrab and Rustum" to works of Frost, Sandburg, and Masters to the choral speech of Norman Corwin's plays. Yet "in gaining his audience," Kaplan noted, the "poet of the air has presented a 'public' poetry that is hopeful and affirmative in spirit. . . . The positive element in radio poetry supplies the balance which keeps poetry in equilibrium and prevents it from becoming detached or distorted, criticism that is often made of modern poetry."[47] That characteristic became even more evident as the propaganda needs of World War II increased the demand for patriotic and inspirational verse. Thus the speaking-choir movement helped to shape a set of expectations about culture's public face, of which the controversies in the 1990s over the self-critical aspects of the National History Standards and museum exhibitions were later manifestations.

There were, of course, venues that encouraged a more contemplative mode of reading verse—notably the church service. Yet in that setting the "new poetry" took on still other encumbrances. By conflating poetic and biblical texts, some

American Protestant clergy made the genre both a means of grace and of marketing. The best example of this phenomenon was Methodist minister William L. Stidger (Fig. 6). Pastor in the early 1920s of Linwood Methodist Church in Kansas City, Stidger was professor of homiletics at Boston University School of Theology from 1928 to 1949. A prominent author and lecturer with a flair for publicity, his acquaintances ranged broadly, including Amherst College president Mark Hopkins, Luther Burbank, Henry Ford, and Sinclair Lewis.[48] Stidger's essays from the teens and his close friendship with poet Edwin Markham bespeak a sympathy for the outlook of the Social Gospel. Nevertheless, his writings, especially in the 1920s and 1930s, resonate with a faith in American individualism, virtue, and manliness that link him as well to the circle of Theodore Roosevelt and Edward Bok (both of whom he admired).

By his own admission, Stidger in 1917 fell for a ploy of William Allen White's publishers, who flattered him and other "leading" ministers by giving them autographed copies of White's latest novel. Stidger used it as the basis for his first "Dramatic Book Sermon," in which a contemporary or classic work furnished connections to biblical teachings. This innovation in homiletics, Stidger explained, derived in part from "Jesus Christ Himself," who drew his teachings from "the library of the Old Testament."[49] Other figures—Noah Porter, Austin Phelps, and Methodist bishop William A. Quayle—supplied precedents for integrating literary study and formal worship. Yet Stidger went further by developing book discussion

into a formula that he eventually made a fixture of the Sunday evening service in his congregation. He also proselytized on behalf of the device to his ministerial colleagues, who responded by replicating "book sermons" throughout the United States.

To this endeavor, Stidger brought understandings about the rewards of reading that reflected both older traditions and new cultural anxieties. Like progressive teachers, Stidger viewed with alarm the emergence of a "Motion Picture Mind" and the "poor empty shelves of the bookcases in the average American home."[50] In *The Place of Books in the Life We Live*, he particularly emphasized the potential of literature to "unlock" for children the gate to "kingdoms" removed from "the commonplace things of the material world." For adults as well, books (properly chosen) promised a number of benefits. First, reading offered, as Stidger phrased it, the "regeneration of a human soul." Drawing on the long-standing convention of depicting books as vehicles for transport to another realm, he insisted that stories of "great men" enabled the reader to "leave behind him all of the petty things of the present Age to live in the spirit of the Ages." Such a voyage furnished a vision of the eternal that brought individuals closer to God. Second, as Stidger remarked (quoting Bishop Quayle), the capacity of books to "take us out of ourselves"—to abandon business cares and even the quest for information—made reading an invaluable source of "pleasure" and "delight." Although both Stidger and Quayle tied the "lure" of books to sensory images—"the warmth of holding a volume in the hands"—their emphasis was on experience as a source of piety and inspiration rather than as an end in itself. Similarly, the armchair travel that reading permitted—which Stidger characterized as "bulging back the world's horizons"—was instrumental to discovering "new ideas, new impulses, new ideals, new aspirations."[51]

Stidger also invested reading with less lofty purposes. Interestingly, the metaphor he adopted to denote the power of print contained both material and mystical allusions: a book was a "magic stone that will turn the world to gold." He was entirely comfortable with the language and techniques of marketing; if Bruce Barton was in a sense an adman-turned-preacher, Stidger may be seen as a preacher-turned-adman. Thus he described the assistance that books could provide a floundering young person as "the big boost." To be sure, this "boost" was in part spiritual—"I needed Light[,] I needed an Epiphany," he wrote of his own struggles—but it was also an aid to professional advancement. That was especially true, Stidger claimed, for the clergy who followed his example by invigorating their messages with literary texts. The book sermon, he observed, was the "finest drawing card" he knew. It resuscitated the midweek prayer meeting (which Stidger transformed into Family Night); it satisfied the demands of the college graduates who, by the end of the 1920s, dominated congregations like Linwood; and it

enhanced the lives and stature of pastors who became "almost over night" more "effective" and "popular." There was thus "no more pragmatic preaching vehicle" at hand.[52]

Within Stidger's ideology of reading, poetry held a central place. An amateur poet himself, he incorporated into his monographs numerous verses in praise of books ("And we thank Thee, God, / For the deep in them; / For the rhythmic swing / And sweep in them").[53] Preaching through poetry, Stidger maintained, was the most efficient way to strengthen faith and increase church attendance. As "the divinely ordained vehicle" of spiritual truths," poems were "bright darts" that preachers could shoot into the "hearts" of their congregations.[54] In another counterpoint to the view of mainstream publishers who bemoaned the paltry market for single volumes of verse, Stidger declared at the end of the decade that "the preacher who uses poetry is sure of a hearing today." The people, he contended, "not only need poetry in this age, but they are wistful for it. They love it. They respond to it. It works. It lures them. It fascinates an audience."[55] Moreover, because poets had learned economy of expression, they furnished ministers with countless lines for exegesis and elaboration. Subsequent to his success with the "Dramatic Book Sermon," Stidger created a variant—the "Symphonic Sermon"— in which a poetic couplet repeatedly reinforced the preacher's message the way that a musical theme recurred throughout a composition.

In articulating his outlook toward poetry and reading generally, Stidger adopted the stance of the expert: as he explained in the foreword to *There Are Sermons in Books*, he publicized the book sermon as a response to "preachers all over America" seeking his recipe for success. Nevertheless, Stidger's position, although laced with the same rhetoric of "service" to the community that corporate leaders employed at the time, betrays a hint of uneasiness about the nature of religious authority in the "business civilization" of the post–World War I period.[56] One might plausibly argue that the terms in which he embraced books both mirrored and fostered what Jackson Lears has called the "weightlessness" of liberal Protestantism by the late nineteenth century. In any event, Stidger took it upon himself to advise the publishing industry about how to expand its sales, a role born of friendship with "book men" but expressive as well of his arguably hope-laden notion that "the word of a preacher in commendation of a book" carried greater weight than the judgment of a newspaper columnist. "I say that I believe that it would be a more direct way of getting to a new reading market," he explained, "if Book Publishers and Book Sellers would introduce their wares more and more through preachers. I believe actually that the Book World is missing a good guess by not more and more sending their books to Preachers for review."[57] By dubbing the minister "the man of Books," thus implicitly fending off competition from secular journalists, educators, and critics, Stidger may have evinced longings for an

imagined earlier day when the public deferred to the clergy on aesthetic as well as ethical matters.

Whether or not he felt himself on an insecure foundation, however, Stidger had his own angle of vision that determined his strategies of enticement. An excerpt from his paean to poetry in *The Place of Books* may serve as a summary of the extent to which the boundary between early modernism and the romantic or idealist verse that preceded it—a boundary so essential to the self-definition of the "new poets"—was, for some readers, less a fortress wall than a permeable membrane:

> My Goethe, Dante, Omar too;
> One likes the old, one likes the new.
> . . . A Hugo, Stevenson, Carlyle;
> And dear old Dickens with his smile;
> . . . Some Gibson, Lindsay, and Millay;
> Where shadows laugh and run and play;
> . . . Our ancient Keats and Shelley too;
> Our Rupert Brookes; our old, our new;
> Carl Sandburg and the Vers Libre—
> Spoon River's Bleak 'Anthology';
> Our Amy Lowell and her tribe
> The Orthodox must scold and chide;
> A thousand poems and a song;
> A hundred authors and a throng
> Of characters to love
> And hate! . . .

Edwin Markham, whose biography Stidger published in 1932, remained his chief enthusiasm, yet in *Planning Your Preaching*, issued in the same year, Stidger commended the verse of Richard Watson Gilder, Presbyterian minister Henry Van Dyke, Robinson, Frost, and Don Marquis (to indicate only the range of his American favorites). The sources he suggested as reference works encompassed Burton Stevenson's *Famous Single Poems* as well as the collections of Untermeyer and Marguerite Wilkinson. Similarly, the conventional dichotomies between serious and light verse, between the high and the popular, vanished in his essay collections on poets. One, *Flames of Faith*, was divided instead by gender, yet it brought together from a single perspective Millay, the sentimental magazine poet Edgar Guest, and Strickland Gillian, a humorist who, Stidger averred, "keeps faith alive in the hearts of a great group of men who never heard tell of Tennyson, or Browning, or Poe."[58]

Stidger was able to blend "the old, the new" by recasting all his subjects as "poet-preachers." The strategy that afforded him such a reading entailed what might be called (despite his liberal Protestant affiliation) a fundamentalist or literal-

ist construction of references to faith, God, prayer, and the soul. As Stidger interpreted texts, those terms obliterated other facets of a poet's work and outlook; moreover, they functioned as a kind of leveling tool that allowed him to ignore distinctions based on structure or craft. Whereas speaking-choir proponents valued Lindsay, for example, primarily because of his manipulation of sound and rhythm, Stidger heard in "The Congo" and "General William Booth Enters into Heaven" only the poet's affirmations of Christian tenets.[59] Lindsay's use of the word "prayer" in his image of electric signs on Broadway was thus not so much an indication of his attunement to the urban atmosphere as a token of his devoutness.

Of course, Lindsay, possessed of a mystical and missionary temperament, provided a sizable basis for regarding his efforts in such terms; although more Swedenborgian than Protestant, he saw himself as spreading a "gospel of beauty." A more striking appropriation is Stidger's reading of Millay (the embodiment of the progressives' preoccupation with living intensely and, needless to say, the emblem of bohemian youth culture in the 1920s) as a conventionally religious poet. Of Millay's "Renascence," a poem that literary critics have construed as a discovery of the goodness manifest in nature ("God I can push the grass apart / And lay my finger on Thy heart!"), Stidger declared: "Then came something into this soul . . . nothing less triumphant than a good old-fashioned experience of what we call conversion." In other words, he transformed the transcendentalist or romantic God into a Methodist one; the narrator's despair, self-doubt, and consciousness of evil became "a running narrative of a man who, buried in materialism, cynicism, hate and sin, was washed from his grave into a new life and a new birth."[60]

To be fair, Stidger discovered "Renascence" before 1920, the year that *A Few Figs from Thistles* and *Second April* spread Millay's reputation as a Greenwich Village radical. In fact, Stidger's account of encountering Millay's verse argues against a trickle-down model of diffusion: he reported that he first happened upon one of her poems not in an anthology but, rather, in the "literary magazine" where it was initially published; later he found an excerpt from "Renascence" in what he described as a "Book Column"; finally, he acquired the small edition entitled *Renascence and Other Poems* that Kennerley brought out in 1917. Yet Stidger classified Millay as the greatest modern poet-preacher as late as 1932, when he praised all of her writings through *A Buck in the Snow*. To make his interpretation stick, Stidger had not only to ignore the verse in which Millay explicitly flouted Christian morality but also to suppress the arguably sexual imagery (e.g., the ecstasy of "God's World") in her other work. The point is not that Stidger erroneously considered Millay a Christian poet; as the tables of contents to compilations of religious verse attest, the category is sufficiently fluid to accommodate the vaguely spiritual as well as the devotional or doctrinal. It is, rather, that in implying that the greatest poets buttressed entrenched theology and in attaching business ideals to the rationale for

reading them, he provided a striking contrast to anthologists who equated the "best" with reactions against dominant values. Stidger thus forcefully illustrates, again, the importance of identifying the transformations in meaning and function that the process of dissemination could entail.

In *Planning Your Preaching*, Stidger revealed his own awareness of the multiple sensibilities and agendas that mediated early modernism for the reading public. The metaphor he adopted to convey that insight is especially apt, both in evoking an era and in wresting poetry from the realm of high art. "One man drives a Ford in one way," Stidger explained, "with his own peculiarity of handling steering-gear, brakes, and throttle. Another man uses the vehicle in another way. It is just a vehicle to carry a load to a certain destination, toward a certain objective or goal. So are certain methods and certain suggestive types of preaching. So are poems and books."[61] To weigh the cargoes that educators, choral speakers, and ministers transported as poetry readers, and to explore the routes over which they carried them to their audiences, is to acquire a better sense of the map of American culture: of the places where historians have found the modern, and of roads not taken.

NOTES

1. On the *Tristram* event, see Edwin Arlington Robinson File, Macmillan Co. Papers, Rare Book and Manuscript Division, New York Public Library; Van Doren, *Three Worlds*; and Neff, *Robinson*, 226–28. The Scribner's figure is from the card files, Charles Scribner Collection, Firestone Library, Princeton University. Neff (p. 228) reported that "even in the trough of the depression, 1932, when the *Collected Poems* dropped to 723 copies, it [*Tristram*] sold 1,846. Still better, it raised the circulation" of Robinson's later volumes "to over three times the average of their predecessors."

2. Duffey, *Poetry in America*.

3. Monroe, *A Poet's Life*, 270 (Williams). Perkins has called my subjects "popular modernists," but that phrase seems to me to beg the question of why the "new poets" reached a wide public. I have preferred the roughly accurate term "early modernists," while simultaneously suggesting that the category of "modernism" may not be entirely serviceable in light of the transformations that the process of dissemination wrought. See also Spiller et al., *Literary History*. On Robinson, see esp. Neff, *Robinson*.

4. Neff, *Robinson*, 226.

5. For a theoretical perspective that distinguishes between an insular modernism and an avant-garde hospitable toward mass culture, see Huyssen, *After the Great Divide*. Huyssen, however, is interested in neither the new poets nor the processes of popularization I describe herein.

6. Golding, *From Outlaw to Classic*, 22. The work on canon formation, textbooks, and anthologies includes Abbott, Lynch and Evans, Golding, and Nelson.

7. I have discussed the curriculum more fully in "Listen, My Children: Modes and Functions of Poetry Reading in American Schools, 1880–1950," in Karen Halttunen and Lewis Perry, eds., *Moral Problems in American Life* (Ithaca: Cornell University Press, 1998). The sample was drawn from the collection of courses of study at Teachers College Library, Columbia University, New York.

8. McMurry and McMurry, *Method of the Recitation*, 329–32.

9. Fairchild, *Teaching of Poetry*, 164 (first quotation); Leonard, *Essential Principals*, 248 (second quotation).

10. Leonard, *Essential Principals*, 125.

11. On progressive education generally, see Kliebard, *Struggle for the American Curriculum*; Cremin, *Transformation of the School*; and Zilversmit, *Changing Schools*.

12. Mearns, *Creative Youth*, 83.

13. Compton's (*Who Reads What?*) chapter on Sandburg provides additional impressions of his audience.

14. That Millay topped the list is not surprising—she had won a Pulitzer Prize in 1923 and perfected her persona as young rebel. What is striking is that Mearns's students omitted her morally unobjectionable lyrics in favor of eyebrow-raisers like "I Know I Am but Summer to Your Heart" and "Recuerdo." Robinson, still in his pre-*Tristram* phase, placed in the bottom third of the "favorites-so-far."

15. Mearns, *Creative Youth*, 42–49.

16. Ibid., 51.

17. Ibid., 43–44, 10.

18. This language appears, e.g., in Leonard, *Essential Principles*, 26, 56, 201–12, and Seely, *Enjoying Poetry*, 145.

19. Hooper, *Poetry in the New Curriculum*, 38, 19, 94.

20. Spiller et al., *Literary History*, 1342 (Eliot); Jarrell, *Poetry and the Age*, 7. The claim about passivity appears in a quotation from Allen Tate in Abbott, "Modern American Poetry," 214.

21. Mearns, *Creative Youth*, 86; Duffey, *Poetry in America*, 71–73. On Millay, see, e.g., Macdougall, *Letters of . . . Millay*, ix, 76, and "The Literary Spotlight," 272–78.

22. Mearns, *Creative Youth*, 28, 129, 104–6.

23. Keppie, *Teaching of Choric Speech*, 11.

24. A good summary of the history of speaking choirs is in de Banke, *Art of Choral Speaking*.

25. de Banke, "Notes on the Verse-Speaking Choir," 11.

26. DeWitt, "Shall We Recite as Groups?," 6.

27. Gullan, "Spoken Verse," 211.

28. Keppie, *Teaching of Choric Speech*, 28; de Banke, "Notes on the Verse-Speaking Choir," 70.

29. For the connection to "personality adjustment," see, e.g., Robinson and Thurston, *Poetry for Men*, 10; Hicks, *Reading Chorus*, 4; and de Banke, *Art of Choral Speaking*, 195.

30. Keppie, *Teaching of Choric Speech*, 13, 92.

31. Wilkinson, *Poetic Way of Release*, 112, 17, 51, 70, 72, 76, 209–11.

32. Overstreet, *Guide to Civilized Leisure*, 50, 48–49.

33. Gullan, "Spoken Verse," 212; de Banke, "Notes on the Verse-Speaking Choir," 71.

34. DeWitt, "Shall We Recite as Groups?," 62.

35. de Banke, "Notes on the Verse-Speaking Choir," 27.

36. Ibid., 26.

37. Sanderson, "Choirs That Speak," 119.

38. Keppie, *Teaching of Choric Speech*, 16, 37; de Banke, "Notes on the Verse-Speaking Choir," 128, 130.

39. Robinson and Thurston, *Poetry for Men*, 10, 31 (first quotation); Kaucher, "The Verse-Speaking Choir," 147 (second quotation).

40. Burdsall, "Choral Speech in the English Class," 181 (first quotation); Hicks, *Reading Chorus*, 7 (second quotation).

41. Reynolds, "Concerted Reading," 167. There was some dispute among choir leaders about whether or not groups should express "personal thought"; DeWitt ("Shall We Recite as Groups?," 51–52), e.g., advocated "experimenting" to find a way to do so.

42. Gullan, "Spoken Verse," 241–42.

43. Hicks, *Reading Chorus*, 7.

44. Kaucher, "The Verse-Speaking Choir," 150–51. The best survey of the American repertoire is

Gullan, *Choral Reading*. Virtually all of the writings on speaking choirs, however, contain examples of suitable texts. Eliot is prominently featured in the bibliography to DeWitt.

45. DeWitt, "Shall We Recite as Groups?," 147; Gullan, "Spoken Verse," 29.
46. de Banke, "Notes on the Verse-Speaking Choir."
47. Kaplan, *Radio and Poetry*, 119, 240.
48. Stidger, *The Place of Books*, 70.
49. Stidger, *There Are Sermons in Books*, xv.
50. Ibid., xi.
51. Stidger, *The Place of Books*, 24, 67, 146, 194–98, 191, 125.
52. Ibid., 83, 88, 41–42, 101, 109.
53. Stidger, *There Are Sermons in Books*, xix.
54. Stidger, *Planning Your Preaching*, 44–45.
55. Stidger, *Preaching Out of the Overflow*, 204.
56. Stidger, *There Are Sermons in Books*, 102.
57. Ibid., 115.
58. Stidger, *The Place of Books*, 133, *Planning Your Preaching*, 46, and *Flames of Faith*, 171.
59. Stidger, *Giant Hours with Poet Preachers*.
60. Stidger, *Planning Your Preaching*, 54.
61. Ibid., xv.

BIBLIOGRAPHY

Abbott, Craig S. "Modern American Poetry: Anthologies, Classrooms, and Canons." *College Literature* 17 (1990): 209–21.
Burdsall, Marjorie E. "Choral Speech in the English Class." In DeWitt, *Practical Methods*.
Compton, Charles H. *Who Reads What?* New York: H. W. Wilson, 1934.
Cremin, Lawrence A. *The Transformation of the School: Progressivism in American Education, 1876–1957*. New York: Knopf, 1961.
de Banke, Cecile. "Notes on the Verse-Speaking Choir." In DeWitt, *Practical Methods*, 69–74.
——. *The Art of Choral Speaking*. Boston: Baker's Plays, 1937.
DeWitt, Marguerite E. "Shall We Recite as Groups?" In DeWitt, ed., *Practical Methods in Choral Speaking*, 1–64. Boston: Expression Co., 1936.
Duffey, Bernard. *Poetry in America*. Durham: Duke University Press, 1978.
Fairchild, Arthur H. R. *The Teaching of Poetry in the High School*. Boston: Houghton Mifflin, 1914.
Golding, Alan. *From Outlaw to Classic: Canons in American Poetry*. Madison: University of Wisconsin Press, 1995.
Gullan, Marjorie. "Spoken Verse." In DeWitt, *Practical Methods*, 203–14.
——. *Choral Reading*. New York: Harper, 1937.
Hicks, Helen Gertrude. *The Reading Chorus*. New York: Noble and Noble, 1939.
Hooper, John. *Poetry in the New Curriculum: A Manual for Elementary Teachers*. Brattleboro, Vt.: Stephen Daye Press, 1932.
Huyssen, Andreas. *After the Great Divide: Modernism, Mass Culture, Postmodernism*. Bloomington: Indiana University Press, 1986.
Jarrell, Randall. *Poetry and the Age*. New York: Ecco, 1953.
Kaplan, Milton Allen. *Radio and Poetry*. New York: Columbia University Press, 1949.
Kaucher, Dorothy. "The Verse-Speaking Choir." In DeWitt, *Practical Methods*, 87–99.
Keppie, Elizabeth E. *The Teaching of Choric Speech*. Boston: Expression Co., 1939.
Kliebard, Herbert M. *The Struggle for the American Curriculum, 1893–1958*. Boston: Routledge, 1986.
Leonard, Sterling Andrus. *Essential Principles of Teaching Reading and Literature*. Philadelphia: J. B. Lippincott, 1922.

"The Literary Spotlight." *Bookman* (November 1922): 272–78.

Lynch, James J., and Bertrand Evans. *High School English Textbooks: A Critical Examination*. Boston: Little, Brown, 1963.

Macdonald, Dwight. "Masscult and Midcult: I." *Partisan Review* 27 (Spring 1960): 202–33.

——. "Masscult and Midcult: II." *Partisan Review* 27 (Fall 1960): 589–631.

Macdougall, Allan Ross. *Letters of Edna St. Vincent Millay*. New York: Harper, 1952.

McMurry, Charles, and Frank McMurry. *The Method of the Recitation*. New York: Macmillan, 1921.

May, Henry. *The End of American Innocence*. Chicago: Quadrangle, 1964.

Mearns, Hughes. *Creative Youth: How a School Environment Set Free the Creative Spirit*. Garden City, N.Y.: Doubleday, Doran, 1925.

Monroe, Harriet. *A Poet's Life: Seventy Years in a Changing World*. New York: Macmillan, 1938.

Neff, Emery. *Edwin Arlington Robinson*. New York: William Sloane, 1948.

Nelson, Cary. *Repression and Recovery: Modern American Poetry and the Politics of Cultural Memory*. Madison: University of Wisconsin Press, 1989.

Overstreet, H. A. *A Guide to Civilized Leisure*. New York: Norton, 1934.

Reynolds, G. F. "Concerted Reading." In DeWitt, *Practical Methods*, 165–67.

Robinson, Marion Parsons, and Rozetta Lura Thurston. *Poetry for Men to Speak Chorally*. Boston: Expression Co., 1939.

Sanderson, Virginia. "Choirs That Speak." In DeWitt, *Practical Methods*, 117–25.

Seely, Howard Francis. *Enjoying Poetry in School*. Richmond, Va.: Johnson Publishing Co., 1931.

Spiller, Robert E., et al., eds., *Literary History of the United States*, 3d ed. New York: Macmillan, 1963.

Stidger, William L. *Giant Hours with Poet Preachers*. New York: Abingdon, 1918.

——. *Flames of Faith*. New York: Abingdon, 1922.

——. *The Place of Books in the Life We Live*. New York: George H. Doran, 1922.

——. *There Are Sermons in Books*. New York: George H. Doran, 1922.

——. *Building Up the Mid-Week Service*. New York: Doran, 1926.

——. *Preaching Out of the Overflow*. Nashville: Cokesbury, 1929.

——. *Planning Your Preaching*. New York: Harper, 1932.

Van Doren, Carl. *Three Worlds*. New York: Harper, 1936.

Wilder, Amos. *Spiritual Aspects of the New Poetry*. New York: Harper, 1940.

Wilkinson, Bonaro. *The Poetic Way of Release*. New York: Knopf, 1931.

Yeomans, Edward. *Shackled Youth*. Boston: Atlantic Monthly Press, 1921.

Zilversmit, Arthur. *Changing Schools: Progressive Education Theory and Practice, 1930–1960*. Chicago: University of Chicago Press, 1993.

JOHN F. KASSON

Dances of the Machine in Early Twentieth-Century America

The worlds of work and dance may appear to be poles apart. Nonetheless, in their common origins, work rhythms and dance rhythms—the cadences by which we "keep together in time"— are older than history itself, and they form some of the most deeply felt elements in a culture.[1] With the emergence of an advanced industrial economy in the early twentieth century, these rhythms and relationships changed immeasurably. Modern machine production drummed irresistible new beats and demanded new patterns of highly coordinated human movement that affected the entire society and became one of the defining elements of modernity. In the realm of work, the paradigm of this transformation was the modern factory, epitomized in the Ford assembly lines developed to produce the Model T; in the realm of dance, it was the theatrical spectacle number that reached its zenith in the mechanically reproduced and distributed Hollywood musical of the early 1930s. This essay focuses on the elusive relationships between these two developments and their key roles as icons and rhythmic embodiments of modernity. I wish to revisit some of the most familiar instances of mass production and mass leisure in order to invite readers to think of them, playfully but seriously, as *dances*, which, whether assuming the form of industrial drills or fantastic pageants, powerfully expressed the new technology and organization of modern life with all of its beauty and alienation, promise and pain. To do so, I believe, allows us to comprehend more deeply how the demands of mechanical production in the early twentieth century stimulated not only profound changes in the workplace but also what may be regarded as varieties of modernism in the popular arts. Here, then, are four ballets mécaniques, four dances of the machine.

HIGHLAND PARK: FORD'S DANCE OF THE ASSEMBLY LINE

The promise of mass production assumed utopian dimensions in the early twentieth century, and its greatest visionary was unquestionably Henry Ford. The development of the moving assembly line at Ford's Highland Park plant outside Detroit beginning in 1913 revolutionized the automobile industry and became a transcendent symbol of the possibilities of synchronized human labor in intimate partnership with machinery (Fig. 1). Granted, the only dance Ford ever self-consciously encouraged was square dancing, and he certainly was not thinking in terms of dance movements at Highland Park. But as he and his associates sought constantly to increase production of the Model T, they became, in effect, choreographers in new dances of the machine, creating some of the most brilliantly innovative and influential patterns of the age. Like many other choreographers, however, they were martinets whose numbers took a devastating human toll. If modernism may be understood, among other things, as a cluster of efforts to find new aesthetic vocabularies to express the innovative terms of industrial life in the twentieth century, then the Ford Motor Company served as one of the great fountainheads of modernism. The forms that it pioneered, following the instrumental logic of mass production, would shape a host of expressive responses in painting, photography, literature, and the fields that especially concern this essay, film and dance.

Large-scale factory production in the United States was a century old by 1913, if one dates its beginnings from the Boston Associates' 1815 textile mill in Waltham, Massachusetts, the immediate predecessor to the immense factories of Lowell and other New England mill towns. Yet Highland Park marked a major departure in the pace and character of human-machine production. To realize the vision of Ford and his associates of a car for the multitude at the cheapest possible price demanded not only specialized new machines, but also more extensive and intricate coordination between mechanical production and human operatives than anything previously known.

The new dance of the assembly line began on April 1, 1913, in Ford's flywheel magneto assembling department (Fig. 2). Twenty-nine workers who had stood at separate workbenches hitherto now found themselves facing a row of flywheels that slid along a continuous surface. Previously, each man had individually put together an entire flywheel magneto assembly from sixteen magnets with their supports and clamps, sixteen bolts, and other parts, a job that took about twenty minutes. Now this process was minutely subdivided and tasks were specialized, so that a man put only a single part on the assembly, added a few nuts, or simply tightened them, then pushed the flywheel a foot and a half or so to the next worker. Each performed his little step over and over for nine hours. Even by the end of the

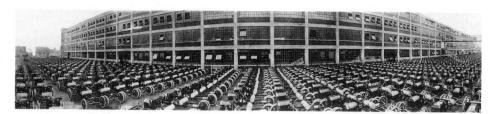

Figure 1. The promise of mass production: one day's output, Ford Motor Company, Highland Park, 1914. (Collections of the Henry Ford Museum and Greenfield Village; Ford Archives P833.682)

first day, the transformation in output was impressive. Workers who had earlier produced a new assembly every twenty minutes now averaged one every thirteen minutes and ten seconds. Ford production engineers introduced refinements almost immediately. By pulling the magnetos along the line with a chain at a set rate, they found that they could regularize the workers' pace. Within another year, flywheel magnetos were coming off the line at a rate of one every five man-minutes. Assembly line methods had cut the original time in fourth.[2]

Ford managers and engineers quickly experimented with similar methods in other departments (Fig. 3). Automated machines, standing virtually side by side, were accorded key positions on the shop floor. As the circulation among these machines increased in scope and pace, conducted by conveyors, gravity feeds, and a growing number of subassembly lines, the men on the line became correspondingly confined and repetitive in their actions. Division of labor reached new heights, so that workers came themselves to resemble machines in their simple, robotic movements. "The man who puts in a bolt does not put on the nut," Ford approvingly declared; "the man who puts on the nut does not tighten it." Each worker, Ford remarked euphemistically, was relieved of "the necessity for thought" as "he does as nearly as possible only one thing with only one movement."[3]

The achievement of a continuous flow of production along moving assembly lines, first applied to magnetos, engines, and transmissions in 1913 and to chasses early in 1914, has frequently been described in terms of flowing water, as rivulets fed into streams, which were channeled in their turn into rivers and building to a "Great Flood."[4] But it still more resembled an intricate dance, part military drill, part industrial ballet, as every position and movement of every worker was adapted to the requirements of modern mass production. In this dance of the assembly line, men and machinery oddly exchanged attributes. Parts became animated and marched steadily from one station to another. Workers became more stationary and mechanical: a highly synchronized, increasingly immobile and deskilled corps de ballet as they participated in the intricately sequenced and continuous flow in which the ballerinas, Ford's adored Tin Lizzies, gathered their parts and were triumphantly borne aloft—by 1925 every thirty seconds of the working day (Fig. 4).

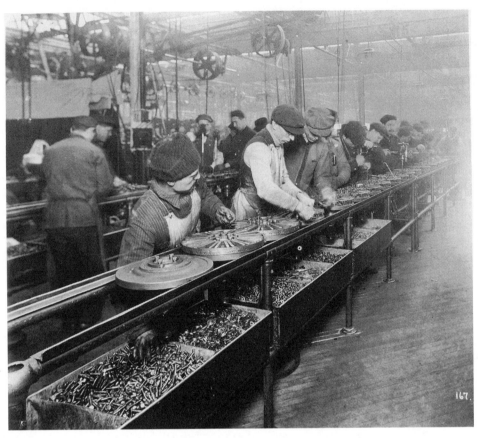

Figure 2. The birth of Ford's ballet mécanique: assembling the flywheel magneto, Ford Motor Company, Highland Park, 1913. (Collections of the Henry Ford Museum and Greenfield Village; Ford Archives P.833.167)

The spectacle of this smoothly flowing, intricate production might be regarded as not only a dazzling industrial feat but an object of beauty as well. A century before, when Francis Cabot Lowell reinvented a power loom, which promised to permit the organization of all manufacturing processes from raw cotton to finished cloth within a single integrated mill complex, his coinvestor Nathan Appleton reported that the two men sat "by the hour, watching the beautiful movement of this new and wonderful machine, destined as it evidently was, to change the character of all textile industry."[5] So too the development of moving assembly lines was clearly destined to revolutionize the character of automotive production, and it too was proclaimed beautiful. Describing the chassis assembly for *Engineering Magazine* in 1914, industrial engineer Horace Arnold enthused that the process "affords a highly impressive spectacle to beholders of every class, technical or nontechnical."[6]

Far more than Arnold acknowledged, however, the beauty of the dance depended on the class perspective of the observer. What was beautiful to an engineer could be a *Totentanz* to a worker on the line. Arnold did not add that during the

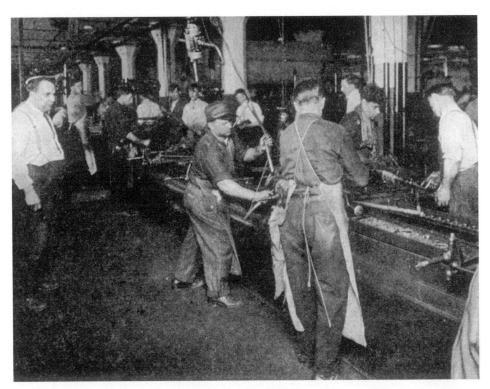

Figure 3. Expanding the corps de ballet: foreman and workers on front-axle assembly line, Ford Motor Company, Highland Park, 1913–14. (Collections of the Henry Ford Museum and Greenfield Village; Ford Archives, N.O.19505)

previous year, labor turnover at Highland Park reached 380 percent, eloquent testimony to the dance's exhausting pace. To mollify his workforce, Ford in January 1914 announced his vaunted five-dollar day (for qualified workers), though problems persisted. As the wife of one assembly line worker wrote anonymously to Ford two weeks later, "The chain system you have is a *slave driver! My God!*, Mr Ford. My husband has come home & thrown himself down & won't eat his supper—so done out! Can't it be remedied? . . . That $5 a day is a blessing—a bigger one than you know but *oh* they earn it."[7]

MODERN TIMES: CHARLIE CHAPLIN'S BALLET MÉCANIQUE

Ford's transformation of automobile assembly from static to dynamic principles bears inexact but important analogies with roughly contemporaneous developments in the history of film. The industrial ballet that Ford pioneered at Highland Park depended on breaking down the processes of production into their most minute components and organizing them in the most efficient and repeatable sequences. So, too, filmmakers necessarily assembled each movie discontinuously,

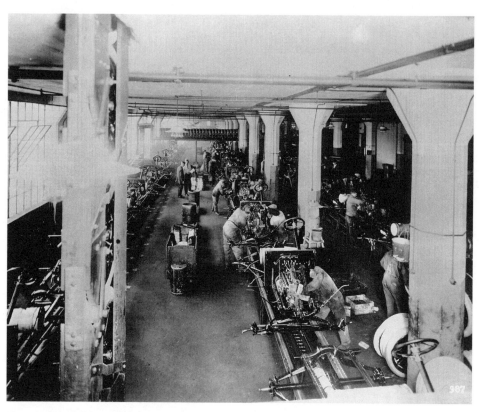

Figure 4. March of the Tin Lizzies: general view of "the line," Highland Park, 1914. (Collections of the Henry Ford Museum and Greenfield Village; Ford Archives neg. no. 833–987)

making sequences piecemeal (and often with immense repetition) and increasingly learning to follow, not narrative logic (any more than Ford assembled his cars from the tires up), but the most efficient use of sets and personnel. Obvious and fundamental to the medium of film was what art historian Erwin Panofsky identified as early as 1934 as "the *dynamization of space* and, accordingly, *spatialization of time*."[8] Whereas live theater presumed the audience's static perspective on the stage and action, film permitted, and soon demanded, that spectators surrender imaginatively their fixed positions: to view the movements implied by the camera and the cutting and editing as a continuous flow of space, carrying them along with it. The possibilities were incalculably enhanced for presenting the world in dynamic terms, as an integration of collages, multiple perspectives, variable speeds, shifting and intricate rhythms. In this sense, all film might be regarded as inviting viewers to join in new dances of the machine. But, more particularly, movies displayed a remarkable affinity for technology as a subject, theme, and metaphor for the new. Moviemakers quickly became among the most profound—and incontestably the most popular—painters of modern life. Chief among these modernists for the multitude were the great makers of silent comedy.

For if mechanization made some jobs harder, it made the comedian's easier. At the very beginning of the twentieth century in his influential lectures on laughter, French philosopher Henri Bergson declared, "The attitudes, gestures and movements of the human body are laughable in exact proportion as that body reminds us of a mere machine."[9] The comic possibilities of mechanical bodies as well as of animated objects, frequently operating at cross-purposes, formed the basis of much of American silent comedy, particularly in the work of the three greatest masters: Charlie Chaplin, Buster Keaton, and Harold Lloyd. The silent film comedians quickly developed a distinctly cinematic vision in which the presence, pace, rhythms, and often recalcitrant wills of modern inventions played a major role. Thus, in *Get Out and Get Under*, Lloyd gamely opened the hood of his Model T to repair the engine, only to be comically swallowed by it. First his head disappeared under the hood, then his shoulders, and so, by degrees, the rest of him, right down to his feet.[10] Some of Keaton's greatest films, such as *The Navigator* and *The General*, made machines (here a steamship and locomotive, respectively) virtual costars.

Yet the work of these great silent comedians was decisively displaced by a further technological innovation: the advent of sound in 1927. As other silent filmmakers either withdrew or attempted to adapt to the changed character of the medium, Chaplin stubbornly clung to the silent tradition—and virtually stopped making movies. Following the January 1928 release of *The Circus*, he produced only one film, *City Lights*, in the eight years before the February 1936 premiere of *Modern Times*.

Modern Times is thus a critique of the increased demands of modern technological society in a double sense. On one level, it satirizes the callousness of an impersonal mass society indifferent to the worth and beauty of the individual human imagination. Chaplin traced the film's inspiration directly to the plight of Detroit workers who, in his words, "after four or five years at the factory-[conveyor] belt system, became nervous wrecks."[11] A decade earlier, in 1923, Chaplin had visited such factories. Indeed, he was escorted on a special tour of the Highland Park plant by Henry Ford himself and his son Edsel—during which the din of assembly forced them to shout into one another's ears (Fig. 5).[12]

On a second and more personal level, the critique of Chaplin's film was also infused with his deep unhappiness as a filmmaker with the technology of sound. The demands and expense of "talking pictures" made impossible his earlier practice (one shared by Keaton and Lloyd) of freely "improvising as he went along, advancing the plot as notions came to him."[13] In addition, the poetic world of the Tramp, with its indebtedness to sentimental melodrama as well as to mime, depended on silence, Chaplin believed; "the first word he ever uttered would transform him into another person."[14] Silent films were never truly silent, of course;

Figure 5. Touring the stupendous Ford system: Chaplin with Edsel and Henry Ford, Highland Park, 1923. (Collections of the Henry Ford Museum and Greenfield Village; Ford Archives neg. no. 0-4144)

they presumed and relied on musical accompaniment, so that, as Panofsky noted, they assumed somewhat of the character of ballet.[15]

Sound in this sense in Chaplin's 1936 film is an inextricable part of the frenetic and regimented character of modern life (as it was of Ford's factory), and the Tramp's (and Chaplin's) commitment to the poetry of the silent era becomes another aspect of his character's wistful longing for grace and poetry in a society increasingly preoccupied by instrumental (and ultimately inhuman) values. The harsh, mechanized alarms and whistles in *Modern Times*, including the blare of speech over loudspeakers, recordings, and radios (face-to-face conversation continues to be silent), represents, among other things, Chaplin's protest at the noisy world that had killed the silent tradition.[16] The celebrated dance of the machines that Chaplin created in the film must be seen in this double context.

Much of *Modern Times* takes place in a futuristic factory strongly reminiscent of the autocratic factory in René Clair's brilliant satire *A Nous la Liberté* (1931). The action comically yet caustically reveals how thoroughly the factory regime assaulted every vestige of individual freedom and dignity—on the job, in rest room retreats, even during the lunch break, when the hapless Tramp participates in the

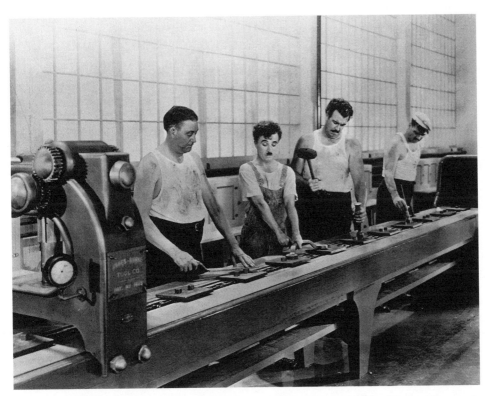

Figure 6. The punishing pace of production: Chaplin's Tramp on the assembly line, Modern Times. *(Courtesy of Turner Entertainment and Film Stills Archive, The Museum of Modern Art, New York)*

trial of a feeding machine. Later that afternoon as the conveyor belt is speeded up, Chaplin's Tramp finally snaps under the strain. He frantically pursues his narrow task even as the conveyor belt reels him into the machinery's gigantic cogs and gears—like an automaton in an immense music box, the music of the sound track suggests (Figs. 6 and 7). Then, as he persists in his compulsive movements, all the impulses repressed by the factory regimen burst forth, and his dance begins.

Given the prim, fastidious character that Chaplin's Tramp had assumed, it is a surprisingly and significantly libidinous dance. Only a few years before *Modern Times*, Italian Marxist Antonio Gramsci, writing from a Fascist prison cell, had observed with reference to Ford, "The truth is that the new type of man demanded by the rationalisation of production and work cannot be developed until the sexual instinct has been suitably regulated and until it too has been rationalised."[17] At Ford and elsewhere, the dance of the assembly line required not only that each worker surrender his intelligence and initiative to his employer, but also that he leave all his imaginative life (including his erotic longings) outside the factory gates.[18] The Tramp's dementia exemplifies both this intense repression and its breakdown. The physical and mental fatigue of laborious repetition unleashes its opposite: a manic ballet filled with forbidden impulses and erotic desires (Fig. 8).

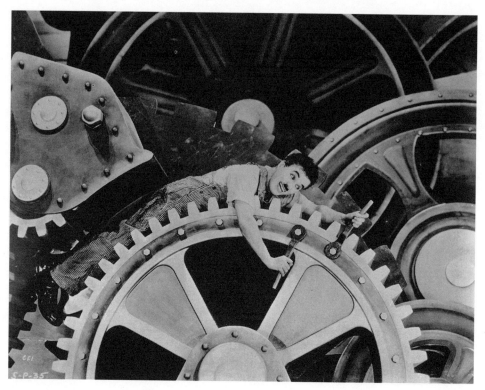

Figure 7. Enmeshed in the gigantic machinery, Modern Times. *(Courtesy of Turner Entertainment and Film Stills Archive, The Museum of Modern Art, New York)*

In this respect, Chaplin includes a compressed homage to what remains the most celebrated modernist ballet of such impulses and desires, Vaslav Nijinsky's *Prélude à l'Après-midi d'un Faune* of 1912 (Fig. 9). "Your comedy is *balletique*, you are a dancer," Chaplin reported the great Nijinsky telling him in December 1916; in this dance Chaplin returned the compliment, even as he parodied the mincing steps of classical ballet that Nijinsky did so much to overturn.[19] Lifting his wrenches to his ears to suggest horns, the Tramp briefly evokes Nijinsky's subversive masterpiece, which Chaplin deeply admired. Nijinsky had depicted the slow unfolding of a faun's sexual awakening to a nymph, his desire, pursuit, loss, and carnal embrace of the nymph's scarf. The Tramp, by contrast, once he involuntarily revolts from his confined position and narrow task on the line, rapidly seeks to apply his wrenches to anything remotely suggesting a loose bolt: first, his coworkers' noses and nipples, then the buttons and breasts of a young woman. After a distracted chase out of the factory (and the pursuit of a large-breasted matron wearing particularly big and inviting buttons), the Tramp returns for a final ballet of sabotage. With manic glee, he pulls the levers that control the assembly line, explodes the machinery, and, parodying a nymph at play, squirts oil in the face of everyone about him. For the first time, the Tramp is not only rebellious but also innovative in his actions—

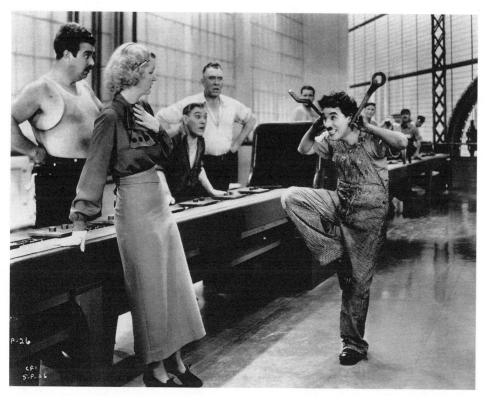

Figure 8. Afternoon of an industrial faun, Modern Times. *(Courtesy of Turner Entertainment and Film Stills Archive, The Museum of Modern Art, New York)*

though still gripped by a delirium induced by the enforced repetitive movements of the assembly line (Fig. 10).

The scene thus establishes a contrast that will recur again and again. Indeed, the entire film may be read as a series of struggles between the demands of a relentlessly impersonal social order—symbolized by enforced rhythms and lock-step institutions—and the Tramp's effort to hold onto a place of personal independence, imagination, and beauty—symbolized by mime and dance. Although the contest is appallingly one-sided, the Tramp refuses to be defeated. Significantly, however, he is often forced to fight on his enemies' ground, and his moments of greatest rebellion occur only when he has lost conscious control. He and later the waif whom he befriends (played by Paulette Goddard, who would soon become Chaplin's wife) are pursued by various authorities until at last they flee the city and, so far as possible, modern times altogether. The concluding scene contrasts with the jaunty walk with which Chaplin ended his two-reeler *The Tramp* (1915), even as it anticipates the end of Chaplin's next film, *The Great Dictator* (1940), with its denunciation of the "machine-men" of the Third Reich. Though they are not to be compared to Nazis, the machine-men by 1936 have already won.

Figure 9. Faun and nymph: Vaslav Nijinsky with Lydia Nelidova in Prélude à L'Après-midi d'un Faune. *(Photograph by Adolf de Meyer; New York Public Library for the Performing Arts)*

THE ENGINE ROOM AS RHYTHM SECTION: THE LEISURED MALE DANCES

A year after Chaplin's *Modern Times*, Fred Astaire, the greatest dancer in the history of film, perhaps the greatest Western dancer of the twentieth century in any medium, performed his own dance of the machine, the "Slap That Bass" number in *Shall We Dance* (Fig. 11). The two dances are starkly different, and they reflect sharp differences in social perspective, in attitudes toward modern technology, in dance vocabularies and ambitions, and in attitudes toward talking pictures.

Whereas Chaplin's ballet mécanique was inspired by sympathy for industrial workers reduced to the position of robots, Astaire's reflected its origins in the privileged position of the film's director, Mark Sandrich, as he toured the boiler room on a luxury liner.[20] In the insouciantly implausible story of *Shall We Dance*, Astaire plays an American dancer, Pete Peters, who to advance professionally has assumed the persona of a Russian, changed his name to Petrov, and become a classical ballet star. But his real love (like Astaire's own) lies far from ballet in a

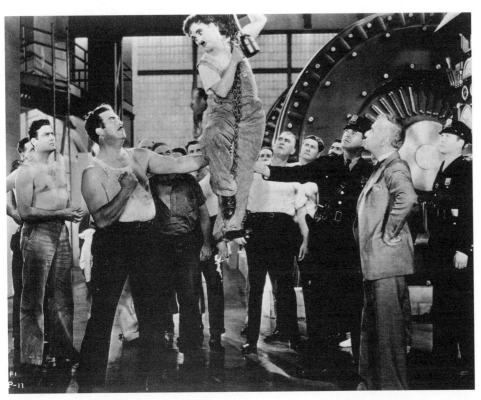

Figure 10. The Tramp surrounded, Modern Times. *(Courtesy of Turner Entertainment and Film Stills Archive, The Museum of Modern Art, New York)*

modern, "outlaw style": an eclectic mixture centered on American popular and romantic forms, particularly tap and ballroom dancing. He is especially interested in incorporating new rhythms into his dances, to take ballet and to make it modern. As he sails from Paris to New York on a luxury liner, he is inspired to create a new dance built on the contrasting rhythms of the machines of the engine room and African American jazz, to which Astaire owed so much.

The setting for this number rivals Chaplin's factory in its emphatically "modern," immaculate machinery, but it contains not a hint of anxiety or fatigue. An easy jive bubbles up from the African American workers as the chromium-plated machines provide an amiable rhythm section.[21] The men begin working to the machine rhythms but almost immediately break off to create a relaxed musical interlude that plays off the mechanical beat. Easily, apparently effortlessly, they do what Chaplin's Tramp could do in the factory only when he went berserk: improvise, creating new musical possibilities out of the soundscape about them. Some play instruments; others mime them with their voices. Within the context of the scene, their music is not a product, and certainly not an instance of alienated labor, but the expression of a lyric impulse, performed for no one's pleasure but their own.

Astaire's character begins as an enthusiastic onlooker to the jiving workers/

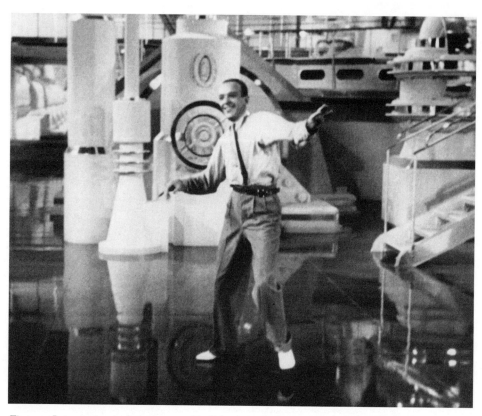

Figure 11. Improvisations in the engine room: Fred Astaire's "Slap That Bass" sequence, Shall We Dance. *(Courtesy of Turner Entertainment and Film Stills Archive, The Museum of Modern Art, New York)*

musicians, but almost immediately he moves from spectator to singer and then, gloriously, to dancer. Exulting in the fact that, in Ira Gershwin's lyrics, "the happiest men all got rhythm," he launches into a jubilant series of steps, incorporating balletic elements and fluid gestures within a dazzling jazz-inspired set of tap riffs. Then, swinging over a railing as if in a zoo of mechanical creatures, he moves into what might be regarded as a series of challenge dances with individual machines. He easily mimics the dumbly repetitive movements and rhythms of each, and then polyrhythmically improvises on them. Instead of compelling him to labor to their pace, as in Chaplin's film, the machines seem to amuse him. His success as a dancer depends on freedom of movement, rhythmic intricacy, and inventiveness—distinctively human qualities that machines cannot duplicate. The dance culminates with a dizzying set of steps and twirls up a ramp, in which, like the "Bojangles of Harlem" number in *Swingtime* a year earlier, he is joined momentarily by his shadows to magnify his presence. It is an exuberant finale of human vitality and creativity. The scene ends with the black workers applauding his supposedly impromptu performance, acknowledging him as not simply an imitator but a master innovator who, like them, has made jazz a way of life.[22]

If Chaplin's own resistance to sound technology formed a subtext to his dance with the machine in *Modern Times*, Astaire's preference for sound film as the ideal medium for his dancing surely informs "Slap That Bass." Once Astaire arrived in Hollywood in 1933, he appears scarcely to have looked back to the Broadway stage, even though he had performed before live audiences since the age of five. Contrary to his casual and sunny movie persona, offstage Astaire was relentlessly self-critical, anxious, and insecure, and he found in film a medium more suited to his perfectionism. Not only was he the chief dancer in his films, but also the major choreographer and director of the dance sequences. Indeed, Astaire established an approach to filming dance that quickly became the Hollywood standard for the next two decades. The essence of that approach was to make the camera an unobtrusive but supportive dancing partner, whether Astaire performed a solo or a duet.[23] He understood the camera's strengths and limitations well. It was like a Cyclops wearing blinders, with a flat, narrow perspective that could not encompass a wide stage, but that could concentrate intently on objects directly ahead and follow the most intricate steps. Astaire held the camera at a fairly consistent, comfortable proximity, pulling it forward and back with him as he moved, and refusing to let its attention wander in any way. In duets with Ginger Rogers, Astaire stayed close to her so the camera could see both of them at once. But solos offered Astaire his greatest freedom as a dancer, as is evident in "Slap That Bass." Astaire here dances both with the machines that we see and with the machine technology of film itself—though he discreetly never acknowledges their liaison by directly returning its adoring gaze.[24]

BUSBY BERKELEY AND CINEMATIC SPECTACLE

The mode of dance cinematography that Astaire most fervently opposed and sought to eradicate was, of course, that of Busby Berkeley. In 1933, the year that Astaire began his film career with RKO, Berkeley was creating some of his most memorable dance sequences for Warner Brothers in the films *42nd Street*, *Gold Diggers of 1933*, and *Footlight Parade*. Some of these may also be regarded as dances of the machine, but in ways less obvious than those we have considered thus far. Most directly, they were ballets mécaniques in the sense that, as many critics have observed, Berkeley "made the camera dance." As director of dance sequences, he carried the tradition of musical spectacle to new heights, employing all the technical machinery at his command to create inventive and often self-aggrandizing cinematic triumphs, emphasizing virtuoso camera work, extensive editing, and frequent special effects.

Yet in addition to this self-reflexive sense, Berkeley created dances that expressed a vision of the modern world made possible by mass production and

profoundly shaped by its aesthetic and rhythms. Strange as it may be to suggest it, the great Busby Berkeley production numbers can be regarded as the flip side of Henry Ford's assembly line.

Berkeley's cinematic spectaculars built on a rich stage and screen tradition that bears suggestive relationships to the rise of mass production at Ford and elsewhere. In the 1910s and 1920s, during roughly the same time that Ford was developing his system, Broadway producers mounted spectacles of mass consumption involving larger and more intricate aggregations of dancers than ever before. Although Broadway choreographers drew on a variety of dance traditions, their hallmark became "precision" dancing. Extravagant annual revues, such as the *Ziegfeld Follies*, the Schubert Brothers' *Passing Show*, *George White's Scandals*, and the *Earl Carroll Vanities*, dominated the New York stage until the onset of the Great Depression and the rise of sound films hastened their exodus to Hollywood.

The basis of all these productions lay in the display of female bodies in rapid, intricate, precise, and often fantastic patterns—the cavernous stage of the New York Hippodrome could hold over six hundred dancers at once.[25] In the broadest sense, the assembly line had its historical counterpart in the chorus line. The regiments of workers pursuing ever more specialized tasks in rapid, synchronized assembly found their inverted image in teams of nearly nude chorines, carefully grouped by size and appearance, performing elaborate dances of mechanistic precision, synchronization, and regimentation. "It is system, system, system with me, I believe in numbers and straight lines," declared influential Broadway choreographer Ned Wayburn in 1913, the very year in which Ford and his associates began their assembly revolution at Highland Park. And just as at Ford and elsewhere, managers stressed the "scientific" selection of the right worker for each task, Wayburn and other choreographers assigned their female dancers specialized tasks and divided them according to newly standardized sizes and shapes (with slang terms for each, drawn overwhelmingly from the world of livestock). In 1913, for example, these were differentiated into five categories: (1) "show girls," 5′7″ and above; (2) "chickens" or "peaches," 5′5″ to 5′7″; (3) "squabs," 5′2″ to 5′6″; (4) "ponies" or "thoroughbreds," 5′3″ to 5′5″; and (5) "pacers" or "broilers," 5′ to 5′3″.[26] In addition, the fast-paced, innovative, and complex patterns of production of Ford's Highland Park and, by the later 1920s, River Rouge factories found their analogy in Berkeley's extraordinary stage productions. As a *New York Times* critic admiringly observed in 1928, these dance numbers combined the utmost speed of which the human body was capable with "complicated and subtle rhythms that many a trained musician or a trained artist-dancer would find next to impossible to perform."[27] Gramsci had maintained "The exaltation of passion cannot be reconciled with the timed movements of productive motions connected with the most perfected automatism."[28] Berkeley and other dance directors apparently believed just the opposite. In their work, the mechanical and the erotic met and merged.

*Figure 12. Busby Berkeley's "Machinery Ballet," The Earl Carroll Vanities of 1928.
(University of North Carolina at Chapel Hill)*

The analogies between these Broadway revues and the assembly line could often be obscured by the late Victorian trimmings that garnished many musical production numbers; yet at times choreographers, including Berkeley himself, made the parallels startlingly overt. To cite but one instance, for *The Earl Carroll Vanities of 1928*, Berkeley devised "The Machinery Ballet," a number, according to the program, that was directly inspired by a tour of a Ford factory (Fig. 12). The number began by evoking the factory gates; then it offered its own version of the assembly line. As fiery lights flashed and smoke belched, robotic chorines danced in metallic costumes fitted with dials and switches. They whirled and spun, rose and fell in repetitive gestures as they continuously cycled past a series of platforms. Above them, a single dancer slowly turned cartwheels like a human cogwheel, then concluded with a lockstep march. In "The Machinery Ballet," Berkeley succeeded in creating a number that was both the hit of a revue famous for its raunchy appeal and a dance that critics compared to such recent modernist developments as Russian constructivist art, Karal Capek's play *R.U.R.* (1923), and Fritz Lang's film *Metropolis* (1926).[29]

On a deeper level, the theme of the assembly line informs many of Berkeley's dances, even—perhaps especially—when its imagery is explicitly purged. Such is the case with the final dance number to be considered in this essay, "By a Waterfall" from *Footlight Parade* (1933).

Like *42nd Street*, made earlier the same year, the storyline of *Footlight Parade* emphasizes how the work of putting on a production number resembles a factory in its relentless labor, anxiety, and fatigue. By contrast, almost all of the musical numbers themselves appear to emerge fully achieved without any glimpse of rehearsals or suggestion of internal effort. By capturing this bifurcation between work and consumption, denial and display, these films register the deeper rhythms

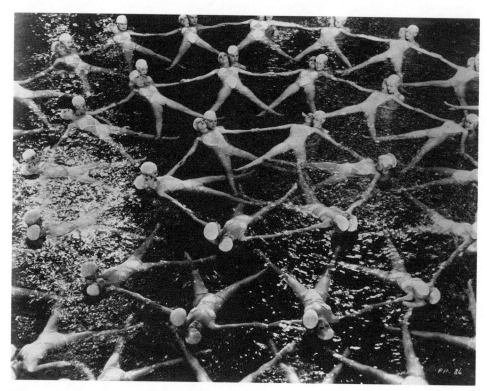

Figure 13. Interchangeable nymphs: Busby Berkeley's "By a Waterfall," Footlight Parade. *(Courtesy of Turner Entertainment and Film Stills Archive, The Museum of Modern Art, New York)*

of modern industrial capitalism. At the same time, despite their character as backstage musicals that supposedly show us the effort that the theater audience never sees, they not only preserve but also give new meanings to what Karl Marx satirically termed commodity fetishism, in which capital (here, musical spectacle and female pulchritude) seems to reproduce itself magically apart from human labor.

"By a Waterfall" is the supreme instance of the Berkeley dance that insists on its utter remove from the world of mechanical production—only to testify to that world's underlying values. Here Berkeley gives us another dream of nymphs—not just one nymph (as in Chaplin) or a cluster (as in Nijinsky) but hundreds of them. The number begins with a shot from the perspective of a stage audience—and then gaily tugs moviegoers imaginatively out of their seats to witness effects impossible to capture on stage. After a prologue in which Dick Powell sings a song to Ruby Keeler and then falls asleep, she slips off her dress to caper with a veritable colony of water nymphs around a spectacular woodland waterfall that melds into an enormous swimming pool. As the beaming nymphs frolic in the water, Berkeley's camera joins wholeheartedly in the water play. It repeatedly dives under the surface and pops up again as it sports with and ogles the chorines. Then, it ascends to a commanding perspective as the interchangeable water nymphs lose their indepen-

Figure 14. Human fountain in "By a Waterfall," Footlight Parade. *(Courtesy of Turner Entertainment and Film Stills Archive, The Museum of Modern Art, New York)*

dent human appearance entirely (Fig. 13). Concealing all but their heads and arms beneath the surface of the water, Berkeley organizes them like mechanical components into a spectacular series of abstract patterns. Assembled in straight lines with each girl placing her hands on the shoulders of the one in front of her, they merge, first, into sinuous rows. Then, as they drop their heads and bring their extended arms together to form triangles, they cluster in revolving kaleidoscopic wheels. Then the scene and perspective shift once more. The nymphs form an elaborate, five-tiered, rotating fountain that is enlarged still further through its reflection in the water (Fig. 14). Their individual bodies are recognizable once more, and their spread legs (a reiterated motif in this number as in much of Berkeley's work) carry an unmistakable implication of sexual availability. In these sequences, the chorines suggest structures that are both organic and industrial: snakes that might also be chains, geometric flowers that might also be gears, fountains that might also be turbines. The streams of water in the fountain sequence create an almost urinary or ejaculatory motif—perhaps a final outpouring of relief from the pent-up regime of the factory. Here is a brave new world of play fitted to Ford's assembly line. What remains at once abstractly beautiful and humanly disturbing about both is the way in which individual bodies are completely subordinated to the requirements of the larger impersonal design. The dream of erotic bliss cloaks the nightmare of industrial drudgery.

Whether these four dances celebrated the promise of modern industrial society or, in the case of Chaplin, protested against it, all pointed to the ways in which

modern machinery and the organization of mass production fundamentally altered the bodily rhythms governing work and play alike, from fatigue to erotic pleasure. The values of speed, standardization, interchangeability, uniformity, division of labor, and specialization of task had been prominent in American industrialization for at least a century by the time that Ford introduced assembly line production to Highland Park, but the potential of their full implementation and the aesthetic challenge that these values involved had never before been so fully grasped. Among those who responded most immediately and creatively were Hollywood comedians and choreographers, both keenly attuned to the literal and metaphoric rhythms of modern life. As they explored the aesthetic possibilities of a new, self-consciously modern Machine Age, they revealed some of its political stakes as well. A defining element of individuality in an age of mass production, their work suggests, was the freedom to create one's own dance out of improvised rather than compulsory rhythms and patterns. "Man's chief difference from the brutes," wrote William James, "lies in the exuberant excess of his subjective propensities. . . . Prune down his extravagance, sober him, and you undo him."[30] He might also have been defining a key difference between human beings and machines.

NOTES

1. McNeill, *Keeping Together in Time*. McNeill speculates that not only is the ability to perform dance and drill a unique human achievement; it also may be an essential element in our evolution to human society.

2. Hounshell, *From the American System*, 247–48. Hounshell's figures for the original output per worker are clearly erroneous, however.

3. Ford, *My Life and Work*, 83, 80.

4. Hounshell, *From the American System*, 244.

5. Appleton, *Introduction of the Power Loom*, 15. On both Lowell, Mass., and the aesthetics of machinery and machine production in the nineteenth century, see Kasson, *Civilizing the Machine*.

6. Arnold and Faurote, *Ford Methods and the Ford Shops*, 135. Prepared in 1914, this work was previously published in *Engineering Magazine*. The relative contributions of Arnold and Faurote are detailed on p. iii.

7. Hounshell, *From the American System*, 257–59.

8. Panofsky, "Style and Medium," 18.

9. Bergson, "Laughter," 79.

10. Brownlaw, *The Parade's Gone By*, 463.

11. Chaplin, *Autobiography*, 415.

12. "Chaplin Hero of the Masses."

13. "Chaplin: Machine-Age *Don Quixote*," 26.

14. Chaplin, *Autobiography*, 397.

15. Panofsky, "Style and Medium," 20.

16. Chaplin, *Autobiography*, 397, 412–13.

17. Gramsci, "Americanism and Fordism," 297.

18. Smith, *Making the Modern*, 51.

19. Chaplin, *My Autobiography*, 202–6. Chaplin had earlier made use of Nijinsky's ballet in the 1919 film *Sunnyside*; see McDonald and Mark Ricci, *Complete Films of Charlie Chaplin*, 160.

20. Thomas, *Astaire*, 130.

21. Croce, *The Fred Astaire and Ginger Rogers Book*, 120.

22. Berliner, *Thinking in Jazz*, 487.

23. For convenience I speak here of a single camera, but at this time Astaire generally used three cameras more or less side by side. In a highly revealing interview conducted in 1937, the year of *Shall We Dance*, Astaire declared: "If possible, one 'take' will be used for the whole dance. If, however, the 'B' take is much better in one sequence while the 'A' is better in another, the best sequences are pieced together, but the sequence of the dance itself is never broken." Eustis, *Players at Work*, 108. John Mueller (*Astaire Dancing*, 19) notes that Astaire performed only a few trios and still more rarely made a chorus an integral part of his choreography.

24. Eustis, *Players at Work*, 110–16; Mueller, *Astaire Dancing*, 16, 27–30.

25. Rubin, *Showstoppers*, 75.

26. Morgan, "Handling Humanity in the Mass," 146; Cohen, "Dance Direction of Ned Wayburn," 141, 158–59.

27. "The Dance: New Musical Comedy Talent," sec. 7, p. 6.

28. Gramsci, "Americanism and Fordism," 305.

29. "Even Broadway at Last Begins to Understand," 626; Seldes, "Splash!," 21; Rubin, *Showstoppers*, 52.

30. James, "Reflex Action and Theism," 132.

BIBLIOGRAPHY

Appleton, Nathan. *Introduction of the Power Loom, and Origin of Lowell*. Lowell, Mass.: Penhallow, 1858.

Arnold, Horace Lucien, and Fay Leone Faurote. *Ford Methods and the Ford Shops*. New York: Engineering Magazine Co., 1915.

Bergson, Henri. "Laughter." In Wylie Sypher, ed., *Comedy*, 58–190. Garden City, N.Y.: Doubleday, 1956.

Berliner, Paul F. *Thinking in Jazz: The Infinite Art of Improvisation*. Chicago: University of Chicago Press, 1994.

Brownlaw, Kevin. *The Parade's Gone By*. New York: Bonanza, 1968.

Chaplin, Charles. *My Autobiography*. New York: Simon and Schuster, 1964.

"Chaplin Hero of the Masses." *Detroit News*, October 16, 1923.

"Chaplin: Machine-Age *Don Quixote*." *Literary Digest* 120 (November 2, 1935): 26–27.

Cohen, Barbara Naomi. "The Dance Direction of Ned Wayburn: Selected Topics in Musical Staging, 1901–1923." Ph.D. diss., New York University, 1980.

Croce, Arlene. *The Fred Astaire and Ginger Rogers Book*. New York: Galahad, 1972.

"The Dance: New Musical Comedy Talent." *New York Times*, July 22, 1928.

Delattre, Roland A. "The Rituals of Humanity and the Rhythms of Reality." *Prospects* 5 (1980): 35–49.

Eustis, Morton. *Players at Work: Acting according to the Actors*. 1937. New York: Benjamin Blom, 1969.

"Even Broadway at Last Begins to Understand." *Journal of Electrical Workers and Operators* 22 (December 1928): 626.

Feuer, Jane. *The Hollywood Musical*. 2d ed. Bloomington: Indiana University Press, 1993.

Ford, Henry, with Samuel Crowther. *My Life and Work*. Garden City, N.Y.: Doubleday, Page, 1923.

Gramsci, Antonio. "Americanism and Fordism." In Quintin Hoare and Geoffrey Nowell Smith, eds. and trans., *Selections from the Prison Notebooks*, 279–318. New York: International Publishers, 1971.

Hounshell, David A. *From the American System to Mass Production, 1800–1932: The Development of Manufacturing Technology in the United States*. Baltimore: Johns Hopkins University Press, 1984.

James, William. "Reflex Action and Theism." In *The Will to Believe and Other Essays in Popular Philosophy*, 111–44. 1897. Reprint, New York: Dover, 1956.

Kasson, John F. *Civilizing the Machine: Technology and Republican Values in America, 1776–1900*. New York: Viking Press, 1976.

L'Après-midi d'un faune: Vaslav Nijinsky, 1912. Thirty-three photographs by Baron Adolf de Meyer, with an essay by Jennifer Dunning and contributions by Richard Buckle and Ann Hutchinson Guest. New York: Dance Horizons, 1983.

Lynn, Kenneth S. *Charlie Chaplin and His Times*. New York: Simon and Schuster, 1997.

McDonald, Michael Conway, and Mark Ricci. *The Complete Films of Charlie Chaplin*. Secaucus, N.J.: Citadel, 1965.

McNeill, William H. *Keeping Together in Time: Dance and Drill in Human History*. Cambridge: Harvard University Press, 1995.

Morgan, Mary. "Handling Humanity in the Mass." *Theatre Magazine* 17 (May 1913): 146–47, vi.

Mueller, John. *Astaire Dancing: The Musical Films*. New York: Knopf, 1985.

Nectoux, Jean-Michel. *L'Après-midi d'un Faune: Mallarmé, Debussy, Nijinsky*. Les Dossiers du Musée d'Orsay, 29. Paris: Ministry of Culture, 1989.

Panofsky, Erwin. "Style and Medium in the Motion Pictures." *Critique* 1 (January–February 1947). Report in Daniel Talbot, ed., *Film: An Anthology*, 15–32. Berkeley: University of California Press, 1966.

Robinson, David. *Chaplin: His Life and Art*. London: Collins, 1985.

Rubin, Martin. *Showstoppers: Busby Berkeley and the Tradition of Spectacle*. New York: Columbia University Press, 1993.

Seldes, Gilbert. "Splash!" *New Republic*, August 22, 1928.

Smith, Terry. *Making the Modern: Industry, Art, and Design in America*. Chicago: University of Chicago Press, 1993.

Thomas, Bob. *Astaire: The Man, the Dancer*. New York: St. Martin's, 1984.

CAROL J. OJA

··

George Antheil's *Ballet Mécanique* and Transatlantic Modernism

We of twenty are frankly tired of the experiments of "Les Six," and of the clan-worshippers of Stravinsky and Schönberg. Coming fresh-eyed and eared to the scene it looks to us very much like the ancient fetish of Wagner, only this time it is the Three-Headed-God, Satie-Schon-Strawagnerism!

Strawagnerism! why not?

But we of twenty come to this condition eager, and with other sounds in our heads which demand still a new machinery and a new aesthetic. We come born with a different sense of organization and development.

—*George Antheil to his patron Mary Louise Curtis Bok, August 1922*

Radical young American composers of the 1920s often issued bold proclamations. Intent on shedding postcolonial insecurities, they did not want to be viewed simply as "American composers" but rather as "international modernists," hoping to gain full citizenship in an active transatlantic community. As is well known, many of them traveled and studied abroad, especially in Paris. Less acknowledged, however, is the degree of cultural reciprocity that existed. As Edmund Wilson observed early in the decade, Americans were "startled" to find Europeans "looking longingly" in their direction.[1] For every major residency in Europe by Aaron Copland, Roger Sessions, or Virgil Thomson, there was a much-publicized American tour by Béla Bartók, Darius Milhaud, Maurice Ravel, or Igor Stravinsky or a full-fledged move to the United States by Edgard Varèse or Dane Rudhyar. While Americans sought to keep current with the newest compositional trends abroad, there was avid curiosity on the other side of the ocean about the skyscrapers, films, and popular music that seemed to symbolize a glistening future. Recent American compositions began to appear at newly emerging "international" music festivals in Europe, and American composers successfully presented entire concerts of their

works abroad.[2] Although these fresh-faced Yankees did not enjoy the exalted status of grand European masters, they attained an unprecedented level of international exposure and recognition. A transatlantic modernist movement was taking shape.

Among the many composers striving for this international status, George Antheil (1900–1959) presents an especially intriguing case. A native of Trenton, New Jersey, who became one of the most famous American expatriates of the twenties, he was dramatically affected by international impulses—especially those of the machine movement. As a youth in Trenton he was already gazing abroad, absorbing newly published scores of Igor Stravinsky and Arnold Schoenberg and forming friendships with budding American modernists who held similar transatlantic visions.[3] When he appeared first in London, then in Donaueschingen and Berlin during the summer of 1922, Antheil did not plan to study with a renowned European, as convention might have dictated, but to make a splash as "a new ultra-modern pianist composer."[4] He displayed none of the hesitant diffidence of a naive provincial. Rather, the twenty-two-year-old carried himself with a calculated swagger, boasting that he was a "futurist *terrible*" and identifying with the international avant-garde.[5] He also gave voice to the growing cultural confidence of his compatriots, loudly proclaiming the decadence of Europe and the potential of his own land. "Civilization moves towards the west," he wrote to his Philadelphia patron, Mary Louise Curtis Bok, soon after arriving in London. "Our only hope is America. . . . Musically—creatively—Europe is exhausted. . . . The War—cataclysmal horror—has changed everything, all fundamentals. . . . This is a new world!"[6]

What followed was a kind of bicontinental tango. Antheil remained abroad until 1933, striving to build a career there and doing so with a knack for flamboyant self-promotion. At the same time he kept a foot on home soil, especially through performances of his works in various new music concerts in New York. Yet as this transatlantic dance unfolded, it turned out to be New York, not Paris, where his most ambitious artistic undertaking of the twenties took place: the American premiere of *Ballet Mécanique* at Carnegie Hall on April 10, 1927 (Fig. 1). It was a high-stakes event. Antheil not only had the audacity to rent one of New York's most sacred temples of art music for an entire concert devoted to his own modernist compositions—an extraordinary step for a young American composer—but he also aimed to make the most of it.[7] With the help of a professional publicist, he staged an elaborate spectacle complete with newly commissioned backdrops, an African American orchestra (W. C. Handy's, which premiered Antheil's *Jazz Symphony* on the same program), and a dazzling battery of machines onstage. The event recalled the extravagant spectacles of P. T. Barnum and foreshadowed performance art of the 1960s. It spurned long-standing distinctions between "high" and "low" art. Moreover, Antheil's gave his concert five weeks before the May 16 opening of the now-famous "Machine-Age Exposition," installed in New York's

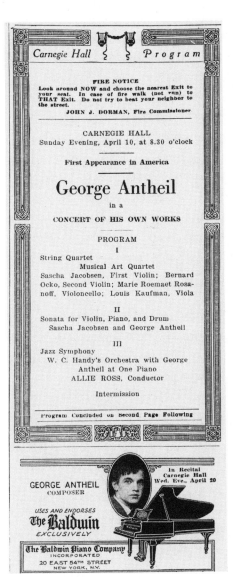

Figure 1. Publicity flier for Carnegie Hall premiere of Ballet Mécanique on April 10, 1927. (Music Division, The New York Public Library for the Performing Arts, Astor, Lenox, and Tilden Foundations)

Steinway Hall and organized by Jane Heap, who had previously published excerpts from Antheil's machine-inspired compositions in the *Little Review*.

Both *Ballet Mécanique* and its American premiere brim with implications about transatlantic modernism. Yet the work has been most often understood in terms of its strong base in Europe. Antheil composed it in Paris between 1923 and 1925, and the world premiere took place there on June 19, 1926. Added to that, it had a French title and was conceived simultaneously with a film by the same name, directed by Fernand Léger, a noted European modernist. Less understood, however, were the deep roots of *Ballet Mécanique* in the New World, reaching far into Antheil's formative artistic experiences. Before setting sail for Europe, he had

already initiated a series of compositions focused on the machine and had witnessed the early rumblings of New York Dada, itself a product of transcontinental migrations. *Ballet Mécanique* thus sits amid an intricate nexus of European and American cultural connections in the late 1910s and 1920s.

Just as important, *Ballet Mécanique* deserves credit for some stunning compositional innovations. Often dismissed as a mere gimmick, it is instead a fundamentally radical composition incorporating such techniques as silence, noise, and the extreme use of literal repetition—techniques that decades later would be declared revolutionary. It anticipates the work of John Cage and challenges Edgard Varèse's *Ionisation* of 1929–31 for the distinction of being the first composition solely for percussion. Moreover, it has profound ties to such contemporary interests as hyperspace theory, which, in turn, connects it to experimental trends in the visual arts. For these reasons, *Ballet Mécanique* invites a fresh examination.

To gain a sense of the forces that shaped *Ballet Mécanique*, it is necessary to reach back before the conception of the piece to Antheil's modernist awakening in the United States. In his autobiography, Antheil depicted this time in stark terms, spinning a myth about himself as a congenital futurist, sprung not from the soil but from steel and concrete: "I had been born in Trenton, New Jersey, across the street from a very noisy machine shop. . . . A year later my parents moved several blocks away to across the street from an infinitely more silent but also infinitely more ominous structure, the Trenton State Penitentiary."[8] With a flair for melodrama, Antheil presented his childhood as a metaphor of the Machine Age (Fig. 2).

But youth, for Antheil, brought more than "vistas of distant smokestacks."[9] In 1916, when he was sixteen, Antheil began traveling to Philadelphia, where he studied composition with Constantin von Sternberg, a pupil of Franz Liszt. A staunch upholder of European musical traditions, Sternberg gave his student a "severe theoretical training," by no means opening his ears to new sounds.[10] Yet Sternberg recognized the young man's talent, recommending him to Mary Louise Curtis Bok, who became Antheil's patron for the next nineteen years (in 1924 Bok founded the Curtis Institute in Philadelphia).[11] Study with Sternberg also brought Antheil another benefit: he now had regular access to a city percolating with new art. In 1919 Antheil extended his geographic range further, taking the train regularly to New York, where he began composition lessons with Ernest Bloch, a European immigrant who was aesthetically more progressive than Sternberg but no radical. By 1921, if not before, Antheil's New York visits also included "gatherings of ultras," as he described them.[12] There, in the earliest days of America's modernist music movement, he met critic Paul Rosenfeld and composer-pianist Leo Ornstein—two of its key architects—at the same time as his circle grew to include such figures as *Little Review* editors Margaret Anderson and Jane Heap,

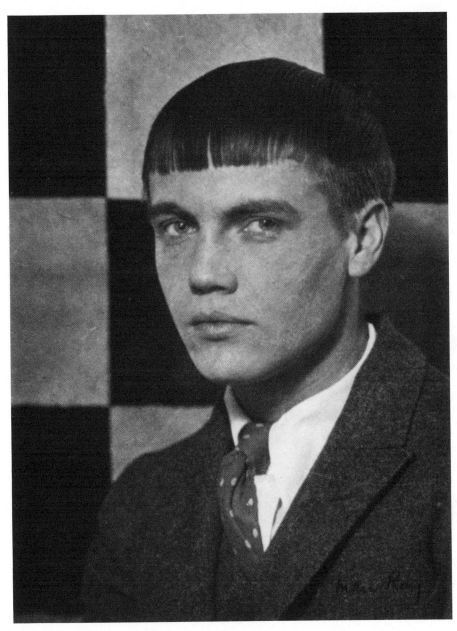

Figure 2. Man Ray, George Antheil, *1924. Photograph.*

photographer Alfred Stieglitz, and painter John Marin.[13] All the while he devoured newly published compositions by Europeans, reporting to Mrs. Bok in 1921: "There are few modern scores with which I am not a little acquainted—and of some (i.e., the Bloch Suite; Schönberg 'Orchesterstücke') I know every note by heart."[14] A week after writing this he told his patron even more, sharing the intensity of his self-driven education: "I am, beyond other things, also becoming acquainted—at odd moments—with several new Strawinsky scores, the very latest,

scarcely yet off print. They are 'Renard' and 'L'Histoire du Soldat' both of which are tragic and funny. I am also becoming acquainted with the very latest work of the now-famous Parisian 'Six'—I mean their orchestral scores which are not known in America, as are the new Stravinsky scores."[15]

In Trenton in 1921 Antheil composed his first machine-based work, *Second Sonata, "The Airplane"* for solo piano. It launched a series of pieces inspired by technology, including *Sonata Sauvage* (1922–23), *Third Sonata, "Death of Machines"* (1923), *Mechanisms* (ca. 1923, not extant), and ultimately *Ballet Mécanique* (begun in 1923). With the *Airplane Sonata* Antheil revealed his exposure to various transatlantic modernist strains, of which the most fundamental was futurism. Beginning with Filippo Marinetti's *Futurist Manifesto* of 1909, the airplane had achieved the status of an icon. It turned up in works as diverse in time and nationality as Franz Kafka's *Die Aeroplane in Brescia* of 1909 and the journal of American poet Harry Crosby, who in 1929, two years after Charles Lindbergh flew over the Atlantic, envisioned aviators as "the new Christ" and airplanes as "the new Cross."[16] The *Airplane Sonata* grew out of this same impulse. In an even broader sense, it showed a young composer drawing on new compositional techniques and using them to establish a voice within the machine aesthetic. Antheil incorporated both tone clusters (dissonant groups of pitches closely spaced together) and insistent ostinatos (short repeating rhythmic and melodic patterns), which he must have learned from studying the music of Stravinsky and Ornstein. But in his hands, they became tools for articulating the "music of precision," as he later dubbed his machine style.[17]

During the years leading up to the *Airplane Sonata*, Antheil was also positioned to witness the unfolding of Dada in both Philadelphia and New York. Although his machine music has previously been connected to Dada, it has been assumed that Antheil came in contact with the movement in Europe after arriving there in 1922, not in the United States.[18] For some of his American contemporaries, this seems to have been the case. Writer Malcolm Cowley, for example, was described by a colleague as "gaping a good Western Pennsylvania gape" when he first encountered Dada in Paris in 1923.[19] But Antheil's initiation took place at home, a microcosm of the international exchange that characterized Dada as a whole. Just as he started venturing to Philadelphia and New York, Dada was springing up simultaneously in both cities, as well as in Zurich. Francis Picabia and Marcel Duchamp, two of its key figures, had both reached New York within the previous several years, as had Edgard Varèse, who sailed to the United States in 1915. These newly arrived Frenchmen launched artistic experimentations in New York amid the chaotic swirl of ideologies and "isms" that fed into Dada, ranging from futurism to the cubism of artists as different as Pablo Picasso and Max Weber. Ultimately, though, New York Dada centered around an obsession with technology. "We are living in the age of the machine," declared a front-page article in Alfred Stieglitz's journal *291* in 1915; "Man made the machine in his own image."[20]

The degree of Antheil's contact with Dada in America during the late 1910s remains speculative, but there is reason to believe that he encountered both musical compositions and visual artworks inspired by the aesthetic. With its pride in being a "matrix of nonsense" and its disdain for labels, especially among Americans who wanted to avoid being identified "yet again [with] something European," New York Dada left a somewhat murky historical trail.[21] Few American composers associated themselves with the term, even though their aesthetic seemed connected to Dada. Beginning around 1913, Leo Ornstein had created a sensation in both Europe and America with works such as *Suicide in an Airplane* and *Wild Men's Dance*, some of which incorporated tone clusters (the same clusters that were a likely source for the *Airplane Sonata*), but he was most often dubbed a "futurist" or "ultra-modern." Antheil referred to Ornstein in letters about his own junkets to New York, writing in early 1922 of a composition he had given "Leo Ornstein three years ago—a little piano piece which he liked and asked for—certainly a painfully immature work."[22] A few months later, as Antheil prepared to set off for London and establish a career abroad, he hired Ornstein's manager, Martin H. Hanson.[23] Antheil's correspondence from this period makes no mention of Varèse, but he was the other main musical figure in America then intrigued by the machine. Varèse deliberately avoided any direct identification with Dada, yet recent research confirms his connection to the movement.[24] In 1918 he began *Amériques*, composed for orchestra with a battery of machines, including fog horn, steamboat whistle, and siren; machines remained central to his entire compositional output.[25] Varèse and Ornstein stood out as isolated cases in America, however, and their works were performed infrequently.[26]

The Dada-inspired visual artists who inhabited Antheil's homeland were, by contrast, more prolific and more outspoken about their connection to the aesthetic. Beginning around 1916, in Philadelphia and New York, a group of painters including Duchamp and Picabia, as well as Morton Schamberg, Charles Sheeler, Max Weber, and others, all pursued ideas that soon cropped up in Antheil's music, whether glorifying the machine or lampooning the pretensions of "high art"—or both. In iconography, technique, and attitude, they struck a pose strikingly similar to Antheil's own.

The paintings of Morton Schamberg (1881–1918), a Philadelphian, open a door to this world. Well known for championing the machine, Schamberg became prominent in Dada with a series of works from around 1916, exhibited just as Antheil was first visiting the city. Schamberg approached technology in two basic ways. Either he rendered mechanical objects in exacting technical detail, as in *Machine Forms: The Well* (Plate 11), which precisely delineated the construction of a drill, or he transformed some aspect of a machine into an abstract, cubist-inspired design, as in *Composition* (Fig. 3), which takes off from images of a wheel and other

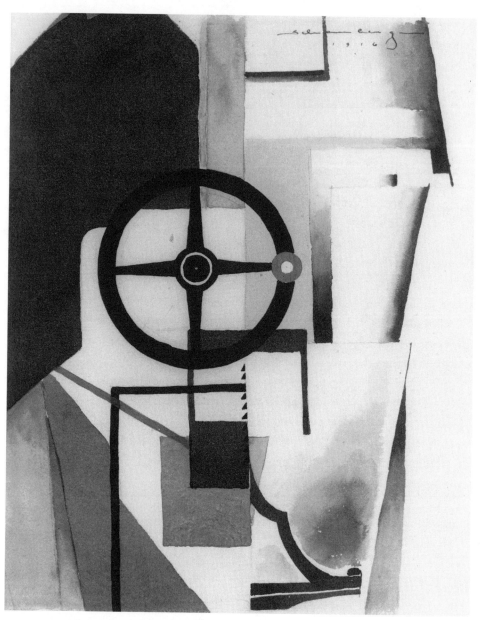

Figure 3. Morton Schamberg, Composition, *1916. Watercolor and graphite. (Columbus Museum of Art, Ohio, Gift of Ferdinand Howald)*

basic geometric shapes. Other Dadaists, most notably Duchamp (Fig. 4), found different approaches to the machine, constructing so-called readymades in which found objects were simply presented as art, with no creative intervention. Duchamp's *Fountain* (Fig. 5), a porcelain urinal fabricated in New York in 1917, was perhaps the most notorious case. Designed for shock value, it issued a direct challenge about the nature of creative expression.[27]

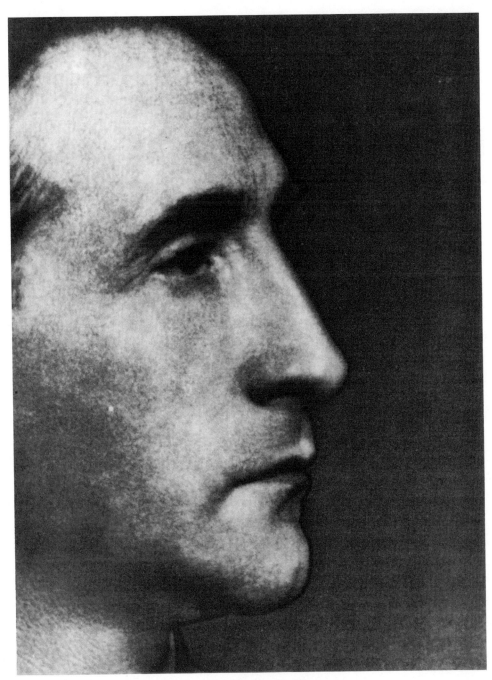

Figure 4. Man Ray, Marcel Duchamp, *ca. 1922. Photograph.*

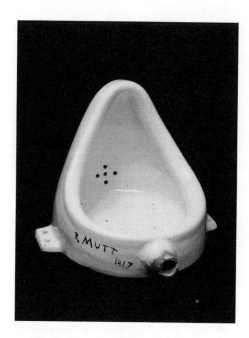

Figure 5. Marcel Duchamp, Fountain, *1917. Porcelain urinal on its back. (Photograph by Alfred Stieglitz; Philadelphia Museum of Art)*

Amid these possible aesthetic connections and historical might-have-beens, Antheil had one documentable ancestor in the New York Dada movement: a drawing by Picabia titled *Ballet Mécanique* that graphically detailed part of a car axle. Like Duchamp's *Fountain*, Picabia's *Ballet Mécanique* was published—in this instance, on the cover of his own American Dadaist magazine *391* in August 1917.[28] The title *Ballet Mécanique* also resonated beyond Antheil, turning up again in 1931 in a conté-crayon drawing by Charles Sheeler (Fig. 6) that depicts a Ford Motor Company plant outside of Detroit.[29] The source of Sheeler's drawing, in turn, can be traced to a series of photographs by him of the same plant commissioned by an advertising agency in 1927—the year of Antheil's Carnegie Hall performance.

When in 1923, as a recent arrival in Europe, Antheil began work on his own paean to a "ballet mécanique," he turned to an image already known in the United States as part of a vital transatlantic aesthetic. Antheil shared with Schamberg, Picabia, and other American-based Dadaists a vision of experimentation and irreverence. Like them, he aimed for art that did not take itself too seriously—art, as Jane Heap wrote, that "laughs, jeers, grimaces, gibbers, denounces, explodes, introduces ridicule into a too churchly game."[30] His *Ballet Mécanique* was a percussive extravaganza that glorified technology by using actual machines, mechanical instruments, and principles of mechanical construction. It combined the various approaches taken by visual artists to the machine, fusing realistic technical rendering (in Antheil's case, simulating the sounds of machines) with fanciful reinterpretation (using technology as inspiration for compositional experiments) and ready-

Figure 6. Charles Sheeler, Ballet Mécanique, *1931. Conté-crayon. (Memorial Art Gallery of the University of Rochester, Gift of Peter Iselin and his sister, Emilie Iselin Wiggin)*

mades (presenting machines as musical instruments). Antheil connected *Ballet Mécanique* to machine ideology in a series of public and private statements, including a 1925 letter that conveyed his ambitious vision with futuristic imagery, telegraphic prose, and characteristic bluster: "My first big work," he wrote. "Scored for countless numbers of player pianos. All percussive. Like machines. All efficiency. No LOVE. Written without sympathy. Written cold as an army operates. Revolutionary as nothing has been revolutionary."[31] He also consistently made comparisons with the visual arts when discussing his innovations in *Ballet Mécanique*, declaring that painters affected his particular vision of a new music: "We of the future find our sense of organization from Picasso rather than Beethoven or Stravinsky for that matter."[32]

Antheil's rhetoric went hand in hand with some startling musical advances that are revealed in a long-neglected 1926 manuscript score.[33] First among them is the use of silence. Although today John Cage stands as the great innovator with silence—especially for the notorious *4'33"* of 1952—he had a significant predecessor in Antheil. Near the end of the 1926 version of *Ballet Mécanique*, Antheil incorporated increasingly prolonged stretches of silence, leading into them with episodes of unaccompanied electric bells. The modules begin toward the end of the piece with several-measure units; eventually, they increase to a 64-beat gulf. Occurring irregularly and disjunctly, these tears in the basic fabric of sound perilously suspend the musical momentum, and their announcement by electric bells incorporates a Dada signifier. At what Tristan Tzara called "the début of Dadaism in Paris" in 1920, Tzara read a newspaper article while an electric bell rang so loudly that no one could hear what he said.[34]

In rationalizing his episodes of silence, Antheil seems to have had no interest in using them to introduce ambient noise, as Cage later did. But he shaped his own theoretical justification, basing it on speculation in vogue at the time about the fourth dimension, a facet of hyperspace theory. Antheil spelled out the connection between *Ballet Mécanique* and the fourth dimension in his manifesto, "My Ballet Mécanique: What It Means," published in the German modernist periodical *Der Querschnitt* in September 1925 (it also appeared in the Dutch magazine *De Stijl*). The opening sentence reads, "My *Ballet Mécanique* is the new *fourth dimension* of music." Antheil continues:

> My *Ballet Mécanique* is the first piece of music that has been composed *out of* and *for* machines, *on earth*. . . .
> My *Ballet Mécanique* comes out of the first and principal stuff of music—*time-space*.[35]

Although Antheil's pronouncements about "time-space" have attracted some attention, they remain oblique, and the compositional ramifications of his odysseys with the fourth dimension have not been explored.[36] With his vision of representing time-space through music, Antheil embraced a major artistic passion of the early twentieth century—one that also affected a variety of visual artists, especially the cubists, and drew its inspiration from then-popular theories about hyperspace. Time-space inspired the conceptual realm of Antheil's *Ballet Mécanique*, providing a compelling rationale for its innovations.

Since Antheil's heyday, science has moved on to black holes and ten-dimensional time-space theory. But in the early twentieth century, it was the fourth dimension that loomed as a higher, unseen component of space, beyond height, width, or depth. It hovered on a hazy border between pop cosmology and true physics, with roots extending into the emergence of non-Euclidian geometry in

the nineteenth century, and it surfaced in such different spheres as Helena Petrovna Blavatsky's *The Secret Doctrine* of 1888, a fundamental text of theosophy, and H. G. Wells's *The Time Machine* of 1895.[37] During Antheil's childhood, popular magazines in the United States generated considerable literature on the subject, especially in 1909, when *Scientific American* sponsored an essay contest for "the best popular explanation of the Fourth Dimension." According to Linda Dalrymple Henderson, the fourth dimension became so widely known that it was "almost . . . a household word by 1910."[38]

The fourth dimension offered visual artists on both sides of the Atlantic a potent tool for theorizing experimental techniques. Most linked it with space rather than time, and the variety of explanations they concocted gives a sense of how fundamentally elusive the concept remained. In 1911 Guillaume Apollinaire wrote that the cubists dealt with "new measures of space . . . designated by the term *fourth dimension*"; one year earlier American painter Max Weber, who had just returned to the United States after an extended stay in France, published an article in Stieglitz's New York journal *Camera Work*, titled "The Fourth Dimension from a Plastic Point of View."[39] There he envisioned the fourth dimension as "the consciousness of a great and overwhelming sense of space-magnitude in all directions at one time." Others followed suit. Morton Schamberg heralded the opening of the famous Armory Show in 1913 with an article for the *Philadelphia Inquirer* in which he examined the impact of the fourth dimension on avant-garde painting, equating it with the "harmonic use of what may arbitrarily be called volume."[40] Three years later Schamberg organized "Philadelphia's First Exhibition of Advanced Art," including paintings by Dadaists and exponents of the fourth dimension, such as Weber, Duchamp, Picabia, and Man Ray. In that same year Antheil began traveling to Philadelphia for composition lessons.

For Antheil, unlike contemporary painters, it was the temporal facet of the fourth dimension that captured his imagination, inspiring the long stretches of silence at the end of *Ballet Mécanique*, as well as other daring passages. His attention turned in this direction just a few years after Albert Einstein, in November 1919, announced his "General Theory of Relativity," which shifted most discussions of the fourth dimension from space to time.[41] In an unpublished manuscript from 1927, the year of *Ballet Mécanique*'s American debut, Antheil directly linked "time" and silence. "Time," he wrote, is "the principal subject of my meditations. Time! Time must be filled—'it is the space of our musical canvas.'" He went on to call *Ballet Mécanique* "the dead line, the brink of the precipice. Here at the end of this composition where *in long stretches* no *single sound occurs and time itself acts as music* [his emphasis]."[42] Through his passages of silence, then, Antheil aimed to project the fourth dimension by baldly exposing time—leaving it essentially suspended on its own, thereby turning it into a compositional device.

Antheil also used the fourth dimension to theorize another compositional experiment: the extreme use of repetition. Although repetition is fundamental to *Ballet Mécanique*, it most often appears in small doses. But there is one point three-fifths of the way through the piece where a fluctuating pattern of six- to eight-note clusters repeats for an extraordinary total of thirty-four times. At first it does so with slight internal mutations, but once the pattern settles into a hard-hitting groove, the passage barrels forward with mind-numbing redundancy. Antheil later linked his experiments with repetition to his obsession with time; he also saw them as emulating the techniques of painters. Typically, he exaggerated the details: "In the *Ballet Mécanique* I used time as Picasso might have used the blank spaces of his canvas. I did not hesitate, for instance, to repeat one measure one hundred times; I did not hesitate to have absolutely nothing on my pianola rolls for sixty-two bars."[43] The 1926 manuscript includes no section where "one measure" repeats "one hundred times." Yet with the module that recurs thirty-four times, Antheil achieved the essence of his claim. This passage has an interesting parallel in the "Entr'acte symphonique" of Erik Satie's *Relâche* of 1924, which accompanied the interpolation of an abstract film by René Clair into a ballet with sets by Francis Picabia. There repetition is a fundamental building block, with the first section of the work, for example, built of a single measure that recurs two dozen times. *Relâche* and *Ballet Mécanique* share a Dada drive to flout tradition. But they differ significantly in both harmonic language and overall character. Whereas Satie's redundancies are diatonic, Antheil's are mostly cluster-based and convey a more brutal sense of assault.[44]

Over and over in his writings, Antheil almost seems to taunt his readers, daring them to question his credibility. Early on he declared to a friend, "Everybody either thinks I'm a genius or a fake. Either is interesting,"[45] and throughout his published statements, including his autobiography of 1945, he darts back and forth between the visionary and the outrageous. Viewed sympathetically, Antheil's inflammatory rhetoric can be seen as fundamental to his Dada-based art. Viewed critically, it often crosses the line into the absurd.

With Antheil's assertions about form—which he claimed as the other key innovation of *Ballet Mécanique*—he sets up just such a puzzle, articulating a radical vision inspired by the fourth dimension but making fantastic claims for its realization in his score. He at once shapes an intriguing new conception of form and undermines his achievement by exaggerating it. According to his manifesto, Antheil saw *Ballet Mécanique* as "attain[ing] a single and gigantic form, . . . like a solid shaft of steel." Ten years later, he modified his story somewhat but retained its core: "I personally consider that the *Ballet Mécanique* was important in one particular and that is that it was conceived in a new form, that form specifically being the filling out of a certain time canvas with musical abstractions and sound material com-

posed and contrasted against one another with the thought of time values rather than tonal values."[46] Antheil thus imagined the form of *Ballet Mécanique* in a radical new way, perceiving it as both visual and physical. In doing so he anticipated spatial compositions such as Varèse's *Poème électronique* of 1957–58 or even sculptural sound installations of the 1970s by Max Neuhaus. At the core of Antheil's vision was the "physicality" of *Ballet Mécanique*, and he hammered this home in the deliberately provocative conclusion to his manifesto: "Now I hope to present you with . . . *the first physical realization of the fourth dimension*. I am not presenting you with an abstraction. I am presenting you with a *physicality like sexual intercourse*."[47] Scatalogy was prevalent in Dada, whether in Duchamp's *Fountain* or Act Two of Satie's *Relâche*, where Satie inscribed the words "ballet obcène [*sic*]."[48]

Yet while *Ballet Mécanique* commands a strong corporeal presence, it does so largely through the impact of hard-hitting timbres and repeated patterns, not through any exceptional structure. In other words, Antheil came up with a novel concept but his musical text was less exceptional. When he climbed down from the realm of visionary metaphors and attempted a straightforward description of the work's structure, he claimed that the "formula" of *Ballet Mécanique* consisted of "AAAAAAAAAAAAAAAAAAAAAAAAA"—or a single section repeated twenty-five times.[49] This, too, was far from the actual achievement. Although Antheil's repetition of patterns reaches an unorthodox length in the section already discussed, he by no means builds an overall structure based on such fundamental redundancy. Rather, he uses a series of patterns, often including internal repeats, that sound for widely varying time periods. Each pattern is abruptly replaced by another. At times the modules recur (especially the first one, which serves a traditional, ritornello-like function). This approach to form is based on the block structure of Stravinsky as well as that of Satie, and it further strengthens the connection between Antheil's music and visual artworks inspired by the machine aesthetic.

The opening of *Ballet Mécanique* gives a sense of how Antheil handles his patterns, attaining a musical parallel to paintings such as Morton Schamberg's *Machine Forms: The Well*, where a machine was precisely rendered. Though Antheil later averred that he "had no idea . . . of *copying* a machine directly down into music," there are significant patches of *Ballet Mécanique* where he accomplishes that very goal.[50] Like gears grinding in place and then shifting to another speed, Antheil's patterns at the opening can be heard as simulating motoric motion. They repeat for a time and then abruptly replace one another. First, a multilayered ostinato in the pianolas irregularly alternates four chords. This initial pattern is then interrupted by erratic chromatic octaves, and these octaves, in turn, assume different incarnations—repeated literally, placed in different ranges, lasting different lengths. Next, a related pattern uses variants of the opening chords. Soon after that, yet another pattern enters—this one syncopated and built of fifths. After the close of

the opening section, a whole new unit of pendular clusters and glissandos abruptly introduces new textures, extreme registers, and a more open musical space.

At the same time as this blocklike structure is fundamentally Stravinskyan, it is based on contrast, a concept promoted by Fernand Léger, who directed the experimental film intended to accompany Antheil's score. The nature of Léger's collaboration with Antheil remains mysterious.[51] The score and film were not performed together until October 18, 1935, when a version of Antheil's score for pianola alone was coordinated with the film at the Museum of Modern Art in New York. Yet Léger provides another clue to the transatlantic reciprocity that defined Antheil's involvement in Dada and the machine aesthetic. Although Léger did not visit the United States until 1931, eight years earlier he had published there an English translation of his two-part manifesto, "The Esthetics of the Machine," in Jane Heap's *Little Review*; the first installment appeared in the same issue as an excerpt from Antheil's *Airplane Sonata*.[52] In it Léger outlined a rationale for how the machine could "hold a legitimate place in the world of the beautiful." In the same year he declared that "contrast" was fundamental to his art, writing of "organization through contrast" and of contrast "as a method of creating an equivalence to life" (Fig. 7). He also attended Antheil's debut concert in Paris on October 4, 1923, when the composer played his *Sonata Sauvage*, *Mechanisms*, and *Airplane Sonata*.[53] Léger's film version of *Ballet Mécanique* (1923–24) put his theory about contrast into practice, using chaotic simultaneity and abrupt juxtapositions of radically dissimilar objects. Built as a flickering montage—from an opening cubist rendition of Charlie Chaplin (Fig. 8) to shots from real life (traffic, feet in motion, a pulsating pile of quiche pans) and moving machinery—it bears a close conceptual relation to the rapidly changing patterns in Antheil's score. Both the film and music also use recurring motifs: in the film, the image of a woman's face, which is increasingly distorted, and in the music, the opening ostinato pattern, which returns in continually evolving incarnations.

Another essential trait of *Ballet Mécanique* is its scoring for an ensemble of percussion and machines. Antheil's work stands near the head of a revolution extending from the Italian futurists, through Varèse's *Ionisation* of 1929–31, which uses a siren as part of its all-percussion ensemble, to John Cage's *First Construction in Metal* of 1939, which employs anvils and brake drums, and his *Imaginary Landscape No. 3* of 1942, which calls for variable-speed turntables and an electric buzzer. Antheil's 1926 manuscript for *Ballet Mécanique* includes three xylophones, electric bells, two wood propellers (one small, one large), a metal propeller, a tamtam, four bass drums, a siren, two pianos, and a pianola. For the Carnegie Hall performance he enlarged the scoring to six xylophones and ten pianos (the pianists included fellow modernist composers Aaron Copland and Colin McPhee, ethnomusicologist George Herzog, and new music virtuoso Carol Robinson), reportedly also

Figure 7. Still from Léger's film Ballet Mécanique. *(Courtesy of Turner Entertainment and Film Stills Archive, The Museum of Modern Art, New York)*

adding whistles, rattles, sewing machine motors, and two large pieces of tin.[54] Here, too, Antheil built on foundations laid by earlier modernist compositions, especially Stravinsky's *Les Noces* of 1914–21, which used a percussion-based orchestra including four pianos, a xylophone, timpani, a bell, and drums. Also Varèse's *Amériques* of 1918–21 and *Hyperprism* of 1922–23 incorporated sirens.

Figure 8. Still from Léger's film Ballet Mécanique. *(Courtesy of Turner Entertainment and Film Stills Archive, The Museum of Modern Art, New York)*

At the core of Antheil's machines was the pianola (or player piano), which suggested yet another connection to Stravinsky. A mechanical instrument popular in parlors early in the century, the pianola used pumping pedals to turn a pre-punched paper roll and activate a keyboard. It served a related function to the compact disc player today, giving an untutored musical enthusiast the capacity to generate sound and becoming a transitional vehicle between the active amateur musical culture of the nineteenth century and the passivity of the late twentieth. With its undifferentiated sound surface, the pianola contributed substantially to *Ballet Mécanique*'s motoric character. In different versions of the score, Antheil varied the number of pianolas. Early on in Paris, he conceived it for sixteen, all run from a common control; by 1926, in working out the version of the score ultimately used in Carnegie Hall, he incorporated only one; and in his 1953 revision, he eliminated the instrument altogether.[55] There were also instances when the work was performed on solo pianola, most notably at the International Society of Contemporary Music's festival in Baden-Baden during the summer of 1927, a few months after the New York premiere, when "a garbled version" of *Ballet Mécanique* was heard because of "a badly functioning mechanical piano."[56] Stravinsky had

already written for player piano when Antheil began his work, most notably his *Study for Pianola* of 1917 and a series of transcriptions for pianola of *Petrushka*, *Pulcinella*, and *Les Noces*, among other works, in the 1920s.[57]

The remaining machines in *Ballet Mécanique* are essentially readymades: genuine mechanical objects that contribute unorthodox timbres and an aesthetic jolt. Yet they are not just thrown in at random by Antheil but carefully worked into the score, often having structural significance. Whenever the siren enters, for example, the work seems to career forward, even to be on the verge of losing control. While the siren produces a sense of chaos so central to Dada, it also signals the appearance of new sections. At the opening, for example, the first such transition is heralded by a 12-bar passage in which the siren gains momentum, exploding wildly once the new material appears. Several other instances occur, most notably at the end of the final chasm of silence, where the siren propels the work to its conclusion with a sense of reckless abandon. Airplane propellers also provide structural markers—most notably in the last part of the section of relentless repetition and at the beginning of the section featuring silence, where they combine with an electric bell. By articulating internal subdivisions in this way, the machines emphasize the sense of cinematic contrast that binds Antheil's score to Léger's film.

Pasting together the transatlantic migrations, Dada connections, hyperspace imaginings, and compositional advances of Antheil's *Ballet Mécanique* yields a collagelike historical profile as richly chaotic as Dada itself. Yet a few more pieces make up the mix, beginning with primitivism and, by extension, Antheil's stance on race.

Gorham Munson, an American literary contemporary of Antheil, observed the affinity between primitivism and the machine aesthetic early on, coining the phrase "skyscraper primitive," and Antheil himself clearly perceived primitivism as one of the pistons in his hard-pounding hymn of praise to the machine.[58] All the banging, hammering, and siren blowing of *Ballet Mécanique* create a visceral excitement; at the same time, the overall surface of the work often seems flat and nondirectional. Like the 1884 novel *Flatland: A Romance of Many Dimensions* by British author Edwin Abbott, which helped popularize the notion of the fourth dimension, and the paintings of the cubists, which were so deeply affected by hyperspace theory, Antheil may have aimed to generate a sense of the fourth dimension by eliminating the third—that is, by creating the musical illusion of a two-dimensional surface. Among contemporary artists exploring the same possibility was Max Weber, who in his article about the fourth dimension suggested that "splendid examples" of "the dimension of infinity" existed in "Archaic" art, as well as that of the Congo.[59]

In 1923 Antheil mused about this unlikely seeming fusion in relation to his machine-inspired sonatas: "I feel that in these few pages I have embraced all

mankind, the fear, impossible hopes, and electricity of the unconscious from the primitive to the mind that dies in the airplane."[60] Whereas most of those works bore titles rife with mechanical imagery, one had a primitivist thrust: *Sonata Sauvage*, which had a first movement shockingly titled "Niggers." This sonata exposed another of the perplexing contradictions in Antheil's character. At the same time as he was capable of using such a crude slur, he could also summon up racial sensitivity. In a private letter written in 1925, he claimed *Ballet Mécanique* to be "symbolic of New York crushing our negro," adding that it had "a primitive rhythm."[61] And he made subsequent statements connecting *Ballet Mécanique* to African Americans. In publicity before the American premiere, he called *Ballet Mécanique* an attempt "to express America, Africa, and Steel," and in notes written during the first of a series of attempts to edit the score, he described its "first 'theme'" as characteristic "of mechanical scientific civilization" and its "second and third" themes as "barbaric ones, not unrelated to the American continent, Indian, Negro."[62] Antheil's instrumentation fused the primitive and the mechanical, uniting brittle xylophones, resonant of their African forebears, with the various machines already cited; he also circulated in a Parisian community intrigued by African Americans. White American Dudley Murphy, for example, who was cinematographer for Léger's *Ballet Mécanique*, went on to produce a number of important "race" films in the United States, including Bessie Smith's *St. Louis Blues* and Duke Ellington's *Black and Tan Fantasy* (both in 1929).

With *Ballet Mécanique*'s New York performance, Antheil aimed for a level of racial integration that was cropping up occasionally in new music circles. For the same Carnegie Hall concert, he hired a famous African American ensemble—W. C. Handy's Orchestra, led for this performance by Allie Ross, a prominent Harlem conductor—to give the premiere of his *Jazz Symphony*. New York's modern music societies were taking similar steps. Florence Mills, a star of black revues, had performed William Grant Still's *Levee Land* for the International Composers Guild in 1926, and in the same year Jules Bledsoe, the original "Joe" in Jerome Kern's *Showboat*, premiered Louis Gruenberg's *The Creation* for the League of Composers.[63] Antheil also cast the *Jazz Symphony* in the rhetoric of race, declaring it to be "a reaction towards negro jazz as away from 'sweet' jazz" (i.e., the brand of polished, polite jazz performed by mostly white ensembles, such as Paul Whiteman's).[64] By doing so he showed an exceptional awareness of the difference between black and white performance styles of the day. His Carnegie Hall concert attracted a more diverse audience than usual. One chronicler commented on its unusual high-low juxtapositions, with "elite subscribers of the Beethoven Association and the Philadelphia Orchestra rubb[ing] shoulders with habitués of night clubs and vaudeville artists."[65] Another noticed that the audience was "filled with the most important people in the City," adding, "to make it more amazing, [there was] one box, even, of negroes."[66]

The New York premiere of *Ballet Mécanique* also involved an exceptional focus on consumer marketing. Antheil approached the event more like a Broadway show than a highbrow concert. He hired a producer (Donald Friede, then vice president at the publishing firm of Boni and Liverwright) to promote it aggressively, and Friede saturated the press with hype about a "sensational American modernist composer."[67] Another gesture toward commercial appeal came in commissioning two stage backdrops from Joseph Mullen, who was then in the midst of a brief career in the theater.[68] Both sets stunned the audience. The one for *Ballet Mécanique* was somewhat benignly perceived, with "a futuristic city of skyscrapers" and "a series of enormous noise-making machines: whistles, riveting machines, airplane propellers, spark plugs, excavating machines." It also had a Dadaesque allusion to Duchamp's *Fountain* with "a more-than-life-size figure of a man jumping off a diving board that seemed to be attached to a curved pipe of the sort generally used in connection with a toilet."[69] But it was the backdrop for the *Jazz Symphony* that really created a stir. Modeled after nightclub sets of the day, it exploited racial taboos, showing "a gigantic Negro couple dancing the Charleston, the girl holding an American flag in her left hand, while the man clasped her ecstatically around the buttocks."[70]

The cumulative hubris of *Ballet Mécanique*'s New York premiere provoked a hostile response in the press, with the critics calling the concert "a bitter disappointment" and dismissing the much-trumpeted *Ballet Mécanique* as "unconscionably boring, artless, and naive."[71] Antheil aimed for a *succès du scandale*—the sort of tomato-throwing, epithet-yelling reception that had launched works such as Stravinsky's *Rite of Spring* in Paris in 1913. But he strained so hard for notoriety that his efforts backfired. As one headline put it, "Expected Riots Peter Out at George Antheil Concert—Sensation Fails to Materialize," typifying the critical response as a whole.[72] Even fellow composers were skeptical. A letter written by Charles Seeger, an "ultra-modern" of Antheil's day, to Carl Ruggles, another experimentalist, dismissed *Ballet Mécanique* as "good vaudeville," apparently seeing no redemption in its compositional experiments or its challenge to the privileged conventions of high art.[73]

With his failure in New York, Antheil watched his dream evaporate of having the rest of his career "take care of itself," as he had once hoped.[74] Instead, the "damned 'Ballet Mécanique,'" as Antheil later cursed it, became his "*nightmare.*"[75] Immediately afterward, he began complaining that the event had put him in "a wholly false light," and he never completely pulled himself out of the resulting debris.[76] He still seemed to believe in the potential of scandalmongering when he titled his 1945 autobiography *Bad Boy of Music*. But the book never managed to restore his status as a rebel. By 1968, when composer-writer Ned Rorem wrote a new introduction to Ezra Pound's *Antheil and the Treatise on Harmony*, he gave a stark

assessment of Antheil's collapsed reputation: "George Antheil. His name to our young is not even a name, and his performances number zero."[77]

Perceived for decades as a misfire—a "flop mécanique" according to its producer Donald Friede—*Ballet Mécanique* can no longer simply be dismissed as a dud. Rather, it stands as a remarkable manifestation of the machine movement, showing energetic interchanges between musicians and visual artists during the 1910s and 1920s. Peeling away the excesses in Antheil's rhetoric and returning to the 1926 manuscript score reveals a composition of imagination and substance that deserves far more respect than it has received to date—especially for anticipating such experimental techniques as silence and readymades (later dubbed "found objects" or "musique concrète") that would occupy inventive composers decades in the future. These traits, in turn, bear witness not only to raw native talent, but also to a richly interconnected Western culture, one where an eager young composer, hailing from a hometown better known for steel mills than high art, could have opportunities to encounter radical new ideas of both European and American origin. Long-held assumptions about the cultural naïveté of young American composers when they reached the Continent during the 1920s need to be reexamined, as does the notion that they were singularly intent on achieving national distinctiveness. Antheil's *Ballet Mécanique* helps to show composers of his generation less as isolationists and more as active players in an international arena. With his noisy salute to the Machine Age, Antheil roared in a transatlantic language, and he did so with distinctive American inflections.

NOTES

1. Wilson, "Aesthetic Upheaval in France." 49.

2. All of the various new music societies formed in New York had some international aims. The International Composers Guild (1921–27) presented mostly new works from abroad, and the League of Composers (founded in 1923 and still in operation) did the same initially. But with the Copland-Sessions Concerts (1928–31) and the Pan American Association (also begun in 1928), there was a new twist: they largely featured works by Americans but presented some of their concerts abroad. From its inception in 1922, the International Society for Contemporary Music increasingly included American composers in its annual festivals.

3. "Transatlantic" not only helps characterize the nature of Antheil's contact with modernism but also is the title of an opera composed by him in 1927–28 and premiered in Frankfurt in 1930.

4. Antheil to Bok, February or March 1923, as quoted in Whitesitt, *Life and Music of George Antheil*, 7. Whitesitt's biography has provided crucial archival material for this essay. The "futurist" or "ultramodern" composer-pianist was a distinct breed of the day, pioneered by Leo Ornstein beginning in the early 1910s and continued in the 1920s by both Antheil and his American contemporary, Henry Cowell. European modernists such as Igor Stravinsky and Béla Bartók exemplified the type as well.

5. Antheil to Hart, [June 26, 1922].

6. Antheil to Bok, [June 1922].

7. Another notable case was that of Henry Cowell, whose New York debut as a composer-pianist had taken place in Carnegie Hall on February 4, 1924.

8. Antheil, *Bad Boy of Music*, 13–14.

9. Ibid., 14.

10. Ibid., 16. Sternberg published an article titled "Against Modern'ism,'" which is a strong reactionary statement about recent compositional developments, calling for "musicians and music-lovers [to] demand from the divine art more than mere 'cleverness'" (p. 1). In a letter written later that year, Antheil acknowledged Sternberg's traditionalism, saying that his teacher had "lectured" him "concerning 'modernistic' art and music. . . . I did not understand and was astonished. . . . Still I adore Mr. Sternberg—he is my musical godfather and without whose severe and yet kindly training I would be nowhere today and I must listen;—for a little conservatism will do the radical no harm, even as a little radicalism will do the conservative no harm." Antheil to Bok, November 10, [1921].

11. Whitesitt, *Life and Music of George Antheil*, 6.

12. Antheil to Hart, May 9, 1922.

13. Antheil shared a house with Anderson and others in Bernardsville, N.J., during the summer of 1921. In this same period Antheil was involved in plans to form a "modern artists society," which he termed "an international thing" that would involve Ezra Pound, Mary Garden, Picabia, and Picasso. "It is a kind of society which will have as its object the propaganda of modern art, and will among other things establish in New York City a kind of 'Salon' or meeting ground for the exchange of ideas, and a magazine devoted to the most modern art . . . *and* a small symphony orchestra especially designed to present modern and ultra-modern works." Antheil to Bok, [December 14, 1921]. Antheil mentions this society in other letters as well. It apparently did not materialize but sounds like a competitor to Varèse's International Composers Guild and a forerunner of the League of Composers, as well as its magazine *Modern Music*, begun in 1924. Plans for this society also suggest that Antheil knew Pound before reaching Europe. Pound's notorious *Antheil and the Treatise on Harmony with Supplementary Notes* is part of Antheil's story in Europe and is summarized briefly in Whitesitt, *Life and Music of George Antheil*, 16–19.

14. Antheil to Bok, [December 7, 1921]. The pieces he refers to are Ernest Bloch's *Suite for Viola and Orchestra* of 1919, which gained considerable publicity through winning the Coolidge Prize, and Arnold Schoenberg's *Fünf Orchesterstücke* of 1909, first performed in the United States by the Boston Symphony Orchestra in 1914.

15. Antheil to Bok, [December 10, 1921]. *Renard* was published in 1916 (Geneva: Ad. Henn) but not premiered until May 1922 in Paris. With *L'Histoire*, Antheil must have been referring to a suite arranged for violin, clarinet, and piano and published in 1920 (London: J. and W. Chester); the full score was not issued until 1924 (White, *Stravinsky*, 239, 264, 275). Antheil mentioned "Les Six" just as the first round concluded a monthly series of articles by and about Satie and "Les Six" that were published in *Vanity Fair* in 1921: Satie, "A Hymn in Praise of the Critics" (September) and "A Lecture on 'The Six'" (October); Paul Rosenfeld, "The Musician as a Parodist of Life: The Newest French Group Compose in a Spirit of Gay Contemptuous Irony and Unpretentious Charm" (November) and "Satie and 'Socrate'" (December).

16. Crosby, *Shadows of the Sun*, 146.

17. "Music of Precision" is the title of the chapter about *Ballet Mécanique* in Antheil, *Bad Boy of Music*, 131–43.

18. See, e.g., Whitesitt, *Life and Music of George Antheil*, 13–14.

19. Munson, "The Fledgling Years," 46.

20. Paul B. Haviland, untitled essay, *291* 7–8 (September–October 1915): 1, as quoted in Tashjian, *Skyscraper Primitives*, 43.

21. Tashjian, *Skyscraper Primitives*, 14 (first quotation); Kuenzli, Introduction to *New York Dada*, 5 (second quotation).

22. Antheil to Bok, [January 14, 1922].

23. In an uncharacteristically mature letter to his patron, Antheil sensibly laid out his plans for a debut as a pianist in London and told of visiting his "old friend, Mr. M. H. Hanson." Antheil to Bok, [April 17, 1922].

24. Olivia Mattis devotes a chapter of her dissertation to "Varèse and Dada," arguing that Varèse's later denials of involvement with the Dada movement were part of his "revisionist" drive. She piles up significant evidence, including mentions of Varèse in the diaries of Beatrice Wood, "a ceramic artist who met Varèse in 1916 shortly after his arrival in New York" and was a lover of Duchamp, as well as letters from Varèse to Picabia written around the same time. Mattis, "Varèse and the Visual Arts," 122–48.

25. Unless Antheil had an opportunity to view the score to *Amériques* while Varèse was at work on it (and to my knowledge there is no documentation for such an encounter), he probably did not hear the piece until after *Ballet Mécanique* was completed—if at all. *Amériques* did not receive its premiere until 1926 by Leopold Stokowski in Philadelphia.

26. Ornstein essentially retired from the concert stage in the early 1920s, giving only occasional recitals after that date, and performances of Varèse's music started up soon after that with the founding of his International Composers Guild in 1921. The guild performed Varèse's *Offrandes* in 1923 and averaged one work each year by him until 1927, when the organization folded.

27. *Fountain* was disseminated among American modernists through publication in the little magazine *The Blind Man* in May 1917. Schamberg confected a related readymade in 1918 titled *God*, which was "an assemblage with a convoluted and tarnished brass plumbing trap set in a miter box" (Tashjian, *Skyscraper Primitives*, 206). In a letter to Bok from Berlin on April 5, 1923, Antheil mentions writing a *Jesus Christ Sonata* (not extant) (Whitesitt, *Life and Music of George Antheil*, 202).

28. The link between Picabia's sculpture and Antheil's composition was first pointed out by Maurice Peress in liner notes for his 1992 recording of the original score to *Ballet Mécanique* (Music-Masters, 67094-2, p. 16), inspiring me to explore Antheil's connection to American Dada.

29. See Erica E. Hirschler, [*Ballet Mécanique*], in Peters, *Memorial Art Gallery*, 212–13. My thanks to Erica Hirschler for telling me about Sheeler's drawing.

30. Jane Heap, "Dada," *Little Review* 8 (Spring 1922): 46.

31. Antheil to Hart, [March 9?, 1925].

32. Antheil to Bok, [August 1922].

33. Most of Antheil's compositional innovations in *Ballet Mécanique* are unknown today because of the composer's wholesale revision of the score in 1953 for publication six years later by Templeton Publishing Co. He shortened the composition by ten minutes, aiming, in his words, to make it "more concise." In doing so he excised the experimental sections, cutting out the ones with silence and extreme repetition (which are discussed in the pages that follow). He also removed the pianola and added a glockenspiel, giving the work more tinkly effervescence than brute authority. The 1959 imprint continues to be used by performers, with one exception: the 1992 recording conducted by Maurice Peress.

34. Tzara, "Some Memoirs of Dadaism," 70. An example of the transatlantic twists in Dada, the article including this quotation was written by the Swiss grandaddy of the aesthetic and published in America.

35. Antheil, "My Ballet Mécanique: What It Means" and "My Ballet Mécanique."

36. Whitesitt provides essential sources for probing Antheil's connections to time-space, and Henderson (*The Fourth Dimension*, 328–30) opens up the discussion of Antheil's connection to hyper-space theory. Henderson does not deal specifically with Antheil's music, but she does provide much of the background that follows about the popularization of the fourth dimension.

37. Theosophy, in turn, affected certain modernist composers. See Tick, "Crawford's 'Spiritual Concept.' "

38. Henderson, *The Fourth Dimension*, 41 (quotation from *Scientific American*), 43 ("a household word").

39. Guillaume Apollinaire, "La Peinture nouvelle: Notes d'art," *Les Soirées de Paris* 3 (April 1912): 90, and Max Weber, "The Fourth Dimension from a Plastic Point of View," *Camera Work* (July 31, 1910): 25, are both quoted in Henderson, *The Fourth Dimension*, 44 and 168 respectively.

40. Schamberg's statement, from "Post-Impression Exhibit Awaited," *Philadelphia Inquirer*, January 19, 1913, is quoted in Henderson, *The Fourth Dimension*, 173–74.

41. In 1922 Dane Rudhyar, a French American experimentalist composer who was a near-contemporary of Antheil, announced that "the theory of Relativity is sweeping the intellectual world of to-day" (Rudhyar, "The Relativity of Our Musical Conceptions," 108).

42. Antheil, untitled manuscript, beginning "The drawings of Miro," ca. 1927, quoted in Whitesitt, *Life and Music of George Antheil*, 104–5.

43. Antheil to Slonimsky, July 21, 1936.

44. In his typically combative way, Antheil saw *Relâche* as a competitor. In *Bad Boy of Music*, he recounted the following sequence of events: first "announcing to the press" that he was at work on *Ballet Mécanique*, then having Dudley Murphy become interested in making a film counterpart, and finally having Murphy invite Léger "to collaborate." After Léger consented to do so, according to Antheil, "Satie immediately announced that he too would write a mechanical ballet, to be called 'Relâche.' It was to be accompanied (in part) by a surrealist film by René Clair and Man Ray" (pp. 134–35).

45. Antheil to Hart, [December 16, 1921].

46. Antheil to Slonimsky, July 21, 1936.

47. Antheil, "My Ballet Mécanique: What It Means," 791.

48. Gillmor, *Erik Satie*, 251.

49. Antheil, untitled manuscript, ca. 1927, quoted in Whitesitt, *Life and Music of George Antheil*, 105.

50. Antheil, *Bad Boy of Music*, 140.

51. In *Bad Boy of Music*, Antheil claims that he initiated the project (p. 135), and a monograph about Léger asserts that Antheil "saw and admired the film and composed the music shortly afterwards" (De Francia, *Fernand Léger*, 59). De Francia erroneously credits Virgil Thomson's autobiography as his source.

52. Léger, "Esthetics of the Machine / Manufactured Objects / Artisan [Part I]," 46.

53. Léger, "Notes on the Mechanical Element [1923]," 30, and "Notes on Contemporary Plastic Life [1923]," 25, both reprinted in Léger, *Functions of Painting*. Antheil's Paris debut was reviewed by Caesar Searchinger, who noted Léger's presence there. "The Greatest Coup of the Age," *Der Querschnitt* 4 (1924): 47–48, as quoted in Whitesitt, *Life and Music of George Antheil*, 19.

54. The pianists are listed in the program for the concert; Eugene Goossens conducted. The additional noisemakers are cited in a front-page story about the event in the *New York Herald-Tribune*: "Boos Greet Antheil Ballet of Machines." The scoring of *Ballet Mécanique* varied from one performance to another.

55. These incarnations are documented in Whitesitt's work catalog, *Life and Music of George Antheil*, 227–28.

56. Copland, "Baden-Baden," 34. After the Carnegie Hall debacle, this was yet another nail in *Ballet Mécanique*'s coffin.

57. White, *Stravinsky*, 619–20. Gershwin, too, made a number of recordings on the instrument.

58. Munson, "Skyscraper Primitives." This title was subsequently used by Tashjian in his study of New York Dada.

59. Weber, "The Fourth Dimension." Apollinaire made a similar connection, finding that the fourth dimension attracted "many young artists who contemplate Egyptian, negro, and oceanic sculptures, meditate on various scientific works, and live in anticipation of a sublime art" (Apollinaire, *Les Peintres Cubistes*, 16–17, as quoted in Henderson, *The Fourth Dimension*, 80).

60. Antheil to Bok, [April 5, 1923].

61. Antheil to Bok, [October 19, 1925].

62. The first quotation turns up in many publications, including "Goossens to Conduct 'Ballet Mécanique' " and program notes for the Carnegie Hall concert ("George Antheil: First American Appearance in a Concert of His Own Works"). The second quotation is found in Antheil, "Composer's Notes on 1942–43 Re-Editing."

63. At the same time minstrel conventions persisted, as African American characters continued to be depicted by whites in blackface. Among New York's modernists, this occurred at the Metropolitan Opera with the world premiere of John Alden Carpenter's *Skyscrapers* (1926) and the American premiere of Ernst Krenek's *Jonny spielt auf* (1929).

64. Antheil, as quoted in "George Antheil: First American Appearance in a Concert of his Own Works."

65. "Antheil's 'Ballet Mécanique' Causes a Near Riot," 19.

66. Billy, "George Antheil." African Americans had a significant history in Carnegie Hall, however, with a series of concerts conducted there by James Reese Europe with the Clef Club Orchestra from 1912 to 1914. Also, W. C. Handy staged a major Carnegie Hall concert the year after his orchestra appeared there with Antheil.

67. Concert flier for the New York premiere, as quoted in Whitesitt, *Life and Music of George Antheil*, 31. A full account of the aggressive marketing of this concert is contained in Whitesitt, 31–33; also in Donald Friede's autobiography, *The Mechanical Angel*, 44–61.

68. Mullen's stage career was short-lived, extending from 1924 to 1931, when he began working as an interior designer (Owen, *Scenic Design on Broadway*, 133).

69. Friede, *The Mechanical Angel*, 49.

70. Ibid.

71. The first quotation is from Pitts Sanborn, who was by no means a foe of contemporary music. He published a number of articles in *Modern Music* chronicling the performance of new works (mostly European) in New York (Sanborn, "G. Antheil Presents"). The second quotation comes from Lawrence Gilman, less a supporter of modernism than Sanborn, but more open-minded than some of his colleagues. This brief excerpt barely gives a flavor of how searing the whole review was (Gilman, "Mr. George Antheil Presents His Compliments"). Both clippings, together with many others from the concert, are in the Antheil Collection, Music Division, Library of Congress.

72. Samaroff, "Expected Riots Peter Out."

73. Seeger to Ruggles, [1927].

74. Antheil to Bok, [?January 4, 1926].

75. Antheil, *Bad Boy of Music*, 138.

76. Antheil, as quoted in "Father of Mechanical Symphonics [*sic*] Dislikes Being Called Jazz Artiste," pasted into a letter from Antheil to Bok, October 24, 1927.

77. Rorem, Introduction to a reprint of Ezra Pound, *Antheil and the Treatise on Harmony*, 7.

BIBLIOGRAPHY

Antheil, George. Letters, Antheil Collection, Music Division, Library of Congress:
Antheil to Mary Louise Curtis Bok, November 10, [1921]; [December 7, 14, and 20, 1921] (written from Philadelphia); [January 14, 1922] (written from Philadelphia); [April 17, 1922] (sent special delivery from Titusville, N.J.); [June 6, 1922] and [June 1922] (both written from London); [August 1922]; [April 5, 1923] (written from Berlin); [October 19, 1925]; [?January 4, 1926]; October 24, 1927.
Antheil to Stanley Hart, [December 16, 1921], and May 9, 1922 (written from Philadelphia); [June 26, 1922]; [March 9?, 1925].
Antheil to Nicolas Slonimsky, July 21, 1936.
——. "My Ballet Mécanique." *De Stijl* 6, no. 12 (1924–25): 141–44.
——. "My Ballet Mécanique: What It Means." *Der Querschnitt* 5, no. 9 (September 1925): 789–90.
——. "Antheil's 'Ballet Mécanique' Causes a Near Riot." *Musical Leader* 52 (April 21, 1927): 19, 109.
——. *Bad Boy of Music*. Garden City, N.Y.: Doubleday, Doran, 1945.
——. "Composer's Notes on 1942–43 Re-Editing." *Ballet Mécanique* (N.p.: Templeton, 1959).
Apollinaire, Guillaume. *Les Peintres Cubistes: Méditations esthétiques*. Paris: Eugène Figuière, 1913.

Billy, "George Antheil," "Paris Comet" [probably a column title], August 10, 1927. Unidentified clipping, New York Public Library at Lincoln Center.

"Boos Greet Antheil Ballet of Machines." *New York Herald-Tribune*, April 11, 1927.

Copland, Aaron. "Baden-Baden, 1927." *Modern Music* (November–December 1927): 31–34.

Crosby, Harry. *Shadows of the Sun: The Diaries of Harry Crosby*. Edited by Edward Germain. Santa Barbara, Calif.: Black Sparrow Press, 1977.

de Francia, Peter. *Fernand Léger*. New Haven: Yale University Press, 1983.

"Father of Mechanical Symphonics [*sic*] Dislikes Being Called Jazz Artiste." *New York Herald, Paris*, October 24, 1927.

Friede, Donald. *The Mechanical Angel: His Adventures and Enterprises in the Glittering 1920s*. New York: Knopf, 1948.

"George Antheil: First American Appearance in a Concert of His Own Works." Program, Carnegie Hall, April 10, 1927. Clippings, New York Public Library at Lincoln Center.

Gillmor, Alan M. *Erik Satie*. Boston: Twayne, 1988.

Gilman, Lawrence. "Mr. George Antheil Presents His Compliments to New York." *New York Herald-Tribune*, April 11, 1927.

"Goossens to Conduct 'Ballet Mécanique': Letter from Antheil Throws Light on Composer and His Musical Credo—How He Views Himself and Europe." *Musical Leader* 52 (February 24, 1927): 5.

Henderson, Linda Dalrymple. *The Fourth Dimension and Non-Euclidean Geometry in Modern Art*. Princeton: Princeton University Press, 1983.

Kuenzli, Rudolf E. Introduction to *New York Dada*, edited by Kuenzli. New York: Willis Locker and Owens, 1986.

Léger, Fernand. "The Esthetics of the Machine/Manufactured Objects/Artisan and Artist [Part I]." *Little Review* 9, no. 3 (Spring 1923): 45–49; [Part II], 9, no. 4 (Autumn–Winter 1923–24): 55–58.

——. *Functions of Painting*. Translated by Alexandra Anderson. Edited by Edward F. Fry. New York: Viking, 1965.

Mattis, Olivia. "Edgard Varèse and the Visual Arts." Ph.D. diss., Stanford University, 1992.

Munson, Gorham. "The Skyscraper Primitives," *The Guardian* 1, no. 5 (March 1925): 164–78.

——. "The Fledgling Years, 1916–1924." *Sewanee Review* 40, no. 1 (January–March 1933): 24–54.

Owen, Bobbi. *Scenic Design on Broadway: Designers and Their Credits, 1915–1990*. New York: Greenwood, 1991.

Peters, Susan Dodge, ed. *Memorial Art Gallery: An Introduction to the Collection*. Rochester, N.Y.: Memorial Art Gallery, 1988.

Pound, Ezra. *Antheil and the Treatise on Harmony with Supplementary Notes*. Paris: Three Mountains Press, 1924. Reprint, New York: Da Capo Press, 1968.

Rudhyar, Dane. "The Relativity of Our Musical Conceptions." *Musical Quarterly* 8, no. 1 (January 1922): 108–18.

Samaroff, Olga. "Expected Riots Peter Out at George Antheil Concert—Sensation Fails to Materialize." *New York Evening Post*, April 11, 1927.

Sanborn, Pitts "G. Antheil Presents." *New York Telegram*, April 11, 1927.

Seeger, Charles. Letter to Carl Ruggles, [1927]. Ruggles Collection, Beinecke Rare Book and Manuscript Library, Yale University, New Haven.

Sternberg, Constantin von. "Against Modern'ism.'" *Musical Quarterly* (January 1921): 1–7.

Tashjian, Dickran. *Skyscraper Primitives: Dada and the American Avant-garde, 1910–1925*. Middletown, Conn.: Wesleyan University Press, 1975.

Tick, Judith. "Ruth Crawford's 'Spiritual Concept': The Sound-Ideals of an Early American Modernist." *Journal of the American Musicological Society* 44, no. 1 (1991): 221–61.

Tzara, Tristan. "Some Memoirs of Dadaism." *Vanity Fair*, July 1922, 70, 92, 94.

White, Eric Walter. *Stravinsky: The Composer and His Works*. 2d ed. Berkeley: California University Press, 1979.

Whitesitt, Linda. *The Life and Music of George Antheil, 1900–1959*. Ann Arbor: UMI Research Press, 1983.

Wilson, Edmund. "The Aesthetic Upheaval in France: The Influence of Jazz in Paris and Americanization of French Literature and Art." *Vanity Fair*, February 1922, 49.

RANDY MARTIN

Modern Dance and the American Century

odernism concerns compulsory movement. It engenders the ceaseless embrace of the new and the anxiety over what is lost. Its authority rests upon an urge to exclude, but its longevity depends on a return of the excluded. Modern dance, heralded as distinctly American, advances itself as an exploration in pure motion. Whatever meaning might be attached or story told, the movement is the thing. It is what to watch out for and what to be taken in by. In more than name only, therefore, this dance is twinned with its historical movement. Dance that is made to be seen, shared in concert, has been seen by fewer spectators than many other contemporary cultural forms. Yet dance stands to reveal more than its numbers would allow, for it brings into focus the means, the very techniques, through which the modern self is made. These numerous ways of conducting ourselves (whether licensed, like driving or plumbing, or schooled in life's less formal byways, where tastes are shopped for, and pedestrians cross and queue) are nestled among bodies in motion. To the extent that the self is inflected with a national identity, the tale of modern dance's own coming into being is at once a story of the century in which the United States itself comes into world prominence, asserts its dominance, and begins, at century's end, to cede that ground without a clear successor.

There have been many synoptic historical accounts of modern dance's development in the United States. I want to borrow from that history to sketch in very broad strokes what modern dance reveals about the larger questions of American modernism. These questions concern the techniques for embodying a sense of the national that is itself in motion. Such national sensibilities innovate to produce the conception anew that Americanness was always there, in the face of factors that would cast the stability of the concept of a singular national form into doubt. America as an imagined place, as a state of being, exists in tension with a modernity

that expands to the limits of certain frontiers only to abandon these in search of others. Yet these breaks with the old terrain are never as total as they are presented to be. The imperative to accumulate and move on carries through each particular manifestation of the national ideal. The frontiers of America operate as much as ideological boundaries meant to consolidate multiple experiences as one, as they are physical barriers meant to exclude the other Americans that are forced to trail "the tiger." Properly speaking, using America to name a single nation is a misnomer, but a highly significant one, for the omission of other states that could claim the same identity is itself part of the dynamic of exclusion and inclusion that characterizes the construction of the United States as a modern nation. Embodied in this national identity is the contest to make a divided society adhere as a community of equals, and to make it seem that a global power could depend on no one other than itself.

This essay explores how Americanism, modernism, and capitalism are entangled by visiting four moments in the historical travail of modern dance. It will examine the ostensible origins of modern dance at the turn of the nineteenth century by its most celebrated expatriates, Loie Fuller and Isadora Duncan; its Americanization through Ruth St. Denis and Ted Shawn, Martha Graham, and Doris Humphrey, who all assimilated other sources to construct their dance techniques in the twenties, thirties, and forties; and the period of the so-called dance boom, from the mid-sixties to the mid-eighties, when dance was institutionalized and technique aspired to a certain universalism. Finally, it will provide a brief reflection on dance's current conditions.

This periodization of dance is also meant to complicate the usual accounts of when modernism "ended." The persistence of an explicit modernism within dance suggests an exceptionalism that may turn out to be less exceptional than the standard accounts allow. From my own perspective, the close of the twentieth century has spelled neither the demise of the specific creative energies that propel modern dance nor the end of society's movement in this place that claims for itself (among other things) the name America. But the forces that made it possible to speak of a nation and its modernity as a distinct "project" may have changed their complexion and with it, the means through which Americans might know themselves in the world. To these questions of how we make our identifications with the present, the history of modernism as it was danced provides a critical arena for reflection.

Dance, that ineffable motion that inscribes space, also makes time. Where dance is staged is more than a surface on which the world beyond is reflected. If dance shows something of its times, it is precisely because those times are many and not one. To apply dance to the understanding of modernism in America more broadly is therefore to assume that modernism moves, like dance, because conflicting forces make their demands on the present such that the contemporary moment

never stays still. The account of the movement in dance must help explain these contradictions rather than treating social context as a static portrait that is readily expressed in dance.

What makes for the incessant newness of the modern is not simply that forms and ideas are constantly thrown up, but, more fundamentally, that the very means to produce the new is constantly being revolutionized. Capitalism has carved a historical space for itself on the ideological grounds that in making society, people make themselves. The social process by which capitalism comes into being is frequently dubbed modernization, and this process most conventionally measures its movement in terms of technological change. Of late, it has become easier to speak of the means through which selves are made, not simply through the embrace of cognitive codes that allow decisions to fit their world, but through a capacity for practical accomplishment, a sentient orientation toward what is taken as real, as possible, as desirable in any given historical moment. These languages of selves have been greatly enriched by those social movements oriented around the divides of race, gender, sexuality—dimensions of human affairs that extend what gets produced and consumed, but also expand how and where politics is enjoined.

The self is fleshed out, made active, embodied through myriad techniques. In the classical accounts of modernization, the pursuit of ever more proficient technical means threatens to become an end in itself, thereby eclipsing the movement of society toward an enlightened state. In this regard, the universalization of technique and technologies of mass production masks their own means of progress by overwhelming the human interests they are meant to serve. The last best hope for genuine advancement resides with those who make their own techniques or claim to refuse the instrumentality of the merely technical, namely artists. The disavowal of technique in favor of featuring the art's materials or forms turns out to depend on shifts in the means through which art is accomplished as a practical activity, this last being a more general understanding of technique. By this reckoning, modernism is the movement of technique by those exemplary selves or sovereign subjects who remain unsullied by the overwhelming demands of the technical, which reduces reason to the efficiencies of a profit-taking market. It is no wonder that, in this context, a Picasso becomes such an icon of a heroic modernist who transcends the strictures of the modern world. Hence, within capitalist society, it is the artist rather than the capitalist who, by creating for the value of progressive creativity, bears the mythological burden of modeling what the unbowed, undivided self, the individual, is to be.

Needless to say, this is a tall order, one that plays as much mischief on understanding what artists do as it does to grasping ourselves in society. On closer inspection, the notion of a "great divide" between the few and the many, between high art of the lonely but authentic genius and mass culture of the mindlessly

commodified public, turns out to cleave as much as it splits. In this conception, art is more an epiphany than a process of production, and laboring activity of any sort is denied its moment of social creativity.

My own focus here on the genesis of modern dance technique is intended to problematize this standard idea of modernism. For the dancer, technique is both the authority that disciplines the body and the means through which the performer is freed from the choreographer's instrumental direction in order to give life to performance. For modern dance in particular, the development of a unique syntax for movement was the basis for choreographic innovation that maintained the signature of the author, modeled as it was on the proclivities of her own body. The medium of dance, the materiality of which is the body, achieves its formal aesthetic properties by means of a technique.

The institutionalization or amassed production of technique, first in the schools that provided economic support for the dance companies, and later in colleges, universities, and institutes in the United States and abroad, allows the choreographer's mark of a personal creative authority to persist in her absence. The simple polarity that art is an instance of sheer creativity freed from the labor that made it and laborers are downtrodden beings, wholly subjugated to technical rationalization of work and leisure, is one in need of complication. To this end, a study of modern dance technique presents the prospect of an emancipation from labor subjugated to technical command, by means of labor that constantly expands the capacities of the technical at its disposal. This is a process that enters the realm of commodification when dance parleys the market, only to convert the purchase of dance time into the pleasures of its use.

MYTHS OF ORIGIN

Where did it all begin? For American modern dance this is a rather freighted question not simply because the originators saw their work flourish elsewhere, but because the sources for what was to become the new dance lay dispersed all around it. Contrary to the picture of the late-nineteenth-century United States as an inhospitable dance desert, the concern with physical culture and the appetite for dance as spectacle were already well established.[1] Whereas romantic ballets, imported from Europe, had enjoyed popular success in the middle of the nineteenth century, and both Fuller and Duncan had studied with Italian ballerina Marie Bonfanti, other performance idioms held public attention as the draw of ballet waned toward that century's end.[2] Minstrelsy, the multitargeted parodies in song and dance born of white attraction and antipathy to black identity, was fundamental to the emergence of an American popular culture.[3] Minstrelsy got its start in the 1820s (the same decade that the romantic ballets came) and is pegged to white

actor Thomas Rice's theft of the dance and name of Daddy Jim Crow, a slave he watched behind a theater.[4] Minstrelsy allowed for the expression of racial rivalry as in the 1844 dance competition between black-faced John Diamond and Juba (William Henry Lane), a freeman who had amalgamated steps from the Irish jig and the African Giouba.[5] The rudeness and sexual indiscretions enacted onstage also constituted a white working-class parody of an emerging bourgeois morality.

The rectitude of that moral code was embodied in a pedagogical form known as expression, which sought to imbue the public speech of professionals with a convincing elegance of gesture appropriate to their claims as specialists to embody a more general truth. The conception of liberal arts education in the United States was already different from that in Europe, where it was thought that the use of the hands would sully the status of the free person. A certain manualism was reflected in the more technical orientation of the land-grant colleges established by the 1862 Morrill Act.[6] The most influential of the expression theorists was François Delsarte (1811–71). Delsartism took itself to be a scientific approach to the real basis of aesthetics in human movement as rhythmically animated by breath. Initially imported as a method of training performers, it had become, as disseminated in the United States through such figures as Steele MacKaye (1842–94) and Genevieve Stebbins, a more general philosophical aesthetic that extended the scope of earlier training in expression and elocution.

By the end of the nineteenth century, approaches to physical culture, Delsartian techniques preeminent among them, generated dozens of books and could be studied in schools across the country and practiced by "respectable women."[7] The movements, accompanied by breath, loose-flowing garments, and Greek-inspired design, had a self-consciously anti-Victorian element that sought to relax the closeting hold on the private sphere's holiest shrine, the body. The first dance modernists professionalized the movement that had initially sought to form the professional body and then set it free. Loie Fuller made her name in the land of Delsarte, where Isadora Duncan first saw her perform at the Paris Exhibition in 1900; Ruth St. Denis, who saw Stebbins perform in 1892, lionized Delsartian technique (Fig. 1).[8]

Although she preceded and inspired Duncan, Loie Fuller is generally treated as less influential, not the least because she was deemed technically deficient and generated no movement legacy, both of which are central affirmations of modernist criteria in dance. Yet her work with costume, stage lighting, and photoluminous chemistry (in a collaboration with radiation experimentalist Marie Curie) was sustained by its own theory of movement expression as kinesthetic communication:

> To impress an idea I endeavour, by my motions, to cause its birth in the spectator's mind, to awaken his imagination, that it may be prepared to receive the image.

Figure 1. Loie Fuller, La Danse du Lyse.
(Courtesy of Rodin Museum, Paris)

Thus we are able, I do not say to understand, but to feel within ourselves as an impulse an indefinable and wavering force, which urges and dominates us. Well, I can express this force which is indefinable but certain in its impact. I have motion. That means that all the elements of nature may be expressed.[9]

Interestingly, these ideas would be replayed, unattributed, twenty years later in the seminal definition of modern dance as "metakinesis" by critic John Martin, and they anticipate as well the conception of semiosis formulated by American pragmatist Charles Sanders Peirce.[10]

Although Fuller was a child actress who had toured Europe and the United States, she represents her entry into modern dance by means of a discovery. In desperate need of a costume for a theatrical role, she came upon a "small casket" that had, somewhat mysteriously, been sent to her from India.[11] From this oriental box she withdrew a diaphanous, oversized silk dress. Her efforts to move within this foreign gown that billowed and enveloped her led to the "Serpentine Dance" (1892), which, in turn, was the basis of an ill-fated German booking that left her stranded and able only to get as far as Paris, where she had an auspicious dance debut. She continued to perform and develop the technical accoutrement of her trade in waves and photons until 1926, two years before her death. An oriental source, a theory of pure motion as communication, a science of presentation: these will be themes that recur in the history of American dance modernism.

Isadora Duncan celebrated an America she could not inhabit. A Communist,

feminist, and cultural radical, she came to tour the United States from the Soviet Union in 1922 with her husband, poet Serge Esenin, and was met with harassment from immigration officials, politicians, the press, and clergy, one of whom called her a "Bolshevik hussy." In an essay published in *Hearst's American Weekly* of January 1923, she replied that she was leaving the "loathsome United States" where children are fed "canned peas and canned art," yet saw in "those downtrodden exploited ones, the promise of America" marching to the tune of the Internationale.[12]

But if the actuality of American life rendered it inhospitable to Duncan, she formulated an image of dance in the land, after Walt Whitman's song rather than the Internationale, that proved equally difficult to realize on American soil. For the terrain that she saw as the "origin" of her dance Americanism was established against such foils as "the South African savage," the "redskin," ballet, and "so-called bodily culture." Rather, the source of this dance "will be clean," "no rhythm from the waist down; but from the solar plexus, the temporal home of the soul."[13] It is less significant here that Duncan misrepresents her relation to the very sources that are fundamental to her own formation than that she fuses the identity of self and nation through the embodiment of a self-discovering technique for movement.[14]

The banishing of all traces of cultural difference and technical influence stages as a first principle the immaculate conception of American dance from within Duncan's own body. Her internationalism as a dancer pertained to the circulation of the forces of an American imaginary that were asserting themselves as Duncan ventured abroad (her first success was in Budapest in 1903).[15] In a sense, Duncan anticipated the global retort to U.S. imperialism and carried it back to her native land. But her own reception to her originary modernism was predicated on the possibility of letting loose a certain Americanism on the world. As cultural envoy as much as exile, she embodied the birth of the American century—one that would assert its own cleansing body against other influences and techniques (Fig. 2).

Perhaps the most striking aspect of Duncan's legacy was the reverence she left among her public. Through her spherical movements, rising and falling, weighted steps, curving neck, performed in her signature shrouds of Chinese or Indian silk that undulated in coverings and exposures, Duncan transformed her entire body into an object veiled with the promise of revealing an unspeakable truth. The critical gaze, already tooled by the oriental thematics of romantic ballet, could pause and catch itself through this newfound reflection on the dancing body as a medium for physicalizing the visual.[16] Hence, in 1909 French playwright Henry Lavedon wrote of Duncan: "with splendid freedom of action, the young woman draws herself up to her full height and steps out into dance, limbs nude, strong, firm as Greek marble in the light, the folds of the tunic falling away as a background to the flexible finely modeled knees; in the firm, clear flesh, the head alert, the eyes insatiable, every pore exquisite."[17] Lavedon, like so many others, was

Figure 2. Isadora Duncan. (Photograph by Limet; courtesy of Rodin Museum, Paris)

captivated by this opportunity to dwell on the body-as-body with a mixture of meticulous detail associated with a scientific ardor for viewing and the pleasures attached to this activity as an end in itself. With modern dance, modernism's lone moving spectator, the flaneur, now resided among the public in attendance.[18]

The lingering attention to movable form that brought about this language of the body suggests a technique of self-recognition in the course of being effected by something else. Seen as a constituting act of a modernist public that could be shocked again and again and that could fix its gaze on another only to avert it back to itself, Duncan's claims to have found the national soul in her body make sense. For her innovation rests less on any horizon of movement she may have surpassed through self-discovery, than to have provided the occasion for an arrested attention on the making and passing of the eternal present.

MODERN APPROPRIATIONS

"Beyond the veil of our actual, common days is the Eternal Now which is seeking ever to reveal itself. . . . Pure dance has no bounds."[19] These are the words of Ruth St. Denis, whose school and company, Denishawn, with Ted Shawn was the first modern dance institution in the United States, and whose use of the East—the veil in particular—had become something of a signature in her work

Figure 3. Ruth St. Denis. (Photograph by Ludwig; courtesy of Rodin Museum, Paris)

("Radha," "Egypta," "The Cobras," "The Incense" in 1906). Martha Graham and Doris Humphrey both danced with Denishawn, and St. Denis, unlike Duncan, was explicit about her debts to cultural influences and to Delsartian technique. Although couched in terms of orientalist mysticism, the "Eternal Now" invoked an emphasis on what could appear in the present that allowed the world's movement sources to be taken up as the culturally boundaryless "Pure dance" that characterized American dance modernism (Fig. 3).

Martha Graham's nearly seventy years of choreographic output (from her first concert in 1926 to her death in 1991) has made hers the name most associated with American modern dance. Her conception of exactly what this means is telling. She is the quintessential modern dance self whose body gave birth to a technique for being American. Although the Graham Technique is literally trademarked around the world, Graham herself, like Duncan before her, preferred to speak in naturalized terms of her means of choreographic accomplishment, rather than ascribing her choreographic capability to a form of kinesthetic knowledge lodged in a technique. "Don't say I invented a school of movement. I only rediscovered what the body can do."[20]

Despite changes over the decades that incorporated the expanding movement ranges of her dances, the heart of the technique remained the oppositional pelvic movement of contraction and release, which, more than Duncan's centering of movement in the solar plexus, provided a basic choreographic grammar that rested on a specific tooling of the body. The interdependence of choreography and

*Figure 4. Martha Graham.
(Courtesy of Jerome Robbins Dance Division,
New York Public Library)*

technique, displayed in the accretion of movement exercises and phrases that comprise the Graham "syllabus," stamped each dancer's body with the authority of the creator. The genealogies of dance traced through the many students of Graham and her technique give specific corporal content to the community of strangers we call nation (Fig. 4).

Paradoxically, however, the Americanness of this nation that flowed from Graham's body into others had specific cultural influences that were foreign to her own biography. For from her own perspective it was the bodies of others that constituted her "sources." She alludes to this process of appropriation (the possibility to "adopt a dance" of "another people") in a statement about her technique that argues for African and Native American dance as "our two forms of indigenous dance." She goes on: "These are primitive sources which, though they may be basically foreign to us, are, nevertheless, akin to the forces which are at work in our life. For we, as a nation, are primitive also—primitive in the sense that we are forming a new culture."[21] The juxtaposition here between the primitive (other) and the modern (self) begins to make sense of the denial of the technical as a foundation for technique. Here there is no labor, only discovery, so that national identity can appear as a moment of pure expression rather than as a movement that requires work and training, as an assimilation of sources rather than an appropriation of what others have made.

Contemporary to Graham, Doris Humphrey sees the birth of dance theory as a

unique aspect of the 1930s, when the "shocks" of "social upheaval" "reached all the way down to the thoughtless lives of dancers, especially in America."[22] This physicalization of shock, the incorporation of shifting social forces, in turn forced a reflection on its own conditions. Humphrey's articulation of her choreographic technique as an approach to movement treats the problem of sources in more ecumenical terms, but nonetheless it links abstract principles or "elements" of movement—design, dynamics, rhythm, and motivation—to an imperative for innovation born of an "emphasis on contrast" that she speculates may be "particularly American." "The adventurousness and restless spirit of a still-young nation certainly permeates almost everything about us; we are notorious for being less leisurely than most other peoples in our ways, and more demanding of variety" (Fig. 5).[23]

In certain respects, this is the inversion of Graham's formulation in that difference is an American demand rather than an influence, and a regimen of work is a condition for innovation. What renders these dispositions to movement American, then, is less any particular cultural referent than a conception of culture where an unmediated relation to nature produces the discovery of an absolute condition of change. Like Graham, Humphrey's technique is represented as a discovery rather than an invention of the body's "first," "natural" movement. Humphrey asks "what will the body do by itself?" and her discovery is a "falling" (off balance, as in a swinging forward lunge) that is followed by a "recovery."[24]

Like Graham's contraction and release, the fall and recovery is something of a ur-movement that enables all others and marks for Humphrey that most fundamental of contrasts, that between life and death. For both women, the youth of the nation is a crucial material condition for getting at the source of newness in dance,

which has more to do with revealing the naturalness of change, of freeing culture to follow the moving forces of nature, than specifying a set of attributes. In this regard, the means toward the new take precedence over newness as end. There is, in these rationalizations of modern dance technique, a certain specification of America as a natural place that is rendered most explicitly in John Martin's formulation that "physical environment is of utmost importance in the shaping of the arts." For Martin, American culture was conditioned by its "distance from centers of authority" that engendered a pioneering impulse that matches the national geography with emotional and mental exploration.[25]

Purity without the dirty hands of cultural appropriation, productivity without any trace of exploitation, liberating isolation without reference to what is being occupied, progressive movement without loss to war or economic depression: each of these problems in the foundation of a nation could be located in the pronouncements of American modernists such as Duncan, Fuller, Graham, Humphrey, or John Martin. This is not to say that the dancers and their critics acted in bad faith or lacked political sensibilities. Like Duncan before them, the thirties especially were marked by choreographic alliances with the Left.[26] What is more interesting is the effectiveness to which these modernist techniques marshaled bodies to their cause. The appeals of a self-naturalizing progressive movement were clearly not restricted to modern dance. As a popular movement of the 1920s and 1930s, dance marathons celebrated the productivity of the body, the race to extend its limits, the pioneering of self as the newly anointed winner or record breaker, and the creation of spectacle out of what otherwise might appear routine.[27]

We see in the years that American modernism was installed in the land no less a response to the Great Depression than the industrialization of leisure and consumption that went by the name of Fordism, the assertion of productivity without end (or recognition of beginnings) as a presumed national trait. This aspect of modernism had both its resistance and its conscience in labor and civic movements as well as in the work of artists. Yet the purification of dance and its body in a critical but also a larger cultural environment that would recognize only advancement imagined a version of progress through movement that even oppositional currents would in some measure adopt. Indeed, the language of moving forward, of making society anew, became inextricably bound with the conception of social change. The nation was the output of this great machinery.

NEAR UNIVERSAL

Trisha Brown tells us:

Pure movement is a movement that has no other connotations. It is not functional or pantomimic. Mechanical body actions like bending, straightening, or

rotating would qualify as pure movement providing the context was neutral. I use pure movements, a kind of breakdown of the body's capabilities. I also use quirky, personal gestures, things that have specific meaning to me but probably appear abstract to others. I may perform an everyday gesture so that the audience does not know whether I have stopped dancing or not and, carrying that irony further, I seek to disrupt their expectations by setting up an action to travel left and then cut right at the last moment unless I imagine they have caught on to me, in which case I might stand still. I make plays on movement, like rhyming or echoing an earlier gesture in another part of the body at a later time and perhaps out of kilter. I turn phrases upside down, reverse them or suggest an action and then not complete it, or else overstate it altogether. I make radical changes in a mundane way. . . . If I am beginning to sound like a bricklayer with a sense of humour, you are beginning to understand my work.[28]

Here Brown signals much of what is to be considered postmodernism in dance: use of pedestrian movement to foreground everyday experience, exploring the strangeness of familiar gestures stripped of their context, conceiving the invention of dance as already within view of the audience, and rendering familiar the strangeness of difference. As choreographer and innovator, Brown has been one of the most consistent presences to emerge in what has been referred to as the boom in dance, a period that might be loosely bracketed between the mid-1960s and the mid-1980s.[29] Dance flourished against the backdrop of a nation that was passing through the crest of its preeminence, an assessment that would have seemed premature in the mid-1960s but past due by the 1980s' "lost decade" of expansive credit and burgeoning debt.

Brown's early training in the 1950s had touched modern dance's roots. She studied with José Limón, Louis Horst, Merce Cunningham, and, most influentially, Anna Halprin, a seminal figure in improvisational process, who had once herself danced in Humphrey-Weidman choreography on Broadway.[30] Trisha Brown's participation in the 1960s Judson Church concerts is usually seen as a break with that past. Her international success over the past twenty years represents not only a personal triumph but also a certain globalization of dance's choreographic, performance, teaching, and scholarly circuits.

As with other cultural expressions, the meanings and instances applied to the prefix "post" are multiple and not without contention when applied to modern dance.[31] In the simple terms of what (or more precisely who) comes after the great moderns in dance, the move to postmodern dance is carried by a shift in what is taken as technique. In the words of Sally Banes, the seminal dance critic of this transition:

One way to draw attention away from matters of virtuousic technique is to demystify it by making dances that acknowledge their own process of being

made. Another is to simplify the choreography so drastically that technique is bypassed, and related to such simplification is the use of natural movements. Natural movements present the body concretely, showing the body engaged in the kind of casual, everyday postures that one associates with ordinary actions. Thus anything, from doing somersaults to standing still, from combing one's hair to walking to eating to telling stories, can become material. What makes a movement a part of a dance, rather than simply an ordinary movement, is that it is installed in a dance context. . . . For the post-modern choreographers of the 1960s and '70s, "natural" means something quite different [than it did for Duncan, Fuller, Graham, and Humphrey]. It means action undistorted for theatrical effectiveness, drained of emotional overlay, literary reference, or manipulated timing.[32]

With these dance innovations, it is the language of movement itself that is featured in the dancers' reflections onstage and off. Here, truth in movement became a means without ends. One of the most engaging programmatic statements of the centrality of the technical in dance composition is Yvonne Rainer's "The Mind Is a Muscle." She conceptualizes a physical economy based on "what is seen in terms of motion and stillness rather than of actual work."[33] She formulates what will become known as release technique:

The execution of each movement conveys a sense of unhurried control. The body is weighty without being completely relaxed. What is seen is a control that seems geared to the *actual* time it takes the *actual* weight of the body to go through the prescribed motions, rather than an adherence to an imposed ordering of time. In other words, the demands made on the body's (actual) energy resources appear to be commensurate with the task—be it getting up from the floor, raising an arm, tilting the pelvis, etc.—much as one would get out of a chair, reach for a high shelf, or walk down stairs when one is not in a hurry. The movements are not mimetic, so they do not remind one of such actions, but I like to think that in their manner of execution they have the factual quality of such actions.[34]

The theatrical effect of the performance, then, is to produce the facticity of bodily action. While Rainer confronts theatrical artifice, she is not free of reproducing a certain version, here of the actual through the use of the apparent. In this theater, the body is presented as doing what it must do, a turn of events that lends a certain absolutism to the present circumstances. Although no reference is made to nature per se, the absence of any cultural reference suggests that the focus on these bodily movements serves as a platform for the universalization of a particular practice. This reflexive but un-self–reflective generalization of the con-

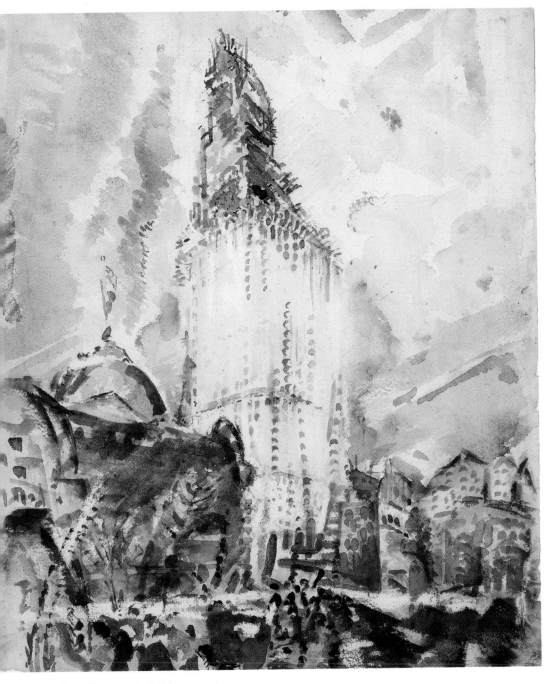

Plate 1. John Marin, Woolworth Building, *no. 28, 1912.*
(National Gallery of Art, Washington, D.C., Gift of Eugene and Agnes E. Meyer)

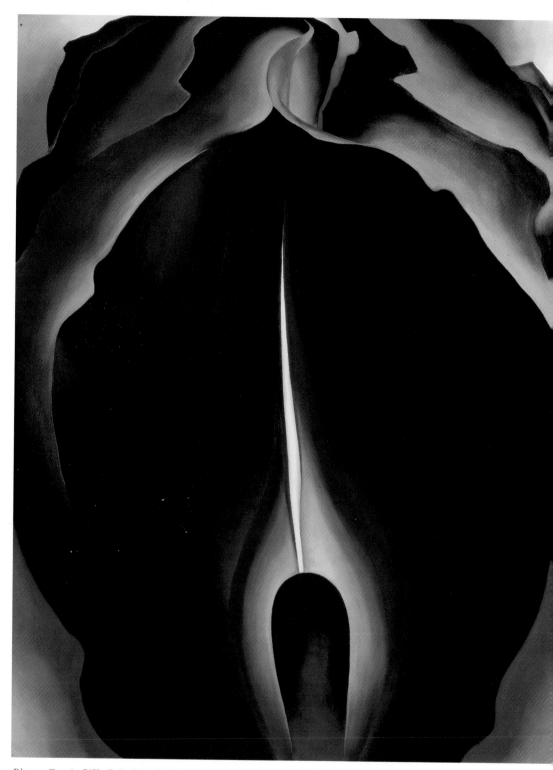

Plate 2. Georgia O'Keeffe, Jack-in-the-Pulpit, *no. 4, 1930.*
(National Gallery of Art, Washington, D.C., Alfred Stieglitz Collection, Bequest of Georgia O'Keeffe)

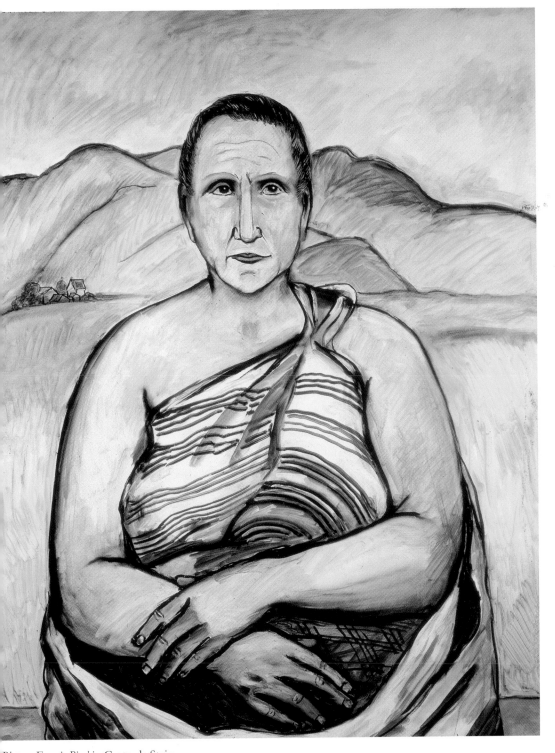

Plate 3. Francis Picabia, Gertrude Stein.
(Yale Collection of American Literature, Beinecke Rare Book and Manuscript Library, Yale University)

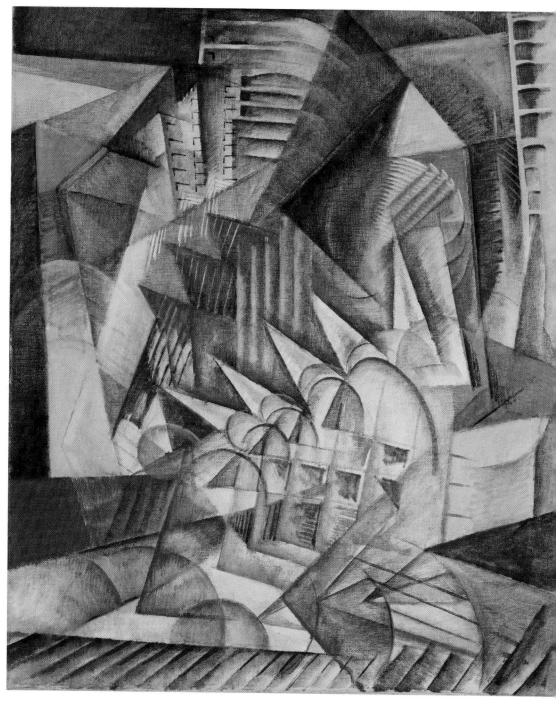

Plate 4. Max Weber, Rush Hour, *New York, 1915.*
(National Gallery of Art, Washington, D.C., Gift of the Avalon Foundation)

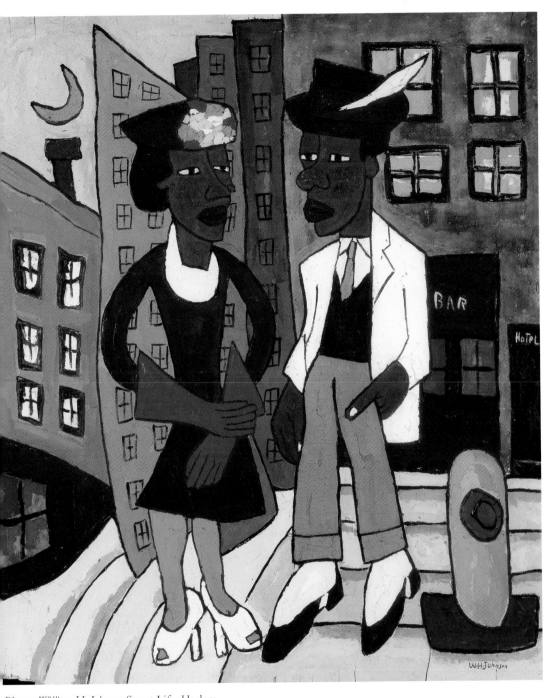

Plate 5. William H. Johnson, Street Life, Harlem.
(National Museum of American Art, Smithsonian Institution, Gift of the Harmon Foundation)

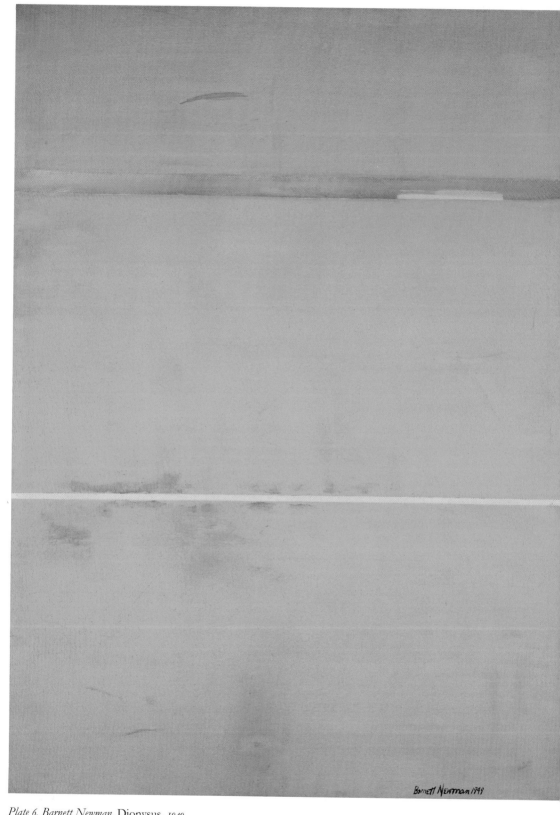

Plate 6. Barnett Newman, Dionysus, *1949.*
(National Gallery of Art, Washington, D.C., Gift of Annalee Newman)

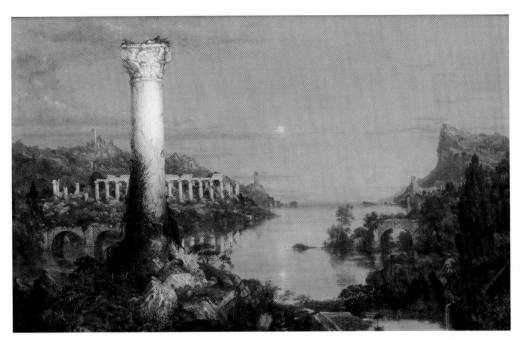

Plate 7. Thomas Cole, The Course of Empire: Desolation.
(Collection of The New-York Historical Society)

Plate 8. George Bellows, Both Members of This Club, 1909.
(Chester Dale Collection, National Gallery of Art, Washington, D.C.)

VIRGINIA

Plate 9. *Frontispiece from* Virginia, *by Ellen Glasgow. (New York: Doubleday, 1913)*

The Brown Madonna

Plate 10. Frontispiece from The New Negro. *(New York: Albert and Charles Boni, 1925)*

Plate 11. Morton Schamberg, Machine Forms: The Well, *1916. Oil on canvas, location unknown.*
(Reproduction from Ben Wolf, Morton Livingston Schamberg *[Philadelphia: University of Pennsylvania Press, 1963]).*

Plate 12. Bill T. Jones, Still/Here. *(© Beatriz Schiller, 1999)*

Plate 13. Peter Blume, Vineyard, 1941. Mural Study for Geneva, New York, Post Office.
(Marlene Park and Gerald E. Markowitz, Democratic Vistas: Post Offices and Public Art in the New Deal
[Philadelphia: Temple University Press, 1984], plate 1)

Plate 14. Stuart Davis, Swing Landscape, *1938.*
Tempera sketch for mural in Williamsburg Housing Project, New York City.
(Indiana University Art Museum,
Photograph by Michael Cavanagh and Kevin Montague;
© Estate of Stuart Davis/Licensed by VAGA, New York, N.Y.)

Plate 15. Moses Soyer, Artists on the WPA, *1936. Oil.*
(National Museum of American Art, Smithsonian Institution, Gift of Mr. and Mrs. Moses Soyer)

Plate 16. Anton Refregier, Sand Lot Riots. *Panel of History of San Francisco, San Francisco, California.*
(Marlene Park and Gerald E. Markowitz, Democratic Vistas: Post Offices and Public Art in the New Deal
[Philadelphia: Temple University Press, 1984], plate B)

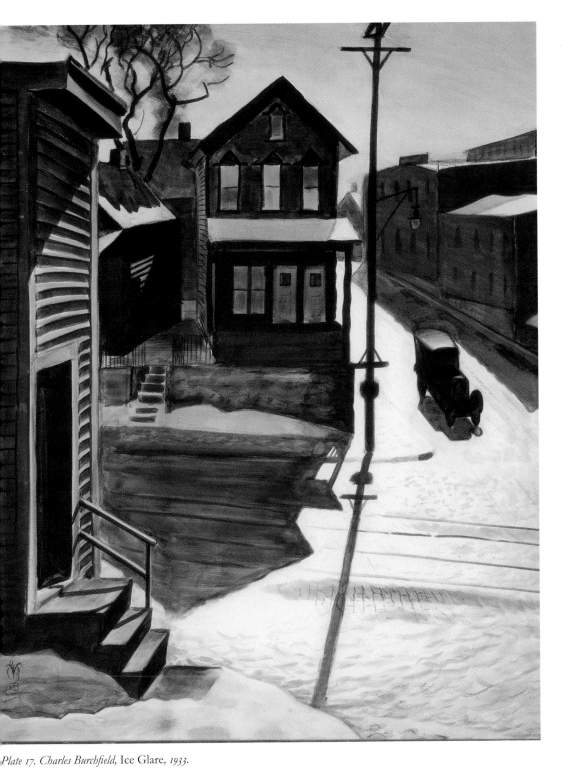

Plate 17. Charles Burchfield, Ice Glare, 1933.
Watercolor on paper, sight: 30¾ x 24¾ in. (78.1 x 62.9 cm).
(Whitney Museum of American Art, Purchase 33.64)

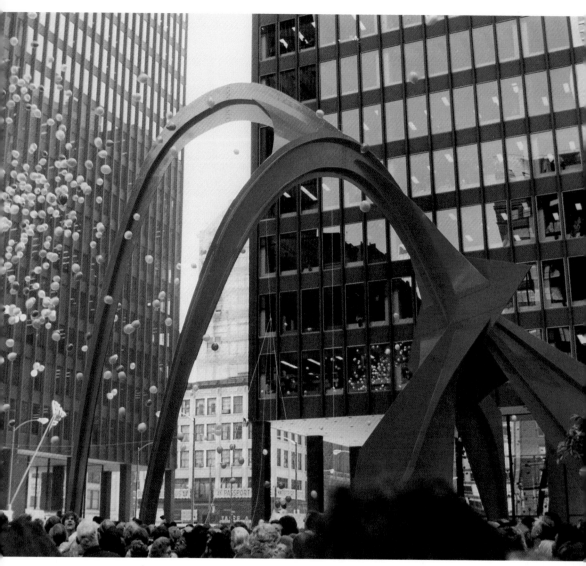

Plate 18. Dedication ceremonies for Alexander Calder's Flamingo, *October 25, 1974.*
(Courtesy of Art-in-Architecture Program, Public Buildings Service, General Services Administration)

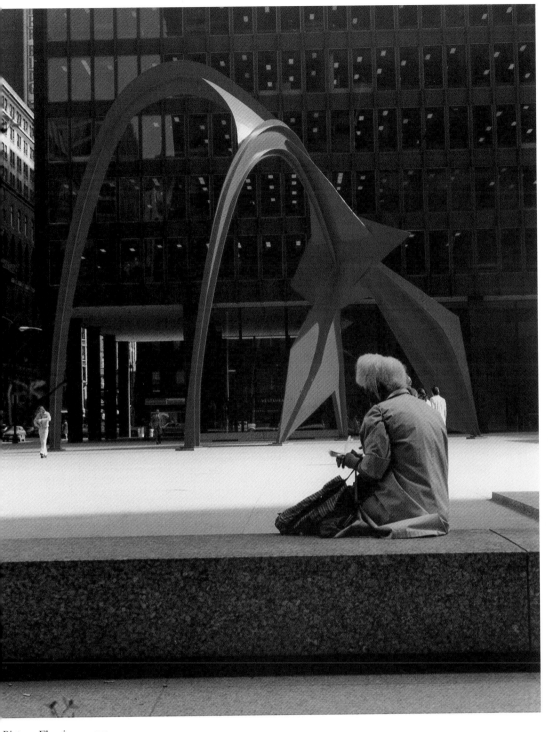

Plate 19. Flamingo, *1974.*
(Courtesy of Art-in-Architecture Program, Public Buildings Service, General Services Administration)

Plate 20. George Sugarman, Baltimore Federal, 1977.
(Courtesy of Art-in-Architecture Program, Public Buildings Service, General Services Administration)

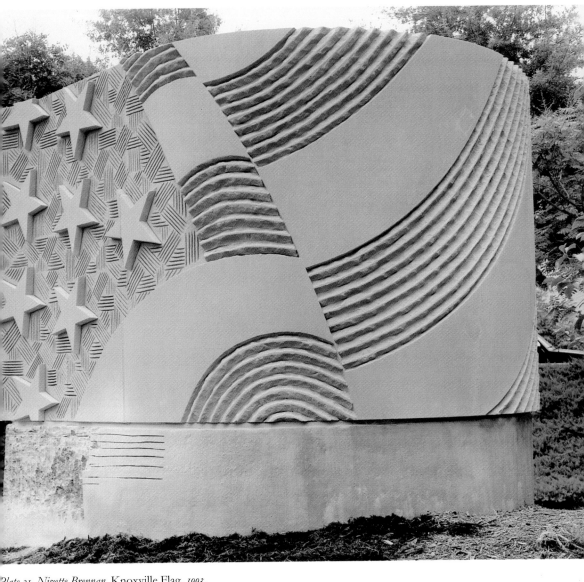

Plate 21. Nizette Brennan, Knoxville Flag, *1993.*
(Courtesy of Art-in-Architecture Program, Public Buildings Service, General Services Administration)

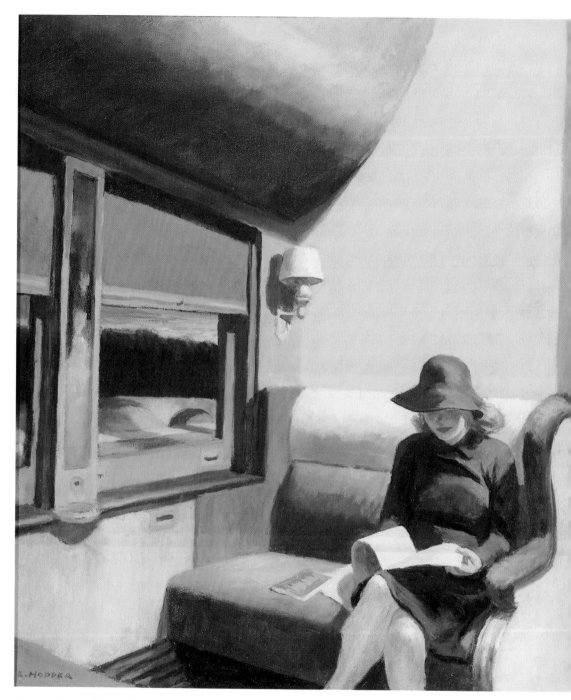

Plate 22. Edward Hopper, Compartment C, Car 293, *1938. (Collection IBM Corporation, Armonk, New York)*

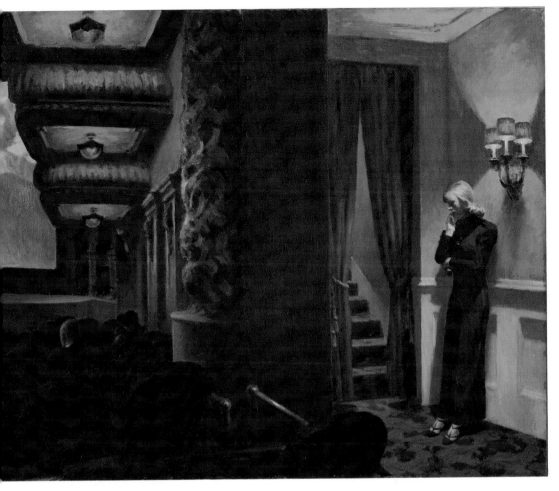

23. *Edward Hopper,* New York Movie, *1939. (The Museum of Modern Art, New York)*

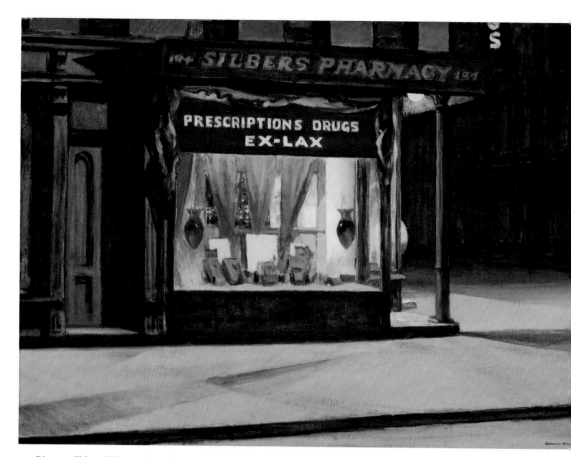

Plate 24. Edward Hopper, Drug Store, *1927.*
(The Museum of Fine Arts, Boston, Bequest of John T. Spaulding)

ditions for making bodies work is consistent with the apotheosis of the U.S. global projection of itself as an absolute condition of progress.

It is intriguing in the context of expansion to consider the break with the development of eponymous dance technique associated with the "historical moderns" (who were contemporaries of those who emerged in the 1960s). Simone Forti, Yvonne Rainer, Steve Paxton, Deborah Hay, Kenneth King, Douglas Dunn, and Grand Union contributed to a significant reorientation of the approach to dance movement. Further, Trisha Brown, David Gordon, Lucinda Childs, and Meredith Monk enjoyed touring opportunities that were unavailable to their forebears in their formative years. Yet the techniques that became institutionalized precisely during this period, when universities expanded and established dance departments, were those of choreographers who had made their mark in the 1930s and 1940s, so that by 1968 there were 22 independent dance departments and 110 campuses where students could major in dance.[35]

The Great Society expansion was felt in dance circles beyond the university with the establishment of the National Endowment for the Arts (NEA) in 1965, and it was with an NEA grant of $142,250 that Martha Graham was able to make her first national tour in fifteen years in 1966. As with other constructivist programs, government funding for the arts was viewed as a political palliative, not simply a celebration of the national patrimony. President Lyndon B. Johnson, signing the Endowment bill on September 29, 1965, proclaimed, "For it is in our works of art that we reveal to ourselves, and to others, the inner vision which guides us as a nation."[36] Arts funding was a part of a larger strategic response to counter the popular mobilizations of the day that were said to issue from a surfeit of leisure time and activity uncontrolled by work discipline. The public dissemination of art would provide a unifying call that would civilize this nation (and others) and cover dissent with a common aesthetic legacy. At its height in the late 1970s, Endowment funding was aimed not only at the development of choreographers but also at support of presenters and their venues. Monies were also given to arts management, a field pioneered in 1962 by the Ford Foundation, whose arts director, McNeil Lowry, was instrumental in modeling what the NEA would become.[37]

Interestingly, state support for the arts began not as domestic but as foreign policy. The Division of Cultural Relations of the State Department was created in 1938 to open an ideological front in Latin America. Fifteen years later the U.S. Information Agency (USIA) was established as a global counterweight to what were seen as the ideological appeals of communism.[38] In particular, the USIA's arts initiatives were designed to "correct and humanize the image of the American people held by other peoples . . . disposed to look down upon the United States as a nation concerned only with the creation of material wealth and with satisfactions provided by creature comforts and ingenious gadgets." Martha Graham was the

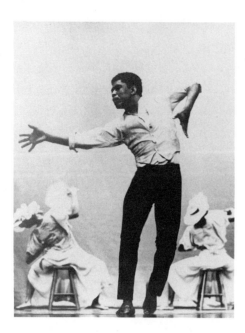

Figure 6. Alvin Ailey. (Photograph by Fannie Heller Melcer; courtesy of Jerome Robbins Dance Division, New York Public Library)

first of the moderns to tour abroad in 1956, when such trips were institutionalized under the International Cultural Exchange and Trade Fair Participation Act passed that year. She was followed by José Limón, Paul Taylor, Alvin Ailey, and dozens of others as funding for the program expanded precipitously in the late fifties from $5 million to $22.8 million, despite State Department efforts to reduce it (Fig. 6).[39]

Although the conditions for dance's global circulation were instrumental, this did not result in a singular official American art form. Rather, the message sent was of freedom of expression based on a manifest plurality of individual forms. President John F. Kennedy, early to recognize the domestic political capital to be gained by arts funding, also saw in it a counter to the Soviets, who "recognize even though they manipulate this desire, the tremendous interest people have in the arts." For him, artistic freedom validated national character: "In serving his vision of the truth, the artist best serves his nation."[40] The institutional infrastructure of modern dance was being constructed at a national level, and this served in no small way to circulate and solidify the names of a prior generation precisely when something different was making its appearance. These social conditions served to prolong the modernist moment in dance.

Yet this was not simply a matter of an older guard eclipsing the brilliance of one more advanced. The persistence of natural or pure movement as an organizing trope for an ongoing technical innovation in dance joined together what might otherwise appear as contrary currents. On the one hand were the institutionalizing forces (the creation of dance departments, government funding, and touring networks) and, on the other, anti-institutionalizing energies (the florescence of

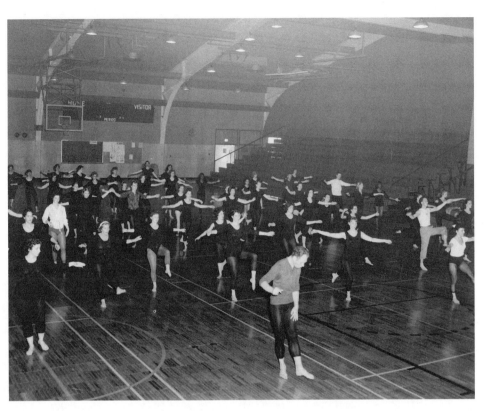

Figure 7. Merce Cunningham.
(Photograph by Cameo Studio; courtesy of Jerome Robbins Dance Division, New York Public Library)

independent choreographers performing in nontraditional spaces such as Judson Church). In this conjuncture of the name that rides a flourishing institutional edifice (a Graham or a Limón) and a more anonymous gesture toward a communitarian nature (found in the pedestrian movement of Judson), one can read something of the contours of national identity whose flush of confidence would soon be betrayed. In many respects, those who came after the modern pioneers were engaged in political art. Merce Cunningham's use of chance techniques to generate the sequence of movement phrases in performance touched on a process without subject that refused the Western mythos of self projected on the artist-as-genius (Fig. 7). In the seminal Judson Dance Theater, pedestrian movement laid claim to the discovery of "democracy's body."[41] The publics gathered around dance and the performers themselves often opposed the Vietnam War or supported the Black Panthers at events. These events had to be understood as more than strictly countercultural or confined in their critical ambit to an attack on theatrical convention. Yet, in less explicit ways, the kinesthetic assumptions that gave rise to their dance work underwrote certain features of a newly definable Americanism based more on collaborative than upward mobility.

In a climate already uneasy with the American dreamscape, it is difficult to find the programmatic claims to a national identity of dance such as those issued by Duncan or Graham (their own critiques notwithstanding). Yet it is possible to associate the very absence of these statements with a certain stability of American identity that is being universalized in the grounding of these particular cultural practices of the body in nature—a constant temptation of the dance movement that flows from release technique.[42] No less than the shock registered by the publics of Duncan and Fuller, the performer's claim to assimilate these pedestrian others in the audience to her own body marks a context in which the present appears so obvious that it need not be named. The denial of aesthetic influence is no less an aesthetic, and the naturalization of movement no less locates a given situation as its ground zero. At the height of U.S. imperial prowess there appears a claim of discovery within a highly specified frame, of a universal body authorized only by the truth of its movement in a neutral context. From this perspective, the convergence of art and its publics is treated as a new form of common sense that celebrated, against its own best impulses, American global hegemony.

DANCING 'TIL DAWN

With century's end, there has been no shortage of prognostications about the demise of those cultural energies that opened America's great leap forward. In dance, the boom of the sixties, seventies, and eighties is said to have gone bust, a victim of the same popular success that effaced its previously restricted economy.[43] This putative aesthetic decline, an erosion of the autonomy of the culture of modernism, has been marshaled to justify ending public funding for the arts, which in turn jeopardizes the development of dance. If there is a term to characterize dance's current situation, it is *risk*. This concept has several meanings, and unpacking some of them may help clarify what has become of the relation between modernism and the nationalism through which dance had developed.

Periodization, one of the devices used to organize this essay, is particularly complicated in dance, in part because no historical practice or style appears to cease circulating on the contemporary scene. The works of Duncan, Shawn, Graham, and Humphrey exist in perpetual revival aided by the development of an academic infrastructure of recovery and reconstruction that promises a more self-critical view of canonization than fields that claim more stable aesthetic artifacts.[44] The forms and techniques that are internal to the history of modern dance (its compulsory movement) are discontinuous with respect to one another to the extent that no homogenizing master technique produces a convergence of bodily expression. Nor is there any clear break between residual and emergent innovations. Although there is a sense in which nothing in dance stops happening, there is

clearly a context of diminished resources and opportunities to support the development of dance as a field that does introduce strains on creative production. But more strident still is the complaint against dance (and the arts more generally) that it has by its politicization brought on its own demise.[45] This attribution of blame as self-failure is consistent with an influential anthropological meaning of the term "risk," a threat of breakdown in the normative boundary between self and other that justifies punishment and affirms the purifying sanctity of social codes.[46]

Cracks in the armor of aesthetic autonomy have always been available to the observer attuned to them. Now it could be said the belief that dance is its own master had been compromised. Notions of the autonomy of art had the benefit of making it possible to speak clearly about the relation between what was inside and outside dance, namely a clear opposition between expressive form and social context. Maintaining this boundary permitted modern arts (and nations) to externalize assessments that would undermine their claims to a kind of moral, domestic 'purity' on which the privileged status of art rested. The self-conscious efforts of critical dance to blur the boundaries of art and life so that the relation between them might be specified (unlike the early postmoderns discussed above) place dance in the precarious position of constituting a population at risk (of losing its singular place in the world).[47] Rather than appealing to nature, what authorizes such contemporary dance tends to be some recognition of its own multicultural context. In this version of multiculturalism, there is no longer the sense that cultures themselves are clearly separable and therefore appropriable in the manner that had historically been available to modern dance.

In terms of technique, risk figures in the last ten years as a positive value in dance innovation. Its influence can be traced as a move from the pedestrian foundations of release technique to a dance pyrotechnics whose ability to mobilize the momentum of falling bodies winds up denaturalizing the body by extending the parameters of the possible. A whole vocabulary has developed that allows the arms to propel the body into the air the way in which only the legs might once have, or to spring from the floor from the tops of one's feet rather than from the soles. Such inversions and decenterings accumulate to reconfigure our sense of how bodies operate, not as the imitation of angels or nymphs, but in a keen awareness of how dance draws from its environment. From Pooh Kaye to Elizabeth Streb, one can observe the marshaling of movement in the service of breaking the boundaries of what an individuated dancing body might produce (Fig. 8). Risk drives interdependencies of body against body beyond the mechanics of partnering (as gender disappears as a determinant in who can lift whom) to a genuine collectivity of decentered weight sharing. This places the impetus of movement outside the individual body (a possibility opened up by the explorations in contact improvisation), where it is literally the place that the bodies meet that drives the outcome of the movement.[48]

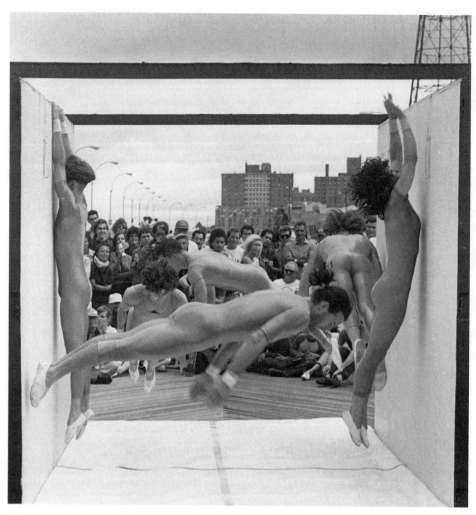

Figure 8. Elizabeth Streb at Coney Island. (Photograph by Tom Brazil)

What accompanies these innovations in dance, however, is a shift in the alignment between the institutional supports of dance and the demands placed on the arts more broadly to circulate national identity. The peculiar affinities between foreign and domestic policy found in the parallel missions of the USIA and NEA reached their nadir at the end of this century. The state has turned from civilizing palliatives to policing urban unrest and from countering the crude consumerism of the United States to promoting it worldwide through a new order of global agreements. Artistic space, displaying the self invented through technique—the free-willed individual—appears to have vanished and with it the capacity of the arts to negotiate the contradictory articulation between universal personhood and a particular nation. The notion that the trajectory of the revolution in technique is itself a condition that achieves the limits of modernization, where the prospects of harm and uncertainty are induced by society rather than nature has been called a "risk

society," one where "Ecological disaster and atomic fallout ignore the borders of nations."[49] The idea that in this world risk is supposedly without physical boundary becomes difficult to square with new, prisonlike forms of spatial apartheid that make the beneficiaries of global expansion secure against the demands of the excluded, whether in Rwanda, Somalia, Bosnia, or South Central. Politically, this notion of risk implies that nations cease to be the most fundamental units of societal development, and citizenship has less purchase on what the state provides.

Clearly these conditions do not manifest themselves in a singular or typical dance form. But they do reveal a range of symptoms. Modern dance, long associated with the United States, is being deterritorialized not by the State Department, but by self-organized performance networks, community projects, a proliferation of urban dance scenes, live corollaries to an MTV kinesthetic, and a self-conscious appropriation of the political and critical externalities of dance into the performance process itself. One piece that embodies many of the contradictions of denationed contemporary dance is the choreographic work *Still/Here* (1994) by Bill T. Jones (Plate 12).[50] It addresses risk in its diverse meanings. It is an exuberant dance that is performed in defiance of death and uses video interviews on stage to link Jones, who is HIV positive, to his company in abstentia. Some of the movements have been gathered through community workshops with people who are themselves dying of various illnesses. There is an economy of scale in the production that both defies current scarcities that constrain stage values and mirrors the concentration of resources characteristic of other industries. Finally, there is a sheer intensity of dancing that pools the multiple virtuosities of a multicultural company that deploys risk in movement to combat the insinuations of dance as a movement at risk.

Beyond the interest of the work itself, this piece gained notoriety for the critical reception it garnered, as it was based on a life outside of live performance. One eminent dance critic, Arlene Croce, wrote a much discussed account of why she refused to attend the dance. Hers was a sort of antireview in which she argued against seeing the work on the grounds that it was "victim art." She objected to blurring the boundaries between death and its representation, thus making the critic a victim to an art form that appeared to speak for itself, rather than relying on the voice of the critic for its public representation.[51] She claimed to be coerced by the fact of death—unable to treat the formal properties of the dance as such—and referred to Jones as an artist who, by responding to her criticism on stage, usurped her voice.

The complicity of dance in bringing its own conditions of representation into crisis indicates that removing funding for the arts and other social policies is not simply a condition that dance must face when there is no more national dream to embrace. Whereas dance was once part of a movement that unleashed the nation,

it now holds out the possibility of surviving those forces that would put its own historical conditions of production at risk. At present, dance is no less useful in figuring the technique of self than it was a century ago. What it now offers is a commitment to collective self-constitution beyond the national stage. The grounds from which dance draws its inspiration may depend more than ever before on global movements.

NOTES

1. See Terry, *The Dance in America*, and McDonagh, *Complete Guide to Modern Dance*.
2. Ruyter, *Reformers and Visionaries*, 8.
3. See Lott, *Love and Theft*.
4. Haskins, *Black Dance in America*, 16.
5. Ibid., 17–18.
6. See Steve Fuller, "Does Science Put an End to History."
7. Ruyter, *Reformers and Visionaries*, 29.
8. Ibid., 23–24.
9. Loie Fuller, *Fifteen Years*, 71.
10. John Martin, *The Modern Dance*, 13–14; Peirce, *Collected Papers*, 135.
11. Loie Fuller, *Fifteen Years*, 27.
12. Duncan, "America Makes Me Sick," 136.
13. Duncan, "I See America Dancing," 48.
14. Duncan, *My Life*.
15. Terry, *The Dance In America*, 41.
16. See Randy Martin, "Dance Ethnography."
17. Loewenthal, *The Search for Isadora*, 10.
18. See Susan Buck-Morss, *Dialectics of Seeing*.
19. St. Denis, "The Dance as Life Experience," 21, 25.
20. Schorr in Horosko, *Martha Graham*, 37.
21. Graham, "Affirmations, 1926–37."
22. Humphrey, *The Art of Making Dances*, 18.
23. Ibid., 47.
24. Humphrey quoted in Stodelle, *Dance Technique of Doris Humphrey*, 19.
25. John Martin, *America Dancing*, 63.
26. See Franko, *Dancing Modernism*.
27. See Carol Martin, *Dance Marathons*.
28. Trisha Brown quoted in Livet, *Contemporary Dance*, 54.
29. See Sussmann, "Anatomy of the Dance Company Boom."
30. Jean Morrison Brown, *The Vision of Modern Dance*, 127.
31. See Banes, *Terpsichore in Sneakers*, xiv; Banes and Manning, "Letters"; Manning, "Modernist Dogma"; Foster, *Reading Dancing*; and Randy Martin, *Performance as Political Act*.
32. Banes, *Terpsichore in Sneakers*, 17.
33. Rainer, "The Mind Is a Muscle," 144.
34. Ibid., 147.
35. Marquis, *Art Lessons*, 26.
36. Quoted in Jan Van Dyke, *Modern Dance in a Postmodern World*, 25.
37. Marquis, *Art Lessons*, 64.
38. See Elder, *The Information Machine*.

39. Thomson and Laves, *Cultural Relations*, 125 (quotation); Lowry and Hooker, "Role of the Arts," 59.

40. Both Kennedy speeches are quoted in Marquis, *Art Lessons*, 55–56.

41. See Banes, *Democracy's Body*.

42. Foster, *Reading Dancing*, xiv, and "Dancing Bodies," 494.

43. See Copeland, "A Curmudgeonly View."

44. See Palfy, *Dance Reconstructed*.

45. See Marquis, *Art Lessons*; Phelan, *Unmarked*; and Dubin, *Arresting Images*.

46. See Douglas, *Risk and Blame*.

47. See Randy Martin, *Critical Moves*.

48. See Novack, *Sharing the Dance*.

49. Beck, *Risk Society*, 23.

50. Michael E. Brown and Randy Martin, "Left Futures," 65.

51. See Croce, "Discussing the Undiscussable."

BIBLIOGRAPHY

Banes, Sally. *Democracy's Body*. Ann Arbor: UMI Research Press, 1984.

——. *Terpsichore in Sneakers: Post-Modern Dance*. 2d ed. Middletown: Wesleyan University Press, 1987.

Banes, Sally, and Susan Manning. "Letters." *Drama Review* 121 (Spring 1989): 13–16.

Beck, Ulrich. *Risk Society: Towards a New Modernity*. London: Sage, 1992.

Brown, Jean Morrison, ed. *The Vision of Modern Dance*. Princeton: Princeton Book Publishers, 1979.

Brown, Michael E., and Randy Martin. "Left Futures." *Socialism and Democracy* 9, no. 1 (Spring 1995): 59–89.

Buck-Morss, Susan. *The Dialectics of Seeing*. Cambridge: MIT Press, 1989.

Copeland, Roger. "A Curmudgeonly View of the American Dance Boom." *Dance Theatre Journal* 4, no. 1 (1986): 10–13.

Croce, Arlene. "Discussing the Undiscussable." *New Yorker*, December 26, 1994/January 2, 1995, 54–60.

Douglas, Mary. *Risk and Blame*. London: Routledge, 1992.

Dubin, Steven C. *Arresting Images: Impolitic Art and Uncivil Actions*. New York: Routledge, 1992.

Duncan, Isadora. *My Life*. New York: Boni and Liveright, 1927.

——. "I See America Dancing." In Sheldon Cheney, ed., *Isadora Duncan: The Art of the Dance*, 47–50. New York: Theater Arts Books, 1928.

——. "America Makes Me Sick." In Franklin Rosemount, ed., *Isadora Speaks*, 129–36. San Francisco: City Lights, 1981.

Elder, Robert E. *The Information Machine: The United States Information Agency and American Foreign Policy*. Syracuse: Syracuse University Press, 1968.

Foster, Susan. *Reading Dancing: Bodies and Subjects in Contemporary American Dance*. Berkeley: University of California Press, 1986.

——. "Dancing Bodies." In Jonathan Crary and Sanford Kwinter, eds., *Incorporations*, 480–95. New York: Zone, 1992.

Franko, Mark. *Dancing Modernism: Performing Politics*. Bloomington: Indiana University Press, 1995.

Fuller, Loie. *Fifteen Years of a Dancer's Life*. Boston: Small, Maynard, 1913.

Fuller, Steve. "Does Science Put an End to History, or History to Science?" *Social Text* 46/47 (Spring 1996): 27–42.

Graham, Martha. "Affirmations, 1926–37." In *Martha Graham*, edited and with a foreword by Merle Armitage, 99–100. 1937. Reprint, Brooklyn, N.Y.: Dance Horizons, 1966.

Haskins, James. *Black Dance in America: A History through Its People*. New York: Thomas Y. Crowell, 1990.

Humphrey, Doris. *The Art of Making Dances*. New York: Grove Press, 1959.

Livet, Anne, ed., *Contemporary Dance*. New York: Abbeville Press, 1978.

Loewenthal, Lillian. *The Search for Isadora: The Legend and Legacy of Isadora Duncan*. Pennington, N.J.: Dance Horizons, 1993.

Lott, Eric. *Love and Theft: Black Face Minstrelsy and the American Working Class*. New York: Oxford University Press, 1993.

Lowry, W. McNeil, and Gertrude S. Hooker. "The Role of the Arts and the Humanities." In Paul J Braisted, ed., *Cultural Affairs and Foreign Relations*, 45–87. Washington, D.C.: Columbia Books, 1968.

Manning, Susan. "Modernist Dogma and 'Post-Modern' Rhetoric: A Response to Sally Banes' *Terpsichore in Sneakers*." *Drama Review* 120 (Winter 1988): 32–39.

Marquis, Alice Goldfarb. *Art Lessons: Learning from the Rise and Fall of Public Arts Funding*. New York: Basic Books, 1995.

Martin, Carol. *Dance Marathons: Performing American Culture in the 1920s and 1930s*. Jackson: University Press of Mississippi, 1994.

Martin, John. *The Modern Dance*. New York: A. S. Barnes, 1933.

——. *America Dancing: The Background and the Personalities of Modern Dance*. New York: Dodge Publishing Co., 1936.

Martin, Randy. *Performance as Political Act: The Embodied Self*. New York: Bergin and Garvey, 1990.

——. "Dance Ethnography and the Limits of Representation." *Social Text* 33 (1992): 103–23.

——. *Critical Moves: Dance Studies in Theory and Politics*. Durham, N.C.: Duke University Press, 1998.

McDonagh, Don. *The Complete Guide to Modern Dance*. New York: Doubleday, 1976.

Novack, Cynthia. *Sharing the Dance: Contact Improvisation and American Culture*. Madison: University of Wisconsin Press, 1990.

Palfy, Barbara, ed., with Claudia Gitelman and Patricia Mayer. *Dance Reconstructed: Proceedings of a Conference on Modern Dance Art Past, Present, Future, October 16 and 17, 1992*. New Brunswick, N.J.: Rutgers University Press, 1993.

Peirce, Charles Sanders. *Collected Papers: Book 2*. Cambridge: Harvard University Press, 1931.

Phelan, Peggy. *Unmarked: The Politics of Performance*. London: Routledge, 1993.

Rainer, Yvonne. "The Mind Is a Muscle" (1966). In Jean Morrison Brown, ed., *The Vision of Modern Dance*, 141–50. Princeton, N.J.: Princeton Book Publishers, 1979.

Ruyter, Nancy. *Reformers and Visionaries: The Americanization of the Art of Dance*. New York: Dance Horizons, 1979.

Schorr, Gertrude. In Marian Horosko, comp., *Martha Graham: The Evolution of Her Dance Theory and Training, 1926–1991*. Pennington, N.J.: a cappella books, 1991.

St. Denis, Ruth. "The Dance as Life Experience," [1924–25]. In Jean Morrison Brown, ed., *The Vision of Modern Dance*, 21–25. Princeton: Princeton Book Publishers, 1979.

Stodelle, Ernestine. *The Dance Technique of Doris Humphrey and Its Creative Potential*. Princeton: Princeton Book Publishers, 1978.

Sussmann, Leila. "Anatomy of the Dance Company Boom, 1958–1980." *Dance Research Journal* 16, no. 2 (Fall 1984): 23–28.

Terry, Walter. *The Dance in America*. New York: Da Capo, 1953.

Thomson, Charles A., and Walter H. C. Laves. *Cultural Relations and U.S. Foreign Policy*. Bloomington: Indiana University Press, 1963.

Van Dyke, Jan. *Modern Dance in a Postmodern World: An Analysis of Federal Arts Funding and Its Impact on the Field of Modern Dance*. Reston, Va.: National Dance Association, 1992.

WILLIAM E. LEUCHTENBURG

..

Art in the Great Depression

I n a good many accounts of twentieth-century painting and sculpture, the decade of the 1930s is deplored as "the dreary aesthetic stepchild of American art." To some, this verdict may seem inordinately harsh, for never before or since has the national government offered so much encouragement as it did in the age of Franklin D. Roosevelt. The New Deal ventures, one historian has noted, have "become synonymous with . . . elephantine post-office allegories"; another has written, "Considered eclipsed by the brilliant flowering of abstract art in succeeding years, the projects appear irrelevant to today's styles and interests."

Even at the height of enthusiasm for federal patronage, Alfred Stieglitz advocated paying the jobless monthly stipends but forbidding them to touch a canvas, and Waldo Pierce, a beneficiary of the Roosevelt program, wrote an official to inquire jocularly "why they didn't employ half the artists to paint the murals in during the day and the other half to paint 'em out by night, with malice toward none, not even the building, employment for all and leaving the edifice in all its primal purity of wall." The projects, said *Fortune* in the 1930s, ran the danger of becoming "a kind of artistic Old Soldiers' Home for . . . hack painters," and *Time*, in a generally friendly assessment, reported that "many an ill-trained dauber . . . whose hand was out" was given a place "at a Government easel." Even the most selective of the programs did not escape censure. One of the more ambitious sculptures—a pair of massive eagles in green stone intended for the top of the Social Security Building in Washington—looked, said one critic, as if its creator had "washed down pistachio ice cream with Irish whiskey." In the end, these "limestone dodos," costing five thousand dollars, wound up with an automobile dealer in Alexandria who bid twenty-five dollars.

In an era when publicists hailed Thomas Hart Benton, John Steuart Curry, and Grant Wood for their wholesome values, innovative, especially abstract, artists had

no chance, commentators have said, and the very words of the "cornbelt academy" appear to prove them right. "I wallowed in every cockeyed ism that came along and it took me ten years to get all that modernist dirt out of my system," Benton told Thomas Craven, the Hearst chain's conservative art authority. Afterward, Benton explained: "John Steuart Curry and Grant Wood rose along with me to public attention in the thirties. We were different in our temperaments and many of our ideas but we were alike in that we were all in revolt against the unhappy effects which the Armory Show of 1913 had on American painting. We objected to the new Parisian aesthetics which was more and more turning art away from the living world of active men and women into an academic world of empty pattern." It was for this reason that in 1934 *Time*, in a lengthy, widely noted article, heaped praise on the "American scene" painters who were "destined to turn the tide of artistic taste" against "the crazy parade of Cubism, Futurism, Dadaism, Surrealism," a judgment that appalled modernist aesthetes.

The drumbeat of criticism became considerably louder when the Great Depression ended. Rarely has a movement been extinguished so quickly. At a time when the United States was thinking increasingly in global terms, a wholly native art appeared to be inappropriate, and the arrival in the United States toward the end of the thirties and in the early years of World War II of figures such as Marc Chagall, André Breton, and Piet Mondrian spotlighted the provincialism of the Midwestern regionalists. During the war, one observer wrote that Benton and his school had gone "American so raucously, so insistently, that they provided and inspired an enormous flood of dull, routine anecdotes—Americana on a four-alarm binge," with "lyrical canvases tumbling in unending procession from chauvinistic brushes." This "narcissistic reverence for home-made products" was "destructive to progress, ideologically and esthetically," for it shared with fascism a fondness for "local, familiar narcotics." In the postwar era Jackson Pollock, who had been Benton's pupil, declared, "The idea of an isolated American painting, so popular in this country during the thirties, seems absurd to me just as the idea of creating a purely American mathematics or physics would seem absurd."

Commentary over the past half century has largely echoed these views. "The 'hardboiled' pose of the Social Realists and Regionalists," Irving Sandler has written, "led to paintings of distressing triteness, affectedly crude rather than strong, and devoid of formal interest." Often the work of muralists "accomplished little more than to fill empty wall space," a not unsympathetic historian has written. "On the whole the federal mural program seems to have produced mediocre results." One critic has lamented that "during the crucial phase of his career, Philip Guston's development was slowed by the necessity of accepting, for economic reasons, a series of government-sponsored mural commissions, in which his ideas were inevitably influenced by the prevailing standards"; Adolf Dehn recalled

federal patronage as "sad—for my own creativity." In her survey of the twentieth century, prominent critic Barbara Rose encapsulated the perception that the art of the period was "retrograde." The regionalists "have been forgotten, and for good reason," she concluded, "since they painted in a dead provincial manner that pandered to the worst element of popular taste and did nothing to add to the development of American art."

So insistent is the chorus of disapproval that it seems foolhardy to demur, but, in truth, the art of the thirties has been dismissed too casually. Granted, much of the work was jejune, and the imperatives of hard times did put nonobjective artists, who were taunted with heeding a private muse and genuflecting to European tastes, on the defensive. Yet the decade was also one of considerable creativity that resulted in canvases and sculpture of enduring worth. Even abstract art, which burgeoned in the postwar era, owes much to the seedbed of the FDR years. The Museum of Modern Art had been founded only a year before the decade began; in 1931 the Whitney Museum of American Art opened its doors, and in 1939 the Museum of Non-Objective Painting (later "the Guggenheim") started. Abstract artists received sustenance, too, in Albert Gallatin's Museum of Living Art in New York University at Washington Square. Francis O'Connor, the foremost authority on the New Deal arts projects, has gone so far as to say, "One cannot escape the reality that something very vital—indeed, something revolutionary—happened to American culture during the 1930s."

II

The onset of the Great Depression after the stock market crash of 1929 had a savage impact on the lives of American artists. Far more than those in other pursuits, artists were concentrated in a single place, Manhattan, and the experience of New York City in these years speaks volumes for their fate. One artist has recalled: "Washington Square was one big bed at night—not a blade of grass uncovered. Hoovervilles in the drained reservoir in Central Park, on the banks of the Hudson, on the lower East Side." Will Barnet, then a beginner at the Art Students League, has said of this time: "It was like a war going on. There were bread lines and men lined around three, four, five, six blocks waiting to get a bowl of soup. . . . One felt this terrible dark cloud over the whole city."

As the crisis worsened, painters and sculptors found that patrons no longer bought their work, galleries folded, and museums cut back drastically on acquisitions. Marsden Hartley, with, as he pointed out, "twenty pictures in American museums," reported bleakly: "There is little sense of security anywhere, so I have lived more precariously the last two or three years than I have known since I began to be exhibited and the uncertainty adds no whit whatever to the peace of mind

that is necessary for decent works." Others fared far worse. "Many of us," Philip Evergood later said, "felt the chill which the fear of starvation brings to people." By 1932, Matthew Josephson wrote, the art colony of Woodstock, New York, "with its two hundred artists and art students seemed to have become completely moribund."

Bereft of means of support, some artists were reduced to begging for food on street corners and sleeping on subways, while others resorted to barter. At the Syracuse Museum, a painter exchanged an oil for the service of an obstetrician, and at a mart conducted by the Society of Independent Artists at the Grand Central Palace in Manhattan in 1931, one critic wrote: "A canvas for a wedding ring. A water color for a new shirt. An etching for a carton of cigarettes and the price of a bottle of wine! . . . Broke, or nearly so, they have come . . . to offer their dreams in paint." Raphael Soyer traded his paintings for food and clothing, and Arshile Gorky, who, his wife has said, thought of the depression era as "the bleakest, most spirit-crushing period of his life," shifted to pen-and-ink sketches because he could no longer afford paint. "Depression—who can describe the hopelessness that its victims knew?" asked Moses Soyer toward the end of the decade. "Perhaps no one better than the artist taking his work to show the galleries. They were at a standstill. The misery of the artist was acute. There was nothing he could turn to."

For the art community, it was a stroke of good fortune that in November 1932, in the trough of the depression, the country elected the governor of New York, Franklin Delano Roosevelt, as president of the United States. During FDR's governorship, his relief director, Harry Hopkins, had initiated a works program for artists that, though modest, made it possible for struggling beginners such as Jackson Pollock to take free classes. When Roosevelt entered the White House in March 1933, he had nothing particular in mind for artists, but he did create an ambience where all things seemed possible. In that halcyon spring, he sent fifteen messages up to Capitol Hill, and Congress enacted all fifteen programs, including one particular innovation: massive relief for the unemployed.

It was in this heady atmosphere that, in May 1933, in the midst of the First Hundred Days, painter George Biddle wrote his Groton and Harvard classmate Franklin Roosevelt:

> The Mexican artists have produced the greatest national school of mural painting since the Italian Renaissance. Diego Rivera tells me that it was only possible because [the president of Mexico] Obregon allowed Mexican artists to work at plumbers' wages in order to express on the walls of the government buildings the social ideal of the Mexican Revolution.
>
> The younger artists of America are conscious as they have never been of the social revolution that our country and civilization are going through; and they would be eager to express these ideals in a permanent art form if they were given

the government's cooperation. They would be . . . expressing in living monuments the social ideas that you are struggling to achieve. And I am convinced that our mural art with a little impetus can soon result, for the first time in our history, in a vital national expression.

The president, with strong encouragement from his wife, responded favorably to Biddle's overture, and in December 1933 the Treasury Department established the Public Works of Art Project (PWAP) under Edward Bruce, a former Columbia football star and graduate of Columbia Law School who had given up a career in finance to study in Italy for six years under Maurice Sterne and had become an accomplished painter. Over the next half year, the project spent more than a million dollars allotted by yet another New Deal agency, the short-lived Civil Works Administration (CWA), to support nearly four thousand artists. The PWAP came just in time. "I am almost ready to give up," one artist wrote. "I have one hope left—the CWA, and it'll probably fizzle out the way all other hopes did. In that case it is eight-bells for me."

Under the CWA, headed by Hopkins who had come down from Albany to Washington, artists got not a relief pittance but artisans' wages, and they turned out more than 15,000 pieces—oils, watercolors, prints, sculpture, even Native American blankets and pueblo pottery. But it was the murals, a tiny fraction of the total, with which the PWAP was largely identified. Greatly influenced by the Mexicans—Diego Rivera, José Clemente Orozco, and David Siqueiros—they did much to inspirit the muralist movement in America that had gotten a fresh start with Benton's walls at the New School for Social Research in 1930.

The Public Works of Art Project had its share of difficulties. Bruce named to chair the regional office centered in New York City Juliana Force, director of the Whitney Museum, who was shot at from all sides. Conservatives objected that she was too sympathetic to modern art; more troublesome by far, though, were critics on the Left who on one occasion marched from Washington Square to the Whitney, compelling her to call out the police. On another occasion, she was besieged by five thousand demonstrators who encircled CWA headquarters singing the Internationale.

Yet, for all its tribulations, the project, due in good part to the energy of the indefatigable, resourceful Bruce, turned out to be a decided success, and when the stopgap CWA expired in June 1934, the Treasury gave Biddle's idea a second life by undertaking a new venture, the Section of Painting and Sculpture, which was essentially a re-creation of the Public Works of Art Project. It would last for nearly a decade. Like the original agency, the section was not a relief operation but an effort to improve the appearance of public buildings, especially post offices and courthouses, with murals and sculpture. It based employment not on need but on merit.

Figure 1. William Gropper, Construction of the Dam. *(U.S. Department of the Interior, Washington, D.C.; Fine Arts Program, Public Buildings Service, U.S. General Services Administration)*

Once again, Secretary of the Treasury Henry Morgenthau Jr. tapped Ned Bruce, who sometimes ran this program, as he had the PWAP, with a heavy hand. A man of decided opinions, he had written an article rejoicing that the Public Works of Art Project was "amazingly free from isms and fads and so-called modern influences." He did not like public buildings that were too cerebral or that looked like the National Gallery of Art, "that pink marble whorehouse." Earlier, his assistant director had declared, "Any artist who paints a nude for the Public Works of Art Project should have his head examined," and the section denied Yasuo Kuniyoshi a commission for a mural because he had submitted a sketch of, in the words of a shocked official, "a buxom woman being raped in Central Park with the two fingers of God Almighty pointing to where X marks the spot." There was also occasional local interference. In Westport, Connecticut, Treasury project artists were forbidden to delve into "cubism, futurism, and all forms of modernism." Much more widely publicized was an episode in San Francisco, where authorities were dismayed to discover that murals for Coit Tower showed a worker reading a Communist newspaper, a display of books by Karl Marx and proletarian authors, and the legend, "Workers of the World Unite." After a heated controversy, a hammer and sickle was painted over, but the rest remained. None of these instances of public censorship, though, matched the most conspicuous fracas of the

Figure 2. Reginald Marsh, The Harbor, the Skyline, and the Statue of Liberty. *(The Custom House, New York City; Fine Arts Program, Public Buildings Service, U.S. General Services Administration)*

decade when in 1934 Rockefeller Center effaced a mural by Rivera that glorified Lenin.

Still, under Bruce's direction, and drawing on funds of the Public Works Administration, the Section of Painting and Sculpture completed about one thousand murals, a number of them of high quality, including William Gropper's panels for the Department of the Interior (Fig. 1). To embellish the new Department of Justice and post office buildings in Washington, the section commissioned a remarkable cadre: painters George Biddle, John Steuart Curry, Rockwell Kent, Leon Kroll, Reginald Marsh, Henry Varnum Poor, Boardman Robinson, Eugene Savage, and Maurice Sterne, and sculptors Paul Manship and William Zorach. (Thomas Hart Benton and Grant Wood were also chosen but withdrew.) In addition, the section ran, for a time, another program, the Treasury Relief Art Project (TRAP), whose most important product was Reginald Marsh's elegant series of a dozen murals in fresco secco about New York harbor for the dome of the rotunda of Cass Gilbert's U.S. Customs House on the Battery in lower Manhattan (Fig. 2). Lloyd Goodrich, long the director of the Whitney Museum, judged the cycle to be "one of the most impressive creations in the history of American mural art."

The activities of the section, while improving a great many government buildings, did little to help the mass of jobless artists, but in 1935 that situation changed dramatically. Early that year, Congress, at FDR's behest, voted nearly five billion dollars, the largest single peacetime appropriation by any nation in the history of the world, to put unemployed men and women to work. To administer this grant, Roosevelt set up a new agency, the Works Projects Administration (WPA), again under Hopkins, who, instructed by the president to "try to work out a project for the artists," created cultural programs for jobless writers, actors, musicians, painters, and others. To head the Federal Art Project (FAP), Hopkins named Iceland-born Holger Cahill, a former farmhand, cattle puncher, reporter, and Greenwich Village habitué. Cahill had made a name for himself by building the Newark Museum's collection of contemporary U.S. art and mounting two notable shows of American folk art. The basic design of the project, however, came from a New York woman with considerable experience in running relief programs for artists, Audrey McMahon, who was chosen to supervise the program in New York City, where more than 44 percent of artists on the WPA rolls lived.

In addition to providing sustenance for easel painters, muralists, and sculptors, the Federal Art Project sponsored the Index to American Design, a compilation that one publication said "is to U.S. design what the Code Napoleon was to French law"; accounted for half a million photographs, including the much-admired work of Berenice Abbott; encompassed a graphics division that turned out nearly a quarter of a million prints, resulting in marked advances in silk screen and in color lithography; and in more than a hundred cities, particularly in the South and West, established over one hundred community art centers with gallery workshops that drew eight million visitors. Goodrich called the projects "the greatest single factor in our history for extending the influence of art throughout our people."

III

Though a number of writers have treated the Federal Art Project of the WPA with considerable disdain, that was not the response of artists at the time. The biographers of one painter, still obscure in this period, have written:

On the morning of August 1, 1935, Jackson and Sande Pollock awoke to startling news: "They're hiring artists." People dashed through the streets of the Village, clutching paintings under their arms, spreading the news from door to door. May Taback Rosenberg, whose husband Harold would become a leading art critic in the 1950s, was one of those who heard the alarm. "They were shouting with the excitement of children at a zoo," she later wrote. " 'Hurry. Grab some paintings. Hurry! Grab anything you've got framed and come along. Hurry.' " . . . After years of destitution, of languishing in cold-water flats and

empty galleries, most of the Village's two hundred artists and art students could hardly believe their ears. "It was like winning a lottery for ten million dollars," recalls one of them. "We couldn't believe that you got paid *steady*; twenty-three dollars a week, just to paint. It was the *craziest* thing we ever heard of."

Even after two years had gone by, many artists continued to draw encouragement from the prospect of government support. A painter who was eighteen when he arrived in New York in 1937 has recounted:

Snuggling up to the action right off, I went to the opening of a splendid water-color show at the old Whitney Museum on 8th Street, swallowed my first martini, patted Juliana Force on the ass and settled down for a long winter's night during which my three-hundred-dollar nest egg was swiftly dispatched.

It was then that I began to think seriously of the WPA/FAP, which was the single source of income for the artists I knew. The Project paid about eleven hundred dollars per year, a willowy fortune to me, and a prudent couple could survive handily if they ate with caution and watered down the gin.

Artists found the chance to pursue their métier inspiriting. In 1936 muralist George Biddle wrote Bruce: "All goes surprisingly well and I never worked so hard or with such enthusiasm. I get up at 6 o'clock, am on the scaffolding before 7 and always work 10, 11 or 12 hours. . . . I cannot tell you the real passion I have for this lovely medium." Another artist recalled: "I used to get up at 6 A.M. and stand in a line of 300 people. By the time I got near the door, the jobs were already filled." But the government commissioned him to execute two murals for post offices in Massachusetts. "The projects," he testified, "inspired my best work."

In the diary he kept while engaged on the WPA building at the New York World's Fair, Anton Refregier recorded:

January 1939—The work is going full swing. The workshop is the closest to the Renaissance of anything, I am sure, that has ever happened before in the States. . . . Everyone feels and knows that we must do our utmost. We know that there are a bunch of commercial mural painters preparing murals for the different buildings of the Fair. . . . They are making at least ten times more money than we are. But they can have it. Theirs will be the usual commercial crap. They are not moved as we are by our content—by our search for creative and contemporary design—by our concern for people. WE are the mural painters. We hope we are catching up with our great fellow artists of Mexico. We will show what mural painting can be!

April 1939—The Fair is about to open. Today I was in Flushing Meadow to watch the installation of the murals. I have a feeling of tremendous satisfaction. . . . The work . . . of Guston, Ludins—is superb. Our building is a gem, and millions of people will see it.

Refregier was exultant when on a summer day visitors to the fair cast ballots on the exhibits; he won second prize in the competition for indoor murals, Philip Guston first prize for the best outdoor mural.

"It kept the arts alive," maintains one New Deal muralist. "The projects kept the arts above water at a time when they could have gone under. It turned what could have been a dead period into something very vital, vibrant." Since sales to galleries were minimal, "the Project," one painter stated, "was our lone lifeboat," and a sculptor called the arts program "a providential thing." A painter whose work would later be purchased by a number of museums said, "I do not know if I could have even continued to be an artist if not for the WPA." Willem de Kooning, an illegal alien from the Netherlands who had dabbled in painting but had spent most of his time on odd jobs in a country he thought hostile to art, attested: "I got on the WPA. . . . The year I was on gave me such a terrific feeling that I gave up painting on the side and took a different attitude. After the Project I decided to paint and do odd jobs on the side."

Years afterward, most of the veterans of the Federal Art Project remembered it fondly. When Francis O'Connor surveyed artists who had been sustained by the WPA, 88 percent responded that employment had been aesthetically "rich and satisfying." "What a break it was," one painter has said. "We were all young, and there was no such animal at the time as a master of fine arts degree, so the WPA really amounted to a graduate program in art. It was an experience we shared. It was really the first art community I was ever aware of." Decades later, Robert Gwathmey told Studs Terkel: "Artists have to live, right? Eat, sleep, breathe, build. The great difference is when you have a government as a patron . . . who made no demands on you at all, there were no enlarged notions of making that extra buck. That was a very free and happy period."

The WPA nourished thousands of artists—painters such as Joseph Stella and Balcomb Greene, sculptors like Ibram Lassaw and José de Rivera. One artist remembered: "The payroll in New York embraced at various times just about everybody who ever stretched a canvas, rigged an armature or pulled a proof. Davis, Hartley, Gorky, de Kooning, Reinhardt, Rothko, Pollock, Guston, Gropper, Refregier, Evergood, Will Barnet and the three Soyer brothers are only a few in the grab bag of memory who put in a hitch on the Project before it was dismantled in 1943." Over the eight years when Pollock was on and off the WPA, engaged in activities such as a mural for Grover Cleveland High School in the borough of Queens in New York City, his income from the government totaled less than $8,000. Nonetheless, O'Connor has pointed out, "the resulting financial security . . . permitted him to experiment freely, developing a personal style that became more apparent after 1938."

Though there were isolated incidents of censorship, most artists felt unshackled.

Roosevelt was frequently under fire from conservatives for fostering subversive depictions of American society, but Cahill declared, "Never once did I hear of a word of criticism from the White House . . . saying 'Why did you paint those awful pictures? Why do you allow your artists to do this?' Nothing. Never." When the chairman of the Maritime Commission, Joseph P. Kennedy, reviewed Marsh's sketches for the Customs House, he objected that featuring foreign flag vessels was contrary to government policy and wanted a U.S. passenger liner substituted for the *Queen Mary*. New Deal officials paid him no heed, and Marsh went ahead undisturbed. Bernarda Bryson Shahn, who collaborated with her husband, Ben Shahn, on a number of murals, has said: "The period has been misunderstood. I can't imagine a more liberal atmosphere than the one we worked in at that time. We didn't feel constrained about the subject matter at all. We painted what we would have been painting anyway." Similarly, another participant, Abe Ajay, has observed: "There was never, to my knowledge, any pressure by the Project administration to influence the direction or style of an artist's production. The Social-Surrealist Philip Evergood was supervisor of the easel division for a while, and Burgoyne Diller headed the mural section, promoting the work of abstractionists like Arshile Gorky, Ilya Bolotowsky, Stuart Davis and Byron Browne."

Artists sometimes prevailed because they found support in the community. Evergood, who was assigned to a mural for the Richmond Hill Public Library in New York (Fig. 3), recalls:

> First the local chapter of the DAR [Daughters of the American Revolution], a bunch of loonies, protested that I had depicted "foreign types"—can you imagine it? What else in America? . . . Then a little clergyman objected to the mammary glands of the women being too well-delineated. He didn't like that, for Pete's sake. So my mural went on trial before the Art Commission, and they voted to keep it. . . . A factory worker from Richmond Hill stood up in the hearing and said he had been coming in to watch me work for over a year—the whole time I'd been there up to then—he'd brought his kids in too. He told the Committee that I'd put my soul into this work, and that if I was forced to paint it out, he'd leave Richmond Hill. That was the clincher. They voted unanimously in favor of letting it stand.

In the course of its relatively short life, the Federal Art Project, spending seven times as much as all the other programs combined, turned out more than 100,000 easel paintings and nearly 18,000 pieces of sculpture, as well as more than 2,000 murals, including Edward Laning's striking adornment of the main hall of the New York Public Library. Henry Varnum Poor, who had been skeptical of the idea of public patronage, said: "What has happened and in such a short time is almost incredible. From a government completely apathetic to art, we suddenly have a

Figure 3. Philip Evergood, The Story of Richmond Hill, *1936. Detail of mural, oil on canvas. (Richmond Hill Public Library, Queens, New York; Photograph, Archives of American Art, Smithsonian Institution)*

government very art conscious. Public offices are decorated with fresh paintings instead of old prints." The projects, declared Lloyd Goodrich and John I. H. Baur, did "more for contemporary creation than any single agency in our history."

The quality of the work by the best of the FAP artists is suggested by the response of the museums. Of the 115 artists the Whitney picked to exhibit in 1937, 28 were on the WPA rolls. Other institutions were even more hospitable. In 1941 the top prizes given by the Metropolitan Museum of Art went to Ivan LeLorraine Albright and Jack Levine, both graduates of the Federal Art Project, and other awards were snared by such current or former FAP artists as Evergood and Mark Tobey. Even more striking were the results of the Chicago Art Institute Annual in 1942: every one of the prizes was taken by an artist from the ranks of the WPA.

IV

Although these artists belonged to a number of schools, or to no school at all, most of them turned away from the European influences that, especially since the Armory Show, had been dominant. The notion of painting American subjects did not, of course, begin with the Great Depression; the Hudson River School is only one example of previous manifestations. The years after 1929, however, witnessed self-conscious reliance—in the American scene, regionalist, and social protest

movements—on a native idiom and a deliberate rejection of those years when, in the words of critic Forbes Watson, "Francomania drove the Americans before it like blind slaves." During the 1930s, Oliver Larkin later observed, "a Shaker barn became as legitimate an object for study as a Florentine palace." Some of this departure could be seen a bit earlier, as in John Steuart Curry's *Baptism in Kansas* in 1928, but it first developed a critical mass in the 1931–32 season with "the American Wave." The opening of the Whitney Museum semaphored the changed emphasis. The Whitney, though receptive to a wide range of artists, was soon showing American Scene painters such as Benton and in 1935 mounted an exhibition on American Genre. On both of the programs Bruce supervised, he made clear that he expected employees to favor the American Scene. Their work, he wrote, exuded "the same feeling I get when I smell a sound fresh ear of corn. . . . They make me feel comfortable about America."

Critics attuned to the dernier cri from Paris denounced the American Scene for purveying a prettified greeting card view of the country's past, often with reason, but no one who brushes off Grant Wood as merely a painter of affirmative nostalgia can have taken a close look at his 1930 *American Gothic* or his well-known portrait of DAR ladies. Indeed, Matthew Baigell has written, "Perhaps no artist savaged the Middle Western face and character as brutally." The figures in the DAR painting, he goes on to note, are "three old snobs, one of whom is clearly senile." Wood's *The Midnight Ride of Paul Revere*, he adds, implies that that legendary feat should be "dismissed with something akin to a giggle," and *Parson Weems' Fable* clearly "mocks the sacrosanctity with which Americans have cluttered their view of [George] Washington."

Only a few painters such as William Gropper turned out social protest art, but they had a disproportionate influence. As Baigell has suggested: "Try, for a moment, to reconstruct images of the 1930's in your mind's eye. More than likely, your imagination will focus upon scenes that are derived from familiar paintings: a dust-bowl landscape, a dour Middle Western couple, or perhaps some Bowery derelicts." In an address to the American Artists Congress in 1937, Max Weber urged: "Take time off from the life-class and go out among the people who toil in the mills and shops. . . . Let the student look upon the artisan and mechanic as did the ancients upon their gladiators, discus throwers and wrestlers." Ben Shahn asked: "Is there nothing to weep about in this world anymore? Is all our pity and anger to be reduced to a few tastefully arranged straight lines or petulant squirts?" In 1936 Biddle observed that, in an exhibition of art from two nations, in the very year of the Front Populaire, not one French painting revealed preoccupation with social issues, whereas, of the U.S. canvases, "seventy-four dealt with the American scene or with a social criticism of American life; six with strikes, or with strikebreakers; six with dust, sand, erosion, drought, and floods. There were no nudes, no portraits, and two still lifes."

Some of the social realists deliberately set out to expose the seamier aspects of society, and not a few were avowed Marxists. Moses Soyer, who cautioned against being "misled by the chauvinism of the 'Paint America' slogan," advised: "Yes, paint America, but with your eyes open. Do not glorify Main Street. Paint it as it is—mean, dirty, avaricious." Siqueiros organized a workshop in New York where painters turned out posters of Earl Browder and other Communist leaders. Raphael Soyer later recalled affectionately the "memorable evening" when, "spellbound," he observed Diego Rivera, in a blue shirt and red tie, an "immovable, gigantic man towering above" his audience, address the John Reed Club.

To the dismay of conservative legislators, government patronage enabled these artists to promote their perception of a corrupt social order. As Larkin commented, "The world of Joseph Hirsch and of Jack Levine was the northern city

where slick lawyers whispered confidences and policemen hobnobbed with ward politicians in back rooms; and both were in their twenties when Federal Art gave them encouragement and support." "In no other nation," concluded Lloyd Goodrich and John I. H. Baur, "did artists say so frankly, loudly, and persistently what was wrong with their country. And many did so while on the Federal payroll—a unique example of democratic freedom of expression."

Even the social realists, it should be noted, pursued native themes—to such an extent that their work is often indistinguishable from that of the American Scene. Gropper, usually associated with savage satires of Establishment notables, crafted a mural for a Long Island post office that emanated yearning for a bucolic idyll (Fig. 4), and Peter Blume, best known for his mid-1930s canvas *The Eternal City*, reducing Mussolini to a lurid, repellent jack-in-the-box, rendered for an upstate New York post office the delicate tendrils of a grapevine on a promontory above a tranquil stream (Plate 13). The training of Evergood was so European that he had actually been educated at Eton, but in the thirties he forsook European styles because he found them inappropriate for the only contemporary subjects that were worthwhile—"the down-to-earth robust rawness of a steel worker's boot, or his wrinkled salt-caked sweater, or his grimy blue jeans."

Moreover, an interest in working-class topics did not necessarily preclude a celebration of the American system. In Ben Shahn's mural for a New Jersey community renamed *Roosevelt* in honor of FDR, Jewish refugees find happiness thanks to labor unions and the New Deal. To "Communist boulevardiers" who denounced the American Scene painters as fascists, Marsh responded: "Well, what should we do—be ashamed of being what we are—or imitate Orozco, Grosz, African Sculpture, and draw endless pictures of gas masks, 'Cossacks' and caricatures of J. P. Morgan with a pig-like nose? . . . Whatever you say, there is a tradition to be proud of."

V

Yet, if the archetypal work of the 1930s was a mural such as Biddle's *Tenement* or a piece of sculpture like Aaron Goodelman's moving *Homeless* (Fig. 5), these were also the years when surrealism, magic realism, and precisionist abstraction took hold; when Alexander Calder created his first mobile and when George Grosz and Josef Albers arrived, early in the decade, from Europe. In sharp contrast to the impression that 1930s art consisted wholly of brawny factory hands in Stalinist poses is the statement of the prominent magic realist Ivan Albright: "I have painted herrings that changed from purple to an orange oxide, women whose torrid flesh folds resembled corrugated mush, lemons and imitation fur, purple glazed leaves that exuded a funereal odor, and tawdry costume rings whose size all

Figure 5. Aaron Goodelman, Homeless, *1936. Plaster. New York City Project. (Francis V. O'Connor, ed.,* Art for the Millions: Essays from the 1930s by Artists and Administrators of the WPA Federal Art Project *[Greenwich, Connecticut: New York Graphic Society, 1973])*

but covered actor-less hands." In 1936 the American Abstract Artists was founded, and the following year, in an article in *Art Bulletin*, a critic wrote that "the new wind is blowing American painters very definitely towards abstraction. . . . It has altered the manner of the social protest painters from Aaron Bohrod to William Gropper. It has increased the following of a school new to literalist America, the school of pure abstraction."

Though they are in a minority, certain critics have recognized these tides of change. Hilton Kramer, in particular, has observed:

> The illusion still persists in many quarters that the thirties were primarily an epoch of social realism in American art, but in retrospect it is now clear that the best American art of the Depression era was already committed to an exploration of modernist forms, which, in practice, meant an absorption in cubism, constructivism, surrealism, expressionism, and their various off-shoots and amalgams.
>
> One can trace this commitment to modernism in the work which David Smith, Arshile Gorky and Willem de Kooning produced in the thirties, in the activities of the American Abstract Artists group, . . . and in the art of certain older artists—especially Stuart Davis, Milton Avery, and Alexander Calder.

Davis, regarded as "the country's leading modernist," had done significant work earlier but did not articulate his aesthetic until the 1930s. For the 1935 exhibition at the Whitney Museum, *Abstract Painting in America*, he wrote a manifesto:

> Our pictures will be expressions which are parallel to nature and parallel lines never meet. We will never try to copy the uncopiable but will seek to establish a material tangibility in our medium which will be a permanent record of an idea or emotion inspired by nature. This being so, we will never again ask the question of a painting, "Is it a good likeness, does it look like the thing it is supposed to represent?" Instead we will ask the question, "Does this painting, which is a defined two-dimensional surface, convey to me a direct emotional or ideological stimulus?"

He expressed outright contempt for the immensely popular regionalists. In 1935 Davis raised a blunt question about John Steuart Curry: "How can a man who paints as though no laboratory work had ever been done in painting, who willfully or through ignorance ignores the discoveries of Monet, Seurat, Cézanne and Picasso and proceeds as though painting were a jolly lark for amateurs, to be exhibited in country fairs, how can a man with this mental attitude be considered an asset to the development of American painting?" Four years later, he wrote disdainfully:

> Domestic naturalism, the chicken yard, the pussy cat, the farmer's wife, the artist's model, Route 16A, natural beauties of the home town, etc., became the order of the day in painting. And on the reverse side of the popular trend toward domestic naturalism were found the more trying aspects of man's struggle with nature and society, such as the picket line, the Dust Bowl, the home-relief office, the evicted family, etc. In mural painting it was the same thing: on the one hand, American history-in-costume, cowboys and Indians, frontier days, picturesque

industrial landscape, etc.; and on the other hand, Mexican muralism, the allegorical worker of bulging muscle and Greco-Roman profile, the fetish of fresco, etc. American art was, and, I wish to add, still is, right back with the Rogers Groups and J. G. Brown's ragged little shoeshine boys.

Modernists, especially abstractionists, often felt no less alienated from the Left. In a lampoon of social realism, Kuniyoshi drew a cartoon showing an art class faithfully replicating an Esso gas pump. Nonobjective artists, Sandler has observed, protested not only against "banal illustration" and "the heavy-handed mimicry" of the Mexicans, but also about "the dishonesty of their subject matter—bloated capitalists protected by vicious policemen beating noble strikers and emaciated women and children," distortions promoted by the cultural commissars of the Communist Party. In the 1950s John Ferren spoke for many others in saying: "Somehow, 'social significance' left us cold, as an aesthetic and as a credo. Not all of us at the same time. Some were converted early and some late, but by 1940 it was understood."

The Federal Art Project, while encouraging "a fresh poetry of the soil" and "art rich in social content," proved hospitable to the nonrepresentational mode. Holger Cahill took the job of national director only after he was warned that if he did not, it would go to the president of the National Academy, Jonas Lie, who was the bête noire of modern artists, especially after he applauded the destruction of the Rivera murals. ("Whitewash," Lie said, "is cheap.") Unlike Bruce, Cahill did not stipulate the American scene. "The huge Federal Art Project . . . was a signal factor in the encouragement of a wide variety of artists embracing all schools," wrote Sidney Janis during World War II. "A measure of security and an accredited place in relation to the social body did much for their self-assurance. Naturally, abstract painters benefited with the others." In the 1930s, an abstract painter has noted, the Museum of Modern Art "catered to the most popular art of the time, American Regionalism. By contrast, the WPA/FAP encouraged everybody."

The New Deal created a haven for abstract artists in the teeth of strong popular resistance. When the art center in Raleigh, North Carolina, the nation's first, put on an exhibit of abstract and surrealist work borrowed from the Corcoran, viewers rebelled. They insisted on, in the words of the center's director, "realistic paintings of the most saccharine type." Marsh recalled what happened when he worked in Washington, D.C., on a post office mural:

Having mounted the scaffold without a colored smock and a Tam O'Shanter resulted in many employees asking when the artist was coming along. This happened even after I had completed full length figures. In all the time I was there, no one asked me my name.

One or two had heard of Kent—three or four had heard of Grant Wood, and

about a dozen of a Mexican who had trouble with Rockefeller Center. One had heard of Michelangelo.

Many volunteered to tell me that Cubism angered them.

Nonetheless, the Federal Art Project persisted. Laning has observed: "It is true that some superb modernists were given an opportunity to try their wings on walls. Stuart Davis, Karl Knaths, Arshile Gorky, Byron Browne, Louis Schanker, and Willem de Kooning made history by being the first exponents of the modern or abstract style in American mural painting. It would be truer to say they initiated abstract mural painting in this country."

In constructing the mammoth Williamsburg Housing Project in Brooklyn, the government provided for social rooms in the twenty buildings, and Burgoyne Diller, whom Laning has called "an abstract artist's abstract artist, . . . a dark, intense young man, utterly serious and dedicated," resolved to put abstract murals in these spaces. He handed this assignment to well-known abstractionists, notably Stuart Davis, who executed his brilliant *Swing Landscape* (Plate 14), as well as to a cadre of young, unheard-of artists, including de Kooning and Francis Criss (Fig. 6)—with significant long-range consequences. In 1969 Henry Geldzahler, curator of contemporary arts at the Metropolitan Museum of Art, wrote, "The familiarity of the young American abstractionists with each other's work in the thirties and forties, fostered in part by the W.P.A.'s role, . . . created a new resonance and a new level of ambition."

By persevering, the project opened up possibilities for innovative artists that would otherwise have been denied them. When the FAP presented a model of Arshile Gorky's mural for the Newark Airport (Fig. 7) to the Art Commission of the City of Newark, an assembly of "rather cool, forbidding characters, . . . the sort of people you would see sitting in the windows of the Princeton Club, or the Yale Club," one of the city elders asked, "Well, that's abstract art, isn't it?" Diller has related, "That unleashed the devil, . . . a tirade of question and cross-questions and accusations about modern art" until a WPA representative of high social status "shamed them into accepting it."

Beyond any particular commissions the government handed out, the FAP created a welcoming atmosphere that has been likened to that of a Parisian café. A familiar painting by Moses Soyer, *Artists on the WPA* (Plate 15), conveys the easy camaraderie that made these painters the envy of those who were not chosen. Far from being a stigma, employment by the government in a make-work program became a badge of honor. Barnett Newman even contended, "I paid a severe price for not being on the project with the other guys; in their eyes I wasn't a painter; I didn't have the label." The FAP environment proved especially important for the modernists, who had not previously found the world so hospitable. Dore Ashton has written: "The W.P.A. was a central fact in the lives of nearly all the abstract

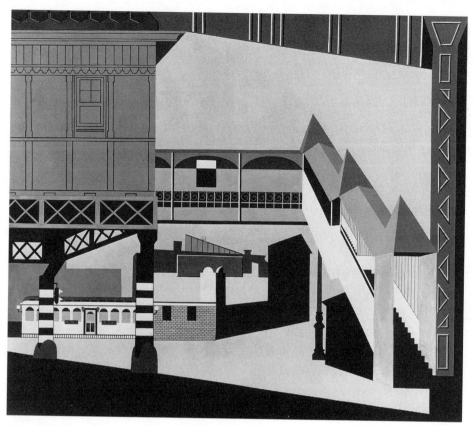

Figure 6. Francis Criss, Sixth Avenue El, *1938. Mural, oil on canvas. Williamsburg Housing Project, New York City. (National Museum of American Art, Smithsonian Institution, Transfer from the Newark Museum)*

expressionist painters. To them, the decade of the thirties represented the Project, and the Project meant the establishment of a milieu for the first time in the United States. If one conscientiously examines all the statements made subsequently by the major artists of the forties and fifties, the obvious value the W.P.A. had for them was that of artistic community. . . . The most compelling force that emerges is their sense of having found one another."

David Smith, liberated by the FAP to experiment with abstract sculpture, later reminisced: "Our hangouts were Stewart's Cafeteria 7th Ave. near 14th St close to Davis' studio and school and 5¢ coffee was much closer to our standards but on occasion we went to the Dutchman's, McSorley's and Romany Marie's. We followed Romany Marie from 8 St, where Gorky once gave a chalk talk on Cubism. . . . It was in Marie's where we once formed a group, Graham, Edgar Levy, Resnikoff, de Kooning, Gorky and myself with Davis being asked to join. . . . We were all what was then termed abstractionists."

Critic William Agee has placed these New Deal experiments in a broader perspective, concluding: "Far from being completely dominated by Regionalism,

Figure 7. Arshile Gorky painting mural panel for Newark Airport in WPA *Federal Art Project studio, ca. 1937 (Archives of American Art, Smithsonian Institution)*

American Scene and Social Protest painting as most easy generalizations would have it, the thirties were in fact a rich and infinitely complex period. It is a watershed, the point at which old issues and problems met with the newer currents that were to emerge in the great flowering of American art after 1945."

VI

Like many other New Deal ventures, the Federal Art Project did not survive the outbreak of war. Eighteen months after Pearl Harbor, it was disbanded—and with scandalous haste. Refregier, who had been so proud of his murals, noted in his diary: "Fall 1940—Now the Fair is dismantled. Burgoyne Diller . . . tried unsuccessfully to find a permanent place for my murals—offering them to high school auditoriums. But nothing came of this. The murals were destroyed." Most of the art distributed to schools and colleges has been misplaced or has been dumped into incinerators. Only two of Gorky's ten panels at Newark Airport have been recovered, and James Brooks's huge mural at the recently built La Guardia Airport (Fig. 8) was, over the years, obscured by several coats of paint. (It has subsequently

Figure 8. James Brooks, Early Flight Models and Leonardo da Vinci, *1955. Detail of La Guardia mural. (David Shapiro, ed.,* Art for the People: New Deal Murals on Long Island *[Hempstead, New York: Hofstra University, 1978], p. 29)*

been restored.) Most of Pollock's paintings for the WPA are gone forever, and Mark Rothko's early canvases were found wrapped around pipes for insulation after they had been sold to a junk dealer at four cents a pound at an auction in Flushing. (When one alert shopper came upon a heap of what had been bought as mildewed canvas at a secondhand shop, he purchased a few hundred at five dollars a piece and walked off with a number of Rothkos and Pollocks.)

Despite the sorry fate of particular works, the Federal Art Project has bequeathed an enduring legacy. Artists from a wide range of ideological stances have seen in the 1930s nothing less than a new chapter in the history of painting and sculpture in the United States. "Wonderful things were being done," Bernarda Bryson Shahn maintained. "American art was almost born then. Although we had a considerable art tradition before, it had always been derived from Europe. The great surge that made American art the world leader came out of the projects." The traditionalist George Biddle claimed that the depression had "a more invigorating effect on American art than any past event in the country's history," a conclusion shared by the radical Stuart Davis, who, though critical of regionalism, nonetheless called the launching of the WPA project "the birth of American art."

The alumni of the New Deal projects left an extraordinary imprint on the postwar age. It has been estimated that "about 80 percent of the painters and

sculptors who gained world recognition in the Forties and Fifties were supported during the Depression by government funds." In a similar calculation offered a generation after the 1930s, Gwathmey remarked, "I'll wager if there were five hundred gallery artists who made it, who are represented by dealers, about four hundred were on WPA." Clement Greenberg, in explaining the postwar art scene, wrote: "The WPA, with its Federal Art Project, had had its part . . . in raising the level of artistic culture in New York. Thanks to the Project, many younger painters had been able to devote themselves entirely to art at a period in their lives when this was most essential. The high seriousness and high ambition which propelled the most advanced American painting in the later nineteen-forties would be hard to account for otherwise."

Those who ridiculed the murals programs failed to grasp both what aesthetic advances they fostered and what thoroughfares they opened. "American artists," one writer has stated, "began to stay clear of 'Greek ladies, with cheese cloth bound about their nipples, cluttered with scales, lambs, sheaves of wheat.' No longer did the young artists of America draw Hellenic nudes representing the spirit of American Motherhood, Purity and Democracy." Goodrich, too, has noted that in the 1930s "the pseudo-classicism of the old mural school, with idealized females symbolizing the civic virtues—nice American girls in cheesecloth" gave way to "realistic subject matter concerned with the life of America, present and past." What this meant for two important artists has been pointed out by Richard McKinzie: "Anton Refregier and Willem de Kooning . . . had worked for an interior decorator who specialized in stylized murals for hotel lobbies and speak-easies in the early years of the depression. The FAP gave them a chance to turn from painting fake Bouchers, Fragonards, palm trees, nude girls, and goldfish and begin to 'look at people's lives' through their painting and, according to Refregier, to 'connect up with the great tradition' of mural art. Both de Kooning and Refregier credited the FAP with advancing them in their profession." Juliana Force said at the time that the WPA turned out "too much mediocre art," not surprisingly because "there can be no true selectivity when the basic reason for choosing an artist is his poverty," and Matthew Josephson later disparaged WPA murals as "generally sloppy and unimaginative," but Refregier's work on the history of California for the central post office in San Francisco (Plate 16) shows how well wrought the FPA wall paintings could be.

The WPA project proved especially important to black artists. It made it possible for Charles Alston to contribute a much-admired mural to the lobby of Harlem Hospital, and it was indispensable to the career of Jacob Lawrence. As a teenager, Lawrence enrolled in a WPA Harlem Art Workshop and then graduated to the Federal Art Project as an easel painter. Without that novitiate at the Harlem Art Center, Lawrence later affirmed, "I would never have become an artist. It was a turning

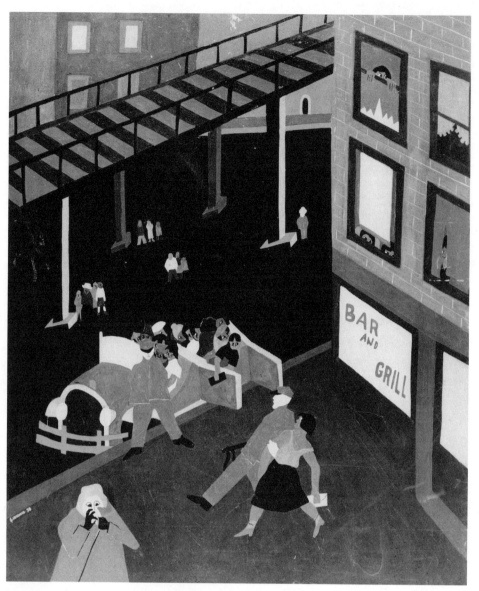

Figure 9. Jacob Lawrence, Night, *1938. Gouache.*
(New York City Project; Archives of American Art, Smithsonian Institution)

point for me." In 1938, while an FAP artist, he completed *Night* (Fig. 9). He was just twenty-one. "Not surprisingly, given these experiences," Amy Fine Collins has written, "Lawrence never became a black separatist. . . . Lawrence still retains an optimism shaped by bright recollections of the Harlem Renaissance and the New Deal. His vision of a liberated humanity firmly embraces whites as well as blacks."

"The New Deal murals," one commentator has said, "paved the way for the following generation who exploded their private experiences, previously the domain only of easel painting, onto mural-sized painting." It was in late 1942, "in the

dying days of the Project, still on the government payroll," his biographers point out, that Pollock "painted his first masterpieces": three canvases with "an imagery far more original, compelling, complex, and accomplished than anything he had yet produced." Even more telling is O'Connor's comment on Pollock: "There is striking evidence that the mural-oriented atmosphere of the thirties impelled him later to paint big. Indeed, his first huge canvas was the *Mural* painted in 1943 for Peggy Guggenheim—the same year he left the WPA/FAP."

The Federal Art Project nurtured almost every important abstract expressionist of the postwar age: Pollock, Rothko, Gorky, Guston, and Ad Reinhardt, among others. Sculptor Robert Cronbach has written: "The outstanding result of the New York City WPA/FAP was the burst of art activity and discussion which it stimulated and supported. . . . This marked the beginning of American (New York) leadership in the world of art. From being a basically provincial center, a 'following' place, New York became the actual center of the art world."

As caustic a critic as Barbara Rose, who has said that save for "a few murals known only through sketches or reconstruction, such as Gorky's Newark Airport mural and de Kooning's sketch for the Williamsburg Housing Project, the WPA programs produced almost no art of any consequence that has survived," has called the Works Projects Administration "a unique but crucial chapter in American art." She adds:

> It radically altered the relationship of art and the artist to the art audience and to society. By making no formal distinction between abstract and representational art, the WPA supported the budding avant-garde's contention that both were equally "American." (However, it must be admitted that far more commissions were given to representational artists.) By affording artists the opportunity— which most had never had—to paint full time, the WPA gave them a sense of professionalism previously unavailable outside the academic context. By giving artists material and time, it allowed them to develop their skills and technique to a new level. Throwing artists together in communal enterprises, the WPA experience provided an esprit de corps that carried over into the forties. . . . The muralists' practice of creating for the large area of the wall rather than for a limited space of the easel picture helped to prepare artists to paint large-scale pictures a decade later.

The art of the 1930s, however, encompassed more than the achievement of the WPA, for well-established painters with no need for government subsidies also continued to flourish. John Marin went on creating seascapes of the rugged Maine coast and images of New York's East River; Charles Sheeler did not stop revisiting the geometry of industrial America; Charles Burchfield, affected by the temper of hard times, turned toward greater realism as in *Ice Glare* (Plate 17), exposing a

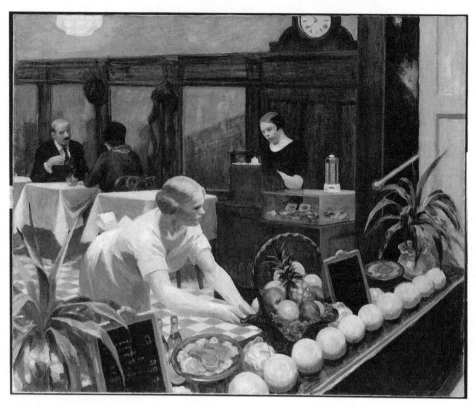

Figure 10. Edward Hopper, Tables for Ladies, *1930. Oil.*
(All Rights Reserved, The Metropolitan Museum of Art)

Buffalo street corner at midday in all its "garish and crude primitiveness and
unlovely decay"; and each spring Georgia O'Keeffe motored west to Taos to create
voluptuous flowers and find inspiration in bleached bones. Of the artists of this
generation, no reputation is likely to prove more enduring than that of Edward
Hopper, who, with impressive staying power and resourcefulness, turned out
during this decade an impressive number of canvases that are forever etched in our
minds: *Early Sunday Morning, Tables for Ladies* (Fig. 10), *The Barber Shop, Room in New
York, Sheridan Theater, New York Movie, Cape Cod Evening.* Hopper, it should be
noted, despised Roosevelt and loathed the very idea of public patronage.

Yet, undeniably, it is the New Deal arts projects that have stamped their mark on
the decade. No one has summed up better what they signified than sculptor Louise
Nevelson, who recalls:

> When I came back from Germany where I studied with Hans Hoffman, . . . I got
> on the WPA. Now that gave me a certain kind of freedom and I think that our
> great artists like Rothko, de Kooning, Franz Kline, all these people that have
> promise today and are creative, had that moment of peace . . . to continue with
> their work. So, I feel that that was a great benefit, a great contribution to our

creative people and very important in the history of art. And not only in the visual arts but in the theater, and the folk arts, there wasn't a thing that they didn't touch on. . . . At that period, people in our country didn't have jobs and the head of government was able so intelligently to use mankind. . . . I think it's a high-light of our American history.

Slowly, the impact these years had on the postwar world is coming to be recognized. By 1940, Clement Greenberg has asserted, New York "had caught up with Paris as Paris had not yet caught up with herself, and a group of relatively obscure American artists already possessed the fullest painting culture of their time." The future abstract expressionists shared with more traditional artists, whose work has often been undervalued, a sense of exhilaration that the nation, or at least the Roosevelt government, esteemed what they did enough to pay them to keep on doing it. "There's something that's unforgettable about that period," Diller recalled a generation later. "There was a sense of belonging to something, even if it was an underprivileged and downhearted time." In like manner, Edward Laning, saying that the WPA project "was my life as artist and mural painter," characterized the 1930s as "our Golden Age, the only humane era in our history, the one brief period when we permitted ourselves to be good. Before that time, all was Business, and, after, it all has been War."

Far from being "the dreary aesthetic stepchild of American art," the 1930s deserve acknowledgment as a decade when the American government responded with admirable ingenuity to the worst economic crisis in its history and when artists often put to good advantage the opportunities offered to them. These developments were not inevitable. "The thirties could easily have been a completely sterile period," sculptor Robert Cronbach reflected. "Instead it formed the basis for the subsequent development of American art as a major force." The abstract expressionist movement of the postwar era, one artist has maintained, was "unthinkable without the encouragement to survive and experiment that was given these artists by the WPA." The art of the 1930s, though, does not require justification by what it made possible in later years. More than a little of it merits esteem in its own right. As early as 1941, the organizer of a Conference of Canadian Arts told that gathering of painters, critics, and teachers that what they were witnessing across the border, and what they should seek to emulate, was nothing less than "a renaissance in art." If that conceptualization seems hyperbolic, it does suggest that the painting and sculpture of the 1930s in the United States commands greater scrutiny and greater respect than it has characteristically been given.

A NOTE ON SOURCES

Anyone who writes about the art projects of the 1930s owes an enormous debt to Francis V. O'Connor. Among his important contributions are *Art for the Millions: Essays from the 1930s by Artists*

and Administrators of the WPA Federal Art Project (Greenwich, Conn.: New York Graphic Society, 1973); *Federal Support for the Visual Arts: The New Deal and Now* (Greenwich, Conn.: New York Graphic Society, 1969); *The New Deal Art Projects: An Anthology of Memoirs* (Washington, D.C.: Smithsonian Institution Press, 1972), and "New Deal Murals in New York," *Artforum* 7 (November 1968).

Other important overviews are Bruce I. Bustard, *A New Deal for the Arts* (Washington, D.C.: National Archives and Records Administration, 1997); William C. Agee, *The 1930's: Painting and Sculpture in America* (New York: Whitney Museum of American Art, 1968); Matthew Baigell, *The American Scene: American Painting of the 1930's* (New York: Praeger, 1974); Belisario R. Contreras, *Tradition and Innovation in New Deal Art* (Lewisburg, Pa.: Bucknell University Press, 1983); Virginia Mecklenburg, *The Public as Patron: A History of the Treasury Department Mural Program Illustrated with Paintings from the Collection of the University of Maryland Art Gallery* (College Park: University of Maryland, 1979); Richard D. McKinzie, *The New Deal for Artists* (Princeton: Princeton University Press, 1973); Milton Brown, *Social Art in America, 1930–1945* (New York: ACA Galleries, 1941); Patricia Hills, *Social Concern and Urban Realism: American Painting of the 1930s* (Boston: Boston University Art Gallery, 1983); Milton Meltzer, *Violins and Shovels* (New York: Delacorte Press, 1976); and Marlene Park and Gerald E. Markowitz, *New Deal for Art: The Government Art Projects of the 1930s with Examples from New York City and State* (New York: Gallery Association of New York State, 1977). Sue Bridwell Beckham, *Depression Post Office Murals and Southern Culture: A Gentle Reconstruction* (Baton Rouge: Louisiana Sate University Press, 1989), and Karal Ann Marling, *Wall-to-Wall America: A Cultural History of Post Office Murals in the Great Depression* (Minneapolis: University of Minnesota Press, 1982), offer differing perspectives on that subject. William F. McDonald, *Federal Relief Administration and the Arts* (Columbus: Ohio State University Press, 1969), and Grace Overmyer, *Government and the Arts* (New York: Norton, 1939), place the programs in an administrative matrix.

The art of the 1930s is discussed more cursorily in Dore Ashton, *The New York School: A Cultural Reckoning* (New York: Viking Press, 1973); Lloyd Goodrich and John I. H. Baur, *American Art of Our Century* (New York: Praeger, 1961); Milton Brown, *American Painting from the Armory Show to the Depression* (Princeton: Princeton University Press, 1955); Matthew Josephson, *Infidel in the Temple: A Memoir of the Nineteen-Thirties* (New York: Knopf, 1967); Oliver Larkin, *Art and Life in America* (New York: Rinehart, 1949); Henry A. Millon and Linda Nochlin, eds., *Art and Architecture in the Service of Politics* (Cambridge: MIT Press, 1978); Barbara Rose, *American Art since 1900: A Critical History* (New York: Praeger, 1967) and her anthology, *Readings in American Art since 1900* (New York: Praeger, 1968); and Irving Sandler, *The Triumph of American Painting: A History of Abstract Expressionism* (New York: Praeger, 1970).

Virtually every artist of the period has attracted at least one biographer, and some have offered their own memoirs. Among the more useful books are George Biddle, *An American Artist's Story* (Boston: Little, Brown, 1934); Lloyd Goodrich, *Reginald Marsh* (New York: Harry N. Abrams, 1972); Gail Levin, *Edward Hopper: An Intimate Biography* (New York: Knopf, 1995); Townsend Ludington, *Marsden Hartley: The Biography of an American Artist* (Boston: Little, Brown, 1992); Steven Naifeh and Gregory White Smith, *Jackson Pollock: An American Saga* (New York: Clarkson Potter, 1989); Frank W. Long, *Confessions of a Depression Muralist* (Columbia: University of Missouri Press, 1997); and Lowery Stokes Sims, *Stuart Davis: American Painter* (New York: Metropolitan Museum of Art, 1991).

Among the huge number of articles on art of the decade, the following are particularly lively or insightful: Abe Ajay, "Working for the WPA," *Art in America* 60 (September–October 1972); Catherine Barnett, "The Writing on the Wall," *Art and Antiques* (March 1988); Erica Beckh, "Government Art in the Roosevelt Era," *Art Journal* 20 (Fall 1960); Joel H. Bernstein, "The Artist and the Government: The P.W.A.P.," in Ray B. Browne, Larry N. Landrum, and William K. Bottorff, eds., *Challenges in American Culture* (Bowling Green, Ohio: Bowling Green University Popular Press, 1970); Ray Allen Billington, "Government and the Arts: The W.P.A. Experience," *American Quarterly* 13 (Winter 1961); Stephen J. Goldfarb, "Memories of a Depression-Era Muralist: Reuben Gambrell and the Rockmart Post Office," *Atlanta History* 37 (1993); Helen A. Harrison, "American Art and the New Deal," *Journal*

of *American Studies* 6 (December 1972); Garnett McCoy, "Poverty, Politics, and Artists, 1930–1945," *Art in America*, 53 (September 1965); Robert C. Vitz, "Struggle and Response: American Artists and the Great Depression," *New York History* 57 (January 1976); Forbes Watson, "New Forces in American Art," *Kenyon Review* 1 (Spring 1939); Alfred Werner, "WPA and Social Realism," *Art and Artists* 10 (October 1975); and Jeffrey D. Brison, "The Kingstoy Conference, the Carnegie Corporation, and a New Deal for the Arts in Canada," *American Review of Canadian Studies* 23 (Winter 1993).

This essay also draws on half a century of research at the Franklin D. Roosevelt Library in Hyde Park, New York, as well as on other manuscript sources, notably the Forbes Watson Papers and the microfilm of the George Biddle Papers at the Detroit Institute of Arts and the Holger Cahill Memoir in the Columbia University Oral History Collection.

CASEY NELSON BLAKE

Between Civics and Politics

The Modernist Moment in Federal Public Art

I

On June 14, 1969, two thousand people gathered in downtown Grand Rapids, Michigan, for the dedication of Alexander Calder's sculpture, *La Grande Vitesse* (Fig. 1). Calder's abstract work was the focal point of a modernist plaza cleared by urban renewal and then named for Michigan's late senator, Arthur Vandenberg. The sculpture had a constituency in the city's cultural and economic elites, who hoped that Vandenberg Plaza would give Grand Rapids a public square comparable to the Piazza San Marco in Venice or St. Peter's in Rome. *La Grande Vitesse* also had a national constituency in the administrators at the National Endowment for the Arts (NEA), who had awarded Grand Rapids the first grant of its new program for Works of Art in Public Places. At the dedication, speakers pointed to the Calder sculpture as evidence that culture in Grand Rapids—and the United States generally—had finally come of age. "Well, it's here!" announced one local promoter. "And nobody is ever going to take it away. It belongs to us. It stands here with the buildings which are so straight and strong and which represent monuments to commerce and industry and to our standard of living. . . . It will belong to you and to your children and to your children's children. They will grow up with it—and they will grow up to it. So, enjoy it—it's ours."[1]

Five years later, on October 25, 1974, the General Services Administration (GSA) dedicated a second Calder sculpture, *Flamingo*, in Chicago, outside the new federal buildings designed by Mies van der Rohe (Plates 18 and 19). Because of the success of the Grand Rapids project, the GSA had chosen Calder to receive the first commission of its newly revived Art-in-Architecture program, a percent-for-art public arts program that had begun under the Kennedy administration only to fall victim to political controversy and budget cuts. Chicago officials made sure they would not be outdone when it came to celebrating the arrival of *their* Calder, which was a good ten feet taller than the one in Grand Rapids. Mayor Richard Daley pro-

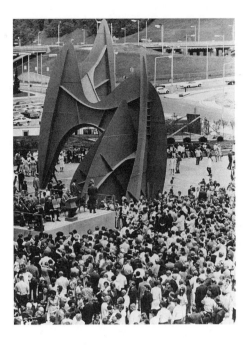

claimed "Alexander Calder Day in Chicago." The *Chicago Tribune* crowed, "It's a Whatchama-Calder!" And the publicity circus surrounding the sculpture took the form of an actual circus parade, inspired by the circus motifs of Calder's early wire sculptures. Thirteen circus wagons, eight clowns, ten unicyclists, bands, elephants, and countless other marchers, including Ronald McDonald and a man in a gorilla suit, made their way down State Street to the sculpture. Among them was Alexander Calder himself, who rode to the dedication in an enormous Schlitz beer wagon pulled by forty horses. As the wagon approached the plaza, hundreds of helium balloons were released into the air, and a ringmaster announced, "Ladies and gentlemen, children of all ages, I present to the people the one and only Alexander the Great, Sandy Calder."[2]

Twenty years after the dedication of the Grand Rapids Calder, federal officials invoked the authority of the public in support of their decision to "take away" a work of public art—in this case, Richard Serra's minimalist steel sculpture, *Tilted Arc*, in lower Manhattan (Fig. 2). The GSA's installation of Serra's sculpture in Foley Square in 1981 touched off eight years of public hearings, lawsuits, petition drives, media commentary, and protests. Judges and office workers in the area complained that the work obstructed their access to Federal Plaza and deepened the inhumanity of an already unfriendly space. In March 1989 the GSA ordered the sculpture to be dismantled and stored in a Brooklyn warehouse. After the removal of *Tilted Arc*, the GSA's regional administrator announced the triumph of the public over "a group of elitists in Washington."[3] "This is a day for the people to rejoice," he said, "because now the plaza returns rightfully to the people."[4]

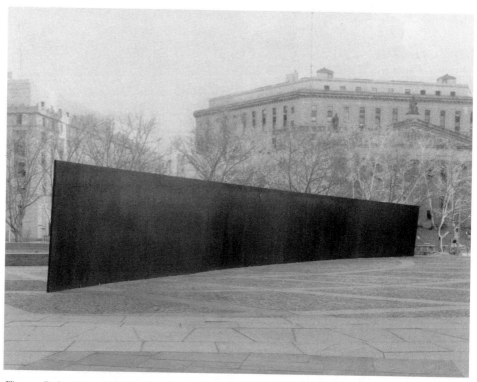

Figure 2. Richard Serra, Tilted Arc, *1981–89.*
(Courtesy of Art-in-Architecture Program, Public Buildings Service, General Services Administration)

The two decades between the installation of Calder's Grand Rapids sculpture and the destruction of *Tilted Arc* mark the modernist moment in federally funded public art. During this period the federal government's two major public art programs—the NEA's Art in Public Places program and the GSA's Art-in-Architecture program—embraced modernism as a national style and commissioned hundreds of abstract murals and sculptures for public spaces around the country. In the aftermath of the *Tilted Arc* affair, it is difficult to recapture the hopes that inspired Washington's original modernist commitments. Yet even today, in our decidedly postmodern and pluralistic moment, arts administrators invoke the heady memory of the confident and unified cultural policy that gave birth to the NEA and GSA programs. The Grand Rapids Calder now serves as the foundation myth for federal arts administrators. The success of Calder's sculpture—which was incorporated into the logos for the city of Grand Rapids, its chamber of commerce, and even its sanitation department—is a recurrent refrain in NEA reminders that a skeptical public will eventually come around to embrace avant-garde art. Jane Alexander, then chair of the embattled endowment, returned to Grand Rapids in June 1994 for events celebrating the twenty-fifth anniversary of the 1969 dedication. A maquette of *La Grande Vitesse* sat in her office in Washington, a reminder of past glories at a time when the endowment's very survival was in doubt.

This essay traces the rise and fall of the modernist project in American public art, beginning with its inception in the arts policy of the Kennedy administration and continuing with the prolonged crisis in popular support for public art that erupted in the mid-1970s and culminated in the removal of Serra's sculpture for lower Manhattan in 1989. The unraveling of that modernist project for public art, so soon after its inception, reminds us that the transition from artistic modernism to postmodernism was not simply a shift in taste or aesthetic style. Rather, the crisis of modernist art in public spaces was intimately related to the crisis of the Kennedy-era liberalism that inspired it. Controversies over public art reveal that the movement from modernism to postmodernism was a thoroughly political process, shaped by deep conflicts over power and the structure of public life. "At stake in every struggle over art," writes Pierre Bourdieu, "there is also an imposition of an art of living, that is the transmutation of an arbitrary way of living into the legitimate way of life which casts every other way of living into arbitrariness."[5] As the site where politics and aesthetics meet in the streets and plazas of our cities and towns, public art has become a flash point for conflicting ways of life in late-twentieth-century America. Controversies over public art thus offer an important vantage point on the troubled recent history of our country's public imagination.[6]

II

The Grand Rapids Calder was the first public installation of the National Endowment for the Arts, which had been established in 1965 as a result of policy decisions that were already well under way by the time of John F. Kennedy's assassination in November 1963. As John Wetenhall has argued, those responsible for cultural policy in the Kennedy White House—especially Arthur Schlesinger and August Heckscher—saw the arts as a way to raise popular tastes, improve national morale during the Cold War, and celebrate cultural freedom in the face of Soviet aggression. Schlesinger and Heckscher urged the president to ensure that the highest standards of design guided federal architecture, public art, government posters, and even postage stamps. Meanwhile, public artists and architects would work closely with urban planners to rebuild downtowns shaken by the postwar exodus to the suburbs—a project that inevitably involved the demolition of historic buildings and traditional working-class neighborhoods.[7]

The New Frontiersmen recalled the classical republican tradition in their assertion that Americans' encounter with a program of major monuments and buildings would prove a resource for national renewal. Heckscher repeatedly cited Pericles' support for civic architecture and sculpture, the implication being that the United States stood poised on the brink of another Periclean age. As Heckscher put it in his 1963 report to the president on "The Arts and the National Govern-

ment," "there has been a growing awareness that the United States will be judged—and its place in history ultimately assessed—not alone by its military or economic power, but by the quality of its civilization."[8] The arts, in his view, would serve the national purpose by inspiring in their viewers a profound respect for the virtue of individual freedom.

Freedom was the central theme of President Kennedy's most extended public remarks on the arts, delivered in October 1963 on the occasion of the dedication of the Robert Frost memorial library at Amherst College. Frost's appearance at Kennedy's inauguration had set the stage for a glamorous alliance of intellectuals, artists, and liberal politicians. And his memory inspired Kennedy's description of "the great artist" as "the last champion of the individual mind and sensibility against an intrusive society and an officious state." The United States, the president continued, should "set the artist free to follow his vision wherever it takes him."[9] By giving artists maximum freedom to do their work, the federal government would demonstrate the cultural superiority of the free world and instill in Americans an appreciation for the rights of the individual.

In light of the current threat to public funding for the arts, there is something inspiring about the Kennedy administration's support for cultural creativity. It is a mark of the self-confidence of the country's political institutions in this period that government officials were not intimidated by the arts, that they were not afraid of the potentially disturbing and dissident work that artists might produce. The commitment by the White House to a common cosmopolitan style for public spaces now appears part and parcel of the generous and inclusive civic culture that won at least lip service from politicians in the age of Kennedy and King—a civic culture premised on overcoming local and parochial attachments in the name of racial integration and loyalty to the state during the Cold War.

That said, the tragedy of Camelot cultural policy lay precisely in its failure to define a larger public or civic function for the arts. In keeping with its celebration of individual freedom, the Kennedy administration made its case for the arts in largely negative terms—in opposition to the domination of culture by the state in the Soviet Union. The result was a highly privatized conception of aesthetic experience that held neither artists nor art audiences to a common set of artistic and moral standards. American arts policy freed the artist to pursue his or her individual vision; its ideal of elevating public taste was likewise defined as a personal matter. This was a recipe for public art without public purpose, an art created for a nation of private individuals.

Camelot cultural policy further undermined the public nature of its public arts program by endorsing an openly elitist commissioning process. Heckscher's report proposed that panels of experts act to insulate artistic judgment from state interference. But the panel system that evolved at the NEA and GSA drastically limited

who had the competence to make decisions about the aesthetics and function of public space. Its insistence on professional authority fit easily with the autonomous aesthetic of modernist formalism. Disdainful of local context and popular conventions, the Kennedy arts advisers articulated a cultural politics that had little use for democratic deliberation about the place of art in public life. Their legacy to the public arts movement was an aesthetic ideology that lacked legitimacy either as a program for moral education by civic leaders or as the expression of popular will—in short, a public art caught between civics and politics.

The contradictions at the heart of this cultural policy became clear during the summer of 1966, in the uproar that followed the installation of Robert Motherwell's abstract mural, *New England Elegy*, in the new John F. Kennedy federal building in Boston. Initial reports mistakenly held that Motherwell's mural portrayed Kennedy's profile at the precise moment of his assassination in Dallas.[10] Office workers in the area and other Bostonians condemned the work as an "atrocity," a "monstrosity," and "a blasphemy to the memory of our late beloved President John F. Kennedy."[11] They questioned the appropriateness of federal funding for such a somber work or for abstract art of any kind. The mural "is a horrible and frightening thing," one man in Cambridge wrote the GSA. "It has nothing to do with the spirit of the dead president."[12] A security guard in the new building—itself a modernist work designed by Walter Gropius—told a reporter, "We're common people. We've never been to art school and we can't figure out what it is."[13]

Once the controversy erupted, critics, arts administrators, and their supporters in the press were quick to instruct such people exactly how to "figure out" what the painting was. Metropolitan Museum curator Henry Geldzahler, a frequent arts adviser to the NEA and the Johnson administration, complained that "a lot of people who are not art experts" had been "widely quoted" in press accounts of the painting.[14] The *Boston Globe* defended Motherwell's selection by reminding readers that "the overwhelming majority of museums, critics and experts" had endorsed abstract expressionist art. One of those experts told the paper that "the public protest over the painting should not be taken too seriously."[15]

The official response to criticisms of Motherwell's *New England Elegy* made it abundantly clear that a policy granting freedom of artistic production to artists did not entail full interpretive freedom for the public. When popular responses to public art questioned the validity of the enterprise, federal arts administrators and their allies rushed to set limits to interpretations of their work. Modernist public art should stimulate individual appreciation, in their view, but not public debate.

III

The political instability of the federal program of modernist public art was evident, in retrospect, at the very moment of its earliest triumph. Despite its

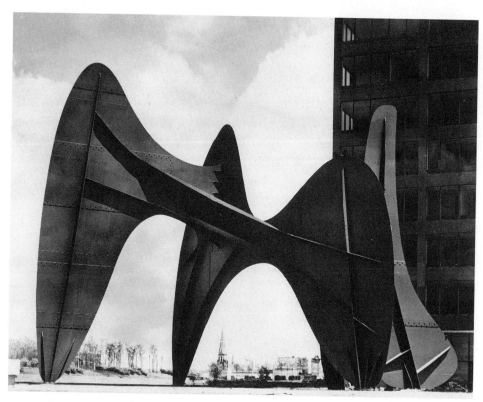

Figure 3. Alexander Calder, La Grande Vitesse, *1969.*
(Courtesy of Nancy Mulnix Papers, Local History Department, Grand Rapids Public Library)

current status as an icon of a golden age of public art, the Calder sculpture in Grand Rapids provoked a debate during the two years before its installation that prefigured the reaction against public art in the late seventies and eighties (Fig. 3).

The advocates of the Grand Rapids Calder saw its installation as the crowning achievement of a program of urban renewal that would put the city on the map as a cultural capital. Their rhetoric portrayed Grand Rapids as a city without a history or local cultural tradition worth remembering—a city whose very identity waited on the arrival of a cosmopolitan symbol. Getting such a symbol required the intervention of specialists unconstrained by the parochial standards of a particular place or by the pressures of local constituencies. Painter Adolph Gottlieb, who visited the city with the other NEA panelists, admitted that "It's unlikely the public will have anything to say on selection of the proposed sculpture for Vandenberg Center." All one could hope for was that a commission by "a committee of knowledgeable men" would eventually "be accepted by a majority of the people."[16]

Calder himself told reporters that it was unnecessary for him to visit Grand Rapids before designing its public symbol. "If the art is good," he said, "it will stand by itself anywhere."[17] The NEA's "knowledgeable men" had given Grand

Rapids a formalist public symbol that, in the words of one supporter, "will transcend time and place."[18]

Once the selection of Calder was announced, however, the sculpture's advocates rushed to describe the artist and his sculpture as quintessentially American. The dedication pamphlet for Grand Rapids described Calder as "all American. Apple pie type."[19] Portraits of the artist in the Grand Rapids paper emphasized Calder's engineering skills and compared him to Gary Cooper. "This has been the mark of Calder," declared one reporter; "that he has always been sure enough of himself to express himself in his own way."[20]

These descriptions of Calder as the last rugged individualist were part of a campaign to overcome residents' uneasiness about the avant-garde culture of the gallery, salon, and museum. Even as the selection process limited aesthetic discrimination to a few trained professionals, selling *La Grande Vitesse* to the public required frequent reassurances that one viewer's interpretation of the work was as valid as another's. In fact, advocates claimed that the advantage of an abstract work lay precisely in its openness to multiple interpretations: modernist aesthetics imposed no constraints on viewers' freedom.

Such claims had little success in winning over local critics, who watched the NEA panel's closed deliberations and questioned whether the Calder sculpture was a "public" object of any kind. Despite all the talk of the sculpture's accessibility to multiple interpretations, they believed that the NEA panelists and their local allies had in fact imposed precise standards of art appreciation on the city. One leading opponent of *La Grande Vitesse* warned against a sculpture like the recently installed Chicago Picasso, which he believed "might not be beautiful to more than a few artists and art lovers."[21] Critics of the Calder piece also objected to its replacing a reflection pool that had been planned for the plaza—a move they condemned as the substitution of a private amenity for public works. "Who is the [sculpture] committee trying to impress," one opponent asked; "are they supposed to be representing the people of Grand Rapids in this project?"[22]

Critics of the Calder sculpture saw themselves as the defenders of memory, place, and tradition against reckless innovation by cosmopolitan modernizers. In their view, the sculpture's promoters were complicit in the urban renewal that had left the city with a modernist plaza in place of its traditional downtown. Opponents pointed out that the old City Hall clock tower, which had long been the defining visual marker for Grand Rapids, had been slated for demolition without a murmur of protest from the city's arts elite. Attempts to save the clock tower had failed, a critic wrote the paper, "because the moderns evidently were ashamed of the great heritage of the yesteryears in Grand Rapids."[23] It was no surprise that the city's "moderns" had selected an expatriate sculptor like Calder, who had spent

most of his life in France. "He is as foreign to Grand Rapids as is Charles de Gaulle and certainly as foreign to Grand Rapids culture."[24]

In addition to the old City Hall clock tower, another memory haunted the Calder debate: the public's memory of turn-of-the-century commemorative sculpture, which seemed to render Calder's abstract form illegitimate as public art. Letters to the editor repeatedly asked why no one had commissioned a sculpture of Senator Vandenberg for the central plaza named after him. Instead of "some foreign-fabricated abstraction," one writer suggested, it would have been more appropriate "to dedicate a heroic-size bronze or marble bust of the senator for all to see, children and grandchildren."[25] Another wrote, "Maybe I could understand if the people of Grand Rapids wanted a monument for our men who have given their lives in Vietnam."[26] For these readers, memorials exemplified both the appropriate form and content for public sculpture. In contrast to Calder's cosmopolitan modernism, such works served an identifiable civic function—honoring heroes slain in service to their country and at the same time giving local residents a sense of place. *La Grande Vitesse* failed on both counts.

Cultural traditionalists were not the only people in Grand Rapids to condemn Calder's abstract sculpture. Antiwar demonstrators tried to disrupt the dedication ceremony. One protester shouted, "You should drop bombs on that damned Calder instead of on the Vietnamese and use the scrap to buy food for the poor."[27] More playful dissenters used trash and scrap metal to create amateur parodies of *La Grande Vitesse*, which they spray-painted in bright red and offered for sale at a fraction of Calder's commission.[28] What linked these critics to advocates of traditional monuments was their understanding that the installation of Calder's work in downtown Grand Rapids was as much an assertion of power as it was an exercise in artistic taste.

Criticisms of this kind were largely ignored as federal administrators and their local allies celebrated the arrival of Calder's abstraction in Grand Rapids. Yet what stands out in retrospect is the extent to which even this early triumph drew criticisms that would reemerge in subsequent challenges to an official program of modernist art in public places. Haunted by the example of earlier forms of civic iconography, abstract public works never won the allegiance of traditionalists seeking an art resonant of national purpose and local memory. And at a time of war and mounting social crisis, the autonomous aesthetic of modernist public art outraged political radicals as a distraction from more pressing needs.

IV

After the installation of the Grand Rapids Calder in 1969, most of the criticisms of federally funded modernist public art came initially from groups on the Left.

NEA public arts grants in the early seventies ran into opposition from environmentalists, who protested the use of green space for public sculpture and from African American activists who denounced modernist works as irrelevant to their cultural traditions and political aspirations. Meanwhile, leading artists and critics began to question the ethics of working with the National Endowment for the Arts while the government was prosecuting the Vietnam War.

With pressure coming from leftist and black nationalist movements in American cities, and from deep within the ranks of the arts community itself, the NEA made strategic concessions to political art even as it kept modernist, nonrepresentational work at the core of its mission. In 1970 the endowment created a short-lived Inner City Murals Program, which presented many small grants to openly political arts organizations and activist groups in black and Hispanic urban neighborhoods.[29] NEA administrators privately voiced reservations about the quality of the work produced by these initiatives, but they nonetheless agreed to fund murals that championed leftist, black nationalist, and feminist causes in a realist style far removed from the endowment's original aesthetic commitments.[30]

Another response to the politics of the early seventies was to award grants to environmental artists like Robert Morris, whose work drew its inspiration from the ecological movement, and to pop and minimalist artists like Claes Oldenburg and Richard Serra, who had left the galleries in the late sixties to create enormous public sculptures that challenged the authority of traditional civic and patriotic monuments. Whereas the early beneficiaries of the Murals Program were often obscure minority artists and community activists, artists like Morris, Oldenburg, and Serra were products of elite art schools and the very New York–centered art market they now dismissed as hostile to political change. When the country's politics moved right in the mid-seventies, they—not the muralists—were left standing as beneficiaries of federal subsidy. The Inner City Murals Program was folded back into the NEA's regular public arts program after two years, and soon the endowment was funding apolitical, decorative work suitable for the gentrifying districts of American cities—abstract "supergraphics" to cover exposed brick walls or the trompe l'oeil realism of Richard Haas. As the leftist protests of the early seventies subsided, explicitly political art by minority artists and radical activists was marginalized.[31]

As late as the mid-1970s, then, the commitment of the NEA and the GSA to a modernist project remained largely unchanged. With escalating budgets under the Nixon, Ford, and early Carter administrations, both programs funded major installations of abstract—and especially, minimalist—sculptures throughout the country. Major GSA commissions by Isamu Noguchi, Beverly Pepper, Clement Meadmore, Louise Nevelson, Tony Smith, and Joseph Konzal were among the many public sculptures that appeared outside of federal buildings in the mid- and late

1970s. During this period the NEA also funded hundreds of nonrepresentational public installations, including pieces by Alexander Lieberman, Ronald Bladen, Mark di Suvero, and Michael Heizer. Now widely derided as "plop art" dropped into public spaces without regard for local context and culture, these works constitute an official style for the seventies that had its origins in the cultural program of the Kennedy era.[32]

What finally undermined that program was neither the challenge from the Left nor the movement of the 1960s avant-garde out of the gallery and into the streets, but the wave of explosive protests in local communities, often endorsed by conservative politicians and pundits, that beset modernist installations beginning in the mid-1970s. These protests were prompted by many of the same grievances that critics of the Grand Rapids Calder had tried to articulate. But now the outcry against public art drew on popular fears of crime and urban decline. As the economic boom of the 1960s gave way to the fiscal crisis of U.S. cities in the mid-1970s, the idea that public art could resurrect downtowns and boost Americans' "morale" became impossible to maintain. Public art invited attack as the most visible manifestation of the liberal state in urban spaces. The very presence of modernist public artworks politicized the aesthetics of public spaces, leading more and more Americans to reject the idea of leaving artistic decisions to a few "knowledgeable men"—and, with it, the notion of a timeless, transcendent art that could "stand by itself anywhere." The result was a political crisis of the liberal-modernist project in public art that has still not been resolved.

The most immediate change in the discourse surrounding public art objects from the mid-1970s through the early 1980s was the shift from a celebration of such objects as symbols and vehicles of urban renewal to their depiction in media coverage, and in political debate, as bearers of urban decay. In Baltimore, federal judges condemned George Sugarman's 1976 design for the city's federal building and courthouse, *Baltimore Federal*, as a threat to security (Plate 20). In the words of one judge, "The artwork could be utilized as a platform for speaking or hurling objects by dissident groups demonstrating in front of the building. . . . the structure could well be used to secrete bombs or other explosive objects."[33] The judges' association of public art with crime was linked explicitly to a desire to restrict the use of public space to predictable, private pursuits. When Sugarman tried to explain the "emotional impact" of his sculpture, one judge snapped, "There is quite enough 'emotional impact' inside the courthouse without attempting to artificially generate it on the outside."[34] *Baltimore Federal* was installed a year later, but only after Sugarman had modified the design to open its interior to outside view and after the GSA had agreed to install a television security system to monitor activities in the area surrounding the building.[35]

In the early eighties, several years after the Baltimore debate, a Richard Serra sculpture designed for a bleak downtown area in St. Louis prompted letters to the editor from citizens who, understandably, feared that its walled-in interior space would become a crime site. "Wait until a woman or child is pulled inside, away from the view of the public, and raped," one resident wrote the paper, "then decide if the $250,000 was well spent."[36]

Such arguments obviously played to popular fears of crime and terrorism, but they also touched a nerve in local residents appalled by the physical devastation of their cities by postwar urban renewal and deindustrialization. Critics held that public art installations and the government buildings they adorned were responsible for the destruction of their communities' civic culture. In Baltimore, a resident asked supporters of the Sugarman sculpture whether they "really admire[d] the penitentiary-like structure" that the GSA had constructed for the city's downtown.[37] From the symbol of a glorious urban modernity in Grand Rapids, modernist public art had become an unwelcome reminder of a modern project gone wrong.

During this period conservatives became more outspoken in their view that modernist public art should give way to more traditional monuments. The judges in Baltimore were among the most vocal leaders of a broad conservative campaign to restore patriotic iconography to official buildings and public spaces. In St. Louis, the 1971 NEA grant that eventually supported Serra's sculpture provoked an angry response from conservative activists who preferred that the money be used for a memorial to Tom Dooley, a local doctor known for his humanitarian work in Southeast Asia. The chairman of the city's arts agency ridiculed the group's proposal for a Dooley memorial as a "junk statue." "You don't go to great talents today and ask for a statue of Dooley," he responded. "They'd laugh at you."[38] But when one local newspaper, city council members, and even the mayor lined up in support of the memorial, NEA officials quickly found $15,000 for the Dooley group.

The arguments for a Tom Dooley memorial found an intellectual rationale in the early eighties in the writings of conservative critics who argued that federally funded public art should "exemplify a common tradition and shared political, cultural, and aesthetic heritage."[39] In the spring of 1984, the Alaska state legislature apparently reached the same conclusion and voted to have Robert Murray's *Nimbus* replaced by a war memorial (Fig. 4). Murray's turquoise steel abstraction had been installed in 1978, with NEA support, outside of the new state courthouse in Juneau, directly opposite the capitol building. The work immediately drew attack from local residents because the commission had not gone to an Alaskan and from state legislators who saw it as a deliberate assault on their authority. Late in Decem-

Figure 4. Robert Murray, Nimbus, *1978–84. (Courtesy of Alaska State Council on the Arts)*

ber 1984 the governor ordered the sculpture removed—an act that prefigured the destruction of Richard Serra's *Tilted Arc* five years later.[40]

V

The controversies surrounding NEA-funded works in St. Louis and Juneau suggest that the political crisis of the liberal-modernist project in public art resulted, ironically, from its successful expansion during the seventies. The modernist center held so long as its insistence on a selection process closed to average citizens enjoyed at least the passive assent of the public. But as arts administrators commissioned more and more works throughout the country, they found it difficult to navigate their way through multiplying constituencies and pressure groups and stick to the modernist course set by the Calder installations. Under attack at both the local and national levels, the federal program for a modernist aesthetic of freedom gave way to open political warfare.

The chief casualty of this politicization of aesthetics was the authority of the panels of artistic experts that had originally given the federal programs their legitimacy. In the heat of the controversy over the proposed Tom Dooley memorial in

St. Louis, one NEA administrator wrote the head of the local public art effort to criticize his politically insensitive dismissal of representational art as "junk sculpture":

> Taking an adversary position to local opinion on the level of taste is . . . dangerous, and . . . is seen as a form of dictation to which local people don't take too kindly and I can't say I blame them.

> One reason we do the Works of Art in Public Places projects through a selection panel is to direct these pressures towards experts who take responsibility for these decisions, decisions not made by you and me.[41]

But by the mid-1970s panels of experts gave the public arts movement little cover. In fact, it was the alleged arrogance of expert outsiders that infuriated local opponents above all else. In case after case, critics of federally funded modernist public art disputed the competence of panelists and charged them with pursuing a cosmopolitan agenda at the expense of indigenous cultures and grassroots participation. Expert panelists, such critics charged, were interested in the colonization of public space by the culture of museums and galleries. The art they commissioned was a bid for public power by people who already controlled private cultural institutions.

The initial response to such attacks was to try to surround modernist installations with more accessible works. At Northern Kentucky State University, the reaction to Donald Judd's 1977 minimalist sculpture, *Box*, was so hostile that university and NEA panelists went out of their way two years later to commission a second piece that would be more popular. Their choice was Red Grooms's *Way Down East*, a homage to Kentucky-born director D. W. Griffith and actress Lillian Gish. Similarly, in 1979 when the city of Hartford considered public art for its rebuilt Civic Center Coliseum, local officials attempted to head off the sort of controversy that had plagued the appearance of Carl Andre's *Stone Field Sculpture* two years earlier. Andre's piece had touched off vociferous protests from the public and politicians alike; the national media pointed to the work as evidence that the government had succumbed to the seventies' "pet rock" craze. Stung by the uproar, Hartford arts administrators decided to canvass local opinion about the work of eight finalists before announcing their selection of conceptual artist Sol LeWitt for the coliseum. But having opened the selection process to public debate, the panel found it impossible to retain LeWitt for the project. Complaints that the city had bypassed African American artists led LeWitt to suggest that he share the commission with Romare Bearden—a concession that failed to satisfy his critics. In the face of mounting objections to his proposal for two geometric pieces, LeWitt withdraw altogether, leaving Bearden's far more accessible murals as the only public art for the coliseum.[42] In a survey of public opinion of the coliseum commission, one Hartford resident spoke for the growing backlash against mod-

Figure 5. Guy Dill, Hoe Down, *1979.*
(Courtesy of Art-in-Architecture Program, Public Buildings Service, General Services Administration)

ernist works in public places: "I think people are tired of New York arty-art. You can keep it in museums where it won't bother anybody."[43]

Conservatives then and now have applauded such criticisms as a reaction against the "adversary culture" of the "New Class" by a "silent majority" of "normal Americans"—to use the rhetoric of Richard M. Nixon and Newt Gingrich. Such arguments are the mirror image of the view prevalent among artists, arts administrators, and their liberal defenders that opposition to informed artistic opinion comes inevitably from ignorant "Know-nothings."[44]

Yet more often than not, the reaction against federally sponsored modernist art for public places in the late seventies and early eighties took a very different form from what one might expect from the standard accounts by conservatives and liberals. As in the *Tilted Arc* debate, much of the opposition to the liberal-modernist project grew out of a respect for local context and functional design and out of a longing for opportunities to deliberate in public about the use of public space. A commitment to public debate lay behind most of the protests of public art installations in this period.

The democratic impulse at the heart of many of these protests can be seen in the campaign against *Hoe Down*, Guy Dill's abstract sculpture for the Hubert H. Humphrey Building in Huron, South Dakota, where Humphrey spent his childhood (Fig. 5). The GSA installed *Hoe Down* in 1979, with the artist noting that he had

chosen its theme and imagery to evoke the "sense of order and dependency on the weather" in the Great Plains.[45] But Dill's efforts to explain the local references in the work (which, he joked, included the initials "HHH" stacked sideways) were unpersuasive. Local critics organized an "undedication ceremony" to protest his work and gathered five thousand signatures on petitions for its removal, but the GSA stood its ground and left the sculpture in place. A spokesman for Huron ACORN, a grassroots activist group, let GSA administrators and South Dakota politicians know that residents expected more control over public art installations in the future: "We are concerned that during the whole process of selecting the 'Hoedown' the GSA gave little or no thought to involving the community in the selection. Huron is *our* community—the Federal Building was built to serve *us*. We feel that we have a right to some kind of say in the kind of art which is chosen to represent our community."[46]

By the mid-1980s demands of this kind had shattered whatever fragile consensus had briefly existed in support of the liberal-modernist project in federally funded public art. Arts administrators and politicians were faced with two choices. They could work to create more inclusive selection processes, in which case they ran the risk of losing control of the process or of prompting public debates that would spill over from aesthetics to other controversial issues. Or they could stem such debates by bureaucratic maneuvers or the outright use of force. Either way, the modernist moment in American public art had come to an end.

It remains to be seen whether the collapse of modernism will result in a commitment to a truly democratic and participatory public arts movement, assisted by public subsidy, or in the open imposition of aesthetic choices by political and economic elites. Recent artistic and political developments are not altogether encouraging.

In the last fifteen years, artists and critics on the multiculturalist Left have essentially withdrawn from the public arts movement that began in the Kennedy era and declared their allegiance to what they now call a "community arts" movement. They condemn much of the work from the sixties and seventies as modernist "plop art" for public space and question the notion of art for a cosmopolitan public, suggesting that "the public" and "the public sphere" are repressive fictions that marginalize difference and diversity. Advocates of the community arts movement point with pride to mural projects like Judy Baca's extraordinary *Great Wall of Los Angeles* (1976–83) or the remarkable *Village of Arts and Humanities* created in the late eighties by Lily Yeh and her associates in North Philadelphia—a project that has transformed a large area of an otherwise bleak and hopeless ghetto into a local cultural oasis. Proponents of such work see these community arts projects as examples of a collaborative art rooted in struggles for justice and group identity. [47]

Despite its many achievements, the community arts movement of the last de-

cade has yet to generate explicit aesthetic criteria for judging its work as public art, as opposed to exercises in community organizing. Moreover, much of the new public art on the Left betrays a deep pessimism about the prospects for cultural and political consensus in contemporary America—indeed, about the possibility of a public of any kind. The best community arts projects proudly root themselves in a local aesthetic and in bids for power and justice by local groups. Their organizers imagine that the makers and viewers of such art will be members of the neighborhood in which it is placed, with little concern for the more diverse and heterogeneous audiences that might gather in downtown streets or plazas. Community art projects directly address the issue of local participation that the modernist movement ignored, but at the cost of any aspiration to a cosmopolitan, democratic culture for the nation as a whole.

For their part, conservatives have responded to the collapse of modernism by mobilizing the localistic reaction against modernism of the late seventies and eighties in the service of a newly lean and mean nation-state. Critic Tom Wolfe is one of the many conservatives who have applauded the work of neotraditionalist public artists like Raymond Kaskey, whose 1985 *Portlandia* graces the facade of Michael Graves's postmodernist Portland City Building. Kaskey's art asks us, with a wink and a nod, to suspend disbelief and imagine that we are again in the presence of the confident civic monuments of our grandparents' day, rooted in a culture of Protestant republicanism. It should come as no surprise that Kaskey subsequently received a GSA commission for the new Ronald Reagan federal building in Santa Ana, California. Kaskey may enjoy more such federal commissions in the future, but it is hard to imagine how his brand of neotraditionalist public art can resurrect whatever imagined cultural consensus underwrote the civic monuments projects of the late nineteenth century. In the aftermath of the modernist moment, any consensus on what cultural heritage Americans share will require sustained, inclusive, democratic debate, not the wistful nostalgia that informs Kaskey's work. Without such debate, there is no reason to question Lawrence Alloway's judgment, made over twenty years ago, "that the resources of the tradition that made nineteenth-century sculpture legible cannot be revived as if nothing had happened."[48]

Or perhaps such public art *can* be revived after all, without public assent or participation, if the powerful use their authority to foreclose other options. A disturbing case in point is the history of a 1993 GSA commission for a federal building in Knoxville, Tennessee. The GSA had selected Nizette Brennan to create a sculpture for the building, but the regional GSA administrator in Atlanta objected to her proposal for an abstract work titled *Aquadrop*. In response, Brennan came up with a proposal for *Knoxville Flag*, a limestone Stars and Stripes, which was finally approved by the GSA over the unanimous objections of its panelists.[49]

Brennan's *Knoxville Flag* signals the replacement of modernism as an official style by a new patriotic realism, dressed up in the rhetoric of conservative identity politics (Plate 21). The GSA dedication pamphlet defends the sculpture as "a monument to the patriotism of the citizens of Knoxville and of Tennessee" and "an enduring tribute to the traditional and contemporary ideals of the region."[50] *Knoxville Flag* makes it absolutely clear that the liberal-modernist project in public art is dead and buried, with both its aesthetic commitments and its panel system discarded in the interests of state authority and civic peace.

The ascendancy of neotraditionalist public monuments should give pause to those cheering the demise of modernist public art. At its best, the modernist public arts movement aspired to the democratization of beauty and the expansion of aesthetic experience. In the case of Brennan's sculpture, the celebration of state power and the creation of a coercive political consensus take precedence over any aesthetic considerations. Brennan's sculpture fits nicely with a conservative ethic that imagines a public life with no surprises—no surprises from artists, no surprises from racial and ethnic minorities, no surprises from crime and violence, and no surprises, above all, from public protests and civil unrest. From this vantage point, the public art movement that began in the Kennedy era deserves our grudging respect despite its elitist cultural politics. The liberal-modernist project of the 1960s contained an implicit commitment to public spaces and a common civic life that citizens seized upon in the controversies of the 1970s and 1980s. That commitment is still worth defending, as the United States retreats to a garrison society where gated communities and prisons take the place of parks and plazas, and limestone flags find favor as public art.

NOTES

Research for this essay was supported by a fellowship from the Woodrow Wilson International Center for Scholars. I am grateful to Michael Lacey and the late Charles Blitzer for their generous support and to my colleagues at the center in 1994–95 who offered many helpful comments on an early version of this article. I am deeply indebted to many people at the embattled National Endowment for the Arts, above all Bert Kubli, Michael Faubion, and Jennifer Dowley, for allowing me to examine the records of the endowment's public arts program. I am equally indebted to Dale Lanzone, Susan Harrison, Merideth Fisher, Paige Weiss, and William Caine at the Art-in-Architecture program of the General Services Administration for granting me access to their files. Gordon Olson and the rest of the Local History staff at the Grand Rapids Public Library were likewise generous with their time and materials. I am grateful, too, for the criticisms and suggestions I received from Thomas Bender, Richard Wightman Fox, Peter Bacon Hales, Jane Kramer, Charles McGovern, Barbara Melosh, Leslie Prosterman, Arlene Shaner, Michael Smith, Lisa Steinman, and Ellen Todd, among others. My thanks also to audiences at Boston University, the Catholic University of America, Columbia University, George Mason University, the Historical Society of Washington, D.C., the New School, Rice University, Scripps College, the University of California-Irvine, Washington University, Wesleyan University, and Yale University for their responses to lectures on related subjects.

1. Mulnix, Calder dedication remarks.

2. Oppenheim, "It's a Whatchama-Calder!"

3. Diamond interview, in Weyergraf-Serra and Buskirk, *Destruction of Titled Arc*, 271.

4. Diamond quoted in Serra, Introduction to ibid., 3.

5. Bourdieu, *Distinction*, 57.

6. There is a growing scholarly literature on the politics of modern public art in the United States. Among the most useful recent works are Bogart, *Public Sculpture*; Melosh, *Engendering Culture*; W. J. T. Mitchell, *Art and the Public Sphere*; Senie, *Contemporary Public Sculpture*; Senie and Webster, *Critical Issues in Public Art*; Doss, *Spirit Poles and Flying Pigs*; and Deutsche, *Evictions*.

7. For Kennedy-era cultural policy, see Wetenhall, "Camelot's Legacy," 142–57, and "The Rise of Modern Public Sculpture," chap. 5. Wetenhall's work is an invaluable guide to the history of arts policy in the postwar period.

8. Heckscher, "The Arts and the National Government," 5–6.

9. Quoted in Wetenhall, "Camelot's Legacy," 152–53.

10. See "Abstract Painting of JFK Death Scene."

11. Scanlon, "An Abomination."

12. Gosfield to General Services Administration.

13. "Abstract Painting of JFK Death Scene."

14. Cohen, "Artist Says Mural Doesn't Depict Death of Kennedy."

15. Kenny, "Art Furor."

16. Mancewicz, " 'Public Will Have No Sculpture Say.' "

17. Calder quoted in Schiffel, "Questions about Sculpture Project."

18. Raymond, "Views Calder Sculpture as Symbol." When Braniff Airline hired Calder to paint one of its intercontinental jets in 1973, it took the characterization of Calder's art as unbounded by geographic limits to its logical conclusion. See the coverage of Braniff's commission to Calder in *Braniff Place International Inflight Magazine*, 1973.

19. "In Commemoration" dedication pamphlet, 5.

20. Mancewicz, "Strong-handed Loner.' "

21. De Jonge, "It's Sculpture Time Again."

22. Lowell Moore, "Writer Voices His Displeasure."

23. Brandel, Letter to the Editor.

24. Moore, "Writer Voices His Displeasure."

25. Frantz, "Insists Bust of Sen. Vandenberg More Fitting."

26. Welch, Letter to the Editor.

27. "Sculpture Steals Spotlight at Dedication."

28. " 'Mini-Calder' Is Fun"; Bornheimer, "Calder Spoof Draws 'Haul It Away' Plea." The history of junk sculptures spoofing or criticizing fine art objects commissioned by local and federal agencies is a fascinating story in its own right, to which I can only make brief reference here. The NEA and GSA files are filled with references to art of this kind, which creators have displayed both as playful commentary on official public art and as vehicles for vehement protest. These junk sculptures, made of pipes, hangers, and other found objects, have less in common with a Dada aesthetic than with what Bourdieu describes as "a deep-seated demand for participation" at the heart of popular hostility to abstract art—a demand that "formal experiment systematically disappoints" and which elite commissioning procedures specifically prohibit (Bourdieu, *Distinction*, 32). Two of the more imaginative efforts of this kind in recent years involved attempts by dissenting artists to embellish public art commissions. In St. Louis in the mid-1980s, pranksters affixed white styrofoam circles to Richard Serra's *Twain*, a triangular array of cor-ten steel plates, giving the piece the appearance of a stack of dominoes. St. Louis officials removed the domino design immediately from Serra's piece. In 1993, in Seattle, an anarchist artist and his friends attached an enormous ball and chain to one leg of Jonathan Borofsky's *Hammering Man* as a pointed commentary on the condition of labor and the political

blandness of most public art. After a newspaper referendum showed overwhelming popular support for *Hammering Man*'s new accessory, Borofsky asked that the ball and chain remain in place. These artistic embellishments are exceptional. Far more common are angry graffiti scrawled on public works and parodies set up in residents' front yards, with price tags calculated at a fraction of the commission to the artist.

29. See Michael Moore, "Art in Public Places."

30. In one of many instances where NEA administrators expressed misgivings about the aesthetics of the early 1970s murals movement, Brian O'Doherty jotted on a letter from a Boston official about the city's 1971 "Summerthing" program, "These murals look like they're kid stuff. Very poor. Aren't *artists* doing them anymore?" His assistant informed the official that the NEA could continue to support future "Summerthings" only if "reputable artists [were] involved to provide at least the initial mural designs and supervise their completion." O'Doherty's note on letter from Kane to Meyer, February 7, 1972, and Meyer to Kane, March 14, 1972.

31. A review of the NEA Art in Public Places program in 1984 confirmed that "virtually none" of the local murals programs from the early 1970s "survived the withdrawal of federal support. The program was discontinued amidst growing concerns by council members, panelists, and staff over the quality of the artwork it placed. This is when the guidelines begin to emphasize . . . 'innovative explorations of new media, sites, and approaches to public art.' Numbers of applications begin to decline and more resources were applied per project. That seemingly subtle change, from having social content define art, to allowing art to define its own context has been the most far reaching development in the field." Michael Moore, "Art in Public Places."

32. Two documents of the federal programs' achievements in the 1970s are Thalacker, *The Place of Art in the World of Architecture*, and Harney, *Art in Public Places*.

33. Jo Ann Lewis, "The 'People Sculpture.'"

34. Quoted in John Blair Mitchell, "Anatomy of a Sculpture Commission," 6.

35. In the aftermath of the Oklahoma City bombing, judges in Baltimore revived their campaign to remove the Sugarman sculpture in Spring 1995, again citing security concerns.

36. Barton, Letter to the Editor.

37. Walker Lewis, Letter to the Editor.

38. "'Dr. Dooley Statue Is Trash.'"

39. Glymour and Stalker, "Malignant Object."

40. One NEA administrator plaintively lamented in a 1987 memo about the work's possible relocation that "the same people seem to be supporting 'Nimbus' over and over. What about support for 'Nimbus' from the non-art elite?" See "Review."

41. O'Doherty to Orchard.

42. See NEA Art in Public Places Files, grants R50-41-121 and 02-440-79, NEA, Washington, D.C.

43. Response to survey for the Hartford Civic Center Coliseum project by the Office of Cultural Affairs, NEA Art in Public Places Files, grant 02-440-799, ibid.

44. For the convergence of liberal and conservative views of public art controversies, see Blake, "'An Atmosphere of Effrontery.'"

45. "Federal Building Sculpture Installed."

46. Roth to Freeman and Jensen.

47. For examples of recent developments in leftist and feminist public art, see Felshin, *But Is It Art?*; Jacob et al., *Culture in Action*; Suzanne Lacy, *Mapping the Terrain*; and Doss, *Spirit Poles and Flying Pigs*. Another work sympathetic to the "community arts movement" that has emerged in the wake of the Modernist collapse is Hayden, *The Power of Place*.

48. Alloway, "The Public Sculpture Problem," 246.

49. Powelson, "GSA Official Nixes Duncan Plaza Sculpture."

50. GSA *Knoxville Flag* dedication pamphlet, in GSA Art-in-Architecture File #AA199, Public

Buildings Service, GSA, Washington, D.C. In this file, see also the minutes and letters by panel members that make evident their opposition to Brennan's second design. It is worth noting, in this regard, the changes that the GSA has instituted in its commissioning process in the aftermath of the *Tilted Arc* affair. On the one hand, the Art-in-Architecture program's panels now include greater representation of local groups and tenants of federal buildings, which suggests a responsiveness to community needs that did not exist when NEA-sponsored panels of artists and critics controlled the process. On the other hand, the new process appears in practice to give unprecedented power to regional and national GSA administrators, since many local panel members defer to their knowledge and authority. The result is a procedure that permits GSA officials to make aesthetic choices with little interference from artists, critics, or other professionals outside of the federal government.

BIBLIOGRAPHY

"Abstract Painting of JFK Death Scene Stirs Furor." *Boston Globe*, August 12, 1966.

Alloway, Lawrence. "The Public Sculpture Problem." *Topics in American Art since 1945*. New York: North, 1975.

Barton, H. Letter to the Editor. *St. Louis South Side Journal*, May 19, 1982.

Blake, Casey Nelson. " 'An Atmosphere of Effrontery': Richard Serra, 'Tilted Arc,' and the Crisis of Public Art." In Richard Wightman Fox and T. J. Jackson Lears, eds., *The Power of Culture: Critical Essays in American History*, 246–89. Chicago: Chicago University Press, 1993.

Bogart, Michele H. *Public Sculpture and the Civic Ideal in New York City, 1890–1930*. Chicago: University of Chicago Press, 1989.

Bornheimer, Hank. "Calder Spoof Draws 'Haul It Away' Plea in East." *Grand Rapids Press*, November 10, 1968.

Bourdieu, Pierre. *Distinction: A Social Critique of the Judgement of Taste*. Translated by Richard Nice. Cambridge: Harvard University Press, 1984.

Brandel, Paul F. Letter to the Editor. *Grand Rapids Press*, November 30, 1967.

Cohen, Cathleen. "Artist Says Mural Doesn't Depict Death of Kennedy." *Boston Globe*, August 13, 1966.

De Jonge, Maury. "It's Sculpture Time Again." *Grand Rapids Press*, February 21, 1968.

Deutsche, Rosalyn. *Evictions: Art and Spatial Politics*. Cambridge: MIT Press, 1996.

Diamond, William. Interview. In Clara Weyergraf-Serra and Martha Buskirk, eds. *The Destruction of Tilted Arc: Documents*. Cambridge: MIT Press, 1991.

Doss, Erika. *Spirit Poles and Flying Pigs: Public Art and Cultural Democracy in American Communities*. Washington, D.C.: Smithsonian Institution Press, 1995.

" 'Dr. Dooley Statue Is Trash.' " *St. Louis Globe-Democrat*, February 23, 1973.

"Federal Building Sculpture Installed." *Huron Daily Plainsman*, July 6, 1979.

Felshin, Nina, ed. *But Is It Art? The Spirit of Art as Activism*. Seattle: Bay Press, 1995.

Frantz, Charles H., M.D. "Insists Bust of Sen. Vandenberg More Fitting for Civic Center" (letter to the editor). *Grand Rapids Press*, January 15, 1968.

Glymour, Clark, and Douglas Stalker. "The Malignant Object: Thoughts of Public Sculpture." *Public Interest* 66 (Winter 1982): 3–21.

Gosfield, John. Letter to General Services Administration. November 25, 1966. GSA Art-in-Architecture File FA897, GSA, Public Buildings Service, Washington, D.C.

Harney, Andy Leon, ed. *Art in Public Places*. Washington, D.C.: Partners for Livable Places, 1981.

Hayden, Dolores. *The Power of Place: Urban Landscapes as Public History*. Cambridge: MIT Press, 1995.

Heckscher, August. "The Arts and the National Government: A Report to the President." May 28, 1963. White House Central Files, box 4: "AR Arts." John F. Kennedy Presidential Library, Boston.

"In Commemoration." Dedication pamphlet for *La Grande Vitesse*. Michigan: City of Grand Rapids and County of Kent, 1969.

Jacob, Mary Jane, Michael Brenson, and Eva M. Olson. *Culture in Action: A Public Art Program of Sculpture Chicago*. Seattle: Bay Press, 1995.

Kane, Kathy D. Letter to Starke Meyer. February 7, 1972. NEA Art in Public Places Files, grant A72-0-1094, NEA, Washington, D.C.

Kenny, Herbert A. "Art Furor." *Boston Globe*, August 12, 1966.

Lacy, Suzanne, ed. *Mapping the Terrain: New Genre Public Art*. Seattle: Bay Press, 1995.

Lewis, Jo Ann. "The 'People Sculpture': Overcoming a Judgment." *Washington Post*, October 13, 1976.

Lewis, Walker. Letter to the Editor. *Baltimore Sun*, May 30, 1975.

Mancewicz, Bernice. " 'Public Will Have No Sculptures Say.' " *Grand Rapids Press*, August 28, 1967.

———. "The Strong-handed Loner Who Made 'La Grande Vitesse.' " *Grand Rapids Press Wonderland West Michigan Magazine*, April 20, 1969.

Melosh, Barbara. *Engendering Culture: Manhood and Womanhood in New Deal Public Art and Theater*. Washington, D.C.: Smithsonian Institution Press, 1991.

Meyer, Starke. Letter to Kathy D. Kane. March 14, 1972. NEA Art in Public Places Files, grant A72-0-1094, NEA, Washington, D.C.

" 'Mini-Calder' Is Fun, Whether Art or Spoof." *Grand Rapids Press*, December 20, 1968.

Mitchell, John Blair. "Anatomy of a Sculpture Commission." *Art Workers News* 6, no. 3 (June–July 1976).

Mitchell, W. J. T., ed. *Art and the Public Sphere*. Chicago: Chicago University Press, 1992.

Moore, Lowell. "Writer Voices His Displeasure over Choice of Sculptor, Fee" (letter to the editor). *Grand Rapids Press*, January 1, 1968.

Moore, Michael. "Art in Public Places: Brief Program History." Memo to Richard Andrews, Michael Faubion, and Bert Kubli, December 11, 1984. Folder in library, NEA, Washington, D.C.

Mulnix, Nancy. Calder dedication remarks. NEA Art in Public Places Files, grant A67-0-97, NEA, Washington, D.C.

O'Doherty, Brian. Letter to Robert H. Orchard. March 12, 1973. NEA Art in Public Places Files, grant A72-0-232, NEA, Washington, D.C.

Oppenheim, Carol. "It's a Whatchama-Calder!" *Chicago Tribune*, October 26, 1974.

Powelson, Richard. "GSA Official Nixes Duncan Plaza Sculpture." *Knoxville News-Sentinel*, August 5, 1991.

Raymond, Glenn T. "Views Calder Sculpture as Symbol of Today" (letter to the editor). *Grand Rapids Press*, February 6, 1968.

"Review." Memorandum, December 24, 1987. NEA Art in Public Places Files, grant R60-41-34, NEA, Washington, D.C.

Roth, Clifford. Letter to Roland Freeman and Dennis Jensen. August 30, 1980. GSA Art-in-Architecture File #AA34, GSA, Public Buildings Service, Washington, D.C.

Scanlon, Paul L. "An Abomination" (letter to the editor). *Boston Globe*, August 19, 1966.

Schiffel, William. "Questions about Sculpture Project Here Are Answered." *Grand Rapids Press*, December 24, 1967.

"Sculpture Steals Spotlight at Dedication." *Grand Rapids Press*, June 15, 1969.

Senie, Harriet. *Contemporary Public Sculpture: Tradition, Transformation, and Controversy*. Oxford: Oxford University Press, 1992.

Senie, Harriet F., and Sally Webster, eds., *Critical Issues in Public Art: Content, Context, and Controversy*. New York: HarperCollins, 1992.

Serra, Richard. Introduction to *The Destruction of Tilted Arc: Documents*, edited by Clara Weyergraf-Serra and Martha Buskirk. Cambridge: MIT Press, 1991.

Thalacker, Donald W. *The Place of Art in the World of Architecture*. New York: Chelsea House/Bowker, 1980.

Welch, Aubrie C. Letter to the Editor. *Grand Rapids Press*, July 12, 1967.

Wetenhall, John. "The Rise of Modern Public Sculpture in America." Ph.D. diss., Stanford University, 1987.

———. "Camelot's Legacy to Public Art: Aesthetic Ideology in the New Frontier." In Harriet F. Senie and Sally Webster, eds., *Critical Issues in Public Art: Content, Context, and Controversy*, 142–57. New York: HarperCollins, 1992.

Weyergraf-Serra, Clara, and Martha Buskirk, eds. *The Destruction of Tilted Arc: Documents*. Cambridge: MIT Press, 1991.

MAREN STANGE

···

Illusion Complete within Itself

Roy DeCarava's Photography

oming of age in the 1940s, photographer Roy DeCarava saw that "black people in America were not viewed as worthy subject matter" for art but rather were usually "portrayed either in a superficial or a caricatured way or as a problem." Undertaking a representation that was "serious," "artistic," and universally "human," he wrote that in his first extended project, on the people of Harlem, he wanted to achieve "a creative expression," not a "documentary or sociological statement."[1] DeCarava's work has been the subject of a recent retrospective at New York's Museum of Modern Art (MOMA) that has traveled widely. This homage is an occasion at once to celebrate the artist's achievement and to acknowledge that qualities understood to signify successful twentieth-century art—such as aesthetic autonomy, serious ambition, and thematic universality—are granted too rarely to images by, or of, African Americans.

DeCarava has photographed throughout his life primarily in New York City, where he was born in 1919 and still lives. He uses a small camera, develops and prints his own images painstakingly (sometimes working for years to get a satisfying effect), and has always relied on available light, even in cramped apartments and dim nightclubs, becoming a master of dark tones, not-quite-blacks that let viewers see into his shadows. From the beginning his style combined intimacy of tone with a dazzling formal vocabulary. Most strikingly in interiors—the portraits of saxophonist John Coltrane performing or the still lifes *Coathanger* (1961) or *Catsup Bottles, Table and Coat*—light and dark values render plastic, expressive qualities, rather than offering literal records. In images such as the radically compressed *Force* (1963) or buoyant *Haynes, Jones, and Benjamin* (1956), the picture frame serves to strengthen the composition's overall structure; vantage points do not monumentalize or dramatize in ways made familiar by the work of an earlier generation's documentary style.[2]

Acknowledged since the 1960s as "the first to devote serious attention to the black aesthetic as it relates to photography and the black experience in America," DeCarava earned the accolade not only because his photographs eschewed journalistic clichés but also because their independent aesthetic pointed the way toward a long desired condition of "spiritual freedom," in the words of critic Alain Locke.[3] Considering in what follows the contours of his career and the significance of his formal achievement, I will show both the terms and the conditions of the autonomy he struggled for and the constraints and contradictions such struggle inevitably engaged.[4]

Raised in Harlem by his mother who had immigrated from Jamaica, DeCarava studied painting and lithography for two years at the highly competitive Cooper Union, leaving in search of a milieu more attuned to his concerns and situation as a black artist.[5] He found it uptown, where, while supporting himself with artwork for the Works Projects Administration (WPA) and commercial concerns, he studied painting, drawing, and lithography at the Harlem Art Center and at the George Washington Carver School for several years in the mid-1940s. Thanks to the New Deal and private efforts such as the Julius Rosenwald Fund, which like the earlier Harmon Foundation offered fellowships specifically for black artists, the 1940s were an especially fertile period in which unprecedented numbers of artists were able to launch or sustain significant careers as New Deal arts programs brought a surge of energy to the Harlem community. DeCarava met or studied with artists like painters Romare Bearden, Elton Fax, Jacob Lawrence, Norman Lewis, and Charles White; sculptor Elizabeth Catlett; and photographer James L. Allen.

He published drawings in *Crisis* and *Opportunity* magazines in 1939, and his first exhibited works were serigraphs (Fig. 1). But in the mid-1940s DeCarava had begun to use photography as a means to sketch ideas for prints and paintings that were, Peter Galassi suggests in his MOMA catalog essay, "already photographic in style," and within two years he had decided to concentrate exclusively on it. The medium offered a method and pictorial vocabulary "ideally suited to his circumstances and sensibility," Galassi points out, noting the value of hand camera portability and relative simplicity to an artist with a job. Finding photography "always changing, . . . exciting, alive and vibrant," DeCarava has also suggested that its immediacy of response offers greater access to the "spirituality" characteristic of African American life, enabling a more direct rendering of "what the artist feels," which can be precluded by the emphasis on technique required in traditional painting.[6]

Some of DeCarava's strongest work, such as *Graduation* and *Gittel* (1950), dates from the late 1940s and early 1950s. Edward Steichen, then MOMA's curator of photography, was invited to attend the artist's first one-person photography show at Mark Perper's Forty-fourth Street Gallery in 1950. Deeply impressed, the story

Figure 1. Roy DeCarava, Hands. *Serigraph reproduced from announcement of exhibition at the Serigraph Galleries, 38 West 57th Street, New York City, November 10–29, 1947. (Brooklyn Museum of Art Library Collection, Artists Files)*

goes, he immediately bought three prints for the museum and encouraged De-Carava to apply for a Guggenheim Fellowship. The grant, awarded in 1952, enabled DeCarava to continue his Harlem project undistracted; by 1955 he had had four one-person shows and appeared in three group exhibitions.[7] The photographs he made during that period of prolific production still stand unparalleled in the creativity, scope, and sensitivity of their approach to the life they record. Four Harlem images were included in Steichen's immensely popular 1955 *Family of Man* exhibition and book, and 140 accompany a text by Langston Hughes in the classic *Sweet Flypaper of Life*, also published that year. The *Flypaper* photographs are part of a body of work on the daily life of family and community that was without precedent; no one previously had photographed Harlem "from an artist's sensibility," as Sherry Turner DeCarava points out, "no one who lived there" had photographed DeCarava's neighborhood except with "commercial or documentary intent," and "[n]o one had photographed black people in . . . [his] manner or even as a subject worthy of art." An early impetus for the project was a desire to photograph his mother's neighbor, and, as Galassi's essay notes, the central sequences on family life were photographed primarily in the homes of two families whom DeCarava came to know well.[8] The book sold out its first printing, won two awards, and went on to appear in two subsequent editions.

In 1958 DeCarava left his commercial artist position to launch a freelance photography career lasting nearly twenty years. With his then wife Anne he operated the Photographer's Gallery on the upper West Side for three years, featuring the work of Minor White, Harry Callahan, Dan Weiner, Ralph Eugene Meatyard, Ruth Bernhard, and Berenice Abbott among others. The Photographer's Gallery and Helen Gee's Limelight were the only galleries devoted solely to vintage photographic prints for sale just as paintings and sculpture were sold in those years.[9] At the same time DeCarava was working toward what he hoped would be a second

book, organized around the theme of jazz and featuring the intensely expressive studies of musicians and audiences he had been making since the 1950s, accompanied by his own long prose poem. Though the book found no publisher, its evocative title, *The Sound I Saw*, was eventually used to name a solo exhibition of the jazz photographs and an accompanying catalog organized and published by the Studio Museum of Harlem in 1982.

As the impact and significance of DeCarava's achievement began to be acknowledged, he joined the faculty of Hunter College in 1975, attaining his current position as City University Distinguished Professor of Art in 1989. Revered by younger black photographers for a "consistent commitment to radical social change," as Larry Neal wrote in 1969, DeCarava had set a crucially "unique example" according to James Hinton, and his influence extended "throughout the field."[10] Active in the late 1940s in the Committee for the Negro in the Arts, DeCarava in the early 1960s had founded and chaired the short-lived American Society of Magazine Photographers Committee to End Discrimination against Black Photographers, leaving to help form and direct the Kamoinge Workshop, whose purpose, like that of the contemporaneous painters' and sculptors' group, Spiral, founded by Romare Bearden, Norman Lewis, and Hale Woodruff, was to foster members' discussion of artistic, political, and racial issues and to ensure a venue for their work.[11] The Kamoinge photographers had produced two portfolio editions and a number of exhibitions when DeCarava left the group in 1966. As a member of the Ad Hoc Emergency Cultural Coalition, he picketed the Metropolitan Museum of Art's controversial *Harlem on My Mind* exhibition in 1969, appalled by the program's emphasis on documentary, rather than artistic, representation of the Harlem community and by the museum's fundamental (and arrogant) misstep in failing to involve Harlem's artists and intellectuals in planning and curatorial decisions. Though invited to exhibit, DeCarava ultimately withdrew his work from the show.[12] Nevertheless, he exhibited extensively in these years; in 1984 *The Sweet Flypaper of Life* was reissued in a larger, redesigned edition, and in 1981 the Friends of Photography published *Roy DeCarava: Photographs*, a major monograph with eighty-two plates, until now the primary printed resource on his work.

Despite a wide spectrum of subject matter—the 1991 *Grass* exemplifies a career-long engagement with nature—and a style that expresses above all the workings of a singular personality. DeCarava remains associated in many minds with social documentary agendas, or he is lumped with his "street" shooting contemporaries who honed 1930s documentary styles into distanced, ironic commentaries on postwar life. Much critical comment has seemed almost perverse in its obliviousness to the beauty and "tenderness"—one of Galassi's favored terms—that is virtually a hallmark of his images. Citing experience with the photographic community that has been "rather bitter," DeCarava has expressed growing frustration over the years.

"Roy DeCarava is an important artist of our time, but most people seem to be missing the point in considering him," insists a 1982 press release from Witkin, his New York gallery. With an "informed eye" or "a modicum of sensibility," they would not be distracted by "his success in terms of his being black," but rather would be able to see him as "a trained artist following in a very old tradition, [and] a human being of intelligence and compassion and awareness." Had Rembrandt found himself in twentieth-century Harlem, he might have chosen "the same means of expressing his aesthetic" as did DeCarava.[13]

DeCarava can lay claim to irony, as in *Out of Order* (1953) or *Louise* (1975), and photographs such as *Stickball* (1952) or *Hallway* (1953) have "something to do with the economics of building for poor people," as he has said.[14] And he is undeniably postwar in sensibility and visual vocabulary, thematically allied with photographers including Helen Levitt and Ben Shahn; DeCarava himself has acknowledged particularly the influence of Henri Cartier Bresson. But the psychological resonance of the luminous *Hallway* or the crisp metaphoric equilibrium of *Sun and Shade* (1952) suggest that (like Cartier Bresson's) his work is rooted in an earlier modernist moment. Sherry Turner DeCarava mentions the early impact of van Gogh's expressionistic linearity, noting as well DeCarava's interest in the Mexican muralists and in J. M. W. Turner, Thomas Eakins, and Edward Hopper, especially for their handling of light.[15] Using the most verisimilitudinous of mediums and always referential rather than nonobjective, DeCarava nevertheless makes form, rather than subject alone, convey his meanings. Thus *Hallway* can be seen as an urban, man-made "equivalent," to use the term Alfred Stieglitz applied to the photographs he made of clouds that were, he said, "*equivalents* of my most profound life experience, my basic philosophy of life."[16] Remembering its making, DeCarava has named *Hallway* "one of my first photographs to break through a kind of literalness," and even as we appreciate the technical execution that enables that transcendence, we must also acknowledge how far its subject is from any traditional artistic canon (except the documentary). It is interesting to compare DeCarava's account of the making of *Hallway* with Stieglitz's account of *The Steerage*, for both recount the successful creation of the image as a major step beyond previous work, one based in part on the dissonance in the image between formal beauty and mundane subject matter.[17] The duality of our experience viewing *Hallway* is unsettling: the image offers at once a dismally claustrophobic tenement hallway, a place that can only be "ugly and brutalizing" actually to experience, and, in the central void with its impossibly narrow opening, a richly symbolic structure suggesting unknowable interiority. Compounding uncanniness are DeCarava's own comments on the "personal," "autobiographical" nature of the photograph, which remind us that he has been there—in both spirit and flesh: "I forced *everything* out of that print" to make the viewer feel "all those things that I had experienced as a child in hallways

[like these] but could not express then," he says, entwining yet further his already inextricable subject and object.

Though he was the "only [black photographer] . . . out there figuring about art" in the 1940s, as he points out, DeCarava's commitment to photography has nevertheless caused art historians until recently to omit him from their accounts.[18] But like his mentors and contemporaries Lawrence, Bearden, Lewis, and White, he was involved in and provoked by the aesthetic debates and uncertainties that David Driskell calls "the crisis of the forties." Not only chronic lack of patronage and opportunity, but also the prescriptions of arbiters Alain Locke and James Porter, who "continually equated 'black art' with 'social analysis and criticism,' not abstraction," provoked a dilemma, according to Driskell: should the artist continue to "document" American black life and injustice in an often "academic" social realist style, or should he or she engage more fully the formal experiment and innovation animating European modernism? In Driskell's dire view, "no viable aesthetic was developed among black artists between 1930 and 1950 because black leaders and intellectuals did not take the artists nor their art seriously"; rather, art was treated as if it must be "a lesson in social history or an instrument of social change."[19]

Although it seems indisputable that, as Ann Gibson has written, social realism was "the style *de rigueur* for representation of and by Negro Americans" at the time, she and other art historians have sketched a moment complicated by somewhat greater flexibility and variety in even Locke's and Porter's notions of appropriate style and subject.[20] Locke in 1925 had called for "a school of Negro art, a local and racially representative tradition," which he based in a "frank experimental development" of what he called "ancestral arts"—the artistic traditions carried from Africa and passed on in African American folk knowledge. By 1940, however, he acknowledged that "African art could yield little through direct imitation," and he credited black artists' "documentation of Negro life" that flourished as part of the 1930s American scene movement and government arts support with leading "the Negro artist" into the mainstream of contemporary American art. Praising art of the 1930s for "sober realism" and "penetrating social vision," he celebrated as well the fact that American scene interest had "permanently removed the notion of the Negro as a restricted province to which the Negro artist might be expected to confine his artistic effort."[21]

For Porter, Locke's "admonition to imitate the 'ancestral arts' could only foster academicism," tending as well to "confuse the special geometric forms of African sculpture with specific racial feeling." Writing in 1943, he suggested that African American artists look rather to the ways that the Europeans Pablo Picasso and Constantin Brancusi had used African forms to broaden their interpretations of "design, architectonic structure, accented planes, and robust masses." Neverthe-

less, Porter did ultimately credit "the Negro art propaganda" with provoking a "search for local atmosphere" and for "those facets of life that had hitherto escaped the understanding interest of the artist." And as the debate among black critics and artists pitted local, illustrative realism against an international abstract style, it paralleled a similar debate about the direction American art generally should take in relation to the international context. As early as 1936, the American Abstract Artists formed to promote American abstraction in the face of major museums' resistance; they claimed that the "amorphous and geometric forms" to be found in their work constructed a universality that transcended any "play on national or racial or class prejudices."[22]

These discourses prevailed as DeCarava began his artistic training. He credits painter and draftsman Charles White, who taught him at the Carver School in 1944 and 1945, as his "strongest influence" at the time.[23] White had worked for the WPA as both a muralist and an easel painter, and, like a number of other Harlem artists, studied in Mexico and incorporated elements of Mexican mural tradition into his art; at the Taller de Grafica in the 1940s he associated with David Siqueiros, Diego Rivera, and Pablo O'Higgins. Then married to sculptor Elizabeth Catlett, who also taught at the "alternative," "left-of-center" school, White was a presence in New York's artistic and intellectual circles in the 1940s and 1950s and a forceful political activist. He exhibited frequently, working increasingly in drawing and lithography, and regularly offering his lithographs in portfolio editions that made them (like photographs) generally affordable. Despite his adherence to styles and techniques acknowledged to be conventional and academic, White has garnered extraordinary respect from all quarters. Citing his widespread influence as a teacher, Mary Schmidt Campbell explains that what he passed on was not pioneering technique but rather a concept of art rooted in his "unique American identity, . . . grounded in a moral position which, cognizant of a historical past, found itself at times inherently at odds with the mainstream." For Driskell, White's art proves that "even within the academic, realist tradition the genius of an artist can elevate him above the literal." Though White "searched the souls of black folks" to find the "unique qualities" registered in his art, the work remains universally accessible because it reveals "fundamentals of [humanistic] truth."[24]

Parallels are evident between the "solitary, emblematic" figures rendered in White's drawings (Fig. 2) and those in DeCarava's photographs, and the photographer acknowledges the influence of White's enthusiasm for black and white mediums as well as his sympathy for the "disenfranchised and miserable."[25] Nevertheless, DeCarava rejected aspects of his teacher's social realist style. White's often-monumental subjects were "dynamic, overpowering figures [that] spoke of strength and dignity," in DeCarava's view, "but they were symbolic rather than human. I wanted my work to be more human. I was looking to express some things I felt."[26]

Figure 2. Charles White, Native Son, Number 2, *1942. (Courtesy Heritage Gallery, Los Angeles)*

The independence and even iconoclasm in DeCarava's work and philosophy make him comparable to abstract painter Norman Lewis (1909–79), although they were not close in the 1940s and thus cannot be said to share formative influences directly. The painter, too, sought to forge a style at once individually expressive and socially significant; his achievement is, like DeCarava's, "a series of unique products whose aesthetic implications have not been fully grasped and whose cultural position has yet to be defined," as Gibson writes.[27]

Though Lewis taught at the Carver School when DeCarava was there, they came to know each other only later, when activism around civil rights and cultural issues brought them together. Also a Harlem native of Caribbean descent, Lewis studied art at Augusta Savage's Harlem Studio of Arts and Crafts, at Columbia University, and at the John Reed Club Art School. He worked in the Federal Art Program of the WPA and was active in the Artists Union and the Harlem Artists Guild, at the same time exhibiting with the American Abstract Artists. Viewing conventional realism as "reactionary" by the mid-forties, he turned as well against the strictures imposed by Lockean "ancestral arts" ideology; he was concerned, he wrote, with "limitations which every American Negro who is desirous of a broad kind of development must face," namely, the categories " 'African Idiom,' 'Negro Idiom,' or 'Social Painting.' " Desiring "greater freedom for the individual to be

publicly first an artist (assuming merit) and incidentally, a Negro," he moved toward a mature style that combined realism and nonobjectivity.[28]

Lewis's work struck viewers as sensual and sensitive, "a visual record of his emotional experience of [the world]." Not a realist but "practically abstract," wrote critic Henry McBride, "he always has a theme which he lets you know." Gibson suggests that most forms in even Lewis's "strictly nonobjective" paintings can be "traced back to Harlem's iron gates, night skies and lights, or people."[29] He exhibited regularly at the avant-garde Willard Gallery for nearly twenty years and was part of the famous "Artists' Sessions at Studio 35," where in 1950 major abstractionists gathered to define the Abstract Expressionist movement. Though insistent that "my own greatest effectiveness would not come by painting racial difficulties but by excelling as an artist first of all," Lewis remained intensely activist; with Romare Bearden and Hale Woodruff, he founded and was first president of the group Spiral in 1963; with DeCarava and others he picketed the *Harlem on My Mind* exhibition in 1968. In 1969 he founded Harlem's Cinque Gallery with Bearden and Ernest Crichlow.[30]

Gibson associates the painter and photographer specifically in the development of an aesthetic she tentatively designates "African space." Citing their presentation of "multidominant" patterns "inspired by African idioms and forms" and the "political motivation of reaffirming an interrupted identity," she asserts that the real unity among the formally disparate "African space" artists was an insistence on their "right to orchestrate a cultural and stylistic multivalence, [to refuse] to align themselves completely with *any* stylistic idiom."[31] Thus, Lewis's broad stylistic range, incorporating references to African motifs as well as to techniques derived from European modernism, was integral to his aesthetic purpose. Consciously juxtaposing such references to both European-derived and so-called primitive styles, Gibson suggests, Lewis demonstrated his mastery of both and undermined the claim of any single one to exclusive, noncontingent authority.[32]

As he moved toward abstractionism in the 1940s and 1950s, Lewis's subjects included studies of Harlem life—musicians, gamblers, domestic scenes, families—and cityscapes, especially in Harlem, paintings that a 1951 catalog described as offering "essences of moods, places, fantasies and fears, the gloom of the city, perhaps, or the chill black and white of winter, but transcending the particular with the unity and simplicity that make private experiences communicable."[33] The atmospherics achieved in one such evocative abstraction, *Harlem Courtyard* (Fig. 3), recall the mood and tonality of DeCarava's earlier studies of the same subject, *Two Boys in Vacant Lot* (1949) and *Child in Window, Clothesline* (1950). Like the photographs, the painting presents a single, monochromatic plane, devoid of spatial depth, sky, or ground. As DeCarava leads our eyes to pick out the tiny scale on which signs of human life manifest themselves against the vastness of tenement

Figure 3. Norman Lewis, Harlem Courtyard, *1954. (Collection of Eric Robertson)*

walls, so Lewis offers a delicate tracery in black that stands out against the gloom. Such a pattern or cluster of small figures, at once abstract and "clearly human," set against a contrasting background, was a repeated, characteristic figure in Lewis's work.[34]

Though Lewis's oil paintings display a full palette, he was also, like DeCarava and other artists, interested in both the "tonal nuances" of black and its possibilities for symbolic social and political representation. As Kellie Jones has shown, Lewis made over fifty paintings in which the color black predominates, by itself and in contrast with white. The mid-1950s abstractions *Blending* and *Harlem Turns White* treat the theme of relations between black identity and the larger white society; the later *Processional* (1964), a tribute to Martin Luther King Jr.'s march from Selma to Montgomery, Alabama, was part of a 1965 Spiral group show of work executed entirely in palettes limited to black and white, as "both an esthetic exercise and . . . a political statement," according to Jones.[35]

Lewis's stylistic eclecticism strikes us now as prescient, and his assertion that "the content of truly creative work must be inherently aesthetic or the work becomes merely another form of illustration" seems merely commonsensical. Nevertheless, as the art historical record makes clear, even conscious inconsistency such as Lewis's was a liability in the categorical 1940s and 1950s, and deviation from social realism could be seen as desertion of the struggle against discrimination and oppression. Just as DeCarava was misunderstood by photographers who

glibly categorized him and was written out of art histories that confined canonical work to academically sanctioned mediums, so Lewis was isolated uptown, where his innovative aesthetic was often viewed with suspicion, and "invalidated" down-town. "His effectiveness as a subject, as one who could direct the action, was denied" among the abstract artists, Gibson has suggested, and his name is rarely mentioned in mainstream accounts of the period. As his then-partner Joan Murray remembered, there was a "strange attitude" toward Lewis: "What was he doing there" among the avant-garde? "He should be painting lynchings."[36]

Hoping to persuade his editor at Simon and Schuster to publish a book of DeCarava's photographs, Langston Hughes argued in 1955 that "We've had so many books about how bad life is, that it would seem to me to do no harm to have one along about *now* affirming its value."[37] Although the assertion has the virtue of success—without Hughes's intervention DeCarava's photographs would certainly be known less widely—its "positive image" emphasis seems reductive, an injustice to the fullness of the work. Over the years DeCarava has sought frequently to mediate between his deep appreciation of the ways that Hughes's text did enhance his photographs (as well as the publishing opportunity the writer afforded him) and his sense of the book as "a slight detour in my development because I don't like themes in terms of photography." Pointing out time and again that despite his "reputation as a documentar[y] photographer, . . . I really never was," he has patiently explained his view that the necessities imposed by thematic illustration "tend to lower the standard" by which images are evaluated.[38]

To read *The Sweet Flypaper of Life* as a documentary is misguided on all counts, since the text Hughes wrote for it is strictly fictional. DeCarava showed about four hundred prints to Hughes, who initially sought to interest a number of publishers in a book of the images alone, but to no avail. Adding a text by the writer was a way to "tie the photographs into a marketable package." "No book by Hughes was ever greeted so rapturously," according to his biographer Arnold Rampersad; curator and historian Deborah Willis remembers from her childhood the impact of its assertion that black people's ordinary stories were "alive and important and to be cherished."[39]

The "grand enterprise" of Hughes's life, according to Rampersad, was "to live by his writing (as no black had ever done) and to make black America not only the major raw material of his art but also, in cunning manipulation and defiance of the white world that controlled publishing, his main audience."[40] Legendary for his generosity and accessibility to younger writers and artists, Hughes was not difficult to approach. But it was especially his Jesse B. Semple, or "Simple," sketches that prompted DeCarava to contact him. Appearing first in Hughes's *Chicago Defender* columns in 1943 and collected into several books in the 1950s, the sketches fea-

tured rambling, humorous conversations between two Harlemites—a college-educated, northern-born narrator and the southern migrant Jesse B. Semple. Ensconced in Paddy's bar, the two men speak their minds, often clashing on potentially explosive subjects. The temporizing narrator, "trying to look on both sides," attempts to counter what strike him as the "foolish questions" that Simple persists in addressing to American racism.[41] The dialogues enact a timely version of a double consciousness that Hughes claimed for his own, writing that the two voices represented "just myself talking to me," their colloquy continuing "[a conversation] that has been going on for a number of years" and that informed his work in genres from poetry and prose to radio and newspaper columns. Like many devoted readers, DeCarava felt that the Simple sketches "really captured Harlem life in words."[42]

Hughes, for his part, was so moved by DeCarava's pictures that he wanted simply to "meditate on [them] and write what came into his head." He had previously published work illustrated by well-known artists including Aaron Douglas and Jacob Lawrence; in *Flypaper*, however, the collaborative process was reversed, the writer responding to the images rather than the artist to the text. Hughes selected 140 images to appear in the book; when he turned to his narrative, DeCarava remembers, he refused to be told "any facts about the persons I had photographed on the streets" because, he felt, "he knew them already." Hughes later suggested that DeCarava make "a dozen or so photographs on my character Simple" to publicize *Flypaper*; these would include "the bar in which Simple originated; some of his other haunts; [and] the types of people he knows."[43]

The Harlem photographs, as DeCarava wrote to photographer and *Aperture* magazine editor Minor White in 1955, were meant solely as "a collection of single photographs of Negro people."[44] Previous studies such as the Photo League's "Harlem Document," undertaken in the late 1930s under Aaron Siskind's direction, had followed the documentary model set by the New Deal's classic Farm Security Administration (FSA) project, which linked photographic coverage to statistical and economic data, seeking to produce a thematic, even scientific, whole. During the depression years 1936–39, photographers Aaron Siskind, Consuelo Kanaga, Sid Grossman, Jack Mendelsohn, Richard Lyon, Harold Corsini, and other members of the radical Photo League's Feature Group photographed systematically in Harlem, ultimately producing two projects, "Harlem Document" and "The Most Crowded Block." Though never published in full, project photographs were widely exhibited in New York, and residents' comments were solicited in Harlem. Like FSA photographers, the Photo Leaguers were guided by "project consultants on statistics and economic information"; Siskind has recalled the various procedures—"talking, listening, looking, . . . [reading and] writing"—that yielded, "finally, the pictures themselves, each one planned, talked, taken, examined in terms of the whole."[45]

The most extensive such photo study of black Americans by the mid-1950s may have been *12 Million Black Voices*, published in 1941 with pictures primarily from FSA files and a text by Richard Wright. It was a book Langston Hughes knew well, having taught it in his creative writing course at Atlanta University in 1947. Though Wright ends his text on an upbeat note, both text and pictures (only two of which show Harlem) present overall a relentlessly chilling image of northern urban life, where, he writes, the death rate exceeds the birth rate, so that "if it were not for the trains and autos bringing us daily into the city from the plantations, we black folks who dwell in northern cities would die out entirely over the course of a few years."[46]

Although its general language seems meant to apply to all northern ghettos, *12 Million Black Voices* was conceived from the beginning to focus on Chicago, where Wright had lived as a young man and where his 1940 best-selling novel *Native Son* is set. The city concerned the FSA as the chief destination of former farmers and plantation workers displaced by the depression and by mechanized agriculture. FSA picture editor and designer Edwin Rosskam was spurred by an appreciation of the novel to propose an FSA project to Wright; once the writer's participation was assured, but before his manuscript was completed, photographer Russell Lee was assigned a two-week coverage of the South Side in which Rosskam also participated. Following FSA practice, Lee and Rosskam's work was guided by sociological readings, in particular the studies made by Horace R. Cayton and W. Lloyd Warner, and it was organized into stories or subseries, such as "Relief Family," "The Face of the Black Belt," and "Day of a Negro Doctor."[47] In Harlem, James VanDerZee had photographed primarily the prosperous and the prominent beginning in the 1920s; James L. Allen and later Carl van Vechten had made striking portraits of Harlem Renaissance luminaries.[48] The "New Negro" special issue of *Survey Graphic* edited by Alain Locke in 1925 featured Winold Reiss's drawings of "Harlem types," and illustrated stories on Harlem appeared occasionally in mass-circulation magazines and more regularly in the national black press, including *Ebony* magazine (founded in 1945). Hughes himself had briefly collaborated with photographer and former student Griffiths Davis on a monthly series of photo stories for *Ebony* in the late 1940s.[49]

In marked contrast to all such projects, DeCarava's "one thought uppermost" when photographing was "to isolate, capture, some thing, person or time that affects me, that moves me." To do this, "I must change it, reshape it into an image which expresses both the object and something of myself," he explained in a long letter to White. Most of the images chosen for *Flypaper*, though necessarily less abstract than the meditative *Hallway*, partake of its power to reshape the world. Hughes "selected those pictures that had a special meaning for him and translated those feelings into the words which grace the pages of our book," providing "the

kind of writing which allow[s] the photographs to live and breathe," DeCarava wrote. "The story does not bind itself too tightly and mechanically around the pictures because the words are felt rather than thought, [of] the heart rather than the mind."[50]

And yet, as DeCarava knew all too well, even the most heartfelt and loosely constructed linguistic message "anchors" a visual image, controlling a viewer's reception of its various potential messages by directing him or her to receive some of them and to avoid others. Photographs and linked text were then, as now, a naturalized form of presentation, for anchorage is an essential feature of omnipresent photojournalism and advertisements. In White's comment or "report" on *Flypaper*, to which DeCarava was replying, he proposed as a "third medium" the "fusion" of words and pictures, especially into book form, mentioning, among other examples, Paul Strand's *Time in New England* and Wright Morris's *The Home Place*. Proclaiming himself "fascinated" to see what DeCarava "will do with this word and picture fusion on the next try," White imagines him to be "starting early in life down a path that is not well trodden." Contrasting DeCarava's "romantic" style with Strand's "classicism," he suggests that the younger artist "consider [Strand's] achievement."[51]

It was against this misdirected advice—difficult not to read as careless and patronizing—that DeCarava set forth a credo:

A photographic print is the end in itself, a law unto itself, to be hung on a wall and to be lived with and enjoyed, in the same manner that one lives with and enjoys a lithograph or woodcut. A photograph is a photograph, a picture, an image, an illusion complete within itself, depending neither on words, reproductive processes or anything else for its life, its reason for being. . . . [Photography] must reject its gaudy isolation and fight for its natural place in the family of art, where each medium is an individual and yet all are brothers. . . . The time will come when photography will cast aside its literary crutch and stand on its own feet as a legitimate means of expression. For me, photography must be visual, rather than intellectual or ideological.[52]

Meant in specific rebuttal of White's career prescription, the statement offers a brilliant metaphor for the subjective autonomy and aesthetic purity that DeCarava sought in his work: as a "literary crutch," words serve only to weaken the photograph, marking it as disabled and "other" among the arts by undercutting and delegitimizing the essential visuality that is or should be constitutive of its meaning. Effectively distancing him from journalists and documentarians, DeCarava's vehement words allied him with other ambitious artists of the time. Though generally made specifically in reference to abstract painting, these artists' statements were sometimes expressed in terms strikingly similar to his. "Forewords and explana-

tory data" cause "paralysis of the mind and imagination," wrote Mark Rothko in 1954, and Clyfford Still maintained that "to interpose any literary allusion is to establish a serious block to communication."[53]

Strategies to avoid the misrepresentation and categorization seen as implicit in the titling of artworks were high on the list of issues discussed at the "Artists' Sessions at Studio 35" (others were audience, community, career, beauty, and responsibility), participants complaining that any kind of title, or even none at all, was taken as a "statement of attitude" helping to "classify" an artist. "An Assumption or a Cruxificion [*sic*] need no title," it was pointed out, so that "the designation of a painting or a piece of sculpture has become more important as a problem than it has been before." In a more philosophical vein, Robert Motherwell emphasized the new epistemological status of abstract art, which presented the possibility that titling was a problem of "how to name what as yet has been unnamed." Motherwell saw modern artists as having "no generally accepted subject matter, no inherited iconography," and therefore involved in the work of "re-invent[ing] painting, its subject matter and its means." Rejecting the manifesto of autonomous purity implicit in numbering, rather than titling, works, the more socially minded Herbert Ferber denied that the work "stands by itself without relation to any other discipline," advising that "we should not cut ourselves off from this great rich world."[54]

Despite socially referential positions such as Ferber's or group member Ad Reinhardt's, however, most (white) Studio 35 participants could afford to dissociate themselves from political concerns in ways that DeCarava and Lewis could not. This emerges starkly in an exchange prompted by Lewis's and Reinhardt's comments on artists' responsibility for, and connection with, ways that viewers in the "outside world" saw their work. In response to Reinhardt's question—"Exactly what is our involvement, our relationship with the outside world?"—group members variously asserted that "they had no position in the outside world," they had chosen to be "unattached to any part of society," and there was conflict between "existing in the world as men and growing in [their] own work."[55]

Nevertheless, the rhetoric of subjective exploration, innovation, and autonomy that DeCarava has shared with this avant-garde places him among them. Just as Lewis refused to spend his career "painting lynchings," so DeCarava refused to be consigned to a particular (and less ambitious) photographic "path." Using language that engaged issues across a broad spectrum of the advanced art world to situate himself and his work in relation to an ideally autonomous aesthetic realm, he necessarily claimed for himself and his work the integrity of medium and materials then taken to be, above all, the sine qua non of art.

Hughes's enthusiasm for DeCarava's pictures responded certainly to their content but no doubt even more to the particular terms on which he had grounded his work in the visual "raw materials" of Harlem. As Hughes had written optimistically

in his landmark 1926 essay, "The Negro Artist and the Racial Mountain," "a black artist should [interpret] the beauty of his own people" and celebrate a "racial world" that acknowledged that "the low down folks, the so-called common element" were the majority. By the 1940s, however, he saw this literary version of the "Negro idiom" devolving, so that "the best of our writers . . . pour their talent into the tragedies of frustration and weakness." Emphasizing a "need for heroes," he deplored the "defeat and death" prevailing in Richard Wright's 1940 novel *Native Son*; dismayed as well by Wright's autobiography *Black Boy* and Chester Himes's novel *If He Hollers Let Him Go* (both appearing in 1945), Hughes called for "a good novel about *good* Negroes who do *not* come to a bad end."[56]

The story he contributed to *Flypaper* enfolds subtle ironies in deceptively plain talk. A conscious mock- and antidocumentary, it subverts at every point the possibilities for the kinds of representations DeCarava disparaged as superficial, caricatured, or sociological. In this carefully crafted life story voiced by a "good Negro," the narrative orders rather than quantifying or exoticizing its Harlem environment; naming all those she's "got to look after," grandmother Mary Bradley traces a map of Harlem structured by myriad family ties and caring connections.[57]

Centrally featured in her story is her grandson Rodney, "put out" by his parents and left to her care. Rodney's offense was becoming the father of his girlfriend (or one of his girlfriends) Sugarlee's child, but Mary willingly works to take care of him—"I always done day's work ever since I come to New York"; "I done rid a million subway cars, and went back and forth to work a million days for that Rodney—because he be's my favorite grandboy." She sees "something in that boy. You know and I know there's something in Rodney. If he got lost in his youthhood, it just might not be his fault, Lord. I were wild myself when I were young—and to tell the truth, ever so once in a while, I still feels the urge."

Mary Bradley meanders through a presentation of the many people who make up her world, Rodney's world, and the larger world of Harlem in the early 1950s. Her grandchildren include Chickasaw, "my most up and coming grandchild, . . . as different from Rodney as day from night," and other "fine grandchildren, like my son Fred's three that lives up by the Harlem River." As there is variety among the "fine people in our race," who include musicians, artists, actors, subway builders, and sign painters, so there are generational differences over music and leisure time tastes, and differences among Rodney's girlfriends, each of whom is presented in both image and text: Sugarlee, who "don't worry her mind with him, and he's the father of her child"; "Caroline [who] says she loves him"; Ada, who works so hard that sometimes when she gets uptown she's "so tired she goes to sleep"; or "Mazie, [who] works just enough to get along." Even explaining the wearying nature of day work, Mary shows us the different ways that women cope: "Sometimes when a woman comes home in the twilight evening, she's so tired she has to set down at

the top of the steps to wait for the crosstown bus. Sometimes a woman goes to work all dressed up, carrying her work clothes in a bundle." Some come home dressed up, but "some be's too tired to change to come home, so they makes the trip in what they work in."

The structure of Mary's narrative undercuts and complicates its meanings even as it presents them. Rodney's parents, cast as the villains of the piece, are nevertheless imaged in a loving embrace, and, as the story progresses, their position as parents is unfixed by other social and familial relationships: they are, of course, also the grandparents of Rodney's offending child and the children, by blood and marriage, of Mary. Hateful toward Rodney, though "he is the spitting image of them both," they appear loving to each other, and, speculates Mary, their motives for putting him out were all too human: they did it just "so's they can keep on good-timing themselves," without, perhaps, reminders of unwelcome grandparenthood too close to home.

Not only are there unanswered questions and ambivalent feelings in Mary's story, but also jokes and wry asides, both verbal and visual, on subjects that constitute the serious core of "sociology," such as the family and even reform itself. In the long sequence on family life constructed around DeCarava's intimate interiors, the story concerns the family of Mary's youngest daughter, Melinda, and her husband Jerry. He is shown as a family man, when he is home: "His children are crazy about him," and "That baby had ruther set on his lap than nurse its mama. Never saw a baby so crazy about its daddy," says Mary. But Melinda has to "be worried with them all day," and not until day's end does she get "a chance to set down and read her paper—if Jerry ain't home." For "one of Jerry's faults is, he don't come home every night. Melinda got the idea she can change him. But I tells Melinda, reforming some folks is like trying to boil a pig in a coffeepot—the possibilities just ain't there—and to leave well enough alone. Long as Jerry brings his wages home, he don't always have to bring his self. And when he does come home—well, I do believe Melinda is getting ready to populate the colored race again."

Because it is spoken by a woman, Hughes's narrative is mediated by classically "feminine" characteristics that are diametrically, even symmetrically, opposed to both the professional detachment of the reporter and the principled vision of the reformer. At the beginning of the book, Mary is introduced on the verge of death but claiming for herself a reprieve. "A little sick, but as yet . . . no ways tired," she turns down an invitation, brought from the Lord by a bicycle telegram messenger, to "Come home." She refuses Him because, "For one thing, I want to stay here and see what this integration the Supreme Court has done decreed is going to be like." At the book's end, her refusal amplified by the explanations and introductions that constitute her narration and back on her feet again, Mary offers an image of

herself, in her "best clothes." The occasion is a hint of romance that has entered her life: the attentions of the widowed janitor downstairs have made her wonder: "Do you reckon I'm too old to get married again?" To him, she tells us, she has affirmed life's hold on her: "I done got my feet caught in the sweet flypaper of life—and I'll be dogged if I want to get loose."

Not only does Mary glory in her attachment to life by comparing herself metaphorically to a common housefly, she also extends the metaphor by describing life itself as not "always so sanitary as we might like it to be." Her willing immersion in the most basic needs and duties and her map of a city structured by love and caring connections remind us by contrast of how nearly universally the documentary narrator is marked off physically, socially, and intellectually from the objects of his or her representation and set above them. Mary's persona is distinguished so thoroughly from the omniscience and portentiousness common to the narratorial "voices of God" prevalent then, and even now, in documentaries, that her voice and figure make the book seem intentionally subversive of such forms.

Just as Mary's words throughout confirm and celebrate her attachment to the messy yet promising proceedings of life itself, so the concluding sequence of the book, in which she presents the final image as a snapshot of herself posed in her best clothes, situates Mary within, subject to and told by, the unfolding story, rather than above and apart from it. Elaborating the fiction that the image is a pleasing representation of Mary that she herself collaborated in making, now owns, and chooses to share with us, the text underscores the complementarity uniting the two artists' work. "This is me," says Mary, canceling the possibility that any documentary, sociological, or erotic scrutiny might capture her image for an objectifying gaze.[58]

Perhaps Hughes's text partners DeCarava's images so elegantly because it signifies in part the writer's own, parallel struggle for autonomy. But it is also true that the text "masks the eloquence of photographs so complete in themselves that they require no elucidation," as Galassi's essay restates the problem.[59] Returning to interrogate the equation of photographic purity with legitimacy that underlies DeCarava's declaration to White, we note that his prophesy has, of course, remained unfulfilled: not only has photography not produced an essential visuality, but also it is the conscious manipulation of intertextual reference that is now current and valorized. To gauge the significance of DeCarava's desired ideal, we can reframe the issue of "words" to enable a wider range of possibility: rather than only marking weakness and inadequacy, intertextual language may act as well to legitimate, empower, and liberate.

The image DeCarava titled *Stickball* appears early on in *Flypaper*, captioned there by Mary's observation that "all the young ones nowadays is just crazy about cars. And no wonder, for "the streets is just full of cars," as the photograph's expansive

vista shows. Although his own captions, DeCarava has said, are meant merely to "describe the salient aspects of the photograph," the title *Stickball* offers more.[60] It directs our attention away from the vista and toward the bases drawn around manhole covers in the street and the game in the foreground played by virtual stick figures, who have paused to let a truck and a car go by. For Minor White, this "photo of the street full of cars is ordinary," and the two preceding pages of *Flypaper* on cars were "a particularly unhappy example of failing to fuse words with pictures."[61]

Though it is difficult to see how White could consider *Stickball* "ordinary," it is true that a viewer who is unaware of the interrupted game misses a central complexity. White's oversight may have been due to the small-sized, blurry half-tone reproductions used in the inexpensive first edition of the book, which make it virtually impossible to see the chalk-outlined bases and the batter's stick. If, as we must presume, Hughes did see these things in the print he used, then the comment offered by his character deepens into irony: too bad, she may be saying, that the streets are full of cars, when they might so much better be full of people. Indeed, as Sherry DeCarava remarks, the photograph indicates both the relatively clean and inviting nature of New York streets in 1952 and the fact that "no safer place exists for these children of the city."[62] Although the street almost bare of traffic and the sense of high, hot summer make the scene seem lazy and relaxed, still and symmetrical, we know that city space does not come without a struggle. The children's move beyond the curb to take the street as well is an imaginative achievement of considerable force; the rules of their game reshape the city to make a space where people and machines are equal contenders.

One of the most striking images in *Flypaper*, made in 1949, appears as the first plate in the 1981 Friends of Photography DeCarava monograph, where it is titled *Graduation*. Displaying a solitary figure in virginal white making her way through an especially dismal urban scene and about to step from brilliant sun into shadow, the image recalls some aspects of the visual irony in FSA photographs such as Dorothea Lange's *Take the Train* or Gordon Parks's portrait of *Ella Watson, U.S. Government Charwoman*. Like Lange, DeCarava uses the found text of a billboard and the iconography of travel; like Parks he places a dignified black woman against a discordant setting. Parks complicated his meaning with iconic reference to Grant Wood's self-denying and self-righteous farm couple, and DeCarava evokes, with equal resonance, the myth of Cinderella. There seems no doubt that social statement is intended. But DeCarava's title is without the pointed irony of those that name the FSA photographs. Rather, the word "graduation" refers us to a familiar, virtually universal ritual, whose regular, cyclical recurrence is dependable. Despite the poignant juxtaposition of a figure symbolic of hope and beauty against an environment that appears vicious in its indifference to her, DeCarava's title directs

us toward neither the "anecdotal descriptiveness" of photojournalism nor the social instrumentality of documentary.[63]

In *Flypaper*, Hughes used this image in a sequence about Harlem's streets; Mary Bradley comments that "it's nice to see young folks all dressed up going somewhere—maybe to a party," but "it's sad if you ain't invited." Again, it is in juxtaposition with the one-word title used in DeCarava's monograph that a viewer appreciates the ambiguity that Hughes may have seen in the image and sought to express through Mary: all dressed up, but only *maybe* to a party? In these surroundings, which indeed seem a dubious locale for formal celebration, is there something else lying in wait for this much-adorned voyager, something of which she is unaware? Even as the word "graduation" "explains" the image literally in relation to such an occasion, it becomes itself a marker of ambiguity. The title denotes the sharp, ritually defined difference between childhood and adulthood that a graduation ceremony marks and that seems to be signified visually in the image, and it connotes a transition that is all but imperceptible, as in the related terms "gradual" or "gradation"; this second sense of the word is directly contrary to the sharp contrast that is visually signified.

Thus such a minimal title can multiply possibilities for response, encouraging a reading of the bisected image and the figure's implied transition from sun to shade, white to black, as signifying opposition generally and as a metaphor for, or metonym of, a range of supposedly natural and inescapable dichotomies—purity and evil, innocence and knowledge, danger and safety, childhood and adulthood. As its emphatic bisection suggests, if this is a graduation, then to reach adulthood as a black woman in Harlem, no longer able to claim even the limited sanctity of childhood, is simply to be swept up as trash.

But what if, abandoning all "literary crutches"—even the ones DeCarava has provided—we organized responses around solely visual signifiers? The constraints of such a limited intertext foreground the striking fragmentation in *Graduation* as a trope, a repeated figure in a purposeful pattern extending throughout the work. For *Graduation* is not the only DeCarava image to allegorize sun and shade. In the picture called *Sun and Shade*, it is easy to see the boy pointing a toy gun as he runs along the sunny part of a broad sidewalk. Though we can scarcely see the child on the shady side, the direction pointed by the "sunny" boy's gun—echoed by its shadow—leads our eyes to the other figure. In the darker portion, which is not solid black, we can see that this boy, too, points a gun at his counterpart. Twinned by their identically combative stances despite the division that defines them, the figures present opposing, even warring, halves or sides of a whole. Such a reading, which depends on penetrating the shadow, is encouraged not by the language of the title, which seems simply to repeat, or describe, what we initially and readily see, but by the visually significant pointing gun. Such carefully composed, eye-

catching tonal contrast, scaled and balanced to emphasize shadow, recurs often in DeCarava's work, defining early classics such as *Catsup Bottles*, *Table and Coat*, and *Woman Resting, Subway Entrance* (1952), as well as the more recent *White Line* (1960) and *Four Arrows and a Towel* (1975).

Another frequently recurring figure in these images is the wall—shutting out the sky, but offering in its place important information. *Graduation* has no sky, nor do the eloquent *Two Boys in Vacant Lot* and *Child in Window*. There are many walls and walled-in spaces in DeCarava's work, but there is much to see in the shadows and on the walls. In *Graduation*, for instance, except for the young woman about to step out of it, the unshadowed, sunlit portion of the image holds little significant detail: the newspapers bearing a headline about the Korean War are in shadow, as are the dustbin, the billboard advertising Chevrolets—the car filled, presumably, with the usual scrubbed white family—the graffittoed nickname "Prince," missing its final "e," and a poster headlined, in Spanish, "the scream of a woman in the night."[64] In contrast, light falls on the wall in the left background that stands in for the sky, and it falls strongly on the ground of the vacant lot, empty and disordered except for a round black shape in its center—an overturned bus stop sign, DeCarava has said— which seems like a fragment of blackness escaped inconsequentially beyond the edge of the shadow.[65]

Growing up poor in Harlem, DeCarava remembers, he had been the "muralist of the block" and once drew a "gigantic cowboy figure" extending across the street from one curb to the other. It was "quite an achievement" to stake this claim to reconfigure city space. "I had to make my world," DeCarava said, "and so I made it mine by drawing and it didn't cost me anything."[66] In the adult artist's work, we see such early mastery brilliantly refigured. Composed within—or out of—spaces that are already structured by the powers that order the city both socially and geograph- ically, many images offer in their "black" portions—on the walls and in the shad- ows that they cast, and in or toward which young people move—the signs and traces of human desire and meaning making. It is here, in the world seen every day, that DeCarava situates the stories we tell and that tell us. Like Hughes and Lewis, he engages multiple registers of style, thought, and feeling, so that complexity itself within the work becomes a metaphor for creativity and spiritual persistence, and innovation interrogates the very "indexicality" of black and white photography. Thus does he (like many others) revalue the sign of blackness, subverting the endlessly overdetermined readings that make blackness always a problem and necessarily superficial and caricatured.

The dream of perfect formal autonomy, which now seems so unmistakably part of a constraining modernism that marginalizes many kinds of talent, has been evidently a necessary illusion and a vitalizing force for art making in the twentieth century. If modernism's constraints have remained unexamined by some African

American artists, perhaps it is because much more immediate and material barriers, thwarting the realization and enactment that can demystify it, have kept (and can still keep) this kind of autonomy a distant ideal.

NOTES

I wish to thank Roy DeCarava, Sherry Turner DeCarava, and Susan Wheatley for detailed, useful responses to an earlier, shorter version of this essay, and also Peter Galassi, Sarah Hermanson, and Mary Lou Strahlendorff, all of the Museum of Modern Art, for assistance and information without which the essay could not have been completed. I am indebted to Grant Kester for support early on, to Dinah Mack and John Osburn for research assistance, to many other people who offered insightful comments on portions or earlier versions of the work, especially Ann Gibson, Laura Wexler, and Judith Wilson.

1. Blue, *Conversations with Roy DeCarava*; Fraser, "For Roy DeCarava," 60; Galassi, Introduction to DeCarava, *Retrospective*, 19.

2. The DeCarava Archive, in Brooklyn, N.Y., has granted no permissions to reproduce photographs here. Images may be seen elsewhere as follows: a sequence of photographs of John Coltrane appears among the sixty images of musicians and audiences reproduced in DeCarava, *The Sound I Saw*, 16–25; additional Coltrane photographs and other pictures can be seen in DeCarava, *Retrospective* and *Photographs*.

3. Photographer James Hinton's oft-quoted statement about DeCarava appeared first in a pamphlet accompanying DeCarava's exhibition *Thru Black Eyes* at the Studio Museum of Harlem, 1969. Later it was quoted in Neal, "*To Harlem with Love*," and in Alinder's Afterword to DeCarava, *Photographs*; see also Carrie Mae Weems, "Personal Perspectives on the Evolution of American Black Photography: A Talk with Carrie Weems," *Oscura* [Los Angeles Center for Photographic Studies] 2, no. 4 (1982): 10–13. Locke ("The Negro as Artist," *The Negro in Art*) positioned "the Negro artist" on the verge of realizing "spirtual freedom" in the 1940s (p. 10).

4. This essay does not intend to respond to all aspects of DeCarava's work and career to date; I envision my interests and emphases as constituting a voice among others in the discussions developing more readily now that the MOMA exhibition and catalog make fine reproductions and thoughtfully assembled information about his career more available than they had been. The 400-odd photographs of jazz musicians, in particular, remain the subject of another study. For the range of DeCarava's subject matter, the interrelations among his subjects, and the ways in which he developed and returned to them, see Galassi's Introduction to DeCarava, *Retrospective*, 11–39, and Sherry Turner DeCarava, "Pages from a Notebook," 41–60.

5. Fax, *Seventeen Black Artists*, 172; Blue, *Conversations with Roy DeCarava*.

6. Galassi, Introduction to DeCarava, *Retrospective*, 17; Blue, *Conversations with Roy DeCarava* ("always changing, ..."); Coleman, "Roy DeCarava," 25 ("spirituality," "what the artist feels").

7. Steichen's role is described in Fax, *Seventeen Black Artists*, 177.

8. Sherry Turner DeCarava, "Pages from a Notebook," 50, 51 (quotations); Galassi, Introduction to DeCarava, *Retrospective*, 19–20.

9. Blue, *Conversations with Roy DeCarava*.

10. Neal, "To Harlem with Love," 25; Hinton, "Thru Black Eyes," n.p.

11. For Kamoinge, see "Personal Perspectives"; for Spiral, see Campbell, "Tradition and Conflict," 45–67.

12. DeCarava wrote in *Popular Photography* ("Can Whitey?," 122) that he found the curators without "respect for or understanding of photography, or . . . any of the other media that they employed," and he saw as well "no great love or understanding for Harlem, black people or history."

13. Blue, *Conversations with Roy DeCarava*; "Roy DeCarava: A Major Retrospective."

14. Quoted in Sherry Turner DeCarava, "Celebration," 14.

15. Coleman, "Roy DeCarava," 23; Sherry Turner DeCarava, "Pages from a Notebook," 42.

16. Quoted in Norman's untitled essay in *Stieglitz*, 12.

17. See Stieglitz's account in ibid., 9–10. DeCarava has discussed *Hallway* in Fax, *Seventeen Black Artists*, 169, and Sherry Turner DeCarava, "Celebration," 14–15. The quotations in this paragraph draw from both sources.

18. Fraser, "For Roy DeCarava," 60. Ann Gibson's work is an exception; see her "Recasting the Canon," where DeCarava is included in the discussion of "African space," 71. Her *Abstract Expressionism* reads the Abstract Expressionist movement in the 1940s in terms of the politics of race and gender.

19. Driskell, "Evolution of a Black Aesthetic," 74, 76–78.

20. Gibson, "Norman Lewis," 22 n. 19.

21. Locke, "Negro as Artist," 10.

22. Porter, *Modern Negro Art*, 96; Lawson, untitled essay in *Lewis: A Retrospective*; Gibson, "Norman Lewis," 13.

23. Blue, *Conversations with Roy DeCarava*.

24. Gedeon, "Elizabeth Catlett," 82 ("alternative" school); Fax, *Seventeen Black Artists*, 175 ("left-of-center" school); Campbell, "Tradition and Conflict," 50; Driskell, "Evolution of a Black Aesthetic," 78. For White's work and life, see Horowitz, "Images of Dignity," 53–59, and Bearden and Henderson, *A History*, 405–17. Campbell (pp. 49–50) discusses Charles White's and other Harlem artists' interest in the Mexican mural movement of the 1930s and its influence on them. For catalogs, clippings, and reviews, see the vertical file on White at the Schomberg Center for Research in Black History, New York Public Library.

25. Galassi, Introduction to DeCarava, *Retrospective*, 15: Galassi's writing (first quotation) and Galassi citing DeCarava (second quotation).

26. Blue, *Conversations with Roy DeCarava*.

27. Gibson, "Norman Lewis," 10. Galassi (Introduction to DeCarava, *Retrospective*, 32) describes their relationship.

28. Quoted in Gibson, "Norman Lewis," 63.

29. Lawson, untitled essay in *Lewis: A Retrospective* (first quotation); Bearden and Henderson, *A History*, 324 n. 15 (McBride); Gibson, "Recasting the Canon," 67.

30. Lewis, "Application." The latter events are detailed in Jones, "Norman Lewis."

31. Gibson, "Recasting the Canon," 71.

32. Gibson, "Norman Lewis," 15–16.

33. Murray's untitled essay in catalog; Jones, "Norman Lewis," 5.

34. Bearden and Henderson, *A History*, 321–22.

35. Jones, "Norman Lewis," 5 (quotations); Bearden and Henderson, *A History*, 321, 324.

36. Lewis, "Application," 65; Bearden and Henderson, *A History*, 322; Gibson, "Recasting the Canon," 71.

37. Rampersad, *Life of Langston Hughes*, 244.

38. Fraser, "For Roy DeCarava," 60.

39. DeCarava to White, November 21, 1955, Art Museum, Princeton; Rampersad, *Life of Langston Hughes*, 249; Willis, *Picturing Us*, 4.

40. Rampersad, *Life of Langston Hughes*, 6.

41. Martin-Ogunsola, "Ambivalence as Allegory," 3.

42. Rampersad, *Life of Langston Hughes*, 65, 242.

43. Ibid., 244 (first and third quotations), 153 (second quotation); Hughes to DeCarava, June 3, 1955 (last quotation), Beinecke Library, New Haven.

44. DeCarava to White, November 21, 1955, Art Museum, Princeton.

45. My account is drawn from Natanson, *Black Image*, 47, 274–75 (quotation). For a recent presentation of Siskind's Harlem work, see Siskind, *Harlem*. Lowe and Millstein (*Consuelo Kanaga*) present a valuable assessment of Kanaga's lifework, including her interest in photographing African Americans. For social documentary tradition and practice, see Stange, *Symbols*.

46. Rampersad, *Life of Langston Hughes*, 128; Wright, *12 Million Black Voices*, 107.

47. Richard Wright was also present and provided guidance during the shoot. See Stange, "'Not What We Seem,'" and Natanson, *Black Image*, 144–45.

48. See Willis-Braithwaite, *VanDerZee*; Holloway, *Portraiture*; and *Rhapsodies in Black*.

49. Rampersad, *Life of Langston Hughes*, 156.

50. DeCarava to White, November 21, 1955, and White, "Report on 'Sweet Flypaper of Life,'" Art Museum, Princeton.

51. Barthes, "Rhetoric of the Image," 38, 40–41; White to DeCarava, January 24, 1956, and White, "Report on 'Sweet Flypaper of Life,'" Art Museum, Princeton.

52. DeCarava to White, November 21, 1955, and White, "Report on 'Sweet Flypaper of Life,'" Art Museum, Princeton.

53. Rothko and Still quoted in Gibson, "Abstract Expressionism's Evasion," 208.

54. Motherwell and Reinhardt, *Modern Artists in America*, 14 (unnamed artists, Ferber), 20 (Motherwell).

55. Ibid., 16. The significance of this exchange is discussed in Gibson, "Recasting the Canon," 72, and Craven, "Abstract Expressionism," 58.

56. Hughes, "Negro Artist," 55–56; Rampersad, *Life of Langston Hughes*, 14–15, 119.

57. The quotations here and below are drawn from DeCarava and Hughes, *Flypaper*.

58. See Kozloff, *Invisible Storytellers*.

59. Galassi, Introduction to DeCarava, *Retrospective*," 22.

60. DeCarava made this statement in response to a question from the author following his lecture at the Museum of Modern Art, January 1994.

61. White, "Report on 'Sweet Flypaper of Life,'" Art Museum, Princeton.

62. Sherry Turner DeCarava, "Celebration," 11.

63. Livingston, *New York School*, 259.

64. I am indebted for this decipherment to Wallen, "Reading the Shadows," 24.

65. Sherry Turner DeCarava, "Celebration," 15.

66. Blue, *Conversations with Roy DeCarava*.

BIBLIOGRAPHY

Archival Sources

Brooklyn, New York
Art Reference Library, Brooklyn Museum of Art
 Norman Lewis Vertical File
DeCarava Archive
New Haven, Connecticut
Beinecke Rare Book and Manuscript Library, Yale University
 Langston Hughes to Roy DeCarava, June 3, 1955, Langston Hughes Papers, General
 Correspondance, box 50, James Weldon Johnson Collection
New York, New York
Schomberg Center for Research in Black History, New York Public Library
 Charles White Vertical File (holds catalogs, clippings, and reviews)

Princeton, New Jersey

The Art Museum, Princeton University: Minor White Archive

Roy DeCarava to Minor White, November 21, 1955

Minor White, "Report on 'Sweet Flypaper of Life,'" [typescript], November 11, 1955

Minor White to Roy DeCarava, January 24, 1956

Books and Articles

Alinder, James. Afterword in *Roy DeCarava: Photographer*. Lincoln: Sheldon Memorial Art Gallery, University of Nebraska, 1970.

Barthes, Roland. "Rhetoric of the Image." In Barthes, *Image-Music-Text*, 32–51. Essays selected and translated by Stephen Heath. New York: Hill and Wang, 1977.

Bearden, Romare, and Harry Henderson. *A History of African-American Artists: From 1972 to the Present*. New York: Pantheon Books, 1993.

Blue, Carroll Parrott. *Conversations with Roy DeCarava*. A film by Carroll Parrott Blue. First Run Features, 1984.

Campbell, Mary Schmidt. "Tradition and Conflict: Images of a Turbulent Decade, 1963–1973." In *Tradition and Conflict: Images of a Turbulent Decade, 1963–1973*. New York: Studio Museum of Harlem, 1985.

Coleman, A. D. "Roy DeCarava: 'Thru Black Eyes.'" *Light Readings: A Photography Critic's Writings, 1968–1978*, 18–28. New York: Oxford University Press, 1979.

Craven, David. "Abstract Expressionism and Third World Art: A Post-Colonial Approach to American Art." *Oxford Art Journal* 14, no. 1 (1991): 44–66.

DeCarava, Roy. *Roy DeCarava: Photographs*. Edited by James Alinder, with an essay by Sherry Turner DeCarava. Carmel, Calif.: Friends of Photography, 1981.

——. *Roy DeCarava: A Retrospective*. Edited by Peter Galassi, with essays by Galassi and Sherry Turner DeCarava. New York: Museum of Modern Art, 1996.

——. *The Sound I Saw: The Jazz Photographs of Roy DeCarava*, with an introduction by A. D. Coleman and essay by C. Daniel Dawson. New York: Studio Museum of Harlem, 1982.

DeCarava, Roy, and Langston Hughes. *The Sweet Flypaper of Life*. 1955. Reprint, New York: Hill and Wang, 1967; Washington, D.C.: Howard University Press, 1984. All quotations in this essay are from the 1967 edition.

DeCarava, Sherry Turner. "Celebration." In DeCarava, *Photographs*, 7–20.

——. "Pages from a Notebook." In DeCarava, *Retrospective*, 40–60.

Driskell, David C. "The Evolution of a Black Aesthetic, 1920–1950." In *Two Centuries of Black American Art*, 59–79. New York: Knopf for the Los Angeles County Museum of Art, 1976.

Fax, Elton C. *Seventeen Black Artists*. New York: Dodd, Mead, 1971.

Fraser, C. Gerald. "For Roy DeCarava, 62, It's Time for Optimism." *New York Times*, June 6, 1982.

Galassi, Peter. Introduction to DeCarava, *Retrospective*, 11–39.

Gedeon, Lucinda H. "Elizabeth Catlett, Francisco Mora, and David Mora Catlett: A Family in the Tradition of the Arts." In *Selected Essays: Art and Artists from the Harlem Renaissance to the 1980's*, 81–87. Atlanta: National Black Arts Festival, 1988.

Gee, Helen. *Photography of the Fifties: An American Perspective*. Tucson, Ariz.: Center for Creative Photography, 1980.

Gibson, Ann Eden. "Abstract Expressionism's Evasion of Language." *Art Journal* (Fall 1988): 208–14.

——. "Norman Lewis in the Forties." In Lewis, *Norman Lewis: From the Harlem Renaissance to Abstraction*, 9–23.

——. "Recasting the Canon: Norman Lewis and Jackson Pollock." *Artforum* (March 1992): 66–72.

——. *Abstract Expressionism: Other Politics*. New Haven: Yale University Press, 1997.

Himes, Chester. *If He Hollers Let Him Go*. Garden City, N.Y.: Doubleday, Doran, 1945.

Hinton, James. "Thru Black Eyes." Pamphlet. Studio Museum of Harlem, 1969.

Holloway, Camara Dia. *Portraiture and the Harlem Renaissance: The Photographs of James L. Allen*. New Haven: Yale University Art Gallery, 1998.

Horowitz, Benjamin. "Images of Dignity: The Drawings of Charles White." *Charles White Drawings*, 53–59. Washington, D.C., Baltimore, and Nashville: Howard University, Morgan State College, and Fisk University Galleries, 1967.

Hughes, Langston. "The Negro Artist and the Racial Mountain." *Nation* 122 (1926). Reprinted in Angelyn Mitchell, ed., *Within the Circle: An Anthology of African American Literary Criticism from the Harlem Renaissance to the Present*. Durham, N.C.: Duke University Press, 1994.

Jones, Kellie. "Norman Lewis: The Black Paintings." In *Norman Lewis, 1909–1979*, 5–8. Catalog for an exhibition held January 31, 1985–March 7, 1985, Robeson Center Gallery, Rutgers, The State University of New Jersey, 1985.

Kozloff, Sarah. *Invisible Storytellers: Voiceover Narration in American Fiction Film*. Berkeley: University of California Press, 1988.

Lawson, Thomas. Untitled essay in *Norman Lewis: A Retrospective*, n.p. New York: Graduate School and University Center of the City University of New York, 1976.

Lewis, Norman. "Application for Guggenheim Fellowship, 1949." In *Norman Lewis: From the Harlem Renaissance to Abstraction*, 65. New York: Kenkeleba Gallery, 1989.

Livingston, Jane. *The New York School: Photographs, 1936–1963*. New York: Stewart, Tabori, and Chang, 1992.

Locke, Alain. *The Negro in Art*. Washington, D.C.: Associates in Negro Folk Education, 1940.

——. ed. *The New Negro*. 1925. Reprint, New York: Atheneum, 1968.

Lowe, Sarah M., and Barbara Head Millstein. *Consuelo Kanaga: An American Photographer*. Brooklyn, N.Y.: Brooklyn Museum of Art in association with the University of Washington Press, 1992.

Martin-Ogunsola, Dellita L. "Ambivalence as Allegory in Langston Hughes's 'Simple' Stories." *Langston Hughes Review* 7, no. 1 (Spring 1988): 1–8.

Miller, Ivor. " 'If It Hasn't Been One of Color': An Interview with Roy DeCarava." *Callaloo* 13 (1990): 847–57.

Morris, Wright. *The Home Place*. 1948. Reprint, Lincoln: University of Nebraska Press, 1968.

Motherwell, Robert, and Ad Reinhardt, eds. *Modern Artists in America*. New York: Whittenborn Schultz, 1951.

Murray, Joan. Untitled essay in catalog, *Norman Lewis: Paintings 1951*, Willard Gallery, New York. In Norman Lewis vertical file, Art Reference Library, Brooklyn Museum of Art.

Natanson, Nicholas. *The Black Image in the New Deal: The Politics of FSA Photography*. Knoxville: University of Tennessee Press, 1992.

Neal, Larry. "To Harlem with Love," *New York Times*, October 5, 1969, 25, 34.

Norman, Dorothy. Untitled essay in *Alfred Stieglitz*, 5–18. New York: Aperture, 1976.

Porter, James A. *Modern Negro Art*, with a new introduction by David C. Driskell. Washington, D.C.: Howard University Press, 1992.

Powell, Richard J. *Black Art and Culture in the 20th Century*. New York: Thames and Hudson, 1997.

Rampersad, Arnold. *The Life of Langston Hughes*. Vol. 2, *1941–1967, I Dream a World*. New York: Oxford University Press, 1988.

Rhapsodies in Black: Art of the Harlem Renaissance, with essays by Richard J. Powell, Simon Callow, Andrea D. Barnwell, Jeffrey C. Stewart, Paul Gilroy, Martina Attille, and Henry Louis Gates Jr. Berkeley: University of California Press, and London: Hayward Gallery, 1997.

"Roy DeCarava: A Major Retrospective: Photographs, 1948–1980." Press Release no. 115, Witkin Gallery, Inc., New York, 1982.

Siskind, Aaron. *Harlem: Photographs, 1932–1940*. Washington, D.C.: Smithsonian Institution Press, 1990.

Stange, Maren. "'Not What We Seem': Image and Text in *12 Million Black Voices*." Unpublished essay.

——. *Symbols of Ideal Life: Social Documentary Photography in America, 1890–1950*. New York: Cambridge University Press, 1989.

Strand, Paul. *Time in New England*. Text selected and edited by Nancy Newhall. 1950. Reprint, New York: Aperture, 1980.

Wallen, Ruth. "Reading the Shadows—The Photography of Roy DeCarava." *Exposure* 27, no. 4 (Fall 1990): 22–26.

Willis, Deborah, ed. *Picturing Us: African American Identity in Photography*. New York: New Press, 1994.

Willis-Braithwaite, Deborah. *VanDerZee: Photographer, 1886–1983*. With a biographical essay by Rodger C. Birt. New York: Harry N. Abrams, Inc., in association with the National Portrait Gallery, 1993.

Wright, Richard. *Native Son*. 1940. Reprint, New York: Harper and Row, 1969.

——. *12 Million Black Voices*. Photo direction by Edwin Rosskam. 1941. Reprint, New York: Thunder's Mouth Press, 1988.

MILES ORVELL

Portrait of the Photographer as a Young Man

John Vachon and the FSA Project

ooking back at his first days working with the Farm Security Administration (FSA) as a photographer, John Vachon recalled:

> Once upon a time when I was 21 years old it was a soft Spring day in Washington, D.C. and I needed a job. As a matter of fact it was the 27th of April, 1936 and I had been cleared for patronage through the Demo Natl Comm. That was the way you got jobs that year. I dont know how many applicants there were, but I got the job. Mr Stryker, Roy Stryker it was told me kindly that it was rather dull work, but he hired me. Perhaps I looked dull to him. So two days later I started in, and very gradually realized that I was working for the Historical Division of the Division of Information of the Resettlement Administration. This was the RA headed by Rex Tugwell in the year when they had AAA, NRA, WPA, PWA. The RA was turned into the FSA for Farm Security Administration about a year later. I dont think any of them are operating any more.
>
> My job was to write captions in pencil onto the back of 8 × 10 glossy prints of photographs. I would copy out such identifications as: Dust Storm, Cimmaron Co. Okla, Migrant mother and child working peaches in Calif, Main street, Selma Alabama, new house of tenant farm family, etc. And then I would take the proper rubber stamp and stamp on the back RA/FSA photo by: Arthur Rothstein. Or it might say Ben Shahn, Dorothea Lange, Walker Evans, Carl Mydans. I had never heard of any of these names.[1]

Out of the FSA file have come the indelible pictures—Dorothea Lange's *Migrant Madonna*, Walker Evans's portraits, Arthur Rothstein's Dust Bowl images—that have served as icons of the Great Depression. Yet, for the most part, the richness of the collection, exceeding eighty thousand prints, is unknown to us, a vast

pictorial archive that defies any single effort to comprehend all of its ramifications.[2] In recent years some collections have taken a regionalist approach, others have been thematic or topical, and still others have concentrated on individual photographers.[3] And whereas early efforts to survey the whole of the FSA project focused on Roy Stryker as director, and on the FSA as part of a larger documentary culture, more recent attempts to understand its significance have emphasized the degree to which the archive is embedded within a larger context of government and corporate ideology.

Our knowledge of this unequaled archive is weakest where we might now be most curious—at the level of production.[4] How did FSA photographers conceptualize their work? What freedom and what constraints did they operate under? To what extent were photographers subsumed under the general program of the FSA? How, in other words, was individual vision mediated or compromised by the agency's supervision? The FSA project was a crucial part of the pivotal turn of American twentieth-century culture—toward a central government's vision of reshaping habits of individualism through agricultural engineering and technocratic control, through social intervention and the rational employment of philanthropic surveillance. What was it like to be a part of this massive effort, which was itself part and parcel of the visual aesthetic arising simultaneously in the pictorial mass circulation magazines and exhibitions that were shaping a national culture?

Obviously there can be no single characterization of the context of production. Where Evans, for example, studiously eschewed the government function of propaganda, enjoying famously uneasy relations with Stryker, Rothstein produced images that deliberately (sometimes too deliberately) illustrated government intentions; where Lange insistently sought the maximum control over the physical production of her images (and their publication), others—like Russell Lee, Stryker's willing student—were content to leave things in the hands of the Washington office. One of the major figures of this documentary effort, John Vachon, has by and large escaped scrutiny but claims our attention in the most striking ways. Introspective, sharply observant, and a gifted writer, Vachon left—in his letters, journals, and notebooks—a wealth of information on the FSA experience and the years leading up to it. His record gives us a sense of the texture of the times and an understanding of the complex mentality—and often vexed circumstances— underlying the production of documentary photography during the late years of the depression and the early years of World War II.

Vachon worked longer under Stryker (six years) than virtually any other FSA photographer; after the war he worked briefly for Standard Oil Company, which was gathering a photographic archive on American life, again under Stryker's direction. In 1946 Vachon accepted, with great excitement, an assignment for the United Nations Relief and Rehabilitation Administration to photograph postwar

Poland.[5] Following his return to the United States he served, from 1947 until 1971, as one of the few regular staff photographers at *Look* magazine, where he was celebrated by his editors as their "poet photographer."[6] Vachon's images have been selectively represented in several collections of FSA work and in journalistic retrospectives, but until now there has been no serious study of his career.[7] Immensely gifted yet deeply suspicious of his gifts, Vachon was anything but self-promoting, and references to him are generally sketchy in writings about the FSA. Another reason for his general neglect is the fact that he began photographing for the agency in 1937, after Evans, Lange, Shahn, Rothstein, and others had already established their reputations. Moreover, his assignments were rarely in the rural South, where the FSA photographers early registered their strongest impact. After working part-time in the field for four years (with the file in Washington his other responsibility), Vachon finally became an "official" photographer in 1941. By then, the FSA was shifting its function to war propaganda and would soon change its name to the Office of War Information (OWI). This later phase of the FSA-OWI has generally been slighted by historians in favor of the agency's earlier work.

Vachon's relative neglect is all the more regrettable because of the extraordinary aesthetic quality of his images and the rich complexity of his sensibility. A study of Vachon will offer a representative picture of what it was like to work for the FSA program, yet one that is also exceptional. A mirror of his times, Vachon was simultaneously possessed of a genius for introspection and a lifetime's ambition to be a writer. Though he published little—some brief writings on photography, a memoir of Stryker, a memoir of his father—his sizable legacy of manuscripts (in addition to the letters and journals, there are works of fiction and poetry) makes it possible to construct an inner portrait of a photographer who was, almost against his will, working at the center of an emerging visual culture.

One of the anomalies of Vachon's career, and in many ways a determining one, is how he came to photography in the first place. Vachon had grown up in an Irish Catholic middle-class family in St. Paul, his father a stationery salesman who traveled throughout Minnesota. John went to St. Thomas College in St. Paul, where he conceived his ambition to be a great writer, perhaps an essayist, and where he also imagined, for a while at least, that he might (what could be a higher calling?) enter the priesthood. At this time Vachon was decidedly of a romantic cast, enjoying long walks, communing with himself and close friends, and engaging in the usual fantasies—and relationships—of a passionate, sexually awakening young man. Gradually the idea of the priestly calling disappeared in the face of competing interests, and Vachon applied for a graduate school fellowship in English at Catholic University. Initially denied the fellowship, he eventually received it days before the semester began in 1935; ecstatic with this turn of events, he rushed

off to Washington, D.C. There he became immersed in his new existence, challenged by the demands of the program even as he began to wonder whether the scholar's life was really what he wanted. As his thoughts turned to more creative writing, he evidently was also indulging himself extravagantly in alcohol and was forced to leave school. Keeping the specifics of his expulsion from his mother (to whom he was otherwise closely accountable and very attached), Vachon stayed in Washington and found work as a messenger—thanks to some Minnesota political influence—at the Resettlement Administration (RA). (He probably would have preferred a job at the Library of Congress.)[8]

His responsibility at the RA (which was transferred to the Farm Security Administration in early 1937) was simply to write a caption on the back of each photograph that was added to the file. Through this process Vachon came to know the file as well as anyone and to absorb the stylistic and thematic parameters of the FSA enterprise; seeing gaps in the file, he offered to take pictures in his spare time of the Washington, D.C., area, which he did on weekends. With Stryker's encouragement (and with borrowed cameras), and under the occasional tutelage of Arthur Rothstein and Walker Evans (who insisted that he train with a large view camera), Vachon began taking longer photographic excursions, ultimately contributing pictures to the file on a regular basis and then becoming a staff photographer. Vachon's photographic work gradually usurped his other responsibilities at the agency, but a good part of his contribution to the FSA before 1941 was in the conception of the archive itself.

The FSA-OWI file as we know it today was organized by Paul Vanderbilt in 1942 and is arranged by subject (e.g., farming, housing, health, etc.). But the initial organization of the file—before Vanderbilt was hired—was Vachon's work, and this he did by grouping assignments within each state, then by picture story or locale within that geographic unit, followed by miscellaneous groupings, such as "Small Town Scenes" or "General Rural Areas."[9] Early on, possibly in 1937, Vachon wrote a memorandum, called (in the Stryker Papers) "Standards of the Documentary File," outlining his own sense of the purpose of the FSA file. Presumably Stryker called for such a document, and it says much for the creative atmosphere of the agency at that time and for how much the twenty-three-year-old Vachon must have impressed Stryker. In fact, Stryker was generally open to the suggestions of his photographers, especially Walker Evans and Ben Shahn, in the early stages of the project, as its purpose was taking shape and evolving beyond the original, more narrowly defined effort to provide publicity for agricultural policies.

Vachon's "Standards" represent a clear milestone in his own intellectual development, a rapid evolution from the early romantic and would-be scholar, yet still evincing a sense of grand destiny: "The documentary urge is the most civilized manifestation of the instinct for self preservation." Vachon here elevates the no-

tion of "documentary" to a position of centrality within twentieth-century culture, together with the conception of the still camera, thus articulating a major shift from the verbal to the visual that had been occurring most notably since the 1920s with the advent of the small camera and the phenomenal growth of pictorial magazines and motion pictures. Vachon recognizes the historical record that can be found in the arts—from Renaissance painting to Hollywood movies—but unlike those incidental pictures of a given culture, "we are today making a *conscious* effort to preserve in permanent media the fact and appearance of the 20th century." He goes on to inveigh against the sentimental or falsely romantic, excessively dramatized "glorification of things typical of our times" (he is thinking of such films as the British *Night Mail* [1936]), arguing instead for a more truthfully "unimpassioned" form whose primary instrument is the camera: "Still photography, not cinematic, is the most impersonal and truthful device yet perfected for factual recording. It is able to include the widest range of subject matter and employ the least plastic materials of all the arts." Leaving a picture for the future of "what people of today look like, of what they do and build," the camera is creating "a monumental document comparable to the tombs of Egyptian Pharoahs [*sic*], or to the Greek temples, but far more accurate."

In fact, it is the photographic file that is the monument, more specifically the FSA archive—"perhaps the only important file of this sort." To Vachon's thinking, the file was not to be an art collection or a picture library; nor was it an antiquarian's file or a technical collection (portraying, say, the detailed story of an experimental farm). Nor, for that matter, should it serve some future photographic editor, looking for "slightly different pictures of the same subject" that might fit into an ideal layout. Its sole purpose, he declared, should be "the honest presentation and preservation of the American scene. If that is done it can be drawn upon like dependable statistics to support or refute. If formed only to present, it can be used to propagandize." Taking a lofty view, Vachon asserted that the file should encompass rural and urban, lower and upper classes. "Like the philosopher," it should include and understand all, yet photographing not "the unique" but "the typical." (His examples suggest what he meant here—Rothstein's image of the boy standing by his cabin, the ruined land in the background; Lee's abandoned Texaco station; Evans's indignant American Legionnaire, his "hill-climbing industrial towns"; Lange's intensely suffering faces.)

Vachon was seeking to combine, in his ideal of documentary photography, both an informed intelligence, the result of prior research, and "*feeling*": "the humorousness, the pity, the beauty of the situation" being photographed. The photographer, in other words, must have a point of view on his subject, and he must want to "freeze instantaneously the reality before him that it may be seen and felt by others." Nevertheless, maintaining the chastity of his vision, Vachon insisted that it

was not the use of the pictures that was important "but the actual existence of the pictures in an organized file."[10]

The purity of Vachon's initial views can be better understood when juxtaposed with those of social scientist Harold Lasswell, who was on leave from the Yale Law School sometime after 1941 on special assignment with the Office of War Information. Lasswell wrote a memorandum called "The Photographer and the Focus of Attention" (also in the Stryker Papers) that outlines a clear surveillance function for the photographer in the service of a propaganda machine led by social scientists. He urged photographers to work with scholars so that the former's "keen eye for the surroundings of other people" could be harnessed to the more systematic analysis of social and economic thought in order to present "an orderly picture of the interrelationships of men in the work-a-day tasks of society." The special function of the photographer was to reveal the "focus of attention"—that is, "the objects, persons and symbols that reach our attention. What people do is profoundly influenced by what comes to their focus of attention. We are in part able to predict and to understand human conduct when we are informed about what people have read, seen or heard."[11]

Lasswell scorned the self-understanding of the individual subject (do not bother asking the Chinese peasant about his own life), trusting the photographer, instead, to "select the typical objects that have come to the focus of attention of a worker in airplane factories, a petty bureaucrat in a Washington office, or an accountant in a Wall Street firm." (This is precisely the opposite of a sentiment expressed by the young Vachon in his journal on April 26, 1936, two days after getting his job as messenger at the FSA and marking a turning point in his attitude toward people: "Learning about people from themselves, by being with them, looking, listening and talking, is a very essential thing, and a fine thing to do. Being bored, indignant, or contemptuous of them is very inferior. . . . I have spent many years of my association with people, in that attitude of mind. But now I am getting away from it, and beginning to write.") Seeing the FSA-OWI project as a perpetual enterprise, Lasswell recommended that "responsible leaders of photography" select "strategic situations" to be photographed, composing a cross section of the United States every five years. The ultimate purpose of the file, then, was not in its abstract potential, but in its actual use—to "clarify the meaning of a free society." For Lasswell, the meaning of pictures was self-evident: "In a democracy all that is needed is clarity—clarity about common goals and about the means of achieving them. . . . Through the powerful medium of photography it is possible to clarify the meaning of words—the *referents* of symbols." (We have, of course, long since outgrown this sense of the self-sufficiency of photography, independent of a textual context.)[12]

Though Vachon's manifesto for a "monumental" archive—which gives primacy

to the photographer over the social scientist and to the file over its use—has a certain undeniable democratic and aesthetic grandeur, it is equally indicative of Vachon's own intellectual temperament—an encyclopedic urge toward encompassing within a single whole the multiplicity of experience, the variety of facts. In a 1973 memoir about his father, Harry Vachon, John recalls, "a school superintendent lent my father a book called *Sidney Morse's Outline of Universal Knowledge*. I read it, and it inspired me to believe that *everything* could be known, if not by me, by someone. And if I could not *know* everything, at least I would know what *could* be known, what there *was* to be known."[13] In reality, the uses of the images came to preoccupy Stryker and the agency almost from the beginning, as they would preoccupy Vachon himself once he began photographing on a regular basis. (In a conversation at Vachon's New York apartment some years later, Stryker and Rothstein agreed that it was during the 1936 presidential campaign that "pictures became important." Rothstein: "Wouldn't you say that that particular period indicated to everyone the terrific impact of photographs, in particular the photographs that were being taken for that project, because they were used so much by the press?")[14] More than once Vachon would remark with pride, in his letters, on seeing his own photographs (or, for that matter, those of other FSA photographers) in various news media. The creation of the file, which Vachon theorized so easily from Washington, was itself a process that he would come to see—once in the field on a regular basis—as a labor of great complexity, fraught with frustrations that he could not have dreamed of.

Vachon liked to say that he became a photographer by accident, that he had, in fact, no prior interest in photography before he went to work at the FSA as a messenger—that this may even have been why Stryker hired him. Although the story is literally true, it belies the extent to which Vachon was, without realizing it, well prepared by personal disposition and intellectual habits for the career he was about to fall into. Indeed, the alternatives available to the lonely, unemployed graduate school dropout seemed few: "I can always become a damn no account begging, bumming, traveling hobo, if ever I get the moral courage to become such. Or I can always go directly to my mother's house, and go on as before, if ever I so lose all feeling and hope for greatness."[15] What Stryker looked for in a photographer, as he told Richard Doud many years later, was "curiosity, it was a desire to know, it was the eye to see the significance around them. Very much what a journalist or a good artist is, is what I looked for. Could the man read? What interested him? What did he see about him? How sharp was his vision? How sharp was his mental vision as well as what he saw with his eyes? Those are the things you look for."[16]

Though wholly accidental, Vachon's becoming a photographer seems in retro-

spect—especially through the lens of his journal—virtually an act of predestination. Consider, to begin with, his strong visual sensibility, evident in the earliest entries in the journal he started when he was nineteen; these reveal an interest in painting and an acerbic critical eye: "So little of value," he observes after attending an annual exhibit of American painters at the Minneapolis Institute (February 8, 1933). He is thrilled at the Century of Progress Art Exhibit in Chicago (May 15, 1933) and reads Roger Fry on Paul Cézanne. Vachon continues to frequent art museums whenever he visits cities and at one point even considers becoming an artist, attending art classes at the Corcoran Art School in Washington, D.C., after dropping out of Catholic University: "I go so far as to think it very possible that I shall become an artist to reckon with" (September 27, 1936). Vachon abandoned this idea as he moved into photography, but his cartoons and drawings would adorn his office and be kept by friends.

What is even more predictive of a photographic career is the strongly visual character of Vachon's journal observations and his conscious wish to express, to memorialize these observations. "What saved today from being an empty void?" the twenty-year-old asks his journal. "Very little—only hearing Cyril Schomer play his violin and seeing when I awoke at four o'clock this afternoon a single bird flying wildly through a storm-stricken sky" (April 18, 1934). A week later he rationalizes his neglect of his reading assignment: "a young man who would rather walk river paths, and follow (by eye) the white swooping gulls, and rejoice in fresh strong winds all of a blue and golden afternoon, does not wrong himself to neglect Swift" (April 27, 1934). That summer he offers his journal an extended description of clouds: "Gradually the blue disappeared entirely and the merged sky was a grandeur of grey, darkling grey, heavy white, and splintering streaks of bright metallic yellow. . . . The forms were real—pictures, or perhaps visions of men—faces I'd never seen . . . I saw generals, strange African savages, old women, queerly garbed children, and delicately beautiful faces of ladies. All these I swear were distinctly limned as though by a master with a pencil, yet not still like drawings, but real wand changing" (July 9, 1934). Not even dreaming of photography, he cannot imagine what would be the ideal mode for preserving some of these visions and images, as when he attempts to describe an expression on the face of an elderly neighbor when Vachon makes an awkward exit from his company: "I fear I can't—a smile— 'Alright, John' in his regular old quavering tone—his weak eyes had in them something which saddened his smile. I cannot express this, only feel it. Shakespeare could express it, or perhaps El Greco. Music would be the best medium. I shall remember it" (August 3, 1933).

But if photography is unknown to him at this point, he at least can imagine some need to correct his overly impressionistic habits, as when he chastises himself for writing too subjectively, too intellectually: "I pray that God will make me more

objective" (March 29, 1934). Even his vocabulary, as he wrestles with his own frustrated creativity after joining the FSA agency in a clerical position, reflects a subliminal movement toward the "framing" technique of photography: how can the artist, he wonders, put a painting into the world, or a piece of music, or a "joyful, pagan, clean" lyric poem? "All three of you, Van Gogh, Debussey [*sic*] and Herrick, produced definite little things out of you, and what was given you. How could you do that? How could you take a little piece out of all this and frame it?" (September 28, 1936).

In March 1934 (while still in college, with assigned reading in the classics of English literature) Vachon takes up James Joyce. "I read first 'Dubliners' and was greatly pleased with my fresh discovery of 'realism.' Next 'Portrait of the Artist as a Young Man,' and I knew not whither to turn. I yet admired Joyce; I had not ever approached grasping him." Reading Joyce on his own, without benefit of priestly or academic intervention, Vachon uses him as a lever to move himself in the direction he was already going, and his journal entries increasingly acquire an air of ironic detachment, set into prose of increasing complexity: "The labyrinthic confusion that hemmed me in could be drawn out to but one path in my mind at that time: (truly I admit this to myself shamefully) I resolved to grow naturalistic; I resolved to find sensual pleasures foremost. . . . in short, I resolved immediately to sin. That is what Joyce did for me" (March 29, 1934). Throughout Vachon's life Joyce remained one of the photographer's ruling passions, a liberating force for his own creativity and an intellectual model for the perennially lapsing Irish Catholic.[17] From this point on, Vachon's reading expands beyond the established English curriculum of the day, with Thomas Wolfe being one of his great favorites, along with James T. Farrell and Sinclair Lewis. In the early forties he begins reading, with even greater delight, Marcel Proust and William Faulkner.

What also emerges from the journal during these formative years, as Vachon moves from college to his brief graduate school experience to his employment with the FSA, is an extraordinary receptiveness to the new modernist currents in the arts and a serious interest in the nineteenth-century roots of modernism. Jazz he is always interested in, noting, with a nice mixture of pedantry and sensuality: "I anticipate no future time when I shall lose my liking for today's many well done jazz bits. Decried though it be, today's jazz displays something of a sensual universality. The spark of genius is entirely within the arranger—masters like Ted Lewis, Whiteman, sometimes, Art Kassel, sometimes, Waring, often, Duke Ellington, and Cab Calloway" (July 20, 1933). Following a concert on March 24, 1934, with an epicurean sensitivity, he writes: "There is a maddened fealty to modernity—Rhapsody in Blue—its maniacal restraint, snarling jazzed rhythm, diabolical phases, all bespeaking something. It is music that must not, cannot, be ignored. The Mpls [Minneapolis] Symphony was unable to give it its fullest meaning. Somehow they couldn't

render the sin and metropolitanism. Gershwin's conception, nevertheless, shone through with clarity."[18] He reads Dostoyevsky, John Dos Passos, William Saroyan, and, as he comes into the FSA, Edward Bellamy's utopian *Looking Backward* and *Equality*; he listens to Wagner, Stravinsky, Debussy; he celebrates Van Gogh.

Also uncannily predictive of Vachon's later career, when he would spend much of his working life away from home, is this musing from 1933, while he was still a college student in St. Paul: "I must make it my lot to live, travel and enjoy life. Then, if I don't rise in the creative field, I can at least have seen, have read, have been, have lived! All of which is a wonderful lot." He adds, reflecting the jazz aficionado he was already becoming, "But God, please take me away from Guy Lombardo who is just commencing his evening whining over the radio" (February 13, 1933). It is hard to identify the deepest sources of Vachon's motivations, but we do know that he kept, with astonishing regularity, a record of all of his travels by air, filling a notebook with the date of a flight, destination, airline, and number of hours in the air. This is not the only evidence of Vachon's compulsivity, but it is one he himself sometimes wondered about, thinking that he might one day write about it. In any case, his postwar years with *Look* magazine produced an ample travel log, evidence—at least from this early perspective—of having "lived."

Entering the FSA initially through the file as a whole and coming to know each photographer's style and methods as well as he did, Vachon began his own photographic work with his vision well educated according to the conventions of the FSA. He recognized himself, in retrospect, as "more than any other photographer who ever worked there, imitative," a judgment that pays scant tribute to Vachon's originality. Evans especially influenced him—it was the "thingness" of his images that Vachon most admired—and he "went around looking for Walker Evans' pictures," even hiring a cab in Atlanta to drive around the city in search of the twin houses (with the ocular porches and the Carole Lombard billboard in front of them) that Evans had photographed and take them again for himself ("when I'd see the honest-to-God Walker Evans in reality, it was like a historic find").[19] Vachon may have thus inadvertently and precociously initiated the rephotographing projects of the 1970s—Bill Ganzel, Mark Klett, and others.[20] Another time Vachon writes his wife Penny that he has been driving around Oklahoma City, visiting former shack towns photographed by Russell Lee and noting immense stockpiles of used tires and vulgar commercial signs—"the kind of stuff Walker Evans and I used to dream about." But he was competing not only with other FSA photographers: in the same letter he notes that a recent spread in *Life* magazine featured images of oil pipeline construction that are similar (some better, some worse) to ones that he has himself recently shot.[21]

In fact, once he moved out of the office and into the field, Vachon's whole

experience of the American landscape was inevitably shaped by the photographs he had seen and by the pressure to see things freshly: "I was awake as we went thru Omaha. I was kind of disappointed, because it looks *so damned* unspectacular, ordinary. It looks like it will be tough to photograph. . . . I took several stray shots around Lincoln—oil tanks, coal yards, gravel pit—The oil tanks, by the way, were the same ones of which Rothstein has a rather good picture in the files." Rothstein is again on his mind in 1942, when he drives through North Dakota, observing in Grassy Butte "a wonderful town that I associate with my earliest feeling for pictures—Rothstein photod its main street, people going to church to pray for rain, etc. in 1936." Later that year he thinks of Russell Lee and John Steinbeck when he drives from Fort Smith to Tulsa and sees "real grapes of wrath stuff, shacks and tin houses, all those starved faces out of Russell Lee pictures."[22]

To the extent that the Farm Security Administration had a unified vision, it was the product of the photographers' familiarity with one another's work as well as their direction by Roy Stryker. Stryker supplied the intellectual framework for the photographers in the field—advising them to read J. Russell Smith's *North America*, for example, to get a sense of the cultural and economic geography of a given region. He also supplied them with "shooting scripts." These were of two kinds: those intended for everyone, regardless of their regional assignment, and those designed specifically for a given locale and photographer. Among the general scripts, Stryker sent instructions to all photographers, at various times over the course of the FSA-OWI years, for pictures on such topics as "Small Town," "Rural," "Industry," "The Highway," "Spring," "Garden Pictures," "Migrants," "Large Urban Railroad Station," "American Gestures," and "Life on the Homesteads." The degree of specificity in Stryker's guidelines is surprising, almost as if he is literally scripting the photographs he requires: at the railroad station, he wants people waiting for trains, buying tickets, just waiting, waiting to meet friends or relatives, paying redcaps, sending telegrams, using slot machines, and so forth ("Suggestions for Photographs"). Stryker was looking for candid shots, but he was also suggesting that his photographers "direct" the picture story, as in these instructions for "community photographs" featuring life in the homesteads, intended to stress the normality of the residents' lives: "Try to arrange that the members of the family are doing something, i.e. the woman canning, shelling peas or hanging out the wash— the man working in the garden, etc." ("Suggestions for Community"). The file needed, he wrote on another occasion, something as specific as "Two women talking *over back-yard fence*" ("Pictures"). On a page entitled, "IDEAS FOR PICTURES," Stryker asks for photographs of the smoking habits of men and their "Telephone habits—. . . at club-house with highball in hand." He wants pictures of women "pulling down girdle; fixing stockings; holding hat on windy day; pulling up shoulder straps; powdering; lip painting; . . . combing hair." The FSA's director seems, at such times, carried away by his own voyeuristic excess.

Scripts for Vachon call for such scenes as, in Iowa, "Town water tanks; . . . Courthouse squares" ("For Vachon Trip") and, in Minnesota and Wisconsin, "housing, home life, community buildings, stores, school, school children" ("Outline"). Again, Stryker previsualizes exactly the kind of photograph he wants, or perhaps exactly the kind of image he thinks Vachon will be able to capture. Regardless, his expressed preference is for the kind of patterned shot that Bourke-White had made popular as early as the late twenties and that carried into the thirties and forties as a sign of modernism: "a shot in early morning or late afternoon to accent the pattern of the turned soil"; "watch for chance to get pictures with early or late light showing *land texture*" ("Random Notes"). At other times he seems to be directing "The Plow That Broke the Plains": "1. low (almost on the ground with camera) and up at plow from 'land side'. 2. dirt rolling from mold-board. Do *not* shoot too fast. This picture should give some sense of the motion of the dirt coming off the mold board." Other cinematic effects include: "Threshing operations—Closeup of grain pouring from chute. . . . Rain (hard to get pix which really 'show rain') . . . 1. Window pane in hard rain. Water running down glass in side of car. . . . Wind (really depends on movie technique)."[23]

At a certain point, Stryker evidently trusted Vachon sufficiently to let him operate on his own, without a script. Occasionally, however, Stryker's failure to supply specific directions would leave the photographer floundering in the field without a sense of what was wanted, and from time to time, in the letters, we find Vachon feeling dry, without ideas, pressuring himself to come up with fresh subjects, fresh angles, begging his wife to feed him possibilities. If few of the particular images Stryker sought appear in the Vachon files, it is no wonder: being in the field required moment-to-moment decisions as well as a sense of what to look for, and the materials presenting themselves in reality might be quite different from what armchair director Stryker imagined in the home office.

In 1960, looking back on the FSA years, Vachon went so far as to deny, in a general way, the existence of Stryker's scripts, remembering instead that he had felt very much on his own. Having been "steered" by Stryker in a certain direction, Vachon at some juncture would feel, in the face of the vast reality before him, a kind of existential moment: "one becomes keenly alive to the seeking of picture material. It becomes part of your existence to make a visual report on a particular place or environment." The turning point, in his own memory, was Omaha (most likely during a 1938 trip), where, he wrote in later years, "I realized that I had developed my own style of seeing with a camera. I mean that I would photograph only what pleased and astonished my eye, and only the way I saw it."[24] Along these lines, it is the camera's ability to "seize the brief evanescent moment" that seemed to him—in a 1949 review of the year's *U.S. Camera Annual*—"to fulfill photography's best function." The work he admired apprehends "the reality of an instant

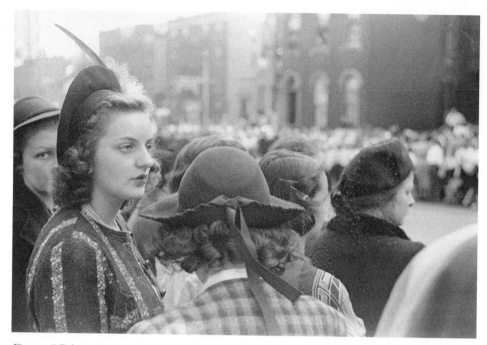

Figure 1. "Girls watching the parade, Cincinnati, Ohio, October 1938." (Library of Congress)

and there it is—in early morning fog, or late afternoon sun, deep shade, light coming in through a window. I find these pictures immediately arresting. They don't make me think of flashbulbs, or focal lengths of lenses, or any other photographic apparatus. They give an actual sense of being in a place, a mood, a moment which lasted long enough to be recorded."[25]

Vachon's best photographs embody this stylistic ideal. They gave him, too, the most satisfaction. Among them are the street photographs he took in Cincinnati during a parade in 1938, when he focused his Leica on the spectators (Fig. 1): "Really got some good material. I dont [*sic*] know what it is worth to John Citizen who is paying for it, but it pleases me, and was a great deal of fun." He added, guiltily, "Our organization really should be part of the WPA art project. That is my only trouble these days, getting an untroubled and respectable consciounce [*sic*] about what I'm doing. The parade was the nuts."[26] Vachon may have been influenced by Evans's street photographs—especially his New York shots of the late twenties that were printed in *American Photographs*—although Evans's book appeared in the fall of 1938 and it is doubtful that Vachon had seen it at this time. Possibly a few of Evans's FSA street photographs—the American Legion parade—influenced him. But Vachon's work has a greater spontaneity and fluidity of composition, looking forward to Robert Frank's photographs of almost twenty years later.

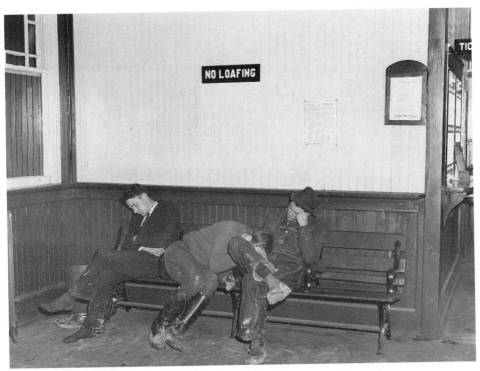

Figure 2. "Boys from other places who have come to work at the Hercules power plant, Radford, Virginia, December 1940. They have been unable to find a room so they are spending their first night in town in the railroad station." (Library of Congress)

Yet the general sense of what was wanted by Washington inevitably, and profoundly, influenced Vachon's work, giving him a frame of vision with which to encounter the world. It allowed him to observe patterns as well as "facts," to explore aesthetic angles and textures, to play with point of view; to view the everyday, the gesture, the details of daily life that might otherwise have escaped observation; to observe relationships and behaviors in public places that would normally compel one to avert the gaze (Fig. 2). The FSA file was, as Vachon understood it, an omnivorous encyclopedia, hungry for images of America in its totality; it was the visual equivalent of the great naturalist novel, engrossing the whole of life with its descriptive capacity.

Vachon understood there to be, in fact, two purposes of the FSA project: "first, to get the pictures of FSA projects that would be used to legitimate the agency's existence and promote the New Deal; second, to create an archive that would in a far broader way represent life in America and in the process allow the photographer his own expression."[27] That broader representation of life centered to a large extent on the small town (Fig. 3). There are, to be sure, many urban images in the FSA file, and Vachon, for one, enjoyed immensely his opportunities to photograph in Pittsburgh, Chicago, St. Louis, Minneapolis and St. Paul, Detroit, and so forth.

Figure 3. "Shady side of Main Street, Elkins, West Virginia, June 1939." (Library of Congress)

(Indeed, a fascinating memorandum in the Stryker Papers argues strongly for making the city a major focus of FSA efforts, inspired by Berenice Abbott's successful *Changing New York* exhibition and book.)[28] But the ideological center of the FSA was more logically, and more continuously, the small town, described in a publicity release as "the cross-roads where the land meets the city, where the farm meets commerce and industry. It is the contact point where men of the land keep in touch with a civilization based on mass-produced, city-made gadgets, machines, canned movies and canned beef." Photographers were to carry the Small Town script with them—in their heads, in fact—as a perennial assignment. They should be on the lookout for stores along Main Street, cars and trucks, menus in windows, ice-cream parlors, the church, people on the street, and—a reflection of prewar gendering—"Men loafing and talking. Women waiting for the men, coming out of stores, window shopping, tending children." Photographers were to be alert to similarities among the towns, indicative of a "national" character, but also to the obvious "regional differences" that would be visible in living standards, crops, clothing, folkways, and the like.[29]

Conceived thus, the small town was clearly a crux of the FSA, a microcosm of the national portrait that the photographers were creating.[30] But in describing the small town as the meeting place for an agricultural and an industrial, mass-

produced economy, Stryker also encompassed the historical moment of the 1930s, when the United States, along with an intractable depression, suffered a movement toward modernity. For Stryker personally, the small town meant something else, a nostalgic symbol of a simpler America—the *"not modern,"* as Terry Smith calls it—an anchor of social and moral tradition amid the churning bureaucracies of Washington. Walker Evans's 1935–36 images of southern small towns first brought out this response in Stryker, and it is something Vachon responded to as well in Evans's work. For Vachon, it may also have connected with his father's life on the road, with its vagaries and adventures, traveling from town to town, which excited the young Vachon and created a pattern for him to follow. On one such trip with his father, Vachon recalled, he experienced the joy of exploring each town "in constant astonishment. I would walk up and down the main street and through the residential streets, investing each store and house with a personality."[31]

If the small town was thus a kind of center, a microcosm of American life, as the FSA conceived it, around that center were the vast historical changes external to it yet indirectly influencing it. Visually, Vachon expresses this sense of change through pictorial contrast—older buildings being torn down to make way for newer ones in cities, for example, or the contrast between a Victorian church and a modern telegraph pole, with its multidirectional wires (Fig 4). Berenice Abbott's *Changing New York*—with its pervasive sense of paradox, expressed through the visual contrast between old and new—may have been an influence as well.

Beyond the core of the small town, Vachon's photographs followed the broad themes of the FSA-OWI during the years 1937–43: from the economic dislocation

Figure 5. "Miner's sons salvaging coal during a strike, Kempton, West Virginia, May 1939." (Library of Congress)

and high unemployment of the earlier period, when the Resettlement Administration was helping its clients in a range of services—food, housing, agricultural practices—and extending through the years of prewar mobilization and wartime itself, when the country was geared, with a single mind and energy, toward the war effort. In general, Vachon's images, along with those of his FSA colleagues, record a nation's shift from the hardships of depression to the energetic mobilization for war. Portraits of the unemployed give way to portraits of workers. Images of slums and poverty are succeeded by images of industrial production on a colossal scale (Figs. 5 and 6).[32] Cutting across these themes, one can see from Vachon's earliest photographs two complementary stylistic tendencies in his work: first, a formalistic vision, evident in the careful framing and composition of his landscapes, architectural photographs, and industrial images; and second, an ability to portray the psychology of everyday life and the character of his subjects through the gestures and expressions of his portraits—individual, group, candid, and posed (Fig. 7).

Vachon, like all of the FSA photographers, was working for the government, but what exactly did that mean? And what did it not mean? At the most mundane level, it did not mean, in the late thirties and early forties, an adequate expense account and decent equipment. Worrying about the day-to-day expenses of his field trips was a constant in Vachon's life on the road: was the hotel too expensive? what could he spend for meals? could he afford to indulge his vices (movies, a drink in a

*Figure 6. "Ramp boats under construction at
the Higgins shipyards, New Orleans, June 1943."
(Library of Congress)*

public place)? After several trips by train, bus, and hitching rides (with needed equipment) into the midwestern countryside for his various appointments, Vachon was forced to buy a car, which meant he then had to worry about the constant expenses (his expenses) for repairs, for batteries, for tires. Tires, especially, became an obsession for the traveling photographer during the war years, when rubber was strictly rationed. Telegrams went back and forth, documents were solicited, political influence was exerted, but to little avail: at best, he rated retreads. Equally annoying was the constant need for fresh supplies—film, flash bulbs—to be sent from Washington to meet him along the way. More than once, Vachon squeaked by on a loan from his mother.[33]

If working for the government meant anything, surely it must have meant having the authority to photograph subjects relating to government programs, but the process was more complex than one might suppose. Meetings with local officials had to be arranged, but then these officials might prove helpful, unhelpful, or too helpful in arranging subjects for the Washington photographer. The latter was a problem if the local official had in mind exactly what should be represented, resulting in images that were boring by Vachon's standards. More than once, he complained to his wife that he could not adequately concentrate on his work—with its requirement of a certain spontaneity and creative response to the situation—because of the need to conform to his host's implicit agenda. Vachon's photographs of agency officials—whether agricultural or social workers—betray the uneasiness of the new role of government during the New Deal: subjects who might appear autonomous and self-sufficient in one picture, appear cowering and

Figure 7. "Rainy day, Indianapolis, January 1942." (Library of Congress)

subservient in another, as they pay attention, dutifully, to the local official who is empowered to "help" them (Fig. 8). More than other FSA photographers, Vachon captured this unease, perhaps a reflection of his own ambivalence toward government authority and toward his own role as a "representative" of that authority.

A rather different problem arose during the war years, when Vachon was attempting to document the industrial machine. Though armed with the appropriate letters from Washington government agencies and boards, Vachon still found it difficult, sometimes impossible, to break through the shield of protection and secrecy surrounding the war industries. The mere presence of a camera was enough to get him arrested on several occasions. Even when he sought advance permission from the local chief of police—to photograph railroad sites, for example—he might have to check with local FBI officials as well. Resistance might come from the particular company itself if it did not want pictures of its manufacturing or handling processes to fall into the hands of the competition. What, after all, was the public interest in the face of private interests?

It is important to remember that the FSA-OWI project did not serve as an indirect arm of corporate America, nor, for that matter, was it operating hand in glove with the larger functions of government.[34] It was an independent entity, negotiating its position and its strategies amid a welter of friendly and hostile government agencies. Indeed, if various congressional forces had had their way, the file itself might well have been destroyed when the FSA-OWI was shut down in 1943; Stryker

Figure 8. "Nat Williamson and E. H. Anderson, an FSA *representative, Guilford County, North Carolina, April 1938. Mr. Williamson was the first Negro in the United States to receive a loan under the tenant purchase program." (Library of Congress)*

managed to pull strings of his own to get the file deposited safely in the Library of Congress.[35] Yet the paradoxes implicit within the Farm Security Administration and in its status as a government agency that frequently fought for survival may arguably have given the photographers in the field a beneficial sense of alienation, an edginess, that translated, at best, into resolutely individualistic visions.

Beyond the ambiguities of the FSA as a whole were the ambivalences of its photographers. Vachon grew self-conscious about performing his job in the face of remarks by some West Virginia locals that his government was "pretty silly." On the other hand, he could be fired up by a sense of competition with the other FSA photographers, as when he heard, in 1942, that John Collier's pictures were being admired "in our little salon group, etc. In fact it fills me up with wanting to go out and photograph with an intensity." Sometimes, as demonstrated in this letter from North Dakota, the sense of confusion and loss of purpose was debilitating: "I'm amazed at the masses of exposed film I keep piling up, always knowing that I haven't been getting anything good. I'm completely losing sight of objectives— don't know why in hell I'm out here. I always get good ideas at night, new ways to go about executing them, and during the day everything flops and fizzles."[36] In

Vachon's case, at least, this ambivalence increased as his employment stretched into the difficult war years. More than once he found himself questioned by the local population: why was a seemingly healthy young man loitering about with a camera while the country was fighting a war?[37] Vachon wondered himself; privileged by his family exemption and his OWI status, he felt guilty and outside of the stream of history. During the later years, the feeling that he was out of touch with Washington, especially with Stryker, grew. In letters to his wife he complains of the vagueness of Stryker's directions and responses to his work; he has a sense that the entire FSA operation has reached a point of uselessness.

On assignment in Lincoln, Nebraska, Vachon steps back and begins to perceive a profound change in America as a whole that emphasizes his feelings of alienation. He has been asked to photograph a graduation class, and he scurries about—it is the end of the semester and commencement is only days away—to find his subjects. The sample he winds up with—assisted by college administrators—is diverse; Vachon can appreciate some of the students but not others, try as he might. It is the latter that are most interesting, in some ways, for Vachon seems uncannily able to read the postwar America in his subjects, an America that is smug and aloof from "the honest to god world" that Vachon—by now well traveled—has seen about him. His bleakest prognosis is read in a young man described as,

> essentially, the industrialist. He comes I gather from a banker family, in Sioux Falls. That is his fence side. He will, eventually, aside from the war, end up as chief of personnel for the Nebraska Power Co. or something like that. What I most feel is that he is the kind of guy I would like to like, a lot, but cant. Must actually stay away from. And that makes me sad. Really sad. Because he is so many of the finest young men in the country, the smart boys, the college boys, the boys who will have the chance to run things. And it looks no good for the future when you see their complacency, their willingness, for instance, to leave the Negro situation as it is. Nothing about that moves them at all. They are part of the backward pullers, they want to be status quo ers. They want to be associated with the 'men who made AMERICA.' "[38] (See Fig. 9.)

Vachon's employment with the Farm Security Administration ended in 1943, when Stryker left and the agency closed its doors. But Vachon had been heading restlessly in that direction for a while. His letters of that summer are filled with the sense that he will not be working for Stryker for long, that he wants to set his own agenda. A last trip up the Mississippi Delta brings out his strong desire to make a final, productive effort: "I want to do my last fling, really work good and hard, thoughtful, get pictures of towns, riverboats, industries, do my very damn best at making a fine set of pictures." As he left the agency in the early fall, Vachon was in the midst of a personal crisis brought on by deteriorating relations with Penny and

Figure 9. "A one-room schoolhouse, St. Marys County, Maryland, September 1940." (Library of Congress)

his determination to hold things together. On September 8, 1943, he sends Penny an envelope containing a single sentence scrawled on a torn scrap of yellow note-paper: "A man can surely do what he wills to do, but he cannot determine what he wills." By October he is working for Standard Oil, but conditions have changed and his sense of freedom is professionally even more in jeopardy: "I cant [*sic*] feel that old freedom at all this trip. More than once today I had the camera poised to photograph a cemetery or an autumn treed street, and I put it away self con-sciously. Maybe you dont understand that, but its funny that way—there cant be any going around and photographing what I see under this set up. I keep thinking: they will want to know WHY I took this."[39] The FSA-OWI period, in retrospect, would begin to take on a special quality—despite the constraints, the confusions, the hardships in the field—as a time of creative freedom. Not surprisingly, Vachon worked for Standard Oil only for a few months, soon encountering an opportunity that was perfect for him then—the chance to photograph postwar Poland for the United Nations. After that came two decades of employment, and countless sto-ries, as one of *LOOK*'s chief photographers.

Though Vachon's career was, in a sense, continuous, from his early days as an FSA photographer to his long employment as an international photojournalist, he maintained a certain distance from it, regarding the whole turn of his life into

Figure 10. "News stand, Omaha, Nebraska, November 1938." (Library of Congress)

photography as something of an accident, if not an act of vexatious calculation. Stryker "made a photographer out of me," he told Richard Doud in 1964. Not that anyone could be shaped in this way, he admitted, but still, "I've always resented it."[40] Bound up with his sense that he had failed to achieve his true ambition—to become a writer—Vachon's misgivings were also the product of his insight into the machinery of modern civilization and his own part in it. The final entry in his journal—started in 1933, when he was nineteen, and maintained on and off until 1954—puts the matter with a startling degree of self-consciousness and ambivalence:

> Full breasted, average age girls walk enticingly on Madison Avenue, their lips sullen with lipstick. I, too, walk through the crowd with other men in grey suits, seeing the girls and considering my fortune. At the corner of Fifth Avenue and 51st Street I stand among the rich, towering monuments—the symbolic and the real centers and representations of the wealth and power of civilization. The money, the clothing, the religion, the ideas, and all forms of the desires and lusts as well as the comforts of the whole world are here, arranged for on this very spot. I am in the middle of it all, and I am moreover part of it. I contribute, through my work with the magazine, to the thinking and forming of values which spreads out from these stone buildings to the pliant acceptors of this false, refined civilization in all parts of the world. I am indeed in an envied

position. And though I say, truthfully, that I reject this civilization, and had rather been no part of it, and surely am so by chance and no wish of mine—I nevertheless rejoice in it, and pander to it, as I fly out in early morning airplanes to photograph a famous ballplayer in Evansville, Indiana, or to see a senator in Washington or Maine (May 4, 1954).

Clear-sighted to an extraordinary degree, Vachon's introspection here captures his sense of destiny, his good fortune, but also his sense of futility: having achieved the enviable status of his professional entitlement, he is simultaneously riven by existential angst. If Vachon's life imitates anyone's fiction, it is less his beloved Joyce than Dos Passos that we might hear in this passage—an awareness that his own existence is wrapped in the totality of modern civilization, its rhythms, its pleasures, its sights and sounds, its comforts (see Fig. 10). Yet deep within, not easily erased by the emoluments of big money, there is an abiding sense of detachment and alienation. If Vachon, during the FSA-OWI years, was taking the measure of a changing country, he was also taking the measure of himself and experiencing deeply the sense of complicity that seems, in his case at least, a part of the achievement of modernism.

NOTES

1. Untitled, undated MS, Vachon Collection. Vachon probably started working on April 27, 1936. He recorded in his journal for Friday, April 24: "Got a job today. Now isn't that the damnest thing? At last, unless something unlooked for looks in, I shall become a 'government employee.'"

2. The best discussions of FSA photography appear in Curtis, *Mind's Eye*; Guimond, *American Photography*; Hurley, *Portrait of a Decade*; Levine, "The Historian and the Icon"; Smith, *Making the Modern*; Stange, "'The Record Itself'"; Stott, *Documentary Expression*; Stryker and Wood, *In This Proud Land*; Tagg, "The Currency of the Photograph"; and Trachtenberg, "From Image to Story."

3. See, e.g., Brannan and Horvath, *Kentucky Album*; Carlebach and Provenzo, *Farm Security Administration*; Evans, *Photographs*; Hastings and Hastings, *Up in the Morning*; Heyman, *Lange*; Hurley, *Wolcott*; Reid, *Back Home Again* and *Picturing Minnesota*; Weigle, *Women of New Mexico*; and Newport Harbor Art Museum, *Just before the War*.

4. Several FSA photographers have written their autobiographies (Gordon Parks, Jack Delano); others, like Lange and Evans, have been the subject of biographies (Milton Meltzer, Belinda Rathbone).

5. Ann Vachon, *Poland*.

6. Kernan, "John Vachon," 71; Morgan, "John Vachon," 97.

7. For previously published selections of Vachon's photographs, see Levy, "Picturing Minnesota"; Orvell, "John Vachon"; Reid, *Back Home Again* and *Picturing Minnesota*; Brian Vachon, "John Vachon"; John Vachon, "Omaha"; Fleischhauer and Brannan, *Documenting America*. I am preparing an edition of Vachon's letters and photographs from the FSA-OWI years.

8. For biographical information, I have drawn on Vachon's letters and journals, in addition to published essays by Brian Vachon ("John Vachon") and Ann Vachon (Afterword in *Poland*). His letters, journals, notebooks, and manuscripts in the possession of the Vachon family will be transferred to the Prints and Photographs Division of the Library of Congress. All quotations from Vachon's unpublished writings are with the permission of Ann Vachon and Brian Vachon, to whom I am indebted for invaluable assistance.

9. Doud, Interview with Vachon, 4. On Vanderbilt's organization of the file, see Trachtenberg, "From Image to Story"; see also Hurley's (*Portrait of a Decade*, 186 n. 36) judgment, with which I agree, that Vanderbilt's system was of more immediate use in retrieving images than Vachon's, but that Vachon's would better meet the needs of the social historian in the long run.

10. Doud, Interview with Vachon.

11. On the centrality of documentary to twentieth-century culture, see Rabinowitz, *They Must Be Represented*, esp. chap. 4, "People's Culture, Popular Culture, Public Culture: Hollywood, Newsreels, and FSA Films and Photographs."

12. Lasswell, "The Photographer and the Focus of Attention." Vachon's conception develops more fully Stryker's initial notion of the FSA project: "I was thinking," Stryker recalled in a conversation some years later, "there was this little thing in the back of my mind, I was going to assemble a lot of stuff and some day it might be useful for the encyclopedia." To which Dorothea Lange rejoined: "The encyclopedia was the big thing then." "Conversation," 26. See also Smith (*Making the Modern*, 296) on the "inventory" as the "key figuring device of the moment."

13. John Vachon, "Minnesota," 24. The exact title of the volume is *A Map of the World of Knowledge*, by Sidney Morse (Baltimore: Arnold Co., 1925).

14. "Conversation," 35.

15. John Vachon, Journal, Vachon Collection.

16. Doud, Interview with Stryker, 5.

17. Singal (*Modernist Culture*, 14) identifies the legacy of William James to modernism as a sense of the complementarity of intellect and passion, with animals and human beings thus on a continuum. For Vachon, Joyce served as the catalyst for achieving a similar complementarity.

18. Another hearing of Gershwin evoked this Whitmanesque response: "Again, Gershwin's 'Rhapsody' crept obtrusively into my blood. It is so comprehensive, so mad, so rhythmic, brazen and blaring, nervous. It seizes me and tightens me and loosens me; it cannot be forgotten when it's got you; it cannot be forgotten." Journal, April 7, 1935, Vachon Collection.

19. John Vachon, "Tribute to a Man," 98.

20. Stryker observed that the first generation of photographers did not face the problems that the later ones did: "Russell [Lee] was the first one of the people who had to match himself up against a going concern, a block of material that was already in, and from that time on every new photographer had to face that problem that they were up against a tough problem there with pictures in the file they had to match, equal or better." "Conversation," 38

21. Vachon to Penny, October 24, 1942, Vachon Collection. Vachon's letters to his wife, Millicent—known as Penny—constitute a major source of information for the photographer's life on the road during the FSA years. The letters are undated, but I have used the postmark on the envelopes—preserved along with each letter—as a guide to their date of composition, since Vachon usually sent off his letters on the same day that he wrote them and mail pickup was often several times a day.

22. Vachon to Penny, October 12, 1938, March 2, October 5, 1942, ibid. In a letter to Stryker, Vachon writes: "Arthur really made quite a dent out here. All kinds of unexpected people ask about him—bell boys, etc. Little boys on the street say 'Arthur Rothstein carries 4 cameras. How many do you carry?' When I am introduced as 'from Rothstein's outfit' I command immediate respect." Vachon to Stryker, April 1940, Stryker Papers.

23. Stryker, "Random Notes" and "Field Notes."

24. Bennett, "John Vachon," n.p.; Vachon, "Tribute to a Man," 98.

25. Vachon, "U.S. Camera Annual," 22.

26. Vachon to Penny, October 11, 1938, Vachon Collection.

27. Doud, Interview with Vachon, 7. Vachon explained: "We'd make pictures designed to appear in the local newspaper or hopefully to get into some Department of Agriculture publication, and those were fairly dull pictures, but that was the chief reason for my traveling with him [a regional information chief] for two weeks. But during all these two weeks, of course, I photographed every-

thing I saw that would go good in the file and that meant, you know, farmers, and deserted houses, and small towns, and building fronts."

28. "The plan for photographing and writing about contemporary America, as a document for the future, is to restrict the first year's researches to about ten major American cities. . . . The documentary approach, no more than the artistic, concerns itself with the merely pretty, obvious or picturesque aspects of contemporary life. There is a reality superior to guidebook wisdom, an observation far more profound than the postcard view of the Empire State Building. It is the contrasts, the paradoxes, the anomalies, the illogicalities of life today which contain the most vital and interesting material for future historians to examine." "Plans for Work." Although Edwin Rosskam was very interested in photographing cities at this time (and had been launched on a short-lived publishing project to do so), "Plans for Work" was not written by him, according to his wife and collaborator, Louise Rosskam. Louise Rosskam to Beverly Brannan, April 25, 1998, private correspondence. The author remains unknown. My thanks to Beverly Brannan and Maren Stange for their speculations on this issue.

29. "The Farm Security Photographer Covers the American *Small Town*."

30. For an excellent discussion of the small-town ideal in the photography of Russell Lee, see Curtis, *Mind's Eye*, chap. 5.

31. Smith, *Making the Modern*, 311; Vachon, "Minnesota," 25.

32. Cf. Smith, *Making the Modern*, 301: "The stylistic point here (for the little it is worth) is that documentary photography is not opposed to modernism, nor is it only realist: it draws in both tendencies; their contrary connotations activate the imagery, not problematically but productively."

33. Cf. Lange in "Conversation," 47, on being on the road: "We were staying out too long, working too hard"—and she goes on with a list of complaints similar to Vachon's experience.

34. Although Smith's general observation—that the FSA acted as a surveillance instrument of the government and that local agents were invisible in their financial roles—may be true, Vachon's photographs frequently depict the marked difference in status between FSA agents and those being served by the agency. Smith, *Making the Modern*, 310.

35. Hurley, *Portrait of a Decade*, 170.

36. Vachon to Penny, June 20, 1939, March 18, February 24, 1942, Vachon Collection.

37. Vachon wrote his wife: "Tell Philip Brown his idea of carrying FSA pictures with one is invaluable. They make clear at once what I used to spend days trying to get across to people." Vachon to Penny, May 6, 1940, ibid.

38. Vachon to Penny, May 22, 1942, ibid.

39. Vachon to Penny, June 5, September 8, October 9, 1943, ibid.

40. Doud, Stryker interview, 16.

BIBLIOGRAPHY

Note: I use the term "Vachon Collection" below to indicate the largely unpublished materials, typescript and manuscript, that the Vachon family will be giving to the Library of Congress.

Bennett, Edna. "John Vachon: A Realist in Magazine Photography." *U.S. Camera*, December 1960.
Brannan, Beverly W., with David Horvath, ed. *A Kentucky Album*. Lexington: University of Kentucky, 1986.
Carlebach, Michael, and Eugene F. Provenzo Jr. *Farm Security Administration Photographs of Florida*. Gainesville: University Press of Florida, 1993.
"Conversation between Roy E. Stryker, Dorothea Lange, Arthur Rothstein, John Vachon." N.d. Transcript, Vachon Collection. 80 pp.
Curtis, James. *Mind's Eye, Mind's Truth: FSA Photography Reconsidered*. Philadelphia: Temple University Press, 1989.

Doud, Richard K. Interview with Roy E. Stryker, Montrose, Colorado, October 17, 1963. Transcript, Archives of American Art.

——. Interview with John Vachon, New York City, April 28, 1964. Transcript, Archives of American Art.

Evans, Walker. *Walker Evans: Photographs for the Farm Security Administration, 1935–1938*. New York: Da Capo, 1973.

"The Farm Security Photographer Covers the American *Small Town*" [publicity release]. Roy Stryker Papers, University of Louisville Photographic Archives, Louisville, Ky. Available on microfilm (Chadwyck-Healy Ltd.).

Fleischhauer, Carl, and Beverly W. Brannan, eds. *Documenting America, 1935–1943*. Berkeley: University of California Press, 1988.

Guimond, James. *American Photography and the American Dream*. Chapel Hill: University of North Carolina Press, 1991.

Hastings, Scott E., Jr., and Elsie R. Hastings. *Up in the Morning Early: Vermont Farm Families in the Thirties*. Hanover, N.H.: University Press of New England, 1992.

Heyman, Therese Thau. *Dorothea Lange: American Photographs*. San Francisco: San Francisco Museum of Modern Art and Chronicle Books, 1994.

Hurley, F. Jack. *Marion Post Wolcott: A Photographic Journey*. Albuquerque: University of New Mexico Press, 1989.

——. *Portrait of a Decade: Roy Stryker and the Development of Documentary Photography in the Thirties*. Baton Rouge: Louisiana State University Press, 1972.

Kernan, Sean. "John Vachon—Profile of a Magazine Photographer." *Camera 3*, December 1971.

Lasswell, Harold. "The Photographer and the Focus of Attention." Roy Stryker Papers, University of Louisville Photographic Archives, Louisville, Ky. Available on microfilm (Chadwyck-Healy Ltd.).

Levine, Lawrence W. "The Historian and the Icon: Photography and the History of the American People in the 1930s and 1940s." In Carl Fleischhauer and Beverly W. Brannan, eds., *Documenting America, 1935–1943*, 15–42. Berkeley: University of California Press, 1988.

Levy, Paul. "Picturing Minnesota: John Vachon and the Photographers Who Searched for the Heart of America 50 Years Ago." *Minneapolis Star Tribune Sunday Magazine*, November 26, 1989, 6–11.

Morgan, Thomas B. "John Vachon: A Certain Look." *American Heritage*, February 1989, 96–109.

Newport Harbor Art Museum, Balboa, Calif. *Just before the War: Urban America from 1935 to 1941 as Seen by Photographers of the Farm Security Administration*. New York: October House, 1968.

Orvell, Miles. "John Vachon: On the Road in Iowa" [letters and photographs]. *DoubleTake* (Winter 1997): 102–13.

"Plans for Work: Plan to Document the Portrait of Contemporary Americans." Roy Stryker Papers, University of Louisville Photographic Archives, Louisville, Ky. Available on microfilm (Chadwyck-Healy Ltd.).

Rabinowitz, Paula. *They Must Be Represented: The Politics of Documentary*. London: Verso, 1994.

Reid, Robert L., ed. *Back Home Again: Indiana in the Farm Security Administration Photographs, 1935–1943*. Bloomington: Indiana University Press, 1987.

——. *Picturing Minnesota, 1936–1943: Photographs from the Farm Security Administration*. St. Paul: Minnesota Historical Society Press, 1989.

Singal, Daniel Joseph. *Modernist Culture in America*. Belmont, Calif.: Wadsworth, 1991.

Smith, Terry. *Making the Modern: Industry, Art, and Design in America*. Chicago: Chicago University Press, 1993.

Stange, Maren. "'The Record Itself': Farm Security Administration Photography and the Transformation of Rural Life." In Pete Daniel, Merry A. Foresta, Maren Stange, and Sally Stein, eds. *Official Images: New Deal Photography*, 66–71. Washington, D.C.: Smithsonian, 1987.

——. *Symbols of Ideal Life: Social Documentary Photography in America, 1890–1950*. New York: Cambridge University Press, 1989.

Stott, William. *Documentary Expression and Thirties America*. New York: Oxford University Press, 1973.

Stryker, Roy. "Field Notes for John Vachon" [shooting script]. N.d., Stryker Papers.

——. "For Vachon Trip to Iowa" [shooting script]. April 1940. Stryker Papers.

——. "Ideas for Pictures" [shooting script]. N.d. Stryker Papers.

——. "Outline of Possible Photographic Work in Minnesota and Wisconsin" [shooting script]. 1940. Stryker Papers.

——. Papers. University of Louisville Photographic Archives, Louisville, Ky. Available on microfilm (Chadwyck-Healy Ltd.).

——. "Pictures Needed for File" [shooting script]. N.d. Stryker Papers.

——. "Random Notes in Iowa for John Vachon" [shooting script]. April 13, 1940. Stryker Papers.

——. "Suggestions for Community Photographs" [shooting script]. N.d. Stryker Papers.

——. "Suggestions for Photographs" [shooting script]. N.d. Stryker Papers.

Stryker, Roy Emerson, and Nancy Wood. *In This Proud Land: America, 1935–1943, as Seen in the FSA Photographs*. New York City: Galahad, 1973.

Tagg, John. "The Currency of the Photograph." In Victor Burgin, ed., *Thinking Photography*, 110–41. London: Macmillan, 1982.

Trachtenberg, Alan. "From Image to Story: Reading the File." In Carl Fleischhauer and Beverly W. Brannan, eds. *Documenting America, 1935–1943*, 43–73. Berkeley: University of California Press, 1988.

Vachon, Ann, ed. *Poland, 1946: The Photographs and Letters of John Vachon*. Afterword by Ann Vachon. Washington, D.C.: Smithsonian, 1995.

Vachon, Brian. "Assignment: Chicago." *Chicago Tribune Magazine*, February 1991, 10–15.

——. "John Vachon: A Remembrance." *American Photographer*, October 1979.

Vachon, John. Journal. Transcribed typescript. 448 pp. Vachon Collection.

——. Letters. Vachon Collection.

——. "Minnesota: Beyond the Cities." *Earth Journal* (Minnesota Geographic Society) 3, no. 6 (1973): 22–27.

——. "Omaha." In Carl Fleischhauer and Beverly W. Brannan, eds., *Documenting America, 1935–1943*, 90–113. Berkeley: University of California Press, 1988.

——. "Standards of the Documentary File." Roy Stryker Papers. University of Louisville Photographic Archives. Louisville, Ky. Available on microfilm (Chadwyck-Healy Ltd.).

——. "Tribute to a Man, an Era, an Art" [commentary]. *Harper's Magazine*, September 1973, 96–99.

——. "U.S. Camera Annual 1949" [review]. *Photo Notes*, Spring 1949, 21–22

——. "Minnesota: Beyond the Cities." *Earth Journal* 3, no. 6 (1973): 25.

Weigle, Marta, ed. *Women of New Mexico: Depression Era Images*. Santa Fe: Ancient City Press, 1993.

LUCY FISCHER

··

The Savage Eye

Edward Hopper and the Cinema

*The first thing we . . . notice is the highly developed, differentiated and dynamic new
landscape in which modern experience takes place. This is a landscape of steam
engines, automatic factories, railroads, vast new industrial zones; of teeming cities that
have grown overnight, often with dreadful human consequences; of daily newspapers,
telegraphs, telephones and other mass media, communicating on an ever wider
scale . . . [one] capable of every thing except solidity and stability. The great
modernists . . . all attack this environment passionately, and strive to tear it down
or explode it from within; yet all find themselves remarkably at home in it.
—Marshall Berman,* All That Is Solid Melts into Air, *18–19*

I n this quotation Marshall Berman is discussing the milieu of nine-
teenth-century modernity and the ambivalent response of artists to
it, but he could well be describing the world contained in the can-
vasses of Edward Hopper, a painter of a later generation. For
clearly Hopper's pictures delineate the contemporary commercial, industrial, and
urban worlds while suggesting a sense of their "dreadful human consequences."
Yet they simultaneously invoke the universe of the mass media—an aspect of
modernity also referenced by Berman. Not only does Hopper's imagery occasion-
ally depict telephones, newspapers, or telephone lines, it also is conceived in the
shadow of the movies—the quintessential mass medium of the painter's age.

Significantly, Berman notes that, although most modern artists rail against a loss
of tradition, they also embrace the new and, through creation, fashion a place for
themselves within it. As he says, modernism is "any attempt by modern men and
women to become subjects as well as objects of modernization, to get a grip on the
modern world and make themselves at home in it."[1]

For Edward Hopper, the film medium functioned in this adaptive manner. A
paradigmatic emblem of modernity, it allowed him access to modernity—all at a
safe distance. Perhaps we might conceive of Hopper as a technological flaneur
who, like Charles Baudelaire's figure of the nineteenth century, was able, through a
cinematic venue, "to be away from home and yet to feel [him]self everywhere at

home; to see the world, to be at the centre of the world, and yet to remain hidden from the world."[2]

"When I don't feel in the mood for painting I go to the movies for a week or more. I go on a regular movie binge."[3]

It comes as no surprise that there are links between the work of Edward Hopper and the cinema. He told us so himself: when he lacked motivation to paint, he went to the movies. Yet despite his apparent enthusiasm for the silver screen, Hopper's testimony casts the cinema in rather questionable terms. It is the kind of activity one engages in by default when not in the mood for something else. Hopper also, rather conventionally, positions film as a low-culture "escape" from the serious task of art making—like the realm of commercial illustration to which he often fled to earn a living. (Significantly, as part of that mercantile project, he was sometimes paid to watch silent films in order to illustrate movie posters.)[4] Finally, Hopper's words reveal a rather traditional view of the cinema as a seductive and addictive medium—a guilty pleasure in which one indulges—that encourages excess (or "binges") in its enthusiasts. But another reading of his statement proposes itself "against the grain:" when faced with a dry spell in aesthetic inspiration, the cinema constituted, for him, an iconic oasis. From the diaries and notebooks of his wife Jo, we know some specific films that he saw, including *Keys of the Kingdom*, *A Tree Grows in Brooklyn*, *Picture of Dorian Gray*, *The Heiress*, *The Third Man*, *Orpheus*, *The Fallen Idol*, *Come Back Little Sheba*, *Rebel without a Cause*, *Mister Roberts*, *Les Diaboliques*, *Bus Stop*, *Moby Dick*, *Twelve Angry Men*, and *Mon Oncle*.[5]

Many artists have indeed recognized and drawn on associations between Hopper's canvasses and the film screen: Herbert Ross, in *Pennies from Heaven*, stages a diner scene that revisits the terrain of *Nighthawks* (1942). And in *Boulevard of Broken Dreams*, Austrian artist Gottfried Helnwein imagines James Dean, Elvis Presley, Humphrey Bogart, and Marilyn Monroe populating *Nighthawks*'s lunch counter.[6] But these homages gesture only toward the most obvious aspect of Hopper's affiliation with the movies: his attraction to the Hollywood "B" picture, with its jaded characters and its bleak urban mise-en-scène. Significantly, however, on the few occasions that Hopper remarked about the cinema more *concretely*, he spoke of experimental film and not the quotidian genre product: works like *The Savage Eye* and *Breathless*, both made in 1959.[7] This discrepancy (between assumed and stated Hopper influences) should alert us to the fact that there is yet much to discover in the nexus of Hopper and the cinema—connections that lurk beneath the apparently legible surface. What J. A. Ward has said of the aesthetic response to Hopper's art applies equally well to the critical confrontation: "In [his] work . . . [the observer] begins in clarity but [this] . . . leads immediately into . . . bewilderment. From there he is led to other uncertainties."[8] In the name of "begins in clarity," we

Figure 1. Douglas Sirk, Imitation of Life. *Frame enlargement.*

must first address the established critical field and rehearse the arguments that have been made about Hopper's relation to the cinema.

"Hopper's penchant for presenting dramatic encounters may have evolved from his love of theater and movies."[9]

Perhaps the most common affinity noted between Hopper's oeuvre and the cinema is the artist's bent for creating "dramatic" situations within his canvasses—what Gail Levin calls an "aura of eerie expectation" or a sense of a world "pregnant with possibility." She is not the only critic to proffer this insight. As Alfred Kazin tells us, "Hopper's pictures have often been compared to stages: Something is about to happen." Attendant to this notion of theatrics is the claim that Hopper's paintings arouse spectator "curiosity," especially through the strategic use of ellipsis. In the words of Robert Hobbs, "Hopper's works depend on . . . the missing part of a narrative." However, like the inscrutable word "Rosebud" that echoes through *Citizen Kane*, the enigmas of Hopper's canvasses are fundamentally insoluble. Hobbs admits that "there are never enough clues to provide a definitive narrative." In characterizing Hopper's anxious mise-en-scène, Hobbs grasps for film terminology: "In his art Hopper stops the narrative that constitutes . . . the montage of a movie to focus on strangely isolated stills. Seen by themselves these stills are mysterious and haunting. They evoke a desire for the rest of the narrative." Such a

Figure 2. Edward Hopper, Night Windows, *1928.*
(The Museum of Modern Art, New York, Gift of John Hay Whitney)

cryptic atmosphere informs Hopper's *Office at Night* (1940), which depicts a secre-
tary standing at a file cabinet behind the desk of her male boss. The nighttime
setting, her glance at the man, her curvaceous body all suggest some erotic episode.
This scene is remarkably similar to one in Douglas Sirk's *Imitation of Life* in which an
actress (Lana Turner) is called one evening to the office of an agent (Robert Alda)
and offered career opportunities in exchange for sexual favors (Fig. 1).[10]

The other commonly cited parallel between Hopper's work and the cinema is
their shared sense of *voyeurism*. Ward uses the terms "prying" and "spying" to
suggest the artist's stance and emphasizes the illicit vision (of "other people's secret
lives") that infuses his canvasses: "[Hopper] is looking at scenes that he is not
intended to see. The self-absorbed figures do not know of his presence; otherwise
they would be embarrassed, startled, or otherwise uncomfortable."[11] Such scopo-
philia is most apparent in the myriad works that position the viewer as gazing
through windows: at the maid in *Apartment Houses* (1923), the clerks in *Office in a
Small City* (1953) or *New York Office* (1962), the couple in *Room in New York* (1932),
the scantily clad woman in *Night Windows* (1928) (Fig. 2), the women at windows in

House at Dusk (1935) or *Cape Cod Morning* (1950), the restaurant patrons in *Night-hawks* (1942). But just as frequently, the situation is reversed. Hopper positions the viewer inside a room spying on someone who looks out a window him- or herself. Such is the arrangement in *Morning Sun* (1952), *Morning in a City* (1944), and *Eleven A.M.* (1926), in which naked or partially dressed women peer out windows as we gaze at them. In other paintings with a voyeuristic cast—like *Hotel Room* (1931), in which a woman in lingerie reads on a bed—the window is in the background, outside the visual field of the "protagonist." Hopper's equation of architectural detail and organ of sight has been noted by Ward, who states that: "In some of Hopper's most frightening paintings, windows become eyes, especially when they appear to be looking into other windows."[12]

For film scholar Carol Clover, women have a particular cultural and generic association with doors and windows. As she notes, "Certainly the portals of occult horror are almost invariably women." Though Hopper's mise-en-scène is relentlessly ordinary and almost hyper-real, it is invested with a sense of the uncanny. Like Clover, Ward links this ambience to the female figure: "In the four paintings of solitary women before windows facing other windows, there is the suggestion of terror."[13]

As film theorists have established, cinema is the voyeuristic medium par excellence, with the camera standing in for the spectator's eyes—most often presumed to be male.[14] Hence, in the film program accompanying the Whitney Museum's 1995 exhibit of Hopper's work (*Edward Hopper and the American Imagination*), Robert Ray wisely programmed Alfred Hitchcock's *Rear Window*—a movie in which a photographer (James Stewart) who is incapacitated by a broken leg spends his convalescence looking at events that transpire in windows glimpsed across an urban courtyard (Fig. 3). In one window, a woman is repeatedly seen dressing and undressing—an activity that fills him with untoward pleasure. Viewed in conjunction with the Hopper exhibit, this film suggests that the windows in Hopper's canvasses tend to function like ersatz movie screens, offering people fantasy vistas. Interestingly, one critic has noted that the windows in Hopper's *Early Sunday Morning* (1930) look like frames of celluloid.[15]

The window/screen metaphor holds not only for the paintings of buildings but also for those of railroad cars, as in *Chair Car* (1965) and *Compartment C, Car 293* (1938) (Plate 22). The windows of these conveyances provide people with continuous, mobile panoramas (like cinematic tracking shots) be the individuals attentive to them or not. Commenting on the parallels between railroad and photographic vision, Suren Lalvani notes: "[T]he perception that is organized by railroad travel which 'no longer belongs to the same space as the perceived objects,' is the same kind of seeing exhibited by photography. Both photography and the railroad journey mediate discursively and technically between observer/traveller and land-

Figure 3. James Stewart in Alfred Hitchcock's Rear Window. *(Courtesy of Turner Entertainment and Film Stills Archive, The Museum of Modern Art, New York)*

scape, providing for a passive spectator who is privy to a world made more visible and whose subjectivity is premised on the collection of views." Speaking of Hopper's work, Hobbs remarks on the conjunction of the artist's interest in the cinematic and the touristic gaze. As Hobbs reflects, "Hopper transformed the sweeping glance of late nineteenth-century dandies who strolled along the recently formed grand boulevards of Paris to the strangely suspended gaze of motorists and moviegoers." Significantly, Hopper once observed that you only "know how beautiful things are when you're traveling."[16]

One might say, in fact, that another quality that links Hopper's paintings to the cinema is their shared obsession with *spectatorship* of one variety or another: be it that of the man who peers out a window in *Hotel by a Railroad* (1952), that of the woman who gazes out the lobby in *Hotel Window* (1956), or that of the resort guests apparently staring at nothing in *People in the Sun* (1960).

This fascination with viewership is taken to its heights in the paintings where Hopper, quite literally, depicts patrons of the theater who await some dramatic or cinematic performance, a distinction that is often not entirely clear. This subject had proposed itself to him early on. In 1919 he was commissioned by the Methodist magazine *World Outlook* to depict a movie house interior, captioned "Movies

give cheap, democratic amusement," a space that the group wished to propose as an alternative to the saloon.[17] Then, in 1928, he executed a drypoint sketch entitled *The Balcony* (or *The Movie*), which depicts two women peering down (ostensibly toward the screen) from seats positioned on a steep incline.

In certain cases the implied view of Hopper's spectators is decidedly voyeuristic: in *Girlie Show* (1941), a stripper struts across the stage as some male orchestra members stand in the pit. But often the spectatorship portrayed has a far more neutral cast. In *Intermission* (1963), a woman sits (as do those in *The Balcony*) facing a stage devoid of action; significantly, her chair resembles a railroad seat. In *First Row Orchestra* (1951), members of the audience wait near the drawn proscenium curtain, and in *The Sheridan Theater* (1937), a patron glances over the balcony of a second-story lobby. In all cases, the performance is either out of the frame or not yet in progress.

But, obviously, the most suggestive picture from a cinematic perspective is the famous *New York Movie* (1939), which, like *The Balcony*, places us directly within the space of a picture palace (Plate 23). In this painting, the projection has already begun and some anonymous black-and-white movie is on the screen, but our attention is riveted on a female usher who stands pensively beyond the audience in a lighted exit area of the auditorium. In her hand she holds a flashlight, an object that reminds us of Andre Bazin's claim that the cinema is like "the little flashlight of the usher, moving like an uncertain comet across the night of our waking dream."[18]

In the catalog for the 1995 Whitney exhibition, writer Leonard Michaels mentions his long-standing fascination with this painting, comparing his response to it with that of a male character in the Otto Preminger film *Laura* who falls in love with the portrait of a woman he has never met. Michaels also speaks of feeling "as if he were *at* a movie, when looking at *New York Movie*" (italics added) and goes on to imagine the life and consciousness of the usherette: "Around midnight, when the last movie ends, she would take off the uniform, put on a black cocktail dress, and not have to think about what shoes to wear. She had a date."[19] His act of narrativization reminds us that, in their notes on his paintings, Hopper and Jo (a former actress) referred to the depicted figures by fictional names. For Michaels, Hopper's "New York movie theater is the eye of darkness."[20]

In configuring the artist's interest in spectatorship, one is reminded of Walker Percy's novel *The Moviegoer*, which concerns Binx Bolling, a bland, Hopperesque protagonist, oddly distanced from the life he leads: "My apartment is impersonal as a motel room. I have been careful not to accumulate possessions. My library is a single book, Arabia Deserta. The television set looks as if it took coins. On the wall over the bed hang two Currier and Ives prints of ice-skaters in Central Park. How sad the little figures seem. . . . How sad the city seems!"[21] Binx's comments on the artwork in his room might well apply to canvasses by Hopper, as might the title of Binx's book, with its allusions to *The Wasteland*.

Significantly, an important item in Binx's apartment is a television, at which he often sits "directly in front . . . bolt upright and hands on knees in [a] ladder-back chair." Like Hopper, Binx is an avid cinephile who finds the screen world more compelling than the real: "In the evenings I usually watch television or go to the movies. . . . Our neighborhood theater . . . has permanent lettering on the front of the marquee reading: Where Happiness Costs So Little. The fact is I am quite happy in a movie, even a bad movie."[22]

Beyond issues of spectatorship, or parallels between windows and movie screens, critics have surfaced other elements (of a formal nature) that link Hopper's work to the photographic media. Levin uses the term "cropping" to describe Hopper's assertively truncated framing and composition. Ward states that the rooms Hopper depicts often "seem as pointlessly cut off by the edges of paintings as in the work of the poorest photographer."[23] While acknowledging the influence of photography on his own painting (and his particular love of the work of Eugene Atget), Hopper also remarks on the differences between the two arts. He feels that photographic images do not "have enough weight" and apparently tries to counter their Unbearable Lightness of Being through painting. Finally, he notes how "The camera sees things from a different angle, not like the eye."[24]

"It seemed awfully crude and raw here [in America] when I got back. It took me ten years to get over Europe."[25]

It is not simply the formal and theoretical parallels between Hopper's work and the cinema (his focus on viewership, his use of the theater/life metaphor, his screenlike windows) that lead critics to make such aesthetic comparisons. Rather, it is the very *content* of his work: his adamant attention to the image of the popular American landscape—the cultural domain of the movies. In Hopper's vision, this is frequently a desolate, urban terrain: tawdry and ugly, inhabited by disaffected, unattractive individuals whom Ward describes as "alien survivors, as stationary and expressionless as mannequins."[26] If filmmakers of the 1920s had celebrated the vital metropolitan world in city symphonies (*Berlin: Symphony of a Great City* by Walter Ruttman, *Man with a Movie Camera* by Dziga Vertov), perhaps Hopper offers us a city dirge. His rejection of saccharine visions of his America (his insistence on the "crude" and the "raw") is articulated in his praise for *Scribner's* 1927 publication of Ernest Hemingway's story, "The Killers" (a work, significantly, adapted for the cinema in 1946). In a letter to the magazine, Hopper writes: "I want to compliment you for printing Ernest Hemingway's 'The Killers' in the March *Scribner's*. It is refreshing to come upon such a honest piece of work in an American magazine, after wading through the vast sea of sugar coated mush that makes up the most of our fiction."[27] Clearly, Hopper's canvasses (like some of the movies he viewed) were antidotes to the "sugar coated mush" of the American Dream.

It is for this reason that so many critics have made the connection between Hopper's oeuvre and the particular genre of film noir—a type of crime drama identified with the 1940s in whose formulaic construction a cynical male protagonist (frequently a detective) becomes enmeshed in a sleazy, paranoid world of urban intrigue, encountering an alluring femme fatale along the way (e.g., *Gilda*, *The Maltese Falcon*, *The Lady from Shanghai*, *In a Lonely Place*, *The Big Sleep*, *Double Indemnity*). Again, many of Hopper's paintings are reminiscent of this cinematic mise-en-scène. The woman with the black hat covering her eyes who rides the train in *Compartment C, Car 293* could be one of noir's elusive females, as might be the woman reading in a chair in *Hotel Lobby* (1943) or the one sitting alone in a restaurant (noticed by a man) in *Sunlight in a Cafeteria* (1958). The train tracks and tunnel depicted in *Approaching a City* (1946) could be the place where a body was dumped or later discovered, as might be the locales of *Manhattan Bridge Loop* (1928) and *City Roofs* (1932). The tryst between two men and a woman in a shadowy office in *Conference at Night* (1949) could mark the genesis of a sinister plot. (In Jo Hopper's notebooks, in fact, she imagined those characters as "garment workers who were cooking up something.")[28]

Aside from these broad comparisons, film critics can find *specific* associations between Hopper pictures and moments of film history—though any particular scholar's free-associative list will vary from that of another's. In writing about film noir, for example, Foster Hirsch describes Fritz Lang's *Scarlet Street* in the following fashion: "The film's unpeopled streets, the elongated shadows, the angular buildings that guard empty space like grim sentinels, recall the eerie night-time cityscapes in the paintings of Edward Hopper." And, in his book on Frank Capra, Ray Carney notes how both Hopper and that film director are "misperceived as realists because, in a distinctively American way, they attempt to suggest that visionaries need not retreat to a Coriolanian 'world elsewhere' but undergo their imaginative experiences in their daily lives."[29] Finally, Robert Ray, in his programming for the Whitney Museum's Hopper exhibit, manufactured a film roster of his own, including *Vertigo*, *East of Borneo*, *The Naked City*, *You Only Live Once*, and *Dodsworth*.

In my own Rorschach test of Hopperesque imagery I would propose the following parallels: between Norman Bates's Victorian residence in *Psycho* (1960) and Hopper's *House by the Railroad* (1925) (Fig. 4) or *Rooms for Tourists* (1945); between the innocuous (but pernicious) Santa Rosa, California, neighborhood in *Shadow of a Doubt* (1943) and the street scene in Hopper's *Sun on Prospect Street* (1934); between the voyeuristic sequences in *Don't Bother to Knock* (1952) and a woman glimpsed in an apartment in Hopper's *Night Windows*; between steamy moments from *Splendor in the Grass* (1961) or *East of Eden* (1954) and a couple in romantic contemplation on a porch in Hopper's *Summer Evening* (1947); between hotel scenes in *Romeo Is Bleeding* (1993) and in Hopper's *Hotel Room*; between the road-movie imagery of

Figure 4. Edward Hopper, House by the Railroad, *1925.*
(The Museum of Modern Art, New York, Anonymous Gift)

Badlands (1974) and the car trip depicted in Hopper's *Jo in Wyoming* (1946); between the film viewing scenes of *The Purple Rose of Cairo* (1985) and the somber theater in Hopper's *New York Movie*; between the gorgeous heroine of *The Strawberry Blonde* (1941) and the cosmopolitan woman stepping out in Hopper's *Summertime* (1943); between the railroad intrigue of *Strangers on a Train* (1951) and the passengers in Hopper's *Chair Car*; between the Mexican locale of *Touch of Evil* (1958) and the street scene in Hopper's *El Palacio* (1946); between the opera sequence of *Letter from an Unknown Woman* (1948) and the elegant theater crowd in Hopper's *Two on the Aisle* (1927); between the dark sense of urban danger in *M* (1931) and Hopper's expressionist *Night Shadows* (1921); between an evening rendezvous by a shop window in *Lady in the Lake* (1946) and Hopper's *Drug Store* (1927) (Fig. 5, Plate 24).

Something else is noteworthy about the final Hopper picture in my personal Rorschach series (*Drug Store*), and that is the Ex-Lax advertisement represented in the sign for Silbers Pharmacy. Undoubtedly, Hopper sees such visual hype as part of the garish (yet mesmerizing) modern urban decor—as is the lighted sign visible outside the window of a restaurant in *Chop Suey* (1929), the Esso sign on the street

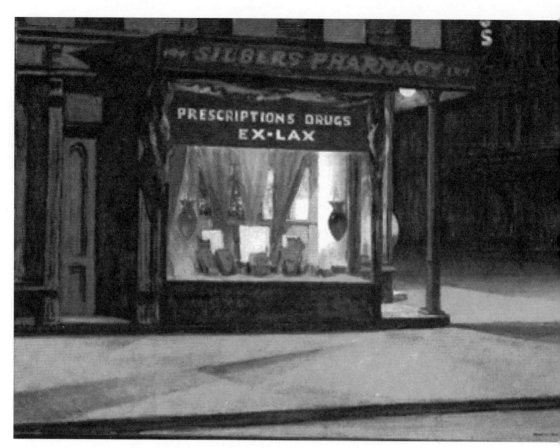

Figure 5. Edward Hopper, Drug Store, *1927. (The Museum of Fine Arts, Boston, Bequest of John T. Spaulding)*

corner in *Portrait of Orleans* (1950), the Hortons Ice Cream sign on the building in *The Circle Theatre* (1936), the Phillies cigar sign in *Nighthawks*, or the Mobil sign at the petrol station in *Gas*. As Hobbs makes clear, "Hopper is the first artist to recognize that visual images in the twentieth century have become so common that they have also become expendable."[30] In a consumer culture, painting itself must represent consumption.

Such commercial imagery in Hopper can be linked once more to the cinema: for example, to a couple who sit on a bench near billboards for Dr. Scholl's Pads and Squibbs Milk of Magnesia in *Mannequin*. But equally germane to this leitmotiv is the pop art movement, led by such figures as Roy Lichtenstein, George Segal, and Claes Oldenburg. Although this theme has been broached in the critical literature, little attention has been given to exploring it, or to considering Hopper's relation to the work of another pop artist—Andy Warhol.[31]

"From what is to the mediocre artist and unseeing layman the boredom of everyday existence in a provincial community, [Burchfield] has extracted that qual-

ity we may call poetic, romantic, lyric. . . . No mood has been so mean as to seem unworthy of interpretation . . . cars and locomotives lying in Godforsaken railway yards, the streaming summer rain that can fill us with such hopeless boredom."[32]

It is clear how Hopper's use of advertising imagery may bear comparison to Andy Warhol's engagement of Campbell's Soup cans since, as Ward has remarked, "What draws us to the paintings of Hopper is his work with the artifacts of our culture." It is also apparent how some of Hopper's key locations (diners, cafeterias, and especially automats) may have appealed to Warhol. As Warhol once wrote: "My favorite restaurant atmosphere has always been the atmosphere of the good, plain, American lunch-room or even the good plain American lunch counter. The old-style Schraftt's and the old-style Chock Full O' Nuts are absolutely the only things in the world that I'm truly nostalgic for . . . I really like to eat alone, I want to start a chain of restaurants for other people who are like me called ANDY-MATS— "The Restaurant for the Lonely Person." It seems likely that, had Hopper had the opportunity, he might well have patronized an Andy-Mat. For, as Alfred Kazin recalls: "[Jo] hated to cook, which is why one so often saw the Hoppers in Village coffee shops and cheap restaurants."[33]

Beyond their shared culinary predilections, there are other, more subtle connections between the worldviews of Hopper and Warhol. Besides the sense of voyeurism attached to Hopper's figures at windows, we might imagine these subjects as so gazing because they are profoundly *bored*. Whereas much of Hopper criticism has focused on the alleged "loneliness" and "alienation" of his characters, it has not attended to the concomitant emotion of ennui. Certainly, this might well describe the attitude of the man looking out the window in *Hotel by a Railroad* or that of the individuals in *Intermission, Seawatchers* (1952), *Automat* (1927), *Morning Sun*, or *Sunday* (1926). Although Levin acknowledges that Hopper himself fought a "constant battle with the chronic boredom that often stifled his urge to paint," she mentions the term only once in relation to his artwork (to characterize his famous movie usher). Mostly, she talks around the concept—describing solitary figures "lost in thought . . . psychologically remote, existing in a private space," or mentions "the absence of activity" in his canvasses. Hobbs notes how Hopper "mined his uneventful life" to find poetry in the "prosaic," and Ian Jeffrey refers to Hopper's figures as "hypnotised."[34] But the term "boredom" goes unuttered by them all.

It is precisely this affect (or lack thereof) that has come to be identified with the sentiments of Andy Warhol. For example, he has written: "I like a rut. People call me up and say, 'I hope I'm not disturbing your rut, calling you up like this.' They know how much I like it."[35] Whereas Warhol's sketches, silk screens, and paintings (with their emphatic colors, wry jokes, star personae) rarely solicit boredom, his films resolutely do. *Empire*, for one, is an eight-hour work in which the camera (and, ostensibly, the spectator) is asked to stare at the Empire State Building. In

Figure 6. Ed Hood and Patrick Flemming in "Boys in Bed" ("The John"), reel 4 of Andy Warhol's The Chelsea Girls. *(Andy Warhol Foundation)*

watching *Empire*, it is assumed that even the most passionate Warhol viewers probably leave the screening room intermittently or talk to their neighbors. If, as Ward has noted, Hopper makes his New York movie theater "so enticing, so glamorous and [yet] so completely empty," Warhol transfers that "vapidity" onto the screen.[36]

Warhol's cinema also shares with Hopper's artwork a propensity for certain kinds of urban routines and locales. If Hopper paints *The Barber Shop* (1931), Warhol films *Haircut*; if Hopper paints hotel scenes, Warhol films *The Chelsea Girls* in a residential hotel (Fig. 6); if Hopper paints people napping in *Jo Sleeping* (1940–45), *Summer in the City* (1949), and *Excursion into Philosophy* (1959), Warhol films *Sleep*; if Hopper paints *New York Restaurant* (1922) and, in other canvasses, depicts Chop Suey joints, cafeterias, and automats, Warhol films such "culinary" works as *Nude Restaurant* (Fig. 7), *Restaurant*, and *Eat*; if Hopper paints an Ex-Lax sign in *Drug Store*, Warhol makes a film entitled *Bufferin*.

In fact, one might claim that Warhol's love of fashion and movie glamour stemmed from an urge to *flee* the very kind of shabby urban banality that filled Hopper's painterly universe. (Gail Levin talks of Hopper's canvasses—with their train tracks, highways, automobiles, and rail cars—as articulating "metaphors for escape.")[37] Unlike Warhol, Hopper dealt with glamour only infrequently—in his

Figure 7. Still from Andy Warhol, Nude Restaurant. *(Andy Warhol Foundation)*

pictures of the theater or in his brief excursion into the world of cosmopolitan elegance (e.g., *New York Restaurant*).

As a child born into a poor section of Pittsburgh in the 1930s, Warhol would have seen his share of urban blight and kitsch. Like Hopper, he had escaped at and through the movies ("Where Happiness Costs So Little")—a "cheap, democratic amusement" for the working class. Though Hopper's *Early Sunday Morning* is modeled on New York's Seventh Avenue, it resembles a street in any smaller-scale American city or town—perhaps, Pittsburgh.[38] But, in such canvasses as *Sunday*, *Dawn in Pennsylvania* (1942), and *Pennsylvania Coal Town* (1947), Hopper gets closer to the geographic realm of Warhol's youth (Fig. 8). Hence, we might read such Warhol films as *Trash* (made in collaboration with Paul Morrissey) as establishing a tension between the Hopperesque world of grim tackiness (that Warhol knew well) and the Hollywood world of campy glitter (that Warhol sought). If, as Ward tells us, "Hopper's paintings reveal the vulgarity of the vulgar,"[39] then he is an early practitioner of the "grunge aesthetic" and Warhol a major successor. Paul Auster (in homage to Hopper) seems to merge the worlds of *New York Movie* and that of Warhol's decadent, underground factory in imagining a disaffected fictional narrator who stumbles into a sleazy Times Square theater:

Figure 8. Edward Hopper, Pennsylvania Coal Town, *1947.*
(Butler Institute of American Art, Youngstown, Ohio)

By midafternoon the weather had become stifling. Not knowing what else to do with myself, I went into one of the triple-feature movie theaters on Forty-second Street.... For ninety-nine cents, I was willing to sit through anything.... Owing to the temperatures outside, the better part of New York's derelict population seemed to be in attendance that day. There were drunks and addicts in there, men with scabs on their faces, men who muttered to themselves and talked back to the actors on the screen, men who snored and farted, men who sat pissing in their pants. A crew of ushers patrolled the aisles with flashlights, checking to see if anyone had fallen asleep.[40]

"If anyone wants to see what America is, go and see a movie called *The Savage Eye.*"[41]

The work of Andy Warhol is not the only experimental/art film to which Hopper's work bears comparison. Rather, the kind of boredom and anomie that appear in Hopper's paintings might apply to the world of *L'Avventura* or *The Red Desert*—leading Andrew Sarris to refer to the films' director as "Antoni*ennui*," instead of Antonioni (Fig. 9).[42] Similarly, we might find the scene of a door abruptly

Figure 9. Michelangelo Antonioni, L'Avventura. (Courtesy of Turner Entertainment and Film Stills Archive, The Museum of Modern Art, New York)

opening onto a landscape in Hopper's *Stairway* (1949) rather like the portal that surrealistically leads to a beach in *Un chien Andalou* (1928). Given all of Hopper's women at windows, one is reminded of a similar image in *Meshes of the Afternoon*— Maya Deren behind a window pane. Finally, in light of Hopper's ubiquitous urban scenes, it is not surprising that a reviewer of Chantal Akerman's *News from Home* would find its haunting, documentary imagery of New York streets like Hopper's "elegiac cityscapes" (Fig. 10).[43]

For the most fruitful parallel between Hopper's work and the independent cinema we might turn to a film that he specifically mentions—*The Savage Eye*, made in Los Angeles by Sidney Myers, Joseph Strick, and Ben Maddow in 1959 (Figs. 11 and 12). It is understandable that Hopper would like a film with this title, for his own harsh, uncompromising view of the American landscape had often been considered "savage" itself. Ward talks of Hopper's "belligerent realism" and claims that his paintings "seem to attack us."[44]

The Savage Eye is an experimental narrative, with documentary overtones, that follows the arrival in Los Angeles of a recently divorced woman named Judith (Barbara Baxley). We learn her story through a two-tiered, voice-over narration that accompanies the imagery. One voice is her own (in stream-of-consciousness format). The other is that of her male and invisible "guardian angel" or "double"

Figure 10. Chantal Akerman, News from Home. *(Stills, Posters, and Designs, British Film Institute, London)*

(Gary Merrill). Through the course of the film the two offer insights and exchanges—in a highly stylized and poetic manner. At one point, for example, the guardian angel invokes "False dreams, to break the prison of the body and be what you never were."

If, in the age of Edward Hopper, New York City was the quintessential, impersonal, American megalopolis, in the post–World War II period it became Los Angeles. If, for Hopper, the tourist and travel routes in the United States were those of the highway and the rail, in a later age it was the air. Suggestively, *The Savage Eye* begins with Judith arriving by plane, as her doppelgänger inquires, "Alone traveler, why?" (It is interesting to note that Andy Warhol found airports fascinating—presumably in their sterility. As he wrote, "Today my favorite kind of atmosphere is the airport.")[45]

As we follow Judith around Los Angeles, she is a solitary figure, like so many characters in Hopper's canvasses. Similar to them, she is rather deadpan: when she looks at store mannequins she calls them "poor effigies" of herself. (Recall that Ward had deemed Hopper's people "mannequins.")[46] Judith is also alienated; at one point she muses, "The touch of human skin makes me sick."

Beyond her Hopperesque sensibility, Judith strikes various poses familiar to us from his paintings. She looks out a variety of windows: in an apartment, in a bus, in a bar. She wanders into locales associated with Hopper's universe: an automat, a

Figure 11. Sidney Myers et al., The Savage Eye, *1959.*
(Courtesy of Turner Entertainment and Film Stills Archive, The Museum of Modern Art, New York)

hair salon, a burlesque house, a street at night. In a Hopperesque gesture, the camera work (executed by Haskell Wexler) focuses on a variety of commercial signs (e.g., one for a "Final Clearance"). Like the protagonists of Hopper's paintings, Judith seems depressed and languishes in bed. (As evidence of her melancholy, she thinks: "Let me sleep!"). Like Hopper's characters, she is also plagued by boredom. Her guardian angel describes the "long quiet drag of the afternoon," and she speaks of people spending their time "waiting." As in the work of Hopper, we frequently peer into store windows—for instance, at fashion dummies—in imagery reminiscent of Atget. But in another store window we find televisions—objects with particular importance for the estranged worlds of Hopper and *The Savage Eye*. For as Warhol once confessed, "I [have] always thought that I was more half-there than all-there—I [have] always suspected that I was watching TV instead of living life."[47]

Certain sequences of *The Savage Eye* are also charged with a Hopperesque sense of potential and of violent drama. In contemplating her ex-husband and his new lover, Judith thinks: "If he'd only say 'Today I strangled her. I'm on trial for murder—you're the only one I can trust. Come home. Come back.'" But it is not only Judith who seems pathetic. It is the entire morose world around her: the people exercising, having their hair done, playing poker, grooming their pets,

Figure 12. Sidney Myers et al., The Savage Eye, *1959.*
(Courtesy of Turner Entertainment and Film Stills Archive, The Museum of Modern Art, New York)

wrestling, attending church. As her guardian angel remarks, "All I see is people *trying* to be cheerful."

Whereas in Hopper's world there seems little hope of change or deliverance, *The Savage Eye* has a strangely redemptive denouement. After suffering a car crash, Judith abruptly recognizes that people are "all secret lovers of one another" and searches for the "courage to say 'no' to nothingness." To these thoughts, her guardian angel replies, "Amen." The film closes with a view of the Pacific Ocean, a vista that reminds us of the more macabre ending of *Meshes of the Afternoon* (which involves the death of a woman in the same body of water).

The disembodied guardian angel in *The Savage Eye* has almost no precedent in the history of cinema, save such embodied forms as the cherub in *It's a Wonderful Life*.[48] The latter is a far more jovial and conventional spirit who seeks to convince a man that his banal life (lived in a Norman Rockwell version of a Hopperesque small American town) has been truly heroic and worthwhile. Although *The Savage Eye* closes on a tentatively affirmative note, it is existential in tone, acknowledging the absurdity of existence at the very moment it attempts (against all odds) to impose on it meaning. But the guardian angel (an unseen observer) is also a voyeur, one who spies on Judith's life and feels empowered to judge, witness, intervene,

and editorialize. Indeed, at one point in the narrative, Judith notices a poster of a giant eye.

In the guardian angel's omniscient, controlling, and savage vision, it is not difficult to see a stand-in (or body double) for Edward Hopper. The angel's disembodied voice-over further identifies him with narrative authority and with the cinematic apparatus as artistic medium. If the guardian angel's project is one of salv*ation*, however, Hopper's is one of salv*age*—of embracing the wreckage (or "trash") of modern life precisely because it is barren, hopeless, and godless (the salvage eye). As Hopper said of the American landscape in 1927, "It is something if a modicum of the brutal reality can be *saved* from the erosion of time" (italics added).[49]

In the guardian angel's incorporeal stance we also find evidence of someone who observes another's life rather than lives his own—a biographical charge that some have leveled at Hopper. (Hobbs claimed that the artist lived an "uneventful" existence; Hopper's wife Jo called him a "hermit" and avowed that he characterized himself as "a watcher." Again, such a state is the ultimate moviegoer's stance, for as Warhol confessed: "People sometimes say that the way things happen in the movies is unreal, but actually it's the way things happen to you in life that's unreal. The movies make emotions look so strong and real."[50]

"Every old master has had his own modernity. . . . It is doubtless an excellent thing to study the old masters in order to learn how to paint; but it can be no more than a waste of labour if your aim is to understand the special nature of present-day beauty."[51]

We might say that if *The Savage Eye* had not been made, Edward Hopper would have had to "invent" it. But perhaps in a way he did, for, as Deborah Lyons remarks, "There may be no other American painter whose imagery has imprinted itself so powerfully on the way we picture our world."[52] In other words, as we (or Judith) move through the world (as contemporary flaneurs), Hopper's art causes us to imagine that we have witnessed before sights that we have never viewed—only because his work has etched "generic" versions of them so decisively into our consciousness. This profound sense of "recognition" also doubles back on itself, making us sure we have walked the streets of Hopper's canvases when, in fact, we have probably not. As Lyons writes, "We may be most drawn to Hopper's work by the odd sensation of having seen such a thing many times before—a mundane view that, when painted by Hopper, suddenly becomes cause for epiphany."[53]

In engaging this paradox, we return to Berman's notion of modernist art as "allow[ing] us to become subjects as well as objects of modernization, to get a grip on the modern world and make [our]selves at home in it."[54] It is such a "grip" that Hopper's paintings provide—not only by granting the rather forbidding modern

world a sense of "present-day beauty," but also by imbuing it with a strangely welcoming aura of déjà vu.

NOTES

This essay is dedicated to Dana Polan and in memory of Donie Durieu.

Thanks to the following people for help on this essay: John McCombe for research assistance, Dana Polan for reading a first draft, Ray Carney for sending me his book on Frank Capra, and Townsend Ludington for his patience in seeing this project through.

1. Berman, *All That Is Solid Melts into Air*, 6.

2. Ibid., 9.

3. Levin, *Hopper: The Art and the Artist*, 58.

4. Levin, *Hopper: An Intimate Biography*, 212.

5. Ibid., 291, 377, 421, 439, 463, 500, 502, 555.

6. Grau, *Hopper*, 109.

7. Levin, *Hopper: The Art and the Artist*, 58.

8. Ward, *American Silences*, 174.

9. Levin, *Hopper: The Art and the Artist*, 52.

10. Ibid., 46, 45; Kaszin, "Hopper's Vision of New York," 31; Ward, *American Silences*, 173; Hobbs, *Hopper*, 20, 16.

11. Hobbs, *Hopper*, 72; Ward, *American Silences*, 171.

12. Ibid., 183. The frightening quality of windows in Hopper's work reminds one of Dana Polan's writing on film noir, a genre to be discussed later in this essay. As he notes: "Windows [in film noir] . . . serve a variety of functions: marks of intrusion . . . the threat of falling . . . or something to be murdered with by being thrown through. . . . Even as vehicles for sight, windows become invested with ambivalent possibilities. Rather than as an appreciation of the 'view,' the window's vision is one that shocks . . . ; but also the danger of being seen from without" (pp. 274–75).

13. Clover, *Men, Women, and Chainsaws*, 70–71; Ward, *American Silences*, 191.

14. Metz, *Imaginary Signifier*; Mulvey, *Visual and Other Pleasures*.

15. I recall reading this comparison of the windows to celluloid as part of my research on this project but can no longer locate the source.

16. Lalvani, *Photography, Vision*, 180; Hobbs, *Hopper*, 14; Levin, *Hopper's Places*, 8.

17. Levin, *Hopper: An Intimate Biography*, 212.

18. Bazin, "Theater and Cinema," 383.

19. Michaels, "The Nothing That Is Not There," 3.

20. Hobbs, *Hopper*, 19ff; Michaels, "The Nothing That Is Not There," 8.

21. Percy, *The Moviegoer*, 66.

22. Ibid., 66–67.

23. Levin, *Hopper's Places*, 11; Ward, *American Silences*, 176.

24. Levin, *Hopper's Places*, 10.

25. Levin, *Hopper: The Art and the Artist*, 27.

26. Ward, *American Silences*, 192.

27. Levin, *Hopper as Illustrator*, 7.

28. Levin, *Hopper: An Intimate Biography*, 408. The association of Hopper's work with film noir is also implicit in Robert Ray's choice of films for the Whitney exhibit (e.g., *The Killers*, *The Naked City*, and *You Only Live Once*).

29. Hirsch, *The Dark Side of the Screen*, 78; Carney, *American Vision*, 9.

30. Hobbs, *Hopper*, 16.

31. Ibid., 102; Levin, "Edward Hopper," 112.

33. Hobbs, *Hopper*, 10; Ward, *American Silences*, 192; Warhol, *Philosophy*, 159–60; Kaszin, "Hopper's Vision of New York," 27.

34. Levin, *Hopper's Places*, 8 (first quotation), and *Hopper: The Art and the Artist*, 53, 145, 45; Hobbs, *Hopper*, 9; Jeffery, "A Painter's Strategies," 13.

35. Warhol, *Philosophy*, 116.

36. Ward, *American Silences*, 102. Like Warhol, Hopper also painted urban landmarks, as in *Queensborough Bridge* (1913).

37. Levin, *Hopper's Places*, 6.

38. Hobbs, *Hopper*, 83.

39. Ward, *American Silences*, 172.

40. Auster, "From *Moon Palace*," 19.

41. Levin, *Hopper: The Art and the Artist*, 58.

42. Sarris, *Confessions of a Cultist*, 280.

43. Holden, "Beauty amid the Beastliness," C16.

44. Ward, *American Silences*, 174, 173.

45. Warhol, *Philosophy*, 160.

46. Ward, *American Silences*, 192.

47. Warhol, *Philosophy*, 91.

48. One might also consider the embodied, but highly unconventional, angel in Wim Wenders's *Wings of Desire*.

49. Silverman, *Acoustic Mirror*; Hobbs, *Hopper*, 10. Carney (*American Vision*) sees more hope for salvation in Hopper's work. He discusses the "transcendentalizing impulse" in the work of Hopper, Frank Capra, and Winslow Homer: "Figures physically, socially, and formally confined are offered imaginative releases from their entailment and immobility. The social body is (and must be) left behind in order to free the visionary eye to movement. All three are equally artists of the spirit" (p. 443).

50. Hobbs, *Hopper*, 91; Kammen, "Hopper Wars"; Warhol, *Philosophy*, 91.

51. Baudelaire, *Painter of Modern Life*, 13.

52. Lyons, Introduction to Grau, *Hopper*, xi.

53. Ibid., xii.

54. Berman, *All That Is Solid Melts into Air*, 6.

BIBLIOGRAPHY

Auster, Paul. "From *Moon Palace*." In Grau, *Hopper*, 17–34.

Baudelaire, Charles. *The Painter of Modern Life and Other Essays*. Translated by Jonathan Mayne. London and New York: Phaidon, 1965.

Bazin, Andre. "Theater and Cinema." In Gerald Mast, Marshall Cohen, and Leo Braudy, eds., *Film Theory and Criticism: Introductory Readings*, 4th ed., 375–86. New York: Oxford University Press, 1992.

Berman, Marshall. *All That Is Solid Melts into Air: The Experience of Modernity*. New York: Penguin, 1988.

Carney, Raymond. *American Vision: The Films of Frank Capra*. New York: Cambridge University Press, 1986.

Clover, Carol. *Men, Women, and Chainsaws: Gender in the Modern Horror Film*. Princeton University Press, 1992.

Edward Hopper, 1882–1967. London: Arts Council of Great Britain, 1981. Catalog for exhibit at the Hayward Gallery, London, February 11–March 29, 1981.

Grau, Julie. *Edward Hopper and the American Imagination*. New York: Norton, 1995.

Hirsch, Foster. *The Dark Side of the Screen*. New York: Da Capo, 1981.

Hobbs, Robert. *Edward Hopper*. New York: Harry N. Abrams, 1987.

Holden, Stephen. "Beauty amid the Beastliness in Portraits of Manhattan." *New York Times*, July 11, 1989.

Jeffrey, Ian. "A Painter's Strategies." In *Edward Hopper, 1882–1967*, 5–16.

Kammen, Michael. "The Hopper Wars." *New York Times Book Review*, October 8, 1995, 15.

Kazin, Alfred. "Hopper's Vision of New York." In *Edward Hopper, 1882–1967*, 19–32

Lalvani, Suren. *Photography, Vision, and the Production of Modern Bodies*. Albany: State University of New York Press, 1996.

Levin, Gail. *Edward Hopper as Illustrator*. New York: Norton, 1979.

———. *Edward Hopper: The Art and the Artist*. New York: Norton, 1980.

———. *Hopper's Places*. New York: Knopf, 1985.

———. "Edward Hopper: His Legacy for Artists." In Grau, *Hopper*, 101–28.

———. *Edward Hopper: An Intimate Biography*. New York: Knopf, 1995.

Lyons, Deborah. Introduction to Grau, *Hopper*, xi–xiv.

Metz, Christian. *The Imaginary Signifier: Psychoanalysis and the Cinema*. Translated by Celia Britton, Annwyl Williams, Ben Brewster, and Alfred Guzzetti. Bloomington: Indiana University Press, 1982.

Michaels, Leonard. "The Nothing That Is Not There." In Grau, *Hopper*, 1–8.

Mulvey, Laura. *Visual and Other Pleasures*. Bloomington: Indiana University Press, 1989.

Percy, Walker. *The Moviegoer*. New York: Avon Books, 1961.

Polan, Dana. *Power and Paranoia: History, Narrative, and the American Cinema, 1940–1950*. New York: Columbia University Press, 1986.

Ray, Robert. "The Mystery of Edward Hopper." Program note for film exhibition component of *Edward Hopper and the American Cinema*, Whitney Museum of American Art, New York City, June 22–August 13, 1995.

Sarris, Andrew. *Confessions of a Cultist: On the Cinema, 1955–1969*. New York: Simon and Schuster, 1970.

Silverman, Kaja. *The Acoustic Mirror: The Female Voice in Psychoanalysis and the Cinema*. Bloomington: Indiana University Press, 1988.

Ward, J. A. *American Silences: The Realism of James Agee, Walker Evans, and Edward Hopper*. Baton Rouge: Louisiana State University Press, 1985.

Warhol, Andy. *The Philosophy of Andy Warhol: From A to B and Back*. New York: Harcourt Brace Jovanovich, 1975.

RAY CARNEY

Two Forms of Cinematic Modernism

Notes toward a Pragmatic Aesthetic

Hark ye yet again,—the little lower layer. All visible objects, man, are but as pasteboard masks. But in each event—in the living act, the undoubted deed—there, some unknown but still reasoning thing puts forth the mouldings of its features from behind the unreasoning mask. If man will strike, strike through the mask! How can the prisoner reach outside except by thrusting through the wall?
—*Herman Melville*, Moby-Dick

Men esteem truth remote, in the outskirts of the system, behind the farthest star, before Adam and after the last man. In eternity there is indeed something true and sublime. But all these times and places and occasions are now and here.
—*Henry David Thoreau*, Walden

hen we look for modernism in the movies, we find at least two distinct forms of expression embodying two different views of experience. I shall call one idealist and the other pragmatic.[1]

IDEALIST STYLE

Visionary Forms of Possession

The idealist tradition takes its name from the importance it attaches to mental events—frequently represented as acts of seeing. Alfred Hitchcock's postwar work is only the most extended illustration of the significance of looking and being looked at in this kind of film. In the peak emotional moments in *Psycho*, *Rear Window*, *North by Northwest*, and *Vertigo*, characters interact with the world almost entirely in terms of acts of seeing and being seen. Visionary relations take the place of social interaction. Needless to say, acts of looking and seeing matter so intensely because they are not merely optical. Vision in the optical sense is a way of repre-

Figure 1. Two look, see, think, or feel sequences (Psycho)

senting vision in the imaginative. Seeing is a metaphor for thinking deeply, feeling intensely, or entering into an especially intimate relationship with something. Over and over again (and especially in the endings of these works), acts of seeing figure states of spiritual, emotional, or intellectual insight or communion.[2]

Hitchcock employs a three-shot sequence that is one of the basic building blocks of idealist film syntax and illustrates the linkage of the two kinds of vision. I call it the "Look—See—Think or Feel" sequence because the first shot generally shows a silent character looking at something, the second shows what the character sees, and the third returns to the character to show him or her thinking, feeling, wondering about, or otherwise reacting to what has just been seen. The movement from the first to the third shot is the movement from optical to imaginative vision. My first set of illustrations presents two examples from *Psycho* (Fig. 1).

The Power of the Gaze

Vision is incredibly powerful in these works. There is no more important event than seeing or being seen. That is illustrated most clearly by thriller and mystery films, where the act of being seen takes on ominous, negative connotations. In *Silence of the Lambs*, *Halloween*, or *Nightmare on Elm Street* vision becomes a form of imaginative control. Even in highbrow films like *The Trial*, *2001*, *Blue Velvet*, or *North by Northwest*, to be watched is somehow to be put under the power of the seer. To be seen, especially if one is unaware of it, is to be imaginatively or physically "possessed" by the gaze and to risk having your identity altered or destroyed.[3]

Notwithstanding his reputation as the inventor of the slasher genre, in Hitchcock's work acts of seeing are far more hazardous to his characters' health than

knives—especially if the character is seen in a private or unguarded moment. Glances are predatory. They steal your soul. In *Psycho*, Marion Crane is threatened by everyone who looks intently at her when she does not expect to be looked at—her boss, the state trooper who spies her sleeping in her car, the used car salesman, Norman Bates (whose spying on her through a hole in the wall is tantamount to sexually violating her), and ultimately, of course, the viewer, whose looking at her in her private, unguarded moments might be said to collaborate with Norman in doing her in.

Indeed, one strand in the plot of films of this sort involves the requirement that the main character get power back by seizing control of the gaze. The character must move from being looked at by others to putting him or herself in a position to look at them. In *North by Northwest*, Roger Thornhill, threatened by being seen by unseen adversaries, triumphs over them by finally being able to spy on them while remaining unseen. Marion Crane has her privacy violated by Norman Bates's gaze, but her narrative alter ego, her sister Lila, regains control by turning the tables visionarily—bringing her own and the viewer's gaze to bear on Norman's private, inner sanctum when he is unaware that his possessions are being seen.

Visionary Community

Visionary relationships are not necessarily threatening, however. As my second group of illustrations, two sequences from Michael Curtiz's *Casablanca*, demonstrates, visionary relationships may be socially integrative and emotionally supportive. In the first sequence, which takes place shortly after Viktor and Ilsa show up at Rick's place for the first time, Viktor, Berger, Strasser, Renault, Ilsa, and Sam are knitted together in a cross-stitched mesh of silent glances; in the second, Rick intervenes to have Jan win at roulette, and Jan's wife, the croupier, Renault, and Carl the waiter briefly form a visionary society of shared feelings and reactions (Figs. 2 and 3).

One of the signs of the difference in emotional import between the acts of looking in these sequences from those in thrillers or mysteries is that in threatening works (*2001*, *Psycho*, *North by Northwest*), glances tend to be unreciprocated, whereas in socially supportive works (like this film) they tend to be reciprocated. That is to say, whereas in Hitchcock vision is usually a one-way street, in Curtiz glances flow in both directions. It is the difference between a gunshot fired by a more powerful character *at* a weaker one and the back and forth of a tennis match between equals. In a socially integrative work, rather than having their identities undermined, the characters have them amplified and reinforced by the network of glances. Insofar as they are woven into a fabric of interdependent and mutually supportive relationships, they accrue power and their actions accrue resonance. It is as if individuals

Lazlo: This time they really mean to stop
me.
Ilsa: Victor, I'm afraid for you.
Lazlo: We've been in difficult places
before haven't we?

Lazlo: I must find out what Berger
knows.
Ilsa: Be careful.
Lazlo: I will. Don't worry.

Figure 2. Glanced relationships (Casablanca)

Rick: Have you tried 22 tonight?
Jan: No. No. I, I guess not.

Rick: I said 22.

Croupier: Faites vos jeux, mesdames et
messieurs.

Croupier: Pair et passe. Le numéro 22!

Rick: Leave it there.

Croupier: Faites vos jeux, mesdames et
messieurs! La boule passe. Faites vos
jeux.

Croupier: Les jeux sont faits. Rien ne va
plus!

*Figure 3. Glanced relationships (*Casablanca*)*

Croupier: 22!

Rick: Cash it in and don't come back.

Figure 3 (continued)

were immersed up to their eyeballs in a pond, so that the smallest thought or feeling instantly sends ripples to every other character, whose answering ripple radiates back to the initial character, reinforcing and enlarging the individual. No one is ever really alone. Everyone is part of a larger visionary community. (Though even in a film like *Casablanca*, socially integrative glances are interrupted by predatory ones in order to create drama. As Figures 2 and 3 indicate, the mutually supportive glances of Ilsa, Viktor, Sam, and Berger are intercut with Renault's or Strasser's more threatening looks and reactions.)

Unmediated Expression

It is not hard to understand the appeal of visionary conceptions of experience. These works offer their characters a stunning access of power (and allow viewers vicariously to participate in it). Characters not only have their identities enlarged, but rise above the limitations of space and time—the space and time required outside of the movies for two people actually to interact with one another physically, socially, and verbally. In *Casablanca*, figures communicate telepathically, projecting their thoughts into each others' consciousnesses with the speed of light. They are radio antennae, transmitting and receiving ideas and emotions with a glance. Freed from the encumbrances of bodily existence, their lethal or supportive laser beam looks zip through space, zapping their adversaries and making connections with their allies.

These films figure an almost unimaginable dream of expressive ease and power. Because visionary expression is unmediated, it is clearer than actual spoken words,

tones of voice, gestures, and movements ever can be. Characters' expressions of themselves are freed from the corruptions of personality, the indirections of ulteriority, and the confusions of imperfect self-awareness. Characters express themselves to each other (and to a viewer) with a purity that is never attainable in an actual, worldly verbal or physical interaction.

Looks speak more clearly than speech ever could. In *North by Northwest*, Roger Thornhill is able to read the intentions and plans of the people in the house on top of Mount Rushmore merely by looking at them through a window for a few minutes; in *Rear Window*, L. B. Jeffries is able to see into the secret recesses of his neighbors' lives by staring across the courtyard at them; in *Casablanca*, characters plumb the depths of each others' souls with a glance. No verbal or physical language could be spoken or understood this clearly and rapidly or at such distances. Words, tones of voice, and bodily expressions can never function this perfectly, especially between figures who otherwise know so little about each other and are so different from each other. Only a disembodied, mental language can constitute such an ideal medium of exchange.

A Picture Is Worth a Thousand Words

It is a hallmark of idealist works that stylistic effects pick up the expressive burden that words and social interactions do not bear. Visual effects speak what words cannot. The final scene of *Casablanca* demonstrates the extent to which stylistic effects do not merely augment, but take the place of social expression (Fig. 4). As Rick, Ilsa, and Viktor say their farewells on the tarmac, the style tells the story much more vividly, powerfully, and completely than the dialogue does. Social expressions between the characters are minimized: Ilsa, Rick, and Lazlo stand almost completely still; their costumes are nondescript; their facial expressions are almost blank; they employ no interesting gestures or body language; their words are minimal and brief (seven short lines in all). Meanwhile, the moment is overflowing with stylistic expressiveness: a rapid succession of tight close-ups, high-key lighting, brisk editing rhythms, emotionally charged musical orchestrations, rhetorical camera movements (dollying and panning movements), and dramatic sound effects (the noise of the propellers and the beeping of Strasser's automobile horn). Rick, Ilsa, and Lazlo are largely exonerated from having to do or say anything, while a dazzling display of stylistic effects "speaks" *for* them.[4] It is as near as narrative film can come to putting pure states of consciousness on screen.

This doubleness—the diminishment of social expressiveness and enhancement of imaginative expressiveness—is crucial to the effect of idealist works. The viewer is plunged into a world of stylistically intense, emotionally powerful, nonverbal, nonphysical expression. No lines of dialogue could possibly communicate this

Figure 4. Style speaking in place of words (Casablanca)

Rick: You better hurry or you'll miss that plane.

intensely, this rapidly, this perfectly. Rick, Ilsa, and Viktor communicate mind to mind, heart to heart, soul to soul—as if consciousness could be transfused— thoughts and feelings poured from one character into another.

Creating Consciousness

Because the main characters interact with their surroundings and with each other at important dramatic moments in visionary works in an almost purely imaginative way, idealist works implicitly downplay the importance of practical action and social expression. In the key scenes, characters need to do or say or otherwise physically express almost nothing. They need *only* think, feel, and "see." To feel something, to know something, to intend something is to *be* it in these films. In a visionary universe, to have good intentions is to be spared the difficulty of having to translate them into complex social expressions.

Hitchcock's characters are never more alive than when they are functioning visionarily. They express themselves through their imaginations, feelings, and thoughts much more vividly than through their words or actions, which is why the scenes involving their social interactions are perfunctory and boring in comparison with those in which they are "seeing." (No one watches a Hitchcock film for the conversations.)

Transcendental Selfhood

Idealist understandings (which inform the overwhelming majority of Hollywood movies) turn experience into a series of mental and emotional events. What

is inside a character, his or her thoughts and feelings, his or her expressions, becomes far more important than what is said or done. Characters' most important expressions of themselves and their relationships with each other are almost completely mental. They are defined almost entirely in terms of their internal states—their ideas, moods, wishes, dreams, intentions, and goals. They become their insides. They *are* their states of subjectivity.

The understanding of experience shifts. These films implicitly tell us that experience is *inside* us. They imply that the most important way for someone (character and viewer alike) to encounter reality is to think about it, feel it, commune with it, understand it. One's relation to experience becomes mental. Eventfulness moves inward, out of the world and into the mind.

These films endorse Isabel Archer's ideal in *The Portrait of a Lady* that you are your consciousness. ("I don't know whether I succeed in expressing myself, but I know that nothing else expresses me. Nothing that belongs to me is any measure of me; on the contrary, it's a limit, a barrier, and a perfectly arbitrary one.")[5] Characters who are proponents of verbal and social forms of expression and interaction—like Madame Merle and Gilbert Osmond in the case of the James novel—are invariably "placed" in limiting ways.

Even though idealist works may use their plots to criticize the main characters' attempts to live their ideals (by punishing them in one way or another—as Isabel herself is narratively punished by James), their styles implicitly endorse their attempts to escape the prison house of language, history, and social interaction. In *Casablanca*, although Ilsa may ultimately be denied her romantic merging with Rick by the narrative, the visual style endorses her romantic ideal far more energetically than the plot denies her its consummation. In *Mr. Smith Goes to Washington*, the Harry Carey, Claude Raines, and Edward Arnold characters may be more powerful than the ones played by Jimmy Stewart and Jean Arthur, but every aspect of the film's style endorses the "weaker" figures' states of imaginative inwardness. Similarly, in *Rebel without a Cause*, the inarticulateness of the James Dean and Sal Mineo characters is clearly valued far more than the volubility of the Jim Backus figure.

Silence, Secrets, Solipsism

One consequence of this devaluation of external expressions and actions is the social marginalization of the principal characters in idealist works. Thrillers and mysteries present the most extreme illustration of the phenomenon. Hitchcock's films repeatedly imagine his characters' most meaningful and intense experiences as taking place when they are silent and alone: L. B. Jeffries sitting alone looking through his camera lens (*Rear Window*), Lila Crane prowling through the Bates

mansion (*Psycho*), Roger Thornhill looking into the windows of the mansion on Mount Rushmore (*North by Northwest*), Scotty Ferguson pursuing Judy/Madeline off in the distance (*Vertigo*). In fact, one might say that the real "horror" in Hitchcock's work has less to do with physical danger than with the horrifying isolation of his characters. Each of his figures serves a life sentence in solitary confinement, locked in an individual cell of incommunicable private consciousness. Their most important feelings and experiences can almost never be spoken or shared with anyone else.

Even *Casablanca*, a film overflowing with crowds, without a single scene in which a character is ever physically alone, imagines its characters to be wrapped in incommunicable states of private subjectivity. The most important experiences and understandings of the main characters are secret and unexpressed. Ilsa and Rick keep their past relationship and their private meetings at Rick's place secret from Viktor; Rick keeps his love for Ilsa and his ultimate plan for her departure secret from her; and Viktor keeps his suspicions about both of them to himself. As in nineteenth-century melodrama (from which this form of cinematic modernism descends), all of the important truths are unspeakable.

A Contradiction

Given the storytelling conventions of mainstream American film, there is an artistic contradiction at the heart of the visionary project. Internal states must be represented in terms of external events. As much as filmmakers like Hitchcock, Curtiz, Kubrick, Lynch, and others are committed to putting consciousness on screen, they must do it within "realistic" forms of narrative presentation. These films are devoted to pulling subjective rabbits out of objective hats. It is not an easy trick to perform, and many of them fail in their attempt, or, like *Apocalypse Now* and *The Shining*, crudely seesaw back and forth between social and imaginative forms of presentation—awkwardly alternating between scenes that are intended to represent states of consciousness and scenes of social interaction and physical action that are meant to keep the narrative moving along. The Romantic poets had it a lot easier. Shelley could simply hail his skylark; he did not have to come up with lines of dialogue for it to speak or actions for it to perform.

Hitchcock's work repeatedly displays an uneasy split between the two forms of expression. Because of his commitment to conventional forms of narrative presentation, he could not altogether avoid having his characters engage in a certain number of social and verbal interactions, but it is clear that he was unable to bring anything like the same degree of interest and inventiveness to those scenes that he did to his depictions of subjectivity. As an illustration, the scenes in *Psycho* in which

characters interact socially at any length are mind-numbingly dull and uninspired, even—as the film's final psychiatric explanation most blatantly illustrates—to the point of being unintentionally comic. My students' snickers at the silliness of the film's final scene represent insights into an expressive crisis at the heart of Hitchcock's enterprise.

Nonvisionary Imaginative Representations

The most common way realistic narratives redirect the viewer's attention away from external events and toward states of consciousness is simply to have characters *say* their thoughts and feelings. Films like *Hannah and Her Sisters*, *Marty*, *The Bachelor Party*, *From Here to Eternity*, *The Best Years of Our Lives*, *The Grapes of Wrath*, *To Kill a Mockingbird*, *Tomorrow*, and *Come Back Little Sheba* may seem different from works like *Psycho*, *Casablanca*, *Citizen Kane*, and *2001* insofar as they have minimal recourse to any of the specific forms of stylistic heightening that I have focused on as transmitters of subjectivity (silent glances, key-lighted close-ups, rapid cutting, emotionally charged musical orchestrations), but they make up for the absence of visionary stylistics by having characters repeatedly state what they are thinking and feeling. Their key scenes consist of characters' extended verbal presentations of their wishes, dreams, thoughts, goals, motivations, intentions, and beliefs. Almost all of their important dialogue passages consist of statements of subjectivity ("I/you/he/she/they . . . want/think/believe/feel/know that . . . etc.").

The verbal expressions in these films perform the same function as the visions, looks, and stylistic effects in the other group of films, providing direct and unmediated access to characters' consciousnesses. They function as more or less pure displays of subjectivity—as if a figure simply and unproblematically *is* the thoughts and feelings he expresses. That may not sound remarkable, but I would note that it is almost never the case with verbal expressions in novels, short stories, plays, or life—where words almost never provide unproblematic access to states of subjectivity. Words in Harold Pinter, Shakespeare, Chekhov, and our conversations with our friends are never free from the obliquity, ulteriority, and imperfection of all of our other expressions of ourselves.[6]

Another way films committed to realistic narrative forms present states of consciousness is through actions and events. When Lila Crane prowls around the Bates mansion, she does not need to say anything for us to follow her thoughts and feelings step by step. When Rick shoots Strasser, his action speaks his thoughts and feelings as clearly as words would. An Arnold Schwarzenegger or Steven Segal film does not need to use tight close-ups or expressive lighting to allow a viewer to follow the main character's every flicker of feeling. Consciousness is written on the screen in capital letters with every lunge or juke.

Inner Weather

In summary, the subject of idealist works is subjectivity—whether rendered by means of look-see-think sequences, heightened visual effects, musical orchestrations, close-ups of eyes and faces, verbal statements of thought or feeling, or intentionally indicative actions. The defining quality of these works is the presentation of states of consciousness in characters and the cultivation of empathetic states of consciousness in viewers.[7]

The driving sequence in *Psycho* provides an unusually clear illustration of how idealist film transforms realistic events into expressions of consciousness (Fig. 5). The nominal events are as follows: Early in the film, Marion Crane steals money from the real estate office in which she works and hits the road with the intention of rendezvousing with her lover. On the final leg of her flight, she drives throughout one entire day and on into the night. As it gets darker, it starts to rain. The storm intensifies and her windshield gets increasingly harder to see through. She blinks and winces as the headlights of oncoming cars glare into her eyes. By the end of the scene, it is late at night, and Marion, lost and uncertain where she can go to get out of the storm, turns off on a side road and pulls into the parking lot of the Bates Motel.

It would be an unimaginative viewer, however, who did not realize that the external events are not really the point of the scene. As even my freshmen in the course Understanding Film realize, Hitchcock systematically and comprehensively transforms the driving, the rain, and the night into representations of subjectivity. The storminess figures a storm of feeling within Marion. The buildup of external disturbance communicates a crescendo of emotional disturbance. The scene is less about geographic disorientation than imaginative lostness, less a depiction of outer than inner weather. Hitchcock makes us so accustomed to metaphoric presentation that we do not bat an eye when the storm suddenly subsides the instant Marion finds a room to spend the night in. When she is calm, by definition the world is calm. Inner weather dictates outer.

Dream Films

In strong idealist works (of which Hitchcock's are virtuosic examples) actions and events are insistently inflected in this way. They are made to carry imaginative meanings that redirect our attention away from the physical surfaces of life and into depths of consciousness. Films in the idealist line make this metaphoric move over and over again. Under the guise of presenting the world, they give us the mind.

The most general manifestation is the symbolic mode of presentation that most American art films employ. Virtually every visual and acoustic event in *Citizen*

Car Dealer: She look like a wrong-one to you?
Patrolman: Acted like one.
Car Dealer: The only funny thing, she paid me seven hundred dollars in cash.

Caroline's Voice: Yes, Mr. Lowery?
Lowery's Voice: Caroline? Marion still isn't in?
Caroline: No, Mr. Lowery. But then, she's always a bit late on Monday mornings.
Lowery: Buzz me the minute she comes in.

Lowery: Then call her sister—if no one's answering at the house.

Caroline: I called her sister, Mr. Lowery, where she works—the Music Makers Music Store, you know—and she doesn't know where Marion is any more than we do.

Lowery: You'd better run out to the house. She may be, well—unable to answer the phone.
Caroline: Her sister's going to do that. She's as worried as we are.

Lowery: No, I haven't the faintest idea. As I said, I last saw your sister when she left this office on Friday. She said she didn't feel well and wanted to leave early; I said she could. That was the last I saw—Now wait a minute. I did see her sometime later, driving—Ah, I think you'd better come over here to my office—quick! Caroline, get Mr. Cassidy for me!

Lowery: After all, Cassidy, I told you—all that cash! I'm not taking the responsibility! Oh, for heaven's sake! A girl works for you for ten years, you trust her! All right. Yes. You better come over.

Cassidy's Voice: Well, I ain't about to kiss off forty thousand dollars! I'll get it back, and if any of it's missin' I'll replace it with her fine, soft flesh! I'll track her, never you doubt it.

Lowery: Oh, hold on, Cassidy! I—I still can't believe—it must be some kind of a mystery. I—I can't—

Cassidy: You checked with the bank, no?
They never laid eyes on her, no? You
still trusin'? Hot creepers! She sat there
while I dumped it out! Hardly even
looked at it! Plannin'! And—and even
flirtin' with me!

*Figure 5. Marion Crane driving to the Bates Motel (*Psycho*)*

Kane, The Trial, Vertigo, North by Northwest, 2001, Heaven's Gate, Apocalypse Now, Blade Runner, and *Pulp Fiction* functions quasi-allegorically. Almost nothing is merely its poor, paltry, realistic self. Every experience is shifted one notch to the side in order to bear a larger, more imaginatively resonant meaning. Take the opening of *Citizen Kane*, for instance. Even the most naive viewer knows that the lugubrious music on the soundtrack, the languorous camera movements and dissolves, the shadowy lighting, the chain-link fence, the "No Trespassing" sign, the dilapidated grounds, the lonely mansion, the dying words of the man in the bed all function metaphorically. Orson Welles is not presenting a real fence or sign or mansion, but images of desolation, wastage, loss, isolation, loneliness, self-destruction.

The symbolic technique imparts the dreamlike quality to many of the best-known works in the American cinematic tradition. Objects and events are relentlessly abstracted: in *Psycho* that includes everything from the storm that Marion Crane drives through, to the Bates mansion (which does not function as a real house at all, but as a symbolic representation of middle-class taboos and repressions connected with smothering mother love, incest, homosexuality, masturbation, insanity, and murder), and everything in it, like the recording of Beethoven's *Eroica* Symphony, which Hitchcock can count on his viewers treating not as a real object (in which case it would be meaningless), but as a symbolic one (having a punning connection with "eroticism").

So highly esteemed is the symbolic method that it is frequently treated as if it were synonymous with cinematic "art." It is taken for granted that this is what "important" or "serious" films do. They make this metaphoric move. Symbolic methods are valued because they offer a stunning enlargement of meaningfulness to the most ordinary events and interactions. The imaginative enrichments that the Romantic poets confined to the realm of reverie and vision are imagined to be available in ordinary life. They move out of the work of art and into the world.

Symbolic modes of presentation also flatter us because they enlarge the importance of the individual consciousness. These films imagine a universe subtly and systematically sympathetic with and responsive to our feelings—as if the pathetic fallacy were no longer a fallacy. The universe resonates with the rhythm of Charles Foster Kane's pulse beat. His loneliness is inflated to Xanadu-scale dimensions. When Marion Crane is upset, it storms. When Rick, Viktor, and Ilsa are emotionally revved, airplane propellers rev up; when they are anxious, Major Strasser's horn beeps; when Ilsa's heart pounds, cannons fire and cities burn.

The Merging of Perspectives

What I am describing is a double process. Works within the visionary/idealist/ symbolic tradition (the most complete designation of the branch of cinematic

modernism I am describing) do not merely shift their characters into distinctively imaginative ways of processing experience; they shift their viewers, too. Viewers enter into the same visionary relation to experience that the characters do. That is to say, these films not only *depict* states of vision and reverie; they use music, silences, and close-ups of faces and objects to *evoke* corresponding imaginative states in the viewer.

Viewers encounter the experiences of these films in the same way that characters encounter experiences within them. They are given the same visionary capacities that characters possess. Characters are endowed with emotional and mental X-ray vision that allows them to see each others' hearts and souls; viewers are endowed with X-ray vision in which figures become transparent and the viewer is able to see deep into their souls and minds, and watch streams of awareness flowing between them. In *Casablanca*, when characters mind-read or visionarily jump through space in a room, the viewer does it along with them.

Characters encounter the world as depths rather than surfaces; viewers encounter the world in the same way. When Marion Crane feels the storm as a series of emotional messages, the viewer feels it similarly. When she ponders stealing an envelope full of money, worries about getting caught by her boss, or wonders what is in the house on the hill; the viewer ponders, worries, or wonders along with her. When Lila entertains imaginative or emotional understandings of the objects and events she discovers in the house, the viewer does the same thing.

The "identification" process by which the main characters in these works become mental and emotional surrogates for the viewer is central to the conflation of imaginative points of view. Identification is fostered by two devices. The first is optical: Point-of-view photographic and editing conventions encourage the viewer to "see through the eyes of" the characters and, to some extent, to experience things the same way they do. The second is psychological: The personalities of the characters are kept deliberately bland and nonspecific to facilitate empathy. To the maximum extent possible, they are allowed to be American Adams and Eves, uprooted from pasts and particulars, and made as generic as possible, so that everybody can imagine themselves to be them.

Psycho's Lila Crane illustrates the various aspects of the blending of the character's point of view with the viewer's. She has no unique or distinctive personal attributes—no past, no future, no specific character. She is her generic emotions (involving being on a quest to discover the truth about her sister). The combination of making her personally so nonspecific and emotionally general allows anyone to "become" her. Her identity is kept loose and baggy enough so that there is lots of room for a viewer to slip into her skin (and no prickly details to snag or trip up the process). But even more important than the general emotional identification is the conflation of the character's and viewer's ways of knowing. As Lila

prowls through the Bates motel and mansion, the viewer goes with her, not only optically seeing through her eyes (so that when she jumps at her reflection in the mirror, we jump with her), but seeing things *in the same way* she does. She attempts to decipher the meanings hidden in the objects in the Bates bedroom and nursery; we attempt to decipher them along with her. She is puzzled by certain objects; we are puzzled. She has insights; we have insights, probing, pressuring, interrogating objects and events to yield meanings in exactly the same way she does.

American Vision

These films positively insist that the viewer and major characters move from optically seeing someone or something to visionarily "seeing" its imaginative significance. The work of art and life is to dive beneath the perceptual surface, to convert matter into spirit. Merely to see something (in the optical sense) is to be in a superficial and potentially deluded relationship with it; to understand it, we must "see" it. For both characters and viewers, vision must be translated into Vision. Sight must be converted into insight. The conversion process is enacted over and over again by characters in idealist film. What is the plot of all of Hitchcock's work, after all, but the efforts of various protagonists to pressure objects and events to yield their "deep" meaning, their "visionary" significance? And what is Hitchcock's style but a parallel effort to entice the viewer to collaborate in pressuring reality in the same way? In the central visionary scenes of Hitchcock's work, every event and object is stylistically inflated to its maximum sustainable imaginative pressure. The mystifications tease characters and viewers into looking beneath the surfaces of life, to move from the physical to the metaphysical.

The move is necessary because, in this understanding of life, material appearances are trivial or misleading, while imaginative depths are profound and revealing. Surfaces betray; social and physical expressions are always, at least potentially, unreliable. Truth is not a property of the actual world, but an essence beyond or within it. It resides in a realm of pure thought and feeling outside the impure world of objects and social expressions.

Sacramental Vision

Films in the visionary/idealist/symbolic tradition enact one of the master narratives of American art—what Ahab calls "strik[ing] through the mask."[8] The makers of these films (and the viewers of them who vicariously participate in their quests) take their place in a long line of American deep divers—extending from Jonathan Edwards, Nathaniel Hawthorne, and Herman Melville to Robert Lowell, Donald Barthelme, and Thomas Pynchon. The world contains secret spiritual and

emotional meanings. The actual perceptual world is meaningless or chaotic until we penetrate its mysteries. The symbolic/allegorical style of these films is devoted to a sacramental, restorative vision. Character and viewer alike are offered the prospect of diving beneath the random, causal surfaces of life to inhabit a realm of coherence and meaningfulness.

With its Puritan origins, it should not be surprising that work and pain are usually associated with this act of penetration. One must undergo acts of self-sacrifice and purgation to redeem reality. The work involved in striking through the mask is the plot of all of Hitchcock's late films. *Dial M for Murder, Rear Window, Vertigo, North by Northwest,* and *Psycho* each begin by having characters and viewers see things that they cannot understand. Vision in the optical sense is abundantly and easily available from the start, while vision in the imaginative sense is baffled. Only after extensive narrative work is performed and suffering undergone is the deliberately deferred imaginative breakthrough granted.

Critical Collaboration

The conversion process enacted by Hitchcock's detectives and Welles's reporter—the ferreting out of secrets and the discovering of hidden imaginative significances—has become the model for American film criticism itself. Essential truth is believed to be located within or behind superficial, accidental, phenomenal reality. The critic's job is to dive beneath the surface, to find the sermon in the stone. The critic translates from the realm of the profane to the sacred. He leaves the body behind in pursuit of the soul. As much as the viewers of these films and the characters in them, the critic pursues a sacramental vision.

The Loss of the World

It is only because of the ubiquitousness of these forms of understanding that we overlook their cost. When something is everywhere, it becomes hard to see. Such expansions of our powers do not occur without corresponding shrinkages. The visionary/idealist/symbolic tradition figures at least five interrelated losses: the loss of sensory and bodily reality, the loss of time, the loss of uniqueness, the loss of otherness, and the substitution of being for doing.

The Loss of Sensory and Bodily Reality
Where one's identity is so largely imaginative, life becomes an out-of-body experience. Insofar as characters glance their relationships into being, read each others' minds, and project their thoughts and desires more or less telepathically, they might as well be brains in vats communicating by video monitor.[9] Their identities

and interactions are dephysicalized. Like Marion Crane driving down the road in *Psycho*, they go up in a steam of thought and feeling. *Casablanca*'s Ilsa and Viktor and *Psycho*'s Marion and Lila do not really have physical identities. Can anyone even remember how they move, hold their bodies, or gesture? They have realized Ralph Waldo Emerson's dream of becoming "transparent eyeballs," but in the process (as he says in "Emancipation in the British West Indies"), their "skin and bones [have become so] transparent [they let the] "stars shine through."[10]

That is the explanation for one of the most paradoxical aspects of Hitchcock's work: the fact that notwithstanding all of the physical intrusiveness in his films (the stalking, attacking, slashing, and killing), there is almost no sensation of tactile contact between his characters. Where possession is so visionary, actual grabbing, touching, and holding are superfluous. When the world is carried up into the mind, its physicality and tangibility—the heft and rub and pinch of experience—are diminished. Where experience is made equivalent to states of consciousness and feeling, materiality is bled out of it. We feel that, even before we may understand it, from the aloofness and detachment of Hitchcock's cushiony camerawork. It puts the viewer at precisely the same distance from physical reality that his characters themselves maintain—frictionlessly gliding somewhere just above the physical world, unsullied by it, hermetically sealed off from contact with it, never dirtying its hands by messily engaging itself with it.

These films are machines for abstraction—in more than one sense of the concept. *Casablanca*, *Citizen Kane*, *Psycho*, *2001*, and *Blade Runner* give us events, objects, and actions swollen with imaginative significance, but drained of concreteness. The spacemen in *2001* go on an imaginative journey, not a realistic one. Kane's sled is a symbol of a lost childhood, not a physical object you could get splinters from. The house in *Psycho* is not a material building of wood and plaster, but a series of nested, ever more private imaginative spaces figuring bourgeois sexual taboos and repressions. The imaginative enrichments in these films are worldly impoverishments. (Contrast Marion Crane's meal in *Psycho* with the meal Antonio and Bruno eat in *Bicycle Thief* to appreciate the pervasiveness of Hitchcock's derealizations.)[11] Where depths are so important, surfaces are diminished in importance. Where experience is treated as a repository of secrets, its outside becomes something we reach through to get to reality.

The Loss of Time

The loss of sensory experience is paralleled by an even greater loss—the loss of time. We see this most obviously in the speed with which relationships between characters are established in visionary works. Because their identities are "ideal," characters can attain instant intimacy on the basis of shared intentions, feelings, and ideas (or become instant enemies on the basis of similarly abstract differences).

Because identities are mental, relationships can take place in fast-forward. Marion Crane sits down with Norman Bates and unburdens herself of her most private thoughts and feelings in the first fifty words she speaks. He does the same to her. Arbogast introduces himself to Sam and Lila and is their partner seconds later. Viktor and Strasser are sworn enemies before they ever meet. Berger pledges his life to Lazlo on the basis of a glance. Where heart speaks to heart and soul to soul, the time-bound awkwardness and pudency of nonvisionary relations are left behind.

The viewer's relationship to the characters and events of these films is as instantaneous as the characters' relationships to them. The meaning of people, places, and things can be taken in at a glance and transmitted from character to viewer more or less instantaneously because of the kind of knowledge it is: knowledge as insight rather than acquaintance. Knowledge (for both characters and viewers) can be this quick. It involves "seeing" something rather than living through it, recognizing it rather than experiencing it, "knowing it" rather than "getting to know it."

The difference between insight and acquaintance might be said to be the difference between "having a thought" and "thinking." Visionary knowledge is about perceiving a truth: Rosebud is an unfillable loss; Norman Bates is his own mother; X is Y. Getting to the end point is the goal. You solve a puzzle to arrive at its solution. Thinking, in contrast, is a way of functioning *in time*. It is an ongoing, continuing way of being in the world, a mode of alertness, sensitivity, and engagement that does not necessarily have any destination at all. In their commitment to unearthing secrets, clues, and revelations, visionary works define knowledge as a goal rather than a process. Characters and viewers suddenly "see" or "know" or "feel" or "think" something—or they do not. The ends of Hitchcock's movies—in which the main character and the viewer are served up a series of explanations that suddenly and completely explain the earlier mysteries—illustrate the atemporal stasis of the acts of "seeing" that occur in visionary works. There are lots of deadlines for knowledge in idealist works, but no sense of duration. Characters and viewers must learn things by a certain point or be penalized, and the attainment of the knowledge may be diabolically delayed (as in Hitchcock's deliberately torturous withholdings of information), but the learning, once it finally takes place, is instantaneous.

The visual and acoustic stylizations of visionary works are part of the detemporalizing of experience. The Strauss on the soundtrack of *2001*, the kick-lighting in *Blade Runner*, the elevated and depressed camera angles in *Citizen Kane*, the outsized sets and short lenses in *The Trial* offer summary, shorthand ways of knowing. These works may seem to be temporally organized, but their stylistic arrangements offer a series of snapshots out of time. Dates may change, and days may pass, but time

more or less stands still within each scene. They push the pause button on the ebb and flow of lived experience. From the point of view of the viewer (and frequently the character as well), understanding takes the place of undergoing.

We "get" these truths (about Joseph K's insignificance, Kane's megalomania, or the comical courtliness of the spaceships' docking) the way we get the punch line of a joke, the cleverness of a TV commercial, or the meaning of a Norman Rockwell painting. We do not live with and live into them the way we learn to appreciate a friend, a Beethoven symphony, or a character and situation in a George Eliot novel.

Such a vision of truth final, complete, and absolute may represent a gain for eternity, but it is a definite loss for life. Do we really want to live in a world in which truth is something that can be seen like a piece of furniture or known like a basketball score? Do we really want art that imagines experience to stand still like a block of ice, when it is so obviously on the move like a stream? As William James asks in "A World of Pure Experience," why do we expect truth to be "a static relation out of time when it practically seems so much a function of our active life?"[12] Outside the movies, it takes time to learn things or have meaningful experiences. It takes time for relationships to develop. It takes time for meanings to be made. The time is not something you can just factor out without changing the nature of the experience.

The Loss of Uniqueness

States of consciousness are impersonal, because thoughts and feelings (at least in the shorthand forms in which these films render them) are generic. Inner states inevitably lack the individuality of expressions. There are no fat intentions or thin intentions, no embarrassed or glib visions, no hesitant or assertive abstractions. Visionary forms of presentation lack the idiosyncrasy of expressions. Our visions are more or less alike; it is the nonvisionary aspects of our lives (our personalities, bodies, gestures, facial expressions, tones of voice) that make us different. We all want the same things. (Who does not want to be good, kind, just?) It is how we express our common intentions that makes us *us*. In this respect, a person's ideas, theories, goals, motives, and philosophies are the least personal (and least unique) things about him or her.

It would not be going too far to say that idealist characters do not really have characters. When your identity is equated with your thoughts, feelings, and aspirations, where life is equated with states of subjectivity, the complex expressive structures we call personality cease to matter. To the extent possible consistent with realistic narrative presentation, idealist work gives us "pure" thoughts, desires, and intentions freed from the impure mediations of personality. The content of a character's expressions is freed from the container of character. The sense of

the words is separated from the tones, timbers, and timing that make each expression unique.

The absence of expressive particularity, idiosyncrasy, and individuality in idealist film extends to the props, costumes, and events. In the initial romantic rendezvous between Marion and Sam in *Psycho*, nothing is particularized or unique. The hotel room might be *any* hotel room; the uneaten lunch might be *any* uneaten lunch; the beep of a car horn outside the window might be the beep of *any* car horn. Even the lover's quarrel is generic. The words and tones are generic. The lunchtime rendezvous is generic. One might reply that the hotel scene is a relatively unimportant one (and that hotel rooms are pretty standardized anyway), but the deindividualized nature of experience is just as striking in subsequent scenes in *Psycho*. When Marion packs her suitcase and flees with the money in her car, when she is stopped by the policeman, when she flees in the storm, when Norman Bates spies on her in her room, when he attacks her in the shower, when Arbogast offers his services to Sam and Lila as a detective, when he cross-examines Norman about whether Marion stayed at the motel, when he sneaks into the Bates mansion, when Sam stalls Norman, when Lila prowls through the mansion—it could really be *anyone* absconding with *any* cash, *any* driver stopped by *any* policeman, *any* voyeur spying on *any* woman, *any* psycho killer murdering *anyone*, *any* private detective searching for clues, and so forth. It could be anyone or no one. There are no individuals in *Psycho*. There are only generic events, generic responses, generic interactions.

It is not just events and actions that are made generic; personal experience itself is depersonalized. The uniqueness and individuality of characters' internal states is played down by idealist presentation. When one or another character in *Psycho* looks up at the Bates mansion, into Norman Bates's office, around Marion's motel room, or at objects in Mrs. Bates's bedroom, there is nothing to distinguish one act of looking, thinking, feeling, or knowing from another. There is no difference between Marion's looks, thoughts, and feelings and those of Arbogast, Lila, and Sam. There is just the impersonal visionary act and the generic emotion.

Actors *are* cattle in this expressive universe. You wheel them in, position them, light them in certain ways, photograph them from several different angles, lay in some music on the soundtrack, and the job is done: generalized mental states replace unique expressions. As John Cassavetes once said to me about mainstream film in general: "There's no behavior." The acting in most idealist/visionary works is as schematic as a Kuleshov experiment. A pantomimed "indication" of an emotion, an abstract "look" (glossed by the mood music that underpins it or the narrative events that precede or follow it) takes the place of a distinctive personal expression. An abstract statement of thoughts or feelings substitutes for the presentation of experiences too unique or changeable to be reduced to ideas.

The impersonality of the characters' existences is driven home by their narrative

interchangeability in visionary works. In *Psycho*, for example, as one figure after another is bumped off or given a new narrative assignment, the next instantly steps in to take over the previous one's duties. Lila can frictionlessly fill in for Marion and Sam take Arbogast's place because they are more or less indistinguishable links in a substitutional chain—narrative placeholders in clothes. There's not even any difference between the men and the women in this respect. At this level of abstraction, gender differences disappear. Everyman has become so generalized that he is no longer identifiably a man.

Far from being a failure or an oversight on Hitchcock's part, it seems clear that the omission of what Cassavetes called behavior was deliberate. As his entire oeuvre testifies, Hitchcock was not interested in expressive uniqueness, but cultural, emotional, and psychological archetypes—general, abstract, imaginative relationships and dependencies. His films are not about what makes us different and irreplaceable (our unique personalities and forms of expression) but what we have in common with everyone else (our dreams, dreads, desires, and fears).

Particularly in its pop culture manifestations, idealist film is founded on the belief in the possibility of group experience. Individuals are defined not in terms of what makes them unique, but by the characteristics they share with everyone else. Look at works otherwise as different from each other as *Citizen Kane*, *Sabrina*, *2001*, *The Graduate*, *Star Wars*, *Thelma and Louise*, and *Apocalypse Now*. The experiences in them have the phenomenological thinness (and ontological generality) of an allegory or a dream. There are no individuals in these films; everyone is a type. Experience is not unique and irreplaceable, but generic and generalized. The characters and situations are abstract markers for superpersonal imaginative positions. Nothing and no one is unique or unprecedented. In fact, like all mass culture/pop cultural expressions, these films would risk illegibility if their characters and situations departed too far from types. To reach the largest possible audience, to the maximum extent possible, they offer everyone's experience in general and no one's in particular.[13]

The Loss of Otherness

In downplaying expressive uniqueness, idealist expression erases personal differences. "Otherness" is lost, In the deepest sense of the concept—not meaning merely sexual, racial, or cultural differences—but alien consciousness in all of its forms. The exposure to otherness in this enlarged sense offers the opportunity to know in new ways, to see and hear with different eyes and ears, to feel unknown emotions, to be granted new powers of awareness, to participate in new forms of sensitivity. Because of their generic understandings, idealist works look in the other direction—toward an all-encompassing sameness of point of view, feeling, and thought.

Although it is often said that the identification process (which idealist works heavily rely on) encourages the viewer to "become" one of the characters, in fact the opposite is closer to what actually takes place: The viewer forces the character or characters to become her. That is to say, rather than going outside herself to inhabit an alien consciousness, the viewer makes the character over in her own image. It is an almost inevitable side effect of the nature of idealist expression. Because characters are kept expressively nonspecific, they function as Rorschach ink blots for a viewer to project her thoughts and feelings onto, as empty receptacles for feelings to be poured into. Rather than being forced out of herself, crashing up against the brick wall of a genuinely alien way of seeing and feeling, the viewer fills the character in with her own emotional and intellectual meanings.

It is precisely because these characters (and the actors who play them) are expressively nonspecific and open-ended that most viewers are so comfortable with them. Insofar as the visions in idealist film represent the point of view of no one in particular, they can become the point of view of anyone in general. The viewer is able to become the seer, to drop effortlessly into what is seen, precisely because no unique individual is doing the seeing. Every teenage girl watching *Titanic* is able to "become" the Kate Winslet character because the character has been robbed of every form of prickly, challenging individuality. The idealist vision fulfills Isabel Archer's dream of being *all* heart and soul, with no troubling Merle-like expressive limitations or particularities. Life is lived in the optative mood—where what you think and feel you are is what you are, which is why anyone can be anything. Idealist art is committed to a fundamentally easy and relaxed relationship between the viewer and what is viewed. But where the gap between self and others is closed so easily, so rapidly, so painlessly, no real learning or discovery can take place.[14]

Being Replaces Doing

I have saved the most serious loss for the last in my list: the loss of active engagement with experience. Idealist/visionary works foster a fundamentally contemplative relationship to experience. Individuals exist to think and feel, to read thoughts and feelings in others, and to allow their own thoughts and feelings to be read. Experience becomes an internal event. Idealist film comes very close to the late-eighteenth-century British cult of sensibility wherein your sentiments and intentions matter far more than anything you may or may not actually say or do. States of feeling and thinking take the place of acts of doing—a point that is almost comically illustrated in *Casablanca* by the narrative importance attached to Ilsa's *imaginative* and *emotional* relationship with Rick (and a viewer's imaginative and emotional appreciation of it) as contrasted with the perfunctory treatment of Viktor Lazlo's actual life and work. Notwithstanding Rick's remarks in the final

scene about how "the problems of three little people don't amount to a hill of beans in this crazy world," the entire film is devoted to proving the opposite: that what Rick and Ilsa *feel* for each other is more important than anything Viktor Lazlo *does* to save the world. (Even what Rick and Renault feel in the final scene is more important than anything they or anyone else may do as a result of it.)

In line with the fact that knowledge in idealist works is a form of insight rather than undergoing, knowing becomes an intellectual event. Knowing is not a way of moving through experience, but a set of truths to be discovered. Truth is out there to be perceived, separate from yourself; it is recognized, not made. Meaning is revealed as a set of abstractions to be contemplated, not created and used as a form of living. Hitchcock's work illustrates the passivity of this understanding of truth. The character is a reader of texts whose meanings exist independently of him. The texts can be cryptic or obvious, and one can be a better or worse reader of them, but one is still only a reader. Truth in these works is "spectatorial"—in both senses of John Dewey's term: passive rather than active, and mental rather than practical. Life becomes a matter of having feelings and thoughts, not a path of action.

Watch ten minutes of *Citizen Kane*, *Psycho*, *2001*, or *Blade Runner* and the point will be clear: In both the optical and imaginative senses, characters exist to see and be seen, and objects and events (a recluse's dying words, a spooky house on a hill, a mysterious monolith on the moon) exist to be seen into. Because idealist works prefer mental and imaginative relationships over physical interactions with experience, experience becomes something you *have* rather than *do*. It is about seeing, feeling, and thinking a certain way, adjusting your angle of vision—not about actually interacting with (and therefore creating the meaning of) persons, places, and things. Knowledge is a mental phenomenon, not a course of practical actions and events. Truth becomes something outside yourself that can be known, rather than a relationship between you and the world. You do not interact with the world in ways that potentially change it and you; you realize, understand, appreciate, feel what it already and unalterably is. You do not *make* realities in this world (children, families, personal relationships, works of art), you *discover* truths that would have been there even if you had never come along.

Idealist/visionary works cultivate spectatorial relations to experience in their viewers as much as they reward them in their characters. When Lila Crane walks through the Bates mansion, the reporter searches for information in *Citizen Kane*, or the astronauts try to understand the monolith in *2001*, the characters' relationship to experience *in* these films is indistinguishable from the viewers' relationship to the experiences *of* them. These works depict contemplative stances in their characters and cultivate them in their viewers. However, as the entire preceding discussion is intended to demonstrate, when experience is taken up into the mind, we may gain our souls but lose the world.

PRAGMATIC WAYS OF KNOWING

Putting Plato in His Place

There is an alternative expressive tradition, though it is far less familiar. I shall call it pragmatic modernism due to its affinity with the writing of Ralph Waldo Emerson, F. C. S. Schiller, William James, Oliver Wendell Holmes, and John Dewey. The differences between the pragmatic and the visionary/idealist/ symbolic positions could not be more striking. In idealist art, as in the Platonic tradition generally, reality is elsewhere—somewhere underneath the world of practical experience and ordinary life. Truth is dephysicalized, detemporalized, and abstracted. It is free from the impurity and contingency of temporal and spatial experience, located somewhere beyond the fluxional expressive surfaces of life in a purer realm of feelings, thoughts, and insights.

The pragmatic artist declines to make the contemplative move. He says that however mutable or hard to understand they may be, there are only surfaces, and that our job is (to adapt Emerson's metaphor) to skate on them. For the pragmatic artist, in William James's paraphrase of Chauncey Wright's formulation, "behind the bare phenomenal facts . . . there is *nothing*."[15] To put it in terms of the Isabel/ Merle dialogue I earlier alluded to: In the pragmatic tradition, we are *not* our pure, ideal intentions (what we aspire to be, want to be, or feel ourselves to be), but our actual, flawed expressions. We are not our deep ideas and insights, but our superficial appearances (what we express ourselves as, what we actually say and do). What shows is all there is. The pragmatic artist is committed to a profound superficiality—in the sense of the concept suggested by Oscar Wilde when he argued that it is only superficial people who do *not* judge by appearances.

Noncontemplative Truth

The pragmatic work calls both viewers and characters back into relation with the complexities and confusions of practical, worldly action and expression. The consequence is to change the conception of what it is to be in the world—or, to put it more precisely, to shift from understanding experience in terms of states of *being* to understanding it in terms of acts of *doing*. Idealist/visionary works ask characters to be; pragmatic works insist that they *enact* their being. Visionary filmmaking is Platonic. Above everything else, it values insight (depicting it in characters and cultivating it in viewers). Pragmatic art insists on the priority of performance (or what William James calls "practice"). Experience is not a matter of perceiving and attaining states of being, but of performing acts of doing. The pragmatic work tells us that it is not sufficient to encounter and possess the world imaginatively; we must interact with it physically, socially, verbally. The pragmatic work tells us that

the world exists not to be seen into, not to be "known" contemplatively, but to be negotiated, manipulated, and "undergone" (in Dewey's term).

Skating the Surfaces of Life

The best way to define a form of filmmaking so opposed to states of abstraction is not abstractly but by example. Although the pragmatic aesthetic finds its finest flowering in the work of a number of postwar American independent filmmakers, there are many non-American examples. Jean Renoir's *The Rules of the Game* is a particularly useful starting point because it lends itself to comparison with *Casablanca*.

Whereas Curtiz insistently moves inward, putting characters' thoughts and feelings on display, Renoir holds his viewers on the outside of life. Characters in *Casablanca* are transparent; we can see into the most secret recesses of their hearts, or they wear them on their sleeves (either by telling us their inner states or by the film's stylistic effects writing their thoughts and feelings on the screen in letters ten feet high). Figures in *The Rules of the Game* are opaque; we cannot read their minds or sink a mine shaft into their souls. Renoir holds us in the realm of behavior, studying impenetrable surfaces. Characters are their insides in *Casablanca*. In *The Rules of the Game*, insides are not only not invisible, they do not really matter. As a line of dialogue tells us, "Everyone has their reasons"—which is a way of saying that your "reasons" for doing something do not matter one way or the other.

Robert, Octave, Jurieu, and Christine will not be reduced to their intentions, goals, desires, or ideals, because for Renoir consciousness can never be disentangled from the forms in which it is embodied. It might be said that for Renoir and all pragmatic filmmakers, consciousness does not exist (at least in the way that idealist works posit it). Consciousness (by whatever name it is called: thought, emotion, imagination, vision, awareness, insight) is merely the name idealists give to their belief that there is an unconditioned, free place independent of or anterior to flawed social expression. Pragmatic artists do not believe that any part of us can float free of social, personal, and historical contingencies in this way. Consciousness cannot be decoupled from those expressive limitations and particularities (including the ones we call "character"), which is to say we might as well stop talking about it.

For Renoir, we are not our internal states, but all of the things that express them: our behavior, tones of voice, facial expressions, gestures, movements, manners, styles of expression. To say the obvious, it is not that Renoir's characters do not have ideas or feelings, but that the pragmatic film refuses to uncouple them from the practical expressive acts in terms of which they manifest themselves. You cannot get to consciousness without going *through* and, to a large extent, remaining *within* expression. Forms matter. Unexpressed, silent, private consciousness (the staple of idealist film) is a fiction.[16]

Idealist film traces experience back to states of subjectivity for the same reason that many people go through life trying to figure out other people's motives and intentions. By reducing the complexity of expressions to the simplicity of intentions, we clarify what is obscure and unify what is diverse. Subjectivity represents a transcendental, resolving understanding—a way of knowing sprung free from the contingencies of history, culture, and gender, and the obliquity of manners and personality. States of subjectivity offer a foundation for understanding that leaves behind the interpretive challenges of actual expression. (How complex, mutable, and inscrutable facial expressions and tones of voice can be; how much simpler to understand are intentions signaled by lighting effects, mood music orchestrations, actions, or utterances.) But like all foundational understandings, idealist understanding inevitably depreciates the surface experiences that it underpins. When life is defined in terms of consciousness, the parts of it that will not be traced back to and reduced to feelings, intentions, and ideas are downplayed.

Truth in Spaces, Times, and Bodies

In idealist works, meaning stands free from the intricacies and compromises of wordly expression. Our understanding of Rick's, Viktor's, Ilsa's, or Sam's words and glances is not deeply affected by the nuances of the delivery of their lines or how they walk, move, and gesture. Christine, Jurieu, Robert, and Octave can never be reduced to abstract statements and sentiments. Their expressions are mediated. Content is contained. Everything Renoir's characters are is inflected by their individual body types and ways of moving (compare Robert's with Octave's), ways of dressing, vocal tones and speech rhythms (compare Christine's with Genevieve's with Lisette's), facial expressions, and mannerisms (compare Marceau's with Jurieu's). That is to say, their *being* is inseparable from its *doing*. Renoir's films are celebrations of expressive particularity, uniqueness, and idiosyncrasy, not merely to give variety to the delivery of the lines, but because in his conception of life these differences make a difference.

It is not an accident that when we remember films like *2001*, *Blade Runner*, or *Apocalypse Now*, we remember disembodied visions, images, or abstract statements, whereas when we remember a film like *A Woman under the Influence*, we recall a hundred sensory details: the different shapes of the children's bodies in their swimsuits, the touching way little Maria walks up the stairs or Mabel hops across the lawn on one foot, Dr. Zepp's greasy, owlish appearance. The abstract meaning of a character's words matters less than the sounds of their voices; *what* they say matters less than *how* they say it: in this instance, Nick's orders-from-headquarters talking *at* people tones contrast with Mabel's shyer and more vulnerable tones. For Renoir, Cassavetes, and all pragmatic filmmakers, what you are is not hidden in the

depths of your heart and soul, but visible right on the surface, expressed by your body, your facial expressions, your behavior, your pacing, your timing, your tones of voice.

Personal Truth

Idealist works are implicitly committed to the possibility of superpersonal knowledge. Hitchcock can stand as an illustration. Although truth in his work generally emerges as the result of one person's efforts and vision (usually the main character's optical and psychological point of view), the end result is the attainment of an ideal understanding in which the point of view of the main character, the director, and the viewer is merged into an objectively verifiable truth. Personal knowledge gives way to impersonal. When Lila Crane finds out the truth about Norman Bates, when Jeff finds out the truth about his neighbors, when Scotty finds out the truth about Madeline, when a viewer finds out the truth about Rosebud, when the astronauts find out whatever they do in *2001*—what is discovered is imagined to be out there to be found. Knowledge is independent of the knower. The thought is sprung free from the particular person who thinks it.

For the pragmatic filmmaker there can be no view from nowhere, no understanding that is not understood. Expressive and perspectival differences can never be factored out. Truth is personal. It cannot be separated from the ways that it is brought into existence—the emotional colorations of particular characters' personalities, their unique acts of intellectual shaping, their specific emotional structures of feeling. For Renoir and Cassavetes, as for a portrait painter or a choreographer, there can be no truth outside of the specific bodies, faces, costumes, manners, and personal styles that express it. Personally *unexpressed, uninflected* truth—truth in general—is a meaningless concept.

Multiple-mindedness

The magisteriality and authoritativeness of idealist lighting and camerawork figure the conviction that there is a best possible way to see and hear everything. Though an idealist filmmaker like Hitchcock may occasionally provide flawed and imperfect visions of reality—deliberately withholding a necessary piece of information, encouraging a misunderstanding, giving a misleading view of the world— to stoke up the suspense, the very premise of idealist style is that from some point of view everything that matters can be perfectly seen and understood. The attainment of that correct view generally occurs in the final scenes of the film.

The pragmatic filmmaker rejects the concept of an "ideal" view, a final truth, a unitary understanding. In William James's term, the world is pluralistic. That is to

say, there are a variety of paths through experience, none superior to or more final than the others. Whereas the single-mindedness of idealist work is implicitly intolerant of variety, pragmatic work embraces it, believing experience is too complex to be reducible to any one understanding. Pragmatic works like *The Rules of the Game*, *Bicycle Thief*, *Faces*, *A Woman under the Influence*, *What Happened Was*, *Mikey and Nicky*, and *The Wife* are committed to honoring many different relations to experience, many different personal perspectives—none necessarily superior to any other. The single-mindedness of idealist style is replaced by multiple-mindedness.

There is always a "right" place to look and a "best" way to understand things in Hitchcock, but in *A Woman under the Influence*, the spaghetti breakfast, the whistling on the bed, the homecoming gathering around the table, and the standing on the sofa scenes force the viewer to hold four, five, six, or more, different (and sometimes conflicting) viewpoints in mind at once, each of which is equally important and valid. There is no right (or wrong) way to speak or act, no best way to think or feel, no ideal truth to attain. Rather than aspiring to rise above the partiality and diversity of different points of view, these films appreciate them and give them full play.[17] Actors and characters in these works are encouraged not only to look, act, and sound as different as possible from other actors and characters, but also as different as possible from themselves at other moments.

Pragmatic Style

A number of specific stylistic differences create these different understandings of experience. The general heading they all fall under is that pragmatic film jettisons point-of-view photography and the subjectivity editing convention to employ photographic techniques that resemble documentary filmmaking.

Giving the Soul a Body

Since subjectivity is their subject, the most important dramatic moments in idealist works are almost always presented in terms of medium-close and close shots that focus the viewer's attention on characters' facial expressions and eyes (which serve as windows into their souls). Although *The Rules of the Game* and other pragmatic works do not eliminate close-ups, they generally favor long- or medium-distance photography in which a figure's face and eyes do not command such an inordinate amount of attention. Pragmatic film lowers the expressive center of gravity, moving it downward from the mind to the body. Characters' souls are not separated from their bodies, movements, and gestures. When your spirit is not confined to your mind but includes your fingers and feet, actions and gestures, the understanding of the soul changes.

A second effect of favoring medium and long shots over close-ups is that characters are not conceived as being essentially separate from one another (as imaginative identities necessarily are), but are understood to bring themselves into fullest existence in their interactions with others. Even scenes in *The Rules of the Game* that employ medium and close shots of a central figure, like the one in which Christine greets Jurieu, almost always have other characters visible in the background or on the sides of the frame (or are intercut with reaction shots of other characters). Insofar as what we are is not a secret hidden inside us, but a product of our visible, public expressions of ourselves, identity is relational.

The Ninety-degree Turn

Since idealist film is so deeply committed to making the character's thoughts and emotions the subject of the shot, in important scenes the actor's face is almost always turned either directly toward the camera to provide maximum visibility or directly away from it to allow the viewer, as it were, to see through the character's eyes. We look directly at Jack Nicholson's face and into Meryl Streep's eyes unless we look through them. In contrast, pragmatic films frequently introduce a ninety-degree angle between the direction the character is facing and the direction the camera faces. The character turns inward to interact with his group, sitting, standing, moving at an angle to the camera position. In idealist film, the character plays to the camera and for the viewer; in pragmatic film, the character functions more or less independently of the camera position, playing to, for, and with the characters around him.

The effect is totally to alter the cinematic experience: The viewer is not inside the characters' heads, sharing their perspectives, seeing through their eyes, but is off to one side of them, looking at them, at a certain distance from them (optically, physically, and imaginatively). The viewer is not inside the scene living it, but outside it, overhearing it. The world exists not as a series of feelings to be shared and minds to be inhabited, but as a collection of alien bodies, voices, movements, and actions to be encountered. Merging gives way to grappling. A world of subjectivities is replaced by a world of objects.

Rather than conflating the perspective of the viewer and the character, so that the viewer effortlessly becomes the character, frictionlessly blending into the character's point of view and participating in it, pragmatic style opens a chasm between the points of view of the characters and that of the viewer. A gap is created that must be reached across. The mystery of genuine "otherness" is born.

The character's point of view is no longer open to the viewer, but is turned away, invisible, and hidden—potentially inaccessible and unknowable. Rather than being on the inside looking out, as in idealist works, the viewer is positioned outside of

*Figure 6. The ninety-degree turn (*The Rules of the Game*)*

private, inward-turned events.[18] (Compare the shots reproduced from *Psycho* and *Casablanca* in Figs. 1–5 with the ones from *The Rules of the Game* in Figs. 6 and 7.)

Genuinely New and Alien Forms of Consciousness

The difference between the two sets of shots is ultimately the difference between a gathering of *us's* and a gathering of *them's*. We can know idealist characters and experiences the way we know ourselves and our own experiences. We are inside them the way we are inside ourselves, intimate with their most secret needs, fears, and wishes. The most we can know pragmatic characters is the way we know someone else. We eavesdrop on a world that exists and moves independently of us, that does not open itself to us but, in fact, veils itself from us and resists imaginative appropriation.

We cannot mindlessly drop into the experiences on screen but must struggle with them, because they are not schematic representations of general imaginative states, but detailed depictions of complex expressive acts. We cannot effortlessly identify with the characters—frictionlessly "becoming" them or having them "become" us—because of their differences from us. They are highly particularized, unique figures who offer new and potentially bewildering forms of feeling and knowing. Because they deviate from our customary emotional habits and intellectual patterns, the gap between them and us is hard to bridge. Even as we reach out to close it, we simultaneously register the impossibility of doing so. The consequence is to induce a double movement—out of ourselves *and* back into ourselves. We are teased and tricked out of our own ways of thinking and feeling to some extent, even as we are simultaneously forced back on our independent critical judgment to make sense of the difference between them and us. Yanked out of our conventional perspectives, we recoil back into them to discover them as if for the first time under the pressure of having been removed from them.

The *value* of these experiences is our struggle with them. The struggle is not something to work through and get beyond. The emotional and intellectual uncertainties, confusions, and divisions of allegiance are the vehicles for whatever learn-

*Figure 7. Multiple points of view (*The Rules of the Game*)*

ing and growth take place. I would note in passing that this registration of other-ness is central to the encounter with most great works of art. The experience of reading James's *The Sacred Fount*, looking at Sargent's *Madame X*, and watching Shakespeare's *Twelfth Night* or Paul Taylor's *Esplanade* is not one of seeing *ourselves* and *our own* ways of being, but of registering a shocking, exhilarating, challenging *difference* between the work and our ordinary perception of the world. The size of the gap is a measure of the degree of otherness that these works expose us to. If the work is a very strong one and the difference a large one, it takes us out of ourselves. It forces us to put our terms and understandings aside and enter into new ones. It teases us out of our old ways of seeing, thinking, and feeling and into a different state of consciousness. It gives us, at least temporarily, new powers, sensitivities, and capacities of awareness.

Unanalyzed Experiences

The style of *Casablanca* and *Psycho* more or less continuously dictates the viewer's interpretations. She is told what to look at and why it matters, and is given plenty of time to figure things out. Objects, events, interactions, and lines of dialogue are given definite, univocal meanings. In contrast, pragmatist works like *The Rules of the Game*, *Bicycle Thief*, *Faces*, and *Mikey and Nicky* situate the viewer in a perceptual space in which there is much more to see and take in, less direction on where to look, less definiteness, and more openness about what it means.

Important characters are not necessarily centrally positioned or key-lighted but are allowed to move around within the frame space—or even out of it. Rather than tersely cutting from important point to point and person to person (as the shots in Figures 2, 3, and 4 do), the camera may rove, noticing events and groups of characters here and there, occasionally taking in bits of background or foreground business that might not be strictly relevant to the main action. Experiences are to some extent unanalyzed. They are not cut into bite-sized pieces (in the form of close-ups) and prepared for easy consumption (with editorializing stylistic glosses), but are kept fairly whole and unprocessed (with fill-lighting, medium and

*Figure 8. Complex, unanalyzed visual spaces (*The Rules of the Game*)*

long shots, group interactions, the absence of musical scoring, and nontendentious narrative placement). Experience is served slightly raw or uncooked. Rather than having his eye directed, his focus clarified, and his interpretation narrowed, the viewer is left a little to his own devices—at least a little free to decide where to look around in the frame, what to pay attention to, and what to think about it. (Notice the visual complexity of the shots reproduced from *The Rules of the Game* [Fig. 8] and compare them with the simpler and shallower visual spaces of the shots from *Psycho* and *Casablanca*.)

Partial, Provisional Meaning

The pragmatic work is semantically loose-jointed. It imagines a universe in which objects, events, characters, and utterances have a more relaxed, less determined relation to meaning than in the visionary work—not only less tightly tied to any one meaning, but also potentially linked to different and perhaps contradictory meanings at the same time. It allows for the possibility of there being different understandings of the same experience. The feeling is communicated that there is more to the world than can be seen or known at any one time, and more possible relations to it and interpretations of it than any one view can include.

Because they treat experience as being semantically a little random or casual, pragmatic works go against the grain of our preferred ways of understanding. We want semantic clarity, definiteness, and definitiveness. Intense and pervasive meaningfulness is frequently understood to be the very definition of artistic expression. Isn't it, after all, the greatness of films like *The Trial, 2001, Apocalypse Now, Blade Runner,* and *Citizen Kane* that essentially everything in them—every shot, prop, camera angle, line of dialogue—clearly and definitively *means* something—something even the lowliest freshman can take in at a glance and decode?

Even putting aside the ways such semantic overdetermination pushes the viewer around, denying interpretive room to breathe, it is worth pondering the aspects of experience that are left out when it is made so semantically coherent: its casualness, accidentality, and adventitiousness; its repetitiousness, digressiveness, and loopi-

ness; its eccentricity, strangeness, and sheer unknowability. To borrow one of Robert Frost's metaphors, if experience is a tent swaying in the breeze, the semantic overdetermination of mainstream art film hammers in the pegs and pulls the guy wires so taut that it removes the interesting wrinkles and wiggle. It takes the play out of life. The pragmatic artist loosens the chains of causality and frustrates or delays understanding to allow a little life (or what William James in *Some Problems of Philosophy* calls "novelty") back in.[19]

Perceptual Relations Replace Conceptual

In *Psycho, Casablanca, 2001*, and other idealist works, just as experience becomes a mental event for the characters, it becomes a mental event for the viewer. Because sound and lighting effects are employed to evoke emotional and intellectual truths, and objects and events are turned into symbols or representations of abstract imaginative truths, the viewer's attention is redirected away from perceptual surfaces to a realm of mental and spiritual depths. The effect is not only to create a powerful impression of meaning undergirding the perceptual surface, but also to distance the viewer ever so slightly from what is seen and heard to a consideration of what it means. The viewer of idealist films is placed in the same slightly abstracted relationship to experience that the characters in the films are—systematically translating from perceptions to conceptions, from sensory experiences to imaginative meanings. Reality is subtly de-realized. The process of learning *about* an experience rather than actually *having* the experience.

Art as Experience

The pragmatic film takes away the aboutness. To watch *The Rules of the Game, Bicycle Thief, Faces, Mikey and Nicky,* or *The Wife* is to be put in the position of uncertainly responding to a shifting, unpredictable sequence of perceptual events not unified by or underpinned by abstract meanings. The viewer cannot make a clarifying move from the muddiness of expressions to the clarity of intentions, from the turbulence of perceptions to the stasis of conceptions. To view group interactions in these works is less to learn *about* a group of characters and situations than to have something resembling the kind of experiences we would have if we were actually thrown into similar situations with similar figures. We are thrust into unglossed, raw experiences, to which it is impossible for us to entertain a contemplative relation. We are denied intellectual distance and control over the experiences presented, forced to remain on the qui vive, surfing the leading edge of a breaking perceptual wave, without being able to anchor understanding in an abstract conceptual system. In this situation, a fundamental perceptual shift, which I

would call the pragmatic turn, takes place: Undergoing replaces understanding. *Living in* space and time takes the place of arts of knowing *outside of* space and time. Thinking gives way to experiencing.

Living beyond Consciousness

When one argues that pragmatic works hold a viewer in the realm of the visible rather than letting him dive down into a clarifying spiritual or conceptual depth, it is important to emphasize that it is not that depths are concealed but that they *don't exist*. Two early works by Mike Leigh can throw light on the situation. *Bleak Moments* dramatizes the relationship of a young woman, Sylvia, with two young men: Norman is a gawky, taciturn lodger who rents a room in her house; Peter is a somewhat older and relatively more poised professional who lives in her neighborhood. It is clear that both men are as hungry for companionship and possible romance as Sylvia is, but what separates *Bleak Moments* from idealist cinematic presentations is that, beyond establishing the three characters' shared desire for companionship, Leigh provides almost nothing in the way of access to their motives and intentions. Sylvia's, Norman's, and Peter's thoughts, goals, plans, and desires are neither verbalized, translated into dramatically pointed looks, nor summarized in mood music or lighting effects.

A later Leigh work, *Meantime*, does something similar in terms of another threesome—this time a triangle involving the relationship of Mark and Colin, two brothers from a lower-class background, and their middle-class aunt, Barbara. As in the other film, Leigh establishes a few general dramatic tensions and inequalities: We see that the brothers are in a competitive relation with each other and that the aunt feels sorry for one of them (Colin) and wants to help him and to encourage him to break free from the other brother's (Mark's) influence. But beyond these basic tensions, the film denies access to Mark's, Colin's, and Barbara's thoughts, feelings, and desires.

The basic conceptual insights and metaphoric forms of understanding that idealist film trades in are simply unavailable in either work, which means that from scene to scene, the viewer is left guessing about the direction a personal interaction may take, what a character will say or do next, and, above all, what precisely a character intends by what he or she says or does at a particular moment. For viewers accustomed to Hollywood's luxurious displays of subjectivity, the experience can be frustrating, bewildering, or downright maddening. Watching Leigh's group interacting is a little like being a stranger attending a family gathering where there is lots of hidden history and unspoken emotional agendas. Clarifying, resolving, "deep" understandings are unavailable; all there is are shifting, complex surfaces. Answers to important questions are unattainable. Specifically, in *Bleak Mo-*

ments: Is Norman romantically interested in Sylvia? Is Sylvia offering herself to Norman? When she teases Peter, is she flirting or mocking him? In *Meantime*: Is Mark out to help Colin be independent or trying to keep him under his thumb? Does Barbara have Colin's interests at heart or her own? Are she and Mark acting selfishly or altruistically?

These questions are not answered, not because Leigh is withholding information, but because they are *not answerable*. The reason that we are not told what Sylvia, Peter, Norman, Barbara, Mark, and Colin really "want" from each other, what they "mean" when they say something, or what their fundamental "intentions" are at a given moment is that such "essential" states of thought and feeling simply do not exist.

As potential lovers getting to know each other, Sylvia, Peter, and Norman themselves really cannot understand their relative positions or know what they want from each other—or whether they want anything at all. Given their situation, such a concept of "knowing" or "intending" is meaningless. These characters do not have basic "motives" or "goals." They do not have "plans" for their relationship. They do not have "visions" of what they "desire" or "need." They do not have secret "wishes" or "ideals" that would clarify things if only we knew them. There is no realm of deep "feelings" or unexpressed "intentions" to get to. There is no substructure of essential "thoughts," "feelings," and "ideas" that can resolve and simplify the genuine vagueness, open-endedness, and unformulatedness of these interactions—and if there were, these scenes would not be worth bothering with. Sylvia and Peter feel their way toward or away from a romantic relationship step by step, and if we are to appreciate the intricacy, sadness, and beauty of their emotional dance it can only be in the same step-by-step way. Colin, Mark, and Barbara play a chess game in which they can never see beyond the current move, and the viewer must learn to function in the same move-by-move way.

Fake Mysteries and Real

Hitchcock and Curtiz (and other idealist/visionary filmmakers) may withhold information about characters' fundamental feelings, thoughts, and intentions or conceal the true meaning of a scene or interaction in a way that creates an effect superficially similar to what the pragmatic artist does; but the difference is that, though a meaning may be temporarily hidden, it is still there and is eventually revealed. The pragmatic denial is more fundamental. It is a denial that life is organized (and comprehensible) in terms of essential, unifying states of consciousness, a denial that fluxional surface expressions are underpineed by essential "deep" meanings.

The mysteries in pragmatic works are real, whereas those in Hitchcock's and

Welles's work, Quentin Tarantino's *Pulp Fiction*, David Mamet's *House of Games*, and Brian DePalma's *Dressed to Kill* are fake. The mystifications in those films can ultimately be gotten beyond (like those in a Sherlock Holmes story). The mysteries in pragmatic films never can. There is nothing to resolve, no secret to uncover, no answer for the next scene to reveal. The mysteries in pragmatic films are not tricks introduced to hold our interest or stoke up dramatic suspense—but are unavoidable side effects of the genuine complexity of the events and characters. They are not something added to a situation; they are just how things are—evidence of an irreducible density in experience that, in the course of the film, we never get beyond, but must learn to live into.

The Mystery of the Visible

Leigh's Norman may seem superficially similar to Hitchcock's; Leigh's Sylvia may seem superficially similar to Hitchcock's Marion. Both sets of characters are fairly secretive, private, and shy. Both seem fairly mysterious. But the difference is that in Hitchcock the reason for the secretiveness is that the character has a secret (concealed thoughts, desires, or actions)—which is to say that there is not any real mystery at all, since once the character's thoughts and fears are revealed, the mystery disappears. The mystery in Renoir's, Leigh's, May's, and Cassavetes's worlds is not premised on a secret. It is not in the depths but on the surface; not in the realm of the invisible, but the visible.

Another way to think of this situation is to notice that Hitchcock usually generates mystery by giving his characters two identities—a public and a private one, nested inside one another like Chinese dolls. Although the discrepancy between them creates whatever mystery there may appear to be, there is actually no mystery in either identity by itself. Each one is coherent, consistent, and intelligible; the gap between them is the only source of mystification. Leigh's characters have only one self. There is no secret identity behind or beneath the surface one. The mystery is in the self that shows—which is a much more complex situation. It is the same mystery that we find in Chekhov's or Faulkner's most interesting characters; in the title characters in *Husbands* (who genuinely don't know what they really want or feel); in *The Killing of a Chinese Bookie*'s Cosmo Vitelli, who does not understand his own emotional needs and desires; or in *What Happened Was*'s Mickey, who is too confused even to know he is confused.

Characters beyond Character

In idealist film apparent vagaries of behavior and expression are harmonized by being traced back to a central, unifying center of selfhood. In fact, the simplicity of

its characters is one of the things that makes Hollywood film (the most extended body of idealist cinematic work) so satisfying to most viewers. However diverse a figure's momentary expressions, personal identity is ultimately revealed to be essentially simple, static, and unitary.

At the muddy bottom of the food chain, in the simplest of action pictures, the *Die Hard*s and *Rocky*s, the characters are more or less completely defined by a few practical goals (e.g., capturing the terrorists) and personal characteristics (e.g., rugged sex appeal). In slightly more sophisticated works like *Casablanca*, *Citizen Kane*, and *North by Northwest*, selfhood is only slightly more complex. Figures like Rick Blaine, Charles Foster Kane, and Roger Thornhill may be shackled with mistaken identities and have qualities or motives that are not revealed to other characters or to the viewer for much of the films, but in the end a dominant identity is ultimately revealed that unifies the apparent diversity.

Although the character may display apparently contradictory characteristics in the course of the film, the differences are ultimately harmonized in a deeper understanding. Both Rick's initial cynicism and his subsequent commitment are revealed to be connected with his earlier romantic relationship with Ilsa. Kane's kaleidoscopic succession of tones and moods (boyishness, charm, buoyancy, swagger, braggadocio, acquisitiveness, nastiness, superciliousness, megalomania, cynicism, rage, and despair) is resolved by being seen as the expression of an unfilled emotional void. The initial heterogeneous understandings are ultimately unified by a subsuming, final understanding. The character in effect stands still—more or less consistently being, acting, and uttering an unchanging essence throughout the film, while the viewer digs deeper and deeper toward the Rosebud that explains it all. What William James ironically wrote in "Pragmatism and Humanism" about the idealist worldview might describe the idealist conception of character: "We live upon the stormy surface; but with this our anchor holds, for it grapples rocky bottom."[20]

The pragmatic filmmaker does not understand personal identity this way. He does not believe that our identities are organized around a central essence, quality, intention, or goal. He is not convinced that the heterogeneity of our experiences and expressions necessarily reflects a central unity, and to pretend that it does is to tell a lie about them. Compare any of Cassavetes's most interesting figures with Norman Bates, Roger Thornhill, or Scotty Ferguson for a crash course on the difference. Though Norman (the most complex of the three) temporarily eludes understanding, he is ultimately revealed to be quite simple. As the psychological explanation that concludes *Psycho* emphasizes, the apparent diversity of his previous expressions is ultimately unified under the rubric of his "mother complex." There is no comparable explanatory key to the main characters in *Faces*, *A Woman under the Influence*, or *Opening Night*. As the title of the second film suggests, Cas-

*Figure 9. Meanings in motion, relationships on the move—pseudo-documentary photography with camera placed off to the side, figuring no particular point of view, circulating the viewer through many different views, neutrally observing (*Faces*)*

savetes's protagonists function less as a definable bundle of attributes than as tuning forks resonating within shifting force fields of "influences." The self as a fixture is dissolved; its boundaries are made permeable; it bleeds into others and lets others bleed into it. In fact, substantives like "selfhood" are too static and bounded to capture the mercuriality of these figures' streaming identities. Chet, Jeannie, Mabel, and Myrtle are less nouns than verbs, less entities than energies, less sets of characteristics than shifting capacities of responsiveness.

To live through the shifts of beats and tonal flickers in the dancing scene in *Faces* (in which two men vie for a woman's affections, and all three keep changing their relationship to each other), or the tonal swoops, imaginative pirouettes, and social adjustments of relationship in the smashed wristwatch scene in *Mikey and Nicky*, or the emotional reconfigurations in the scene between Nicky and his wife in the same film is to find an exhilarating dramatic analogue to the ideal that Whitman articulated in *Democratic Vistas*—of "variety and freedom . . . [and] full play for human nature to expand itself in numberless and even conflicting directions." It is important to emphasize, however, that Whitman's (and the pragmatist's) understanding of the meaning of "variety and freedom" is different from the under-

standing of those terms most common today. Our culture is less interested in the claims and powers of the individual imagination than in sociological descriptions of group behavior, so it is not surprising that our era favors a merely external definition of these words, construing "variety" in terms of racial or sexual diversity, and "freedom" in terms of social, political, and economic possibility. But, as Whitman's own poetry demonstrates, the most glorious manifestation of "full play for human nature to expand itself" is the power of individual *consciousness* to elude containment or prediction.[21] The forms of freedom (or enslavement) presented in *A Woman under the Influence, Faces, Mikey and Nicky*, or *The Wife* are not political or ideological, but imaginative and emotional. When it is defined as an imaginative rather than a sociological achievement, freedom does not represent a position to be attained and held, but a capacity of movement that leaves all fixed positions behind, including the position we customarily call "character."

Self-creating Expression

It is important to register the difference between the pragmatic appreciation of character as not being reducible to "character" and the critical praise lavished on Norman Bates, Hannibal Lecter, and other Hollywood figures because of the alleged complexity of their having "multiple personalities." Norman *seems* complex because he combines personal styles and characteristics that are usually kept separate (maleness and femaleness, maturity and childlikeness, heterosexuality and homosexuality, nurturing and threatening, cleanliness and butchery, cunning and timidity). But, as that list indicates, he is still constructed out of formulas for selfhood. Norman's dramatic cross-dressing actually affirms his dependence on conventional categories of selfhood. (What else are qualities like maleness and femaleness, heterosexuality and homosexuality, maturity and childlikeness but paint-by-numbers conceptions of personality?) Norman is the product of a recipe that combines ingredients that are usually not mixed together, but a recipe nonetheless. Compare him with Mabel Longhetti. Mabel is not a quick-change artist who jumps from one received style or tone to another, but a creative artist of her identity, free from indebtedness to all prefabricated roles, tones, relationships. To watch Mabel, Chet, Jeannie, Myrtle, Seymour, and Sarah Lawson (or Elaine May's Nicky) is to watch identities and interactions with others that are exhilaratingly, even a little scarily, undefined.

In the pragmatic understanding, identity is genuinely nonfoundational. Rather than being nailed down to an underpinning, unifying state of subjectivity, it is allowed to reconfigure itself in a shifting series of movements and countermovements. The self can reform itself as it goes along, turning on itself to critique itself, altering its tones as it moves through experience. The self is potentially mercurial,

watery, flamelike. Characters can change their minds, break their own patterns, and swerve away from their own past tones, moods, and styles. They can present a sequence of behaviors that will not necessarily snap into focus. They can surprise us—and themselves.

Does Consciousness Exist?

There is *no* Mabel—no stable core of subjectivity—underneath or prior to her particular expressions of herself. There is no "self," no bundle of subjectivity separate from its shifting manifestations. Consciousness does not precede and underpin expression. In this understanding of experience, as William James argued, consciousness does *not* exist as an anterior, defining state. There is only expression—mutating, unpredictable, and endlessly creative expression. The most interesting pragmatic characters are genuinely open-ended. Their identities are never formulated, never finished, ever in process, which is why the best way to describe these figures is to think of selfhood not as a state to be attained but as a capacity of movement away from every fixed state. Identity is the tracks left behind by a continuously adjusted path of doing.[22]

Acting Up on Screen

Pragmatic works encourage a different kind of acting from essentialist movies. Traditional American film acting, having developed hand in glove with the idealist forms of presentation favored by Hollywood film, asks the actor to base his character on an originating, controlling subjective state. The actor works from the inside out—deciding on a deep reality and only afterward adding accents, manners, and gestures. The actor's task is to stay in touch with an essential center of consciousness. The outcome, at its best, is the inwardness and intensity of the classic Method acting of Montgomery Clift, Marlon Brando, and James Dean.

Because it is based on creating and cultivating states of individual consciousness, this kind of acting is inevitably individualistic. Whatever their other strengths, the major American film actors—from Dean, Clift, and Brando in the past to Jack Nicholson, Robert DeNiro, Harvey Keitel, Meryl Streep, Christopher Walken, Crispin Glover, and Nicolas Cage more recently—perform their work essentially alone. No matter how many others are present on camera with them, they are seldom genuinely responsive to anyone else. Nicholson steals every scene he is in, controlling the beats, mugging, clowning, doing "star" turns. Keitel delivers his dialogue passages as if they were monologues. Walken, Cage, and Glover communicate the effect of being tuned in to private frequencies that no one else can hear. They wrestle personal demons. They do lots of interesting things, but they do them

more or less on their own—by themselves and to themselves, reaching into their own private reservoirs of feeling and knowledge.

Pragmatic acting goes in the opposite direction. Since it imagines selfhood not in terms of the creation and maintenance of states of private subjectivity, but as a flowing, dynamic process of open-ended responsiveness, it says that rather than burrowing ever deeper into himself, the actor's job is to reach outward ever more sensitively. Whereas Method acting creates isolated packets of inviolable selfhood, the pragmatist says that, like Mabel, Chettie, Jeannie, or Sarah, we create ourselves in negotiation with others and share our identities with them. Identity is not the result of maintaining the integrity of a deep private self but is created, adjusted, and re-created in social interaction. Creativity is not the product of a deep inward consistency but of nimble, flexible responsiveness. We renegotiate who we are with every beat of every interaction. To act is to interact.[23]

Experiential Swerves and Interruptions

What is true of personal identity in nonfoundational works is true of all aspects of experience: It is opened up. The pragmatist does not believe that experience can be mapped in terms of progress along a one-dimensional narrative path. The classic screenwriting formula that "a narrative is a character with a goal, confronted with an obstacle" is a recipe for an essentialist film only. In the pragmatic view, the reduction of life to goals and obstacles, plans and frustrations draws the life out of lived experience. Idealist works unify experience by suggesting that characters can pursue a more or less monotonic narrative trajectory through it; pragmatic works celebrate the diversity and heterogeneity of experience by allowing continuous narrative switchbacks, sidetracks, and divagations.

I am speaking metaphorically, of course, but in fact many visionary and pragmatic films actually present experience in terms of similar spatial metaphors. Experience in *Psycho*, *Rear Window*, and *North by Northwest* is generally mapped in straight lines, whereas experience in *Mikey and Nicky*, *The Rules of the Game*, *The Killing of a Chinese Bookie*, and *Bicycle Thief* zigzags not only imaginatively, but spatially. With a dreamlike consistency, Hitchcock's work defines life in terms of straight-ahead movements through space. Like Marion Crane driving in the rain or Arbogast and Lila making their way up the steps of the Bates mansion, the main characters (and the camera) relentlessly move forward—optically and imaginatively pressuring and forcing encounters with whatever is in front of them. The clear implication is that we understand the world by striking, probing, pushing until we break through the delusive surface and reach a secret inner truth (which in Hitchcock's work is often figured as the interior room in a house or an underground plot or cellar).

*Figure 10. A world without resolving depths—truth that is not mental but physical, expressed in particular voices, bodies, spaces, and times (*Faces*)*

In contrast, the Renoir, Cassavetes, May, and De Sica films suggest that there is no inside, no underneath, no beyond to get to, and no secret to uncover. There is no hidden basement of the psyche to work our way down into, but only delightful, dismaying, distracting surfaces to negotiate—sometimes figured as a maze of passages, hallways, or streets angling off in every direction, at other times figures as a maze of social interactions to be negotiated.

At the same time, even pragmatic filmmakers recognize the powerful claims that idealism has on our imaginations. As William James might have put it, no matter how much experience teaches us otherwise, we *crave* points of anchorage that will resolve the turbulence and turbidness of surface expressions. We *want* to believe in the existence of secrets and resolving depths that will clarify the opacity of experience. In acknowledgment of that psychological reality, pragmatic works frequently include characters on essentialist quests—figures who attempt to maintain fixed trajectories through experience, who search for resolving insights and visionary unifications of the randomness and sprawl of experience, like Wallace Shawn's idiocy about "listening to your heart" in *What Happened Was*—even as their films frustrate their designs for living.[24]

Jurieu, Cosmo, Mikey, and Antonio are figures who might have wandered in

from the other kind of movie. They *attempt* to take express trains to get from point A to B without having to make annoying stops en route, but Renoir, Cassavetes, May, and De Sica narratively derail their progress over and over again. Even as these characters attempt to pursue serious, goal-oriented missions, their films spin them out along weird, semicomic narrative curlicues and tangents—exposing them to fascinating distractions, tantalizingly leading them down emotional blind alleys, forcing unexpected reversals of course and bizarre circlings that as often as not land them back where they started. Whereas Hitchcock narratively rewards Lila's, Roger's, Scotty's, and L. B. Jeffries's single-minded purposefulness, Renoir, De Sica, Cassavetes, and May give Jurieu, Antonio, Cosmo, and Mikey an education in eccentricity and excursiveness.

Nonteleological Experience

The spatial differences between the two kinds of films are echoed by the temporal differences. The essentialist narrative is almost always organized around a problem-solving structure in which earlier scenes ask questions or pose problems that subsequent scenes then answer or resolve. Time is teleological: earlier events inexorably lead to later ones and progressively build on them. The narrative is pointed: it is organized as a series of ever more dramatically resonant confrontations, climaxes, and resolutions. The pragmatic work breaks away from the tradition of the "well made" narrative temporally as much as it does spatially. It educates its characters and viewers to the limits of cause-and-effect understandings of experience. It may allow time to pass and nothing apparently to happen. Characters may "get nowhere" (from the perspective of the essentialist narrative) for entire scenes or may even seem to go backward in terms of their narrative progress. The narrative may be punctuated by a series of delays, hesitations, and pauses. Antonio goes off to a fortune-teller and has to stand in line and listen to other fortunes being told; he follows a man into a soup kitchen and, before he can ask him a question, has to wait while he gets a shave and is forced to sit through part of a church service.

John Lennon wrote that life is what happens when you are making other plans, and, as *Bicycle Thief* dazzlingly demonstrates, everything that makes life most fascinating is the result of unexpected glances and movements at a physical right angle to where we thought we were headed, at an imaginative angle to our intentions, goals, and focuses. When Lila works her way into an upstairs bedroom, she is getting ever closer to the truth; when Antonio does the same thing, he is only pursuing one more dead end. There is nothing under the bed, no secret to be revealed. There are only distractions, diversions, and interruptions that will not yield to the pressure of his own needs and desires. The difference is the difference between thinking of life as a series of problems to be solved or as experiences to be undergone. Teleology gives way to process orientation.

Narrative Pluralism

The essentialist film tends to be centripetal, accumulative, and progressive—spiraling inward from unimportant characters to important ones, from the unknown to the known; progressing from the partial to the complete view, from a provisional understanding to a final one, ever more tightly and revealingly focusing on a central figure, event, or object (be it Rosebud, a monolith, a bell tower, or a house on a hill). In contrast, the pragmatic film tends to be centrifugal, sequential, and digressive—moving away from past positions, abandoning previously gained ground, spinning off in new directions. Its law is not ever-tighter focus, but ever-expanding circulation.

The films I have mentioned by Renoir, De Sica, May, Noonan, and Cassavetes create the impression that the narrative contains a host of alternative narratives embedded within it. When Antonio goes into the police station, when the vehicle announcing when the soccer game zooms by, when the young lovers kiss in the background, or when the woman across the courtyard from the bedroom closes the shutters, we are allowed to glimpse bits and pieces of other stories that, although they do not quite make it into the main story, seem just as likely prospects for development. It is as if at any moment, in any scene, the film could go off in a whole other direction with other characters. The narrative road is constantly forking with roads taken and not taken (the literal metaphor for the characters' encounters with experience in both *Bicycle Thief* and *Mikey and Nicky*).

Given the plurality of stories, perspectives, and truths in this stylistic universe, the only thing to do is to keep circulating. No one view can ever be complete or final. One remembers William James's evocative appropriation of George Eliot's metaphor of life as a swim through a dark, muddy ocean:

> The fundamental fact about our experience is that it is a process of change. For the "trower" at any moment, truth, like the visible area round a man walking in a fog, or like what George Eliot calls "the wall of dark seen by small fishes' eyes that pierce a span in the wide Ocean," is an objective field which the next moment enlarges and of which it is the critic, and which then either suffers alteration or is continued unchanged. . . . Owing to the fact that all experience is a process, no point of view can ever be *the* last one. Every one is insufficient and off its balance and responsible to later points of view than itself.[25]

Living in a Loose Universe

In idealist film, the plot and the characters' goals function as a kind of map to keep viewers and characters on the right interpretive road. They keep viewers informed about what to pay attention to and limit what it may mean. They indicate

how far we and they have come on our journey and suggest how far there is to go before the narrative destination will be reached. The pragmatic film denies the viewer such a straight and narrow path through experience. In its emotional and intellectual zigzags, it resembles the mosaic universe described by James in "A World of Pure Experience: "In actual mosaics the pieces are held together by their bedding, for which bedding the Substances, transcendental Egos, or Absolutes of other philosophies may be taken to stand. In radical empiricism there is no bedding; it is as if the pieces clung together by their edges, the transitions experienced between them forming their cement."[26]

James tells us *about* a mosaic universe; these films put us *in* it. They show us what it looks and feels like to live in a world in which individual experiences do not take their shape from a larger, controlling system of meaning that limits our interpretation of them. Characters and scenes are free to reflect their own individual tendencies, to pursue their own narrative inclinations. The pragmatic narrative imagines a universe with room for inconsistent, unique, and mutable expressions. Its allegiance is to honoring the impulse rather than maintaining the system.

Partial, Provisional Truths

The implication is that life is lived, not from the perspective of eternity, but minute by minute, and that if we would apprehend its truths, we must become present-minded and learn to live in the present. There is something unavoidably incomplete about the effect of pragmatic style. Less than eventuating in a final, conclusive understanding, it is given to opening up possibilities. Less than leaving you with certainties at its end, it is given to removing whatever certainties may appear to have existed at its start. Even the small insights that emerge in the course of a pragmatic work are subject to be corrected by a subsequent change of perspective. To employ one of James's characteristic formulations, pragmatic truths are typically of the form: "this, but *not quite* . . . ," "this, but *a little more* . . . ," "this, but *then.* . . ." Pragmatic knowledge is on the move and in process—continually emerging, decaying, and being reformulated. It does not stand still the way thoughts, symbols, lighting effects, mood music orchestrations, and essential character traits do, but flows the way all living experience does.

Nontotalized Style

The preceding should suggest why pragmatic films avoid generalized stylistic effects like mood music, atmospheric lighting, symbolic props, editorializing camera angles, framings, and blockings. Because they reject totalizing understandings of experience, pragmatic works decline to employ totalizing stylistic devices.[27]

Pragmatic knowledge is tentative, provisional, and multiple. It does not yield to summary treatment. It is less absolute than a visionary insight. That is why no one would ever confuse a scene from *The Killing of a Chinese Bookie* with one from *Citizen Kane*. The Welles film parades one summary formulation after another, whereas the Cassavetes work avoids synoptic views. In James's metaphor, Cassavetes's viewer is asked to negotiate the individual pieces of an experiential "mosaic"—pieces that somehow hold together, somehow are joined and coherent, somehow connect one to the other and form a whole—*without* an underpinning, summarizing, abstract, stylistic "bedding."

Yet it is important to emphasize that pragmatic works do not entirely eliminate overarching narrative systems of causality and purposefulness. The swatches in the crazy quilt do hang together. The sequences of experiences in *Mikey and Nicky* and *The Killing of a Chinese Bookie* are not haphazard or random. Narrative structure in pragmatic works functions the way chromatic structure does in jazz performance—as something to play with and against, as something not to be ignored but mastered by being put in its place. The actors, characters, and creators of pragmatic works move a little independently of the narrative without entirely leaving it behind—like a ballerina who inserts grace notes or dances slightly against the musical structure she is immersed in—swerving away from the plot, sidetracking it, temporarily putting it on hold, yet still in a necessary relation to it. Much of the interest of films like *Faces* and *Mikey and Nicky*, in fact, resides in the ways both the filmmakers and their characters energetically bounce off of the narrative and emotional lines that to some extent limit their movements. The pragmatic artist tells us that it is in such a situation of limited constraint that true creativity becomes possible.

Postmodern Variations

To avoid confusion, I would emphasize the fundamental difference between the pragmatic aesthetic and the postmodern. The rootlessness, present-mindedness, freedom from historical encumbrance, cultivated superficiality, and overall looseness of the pragmatic position may make it seem identical to the postmodern, but the differences are crucial. As films like *The Wife, Mikey and Nicky, Faces, A Woman under the Influence*, and *The Killing of a Chinese Bookie* illustrate, the pragmatic position involves complexly *negotiating* the influences that surround us, not merely reclining into them or gliding along with them. While the postmodern position is slack and relaxed, the pragmatic is tense and muscular. While the postmodern position involves passivity and acceptance, the pragmatic requires power, strength, mastery—on the part of both the artist making the work and the main characters in it. For the pragmatist, anything that is not mastery is misery. The postmodernist goes with the flow of the force field around him, whereas the pragmatist tacks and trims and sails upon and against it, turning its very resistance into a source of power.

As Emerson and William James insisted (and the performances of figures like Jeannie, Chet, and Mabel in Cassavetes's work demonstrate), the pragmatic stance involves expressive *work*—the work of making meanings in a world in which past compositions are constantly decomposing, and new meaning-making meets with continuous resistance. The postmodern position represents an entirely easier, more playful, and less serious stylistic surfboard ride. As James argued, in the pragmatic view there are "real life and death struggles to be waged."[28] These films remind us over and over again that, in their view, life is not a game or a goof: there are real suffering and pain to be undergone and real tragedies to be experienced.

The pragmatic position is completely opposed to the skepticism and suspension of value judgments implicit in postmodernism. In the open-endedness and sprawl of their narratives, in their rejection of monotonic paths through experience and their relish of different angles of vision, pragmatic artists do not argue (in the postmodernist vein) that there are no truths, but that there are many. The pragmatist replaces truth with truths—plural truth replacing unitary truth, present truth leaving past truth behind, your truth compared with my truth. That is entirely different from jettisoning the concept altogether or relativizing it to the point that value judgments become impossible. The pragmatic conviction that no truth is final and no perspective definitive does not result in a suspension of judgment or in making every perspective equal, but in enriching and complicating all judgments and perspectives. Pragmatic circulation does not negate but informs and complicates the act of evaluation. To enter into the perspectivism of *Faces* and the multiple-mindedness of *A Woman under the Influence* is not to be set adrift in a world where everyone and every point of view is equally acceptable, but rather to be put in a better position to judge whether, as William James puts it in "Pragmatism and Humanism," the "flux . . . rises or falls in value" as a result of each character's transformation of it.[29] We can all the more clearly perceive Richard's, Freddie's, Maria's, Chettie's, and Jeannie's individual limitations in the one film and Dr. Zepp's, Nick's, Mr. Jenson's, Mama Longhetti's, and Mabel's in the other because we have had the opportunity to circulate through so many different ways of being and knowing, each of which has been respected and honored in itself. In fact, it is only when the pieces of the experiential mosaic are really allowed to assume their own independent inclinations, are allowed to be completely and utterly themselves, that we can fairly assess the true value of each piece.

Critical Difficulty

Insofar as the pragmatic stance subscribes to the notion of truth as being temporally in flux, it should not be surprising that pragmatic works tend to be organized more around the voice than the eye. The objects of the eye stand still;

the creations of the voice shift and slide. Eye knowledge is always more static than voice knowledge. The vocal glissades of *Faces*, *What Happened Was*, and *The Wife* locate us in a world where meaning streams. It is no surprise that most viewers prefer visionary forms of presentation. The pragmatic viewing experience is far more demanding than the experience of idealist work. Visionary film gives us quick, summary, shorthand truth; pragmatic film offers slow, scrawly truth-in-motion. Visionary work gives us smooth, streamlined, clean knowledge; pragmatic film gives us lumpy, rough, dirty knowledge. Visionary work offers the prospect of deep, insightful, essential understanding, whereas pragmatic film offers mazes of superficial, multivalent, hazy expression. The pragmatic display of energy in motion tests both a viewer's powers to keep up with it and a critic's powers to describe it. After many years of evolution, our brains have become much better at grappling with *things* than with *movements*. We are much better at describing works that offer us metaphoric or symbolic *images* than ones that expand our *powers* of response; we are much more attentive to *stances* than *movements* and more interested in *systems* of relationship and identity than in surging, shifting *flows* of energy. Most criticism has unfortunately internalized an essentialist understanding of life and art, with the result that it is not very good at dealing with the ways pragmatic works make meanings. To this neoclassical understanding of art, masterworks like *Mikey and Nicky* and *Faces* merely seem disorganized or confusing.

New Ways of Knowing

If pragmatic works do not simply drive viewers out of the movie theater, demanding their money back, the result is to induce a state of attentiveness distinctively different from what the visionary film cultivates. Since it is impossible to dive beneath the multivalent, shifting expressive surface to a realm of clarifying thoughts and stable intentions, we cannot coast above a scene, but must become more detail-oriented and more open to temporal changes. We are put on the edge of our seats, noticing, listening, pondering, wondering, speculating, and responding—watching flickers of emotion in faces and ebbs and flows of gestural energy, listening to semidemiquavers in voices—following the second-by-second evolution of a complex interaction without the prospect of an ultimate clarification. We must learn to function without road maps and find our comfort within a world with a degree of unresolvable uncertainty. There is no summarizing, deep truth to take away from the experience; there is only the experience itself.

What counts as knowledge changes. Because we cannot ground our readings of scenes in abstract understandings, we must abandon generalities and accept particulars. We must give up the ideal of thinking as an event in which we leave behind the contingencies of temporal and spatial knowledge, and embrace a sense of

thinking that is spatially and sensorily engaged and temporally on the move.[30] We must change our understanding of understanding. To understand the experiences that the pragmatic work presents—as to understand a great jazz performance—is not to leave the perceptual events behind in order to reach a realm of intellectual abstraction and visionary clarity, but to plunge *into* the sensory experience, synchronizing our rhythms with its flow, sensitizing ourselves to its attributes. Pragmatic works teach us to think *in* space and time, not outside of them. The search for the essences of epistemology must be replaced by a willingness to function within the flowing movements of history. The viewing experience becomes less like searching for the solution to a puzzle to "find out" something that will let you leave the puzzle behind you, than a process of living within an unusually stimulating and demanding set of experiences. There is no resolving truth and no end point to be attained in these films. Our inveterate cultural and intellectual quest for product must be replaced by a willingness to remain in process. Plato's sense of truth as essence must be replaced by Rorty's and Dennett's sense of truth as conversation.

Rough Beauty

A common objection to many of the works I have singled out for praise is that they are raw, rough, unpolished, or downright ugly. Because they deny themselves stylistic clarifications, Cassavetes's and May's works lack the visual and acoustic gorgeousness of Welles's or Kubrick's. *The Killing of a Chinese Bookie* has none of the "beauty shots," luxurious musical orchestrations, or symbolic sets and props that *Citizen Kane* employs. Cassavetes's characters and settings do not lend themselves to symbolic summarization. Their uniqueness (bodies, faces, and voices are particularized; locations are not generic) defies generalization. Their physicality (doors stick and objects scrape, clothing does not always fit; interactions are not chiefly mental) defies metaphoric abstraction.

Idealist film allows the viewer to participate in thoughts and feelings that have an unworldly purity and absoluteness. (What else are the emotions in a film like *Titanic* or *Schindler's List*?) The pragmatic work features compromised, mixed emotions—in which generosity and venality, idealism and cynicism, love and pettiness are as mixed together as they are in real life. The result looks like confusion to many viewers.

An Art of the Ordinary

The beauties in the classics of American idealist film—from Sternberg and Welles to Hitchcock, Kubrick, Spielberg, and Lynch—are fundamentally un-

worldly. They originate in the human imagination, celebrate imaginative achievements on the parts of viewers and characters, and have their ultimate form of expression in stylistic arrangements unique to works of art—effects of light and sound, narrative parallelisms and contrasts, virtuosities of formal presentation. The beauties in Renoir's, Leigh's, Cassavetes's, Noonan's, and May's work, in contrast, are *practical*. They represent acts of awareness, responsiveness, and expression that can be *lived*. The pragmatic artist sees the *world*, not the work of art, as the place where the most important and valuable meanings are made. Rather than establishing a special realm of imaginative transformations somewhere beyond ordinary experience, pragmatic art lets the forms and energies of everyday life reach into the work and those of the work reach into the world.

Every visual and acoustic sublimity in *Citizen Kane*, *The Trial*, *Vertigo*, *Rear Window*, *2001*, or *Apocalypse Now* tells us how uninterested their directors are in the struggles, strivings, and undergoings of ordinary, nonvisionary life. These works are world-denying, world-renouncing, and world-fleeing.

The pragmatic artist argues that we do not have to rise above the mess, mutability, and mundanity of everyday life to be profoundly and meaningfully creative. Renoir's, Leigh's, Noonan's, Cassavetes's, and May's characters participate in the glorious dream that animates all pragmatic art and philosophy: the faith that our supreme acts of creativity do not have to be relegated to a "world elsewhere" of imagination (or artistic style), but that we can be artists of everyday life—expressing ourselves in our everyday personalities, words, gestures, and interactions.

Knowledge That Will Not Formulate

The preceding should suggest that the pragmatic way of knowing is not one more system of knowledge, but in fact a rejection of *all* systems. The heart of the pragmatic understanding is that lived experience overflows *all* forms of understanding—including the forms that these works themselves offer. The pragmatic artist accepts the fact that experience leaks out of all intellectual and stylistic containers. That is why it would completely misunderstand my argument to interpret it as implying that filmmakers can simply shift from "idealist" forms of expression to "pragmatic" ones—as if there were such a thing as a "pragmatic form" that a story could merely be poured into. The pragmatic stance does not provide a recipe to cook up art to order (say, one in which "rough," "partial," "personal," or "physical" forms of expression are substituted for "smooth," "totalized," "absolute," or "spiritual" forms of expression). The pragmatic artist rejects received forms. His mode of expression is less a formulated style than evidence of a stylistic breakdown. Pragmatic style is what is left by the failure of style to suffice. The pragmatic style is what happens when the artist is sensitive enough

to see that his formulas will not quite formulate—when she *accepts* stylistic failure and allows herself to fail over and over again. Pragmatic knowledge is less an alternative to visionary/idealist/essential forms of knowledge than the final waking up from the dream of all absolute, complete views. In that respect, pragmatic films continuously dissolve their own congealing understandings; undermining their own certainties; abandoning their own attained positions.[31] Pragmatic films critique *all* conceptual stances, *all* fixed understandings, *all* efforts to possess experience abstractly. They indicate the insufficiency of all attempts to control and contain experience—even their own. That is why, in the most profound sense, they ultimately bring us back to life.

Embracing the World

The pragmatic work returns us to the ideal of artistic "realization" that Ralph Waldo Emerson invoked at the end of "Experience" when he wrote that "the true romance which the world exists to realize, will be the transformation of genius into practical power." Though this vision of an art of the ordinary represents an admittedly minority position, it is a current energizing the great tradition of American expression—from Emerson to Thomas Eakins, John Singer Sargent, George Wesley Bellows, Henry and William James, and John Dewey in this century. The following passage from Emerson's "Art" must stand for all:

> Beauty must come back to the useful arts, and the distinction between the fine and useful arts be forgotten. If history were truly told, if life were nobly spent, it would be no longer easy or possible to distinguish the one from the other. In nature, all is useful, all is beautiful. . . . Art has not yet come to its maturity . . . if it is not practical and moral. . . . There is higher work for art than the arts. . . . Nothing less than the creation of man and nature is its end.[32]

What would it mean to take this passage seriously—not as a figure of speech or an imaginative extravagance, but as a practical program of action? What would it mean for art to have not the creation of works, but the "creation of man" as its purpose? Pragmatic filmmakers show us one possible answer.

Truth in Time, Space, and the Body

Living as we do in the shadow of Plato's vision of knowledge as being a form of contemplative detachment, pragmatic knowledge does not look like knowledge at all. It looks like randomness or sprawl. It is precisely the brilliance of pragmatic works' nonabstracted, nonintellectualized presentation of experience, their replacement of states of thought with acts of perception, their devotion to "broken"

and "incomplete" forms of knowledge, their acceptance of worldy, expressive compromise, contingency, and imperfection that most viewers and reviewers mistake for sloppiness or disorganization. Where the experiences will not fit into old forms of meaning, there may seem to be no meaning at all. To put it bluntly, in comparison with the virtuosic stylistic accomplishments of *Citizen Kane* and *2001*, works like *Faces* and *Mikey and Nicky* look like a mess.

The working premise of this essay is the belief that it is possible to come to the opposite conclusion. If we properly understand them, pragmatic films may make us realize how life-denying the unworldly beauties of *Citizen Kane* and *2001* are. They may remind us that when you leave out the imperfection, the partialness, and the tentativeness of truth, you have left out a lot of life. You have eliminated most of what makes us human. From the pragmatic side of the divide, the inhuman perfection of the stylistic arrangements of idealist works is a sign not of life but death. Only a corpse can be this perfect.

The work of pragmatic filmmakers has yet to be given its critical due. Even beyond the reasons I have already cited, there is clearly something about pragmatic modernism that camouflages its artistic importance (even as it seems that there is something about idealist modernism that makes it appear artistically valuable beyond its intrinsic merits). Perhaps it comes down to something as simple as the prosaicness of pragmatic characters and narratives. It is deep within us to want art that is more elegant, more otherworldly, imaginatively purer than life. Once we have defined art as being above and beyond the emotional muddlements of ordinary experience, pragmatic narratives do not seem grand enough to be great art. Pragmatic films, almost without exception, are stories of ordinary people with all of the emotional confusions and cross-purposes of ordinary life. There are no grand visions or visionary sublimities to their stories. But, of course, my entire argument is that the ordinariness of the forms and understandings in the works is, in fact, what makes these films most extraordinary. Pragmatic films imagine art not to be set in a special place and artists not to be special figures. They tell us that art does not have to be set above or beyond the forms and forces of everyday life. They show us that art's energies and forms of organization can be continuous with those of the world. They imagine ordinary people, at least potentially, as being artists of their own lives and imagine the average man or woman on the street as having experiences that almost pass understanding and defy artistic expression.

The deepest lesson these works teach us is that the supreme creative possibilities of life can be realized by figures like us in a world like the one we live in. But they also tell us that to rise to that challenge we must let go of old ways of knowing and be willing to accept intellectual clutter and emotional mess in our transactions with both art and life. We must brave an adventure of insecurity.

1. For a detailed presentation of this issue from another point of view, see "Stylistic Introduction: Living beyond Consciousness," in Carney, *Films of Mike Leigh*.

2. Though the acoustic side of the visionary aesthetic is outside the scope of this essay, I would note that music is frequently used to focus and intensify the emotionality of the acts of looking that take place in these works.

3. Feminist critics have made the mistake of equating the power of the gaze with voyeurism and the male domination of females. As my examples are intended to illustrate, rapacious acts of looking and seeing are performed in these films by characters of either gender (or no gender—like the Hal 9000 computer in *2001*) on characters of either gender.

4. The sequence demonstrates that music videos did not invent the use of manipulative hyper-kinetic visual and acoustic effects, but only tuned into frequencies being broadcast in American culture long before the MTV generation was born.

5. Henry James, *Portrait of a Lady*, 398.

6. It is well to remember how unusual it is in art outside of the idealist cinematic tradition for consciousness to be put on display in such a direct way. Chekhov's, James's, Balanchine's, or Sargent's works seldom or never aspire to put characters' hearts and minds on display in this direct way. When Henry James wants to convince us of Fleda Vetch's capacities of caring or Shakespeare wants us to see Othello's imaginative limitations and Iago's and Desdemona's imaginative nimbleness and creativity, they do not simply tell us these things (or have the characters themselves or others around them state them). They have them *perform* them. My point is that idealist films are more or less indifferent to the realm of performance. The pure presentation (whether verbally or stylistically rendered) of the unmediated mental or emotional state suffices.

7. I have much more on the cultivation of states of consciousness in idealist works of art in Carney, *Films of Mike Leigh*, 14–30, 86–87, 155–56.

8. Melville, *Moby-Dick*, 967.

9. For an extended application of this metaphor, see Carney, "Polemical Introduction."

10. Emerson, "Emancipation in the British West Indies," 774.

11. On the denials of sensory reality in idealist film and this scene in particular, see Carney, *Films of John Cassavetes* (1994), 164–73, 199–206, 275–80.

12. William James, "A World of Pure Experience," 1175. I have more on concepts of aboutness and the removal from the sensory flow from life in Carney, *Films of John Cassavetes: The Adventure of Insecurity* (1999), 32–38, and *Films of Mike Leigh*, 72–73, 210–13.

13. It does not seem accidental that generic understandings of experience came to the fore in the culture that crossed the abstractness of postromantic visionary understandings with capitalistic notions of interchangeability. As Tocqueville suggested, it is in the nature of both forces that they level individual expressive differences. On generic understandings of expression, see the preface to the 1996 edition of Carney, *American Vision*, and the pages devoted to "Multicultural Unawareness" on my web site (http://people.bu.edu/rcarney).

14. The most debased manifestation of this ideal of effortless imaginative inhabitation is the mimetic world of prime-time television—whether in fictional shows like *Seinfeld* or news programs like *60 Minutes*. The entire production does nothing but push preestablished imaginative buttons, cycling from one cliché to another.

15. William James, "Pragmatism and Humanism," 602.

16. I have much more on what I here call the pragmatic myth of a free and independent state of consciousness in Carney, *Films of Mike Leigh*, 86–87, 111–12, 135–36. The generality of experience in idealist works is what makes Hollywood movies comprehensible to viewers from different backgrounds—in America and around the world. Although the Renoirian film requires an understanding of specific manners and mores, you don't have to know anything *in particular* to understand intentions, feelings, motives, and ideas.

17. Robert Altman's work raises an interesting side issue in this regard. Insofar as he creates galleries of idiosyncratic figures and complex visual spaces in works like *Three Women*, *Nashville*, *Short Cuts*, and *Ready to Wear*, he might seem to be doing what I am describing. But the difference is that, rather than appreciating a variety of different points of view, Altman clearly judges his characters and situations. He sniggers and jeers at them. He patronizes them and acts superior to them. That is to say, though his work is "open" in what it shows, it is really "closed-off" in its values. The point is that the pragmatic view of experience only trivially involves opening a work up optically or physically; the important openness it must display is emotional and intellectual. (The same qualification applies to the work of Quentin Tarantino, David Lynch, and Joel and Ethan Coen.) As a counterillustration of genuine "circulation" through a range of changing points of view, see Carney, *Films of Mike Leigh*, 90–93, 140–45, 173–77, 202–6.

18. *Bicycle Thief* employs an additional variation on the ninety-degree turn, not only frequently turning the characters and their interactions at an angle to the viewer, but also having them look at something the viewer cannot see. Antonio's wife looks through a window we cannot see into, characters he is pursuing turn corners and disappear into spaces to which a viewer does not have visual access. The geography of the film creates pockets of invisibility.

19. I have discussions of the difference between "loose" and "tight" semantic relations to experience in Carney, *Films of Mike Leigh*, 179–86, 217–22. The narrative sprawl, nontendentiousness, and general semantic relaxation of works like Claudia Weill's *Girlfriends* and Paul Morrissey's *Trash* provide other cinematic illustrations of loose knowledge.

20. William James, "Pragmatism and Humanism," 601.

21. Whitman, *Democratic Vistas*, 496.

22. See Carney, *Films of John Cassavetes* (1994), 143–83, 271–81. This ontological volatility is what confused critics about the work of Cassavetes and May (and convinced them that it was improvised). It goes without saying that even in nonfoundational films many characters may fail to realize the possibilities of ontological openness that are available. In Cassavetes's work as in life, many characters run from freedom and take refuge in conventional roles, styles, and formulas for selfhood. There are a number of minor characters in his work and that of Elaine May who are as narrowly essentialist as any of Hitchcock's: the characters played by Val Avery and Tim Carey in Cassavetes, and the coffee shop clerk, "no smoking" woman, and bus driver in *Mikey and Nicky*, for example. They are dramatic foils who indicate the limitations of identities that can be brought "into focus" and the paltriness of experiences that are reducible to fixed plans and goals. The main characters in these works—Mikey, Nicky, Chet, Jeannie, Mabel, Sarah, and Myrtle—indicate imaginative escape routes out of such dead ends for development.

Cassavetes's preferred dramatic technique is, in fact, to surround his most open-ended characters with figures who fail to realize the same degree of freedom. In *A Woman under the Influence*, for example, Nick is contrasted with his wife Mabel. Nick tries to organize events, conversations, and the people he interacts with into straight and narrow trajectories and to understand them in terms of essentialist perspectives, whereas Mabel embraces true multiplicity. The subject of the film might be said to be the demonstration of how experience escapes Nick's designs on it and eludes his efforts to contain it.

Even more subtly, Cassavetes sometimes situates his most interesting figures on the hazy boundary where their freedom is incomplete and blurs into rigidity. The drama of his work was generated by his characters' subtle movements back and forth, into or out of states of genuine ontological openness—as *Shadows'* Lelia, *Faces'* Louise, Maria, and Richard, and *Husbands'* Harry, Archie, and Gus all illustrate.

23. There are occasional solo flights in pragmatic films (Jurieu in *The Rules of the Game*, Freddy and McCarthy in *Faces*, Nicky in *Mikey and Nicky*, e.g.), but the character is judged adversely for his failure to interact.

24. Cassavetes's *The Killing of a Chinese Bookie* and *Love Streams* present extended illustrations of the

process of including world-fleeing idealist/visionary/essentialist stances within works that are opposed to these ways of being. Cosmo Vitelli is a shoestring dramatist and choreographer, and his personal artistic style is as idealist as that of any of the visionary filmmakers I have mentioned. He devotes his entire life to a Sternbergian effort to use artistic and personal style to create a realm of beauty and order that will wall out the mess and confusion of the real world. *Love Streams*'s Robert Harmon is another figure who is engaged in a similar attempt to retreat into a cabana of the imagination. (He is also an "essentialist" who devotes himself to the belief that every woman he meets has a "secret" that holds the key to her personality.) Both characters' idealizing efforts are dramatically criticized by Cassavetes. The world keeps intruding to disrupt their world-fleeing dreams. For more on Cassavetes's relation to idealist filmmaking practices and specifically on his relation to Welles, see Carney, *Films of John Cassavetes* (1994), 195–202, 229–34.

25. William James, *The Meaning of Truth*, 874–75.

26. William James, "A World of Pure Experience," 1180.

27. The pragmatic filmmaker is much more likely to rely on acting to convey meaning, because acting of the kind that pragmatic works favor is not based on an essentialized understanding of personality or an abstract interpretation of a character's situation. It can be a matter of small details and local effects, a moment-by-moment affair in which meanings made at any one instant are overwritten or altered in the next.

28. William James, "Pragmatism and Humanism," 232–33.

29. Ibid., 598.

30. If it is hard to conceive of thinking as having sensory properties, consider the kinds of thinking choreographers or portrait painters engage in and the kinds of knowledge their work communicates. The works of Eakins and Balanchine represent acts of thought inseparable from the physicality by which the thought is apprehended. What would it mean for a portrait painter or a choreographer to express an idea that was *not* spatial and temporal—a truth that was not in a body? For slightly more on the concept of epistemological "embodiment," see Carney, "Yellow Pages of Theory and Criticism," 138–43, and "When Mind Is a Verb: Thomas Eakins and the Work of Doing," 377–403.

31. In Carney, *Films of Mike Leigh*, 60–62, I have a discussion of how a work can do this.

32. Emerson, "Experience," 492, and "Art," 439–40.

BIBLIOGRAPHY

Carney, Ray. "A Polemical Introduction: The Road Not Taken." *Post Script* 11, no. 2 (Winter 1992): 3–12. Available on the Internet at ⟨http://people.bu.edu/rcarney⟩.
——. *The Films of John Cassavetes: Pragmatism, Modernism, and the Movies.* New York: Cambridge University Press, 1994.
——. "A Yellow Pages of Theory and Criticism." Review of *The Johns Hopkins Guide to Literary Theory and Criticism. Partisan Review* 62, no. 1 (Winter 1995): 138–43.
——. *American Vision: The Films of Frank Capra.* Hanover: Wesleyan University Press/University Press of New England, 1996.
——. "When Mind Is a Verb: Thomas Eakins and the Doing of Thinking." In Morris Dickstein, ed., *The Revival of Pragmatism: New Essays on Social Thought, Law, and Culture*, 377–403. Durham, N.C.: Duke University Press, 1998.
——. *The Films of John Cassavetes: The Adventure of Insecurity.* Boston: Company C, 1999.
——. *The Films of Mike Leigh: Embracing the World.* New York: Cambridge University Press, 2000.
Emerson, Ralph Waldo. "Art" and "Experience." In *Essays and Lectures.* New York: Literary Classics of the United States, 1983.
——. "Emancipation in the British West Indies." In *The Selected Writings of Ralph Waldo Emerson*, edited by Brooks Atkinson. New York: Modern Library, 1992.
James, Henry. *The Portrait of a Lady.* 1881. Reprint, *Novels, 1881–1886.* New York: Literary Classics of the United States, 1985.

James, William. *The Meaning of Truth*. 1909. Reprint, *Writings, 1902–1910*. New York: Literary Classics of the United States, 1987.

——. "Pragmatism and Humanism." In *Writings, 1902–1910*. New York: Literary Classics of the United States, 1987.

——. *Some Problems of Philosophy*. Reprint, *Writings, 1902–1910*. New York: Literary Classics of the United States, 1987.

——. "A World of Pure Experience." In *Writings, 1902–1910*. New York: Literary Classics of the United States, 1987.

Melville, Herman. *Moby-Dick, or The Whale*. 1851. Reprint, *Redburn, White-Jacket, Moby-Dick*. New York: Literary Classics of the United States, 1983.

Whitman, Walt. *Democratic Vistas*. In *Complete Poetry and Collected Prose*. New York: Literary Classics of the United States, 1982.

NOTES ON THE CONTRIBUTORS

Casey Nelson Blake is professor of history and director of the American Studies Program at Columbia University. He is the author of *Beloved Community: The Cultural Criticism of Randolph Bourne, Van Wyck Brooks, Waldo Frank, and Lewis Mumford* (1990) as well as many essays on American cultural and intellectual history. He is currently writing a book on the politics of public art in postwar America.

Robert Cantwell teaches American Studies at the University of North Carolina at Chapel Hill. His most recent book is *When We Were Good: The Folk Revival* (1996).

Ray Carney is professor of film and American Studies at Boston University and director of the Film Studies program. He is the author of ten books, including *The Films of John Cassavetes: Pragmatism, Modernism, and the Movies* (1994), *American Vision: The Films of Frank Capra* (1996), *The Films of John Cassavetes: The Adventure of Insecurity* (1999), *The Films of Mike Leigh: Embracing the World* (2000), and *Cassavetes on Cassavetes*. He is the general editor of the Cambridge Film Classics series and is regarded as one of the world's experts on American film and philosophy. He maintains a Web site at ⟨http://people.bu.edu/rcarney⟩.

Thomas Fahy is a doctoral candidate at the University of North Carolina at Chapel Hill. Currently, he has work appearing in *Prospects*, *Style*, *Women's Studies*, *Shofar*, and *African-American Review*. His dissertation examines freak shows and "freakish" bodies in twentieth-century American literature.

Lucy Fischer is a professor of film studies and English at the University of Pittsburgh, where she directs the Film Studies Program.

She is the author of *Jacques Tati* (1983), *Shot / Countershot: Film Tradition and Women's Cinema* (1989), *Imitation of Life* (1991), *Cinematernity: Film, Motherhood, and Genre* (1996), and *Sunrise* (1998).

John F. Kasson has been professor of history and American Studies at the University of North Carolina at Chapel Hill since 1971. His publications include *Civilizing the Machine: Technology and Republican Values in America, 1776–1900* (1976), *Amusing the Million: Coney Island at the Turn of the Century* (1978), *Rudeness and Civility: Manners in Nineteenth-Century Urban America* (1990). and *Strongmen and Escape Artists: The White Male Body and the Crisis of Modernity* (forthcoming).

William E. Leuchtenburg, William Rand Kenan Jr. Professor at the University of North Carolina at Chapel Hill, is the author of many books, most recently *In the Shadow of FDR: From Harry Truman to Bill Clinton* (1993), *The Supreme Court Reborn: The Constitutional Revolution in the Age of Roosevelt* (1995), and *The FDR Years: On Roosevelt and His Legacy* (1995). He has lectured at the North Carolina Museum of Art, the Springfield Museum of Art, and the Whitney Museum of American Art, for which he has also served as a consultant.

Townsend Ludington is Boshamer Distinguished Professor of English and American Studies at the University of North Carolina at Chapel Hill, where he directs the American Studies Curriculum. He is the author of *John Dos Passos: A Twentieth-Century Odyssey* (1980, 1998) and the editor of *The Fourteenth Chronicle: Letters and Diaries of John Dos Passos* (1973). In addition, he has written *Marsden*

Hartley: The Biography of an American Artist (1992, 1998) and numerous other pieces about American writers and artists and their culture.

Lucinda H. MacKethan is a professor of English at North Carolina State University. Her publications include *The Dream of Arcady: Place and Time in Southern Literature* (1980), *Daughters of Time: Creating Woman's Voice in Southern Story* (1991), and *Scribbling Women: A Guide to Radio Play Series of American Women's Short Stories* (1998). She has recently edited and published two Civil War memoirs by women who grew up on rice plantations in Georgia (1998, 1999).

Randy Martin is professor of sociology and chair of the Department of Social Science at Pratt Institute. His books include *Performance as Political Act: The Embodied Self* (1990), *Socialist Ensembles: Theater and State in Cuba and Nicaragua* (1994), and *Critical Moves: Dance Studies in Theory and Politics* (1998).

Carol J. Oja is Margaret and David Bottoms Professor of Music and Professor of American Studies at the College of William and Mary. Previously, she was director of the Institute for Studies in American Music at Brooklyn College (CUNY). A specialist in twentieth-century American concert music, she is the author of *Making Music Modern: New York in the 1920s* (2000) and *Colin McPhee: Composer in Two Worlds* (1990), as well as the editor of *A Celebration of American Music: Words and Music in Honor of H. Wiley Hitchcock* (1990), *American Music Recordings: A Discography of 20th-Century U.S. Composers* (1982, with Richard Crawford and R. Allen Lott), and

Stravinsky in "Modern Music," 1924–1946 (1982). She has published articles about Marc Blitzstein, Aaron Copland, Colin McPhee, Dane Rudhyar, William Grant Still, Virgil Thomson, and other prominent American composers.

Miles Orvell is professor of English and American Studies at Temple University. He has written on the relationships between photography, literature, and culture in two works, *The Real Thing: Imitation and Authenticity in American Culture, 1880–1940* (1989) and *After the Machine: Visual Arts and the Erasing of Cultural Boundaries* (1995). He is presently working on a history of American photography and compiling a volume of John Vachon's letters and photographs from the FSA years.

Joan Shelley Rubin is professor of history at the University of Rochester. She is the author of *Constance Rourke and American Culture* (1980), *The Making of Middlebrow Culture* (1992), and numerous articles. A coeditor of *A History of the Book in America*, she is working on a study entitled *Poetry in Practice*, for which she received a Guggenheim Fellowship in 1997.

Jon Michael Spencer is director of the African American Studies Program and professor of religion at the University of South Carolina. He is the author of eleven academic monographs, a book of poetry, and a novel.

Maren Stange teaches American Studies at the Cooper Union in New York City. Her publications include *Official Images: New Deal Photography* (1987), *Symbols of Ideal Life: Social Documentary Photography in America, 1890–1950* (1989), and *Paul Strand: Essays on His Life and Work* (1990).

INDEX

formal experimentations by, 180; and futurism, 180; *Third Sonata, "Death of Machines,"* 180; *Second Sonata, "The Airplane,"* 180, 181, 190; *Sonata Savage,* 180, 190, 194; and Ornstein, 181; and innovation, 186; "My Ballet Mécanique: What It Means," 186; and time-space, 186–88, 198 (n. 36); writings of, 188; *Mechanisms,* 190; Paris debut of, 190; and pianola, 193; and primitivism, 193–94; racial attitudes of, 193–95; and Handy, 194, 200 (n. 66); crushed by failure of *Ballet Mécanique,* 195; diminished reputation of, 196; and Anderson, 197 (n. 13); and "modern artists society," 197 (n. 13); and Satie, 197 (n. 15); lost works by, 198 (n. 27); and Picabia, 198 (n. 28); and Léger, 199 (n. 44); and *Rêlache,* 199 (n. 44)

—*Ballet Mécanique,* 7, 180; initially judged a failure, 7; and Dada, 7–8, 188, 193; legacy of, 7–8, 196; and machines, 176, 185, 196; and African Americans, 176, 194; American premiere of, 176–77, 184, 187, 189, 190, 194, 195, 199 (n. 54); publicity flier for, *177*; world premiere of, 177; American roots of, 178; as influence on Cage, 178, 186; and innovation, 178, 188–89; influences on, 178, 193; machines in, 184, 189, 193; ties to visual arts of, 185; rationale for, 186; silence in, 186–87; repetition in, 188, 189; physicality of, 189; and time-space, 189, 193; opening section of, 190; scored for percussion and machines, 190; and pianola, 190, 192, 198; and Stravinsky, 190–92; and Varèse, 191, 198 (n. 25); innovations in, 193, 198 (n. 33); marketing of, 195; response to, 195; recording of, 198 (n. 28); revisions of, 198 (n. 33), 199 (n. 54). *See also* Léger, Fernand: *Ballet Mécanique*

Antonioni, Michelangelo: *The Red Desert,* 348; *L'Avventura,* 348, *349*

Aperture, 290

Apocalypse Now, 367, 372, 380, 385, 391

Apollinaire, Guillaume, 187, 199 (n. 59)

Appleton, Nathan, 156

Architecture, 1, 6, 12, 42; materials used in, 12, 39–40; classical, 13–14, 32, 39; ephemerality in, 14; and monuments, 14; European, 14, 32; Chicago School, 32; Italian Renaissance, 32; neoclassicism in, 32; and Beaux Arts, 32, 37, 40, 42; and skyscrapers, 32, 37–39, 175; Russian, 34; and capitalism, 38; and industrialization, 38; spectacle in, 38; civic, 159. *See also*

White City; World's Columbian Exposition of 1893; *specific architects*

Armory Show of 1913, 187, 228, 238

Armstrong, Louis, 75

Arnold, C. D., 20

Arnold, Edward, 366

Arnold, Horace, 156

Arnold, Matthew: "The Forsaken Mermaid," 133; "Sohrab and Rustum," 143

Art, visual: and Abstract Expressionist movement, 6, 287, 301 (n. 18); pop, 6–7, 265, 344; precisionist abstraction in, 8; government support for, 8–9, 167, 227–41 passim, 258–73 passim; primitivism in, 54; Russian constructivist, 169; and machines, 180, 184; as epiphany, 206; abstract, 227–29, 242–45, 285, 293; conservativism in, 228; and Parisian aesthetics, 228; Mexican, 230–31, 235, 244; community support for, 237, 271–72; social protest, 239; social realist, 243–44, 285, 288; and capitalism, 244; and Left, 244; regionalist, 244; public defunding of, 257; minimalist, 265; and war memorials, 267; and public monuments, 273. *See also.* Cubism; Dada; Futurism; Painting; Photography; Sculpture; Surrealism

Art Bulletin, 242

Arthur, Jean, 366

Artists Union, 286

Art Students League, 229

Ash, Benjamin (the "Spotted Boy"), *77*

Ashcan School, 3

Ashton, Dore, 245

Assembly lines, 168; at Ford Motor Company, 153–55, 171–72; and dance, 154–56, 169, 171; and production time, 155; and flow of production, 155–56; and auto industry, 156; as industrial revolution, 156; and textile industry, 156; and workers, 157, 161, 168; in film, 161; repetitive motion of, 163; and chorus lines, 168

Astaire, Fred, 7, 164–67, 173 (n. 23)

Atget, Eugene, 341

Atlanta University, 60, 291

A Tree Grows in Brooklyn, 335

Auster, Paul, 347

Avery, Milton, 243

Baca, Judy: *Great Wall of Los Angeles,* 271

Backus, Jim, 366